Chumy Cauls

- 1984 -

THE PELICAN HISTORY OF ART

Joint Editors: Nikolaus Pevsner and Judy Nairn

Otto J. Brendel

ETRUSCAN ART

Prepared for press by Emeline Richardson

Otto J. Brendel died on 8 October 1973, shortly before the completion of
this work. Born in 1901 in Nuremberg, he studied mainly under Ludwig Curtius,
Eugen Täubler, Karl Meister, Friedrich von Duhn, and Karl Lehmann-
Hartleben. In 1928 he received his Ph.D. at Heidelberg, summa cum laude. From
1923 to 1926 he served as Assistant Keeper at the Ny-Carlsberg Glyptotek
in Copenhagen. He started his university career as Assistant Professor
of Classical Archaeology at the University of Erlangen and while on leave of
absence was First Assistant at the German Archaeological Institute in
Rome from 1932 until 1936. 1936–1937 he spent as Research Fellow of Durham
University in Newcastle-upon-Tyne. In 1939 he accepted an invitation
by Washington University, St Louis, to teach Classical Archaeology and History
of Art; two years later he became Professor at Indiana University,
Bloomington, and in 1956 at Columbia University. After his retirement he
went on teaching special courses at Columbia University until 1973 and gave a
seminar at Princeton University on Roman painting. His fields were
primarily Greek, Roman, and Etruscan art, but he lectured and wrote on many
other subjects in the history of art.

Penguin Books

Otto J. Brendel · *ETRUSCAN ART*

Penguin Books Ltd, Harmondsworth, Middlesex, England
Penguin Books, 625 Madison Avenue, New York, New York 10022, U.S.A.
Penguin Books Australia Ltd, Ringwood, Victoria, Australia
Penguin Books Canada Limited, 2801 John Street, Markham, Ontario, Canada L3R 1B4
Penguin Books (N.Z.) Ltd, 182–190 Wairau Road, Auckland 10, New Zealand

First published 1978

Library of Congress Cataloging in Publication Data
Brendel, Otto, 1901–1973.
Etruscan art.
(The Pelican history of art)
Bibliography: p. 481.
Includes index.
1. Art, Etruscan. I. Title. II. Series.
N5750.B67 1977 709'.37'5 77-22662
ISBN 0 14 0561.43 9 (paperback)
ISBN 0 14 0560.43 2 (hardcover in Great Britain)
ISBN 0-670-29880-8 (hardcover in the United States of America)

Printed in the United States of America by
Kingsport Press, Inc., Kingsport, Tennessee
Set in Monophoto Ehrhardt

Designed by Gerald Cinamon

CONTENTS

EDITOR'S FOREWORD

The distinguished and varied career of Otto Brendel, who died on 8 October 1973, is summarized on the first page of this volume. To this must be added a word on the man himself.

As the outline of his career indicates, he was exceptionally many-sided in his interests. Apart from his literary accomplishments, as a boy he wanted to be a painter, and throughout his life he kept up his appreciation of music. The first paper of his which I read was on late Titian. William M. Calder III, Professor of Classics at Columbia University in New York, ended a biographical note on Otto Brendel thus:

'He was that rarest of creatures, a humane humanist. He was learned, eloquent, travelled but also hardworking, honest, generous, loyal, a Menschenfreund. Not by accident did he read Goethe so ardently. The world of Art in its widest sense, literary, musical, visual was his kingdom; and because Art was of a certain time and place, history and philology, even in their most arcane subdivisions, won his allegiance.'

When Otto Brendel died this book was not yet finished. Completion would have been impossible if it had not been for the help of Mrs Richardson. Besides writing most of Chapter 31, she contributed paragraphs on recent discoveries and publications, added quite a number of notes, and dealt with the illustrations and with numerous questions of detail. I am very grateful to her, as readers too will be.

Nikolaus Pevsner

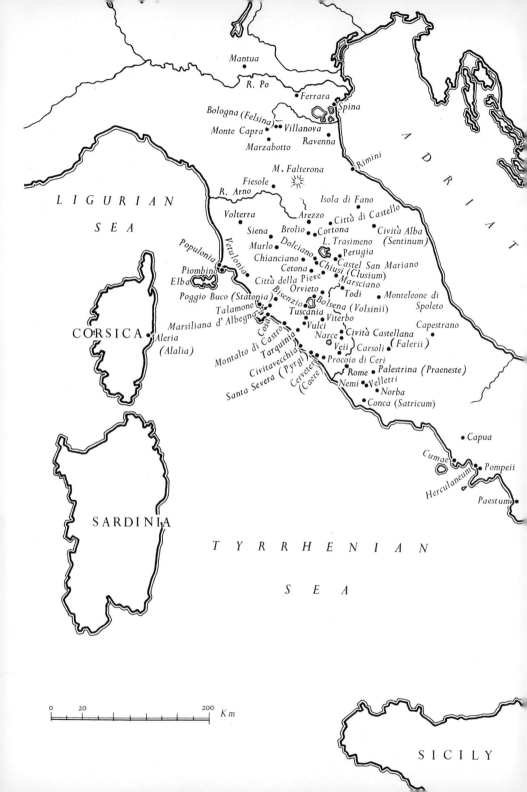

Mantua

R. Po

Ferrara

Spina

Bologna (Felsina)

Monte Capra • Villanova

Ravenna

Marzabotto

M. Falterona

Rimini

LIGURIAN

SEA

Fiesole

R. Arno

Isola di Fano

Volterra

Arezzo Città di Castello

Siena Brolio Cortona Città Alba

Populonia Murlo Dolciano (Sentinum)

Vetulonia L. Trasimeno

Piombino Chianciano Perugia

Elba Cetona Castel San Mariano

Città della Pieve Chiusi (Clusium)

Poggio Buco (Statonia) Orvieto Marsciano

Bisenzio Todi

Talamone Bolsena (Volsinii) Monteleone di

Marsiliana d'Albegna Tuscania Spoleto

Coso Viterbo

CORSICA Montalto di Castro Vulci Capestrano

Aleria Tarquinia Narce Civita Castellana

(Alalia) Civitavecchia Veii (Falerii)

Santa Severa Cerveteri Procoio di Ceri Carsoli

(Pyrgi) (Caere) Rome Palestrina (Praeneste)

Nemi Velletri

Norba

Conca (Satricum)

Capua

Cumae

Pompeii

Herculaneum

Paestum

SARDINIA

T Y R R H E N I A N

S E A

0 20 200 Km

SICILY

ADRIATIC

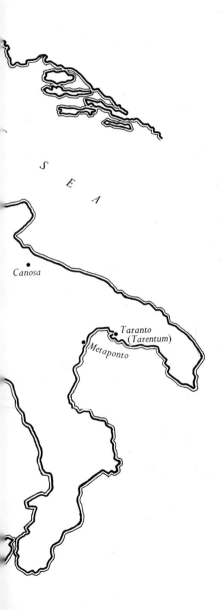

ETRUSCAN ART

S E A

• *Canosa*

• *Taranto*
(Tarentum)

• *Metaponto*

There is no subject, in which we must proceed with more caution than in tracing the history of the arts and sciences; lest we assign causes which never existed and reduce what is merely contingent to stable and universal principles.

DAVID HUME

THE VILLANOVAN AND ORIENTALIZING PERIODS

INTRODUCTION

THE PROBLEM OF ETRUSCAN ART

The arts of the past must be measured by the variousness and quality of their creations; that is, by their contributions to our total store of experience and self-knowledge, as a cultural species. No doubt from this point of view the art of the Etruscans constitutes a very interesting chapter; it also forms one of the most problematic in the ancient Mediterranean. For of the Etruscans as a people we still know but little, and even less of their origin. Only one circumstance stands out and lends a unique importance to the Etruscan materials. It seems that from the beginning Etruscan art was a product of the Italian peninsula – at least so far no trace of it has come to light in any part of the world other than Italy, except such specimens as were exported from Etruria. For all we know this art was thriving in Italian centres. Yet more often than not it followed standards of imagery and representation which developed outside Italy: in Greece.

It is this circumstance which causes so much uncertainty regarding not only the art but the entire civilization of ancient Etruria. On the whole, Etruscan is a branch of the civilization which we call classical. Its motivations, however, and the spirit behind the images were not always the same as in Greece. A special ingredient of style and intention seems active in many Etruscan creations which may well puzzle the observer, precisely because it expresses itself so often in the familiar forms of Greek art, while nevertheless the outcome is not wholly Greek.

This fact suggests to many critics an underlying attitude not only different from, but actually contrary to, the Greek.

On the other hand, to determine definitely what is and what is not a Greek element in a work of Etruscan art is often a precarious undertaking. Its very closeness to the Greek makes Etruscan art difficult to judge. The deeper workings of its production are hidden from us, as is for the most part the meaning of the language which its makers spoke. All we perceive is the obvious result: a constant adherence to Greek standards of representation in an art which nevertheless differs noticeably from the Greek, by scope and purposes. Therefore, to declare Etruscan art a mere derivative of the Greek can hardly serve as a sufficient explanation. Nor can we say that the apparent Grecism of so many – by no means all – Etruscan works was a mere surface form, superimposed on a foreign content. While filling the early Italian cities and provinces, including the city of Rome, with their pictures and statuary, the Etruscans through the centuries established a cultural and artistic tradition quite their own. Their style was 'classical', if we want to use this term, in so far as it founded itself on the concepts, methods, and progress of the Greek; but it was not itself Greek. On the contrary, it constitutes the only known case of a contemporary classical art apart from the Greek.

It follows that we must describe Etruscan art in its relation to its foreign counterparts, and treat it as that which it obviously was: the western equivalent of the classical style. Its generally Greek orientation has to be counted

among its constituent features; the reality and persistence of its rapports with Greek art cannot be doubted. Only when we wish to define the nature and to account for the presence of these leanings do difficulties arise. Yet without a discussion of these two problems, Etruscan art must needs appear as an unaccountable incident, a kind of erratic block in the fields of the classical civilization. One may even doubt to what extent the Etruscans contributed at all to this civilization. Equally uncertain remains their effect, if any, on that last synthesis of ancient culture, the Roman empire. Conversely it remains a moot question whether Roman art can at all be understood without an insight into the character and the conditions of the Etruscan; and if any coherence whatever can be discovered in the various manifestations of art in ancient Italy.

These questions present a challenge not only to our factual knowledge but also to our critical concepts. They urge us to refurbish our tools of investigation. The case of the Etruscans is an irregular one in ancient art if as a rule we expect the same sharp distinction of style between the individual groups and periods which, for instance, existed between Greek and Egyptian art. Certainly the dividing line between Greek and Etruscan art is not equally obvious, and at times appears blurred. The simple fact is that the Egyptian style never made much headway beyond the frontiers of Egypt, while Greek art did. Etruscan works of art imitate Greek art, or often look like Greek art, because the latter was then on the way to setting a world standard. Greek, not Egyptian, subsequently became an 'international style': the Etruscans were the first to make it so.

Therefore, instead of a diverging development, as in the case of the Greek and Egyptian arts, we find in Etruscan Italy a parallel and regional development, based on a community of standards with the Greek not unlike the relation between French Gothic and English Gothic. This parallelism – a development in terms of similarities and discrepancies – we must strive to understand and describe. It is the leading theme of all Etruscan art. Its roots lie in the origin of the new art itself which resulted from a process of cultural migration. To this process we must now turn our attention.

THE DISCOVERY OF ITALY

Greeks and Phoenicians

There can be no doubt that the Mediterranean high civilization established itself in Italy somewhat later than in Greece, and that a transfer of culture from east to west was involved in this process. When exactly the process began it is difficult to say; certainly it did not gain momentum before the eighth century.* Neither has it been possible so far to discern its details with equal certainty in all parts of the peninsula. We do know, however, that the comparative isolation of prehistoric Italy did not end by a single event or a uniform process. Different events in various regions contributed to her cultural transformation, with results which proved fundamental for all later history:[1] that is to say, a change of cultural and social status occurred and more or less affected all Italy, if in various ways. The most important symptom was the rise of new cities, organized as autonomous states, which laid the foundation for an urban civilization of the type already flourishing in the eastern Mediterranean. While the rather sudden urbanization of the ancient Italian culture thus appears as the basic fact, three regions stand out as culturally distinctly different in regard to the manner in which the process was accomplished. They are the area of Greek colonization in the south, including Sicily; the area later called Etruscan, in central Italy; and between these two, the Latin territory with the city of Rome. The low lands north of the Apennines, the valley of the Po, at first remained outside the orbit of these events.

For an outline of art in ancient Italy it is essential that we first understand the nature of the differences between these regional developments, as well as the community that existed

*Unless otherwise indicated, dates are B.C. throughout.

between them. Of the three major areas affected, the southern offers the clearest picture. The following features emerge as significant. The urbanization of the Italian south came about entirely as a result of immigration from abroad. Whether or not the Phoenician settlements along the west coast of Sicily made the beginning is still a moot question;[2] on the whole their cultural effect remained negligible compared to the impact of the Greek cities. The earliest Greek town – the city of Cumae – was founded in the north of the area around 750.[3] Others of later fame followed after the middle of the eighth century, in the southern peninsula as well as in eastern and southern Sicily. Their subsequent histories and deadly rivalry with the Phoenicians lie beyond the scope of this book. What matters is that, seen as a whole, the process of higher civilization in this area appears as a transfer of culture by foreign emissaries, and by concerted effort. The Greeks were more numerous; and eventually their culture prevailed in south Italy.

The Greek settlers arrived in organized groups – this was possible largely owing to advances in the science of navigation made during the eighth and seventh centuries – and they came with the intention to stay. Their cities were founded with an eye to the seaborne trade which permanently connected them with the motherland; and they established themselves amidst a rather backward, 'prehistoric' native population whom they utilized, but hardly transformed culturally. The contrast of language between settlers and colonists lasted for a long time, and the cultural lag of the hinterland in comparison to the superimposed high culture of the trading cities was never quite made up. All in all, we perceive the picture of a truly colonial civilization; that is, a consciously directed extension of Greek culture into Italian territory. As is usual in such conditions, native peasant culture and foreign city civilization came to exist abruptly side by side. But the cities remained Greek, in point of language as well as culture. Their art, which soon began to flower, remained Greek art and must be described as such, notwithstanding certain local characteristics.

Etruria[4]

The situation in central Italy is far less clear. There, also, towns arose and perhaps were founded by a planning effort: the Etruscan cities, of which Tarquinia was the most renowned and possibly the oldest, although nearby Caere (now Cerveteri) and others were hardly more recent. Soon a string of new cities was moving northward along the Etruscan coast to Populonia. Somewhat later the urban civilization of the coastlands expanded into the interior, founding in the Umbrian hills Etruscan fortresses such as Perugia. The Etruscan towns, like the Greek, were probably organized as sovereign communities, but none of them quite attained the free status of a Greek *polis*. Eventually they formed a close alliance amounting to a confederate state – the first of its kind in western history.

What precisely caused the rise of these cities, and who founded them, it is now difficult to say. In historical times the inhabitants of the territory both in and outside the cities spoke Etruscan, a language not known elsewhere, which died out towards the end of the pre-Christian era, just as now certain Gaelic dialects are about to disappear in parts of England and France. The origin neither of this language nor of the people who spoke it can at present be determined. But although a cultural contrast between town and country existed here no less than in the south, and generally has remained typical of Italy to this day, it seems that in Etruria the spoken language often established a bond of communication between the cities and the rural population, of a kind not found among the ancient Greek colonies of southern Italy.

Naturally, the most pressing problem before modern research is to assess the strength and importance of foreign immigration, and to localize its homeland. On this question opinions were divided in antiquity; they still are. An ancient tradition expounded already by Herodotus has it that the Etruscans came to Italy from Asia Minor, but there was no certain knowledge about the matter, and other theories likewise claimed attention; for example that the Etrus-

cans had entered Italy from the north. Nor can our ancient sources give us a reliable indication as to the time when the Etruscan cities were founded. In modern terms the Etruscan question must primarily be treated as a linguistic one; and here it must be noted from the outset that to its solution the study of the artefacts cannot contribute very much.

If on the other hand we base ourselves solely on the archaeological findings, a fairly consistent picture seems now to emerge. In prehistoric times, until the so-called Iron Age (in which we still live), coastal Etruria appears to have been a rather thinly settled region. A new period of cultivation in this area started with a considerable population movement, which from the mountainous inland provinces of central Italy directed itself towards the then comparatively waste coastlands. There is a suddenness about this immigration into a previously neglected shore-country which in some respects suggests comparison with the American gold rush of the eighteen-forties. What exactly attracted the immigrants we can only guess. Deposits of metal were probably one of the reasons – the land around Piombino is still an active mining area. By no means must we picture these people as complete savages or paupers. They possessed knowledge of agriculture and metallurgy, and the products of their crafts, soon perfected in their new homesteads, were of a specific style. The characteristic· art which they came to develop is now generally known as Villanovan.

The exact time of this migration also presents a matter of dispute. Early Iron Age groups were on the move in many parts of Italy around and after the year 1000 – indeed a degree of easy mobility seems characteristic of them. However, according to present knowledge it seems unlikely that any of their movements came to a halt in Etruria or Latium much before the eighth century, an era from which dates most Villanovan art in Etruria. In general one has the impression that around and after the year 800 the western coast of central Italy exercised the greatest attraction for settlers from the mountains not far off. Possibly the discovery or better exploitation of the local metal deposits attracted

foreign traders and native tribesmen simultaneously, offering a prospect of easy money for both, and certainly a chance of cultural improvement for the latter. It does not seem unreasonable to connect the sudden re-evaluation of the coastal stretches in Etruria with the increasing importance of seaborne trade and traffic which at the same time prompted the foundation of Greek colonies along the southern coasts of Italy.

However, the new culture which rapidly sprang up in this territory can hardly be described as colonial. The Etruscan cities, like their Greek counterparts, looked towards the sea. But the oldest, such as Tarquinia, were founded on suitable high plateaus, with convenient outlets to the sea itself, thus combining the characteristics of hill towns and harbour towns: they were not merely fortified harbours like the Greek settlements. At least at the beginning, their populations must largely have drawn on the natives from inland, and their earliest art, which was Villanovan, in all cases about which we can judge was not imported from overseas, and has no counterpart in the eastern Aegean. Nothing in our Etruscan finds indicates an initial wholesale transfer of culture from the eastern Mediterranean, or a direct and continuous connection with a definite motherland outside Italy, such as one would expect from organized groups of foreign colonists. Therefore the archaeological evidence does not favour the assumption of any large-scale immigration from the sea – only of trade. Colonial in the precise sense of the word were the Greek cities of Italy alone.

When during the seventh century imported materials became more plentiful in central Italy, the leading cities of Etruria were already in existence. There are indications that Aegean traders had reached the Tyrrhenian coast before that time, but only after the close of the eighth century did they come more regularly, as we know from the objects which they brought. Apparently in Etruria the Phoenicians arrived first, the Greeks later. In historical times the Etruscans themselves were active traders. The prevalence of objects from the Phoenician orbit

of culture has always been noticed among the foreign articles imported into early Etruria – it is indeed a characteristic feature of the Etruscan civilization, especially in its so-called Orientalizing stage, of which more must be said later on. By contrast, the contemporary materials known from the Greek cities show a more homogeneous cultural pattern: the overwhelming majority of the finds are Greek, by origin or at least by style. In early Etruria on the other hand Greek and Phoenician influences soon began to compete, and the result was a rather varied pattern of culture. It is true that here, just as in the Greek colonies, the imported examples of eastern artefacts exercised their influence chiefly in the cities; but they were put to the service of a society which itself was neither Greek nor Phoenician. Hence the fact mentioned above, that the Etruscan cities did not so much as the Greek turn their back to the hinterland. Their common language, Etruscan, and the popular Villanovan art testify to an initial basic community between town and country, the social differences notwithstanding which here, too, came to separate the urban upper strata from the rural population.

In this way, it now appears, the Etruscan culture formed: not as the extension of a single mother-civilization but from the cross-currents of several contemporary civilizations. It grew on the spot, under the impact of the newly established trade with the east. Not unlike a modern nation, we find historical Etruria sharing the fundamentals of her culture with other high civilizations, while at the same time exhibiting significant regional characteristics. For here, too, the decisive event was a transfer of standards from the high civilizations of the east – Greek as well as oriental – to the new lands of Italy; and, as in southern Italy, the eighth century reveals itself as the crucial period, when the foundations were laid for all future developments in the area. Early trading posts along the coast may well have included groups of permanent foreign settlers. It is likely that the presence in a mixed population of a class of immigrants of this type first established the mercantile interests of the new communities, but we cannot be certain about this. What the archaeological evidence shows is that in consequence of their commercial contacts the Etruscan cities rose to wealth and power. Yet no single oriental country or Greek *polis* – only the civilization of the eastern Mediterranean in its entirety – can be regarded as the mother of Etruscan culture. In her dealings with the Aegean civilizations from which her own culture sprang, Etruria mostly assumed a taking and rarely held a giving part. But although her cultural status may be called regional, or perhaps provincial, in the outcome her civilization was something unique.

Rome and Latium[5]

The third region of Italy which calls for our attention comprises the comparatively small territory of Latium, with the city of Rome. According to tradition Rome was founded in 753. This may be no more than a legend, but it can hardly be far from the truth: in the chain of events here before us, the historical logic implied in it becomes at once evident. The salient point is that in Latium, also, the new chapter begins with the rise of a city; this fact immediately connects the founding of Rome – whatever the term implies – with the parallel and contemporary urbanization of Etruria in the north, as well as the Greek colonization in the south. Obviously the origin of Rome falls in line with that entire trend which during the eighth century established Italy as a pioneer land for eastern settlers and traders, and brought her within the orbit of the higher civilizations. For us it signalizes the formation of a third cultural province among the ancient civilizations of Italy.

In more than one respect the ensuing situation in Latium resembles the conditions of early Etruria. Here, too, we find groups of inland people moving from their hills – in this case the Alban and Sabine mountains – towards the nearby western coast. In Latium we even have a literary tradition supporting the archaeological evidence. Different from Etruria, however, where the presence of additional early settlers from overseas remains at least likely, there can be no question of immigration from the sea in

Latium. The first tangible remnants of Latin culture are entirely of the Italian Early Iron Age type. Two trends can be discerned, and perhaps indicate that two different groups of native culture met in this region. One involved a cremating-people, represented especially by their typical ceramics; the other produced a technically similar but stylistically divergent kind of pottery and simple metal-ware. The latter group practised inhumation in tombs called *fosse*; and because their characteristic implements were mostly found with these burials, theirs became known as the Latin Fossa culture. The cremating group is related to the Villanovans of Etruria; the Fossa ceramics have their antecedents among certain local products of southern Italy. Both, however, were the outcome of typically Italian developments. Imported articles are extremely rare in early Latium. This civilization was even less colonial than the Etruscan.[6]

The subsequent history of Rome is not at issue here, but the relations between the two cultural provinces of Latium and Etruria require a brief explanation, especially with regard to art. Characteristic of Latium is its comparatively isolated cultural growth, even at a time when Greek colonists and eastern traders had already set their mark clearly on the cultural life of south Italy and Etruria. The romantic notion held by the later Romans that their ancestors were a people of shepherds and cowmen was not altogether without substance. Perhaps conditions in Etruria would have remained on a similar level of rustic frugality had it not been for the intervention of the seafarers and traders from the east. Early Rome apparently had no such visitors. At first there is hardly any evidence of active interest in the sea and its traffic. The extreme scarcity of imported materials remains characteristic of Roman archaeology not only in the eighth but throughout the following century. Nowhere in Italy occurred the transition from prehistoric agriculture to classical mercantilism in a manner so comparatively undisturbed, almost reluctant, as in Latium. The Etruscan splendour and luxury of the seventh century have no counterpart in Rome. Perhaps it was not before the Etruscan monarchy estab-

lished itself, towards the end of the seventh century, that a merchant aristocracy formed in Rome, as in other cities of the ancient world.

Yet early Rome, located on the main artery of overland communication between Etruria and the Greek south, was not wholly without connections in either direction. The bridle path leading from north to south, which crossed the Tiber below the Palatine hill, may not have been sufficient to carry much merchandise, but it certainly brought contacts and ideas. Judged by its material vestiges only, early Rome might seem a backward place indeed. As an organized community, a city-state, it appears to be quite on a level with the new cities of Italy. In fact it may well be the political reorganization of a primitive community, rather than an original act of settlement, to which later generations referred as the 'founding' of Rome. Especially when it became clear that Rome was to be the controlling centre of all Latium, the essentially modern character of the new state was revealed. Rome was then more like a Greek city-state, a *polis*, than perhaps any of the Etruscan cities. This fact, and the difference of language, may explain why Rome never completely became an Etruscan town, even when it was ruled by Etruscan dynasties. It was never absorbed in the Etruscan league: therefore it remained a potential centre of gravity, spared for the future.

An abstract concept, the idea of the city-state, indeed seems the first effect of the expanding Aegean civilization on Rome. Again, details escape us. Located between Etruria and the Greek cities south of Naples, the cultural province formed in Latium was open to contacts with both Greek and Etruscan territories, although it evidently had far less direct communication with the eastern Mediterranean than either. Nevertheless, this province was neither wholly Etruscan nor Greek: it differed from both by language and by tradition. Neither at this early time was Latium, like Etruria, a place where native tribesmen and seafaring traders met and, perhaps, mingled. Rather the Latin civilization represents an Italian response to the challenge of the widening cultural horizon.

Concepts, not objects, therefore were the

earliest characteristic products of the eastern infiltration into Latium. Art, the objects, came with the Etruscans and later with the Greeks. There is hardly sufficient reason for us to set the early art of Rome apart from the Etruscan, with which it is so closely allied. On the other hand it is a rather important fact that the Latin historical tradition gives us a few precious clues as to the migrations of artists which probably in a similar way started all local centres of art in Italy, outside the Greek area, but about which we have so little explicit information elsewhere. It seems therefore advisable to deal with these data in the present volume together with the Etruscan, and to do so not as 'Roman art' but as 'art in Rome'.

Thus the scope of this volume outlines itself in the peculiar configuration of historical factors which released Italy from its prehistoric rusticity. Leaving aside the Greek colonial art of the south, our attention must focus on the formation and growth of an Italian, western art which by character and origin was, and for a long time remained, predominantly Etruscan. Only gradually did the Roman centre move into the limelight.

The fundamental factor – not only for the history of art but for the entire history of our culture, which only from that point can be called truly western – was the expansion of a higher civilization from the eastern Mediterranean across the sea into Italian territory. By this leap across hitherto unconquerable distances the area of contiguous civilization was enormously enlarged, with lasting results. The event rates second only to the discovery of America at the end of the fifteenth century. The discovery of Italy, likewise, must be considered a process of long duration. But its decisive phase can be ascribed to the eighth century before Christ, which therefore emerges as a date of paramount importance in our cultural history. It seems apt to begin this account of Etruscan art with the same century.

CHAPTER 2

THE VILLANOVAN STYLE AND GEOMETRIC ART

The Villanovan as a Ceramic Style

We gain our first insight into the irregularity – which is to say the individuality – of Etruscan art by making ourselves acquainted with the art now called Villanovan, for this was the Geometric style of early Italy and at the same time the Etruscan art of the eighth century. By this definition an important parallelism to the Greek development becomes clear at once. In Italy, as in Greece, Classical art started with a Geometric period. In the following we shall apply to the ancient art of Italy the same chief divisions of period which have become customary for Greek art. The significant sequence of a Geometric, Archaic, and Classical style occurred in both countries, because it formed a unified process of evolution. On the other hand it is equally necessary to point out that the early history of Italy led to a Geometric style which differed very much from its Greek counterpart, by origin as well as by the effect it had on the subsequent development of art.

Common to both styles was their basic condition: both were first intended for the decoration of clay vases. By original purpose they must be termed ceramic styles. The name Geometric was applied to Greek vases of this type in order to describe their distinctive decoration, which in most examples consists of a system of superimposed zones filled with abstract, hence 'Geometric', patterns. Among the latter the meander was the most significant single motif. Actually a term such as 'Angular Geometric', rather than merely 'Geometric', would give a more accurate description of this style, for two tendencies meet to produce its characteristics: one is the complete elimination, or at least disregard, of all vegetable ornament; the other is a distinct preference for straight-lined and angular forms rather than for curving or billowing configurations. Villanovan ornament may be called Geometric by the same tokens. It, too, is both abstract and 'Angular Geometric'.

At this point, however, the similarity ends. In Greece the Geometric style emerged from its contemporary surroundings as a rather curious neologism, combining a highly perfected and already ancient ceramic technique with a new and properly Greek discipline of design. Down to the Protogeometric vases of Athens the vague calligraphy of late Mycenaean pottery appears in a state of regression, if judged by the standards of the Cretan-Mycenaean art in which its tradition was rooted. Suddenly, with the class of vases now called Greek Protogeometric, the trend was reversed. A progressive development replaced the previous regression. This turn of direction eventually led to the angular and abstract decoration which imparts to the mature Greek Geometric vases their severe sense of variety, spacing, and colour, reminiscent of textile designs in its measured regularity.

Villanovan art had no comparable technological tradition behind it. Its antecedents are not clear as yet; its total output presents a semi-primitive aspect. Three classes of objects chiefly characterize the Villanovan crafts. They are the impasto urns with incised decoration; the bronze implements with incised decoration; and the painted Geometric vases. Of these three, the urns with engraved decoration must first occupy us.

Villanovan pottery was an impasto, not a glazed ware like the Greek Geometric. Its leading form was a large urn of thick, dark grey or reddish clay, very different from the fine and light Greek Geometric vases. Vessels of this type were frequently used as ossuaries in the Early Iron Age burials of central Italy, when cremation still prevailed amongst the people, but they served the living as well. Their shape, quite

standardized from the beginning, was entirely un-Greek. It has been called biconical, because every vessel consists of two distinct parts: the body, an inverted cone of rather squat proportions, topped by an upright cone which forms a high and broad neck. A low, flaring rim surrounds the wide opening. On one side, somewhat below the middle where neck and body

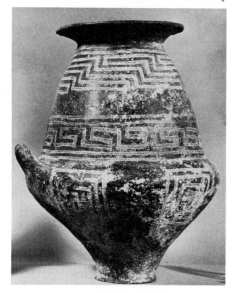

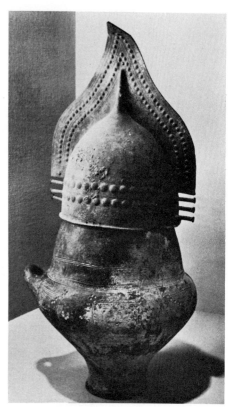

1. Villanovan biconical urn from Tarquinia, with detail, eighth century. Impasto. *Florence, Museo Archeologico*

2. Villanovan biconical urn covered with a bronze helmet, with detail, eighth century. Impasto. *Florence, Museo Archeologico*

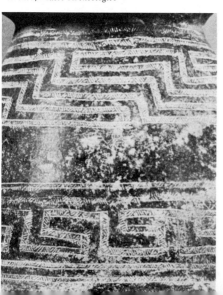

meet and the outline bulges most, each vase has a horizontal handle. The aesthetic effect of the whole is one of solid massiveness. The forms do not grow upward but rather create a strong and

static contrast of poise and counterpoise. From the elastic and sensitive outlines of Greek Geometric vases, the sturdy but somewhat dull monumentality of this simple scheme is far remote [1, 2].[1]

Not all these vases were decorated. If decoration was added, the technique also was definitely more primitive than that of Greek Geometric vases. Ornament was usually engraved in the wet clay. Often the grooves were made comparatively broad and filled with whitish matter, in which case after burning, by their lighter shades, the resulting patterns created a rather colourful effect [1]. Or the design was incised with a pointed instrument into the polished surface before the vase went to the kiln, so that the effect resembled an engraving in metal [2]. Small dots impressed in the wet clay are also found. No varnish like the Greek was used with this type of decoration.[2]

Usually these ornaments concentrate on the body of the vase and the upper half of the neck. As the style develops, a tendency becomes noticeable to give greater emphasis to the upper part or shoulder of the body – the zone of widest circumference. A stress on the horizontal results from this arrangement.

Decorative motifs are few, however. The following constitute the most common patterns: squares filled with crosses, swastikas, or zigzags between the diagonals; broken lines forming open triangles or zigzag ribbons; meanders and related forms, especially the so-called stepped meander. Variations of these basic motifs are of course possible, and often found. Nor did this decoration remain restricted to the vases for which it was obviously invented. It soon came into use on other objects for which it was less suited; for instance, many of the characteristic ossuaries representing primitive huts – the famous Villanovan hut urns – are so decorated [3, 4].[3]

Greek Influence: Painted Vases

The question of stylistic changes among the Villanovan materials is not easy to deal with. Such changes are in fact noticeable; the ques-

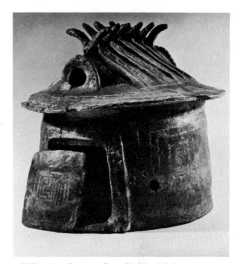

3. Villanovan hut urn from Vulci, eighth century. Impasto. *Rome, Villa Giulia*

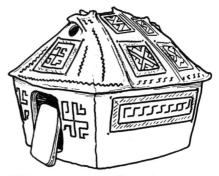

4. Villanovan hut urn from Tarquinia, eighth century. Impasto. *Florence, Museo Archeologico*

tion is, how to interpret them. It must above all be remembered that change and development are not the same thing. In the arts, change can be taken for granted, while development cannot. The reason is that neither the agent nor the direction of development can be assumed beforehand in any change of cultural attitudes such as the styles of art. For instance, it is not possible to argue that art of necessity develops from less to more faithful renditions of natural objects. Roman art certainly developed in the opposite

direction. The meaning and pace of develop-
ment in Etruscan art likewise will require care-
ful attention.

The first conspicuous change of style, still
within the range of Villanovan art, coincides
with a change of ceramic technique. It becomes
manifest in a class of vases which represents an
innovation among the Etruscan materials, in
that the decoration is not engraved but painted.
As far as we can see production of painted vases
in Italy started in Etruria (Tarquinia). The
decoration, still geometric, is competently de-
signed though somewhat sturdy and hefty. In
combination with the stout, squat shapes of the
vessels their design creates a pleasant and colour-
ful, if somewhat provincial, effect. These pots
are good things to have around in a rural house-
hold. Compared to the impasto urns they may
be judged a superior product. But what caused
the change? There is every indication that the
impulse came from abroad; from Greece. For
the first time we observe here a pattern of de-
velopment which became typical of much
Etruscan art, and which is best described,
perhaps, as an education of taste through foreign
examples. Obviously these painted vases came
into being as an attempt at transplanting Greek
ceramic techniques, shapes, and decorations
into Etruria.[4]

For instance, the rather accomplished am-
phora from Siena [5] was probably of south
Etruscan manufacture; but it was clearly made
in imitation of a Greek amphora from the Cy-
cladic islands, perhaps Delos or Thera. Similar
observations hold good with other vases of this
class. In fact the painted Geometric vases of
Italy tell the story of the early Greek trade with
the West in a plausible way. The new forms
which appear among their number, like the am-
phorae and the wide-open mixing bowls on a
high foot [6], are definitely traceable to Greek
originals. The decoration likewise shows the in-
fluence of Greek art in its latest Geometric and
even Postgeometric (Subgeometric) stage; that
is, the presumable prototypes must be dated to
the end of the eighth century. Both the vase
forms and the ornament, as far as they are not
traditional Villanovan, can be referred to orig-

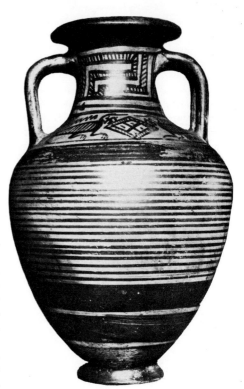

5. Painted amphora,
late eighth–early seventh centuries.
Siena, Museo Etrusco Senese

inals hailing from eastern Greek centres, especi-
ally Cyprus and the Cycladic islands. Occasion-
ally traces of Peloponnesian, probably Argive,
models can be identified among the local Geo-
metric vases of Sicily, where production started
somewhat later than in Etruria. Conspicuous is
the absence of Attic influence, although Athens
was the most flourishing centre of Geometric
art in Greece, for Athens at that time was not a
maritime power. The new art was brought to
Italy from other regions by the seagoing Ionian
traders and the early Greek colonists, among
whom the Corinthians represented a Pelopon-
nesian element. Thus the stylistic analysis cor-
roborates the historical record. An extra-Attic
Greek culture is reflected in the new art of the
West; and it is shown in a state of transition,

from its Late Geometric to its Orientalizing period.

The unique advantage of the Greek potteries lay in their ability to cover fine clay with clear, lucid glazes of varying thickness and colour, which hardened in the fire. No unskilled worker could successfully compete with those in command of this technique. The start of industries producing similar vases in Italy therefore de-

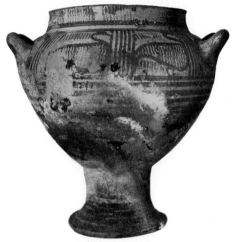

6. Painted mixing bowl on a high foot from Bisenzio, late eighth-early seventh centuries. *Rome, Villa Giulia*

pended not only on imported examples but in addition on the presence of specialized workers. It must be assumed that Greek potters– perhaps itinerant – were active in some of the new workshops. In general the manufacture of this kind of fine pottery remained a Greek monopoly, even during the following centuries; imitations are often recognized by their inferior fabric.

To summarize: the engraved Villanovan and the painted Geometric vases constitute two clearly distinguishable kinds of early Italian pottery. The former represent the domestic craft. The painted vases express the wholesale acceptance of imported standards, adapted to the needs and skill of the local workshops. In that sense only, the latter also form part of the Geometric art of Italy.

Patterns of Development

The painted Geometric wares produced in Etruria and elsewhere in Italy cannot have started much before the end of the eighth century: around 725 approximately, according to Greek chronology. They represent the latest stage of the Italian Geometric development, and their workshops lasted well into the seventh century. On the other hand the Villanovan ceramics with incised decoration must have begun much earlier; how early, no one can say at present. The question is whether the geometric ornaments in this class, too, can be dated in accordance with Greek Geometric development.[5]

Certain details, especially the stepped meanders, make it likely that contacts of some kind indeed existed between early Villanovan ornament and the Greek Geometric style.[6] But the route of their transmission probably did not at first pass through the western Italian harbours. There is now an increasing body of evidence which, instead, indicates an early and active connection between Villanovan art and the Balkan civilizations east of the Adriatic.[7] Indeed a prehistoric line of communication seems to have run across the Balkan mountains to northern Greece and perhaps further, to Asia Minor. In the engraved Villanovan ceramics only certain standard ornaments, not the shapes of the vessels, resemble the Greek. It follows that the ceramic forms were invented without recourse to Greek art, while the decoration may well include Greek elements. As the comparable motifs in Greece belong to the developed, not the early, phases of the Geometric style, a date around 800 would seem the upper limit for most Villanovan decoration of this kind. How at that time a knowledge of Greek Geometric ornament could have been transferred to Italy via the Adriatic remains a question for future studies to answer.

At any rate it becomes clear now that the engraved Villanovan pottery, as a class, preceded the painted vases which depended on Greek examples directly. It is thus possible to stipulate a development of about a century among these

various materials. The first stage may be called Villanovan Geometric; the second, grecizing Geometric. The Villanovan preference for square fields and zigzag ribbons persisted with the grecizing painted vases. But the stepped meander did not retain its prominent role on the second level. Instead concentric circles appeared from the beginning on the painted vases – an innovation in Italy. Among Greek Geometric ornament, this device must be explained as a Mycenaean heritage. Naturally it was absent from the original Villanovan vases, which were independent of the Mycenaean tradition.

Changes in the shapes of Villanovan ossuaries confirm the distinction between two chronological levels of the Geometric style in Italy. The trend was to stretch the outline of the vases. Gradually, as time went on, the urns were made higher and assumed more slender proportions, and the division between body and neck became more articulate. The lower section developed a veritable foot, which was not originally a part of the biconical form. The addition of a foot was almost certainly influenced by the similar tendency characteristic of Greek Subgeometric ceramics, to put all kinds of vases on a high stand or foot. Accordingly the Villanovan vases which follow this fashion may be regarded as more recent than those of squat proportion and without foot. Their shapes were modified in accordance with the advancing Greek taste. No difference can be noticed, however, in the incised decoration itself: its basic stock of motifs remained unchanged and stereotyped, regardless of the passage of time. One is dealing here with a provincial phenomenon: in provincial arts it often happens that styles, once accepted, become frozen in a tradition of workshops and draughtsmanship.

When the painted vases became more numerous, again a standard style of rather poor quality soon resulted in Etruria – a so-called metopic decoration of the Subgeometric domestic vases. This production likewise continued in a stereotyped fashion till it eventually died out. It presents another example of the local stylistic stagnation, retardation, and degeneration which characterize much Italian art. This alternation

from local conservatism to sudden progress set the pattern of the Italian evolution.

Thus together with the painted grecizing vases, Villanovan biconical urns with painted decoration suddenly appear in Etruria [7]. Their ornament was from the beginning on a level with the progressive grecizing vases and, like the latter, included the characteristic Subgeometric motifs of the empty 'metopes' and the concentric circles which were foreign to the biconical

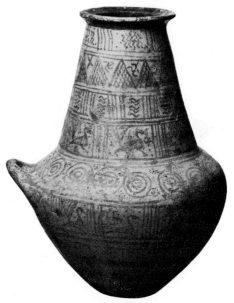

7. Painted biconical urn, late eighth–early seventh centuries. *Copenhagen, Ny Carlsberg Glyptotek*

urns with merely incised – not painted – decoration. Their shapes, too, were of the advanced style described above. Together they form a later group, dating from well into the seventh century. Meanwhile the old factories producing incised vases continued working. Another aspect of the provincial development 'in leaps' enters here, which must be regarded as characteristic of Etruscan art. In Italy it not rarely happened that an older style, bound to a traditional technique and often a special kind of objects, lingered on in outlying areas and estab-

lished workshops even at a time when it had long been made obsolete by more modern products. Only, by then, the traditional style had assumed a different social function. It ceased to be a leading style; it descended to the level of folk art.

Metallic Arts

To the same level as the painted ossuaries with grecizing ornament belong the large bronze vessels of the Villanovan style, of which many are preserved. They testify to a new skill in the treatment of metals in Italy. The vases were made of thin sheets of bronze in which a design was sometimes impressed by way of dies or free hammering (repoussé work). Both techniques have a long history in the ancient Near East and spread during the eighth and seventh centuries to Greece and to central and western Europe. Parts were prepared separately and then riveted together. It may now be regarded as certain that this method of making vases of bronze came to Etruria from the contemporary Balkan civilizations which centred in present-day Hungary. In many cases the technique makes a definitely archaic impression [8]. Yet these metal vases

8. Villanovan biconical urn from Tarquinia, c. 700. Bronze. Tarquinia, Museo Nazionale

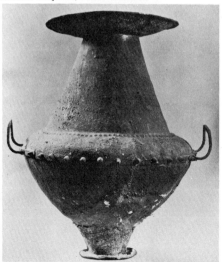

never quite lost their popularity in Italy, and the two-handled so-called *conche* of copper, still used in the mountain villages around Rome, preserve to this day a reminiscence of the old Italian archaic sense of form.

That at the beginning of the seventh century the bronze vases were an innovation is shown by the fact that many were shaped, with considerable pains, after the model of the local clay vases. This fact is especially obvious with the biconical urns made of bronze[8] [9]. If they are decorated, these urns always show the Italic Geometric ornament in its second, advanced stage. Unlike the impasto urns, but like the painted ossuaries, they are systematically divided into horizontal zones in the Greek manner. Concentric circles are common in their decoration, and are sometimes framed by 'metopes'. Conversely in the second, Subgeometric Villanovan group one witnesses an interesting infiltration of the metallic arts into the ceramic style. The metal technique makes for more articulated outlines, in which the parts of the vase are set off from one another by sharp angles and edges. Such analytic precision was not a habit of the early Italian potters. The sharp, streamlined forms of some of the painted Villanovan urns may well, in turn, betray the influence of bronze constructions on the taste of the local potters.

For a considerable time thereafter the popular metallic industries of Etruria and the nearby mountain regions of Umbria continued to make an important contribution to early Italian art. By quality, workmanship, and frequency, their products bespeak the growing wealth of the population at large. Some of these objects are most commonly found in the rural districts. Their originality developed in the adaptation of Geometric design to implements used locally, especially items of costume and armour, for which Greek prototypes were not available.[9]

First in this group the great variety of safety pins (*fibulae*) must be mentioned which distinguishes the native burials of Italy during the entire period. The pins were much in use with all classes of people, for practical purposes and as adornment. Although the invention came from abroad – probably also from the other side

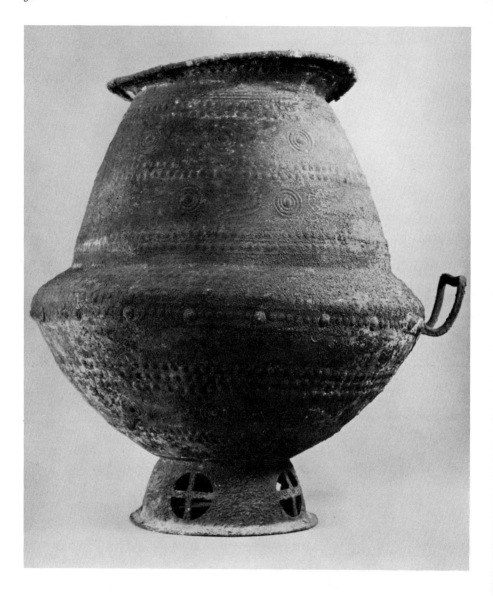

9. Ornamented Villanovan biconical urn from Tarquinia, *c*. 700. Bronze. *Tarquinia, Museo Nazionale*

of the Adriatic[10] – the basic form of this useful device underwent many variations in Italy. Two common types are here illustrated, both equally characteristic of the Geometric period in central Italy. The so-called sanguisuga (leech) type used to belong to a woman's apparel; often the broad back wears an engraved geometric design [10]. 'Serpentine' fibulae were preferred by the

10. Sanguisuga fibula, late eighth century. Bronze. *Vatican, Museo Gregoriano Etrusco*

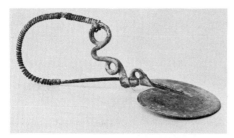

11. Serpentine fibula, late eighth century. Bronze. *New York, Metropolitan Museum of Art*

men [11]. A strong, shining bronze wire was bent to a multiple spiral and hammered flat at one end, so as to form the disc which served the pin as a foot. The contraption is imaginative, and a fine example of free, functional design in early Italian craftsmanship.

To the same class of popular art belong the frequent bronze belts[11] of oblong or oval shape found in the tombs of both men and women. They were probably mounted on leather, not unlike the various leather things with metallic ornaments still popular in the Swiss valleys or among the cowboys of Texas. Many have geometric decoration embossed or engraved on the surface [12]. Perhaps the fashion originated in the Apennine mountain villages. But the belts occur also in other nearby regions, around Bologna and in Etruscan burials of the Villanovan type no less than in the trench tombs of Latium or the Alban Hills. Among their decorations Balkan ('Hungarian') motifs are very common, interspersed with others of probably Greek derivation. During the seventh century and beyond, these belts seem to have formed a standard article of armour and luxury in the dress of the townspeople as well as of the peasants.

Last but not least, it was probably also in the valleys of the mountainous Etruscan hinterland

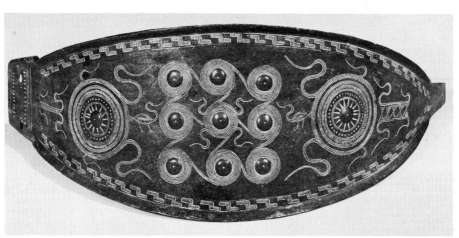

12. Belt from Bologna, *c.* 700. Bronze. *Bologna, Museo Civico Archeologico*

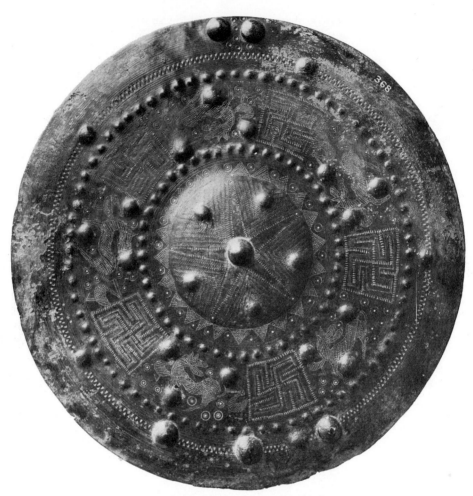

that the various types of bronze discs originated which, padded with leather, were used as armour (by the men as pectorals, or nailed to their shields of wood and leather), or merely sewn to garments and worn as ornaments. These discs became very popular, and are widely distributed in Etruria and central Italy. The specimen shown in illustration 13 represents an excellent example of engraved geometric design.[12] The other [14] is an example of the numerous perforated discs or wheels of all sizes whose accomplished lace-like patterns testify to the inventiveness and colourful decorative taste of the native metalworkers.

13. Disc (armour?), mid seventh century. Bronze. *London, British Museum*

14 (*right*). Perforated disc from Perugia, mid seventh century. Bronze. *London, British Museum*

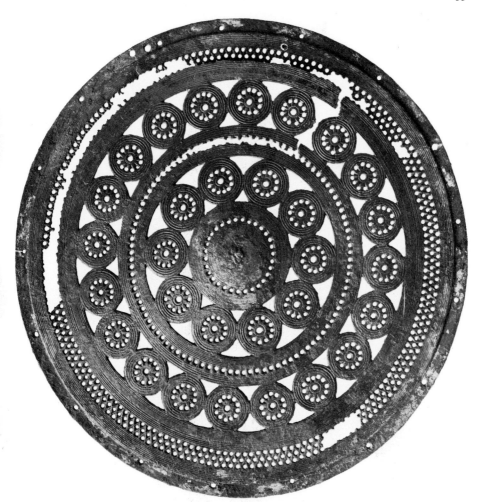

SOCIOLOGICAL AND PSYCHOLOGICAL ASPECTS OF ITALIAN GEOMETRIC ART

The Sociological Split

Greek art and the Greek historians of art have accustomed us to the idea of progress by successive stages. The early Renaissance confirmed the idea. But in early Italy the lesson must be relearned. It is confusing, and has greatly added to our difficulty in building up a workable Etruscan chronology, that often in Italy existing modes of art were not abandoned at once upon the appearance of other styles. Therefore the entire chronology of the Geometric period in Italy seems out of step with the Greek. The likelihood stressed above, that so much Geometric and even Villanovan art was produced as late as the seventh century, might lead to the conclusion that the Geometric period in Italy lasted longer than that in Greece. In a sense that is true; in a similar sense one can say that the Archaic art of Italy extended far into the fifth century, which is the Classical century of Greece. Both statements are true, however, with modifications only.

Actually a large portion of the Italian Geometric production coincided with the importa-

tion and local manufacture of Protocorinthian and other Orientalizing art. In other words, there was a time during the seventh century when Etruscan art must be properly described as being Geometric in some population strata, Orientalizing in others. Interesting in this respect is the often noticed lack of Geometric and the scarcity of Subgeometric materials at the sites of the oldest Greek colonies. Possibly the earliest Protocorinthian fragments found in

15. Footed biconical urn, Arnoaldi style, seventh century. *Bologna, Museo Civico Archeologico*

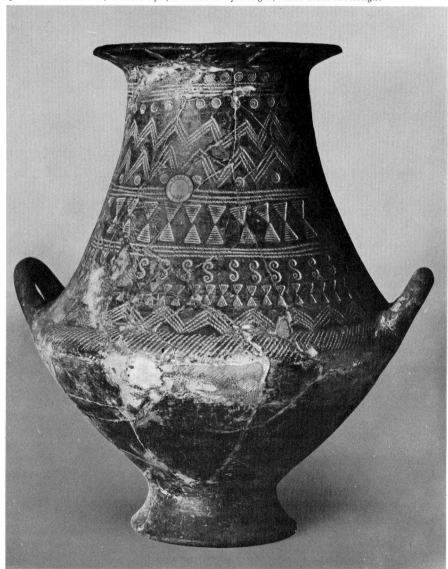

Cumae date before any of the painted Geometric vases preserved from Etruria. This can only mean that the Greek settlers from the start showed little interest in the Geometric style. By the time of their arrival, their taste had turned Protocorinthian.[13]

It is probably no undue simplification of the facts if we suggest that about one generation later, all Geometric art in Italy became a style of the natives. Even so, it still remained a vigorous art, in some cases for centuries to come. Geometric peasant styles formed in various parts of the peninsula. One which falls within our province must be mentioned here. During the second half of the seventh century a regional late Villanovan art arose in the district around Bologna on the northern side of the Apennines. One distinguishes among these materials two successive strata called 'Benacci' and 'Arnoaldi'. Ceramic forms include late varieties of the biconical urn: characteristic of Arnoaldi pottery is the precise and deeply engraved or stamped decoration of which our illustration 15 gives an example. Upon first discovery this region was thought to be the original centre of the entire industry which, from a village near Bologna, then received the name Villanova. This judgement must now be reversed. The trans-Apennine groups represent a comparatively retarded kind of folk art, indeed an offshoot only of the original Villanovan. Yet they still testify to the vitality of the Geometric style in local centres at a time when the leading arts elsewhere had definitely ceased to be 'geometric'.[14]

The Psychology of Italian Geometric Design

The formative centres of Geometric art were located in Greece. If, as seems likely, at least some of the standard motifs in Villanovan ornament were introduced from Greek sources, then the Villanovan style assumes a singular importance for the general history of art: it exemplifies the first reaction of Italian craftsmen to Greek art. But even if no connection existed between Greek and Villanovan Geometric decoration, the latter deserves our special attention. Classical Greek art is unthinkable without its Geometric foundation. It is imperative that we ask, by analogy, how the ancient art of Italy was related to its own Geometric period.

Actually to analyse Villanovan ornament from this point of view, for its contrast to Greek Geometric art, proves highly rewarding [1-4]. It is obvious that the Villanovan Geometric style had at its disposal a smaller variety of patterns than the Greek. But this is not the decisive difference: what is decisive is the fact that the decorative composition itself differs in the engraved Italian urns from that of their Greek counterparts. Yet composition – the relation of parts to the whole – appears to be the very heart of the Greek Geometric style, which in its approach to form was inorganic but structural.

The mature Greek Geometric decoration enveloped the vases in a system of parallel horizontal zones. These rings were but the visible means by which an abstract principle of order could be concretely expressed. The aesthetic effect of the whole springs from subtle qualities of spacing and proportion which operate in the variety of the parts. From these variable factors results a measured and disciplined balance of elements. Often in the main zone one finds a central motif flanked on either side by two identical patterns, resulting in a symmetrical, 'heraldic' combination. Always one is faced with a calculated order, now contrasting, now complying with the flexible ceramic form. In these very formal compositions sensuous and abstract experience enter into a remarkable community.

Perhaps by intention, the Villanovan ossuaries were not so far removed from such a programme. Their decoration, also, is arranged by horizontals. But if a similar principle was active behind their order of ornament, it did not materialize to an equal degree. The ensemble of Villanovan decorative compositions always appears different from the Greek. A certain equilibrium is implicit in their arrangement of details; no more. Rarely if ever was it made as explicit as in the Greek vases. The horizontal lines in which the Geometric system of the Greek decoration became so firmly concrete are often and seemingly at random omitted from the engraved urns. Hence the entire decorative arrangement

looks not strict but loose; not calculated but improvised. Details, patterns, have been accepted from the eastern styles. The system – the Greek Geometric horizontalism – even left its impress on the Villanovan products. But the structural secret, the inner logic, of the Greek works was either not known to the Italian craftsman, or held no meaning for him. Thus the ribbons with meanders beneath the rims of the urns lack their underpinnings of parallel rings [1]. They seem to float; their isolation makes them appear a-structural, as much later the friezes of the Augustan Ara Pacis, with a procession marching on top of the filigree-like acanthus, may be said to be a-structurally placed. Or another example: in the Villanovan ossuaries, the frequent squares with geometric fillings do not form metopes, embedded in a continuous, decorative system. Isolated from each other, they turn into individual motifs, like so many odd windows; or they are lined up disconnectedly, like framed pictures on a wall.

The later makers of the painted vases corrected these mistakes. While the ossuaries in their decoration show no more than a selection of individual patterns, the painted vases repeat the whole zonal system of their Greek Late Geometric prototypes. Also, their decorative repertoire resembles the Greek more closely because the individual motifs are not isolated but rendered as parts of a formal context, clearly shown.

All this is very symptomatic. Time and again in the following centuries Italian artists have misinterpreted or disregarded the structural basis of the Greek art on which they otherwise depended. But before condemning the derivatives, it seems fair that we also realize the creative and liberating power which this naive appreciation, or uncertain knowledge, of the Greek examples exerted on so much Italian art. From their unconcern with the principles combined with their liking for the products of Greek art, the Italians often gained a degree of independence and even originality to which they might not have attained had they been mere copyists or docile disciples. In imitating irresponsibly whatever they pleased of Greek art, they committed a creative error; but they often invented fresh and original works of their own by living up to standards which they either interpreted wrongly, or did not know how to attain. One finds much among their most characteristic products which to us looks foreign; and much that seems an overt revolt, even, against the very spirit of Greek art. In the art of Italy the concept of the classic formed and became problematic at the same time: it was bound to become so.

The last observation has a bearing on another problem which is familiar to everyone acquainted with Etruscan art, and which can already be noticed in the Villanovan Geometric decoration; namely, the tendency to exaggerate forms in one direction, and thereby distort them. Conscious distortion for aesthetic effect, of course, is best known to us from modern art; but similar, seemingly arbitrary, deviations from a formal norm occurred in the arts of many other people and periods. Thus not regularly, but sometimes, one will find the meander around the neck of a Villanovan ossuary strangely elongated. By Greek standards the design seems hybrid; from the exaggerated length of the horizontal bars results an over-emphasis on the horizontal direction. Yet these ornaments are typical of the Villanovan style. Distortions in art may assume many different functions, but this case seems fairly clear. The over-extended meanders of the Villanovan style betray an attitude of their makers towards form. These draughtsmen dealt with the forms of their ornaments as with a finished product. The meander, and probably other forms as well, came to them as ready-made inventions which they felt at liberty to exploit; or as conventional motifs with which they freely experimented. They asserted their mastery over these motifs by the way in which they put them to use: by variation or by distortion. For distortion is a possible way for an artist to use creatively an already conventionalized form. This attitude can be taken as another indication that certain decorative patterns such as the stepped meanders or the square 'windows' reached the Geometric art of Italy ready-made, as something already 'classical'. To these paradigmatic motifs the Villanovan potters reacted

as all mannerists react to a classic form: by an assumed freedom of variation which implies both appreciation and distortion. Undoubtedly one encounters here another basic attitude of ancient art in Italy towards a problem of form.

Man and Beast

One other problem of form remains for discussion in this chapter: the representation of living beings. In the Late Geometric decoration of Italy one finds for the first time geometrically stylized portrayals of humans and animals. Their shapes are peculiarly stereotyped. Like all Geometric design they follow set patterns, typified and remote from the natural image. Some of these abbreviating formulae of representation are very old; but their origin and migrations across the early cultures, before they reached the Geometric style, are not always well known. The importance of these patterned images is clear, however. In all the arts to which they were introduced, they from the outset determined the habits of representation for a long time to come.

For instance the decoration of the bronze disc in London [13] is clearly grecizing Geometric; it may date from near the middle of the seventh century. One recognizes at once the square fields with the hatched swastikas, designed like a textile pattern: similar squares formed the familiar standby of Villanovan decoration. But the animals between the squares have no counterpart in the style of the ossuaries, which is so severely abstract as to exclude organic forms altogether. Such figures appear only during the second stage of Italian Geometric art. In the London disc, in each interspace between two squares a quadruped is flanked by two birds.[15] It is a purely ornamental tripartite arrangement, as in Greek Geometric art; no meaning is implied.

Birds drawn sideways are common in Greek Late Geometric decoration, but they seem of a different species. The difference can be seen if one compares the equally symmetrical arrangement of two birds on the already mentioned vase at Siena,[16] which follows a Greek prototype directly [5]. The birds in the London disc re-

semble not this but another, even more typified design, examples of which occur in other Italian Geometric bronzes; again this latter device probably came not from Greece, but from Hungary. Greek and Adriatic contacts mix easily in this popular art. The birds' heads (swans?) growing from a solar disc on the bronze belt [12] also represent a truly Balkanic motif, while the two-headed monster on the same disc certainly originated in the Near East. Later, in the half-Subgeometric, half-Orientalizing Etruscan ware of the advanced seventh century, birds drawn in strangely curving and fluid outlines appear frequently. The specimens inscribed in 'metopes' around the potbellied vessel [16] probably stem from a Greek ancestry;[17] so,

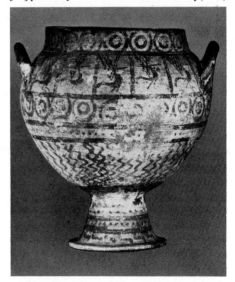

16. Painted krater on high foot, mid seventh century. *Vatican, Museo Gregoriano Etrusco*

I think, did those others lined up along continuous bands, as in our illustration 17, where they are subject to a distorting, curious elongation reminiscent of the similarly distorted Villanovan meanders.

An even more interesting creature in the London disc is the animal looking over its own back[18] [13], for this ancient pattern, which the Etruscan designer certainly gleaned from a

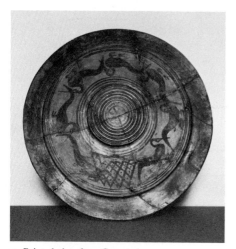

17. Painted plate from Cerveteri,
mid seventh century.
Philadelphia, University Museum

Greek model, illustrates the solution of an old
and basic problem of design. The Geometric
style aims at ornamenting plane surfaces. Its
decoration is strictly two-dimensional on prin-
ciple; it tends to create silhouette-like patterns,
as in the perforated discs. If such a style pro-
ceeds to the portrayal of real objects, it is obliged
to develop representations which suppress the
three-dimensional quality proper to these ob-
jects. Therefore the animal on the London disc
is shown sideways so precisely that only two of
its four legs can be seen; and it turns the head
back in a completely unnatural manner. The
image is flattened-out; it has entered the unreal
world of ornament.

The common concern of all these devices is to
adapt the forms of real objects to a representa-
tion in the plane. Obviously this must come to a
head in the representation of humans. In fact
the latter constitutes a capital problem of draw-
ing and painting at all stages. Something must
be said about it at this point.

When the Greek Geometric style reached full
maturity, it began to include human images in
its decoration. These, however typified, were no
longer purely ornamental: they represented
something specific, as for instance a funeral pro-

cession; some even told a story. But in all cases
the human image was consistently stylized. It
was rendered as a black silhouette, acting side-
ways; for this reason the human figures of Greek
Geometric art ought to be called representations
in profile. Yet with their side views these figures
combined a representation of the torso in full
front, with both shoulders shown; a combina-
tion of aspects impossible in a real person. The
torsos were strictly triangular, and straight out-
lines were preferred whenever they seemed
applicable. In adopting this formula the Greek
Geometric style merely confirmed an early
Mediterranean tradition of long standing. Neo-
lithic rock paintings in Spain and Africa first
coined the type. Egyptian art perfected the for-
mula and made it canonic. Thus the side view
became established, in practice, as the properly
pictorial rendition of both men and animals. As
events proved, the nameless artists of the Late
Stone Age had made a momentous choice. The
latest great style based on a typified profile-
representation of this kind was Greek Geo-
metric painting.

It was also the last. No style in the history of
our art ever again began so methodically, by
drawing its human figures according to the same
characteristic basic formula. For in this funda-
mental matter, for once, the Italian Geometric
style did not, or rather could not, quite follow
the Greek. From the outset symptomatic of
Geometric art in Italy is the scarcity of human
representations. If they do occur, their purpose
is primarily decorative. No Italian Geometric
picture tells a story. Nor was the consistent use
of the composite profile view, which formed the
basis of Greek Geometric painting, ever domes-
ticated in Italy: on the contrary, one may doubt
that the early Italian designers always had a clear
conception of the problem involved in these
representations. If anything, they attempted to
stylize human figures geometrically, in a kind of
frontal aspect.

Thus the famous dancers of the painted Geo-
metric vase from Bisenzio, now in Florence,
must be described as a frontal representation, in
spite of the fact that some heads seem to turn
sideways [18, 19].[19] The decoration of this vase,

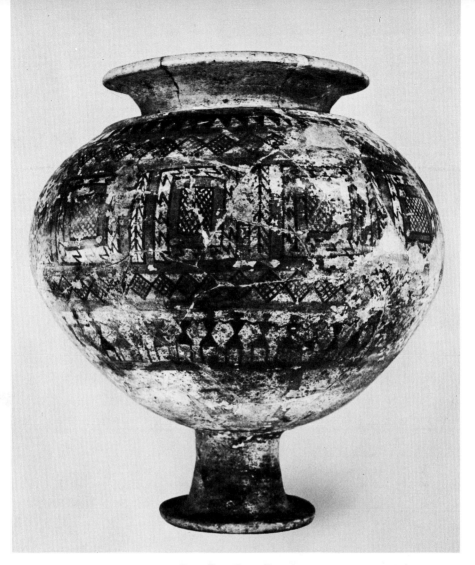

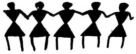

18 and 19. Painted globular krater on high foot from Bisenzio, with detail of dancing figures, mid seventh century. *Florence, Museo Archeologico*

with the well-known squares, is grecizing Geometric; it resembles a textile design and is not unlike an Indian rug. Nevertheless the alleged similarity of the figures to those of the Attic dipylon vases is superficial. The motionless, decorative frontality of these dancing women is Geometric, but not Greek.

Another interesting example is the Geometric stylization of two heraldic groups here illustrated for comparison [20, 22]. The painted stand (*hypocraterium*) from Narce, now at Philadelphia, is a very elegant example of frontal stylization [20, 21].[20] Two horses are shown

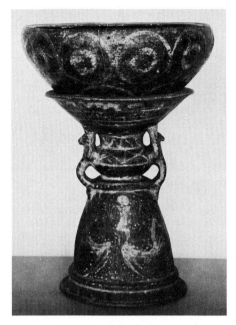

20 and 21. 'Horse tamer' and acrobats
on a painted vase stand from Narce, with drawing,
early seventh century.
Philadelphia, University of Pennsylvania Museum

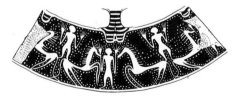

opposite each other. A man stands between them; seen frontally on the back of each animal another similar figure balances on one foot, while setting the other on the horse of the adjoining group, like an acrobat. The whole arrangement forms a continuous decorative pattern. The artist of a black impasto vase in the

Vatican[21] attempted to render a similar composition, but felt less certain about the central figure [22]. He may have known Greek Geometric figures. If so, he had trouble in accepting their combination of frontal shoulders with sideways action. Perhaps he gave too naturalistic an interpretation to this standard device, which he understood primarily as a frontal image. Yet he felt obliged to show the one thigh of his figure from the side, thus producing an effect comparable to a modern cubist painting.

All later ancient art of Greece was built on the methodical experience of the Geometric style.

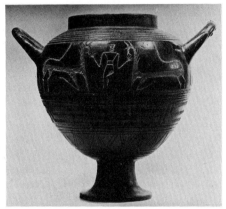

22. Black krater with engraved design,
early seventh century. Impasto.
Vatican, Museo Gregoriano Etrusco

Down to the Classical and Hellenistic periods, even, it remained at heart an abstract art; it was always prone to define visible shapes by the hidden geometry of their structures. Its Geometric period was not really a primitive age, like the Neolithic; nor was it a direct development from Neolithic conditions. Against the rich Mycenaean background the Greek Geometric style formed gradually, by reducing all decoration and design to certain elemental conditions. It was a second, almost artificial, primitivism, from whose intellectual discipline a new art could truly start.

To understand ancient art in Italy one must first of all understand that her local Geometric

period could never have the same effect on the subsequent development as in Greece. Summarizing, one can now name three circumstances which reach to the roots of this matter. These circumstances indicate the difference of primary conditions between the ancient art of Italy and that of Greece. I think that they are best described by the following three points.

1. Unlike that of Greece, the Geometric style of Italy was not an undisrupted local development but received its momentum from imported examples. Its primitive foundation, if any, is still quite unknown to us; its subsequent growth for the most part came with the infiltration of eastern culture into the new lands of the West. As a consequence, Italian art did not share with Greece the Geometric schooling which formed the basis of Greek art. The Italian Geometric period was far too short. This statement implies, among other things, that Italian art was by its historical conditions prevented from setting its own rules at the start. It was not given the time to clarify its own primitive experience, because it lacked the unbroken continuity of development which we find in Egypt and Greece, even, from Neolithic or at least primitive foundations to a Classical style. Instead the early art of Italy was soon dragged into the powerful current of the Aegean development. Rather like the early medieval arts of western and northern Europe, it grew into a world of standards set by others, and already in existence when its own growth began. One can say that the ancient art of Italy was the first in our western world which did not have to start at the beginning. Its systematic foundations were laid abroad, mostly in Greece.

2. Italy became acquainted with Greek Geometric art at a point when the latter was already in decline. Some of the finest achievements of the Greek Geometric style, like the Attic dipylon vases, probably never reached the West. The urbanized society for which the finer Greek Geometric vases were produced did not at first exist in Italy. When a comparable social stratum formed, its members soon acquired a taste for the orientalizing styles. Geometric from the outset tended to become a folk art in Italy.

3. The Geometric style of Italy remained a decorative art. It showed only a passing concern for human figures, and hardly any knowledge of Greek Geometric methods regarding their representation. In general it remained below the level where the human theme became a major interest of art.

These statements do not mean that the Geometric period of Italy passed without any effect whatsoever on later art. The framing devices of the Geometric decoration left their mark in later Italian as they did in Greek art. It can be said that a lasting interest in window-like frames, as a primary element of order, and a preference for square divisions even in continuous friezes remained characteristic of much ancient art in Italy. Quite plausibly the persistence of these compositional preferences can be explained by Geometric habituations. On the other hand, and in contrast to Greek art, Geometric design in Italy from early times showed a tendency to define form by *delimitation from without* – by frames and outlines – rather than by *structure from within*. The pleasure which this art found in decorative or expressive distortions also testifies to an a-structural sense of form; frequently it delighted in the unexpected and bizarre, regardless of the structural meaning or inner logic of its images.

As far as humans appear at all in the repertoire of this art, they are hardly shown as beings in their own right – creatures of will and purpose. They remain ornaments, and their design partakes of the general tendency to create linear configurations, a-structural and seen from without rather than defined from within. A new kind of human image came to Italian art with the advent of the following Orientalizing period. But then it arrived as a given form, coined by Greek and eastern artists. The inner secret of this form, which was structural, was hardly grasped: the shapes were accepted or transformed, as the case might be. The proper Geometric foundation was lacking. As a result of these conditions – its birth constellation – ancient art in Italy, be it Etruscan or Roman, often surprises the student by its abrupt changes from extremely formalistic attitudes to a strangely direct naturalistic intent, and vice versa.

CHAPTER 3

THE ETRUSCAN TOMBS

General Background

It must be repeated here: every advance of civilization which is not universal produces a disparity of cultural levels. From the outset this was the destiny of all civilizations 'higher' in comparison to others that were more retarded. Thus the Egyptian and Mesopotamian cultures stood 'higher' than the Neolithic barbarism of their ancestors and neighbours, from which they detached themselves. At the same time their area was narrowly limited. An important aspect of the ancient Mediterranean situation, with effects not even now quite eliminated, was the initial numerical inferiority of the 'higher' cultures, at a time when the infinitely larger portion of the world belonged to the retarded or undeveloped civilizations.

Thus when the Aegean civilization expanded, and Italy became its western frontier, the same cultural disparity was transplanted into that territory. It seems that already the carriers of the advanced Iron Age cultures, notably the Villanovan, had this effect on the aboriginal peasants among whom they settled. In their new habitats they tended to form clannish organizations, and as soldiers, landowners, and cattle-raisers exhibited many traits of a rural aristocracy. The situation was further aggravated by the new city-republics, which created another stark and lasting differentiation of cultural levels, even if the inhabitants did not all come from abroad, as was probably true of the Etruscan cities and certainly of Rome. In these cities formed the new strata of a landowning and merchant aristocracy, the darker side of which was its disregard for the professions and rural workers. From then on the latter – the Roman *pagani* – mostly kept to themselves and their own customs and folklore, much like the peasants, the *caffoni*, of modern Italy. Not by accident, to

this day, does popular Italian speech refer to the social classes as so many different 'races'.

Once in existence, these population groups went on living side by side in a state of comparative cultural independence, though by no means in complete isolation: they were capable of exercising an influence on one another, as the archaeological record shows ever more clearly. Therefore the inequality of contemporary styles already often referred to became a natural condition of art in Italy, though perhaps the contrasts were never greater than during the seventh and sixth centuries B.C. In Etruria we cannot claim the seventh century as an orientalizing period altogether, as one would in Greece: a considerable portion of its output remained Geometric, as was pointed out before. But now we turn to the other aspect of this Janus-faced century; for a vigorous and flourishing orientalizing current was indeed experienced in Etruria. Among its products are found some of the most splendid works still preserved of early art in the Mediterranean: objects whose rediscovery during recent centuries more than anything else established the fame of Etruria in the modern world. On the testimony of its still extant remnants the Orientalizing period holds a place of paramount importance in the history of the Etruscan culture.

An indication that the Orientalizing style in Etruria started as the art of a wealthy minority is given by the very places from which so many of these objects were unearthed: the famous Etruscan cemeteries, especially those of Vetulonia, Cerveteri, and Tarquinia. Indeed the great Etruscan tombs[1] invite comparison with the burials of Egyptian kings and nobles, or the vaulted tombs of Mycenaean princes. Their principal importance for the history of art, however, rests in their decoration and in their function as depositories of fine implements of all

kinds. To name only one instance: from the seventh century onwards the Etruscans were the most ardent collectors of Greek vases. Many of the best Greek vase paintings are known to us only because the cemeteries of Etruria hid them so well over the centuries, and saved them from destruction. Likewise, much of the finest native art was stowed away in these sumptuous burials. Especially in the tombs of the seventh century objects of precious metals, gold and silver, were no rarity; while during the following century fresco painting on the walls of the subterranean chambers became the vogue. This is best known from the necropolis of Tarquinia, whose gaily decorated walls contribute so much to our knowledge of ancient painting.

Origin and Types

As architectural monuments the Etruscan tombs fall beyond the scope of this volume. But the spirit which prompted their builders cannot be a matter of indifference here. Etruscan art was to a much higher degree than the Greek a funerary art – an adjunct of tombs; the more it developed, the more marked the difference became. An attempt must be made to account for this contrast.

It has been mentioned before that during the so-called Iron Age in Italy two contrasting forms of burial were practised, originally by separate groups and in different regions; and that in Etruria the prevailing rite was cremation. However, by the end of the eighth century inhumation became more common, even in Etruria: the custom changed, though not necessarily the underlying ideas.[2] It seems quite believable that their settled condition and new wealth merely permitted some strata of the population better to express ideas about death and after-life which may long have been common among them, even at a time when their migratory status made cremation more practical. Be this as it may, the great Etruscan tombs were certainly not devised for burials by cremation, a practice which occurred in them only occasionally. On the contrary, their builders wished to preserve the material forms of human existence: they buried the bodies intact, with visible care, and often with the help of huge stone boxes or sarcophagi. Like the Egyptian mastabas of the Old Kingdom, these tombs were made into veritable houses of the dead; and in Etruria, as in Egypt, the desire to make life permanent in effigy became an incentive to art.

The forms of these tombs vary; again, most likely, expediency was the sole reason.[3] Some were hewn into steep cliffs, like the rock tombs of Egypt and Asia Minor. More commonly they were dug into the ground and signalized above it by large mounds (tumuli). In Cerveteri, for instance, one walks through a whole city of tumuli, complete with paved streets and the tracks left by the funeral cars. Round structures predominate, each consisting of a stone base on which the high mound rises like a conical hill; but monuments on a rectangular plan also occur. In the famous cemetery of Tarquinia one descends steps into deep underground rooms. There is no outside architecture as at Cerveteri. Yet in both places the tombs were carved into the rocky terrain. Evidently they were intended as a more elaborate and durable variety of the simpler trench tombs which the poorer still used. Accordingly in northern Etruria, for example at Vetulonia and Populonia where the ground was soft, the tombs had to be built of stone and then covered by tumuli.

What really mattered in all these variations was the interior arrangement. In some instances a long, narrow corridor leads into the mound or the hillside, to one or several burials (tombe a corridoio). In other tombs one finds a large subterranean chamber to which one or two smaller rooms may be added on either side of the entrance (tombe a camera). One trait stands out generally: that is the effort to make the tombs look, inside, like the houses of the living. In the chambers the sloping ceilings of a gabled roof with rooftree are frequently imitated, and the deposits add the furniture and implements required for a real household. Symbolically, they all cater to the physical needs of the dead as if they were still living.

This attitude need not surprise us. A similar mentality can be found in many other peoples at

various times and places. What is surprising, rather, is the late appearance of such monuments in Italy, for by the time the Etruscan tombs began to exhibit this increase in size and wealth, rich burials with large deposits of implements were no longer customary anywhere else in the Mediterranean, with the exception perhaps of Egypt. Foreign techniques occasionally appear, as for instance the vaulted ceilings of the tombs at Vetulonia, which were probably constructed by immigrant workmen – just as the number of imported materials in all the tombs of this kind testifies not alone to the buying power of their owners but also to their foreign contacts. But by and large it seems more natural to understand the forms of these structures not as imports from some altogether uncertain region abroad, but as a more magnificent documentation of ancient, native beliefs. In fact the same insistence on a material after-life of man, only more modestly expressed, had already documented itself in the hut urns and biconical vases covered with helmets of the Villanovan burials. The collective character of many of the large tombs which apparently belonged to entire families, not to individuals only, tallies with the clannish structure of the new Italian society. The material wealth displayed in the funeral monuments reflects the recent prosperity of that society. This after all was the time when the power of the Etruscan confederacy expanded far beyond its original territory, established itself in Praeneste, conquered fertile Campania, and even invaded Rome. Such affluence of goods was new to Italy. For all that, their owners were not necessarily newcomers from other countries. In the general culture of their day – in which the urban civilizations of the Middle East and Greece set the standards – the large Etruscan tombs appear strangely isolated: archaic and obsolete.

Analysis of the Deposits[4]

None of the great Etruscan tombs is dated directly by an inscription or a reliable tradition. Nevertheless, unlike the Villanovan burials with exclusively Geometric contents, tombs includ-ing Orientalizing objects can be fairly securely linked with the chronology of the eastern Mediterranean. This is especially true of the large sepulchral structures which yielded actually imported implements, together with objects closely imitating imported models. The contents of these tombs show conclusively that the fashion for erecting large architectural mausolea in Etruria originated in the Orientalizing period. Moreover, during the same period the more modest burials also are with increasing frequency found to contain foreign articles. The mixed character of many of their deposits makes it possible to assign approximate dates to the accompanying native wares which would otherwise go undated. In this way recent investigations of important Orientalizing tomb groups have succeeded in greatly improving our hold on the early Etruscan chronology throughout the seventh century and beyond.

Indeed from these studies a very enlightening picture can now be gained regarding the entire status of art during the seventh and early sixth centuries. The term 'Orientalizing' was first coined for that phase of Greek art which, in Greece, replaced the Geometric. In many ways this change implied a revolt, or rather a reaction, against the limitations of the Geometric style. The chief event was the inclusion of vegetable patterns in the ceramic decoration. The forms of their stylization – notably the so-called palmettes – were derived from oriental art. The same is true of many animals, for example the lions now often depicted among the decorative elements. At the same time a new concept of painting evolved which allowed for more significant and specific representations of subject matter. Inner design and a variety of colour began to reappear on the vases, and to break the rule of the merely drawn – not painted – black silhouettes to which all Geometric representations had been reduced. Nevertheless the inherent love of geometric forms remained with Greek art. It proved not incompatible with the new turn towards realism. In Greece, to 'orientalize' meant for the artists to humanize the inherited abstract, geometric conception of art; to represent a greater portion of organic nature;

and in the pursuit of these goals to adapt to their own manner of representation a number of motifs pre-formed in Oriental art.

The new movement started almost simultaneously at rather disparate geographical centres. Locations in the eastern Aegean played an important role, especially at the beginning: Crete, Rhodes, the Cycladic islands. On the Peloponnesus this period marks the coming to power of Corinth, which as a producer and exporter of fine ceramics for a while outrivalled Athens. Her seventh-century ware, of an unmistakable style called Protocorinthian, proved enormously successful both at home and abroad. It came to dominate the Mediterranean export, almost to the exclusion of all other centres. This development culminated during the last quarter of the seventh century, at a time when the home workshops were already changing to their mature Archaic, no longer Protocorinthian but Corinthian style. At no time was Greek art so decentralized, so variegated, as during the first half of its Orientalizing period.

Samples of these ceramics, especially Rhodian and Protocorinthian, reached Italy almost as soon as their production began at home; as mentioned above, their importation started around the year 700. However, the earliest shipments went to the Greek colonies, chiefly Cumae and Syracuse. Importation into Etruria developed more slowly, and Early Protocorinthian material remained rare. To judge from the finds, only the Late Protocorinthian and Early Corinthian wares of the second half of the seventh century were shipped to Etruria in quantity, and frequently imitated by local factories. Naturally this influx of new material had its effect on the domestic craftsmen, and eventually could not but change their entire outlook, by moving into focus the representational possibilities of art. In this way Etruria, too, benefited from the advances made in Greece during the seventh century. As in Greece, we would say that the scope and variety of art became greatly widened.

Still, the ensuing situation in Etruria differed from the Greek in many respects. Etruria was an open market, not an original centre of the Orientalizing development. For the Etruscans,

to 'orientalize' meant to learn what art could do, and to learn this partly from Greek and partly directly from oriental examples.[5] Because the local public accepted certain kinds of oriental art as eagerly as Greek art, a fusion of Greek and oriental artistic standards followed which had no counterpart in the East except in a few outposts such as Cyprus and perhaps Crete. Moreover, in Etruria works of art were imported not only as prized possessions but also as models and aids for domestic production; and the Etruscan workshops, unlike those of the Greek colonies, took to Greek-Orientalizing as well as to real oriental art, almost indiscriminately. From their point of view there were no clearly preferable standards of Greek art; in fact during the seventh century these standards were just forming. Therefore among the deposits of the wealthier Etruscan burials of this period, three categories of objects can be regularly distinguished: Greek-Orientalizing and local imitations; oriental and local imitations; and the comparatively free domestic products.

In this manner the contents of the great Etruscan tombs of the seventh and early sixth centuries precisely illustrate the cultural situation of the ancient world at a time when the Graeco-centric culture, as classical antiquity appears to us in retrospect, was still in the making. The selective process was then not yet completed by which, eventually, the standards of Greek art proved victorious. The earlier leading styles, Assyrian and Egyptian, were still actively practised in their respective countries, and quite on a level with the coeval Greek. Indeed, to an unbiased contemporary many of their works must have seemed superior because of their wider range of subject matter, and their realism. Something must therefore be said here about oriental art also, which, together with the art of the Greeks, left its impress on the Etruscan culture reflected in the seventh-century tomb groups.

On the whole neither Assyrian nor Egyptian art seems to have been proselytizing. Originals of both styles can never have been plentiful in Etruria. Yet their achievements were by no means lost to the ancient world. They were transmitted to the West by the exporting centres

of the south-eastern Mediterranean: the Syrian and Phoenician cities (the latter including the Phoenician colony of Carthage in North Africa) and the cities of Cyprus. Traders and perhaps workmen from these regions must have been among the earliest to reach Etruria during the eighth century; during much of the seventh, their products competed with the Greek. Their cargoes occasionally included Assyrian and Egyptian originals, but the majority of their wares came from the native towns of the traders. A rather unified style of minor arts had developed in these eastern centres which easily combined characteristics of Egyptian, Assyrian, and other oriental arts. Its products ranged from straight imitation, for instance of Egyptian faiences, to free variations on oriental subjects. These artisans especially excelled as fine silversmiths, and some of their work in this line is of admirable elegance. The ebonists also should be mentioned. Through portable objects of this kind the Etruscans of the seventh century became acquainted with an odd but interesting assortment of oriental and Egyptian art and iconography, quite different from the Greek. They came to know the representations of human and animal life which formed the setting for the pictures of hunt and war customary in those styles.

The uniqueness of the Etruscan situation consists in the fact that a knowledge of Greek, Phoenician, and, through the latter, of Egyptian and Assyrian art, became available simultaneously through the contingencies of seaborne trade. To the new lands of the West these four cultures and their products, all equally foreign, must have appeared as four different aspects of an essentially identical phenomenon. Together they represented what I previously called the high civilizations of the East. The Greek was only one in their number; and Greek art, even, did not at that time give a very homogeneous impression. The relative density and selection of all these imports, as well as the order of their arrival, the measure to which the public appreciated and the workmen were able to absorb these innovations, determined the development of Etruscan Orientalizing art.

Chronology[6]

A kind of development, or rather progress, among the Orientalizing materials is indeed indicated by the contents of the outstanding Etruscan tombs. But it is a development proper to Etruria; it is not the same as in Greece. Similar to the previously described Geometric, the Orientalizing development of Etruria reflects not so much a consistent progress of style guided by an inherent logic of problems and methods, as the response of domestic industries to the challenge of foreign examples. However, there appears to inhere a certain consistency in these responses, and this can be discovered by proper critical study. The great tombs of Etruria demonstrate primarily the increase and relative importance of her foreign contacts; but in addition they also show the various stages of fusion between native crafts and imported ideas. On the basis of these materials I suggest three chronological divisions, or stages, in the progress of Etruscan Orientalizing art. Each equals roughly one generation.

Circa 680–650: First Stage. Gradual disappearance by 680 of Geometric vases from the wealthier burials; end of the predominantly Geometric period. First chamber tombs. Importation from Greece of Protocorinthian and other Orientalizing art; considerable Phoenician importation of oriental art. Most important tomb group: the so-called Bocchoris Tomb[7] at Tarquinia. This tomb offers a chronological clue in so far as its deposits include a Phoenician imitation of an Egyptian faience vase inscribed with the name of the Pharaoh Bocchoris (probably 718–712). It is a moot question, however, how long the vase was in use before being so buried. Greek material forming part of the same burial makes a somewhat later date than the reign of Bocchoris advisable (*c.* 670).

Circa 650–630: Second Stage. Beginning of the golden age of Orientalizing art in Etruria. To this and the following period belong the most splendid tomb groups of Etruria. Culmination of the Phoenician trade; Etruscan-Orientalizing animal style. Characteristic is the rapid expansion and improvement of the so-called bucchero

industries, and the flowering of domestic metal industries (gold, silver, and bronze). Representative tomb group: Regolini-Galassi tomb,[8] Cerveteri, so-called Cella.

Circa 630–600: Third Stage. Decline of the Phoenician trade and eventual prevalence of Greek imports: grecizing stage of Etruscan Orientalizing art. Characteristic is the increase of domestic ceramics imitating Greek models or assimilated to Greek art and techniques. At the same time a curious 'flamboyant' style develops in the more independent, popular arts: impasto, *bucchero sottile*. In the crafts dealing with precious metals such as gold, silver, or ivory one finds a noticeable interest in imagery, and often a fusion of Greek and oriental elements: to this period belong the first narratives in Etruscan art. Beginning of sculpture (including Canopic portraits). Representative tomb groups: latest deposits in the Regolini-Galassi tomb, Cerveteri; Bernardini Tomb,[9] Barberini Tomb,[10] both at Praeneste.

CHAPTER 4

ORIENTALIZING ART IN ETRURIA

FIRST STAGE

Ceramic Forms

Oriental shapes appear among Etruscan ceramics about the turn from the eighth to the seventh century. At that time imported articles were still rare in Etruria; the Bocchoris vase must have been a thing of considerable value to its Italian owners. But the domestic crafts, likewise, began to accept the new forms, as they had somewhat earlier adopted Greek Geometric models. Indeed a discrepancy between the forms of vases and the applied decoration can often be observed during this early period, the former reflecting oriental influences, while the latter continue in the native Geometric tradition.

A good example of this infiltration of oriental vase forms into Etruscan art is the so-called pilgrim flasks:[1] flat, circular bottles of a shape long familiar to the ancient Near East. We know that Phoenician originals of this type were shipped into Etruria; thus it is not astonishing that Etruscan potteries soon turned out flasks of the same oriental type. But almost simultaneously the idea spread to the metal workshops. The process was characteristic of this importation of art to the new country in that it implied a transfer of form from one craft to another, and from one material to another. As the metallurgists of central Italy started manufacturing flat bronze flasks of the oriental 'pilgrim' shape but embellished with Geometric decoration in the native style, they actually created a new type of object, not in existence elsewhere. For a while these metal bottles with Geometric ornament proved quite a popular article in Etruria [23].

Even more consequential proved the introduction of jugs with beak-shaped spouts,[2] a ceramic type very popular in the Near East from prehistoric times [24]. The form came to Etruria from Cyprus and was at once imitated in the

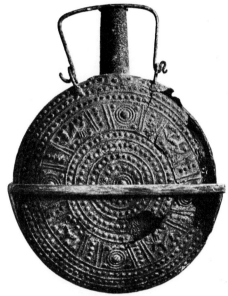

23. Flat pilgrim bottle from Bisenzio, early seventh century. Bronze. *Vatican, Museo Gregoriano Etrusco*

native impasto technique. But it also invited free variations, over and above mere copying. A remarkable three-necked vessel of this kind with the unmistakably oriental 'beak' belonged to the contents of the Bocchoris Tomb [25].[3] Its lenticular body is totally un-Geometric; indeed, un-Greek. It is treated with a certain freedom and linear fluency, reminiscent of Art Nouveau objects of the late nineteenth century. Ever afterwards the beak-spouted jug, in numerous indige. ous variations, remained a popular form in Etruscan Italy. It proved a lasting contribution of the Orient to Italian culture.

Engraved Designs

The growing influx of examples of imported art resulted in a gradual refinement of taste, a

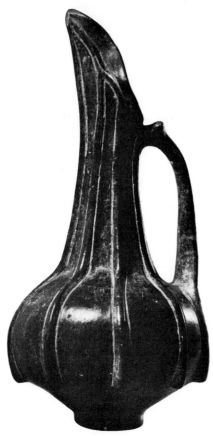

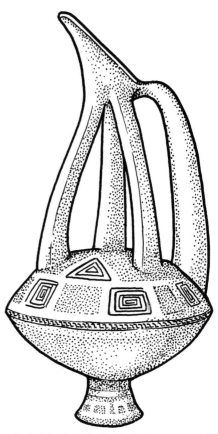

24. Beaked jug from Tarquinia,
early seventh century. Impasto.
Tarquinia, Museo Nazionale

25. Beaked jug from the Bocchoris Tomb, Tarquinia,
c. 670. Impasto.
Tarquinia, Museo Nazionale

greater variety of shapes, and technical improve-
ments. Potters learned to make the surface of
their vases very smooth and shining; the im-
pasto colour turned evenly dark grey, approach-
ing black. In the best specimens a design was
often engraved on the surface, rather than
painted; the engraving technique stressed the
metallic effect. Decoration, too, began to change
style. Most common is a kind of small amphora
decorated with a horizontal double-spiral; the
design must be regarded as a stereotyped Greek
Subgeometric pattern. In these vessels the ce-
ramic form is treated like metal, and the Rego-
lini-Galassi Tomb in fact contained a specimen
made of silver [26].[4] Also among the vases with

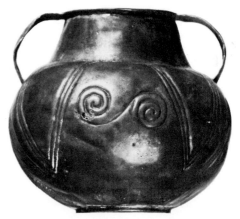

26. Small amphora from the Regolini-Galassi Tomb,
Cerveteri, *c.* 650–630. Silver.
Vatican, Museo Gregoriano Etrusco

incised decoration, the figural representations of the Greek Orientalizing style began to make their influence felt. For the first time in history an Italian school of free design – not merely Geometric – developed in these workshops.

Since this fact bears on a matter of considerable importance, a discussion of detail will be in order. An excellent black jug in the Vatican[5] may serve as an example [27]. The globular shape with beaked spout is clearly oriental; not so the engraved design, which can be recognized as the work of an Italian craftsman possessing some knowledge of Greek Orientalizing decoration. A fish, curiously drawn as if viewed from above, is shown on either side of the spout. Two decorative zones follow, one with palmettes on a high stem, the other with stylized flowers. The entire space beneath is given over to a procession of animals: two stags, a horse, and a serpent. The broad muzzles of the quadrupeds betray their Late Geometric, Greek ancestry; but why, in spite of the similarity of type, do these animals look so different? Obviously their maker used a different approach to drawing – not merely another technique.

Greek artists like to show that natural creatures consist of well defined parts. Theirs is an analytic approach. In their painted and sculptured images the parts are firmly set against one another: the single figure, even, forms an antithetical composition. Also, the bodies have solidity. This wish to represent solid reality may be one reason why at first the Greek vasepainters in the main preferred compact black silhouettes to drawings by outline; for with the black figures the outlines appear mere attributes of the solid mass which they encompass, and which they oppose to the nothingness of the surrounding space.

To all this the animals depicted on the Vatican jug stand in direct opposition. The stag [28] is drawn in mere outline. Its contour encloses nothing – neither an abstract contrapuntal structure nor a natural one of bones and sinews. If it were real, this creature would look like a blown-up rubber animal. Yet it is drawn with great care and certainly not without skill. Only, with this kind of drawing the art consists precisely in

the mellow, fluent line which creates a unified shape, like a pattern. The approach is synthetic rather than analytic. Here, as with the Etruscan

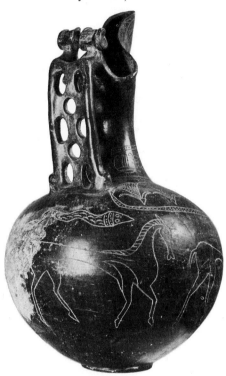

27 and 28. Globular beaked jug, with detail of a stag, early seventh century. Impasto. *Vatican, Museo Gregoriano Etrusco*

Geometric figures, we find the shapes defined by delineation, from without. The drawing is undramatic but not uneventful: on the contrary, it is very suggestive and delicate, and in its own

way it produces a surprising, somewhat sur-realistic effect. With bent legs, dreamily, peace-fully, these animals trot along. The sense of dream is enhanced by the fact, rare in ancient art, that no base line is shown. Thus the whole vase becomes the undefined ground on which the snake creeps and the animals trot – as in a prehistoric rock painting.

I am convinced that all this is no accident; it is a style. More examples can be found, not only in the same typically Etruscan-Italian class of impasto vases with incised design but also in other techniques, such as the embossed reliefs of early Italian bronzes. However, this question leads us to materials belonging to the following period, in which the Orientalizing style of Etruria came to approach its culmination.

SECOND STAGE:
INTERNATIONAL STANDARDS

General Characteristics

By the middle of the seventh century the Orient-alizing art of Etruria had entered its golden age. This statement is based on the evidence of the great tombs; and it should perhaps be modified by the added observation that among the con-tents of Etruscan burials, the discrepancy not only of wealth but also of artistic styles was never greater. During this and the following periods the taste of the wealthy detached itself ever more clearly from that of the ordinary people. Innovations occurred on both levels, however; thus the way was opened for the astonishing variety of objects and variability of shapes which mark especially the following, third period.

The Geometric style, though not yet extinct, dropped definitely into the background around the middle of the century. Metals – bronze or better – were preferred to ceramics wherever feasible; and, as a rule, the richer a burial, the fewer clay vases it now contained. In this period there can be no doubt that the upper social strata began to buy the transportable goods of the East in quantity. They hoarded them in their house-holds as in their tombs: things of finely wrought metal or other precious materials such as amber and ivory, not to mention the more perishable objects like expensive textiles of which no samples have come down to us – only an occa-sional echo in literature. Within a few decades the general level of taste became completely revolutionized.

With this gradual mutation of taste in Italy and its assimilation to international standards we must now occupy ourselves. The new up-surge of artistic activity and inventiveness was at the outset mostly limited to the crafts of daily use, and thereby channelled into fields which we would now classify as minor arts. No brief historical survey can do justice to the ensuing variety of these materials. Instead it will be necessary to concentrate on the really new and significant additions to the already established forms of art in Etruria, as these innovations appear one after the other among our materials. The simultaneous continuation of many popu-lar wares of the older type must meanwhile be taken for granted.

Especially, from now on, we shall have to give increasing attention to representational decora-tion; for in this developed an art with a content, even though Etruscan art continued to lag be-hind both the contemporary Greek and the oriental in this respect. Once more the unusual fact throws light on the fundamental difference between the Etrusco-Italian and the Greek situ-ation during the Orientalizing period. In Greek art the liberating effect of the new oriental con-tacts became at once noticeable; there was a vast store of content waiting, as it were, for the new modes of expression. Italy on the other hand was a land not altogether without art but almost without a native tradition of imagery; and what little imagery the Villanovan style had been ready to include with its ornament remained of a completely impersonal and generic character. No pre-seventh-century Italian work of art of which we know tells a specific story. Because the domestic forms of implements, armour, and jewellery in Italy differed widely from those of the eastern countries, there was a place for a native tradition of crafts, as we saw. To an

extent, elements of Greek Geometric art had been able to fuse with this native art, as a decoration. The advent of the Orientalizing period, however, created a more complicated situation. For the wholesale transfer of an art which in its homelands tended to become increasingly representational and which therefore brought to Italy a wholly new imagery readymade, the domestic arts were less prepared than for the Geometric. This was not entirely a problem of skill; it was also a matter of intellectual readiness. What the student of Etruscan Orientalizing art witnesses is a process of adaptation from foreign prototypes which moved much more slowly and reluctantly than the coeval orientalization of Greek art, because the gap between the domestic level and the exemplars was so much greater.

Imported Sources of Etruscan Art

Naturally the transfer of styles from the eastern countries to the West depended on such types of art as could be shipped with sufficient facility over great distances. We find an interesting comment on this fact in Herodotus. According to his report, the Phocaeans who under Persian pressure were forced to relinquish their town in 545 loaded their fifty-oared ships with their 'movable goods, and in addition the images from the temples and other gift-offerings except the bronzes, stone work, and paintings'.[6] This inventory was certainly typical of many other emigrant groups who between the eighth and the sixth centuries came to colonize Italy. It made allowance for some personal furniture; but votive images from the sanctuaries were brought only if they were small enough for transportation. Temple treasures of precious material were probably included. All works of art on a large scale – statues or paintings – had to be abandoned. We have no reason to believe that the early traders could make a very different selection. The traffic of large sculpture and painting into Italy developed at a much later date. As a rule one must assume that the new sources of imagery and industrial design which underlay the Etruscan Orientalizing art were

altogether small works, of practical and personal use. The bulk of the Greek and Phoenician commercial importation likewise must have been articles of moderate size and weight.

Ceramics loomed large among the Greek materials. One can say that the art of painting came to Italy by way of the Greek Orientalizing vases. Immigrant potters probably helped to diffuse the knowledge of various Greek Orientalizing styles by starting a local production on the lines which they had learned at home. For instance, the common Etruscan imitations of Protocorinthian and Corinthian vases were really a type of domestic art in the Corinthian style; they were not necessarily copies. These potters by training perpetuated not only the techniques but also the rules of design and composition which they had once acquired. They preferred Corinthian models.[7] Another class of the same period, the vases of the so-called Civitavecchia style,[8] show the influence of Rhodes [29].

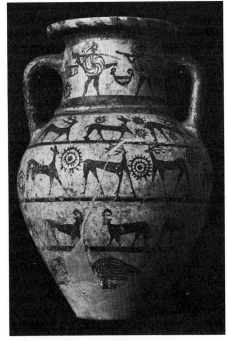

29. Etruscan painted amphora,
early seventh century.
Rome, Villa Giulia (Castellani Collection)

On the other hand, the ivory carvers used a somewhat different set of models. At first, it seems, their craft was chiefly a domain of the Syrians and Phoenicians. Phoenician Orientalizing ivories were actually discovered in Etruria; but Greek prototypes were also in existence. Both kinds offered examples for imitation in native workshops. Moreover, there was always the possibility that ivory reliefs could serve as models to ceramic painters, just as ceramic decoration could be imitated in ivory.[9]

In addition, the well-known Syro-Phoenician and Cypro-Phoenician silver bowls,[10] of which the wealthy tombs of Etruria have furnished us with some truly outstanding examples, must be regarded as a potential source of iconography in Etruria. Scenes of human life in such variety were found in hardly any other art reaching Italy at this period.

Only a small fraction of all this imagery appears actually reflected in the native Etruscan art of the time which concerns us in this chapter. The progress of Orientalizing art was rather slow in Etruria, especially during its two initial stages. The copying crafts naturally developed a degree of facility, to be utilized later. But a survey of the materials attributable to the second half of the seventh century will quickly confirm the impression, gained already from the discussion of the Geometric style, that the more interesting products of Etruscan art were those in which the native craftsmen adapted foreign prototypes to some purpose of their own: either by transferring a design from the material in which they found it to another medium; or by using imported prototypes for the decoration of some object to which no counterpart existed in their lands of origin. Only in these cases of comparatively free adaptation can the evolution of a native Orientalizing style in Etruria be comprehended as a consistent, educative process.

THE ANIMAL STYLE

Representational Art of the Second Period

Three objects stand out among the materials which we ascribe to the middle decades of the

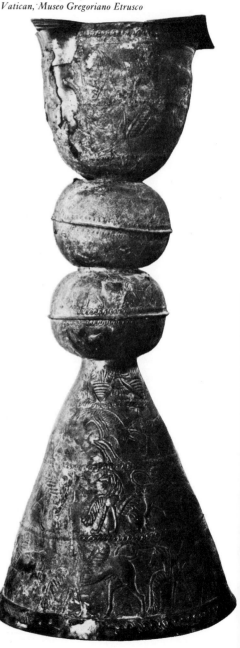

30. Stand from the Regolini-Galassi Tomb, Cerveteri, c. 650–640. Bronze. *Vatican, Museo Gregoriano Etrusco*

31. Cauldron from the Regolini-Galassi Tomb,
c. 650–640. Bronze.
Vatican, Museo Gregoriano Etrusco

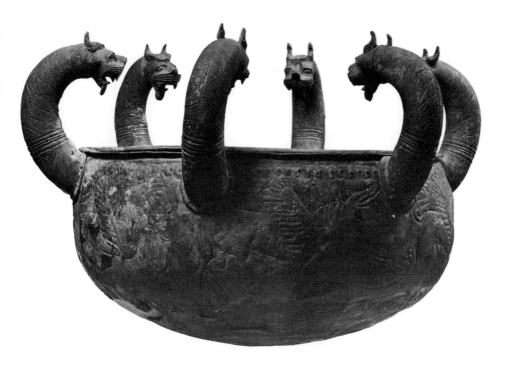

seventh century: the large bronze stand from
the antechamber of the Regolini-Galassi Tomb
[30];[11] the bronze cauldron often placed on this
stand in earlier photographs, although it prob-
ably does not belong to it [31];[12] and the mag-
nificent golden fibula from the so-called cella of
the same tumulus [32].[13]

These three objects, though of different desti-
nation and materials, should be grouped to-
gether because of their decoration. The vase
stand is an excellent specimen of a type of furni-
ture about which more will be said in the chapter

on industrial design. Cauldrons of bronze as in
our illustration 31, decorated with protomes in
lions' or griffins' heads, were a popular item of
Etruscan art of the seventh century. Their
original invention can be traced to the Near
East, perhaps Syria.[14] But the same type of
vessel was also produced in Greece, where they
became known as 'Argive cauldrons'. In Etruria,
Cerveteri, Tarquinia, and Vetulonia became
chief centres of their manufacture. All in all the
cauldrons must have been very common in the
wealthier households, though of their purpose

nothing is known with certainty. Our third example, the golden fibula [32], is of course a thoroughly Italian contrivance, developed from the native type of safety pin discussed above but of giant size. It is a very showy piece and, as regards size and decoration, unique.

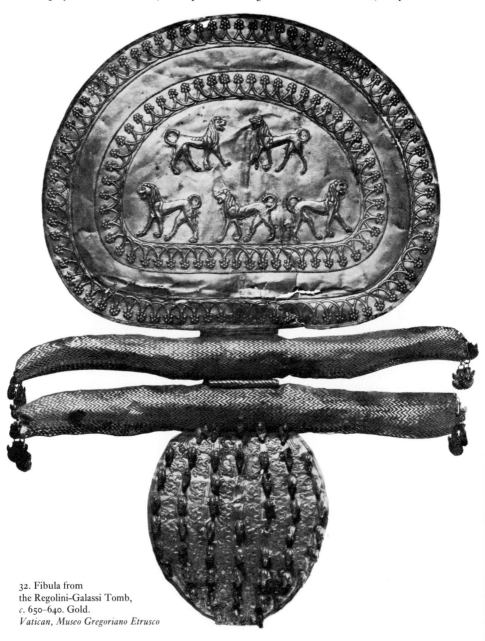

32. Fibula from
the Regolini-Galassi Tomb,
c. 650–640. Gold.
Vatican, Museo Gregoriano Etrusco

In fact, one of the obstacles with which any discussion of the Etruscan Orientalizing treasures from the great tombs must cope is precisely the circumstance that so many items in their inventories are unique pieces. It is difficult to discover a community of style. For instance, there are many Etruscan vase stands among the finds preserved, but no other is decorated exactly like the one from the Regolini-Galassi Tomb [30]. Likewise, in Greece, bronze cauldrons of the type seen in our illustration 31 are not decorated with embossed reliefs: those in our example are definitely of Etruscan workmanship, although the design, which represents a procession of animals, recalls Greek Orientalizing vase paintings. Obviously the Etruscan practice of free adaptation from models picked at random leads to this apparent lack of rules. While the forms of common implements were prescribed in a general way, more often than not the choice of decorative details depended on chance; either on the personal preference and schooling of the craftsman, or on the accidental selection of models at hand. Likewise the application of such decoration to particular objects must often have been entirely at the discretion of the native artist in the absence, as yet, of a stable domestic tradition. Naturally, at this stage, the more ambitious a work of Etruscan art appears, the more unusual it looks to us. The singular importance of the three objects selected for this account consists in the fact that in spite of their apparent diversity, they exhibit a degree of stylistic consistency, not in their shapes – which are different – but in their style of decoration. Among other things, they demonstrate the formation of a domestic style of figures with common characteristics which to us signalize a new stage of Orientalizing art in Etruria.

International Characteristics

The difference from the products of the preceding period will at once be noticed in all three works. It must be described as a progress towards the level of the leading eastern arts, Greek and Phoenician. Three points should be especially mentioned. 1. Interest has definitely shifted from abstract to figural decoration. 2. The primary subject matter now is monsters and animals. 3. The primary principle of composition is the horizontal frieze.

These three points are more or less true of all Orientalizing styles of the eighth and seventh centuries. The styles were decorative, primarily, notwithstanding the fact that the development of figural representation was their chief business. They also were 'animal styles' to some degree, but not to the same degree: the relative frequency of animals, compared with other representations, always remained higher in Etruscan art than in most other Orientalizing schools except, perhaps, the Rhodian. For instance on the Protocorinthian vases which were so popular in Etruria, human figures are much more common. Obviously the native workshops absorbed the foreign influences only partially.

On the other hand the animal representations are more assimilated to eastern styles than they ever were before. As in all Orientalizing art, the figures – monsters and animals – are lined up in horizontal processions marching quietly from one side to the other. Such rows of animals had long been a standard feature of oriental art, especially in the Near East. The superimposed zones of the Regolini-Galassi bronze stand were also used in these styles from the earliest times. However, to assemble a variety of different animals in each zone is a Greek trait; so is the free mingling of fabulous and natural zoology.[15] Oriental art liked to assign one species of animals to each row. While, therefore, by general arrangement, the decoration of the bronze stand is related to Greek Orientalizing art, it can hardly be explained as a mere translation into bronze of a Greek model; for instance, of a Protocorinthian vase. The rendering of the animals is not identical with any specific Greek style. We must consider it an Etruscan variant of the common Orientalizing animal style.

Examination of details leads to the same conclusion. From the point of view of eastern art one is dealing here with a mixed iconography. The sphinxes with the Egyptian 'apron' between the forelegs render a Phoenician type.[16] Their wings, too, are stylized in an oriental

manner; the wing growing from the averse side bends downward.[17] On the other hand there are two varieties of lions, and those with wings may well depend on Greek, Corinthian representations. Those without wings form a very special race, however, because of their long manes. Ultimately this manner of drawing the mane, as if it consisted of long strands of hair, may also have derived from Protocorinthian models, sloppily rendered.[18] But the result was a new type, distinctly Etruscan: the lions on the golden fibula from the Regolini-Galassi Tomb are of the same breed [32]. Furthermore, it will be noticed that most of these animals walk on curiously high legs. The taste for these stilted creatures must have been acquired from Greek Cycladic art, or perhaps from Crete; it was scarcely Corinthian. As the style of the Regolini-Galassi bronze stand and similar monuments emerges from this analysis, one may call it eclectic; but to me it seems best described by a proper name, such as Etruscan-Orientalizing.

Regional Characteristics

In so far as this Etruscan production now appears as a fully-fledged if somewhat irregular variety of Orientalizing art, one must be able to name its regional properties. I shall point out two such characteristics. One regards its approach towards the animal form as a problem of design. What makes these animals look so strangely undecided, undramatic and loose-jointed? In that respect they still resemble the engraved beasts of the first period; and they differ, most obviously, from their eastern counterparts, especially the Greek. Again the explanation must be the same as before. Not that the designers had no talent; what was lacking was the firm, Geometric training which their Greek contemporaries possessed. With each step in the Italian development which we are in a position to follow, this circumstance stands out more clearly, as something constitutional in Etruscan art; it was the one basic factor which made it a different art from the Greek. Greek Orientalizing art in its rather stylized images did

incorporate abstract, geometric principles. To much oriental art, also, a simple but effective geometry was basic. In detail the Etruscan artists adopted many stylizations which their prototypes offered. But during the period with which we are dealing here, they certainly showed no interest in the structural character and the geometrically controlled, rational form of their models. Their emphasis was on representation, not structure. And they persisted in their tendency to conceive of an image as an outward form defined by delineation rather than by structure from within.[19]

Space and Ground

The other point which I wish to make here regards a problem of pictorial composition. It is true that the three examples under discussion in this section are reliefs embossed on thin sheets of metal, not true paintings or drawings. However, in all early arts, reliefs, though endowed with a degree of sculptural elevation on the surface, follow the same general laws of representation as paintings and drawings. Like paintings, and different from statuary in the round, which is essentially three-dimensional, they relate all forms to the level ground on which the images are drawn or from which they emerge; and side views constitute their preferred mode of representation. In this inclusive sense the reliefs of ancient art, and indeed most reliefs, can be treated as equivalent to painting.

Thus in looking once more at the Regolini-Galassi bronze stand [30] one will notice that all the animals seem to move with a peculiar airy lightness. They tread the ground rather insecurely; as if the artist were not yet quite convinced of the necessity of a firm base line.[20] Indeed this is the salient point. It has long been observed that the animals of these friezes, except in the one next to the bottom, walk directly on the ornamental braided ribbons which separate the superimposed zones.

The matter is one of prime importance for all ancient art. Egyptian art first made base lines obligatory for every object represented in a

painting or relief. The reason was partly to introduce an element of formal order. Without base lines the silhouetted images would lack stability and firm direction; they would look haphazard, prehistoric even; that is, less civilized. But another consideration probably also played a role in this Egyptian attitude. The base line effectively severs the figures from the surrounding ground, which by this means, as by an act of will, is declared something outside the representation. Ground and representation become contrasts: the ground has no part in the representation: it has no meaning. Thus by rendering as real the solid soil *on* which we exist, the Egyptian reliefs eliminate the disquieting notion of the undefined space *in* which we exist, and which they refuse to represent.

In the light of these considerations it is astonishing how often, in Etruscan Orientalizing art, animals and other figures were still represented without any base line, as if floating in mid-air. The Regolini-Galassi bronze cauldron and the bronze stand are not the only examples. The five lions on the golden fibula from the same tomb show an identical mode of composition [32].

This free, unsupported manner of representing figures, once outlawed by the Egyptians, subsequently became very rare in most ancient arts. It was not infrequently employed, however, in Assyrian reliefs, probably in order to create the very effect which the Egyptians sought to avoid: to make the relief ground a part of the representation, interpreted as a continuous terrain or open field in which the figures move. By the middle of the seventh century Assyrian reliefs were probably the only leading art form where such representations might still be found. Whether or not this fact had a bearing on the Etruscan monuments before us it is impossible to tell. One thing is certain. From the point of view of Greek Orientalizing art these Etruscan representations constituted an irregularity; indeed, an offence. For Greek art, likewise, avoided the unsupported representation of figures, if for different reasons from the Egyptians. The Greeks were not averse to showing

space, but they did not want to symbolize it by a mere superimposition of figures. Their Geometric training had taught them to insist on an almost architectural, systematic visualization of the effects of mass and weight; and for this reason the figures in a painting must not appear to float. For Greek art, the base line became a necessity. For the Etruscans at the same time it was still a dispensable detail.

THIRD STAGE: CULMINATION

Wider Range of Art

As the seventh century approaches its last quarter, one notices a palpable change of pace in the development and expansion of Etruscan Orientalizing art: only then did it gain real momentum. This observation is borne out by two statistical facts. First, according to our present knowledge, analysis of the finds has shown that in a tumulus as rich as the Regolini-Galassi Tomb the majority of the contents belongs to the latest burials, dating to the last three decades of the century or even a short time beyond. Second, Orientalizing materials with definite stylistic characteristics become really plentiful only during the same decades. The description of style during the two preceding stages had to be based on comparatively few objects, and in each successive period on only one truly outstanding tomb group. Beyond these narrow limits it is still difficult to establish the status of Orientalizing art in Etruria during its early phases. The last stage offers an entirely different picture. First-rate examples attributable to the last quarter of the seventh century have come to us, not only from the ancient heart district of Etruria – the coastlands around Tarquinia, Cerveteri, and Vetulonia – but from all parts of the country, including such outposts as Palestrina (Praeneste) in the Sabine Hills. These materials corroborate each other. The rule of Orientalizing art had now become very nearly complete. Concomitant with it went an enormous upswing in the popular arts and crafts, which often dealt with the new currents in most

interesting ways of their own, as will be seen in Chapter 6.

Formalization of the Animal Style

Also characteristic of this stage is a noticeable increase of Greek influence, reflected especially in the animal friezes, which begin to favour a definitely Greek-Orientalizing selection of imagery. By the same token genuinely oriental details like the Phoenician sphinxes disappear from the Etruscan monuments. In their place appear new beasts of fable like the Greek chimaera, illustrated for example on the bronze skyphos in the Villa Giulia from the Barberini Tomb at Praeneste[21] [33, 34]. In examples such as these, Etruscan art shows the effect of the tendencies which then prevailed in the Greek Orientalizing schools, resulting in a more standardized selection of their ornamental zoology.

fluted bowl, placed on a high foot and surrounded by four supporting statuettes or caryatids: a fashionable form in Etruria at that time. The reliefs round the rim indicate that the artist had knowledge of foreign, probably Syrian, ivory carvings. But the goblet as a whole was an Etruscan work. And the animals which form its frieze certainly look different from those of the Vatican bronze stand [30]. A new formal order has established itself. It is a geometric order, though hardly of inner structure. Each animal can be fitted in a nearly square frame. The order which meets the eye consists in the distribution and equilibrium of visible shapes within an invisibly prescribed, geometric field. What mattered was the resulting normalization of the forms, from the outside, as it were. This geometric order proved quite compatible with the typically Etruscan mannerisms, as for instance the unnaturally long legs of the animals, whose

After all, this was the time when Greek art acquired the stock of animals and monsters which has remained a conventional stand-by of all European decoration ever since, including its indelible lions, griffins, and sphinxes.

At the same time, under the influence of both Greek and oriental prototypes, a tendency to subject decoration and animal representation to a stricter concept of geometric order comes to the fore in many Etruscan works. A measure of geometric discipline develops in Etruscan art of the late seventh century. The famous ivory goblet from the Barberini Tomb, now in the Villa Giulia, offers an instructive example [35].[22] The cup itself was the imitation of an oriental

33 and 34. Skyphos from the Barberini Tomb, Palestrina, with detail of a nude woman on horseback, late seventh century. Bronze. *Rome, Villa Giulia*

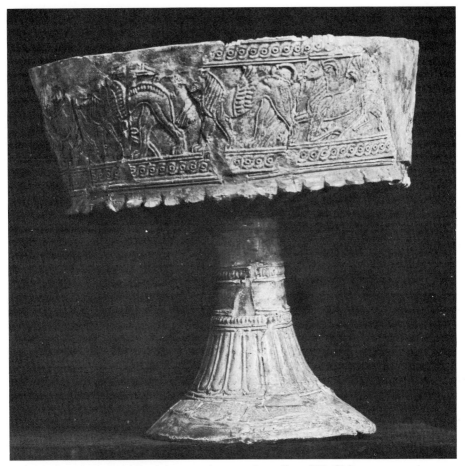

35. Goblet from the Barberini Tomb, late seventh century. Ivory. *Rome, Villa Giulia*

height strangely enhances the softness of their feline walk.

The fact that the animals are securely placed on a base line representing the ground on which they move only carries the obvious insistence on formal stabilization to its logical conclusion. On the whole, this is a new trend in Etruscan art. However, within its own time the Barberini goblet was not an isolated instance. A similar desire for formal stabilization and normalization makes itself felt in other Etruscan works of the same period, for instance the curious ivory hands from the same tomb and in the same

museum,[23] the forearms of which are decorated with carved reliefs perhaps imitating embroidered sleeves [36]; more examples will be met with later. We cannot doubt that the future belonged to this trend.

In surveying Etruscan art of the seventh century one may well be astonished at the diversity of formal concepts, exemplified at such short intervals. Almost side by side we find intuitive-fantastic, objective-naturalistic, and geometric-abstract forms. All these were recognized and practised simultaneously as possible modes of art; none was binding. Among these materials,

a representation like the animal frieze of the
Barberini goblet will be judged an exceedingly
formal work. If it incorporates progress in one
direction – formal order – the freedom and
innocence of earlier Etruscan animal drawings
were lost in the process. A case can perhaps be
made for the greater spontaneity expressed, with
a certain pleasing ease, in those earlier and
coeval works of Etruscan art which were not so
much exposed to the mathematical discipline of
the eastern arts. Nevertheless the subsequent
development disavowed the earlier works, how-
ever much their freshness and innocence may
attract us; in retrospect, theirs now appears the
obsolete performance.

36. Hand from the Barberini Tomb,
late seventh century. Ivory. *Rome, Villa Giulia*

CHAPTER 5

FIGURATIVE AND NON-FIGURATIVE ART

THE HUMAN THEME

Generic Interpretation

Like animals, human figures become more frequent in Etruscan decorative reliefs and paintings towards the end of the seventh century; yet, also like the animals, most of them are represented merely generically: that is to say they represent soldiers, horsemen, and so on, just as the animals represent bulls, lions, sphinxes or what not. Beyond this obvious fact it is difficult to find any meaning in them. As representations of natural beings, they are school pieces – preparatory only to the more definite connotations of expression and meaning which may one day accrue to them. So the animals of the Barberini ivory goblet [35] are no more than a surface decoration, appealing to a taste for which the embroidered or woven carpet was still the peak of art. There is no action, and the forms open no view into a larger world. The ground, impenetrable, closes behind those solemn phantoms as if they were walking along an endless wall.

There looms a major problem of art behind these facts. To become a vehicle for the communication of human experience, art cannot limit itself to ornament nor to the shaping of useful things. First of all it must include the representation of real objects and of man himself; it must in its own terms deal with the world in which man lives. But then, in order fully to realize its aim, it is not enough for art to depict the isolated semblances of things. True, in this world of ours, many objects are quite commonly evaluated in generic terms: it is not necessary to attach a personal name to a lion or a goat. Yet man's inner life is emotional as well as cognitive; and in order to do justice to his range of experience, the range of art must be expanded so as to include the notions of the personal and the specific.[1]

It was perhaps the most consequential effect of the Orientalizing period in Greece that it achieved the transition from a predominantly generic to a specific interpretation of subject matter, although much Orientalizing art nevertheless remained on the level of generic representation, in Greece as in Etruria. But in Greek vase paintings and reliefs a more conscious separation of ornament and representation soon becomes noticeable. Closed pictorial compositions appear on the vases, within which the human figures acquire a new importance as well as a new freedom of action and interaction. Thereby Greek art became less decorative and more humanized. A corresponding development was retarded in Etruria, where, during the period here under discussion, human representations with a specific meaning still were much the exception.

The reason can only be sought in the prevailing differences of intellectual climate. Obviously in Etruria there existed no literary tradition which dealt with human deeds and passions, as the Homeric epic did in Greece. The Italian mind was less humanized. Nor were the Etruscan deities interpreted as personal characters, like the Greek.[2] They remained either helpful or fearsome demons, or impersonal representatives of natural powers.[3] Without the Greek example, they might not even for a long time have been envisaged in human form.

Consequently there was no basis in Etruria for a development like the one which occurred in Greece, where the new representational art was coincident with a new personalized religion – the Greek character gods – and the equally new rise of literary fiction. Homer's Achilles was a freely invented character, like the hero of a modern novel; only the name and the background of the Trojan war were taken from familiar lore. The rise of this fictional poetry, which was unprecedented, fostered in Greece

not only a novel comprehension of the personal nature of man, but also an entirely new attitude towards art as a free creation. The conception that art was not a substitute for reality but a created reality in its own right was uniquely Greek. Hence the newness of Greek art, which, being free creation, set no limits to the communication of human experience; but hence, also, its reluctance concerning subject matter where a substitute reality was indeed required, as for instance the recording of historical events or memorial portraits. Yet these two themes were definitely within the range of interest in Etruscan and Roman art; while on the other hand representations of fiction were never the rule in Etruscan art, and when they occurred were almost always concerned with Greek, borrowed stories. Quite different factors set the scope of art in Italy. For a literary and humanized fictional art, as it then developed in Greece, both the native themes and the concepts were lacking.

Therefore when in the Etruscan minor arts of the seventh century human figures are at all shown, they seem more often than not but the equals of the decorative forms around them. They belong to the world of phenomena, like all other creatures; they are not the masters and sufferers of that world. Nothing shows that they are persons with a human consciousness in which experience centres as in a focus, and that they possess a mind which is the measure of all things. In this respect they hardly differ from the occasional human representations of the Etruscan Geometric style. Only their range of action has broadened, though it is still severely restricted; the new figures can ride horses, mount their chariots, march and run. As yet they are isolated beings; they are hardly capable of interaction.

By equipment and occupation a social type now receives much attention on Etruscan monuments, under Greek influence: the armed warrior. At least it conveys a degree of specification, in terms of social distinction, though no further characterization be implied. Essentially this, too, remains a generic type, midway between the most general category, a man, and the in-

dividualization signifying, for instance, a nameable hero. Like so many representations of Etruscan art, these figures appear viewed from the outside only, encased, dreamily, in their separate and semi-decorative existences, void of a purpose. If to us they often seem inept compared to their Greek counterparts, we notice in fact a disparity not of artistic ability but of intellectual culture.

Greek Narratives

A knowledge of the new Greek literature, or at least of its content, reached Italy by the end of the seventh century. From this time date the first two recognizable narratives of Etruscan art. They relate Greek stories. The monuments in question – of prime importance because of their early date – are rather flat reliefs carved around two cylindrical boxes (situlae) of unknown purpose. Both boxes, discovered near Chiusi[4] and now in Florence, had been fashioned from the hollow section of an elephant's tusk. The decoration consists of superimposed friezes in the typical manner of the developed Orientalizing style, and each box includes among sundry representations the same Homeric story: the flight of Ulysses and his companions from the grotto of Polyphemus. The workmanship differs, but the narrative style is about identical in both examples, and it will be sufficient here to illustrate the one which is better preserved [37].

Four zones of figures are divided by three remarkably fine ornamental ribbons. In the top register, which is partly destroyed, four rams are still visible, walking quietly behind each other and carrying what appear to be four companions of Ulysses.[5] Two men march before them, one armoured, the other perhaps bringing forage; for the boat towards which they move seems to be waiting, ready to be loaded. In the next zone one sees armoured men marching, in a manner reminiscent of Early Corinthian vases; a warrior with a spear rushes to his chariot, departing; of these scenes no sufficient explanation has yet been given.[6] The remaining friezes are quite ornamental, featuring the customary array of animals and monsters; among them are

37. Situla from the Pania Tomb,
Chiusi, end of the seventh century. Ivory.
Florence, Museo Archeologico

a strange centaur with human feet and long
garment who brandishes a large branch of a

tree,[7] and a rather Protocorinthian-looking man
on horseback.

Characteristic of this imagery is the para-
tactical, undramatic, and factual way in which
the figures are lined up. This manner of com-
position merely enumerates facts; it neither

judges them nor groups them from a narrator's point of view. It is not visibly related to an ordering cognitive centre or to a personal consciousness.

One sees how cautiously, timidly almost, the Etruscan artists relinquished the decorative patterns with which they were brought up: the paratactic frieze, with details rhythmically repeated; the procession of figures moving in one direction; the 'row of animals'. Indeed the rams which carry Ulysses and his men into liberty represent no more than another 'row of animals', to which for once a specific meaning has been imputed. Polyphemus cannot be seen, and one may doubt that he was ever represented. In a Greek work of the same time such rigidity of expression would seem utterly antiquated.

Nevertheless, in all its crudeness, the box as a whole is a princely object. There is a peculiar animation residing in some of the decorative figures, like the lion whose face is drawn as if seen from above, rather distortedly. Etruscan artists apparently had a liking for this convulsive distortion. It was a tour de force of the Orientalizing style, which they performed quite frequently. Only in the semi-barbarian art of the early Middle Ages will decorative details again be found so charged with emotion, and imbued with so savage a revolt against the tyranny of the form which encages them.

Oriental Iconography

All artistic representation is conditioned by conventions; and all art must be conventional before it can be original. An iconographical tradition – a selection of themes commonly represented – must form and take root in the popular consciousness if art is to be established anywhere as a current activity. Hence the transfer of art to a new continent is bound to depend on two conditions: it requires skilled workmen as well as transportable examples of artistic representation. For instance in Etruria, if native designers could at all be found and schooled for the new Orientalizing workshops, there still remained the question: what were they to represent? One must not forget that ancient artists

were not as a rule accustomed to work from nature directly. The relative scarcity of representations in early Etruscan art as a whole among other things reflects the scarcity of models from abroad from which an impulse to develop a more extensive imagery might have been derived. One knows the important role which easily transportable examples of art like prints or engravings played in the early days of American culture, under circumstances not altogether different; or the importance of illuminated manuscripts for the early development of medieval art in the colonial countries north of the Alps.

In a way comparable to these more recent instances, as far as one can judge now, the Greek painted vases became a primary source of art in Etruria towards the end of the Orientalizing period. At least by the beginning of the sixth century the forms of representation will be found generally Greek in most manifestations of Etruscan art. But the same observation is not necessarily true of all the content to which that art turned, for by this time Etruscan artists had acquired sufficient freedom and mastery of representational form to attempt occasionally the rendition of subjects which lay outside the limits of the Greek parent art. Funerary portraiture was a case in question, as will be shown presently. Likewise it would seem strange, under the circumstances, if the Phoenician-oriental import had left no mark on the Etruscan imagery developing during this period.

Traces of oriental iconography, alongside the Greek, can indeed be found, just as they could be discovered in the earlier animal style and the industrial arts. Genuine oriental features are obvious, for instance, among the sculptured images of the minor arts which not infrequently echo Syro-Phoenician examples, not only in items of dress and costume but also sometimes in their statuary types (see below, Chapters 7 and 8). However, another aspect of this situation still needs more attention than it has so far received. The possibility must at least be taken into consideration that Etruscan works occasionally represent subject matter acquired from oriental art, which may not be immediately

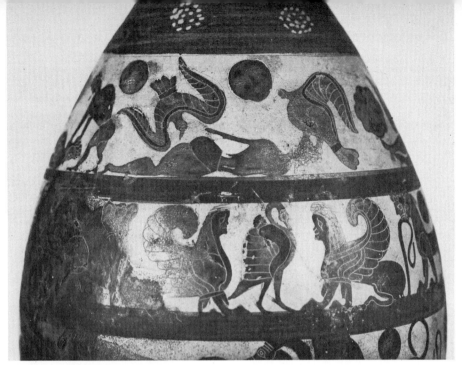

38. Vultures hovering over a dead man,
detail of an Etrusco-Corinthian pitcher,
end of the seventh century. *Rome, Villa Giulia*

obvious to a modern critic because it has been translated into Greek or Greco-Etruscan techniques and forms of representation.

I think that a rather interesting instance of this procedure occurs on two Etruscan vases belonging to the Villa Giulia Museum in Rome, of which one is here illustrated [38].[8] It is a pitcher of good Corinthian form, decorated with animals in superimposed zones in the rather colourful, tapestry-like fashion of the late Protocorinthian style. Both vases are obviously of local manufacture, and their style may be defined as 'Etrusco-Corinthian' towards the end of the seventh century.

What draws our attention to these two otherwise not uncommon specimens is the representations – quite unusual in this style – of dead men with large birds hovering over them. The motif of the slain left to the vultures on the field of battle hails from the most ancient art of the Near East. Greek art by-passed it, as far as we know. Yet on the vases before us there now unfolds the same macabre fantasy, curiously out of

context. How was it transferred to Etruscan vase painting?

Assyrian art offers the nearest parallels, as regards the theme. However the rendering of the human form, both the costume and the bulging outlines, is local and has to be discussed later on. Evidently one is dealing here with the products of an Etruscan *officina* working chiefly in the Corinthian tradition, but which for some reason added this bit of oriental imagery to its stock of models. In this case the means of transmission can hardly have been a Greek vase painting. It may have been a Phoenician silver bowl; or one of the Cretan 'shields' with embossed reliefs which sometimes carry oriental borrowings, and of which reminiscences can perhaps be found also in other Italian monuments of the same period.

In this way Etruscan art assembled a mixed iconography of Greek and oriental elements. The reason why the artists or their public wanted these representations is not always easy to name. Often one has the impression that the

image itself, as in a children's book, constituted a thing of wonder. As yet, during the Orientalizing period, Etruria hardly offered a cultural content of her own for her artists to represent.

Panel Compositions

Considering the conditions of the seventh century one may now conclude that to the Etruscans, as outsiders to all the art imported from the Aegean, many Greek and Phoenician works of the Orientalizing period must have seemed essentially alike in two fundamental points. Both arts were apt to tell a story; and even if no definite tale was told, their favourite mode of arranging figures, humans as well as animals, was in friezes.

Indeed there is a connection between these two facts. To our way of feeling, the frieze is no longer a natural form of composition; this it ceased to be centuries ago. On the other hand in ancient art the frieze had a tradition of long standing, and especially in the Near East was regarded as the suitable form for pictorial narratives at a very early time. Greek art cultivated it for the same reason: not only conceiving of friezes as ornamented ribbons, as they also often did, but developing an epic kind of composition from this decorative scheme. Thus the frieze became known to the Etruscans as a Greek or, more generally, an eastern scheme of composition, with a dual function, either as a decorative device or as a pictorial vehicle of narrative.

In either case friezes constituted an imported item; and one may doubt whether they were ever quite domesticated in Etruscan art. They played no important role in the basic stock of Villanovan decoration, the Etruscan Geometric style. As to the mythical narrative, it always remained a grecizing genre of art in Etruria. A degree of reluctance towards the continuous frieze as a form of composition was therefore felt for a long time to come in Etruscan painting, and the more this was so, the more significance beyond mere ornamentation attached to a representation. It seems that Etruscan art took much more naturally and with more lasting effects to

the alternative, panel composition, which also reached Italy at the time of the mature Orientalizing style. The practice of completely free, unframed design was then still common on the more popular levels of Etruscan art. But in works aspiring to more international standards the new formal discipline now began to express itself, not only in friezes but also in figural representations enclosed by square or nearly-square fields. As figural compositions these representations have no precedent in Etruria; but as a basic device of formal order the square filled with figures can be regarded as no different, in essence, from the windowlike devices of the Villanovan urns or the popular 'metopic' decorations of the Subgeometric vases. It does not seem unreasonable for us to say that by adopting figural compositions in panel form Etruria in fact returned to a decorative principle long practised in her domestic industries. This observation may at least partly explain why, for their effect on the future, the panel compositions proved perhaps the most consequential innovation of the Etruscan Orientalizing style.

As an early example of rare excellence, one may point to a pair of very ornate golden bracelets from the Regolini-Galassi Tomb, now in the Vatican,[9] which once belonged to the same lady who had owned the lion fibula discussed above. But the bracelets clearly were the more modern products, stylistically [39]. A rectangular system of geometric figures – meanders and open triangles – provides a firm frame in which the figural representations are narrowly fitted. The emphasis is on the latter; they fill the large, superimposed, vertical zones in the middle, while the geometric ornament only forms the marginal accompaniment. This distinction between figural *representation* and non-figural *decoration* is remarkable in itself. The fact that all representational fields render the same scene, in decorative repetition, must not blind us to their essentially independent character. For the first time we meet a figural composition in Etruscan art which is constructed like a modern picture: i.e., a representation framed on four sides and thereby set apart from all other elements.

39. Bracelet from the Regolini-Galassi Tomb, Cerveteri, *c*. 630. Gold.
Vatican, Museo Gregoriano Etrusco

Every field shows three dancing women holding each other's hands; trees appear in the intervals between the dancers.[10] The figures still face the observer, in a manner to which a Greek artist would have objected but which for a while was almost traditional in Etruria, as we know from the earlier dancers on the painted vase from Bisenzio [18].[11] Apart from this rather significant fact the style has changed, however. Details are no longer suppressed, and the women are clearly shown to wear long dresses and to have long locks of hair ending in a spiral curl on either shoulder, in the Phoenician fashion; moreover their feet are turned sideways, as an early Greek vase-painter might have drawn them in order to create a transition to the required pictorial view, the profile. From the surrounding abstract ornament these stylized representations stand out like small golden paintings, lush, appealing, and resplendent. Their soft style seems properly Etruscan; certainly it is not Greek. Yet I think that here, as

with the contemporary Barberini ivories and other similar monuments, a Greek element was incorporated in their geometric, formal systematization; and in the case of the Regolini-Galassi bracelets, in particular, that a Greek reminiscence was reflected by the peculiar arrangement of closed representational compositions as a sequence of superimposed fields, as in a modern moving picture.

That is to say, the closed and rectangular, 'metopic' composition which eventually became the leading form of all western painting was then not entirely new. Yet its possibilities had been little explored in earlier art. In Egyptian art, because pictorial representations were almost always founded on base lines, frames around the figures were rarely shown and generally regarded with indifference, if used at all. The Asiatic arts were more frame-conscious and in this sense more geometric; but in their majority they cultivated the frieze and related oblong compositions, where the emphasis is on the horizontal lines above and below, and the lateral limitations often appear as no more than a matter of expediency. Beyond the Babylonian-Assyrian area, panel composition made its art-historical debut in Greek art,[12] and with this important development the bracelets from the Regolini-Galassi Tomb must be aligned. Rhodian gold reliefs and Peloponnesian bronzes with enclosed decorations offer the nearest examples. For the manner of stacking panels one above the other, along a vertical band, Greek, Peloponnesian counterparts can be cited.[13]

Therefore these bracelets acquire considerable symptomatic importance. The same dancing figures might conceivably form a continuous frieze. Actually the frieze was cut up, as it were, to form a series of rectangular pictures.[14] This trend points to the future, and at the same time revives an old Etruscan Geometric preference for decorative squares and near-squares. Likewise the iconography of this composition – dancers between trees – has a bearing on later Etruscan art. Before long we shall meet similar dancers between trees in the Archaic tomb paintings of Tarquinia.

NON-FIGURATIVE ART: JEWELLERY

Persistence of Earlier Forms and Decoration

Personal ornaments of gold have already been mentioned twice, and not at random. Fine jewellery of gold and silver was one of the most flourishing branches of Etruscan art during the seventh century. For the most part, however, it was an art of abstract design, and the figured representations discussed above must be considered as exceptions. In no other important field of art did the aniconic, Geometric taste of decoration survive so long. Nevertheless the works of the Etruscan goldsmiths constitute a most splendid class of ancient artistic industry,

which the history of art must not by-pass. Among their number, which is considerable, are found some of the most spectacular and refined products of Etruscan art of all times. These precious objects confirm the impression that in Etruria – unlike Greece – the best effort of the Orientalizing period went into the making of decorative art, as befits a time of private wealth and luxury.

The most extraordinary cumulative find of Etruscan jewellery came from the so-called cella of the Regolini-Galassi Tomb, which contained the burial of a woman. The large necklace now in the Vatican [40][15] formed part of this deposit. It is of enormous, almost barbaric size, and still quite Geometric in style. Twelve golden beads, flattened on either side, alternate

40. Large necklace from the Regolini-Galassi Tomb, first half of the seventh century. Gold. *Vatican, Museo Gregoriano Etrusco*

with large oblong tubes as intermediary links; each of the latter consists of two blunted cones soldered together at the base. These are simple, well defined shapes. Their only decoration is a geometric pattern of triangles and straight lines, lightly engraved on the surface; it recalls the similarly engraved ornaments of Villanovan bronzes. Decisive for the aesthetic effect are the size of the parts, the quiet alternation of basic, solid form, and, last but not least, the fine pale colour of the gold.

In another necklace from the same tomb very large biconical tubes of gold, of the same type as in the former piece, are used as pendants; they issue in stylized flowers.[16] Each tube hangs from a medallion of amber in a golden frame. Golden rings connect these pendants with the necklace, which consists of two finely wrought chains of gold. The chains, and some of the ornaments, are of exceedingly splendid workmanship. In this piece the Orientalizing style is more apparent.

'Orientalizing Geometric' Style of Jewellery

The native fibula (as in illustrations 10 and 11) also was in this period often treated as an object of high luxury. Thus an admirable specimen of the type called sanguisuga (leech), made of gold, was included with the Regolini-Galassi Tomb [41] and is now also in the Vatican.[17] The techniques used in its decoration, filigree and granulated work,[18] are typical of the Etruscan workshops. One notices, however, that the ornaments themselves again are mostly Geometric. In spite of their transposition to a more valuable material, the zigzags, swastikas, and triangles are not essentially different from the decor of an ordinary Villanovan urn. Only the filigree ornament is new. It consists of an endless chain of 8-shaped figures.

Another fibula in Florence, from the Circolo della Fibula at Marsiliana d'Albegna, is decorated with small figures in the round, representing rows of birds and including a pair of

41. Small fibula from the Regolini-Galassi Tomb, first half of the seventh century. Gold.
Vatican, Museo Gregoriano Etrusco

42. Fibula from Marsiliana d'Albegna, mid seventh century. Gold.
Florence, Museo Archeologico

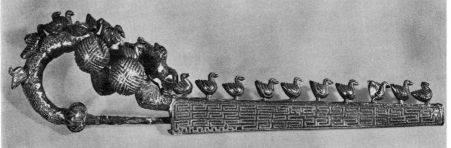

definitely Orientalizing lions [42].[19] Granulated work forms the linear ornament, which is geometric. The most astonishing item in this category is the magnificent, enormously oversized, golden fibula from the Regolini-Galassi Tomb already discussed[20] because of its representations [32]. It is a thoroughly Italian object which owes its form to native custom only. However the common form has been enlarged far beyond need, to parade more of the precious metal and provide more space for a multitude of decoration. Every available surface is covered with ornament. To a Greek eye the bizarre shapes, and the unconcern about a logical formal principle in their combination, must have looked foreign indeed. Seven rows of plump birds decorate the lower disc. The decoration of the large upper disc, or 'foot' of the pin, as we saw, comes closer to the international Orientalizing level of taste. This part includes the previously mentioned lions, in very fine embossed relief, framed by a double band of rosettes whose arched stems form an interlocking chain.

Pieces which give so much emphasis to representational decoration form a minority. On the whole the style of the Etruscan goldsmiths during this entire period remained Geometric. In fact a term like 'Orientalizing Geometric' would be in order to describe the inclusion of new curving ornaments together with others which were carried over from the older Geometric style: it would for example seem apt to characterize a golden bracelet from Vetulonia,[21] now in Florence, a work of great refinement [43]. In this instance the ornament is purely abstract, and handled with the sober restraint of an experienced taste. To this we may add another, most precious example – the golden bowl from Praeneste, now in London [44].[22] This vessel is a variation of the oriental type of fluted bowl, then widely distributed both in Greece and in the West: at least, the oriental type provided the basic form, but the Etruscan artist united this form with a lavish granulated decoration of the greatest accuracy. Around the rim runs a complicated, ribbon-like pattern of stylized leaves which, in a double row alternately rising and hanging, grow from a continuous chain of curving, interlocking and braided stems. Its flow breaks the rigidity of the angular ornament which, either in horizontal or vertical zones, covers almost the entire surface of the vase. A wreath of Phoenician palmettes between two circles of meander, near the bottom, represents the only obvious vegetable form admitted to this abstract, yet flexible and variable decoration [45]. This work is a masterpiece of its kind, with regard both to technique and design.

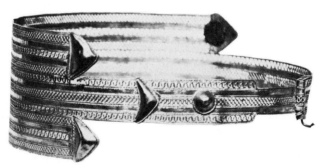

43. Bracelet from Vetulonia, mid seventh century. Gold.
Florence, Museo Archeologico

44 and 45.
Bowl from Palestrina,
with drawing of
concentric bands of ornament
on the bottom,
late seventh century.
Gold. *London,
Victoria and Albert Museum*

CHAPTER 6

POPULAR ART

THE FLAMBOYANT STYLE
OF INDUSTRIAL DESIGN

Vase Stands and Related Forms

In the foregoing chapters the establishment of the new cultural province in central Italy during the eighth and seventh centuries was related as a history of progress towards international standards. In the arts this favoured an increasingly systematic and geometrically disciplined formal performance. Yet while such an account is evidently consistent with a portion of the material, it does not tell the whole story of Orientalizing art in Etruria. There exists another large body of material which must be assigned to the same decades, but which does not fall in with this evolutional scheme. I call this other group the popular current of Etruscan Orientalizing art – for three reasons. It is more numerous; it includes more of the comparatively inexpensive products of the common crafts and also a great deal of mass-production; and it is more withdrawn from the international standards of style. Its bulk in fact represents a quite provincial group and it may well be described as a kind of folk art. Nevertheless this material opens up an aspect of the Etruscan output during the very productive years around the end of the seventh century the importance of which must not be slighted. Etruscan art has rarely shown itself more imaginative and original; and a most interesting observation must be made here regarding its general tendency. One can hardly avoid the conclusion that in those workshops where the domestic craftsmen were left more or less to themselves, although interest in foreign prototypes was not lacking, the general direction of stylistic development ran exactly opposite to the trend followed by the 'high' arts. We are consequently faced with the curious spectacle of two simultaneous currents which not only were

different from the outset but also drew farther away from each other the more they developed. While the more international style of the 'high' arts brought to Etruria a new ideal of formal logic and restraint, the popular taste showed itself increasingly fantastic and exuberant. It was on this level, the popular, that Etruscan Orientalizing art produced the most astonishing examples of what I here propose to call its 'flamboyant' style.

In this class of objects the trend is away from the simple towards the complicated. A rather baroque talent comes to the fore, together with a competent and articulate sense of form which at once convinces us that these artisans have ceased to be dilettanti and become professionals. But like all baroque artists they often exploit inherited forms, not only Greek, but oriental and ancient Italian as well.

A great deal of this newly unleashed inventiveness was due to the growing ability of the artisans to transfer an industrial form from one material to another. As a result, many objects exhibit a somewhat bizarre and baffling, seemingly illogical and experimental, appearance. Metal forms become translated into ceramics, and vice versa. A certain hunger for usable forms expresses itself in these borrowings, caused not only by the demand of the market but also undoubtedly by the wish of the craftsmen to show their prowess.

At first the new forms look rather elementary, though there is no longer anything primitive about them. In this period the large vase stands which were much in vogue both in Greece and Italy, though the idea was probably oriental, form an interesting chapter of Etruscan art. The already mentioned Regolini-Galassi bronze stand [30][1] is an excellent specimen. It consists of two globes on a conical base which carry the bell-shaped top. The simple juxtaposition of these abstract, massive shapes creates a very

effective contrast, all forms being well defined, sturdy, and compact. Apparently these stands with spherical centres constitute a local Etruscan creation. So far their type has not been observed outside Italy.

The shape of these implements was almost certainly invented for bronze. However, imitations in clay (*impasto*) are frequently found and must have been very common in Etruria. Similar stands in Assyrian reliefs and Greek vase paintings often support a great mixing bowl presumably filled with wine for convivial gatherings.[2] The purpose of the many – sometimes quite small – Etruscan examples is not so well known. Some actually carried a vase or cauldron. With others the bell-shaped top may have served as a container. At any rate during the Orientalizing period they were widely distributed in the Etruscan tombs, and, we may assume, in the households as well. An active native industry was busy to satisfy this demand.[3]

It is extremely interesting to follow the gradual mutations of form in the hands of local potters. With the advance of the Orientalizing period the design grows more and more bizarre. The basically static and massive core remains, but the contours begin to swell. The forms assume a curious malleability and plasticity. They seem to obey an autonomous and quite whimsical desire to change, vary, and enrich a given proposition. Obviously in this style a curved form is deemed better than a straight one. Variety and a somewhat gaudy exuberance of surface modelling count for more than structural purity.[4]

This development, which is characteristic of the native crafts, especially pottery, must have occurred during the second half of the seventh century. The large impasto stands of that time, some of which reach nearly a man's size, are typical of the south Etruscan towns and may well come from one workshop, perhaps at Cerveteri. They are complicated structures requiring great technical skill. Clearly the ceramic industry of Etruria was then already approaching the level of mastery for which it later became famous. A very elaborate example – in the sense of the evolution just indicated – is illustrated

46. Vase stand from Cerveteri, late seventh century. Impasto. *Rome, Museo Preistorico*

here [46]. It supports the impasto imitation of an Argive cauldron. This piece and others like it show the flamboyant style in fullest vigour. One can hardly be far wrong in dating them to the last quarter of the century, towards the very end of the Orientalizing style in Etruria. They have moved far from their starting point.

The form is still the traditional one with the two globes, but it has become wholly adapted to ceramic processes, and modified in several ways. Following a tendency already observable in the earlier terracotta stands, the middle part has now become relatively tenuous, so as to form a high stem between the broader base and the top: the parts are integrated, and related to one another by a system of subordination rather

than juxtaposition. A more unified object results, shaped like an hourglass. All outlines curve. The desire is evident to disguise the bareness of the structural forms by ornament, and to break the compactness of their surfaces. Billowy, shallow grooves with sharp edges are modelled in the clay, as with the earlier Fossa ceramics. Obviously a knowledge of this primitive technique was kept alive in the potters' workshops. It was a natural, craftsmanlike procedure. The strange vertical hooks between the spherical parts may denote animals, stylized beyond recognition. What they meant, apparently, was of minor interest. What mattered was the abstract, a-structural variety of forms on the surface; the colourful, rich, somewhat restless appearance of these forms; the complicated instrumentation of essentially simple motifs.

By contrast the vase stand in the Vatican [30] displays a sober and somewhat archaic dignity. A Greek contemporary might have approved of its clear, uncompromising form. On the other hand the baroque taste of the Etruscan potters – the final result of their provincial Orientalizing style – is something unique. It is neither Greek nor oriental, and cannot easily be matched with anything else in the ancient world. As examples of decorative form the large Etruscan vase carriers are among the most fantastic and original contraptions of all ancient industrial art.

IMPASTO AND BUCCHERO

Technique of Bucchero

A similar evolution can be observed in another, very characteristic product of Etruscan industry, the so-called bucchero ceramics.[5] Bucchero, originally meaning a certain kind of earth and the vases made of it, is the name given to a special class of ancient pottery in which the clay is blackened through and through, not just on the outside. The even colour was probably produced by firing in a low, smoking heat; the result can be described as a black terracotta. It seems that this black ware was invented independently in the Etruscan workshops, perhaps as an improvement of the earlier impasto tech-

nique. The vases were usually thrown on the wheel, with decoration often added separately. In this respect also they were superior to the impasto vases of the preceding period; for during the first half of the seventh century the potter's wheel, though not quite unknown, was still used sparingly in Etruria.[6] On the other hand the bucchero ware remained unglazed, like the impasto: the metallic character often imparted to the surfaces came about by a polish, which deepened the black colour in contrast to the highlights. All in all, this new type of pottery represented a vast improvement in technique as well as design over the ordinary impasto. Yet there seems to have been a direct progress from one technique to the other.

Actually, towards the middle of the seventh century the native impasto became sufficiently refined, in some instances, to approach the effect of bucchero. About this time the manufacture of real bucchero must have started, soon to become one of the outstanding products of early Etruscan industry. Evidently at first it was an expensive type of pottery, made of remarkably fine clay (often referred to as *bucchero sottile*, or thin bucchero). Subsequently it became a heavier and more popular ware (*bucchero pesante*, or heavy bucchero). As often in Etruria, the development runs from 'high' art to 'folk' art. In the present chapter we are concerned only with the beginning stages of this development: the heavy types belong to the sixth century and beyond, and must be discussed in their proper context.

Transitional Forms

A large and rather impressive amphora in the collection of the American Academy in Rome illustrates the transition [47].[7] The material is grey impasto, and the even colour, as well as the accuracy of the forms, testifies to the advance of skill and ambition. The technical treatment already comes near bucchero. Yet the forms and decoration definitely follow a native tradition. Indeed the deep, corrugated circles between the handles continue a protohistoric Italian fashion. Again their origin can be traced to the Fossa

ceramics of old whose forms enjoyed a long after-life, especially in the Faliscan region of southern Etruria. Probably this amphora, also, must be ascribed to a Faliscan potter. The eccentric pattern of the fluted circles falls in with the bizarre taste of Etruscan popular art from the late seventh century; stylistically, it is on a level with the large vase stands discussed

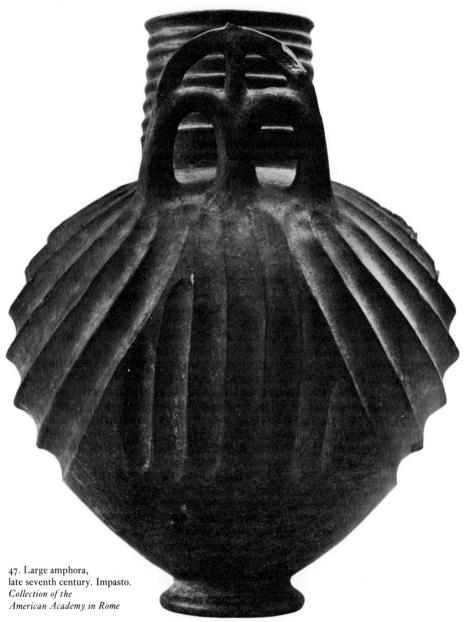

47. Large amphora,
late seventh century. Impasto.
Collection of the
American Academy in Rome

above. These potters take obvious pleasure in the material strength of form; their flutings cut deeply into the plastic clay. Thus the ancient pattern has become systematized and forced into a monumental order of swinging lines, conforming to the new taste for geometric clarity: the outcome was the abstraction of an abstraction.

Bucchero: Grecizing and Orientalizing Forms

In contrast, the new bucchero workshops started production in a markedly Orientalizing style.

Many of their earlier vases merely imitate imported forms like jugs, pitchers, and – an especially popular type – goblets on a high foot; the origin of all these has not yet been sufficiently explained. Also the goblets supported by caryatids recur in this class, quite similar to the Barberini ivory goblet [35]. A fine example in the Vatican is shown as our illustration 48.[8] The caryatids represent winged deities or demons who with both hands hold the long, curving strands of hair falling over their shoulders. Their type, conventional and hardly quite understood by their Etruscan makers, was cer-

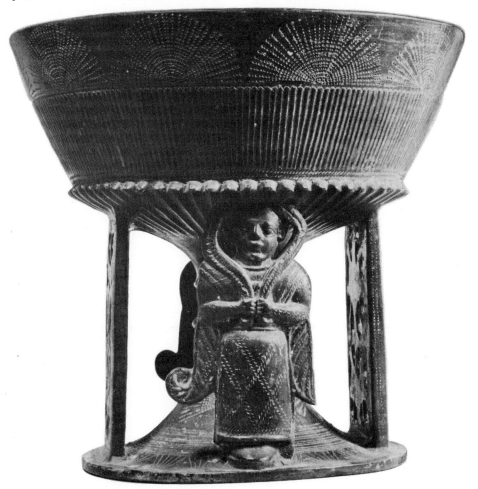

48. Goblet supported by caryatids from Cerveteri, second half of the seventh century. Bucchero. *Vatican, Museo Gregoriano Etrusco*

tainly oriental. The cups themselves are shaped just like the ordinary specimens without caryatids. The very common goblets of the latter type are also often rather elegant things. The thinness of their clay approaches good china. Decoration is simple and appropriate [49];[9] the

ing human figure serves as handle [50]. Two flower-like crowns close the openings on top of the birds' heads, through which liquids could be introduced; the small holes in the muzzles were for pouring. The man stands on the back of this friendly monster, balancing like an acro-

49. Goblet from Cerveteri,
second half of the seventh century. Bucchero.
Chapel Hill, North Carolina,
William Hayes Ackland Memorial Art Center

50. Guttus with human figure handle
from Cerveteri, late seventh century. Bucchero.
Vatican, Museo Gregoriano Etrusco

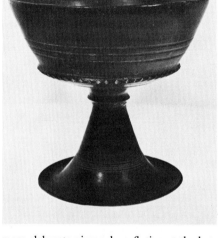

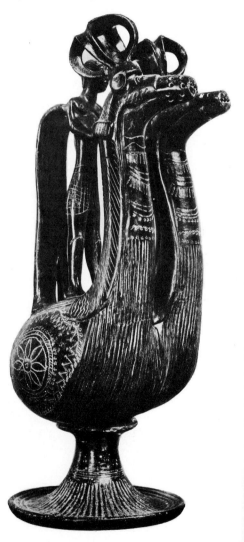

more elaborate pieces show fluting at the bottom, narrowly fluted walls, or a design consisting of small, impressed dots; cf. the fan-shaped patterns of illustration 48.

Nothing seems more contrary to the black material of these implements than silver; yet, strangely enough, many bucchero forms remind us of nothing so much. In spite of their blackness they recall, in effect, the shining surfaces and dainty shapes of finely wrought metal. There can be little doubt that here we are confronted with a kind of pottery designed for wealthy households, by potters who had learned much from their colleagues, the silversmiths.[10]

A rather fantastic object of this sort from the Tomba Calabrese is the beautiful flask (*guttus*) in the Vatican[11] which is formed like a bird with two very high necks and equine heads; a stand-

51. Engraved jug from the
Tomba Calabrese,
Cerveteri, late seventh century. Bucchero.
Vatican, Museo Gregoriano Etrusco

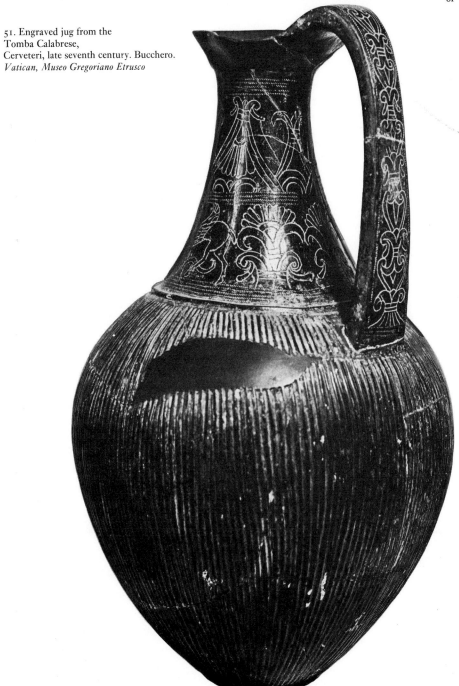

bat, while the actual handle has the shape of a cloak hanging from his shoulders; surprisingly, though the figurine is male, a long pigtail as of a woman is indicated on the cloak. The entire vase is richly decorated with an engraved design, patterns of small dots, and narrow flutings. Probably the idea was derived from oriental, perhaps Cypro-Phoenician prototypes; but certainly it also catered to the taste for the wondrous, imaginative, and absurd of which the Etruscans from the end of the century have given such ample evidence. Again, we can well imagine the same object made of bronze or silver. Only once more has western art produced vessels of a comparable invention: during the Romanesque period. The Romanesque examples also were mostly of metal; and they, too, in their time represented a trend which one might call orientalizing.

Decoration

All this, of course, is industrial art; and in fact many bucchero vases will be found interesting more because of their shapes than their decoration. Many were not decorated at all. Among the ornamented pieces many are mere routine work. Yet once in a while one encounters a decoration of remarkably fine design. At first, ornament was sometimes engraved on the surface, as with the impasto vases. Of this kind is the design on the jug in the Vatican from the Tomba Calabrese, which I illustrate because of its impeccable workmanship [51]; the long-necked shape is related to contemporary vases of silver.[12] Thinly incised, stylized flowers and palmettes surround the polished neck; a vertical row of flowers, in the same technique, decorates the back of the handle. These ornaments have the delicate fluency of a freehand drawing, as one will see if the superimposed flowers on the handle are compared with the similar plants which form the perforated supports of the cup with caryatids discussed above [48]. The orientalizing motif – a tree of papyrus or lotus flowers, as it were – is the same in both instances, and indeed quite usual in Phoenician

and Etruscan art; but the engraved rendition of the jug imparts to it a quasi-personal freshness and vividness.[13]

This Vatican jug, like the caryatid goblet, probably dates from the end of the century. At that time engraved ornament was already on its way out. Within the last thirty years of the seventh century, approximately, the decoration of the bucchero vases changed to low relief, and the latter technique prevailed; eventually, after the turn of the century, reliefs, not linear design, became the characteristic decoration of all Etruscan bucchero. At first the idea was probably adopted for ceramic decoration from prototypes in bronze and other metals. A comparatively early example is a globular vase from Marsiliana [52],[14] of finely levigated impasto,

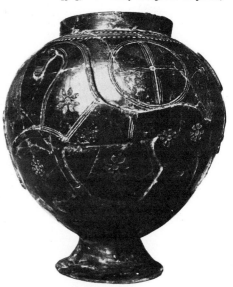

52. Globular vase from Marsiliana d'Albegna, late seventh century. Impasto.
Florence, Museo Archeologico

which shows incised geometric patterns and in addition two large horses in a peculiarly flat relief; the same cake-like reliefs with sharp edges can be observed in contemporary bronzes, e.g. on one of the bronze discs at St Louis [54].

Red Ware with Stamped Reliefs[15]

Similar horses together with other animals appear among the standard decoration of a class of large impasto vases which had also come into use by this time. All vessels show the same sturdy make, coloured red on the surface; the reliefs, flat and sharply outlined, were stamped into the clay before firing. Manufacture of these, which lasted well beyond the turn of the cen-

tury, was probably centred at Cerveteri. Current forms were high, ovoïd storage jars and flat platters or basins; the latter sometimes served as containers for coal-fires. For illustration, we select a storage jar from the Tomba Calabrese now in the Vatican [53].[16] One can see at a glance that the decoration follows new ways not only of technique but also of design. It is definitely grecizing: hence the systematic trend. In the probably somewhat earlier vase

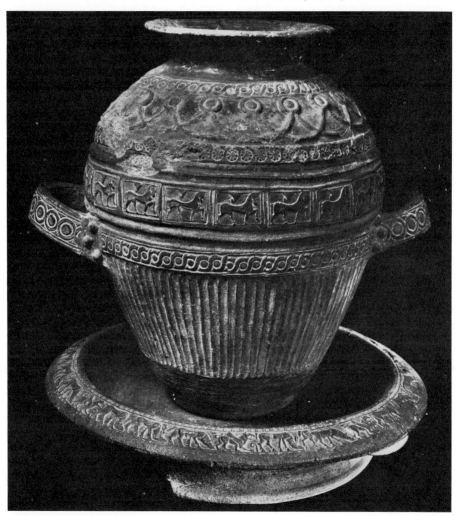

53. Stamped red-ware storage jar
from the Tomba Calabrese, Cerveteri, *c.* 600.
Vatican, Museo Gregoriano Etrusco

from Marsiliana [52] the horses were still rendered without either frames or base lines; in the new class, each stamp includes its design in a rectangular frame. These vases were clearly mass-produced, and their execution is not of great fineness, but they deserve attention as a manifestation of style. Once more, one notices the increasing importance which 'metopic' compositions held for Etruscan art of the years around 600.

Soon afterwards the square reliefs of this red ware were eclipsed by continuous friezes, produced by running a cylindrical mould over the wet clay. Similar friezes were also used on the new types of bucchero which appear about the same time. The bulk of these materials– stamped bucchero and red ware with stamped friezes – dates from the next century. But one thing becomes clear, even now. By the year 600 a renewed and strong influx of Greek art had made itself felt in Etruria. A new grecizing art appears and often contrasts rather sharply with the previously developed orientalizing and popular trends. The latter were then still active; but an important change of outlook towards pictorial compositions was in the making. The rule of the ancient 'one-way' compositions, that is, of rows of animals and the reiterating 'processions', was broken. The idea of pictorial composition itself became redefined; it was now more commonly understood as a representation of objects in an expressly limited field, and on a 'ground' shown and distinguished from 'space'. Within the closed metopic fields, as well as the possibilities of friezes open on two sides, fresh possibilities of dramatic representation were recognized and explored by letting the figures move towards, and act against, each other. As before in Greek, so now in Etruscan art, the variable forms of antithetical composition took their place beside the one-way representations. These were changes of far-reaching consequence, and an epochal significance must be ascribed to them. The age which adopted them had ceased to be an 'Orientalizing' period.

BRONZE RELIEFS

The Barberini Skyphos

Among the treasures of the Barberini Tomb the previously mentioned drinking cup or 'skyphos' of bronze [33] offers a rather interesting example of early Etruscan imagery.[17] The workmanship of its repoussé reliefs is no doubt native Etruscan, although the form was probably imitated from Protocorinthian ceramics, and the iconography, also, is definitely grecizing. On this cup the parade of animals and creatures of fable looks more curious than usual. It features a Greek centaur, two birds which resemble African ostriches, and a panther, the species of which may well have originated in Corinthian vase painting; and among all the beasts and monsters a human figure, perhaps a woman, rides on a galloping horse brandishing a bow and arrow. There is also a Greek chimaera. On the other hand the provincial, popular character of this art is indicated not only by the representational style and technique but also by the absence of base lines. All figures are arranged in two superimposed tiers, upon a row of palmettes which decorates the base of the cup. There are no dividing lines between the zones. The animals seem to walk without support, one above the other, in the manner explained in Chapter 4, which had become outlawed long since in Greek art, but obviously lingered on in the more provincial arts of Italy.

How much meaning we should ascribe to these representations is an interesting question. Ostensibly, little more is shown than the ordinary orientalizing rows of animals. But the presence among them of the human figure and the centaur appears to demand a more individual interpretation: for instance one may ask if the centaur does not actually strike at the sphinx before him; and whether the woman – if she is a woman – on horseback does not represent a nameable huntress, a goddess like Diana [34]. The noncommittal character of the composition makes it almost impossible to answer with certainty, but this does seem a likely explanation. In these monuments the mythical

representations, like any other kind of representations with a specific meaning, detach themselves almost imperceptibly from the ruling genus of the impersonal 'processions'.

Decorated Armour

It seems however that Etruscan art, to the end of the Orientalizing period at least, found a more adequate means of expression in decorative design than in its infrequent narratives. This impression is borne out by another class of popular implements, the embossed bronze discs[18] which developed from the Geometric discs mentioned above [13] (Chapter 2) to become one of the strangest types of Etruscan Orientalizing art. The large disc at St Louis [54] – the most outstanding specimen preserved – was probably nailed to a shield of wood covered with leather; another from the same find may have served as a breastplate [55]. As this type of armour was used only in central Italy and Etruria, the discs represent a strictly local group of objects, without foreign prototypes.[19] The large disc at St Louis is the only extant example which shows human figures [54]. Its style exhibits a curious fusion of Italian Geometric and Orientalizing features: one notices the continuity of the local stylistic tradition.[20] The two figures represent nude women running sidewise in opposite directions, but with frontal shoulders and faces. They are placed symmetrically, in heraldic correspondence with one another; are they dancers or demons? Their type, like that of the two lions below, was probably derived from Early Corinthian vases; but the angular contour betrays a rather Geometric feeling for form, and the W-shaped design of the arms is directly related to the 'acrobats' of the vase stand from Narce [20]. On the other hand the lines within the figures are not in the Geometric style: they are, in fact, rather original, outlining the parts sharply,

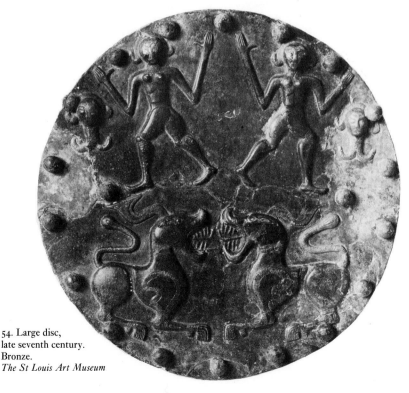

54. Large disc,
late seventh century.
Bronze.
The St Louis Art Museum

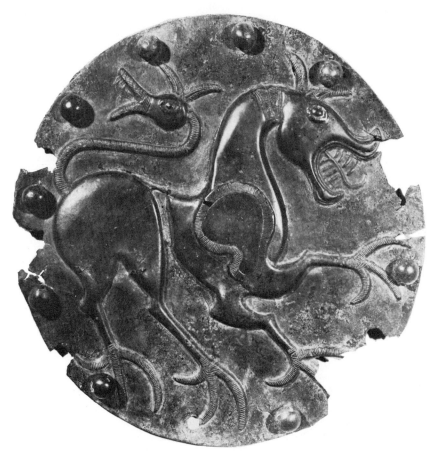

55. Disc (breastplate?), late seventh century. Bronze. *The St Louis Art Museum*

especially the joints. This staccato performance seems quite exceptional in Etruria. Most other discs show Orientalizing animals and monsters – designed with the previously noticed Etruscan gusto for fluent and curving outlines; all exhibit a flair for the unusual, uncanny, and grotesque [55].

These fantasies were hardly invented without meaning. Perhaps they were superstitious devices, intended to add a magic protection to the physical armour. What matters here is the obvious fact that most of them belong to a sub-human sphere of imagery. Their poetic parallels are the folk tales of monsters, witches, and animals which shaped the imaginations of people without writing in an age-old community of daydreams stretching from the Caucasus to the Balkans, and from there to western Europe. In the calligraphic style of the more advanced and thereby more distorted specimens, the wild beasts, transformed by frequent repetition, begin to look like a new species, and indeed like the wolves of the Apennines – the Italian archetype of everything monstrous and fearful. One readily believes that from imaginations such as these the story arose of the children of the woods, the lost princes and wolf-sons, who became the founders of great cities.

CHAPTER 7

THE RISE OF STATUARY

INTRODUCTION:

VILLANOVAN AND RELATED MATERIALS

Special Conditions of Statuary in Etruscan Art

We turn to the art of statuary last. It forms a chapter of unusual interest, one in which early Etruscan art made some of its most consequential choices. But it also presents us with unusual obstacles from the point of view of historical criticism. Often it is difficult to discover a stylistic coherence. Stringent comparisons with other art, from which alone a plausible chronology might be derived, can be drawn but rarely – more rarely than in the minor arts. Because of these uncertainties any account of early Etruscan statuary, at this time, can claim only preliminary validity.

On the other hand it should be acknowledged that the very uncertainties which beset these studies probably reveal an essential quality in the material studied. They can be taken as an index of the separateness of early Italian sculpture, in comparison to the then international standards. For many of these Etruscan creations the contemporary eastern styles seem to lack counterparts. This is so not only because large sculpture was less easily transportable than works of the minor arts, and imported statues were hardly, if at all, available as prototypes for domestic imitation, but also because much early Etruscan statuary was designed to serve local needs which differed from those of contemporary art both in Asia and in Greece. Outstanding among these local needs was the rapidly growing demand for memorial images. In these fields the Etruscan artists were left to their own devices, except for what little help they could derive from the scarce examples of foreign sculpture accessible to them. A much higher degree of originality was thereby forced upon them than on the industrial craftsmen. Thus Etrus-

can sculptors of the seventh century produced the first portraits of western art; they invented the bust as a symbolical form of portraiture; and unaided, so it seems, they created some of the earliest statues approximating life-size preserved anywhere in Europe.

In all these manifestations the important symptom is the emphasis on humans as individuals, or at least as members of a class. To evaluate this fact justly we must recall that portraiture – the intention to portray actual likenesses of people – constitutes a theme which Greek art consistently shunned, not only at this early time but for centuries to come. It can of course be said that with almost equal consistency Etruscan art disregarded, and even misconstrued, the Greek concern with absolute form, rationally controlled; just as the Italian Renaissance artists, centuries later, mistook the remnants of Greek art before them for examples of a fully-fledged naturalism, which they are not. Be that as it may, the early occurrence of portraits – at least portraits by intention – in Etruria goes to show that in spite of all later borrowings from Greece the art of central Italy was faced, from the beginning, with a task conducive to a representational naturalism not present in the East. For the human countenance is a thing of nature; and to undertake the direct representation of it constitutes a procedure, and expresses an attitude, totally different from the creation of images which, however descriptive of natural details, as a whole rather exemplify form as a free domain of art. It is true that the task of producing individual portraits was thrust upon the Etruscan artists by the society for which they worked, at a time when it was hardly possible yet to live up to these demands in a manner satisfactory to modern expectations of similitude. Nevertheless as a result of these conditions, an essentially naturalistic concept of art can be observed in Italian sculpture of the

seventh century for the first time in the history of western art.

It is almost certain that several of the monuments dealt with in the following chapters date from a time beyond the limit here ascribed to the Etruscan Orientalizing period. Actually this chapter on statuary is a transitional one between the Orientalizing and the following Archaic styles of art. But although the chronology cannot be established with the precision desirable for a historical report, especially for works created around the turn from the seventh century to the sixth, three major stylistic groups begin to emerge quite clearly from among these materials. With these three currents I shall deal in the following pages, calling them respectively the Villanovan, Orientalizing, and Grecizing groups of early Etruscan sculpture.

Villanovan Sculpture[1]

The basic rule of statuary is its absolute roundness, as pointed out previously (Chapter 4, p. 51). Greek art from the outset defined the human standing or seated statue as an object existing independently in space without regard to anything outside itself. Its first great sculpture, in the style of the seventh century called Daedalic, possesses the abrupt and uncompromising, self-contained reality of an upright pillar or a block of stone. It exists unconditionally, and does not address itself to anyone in particular; nor does it seem to act with reference to the external world.

Sculpture in the round on a very modest scale appears in Etruria among the output of the Villanovan bronze industries. The earliest examples consist of rather schematically designed small figures representing men, women, and animals. The beginnings of these typified representations can hardly be dated at present because, like most Villanovan types, they enjoyed a lasting popularity, probably all through the seventh century and beyond. One point must interest us here, before others. It regards a principle of composition common to an entire class of these statuettes, which differs noticeably from the Greek concept just explained. In this class

56. Statuette of a woman from the Tomba del Duce, Vetulonia, second half of the seventh century. Bronze. *Florence, Museo Archeologico*

57. Statuette of a warrior from Monte Arcosu, Sardinia, probably seventh century. Bronze. *Cagliari, Museo Archeologico*

the human figures stand erect, preferably with hands outstretched before them [56].[2] Their bodies are treated rather flatly, giving an effect of a background as in a relief, from which the arms gesture into space towards the observer. The same peculiar composition can be found again in some of the finest products of Italian sculpture of this early age, the Sardinian bronzes [57].[3] The latter are much superior to the Villanovan ones because of their larger size and the greater richness of realistic detail shown in the costumes. Nevertheless it seems possible that a connection existed between these two domestic classes of early Italian statuary. Both express a basically pictorial sensibility of space in the manner in which the flat bodies are represented as a foil, rather than as truly solid and rounded objects inviting inspection from all sides.

Actually one will find that over the centuries Etruscan taste often betrayed an inclination to transfer into statuary pictorial, that is relief-like, principles of composition.[4] This tendency clearly prevailed in another class of Villanovan bronzes, here illustrated by a magnificent bit plaque [58].[5] This belongs to a not uncommon

58. Villanovan bit plaque, early seventh century. Bronze. *New York, Albert L. Hartog Collection*

category of popular art which can be described as a kind of open-work relief, rather than as sculpture in the round. The present example is unusually fine. It represents a little horse standing on the back of a bigger one, and two birds

between the legs of the latter; all forms are welded together in a contiguous pattern reminiscent of wrought-iron reliefs. The imagery, semi-Geometric, is obviously on a level with such developed Villanovan types as the 'horse tamer' and related ceramic decorations discussed above [20, 22] (Chapter 2).

A different and more compact kind of statuettes makes its appearance in Villanovan art during approximately the same period. It seems that for the greater part of their time these various modes of sculpture were practised simultaneously, although the last-named group appears in some respects to be somewhat more advanced because it includes more orientalizing features than the two former types. The ceramic workshops likewise at that time began to produce statuettes of a similarly compact form, and to use them for the decoration of vases. I show

as an example a rather amusing bottle from Bologna,[6] with a bull's head and a horse and rider perched on its back [59]: everything still quite in the Villanovan style. Only the horseman is now characterized in more detail as a knight wearing a helmet, and with a shield flung over his shoulder, much as in the great Scaligeri monuments at Verona. To exemplify the early bronzes of this class one may turn to an interesting statuette in Florence which decorated one of the so-called candelabra from Vetulonia [60].[7] It represents a young woman, unclothed, carrying on her head a Villanovan urn of the advanced biconical type; I date this precious little work near the middle of the seventh century.

By the end of the century this Villanovan trend had issued into a kind of domestic art which absorbed many current orientalizing elements, but liked to use them with that uncon-

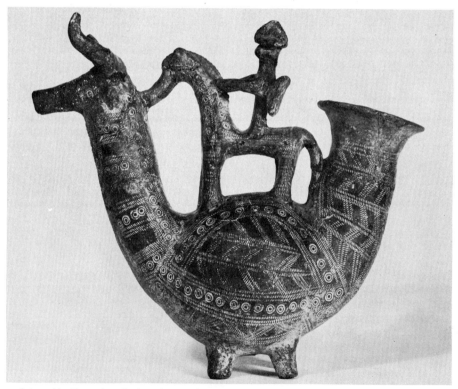

59. Askos with rider on horseback, early seventh century. Impasto. *Bologna, Museo Civico Archeologico*

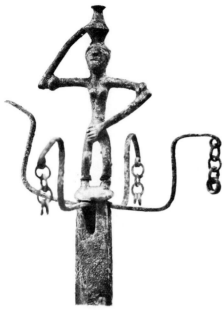

60. Villanovan statuette of a woman with biconical water jar from Vetulonia, mid seventh century. Bronze. *Florence, Museo Archeologico*

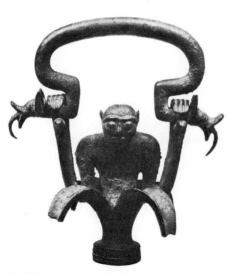

61. Villanovan handle, late seventh century. Bronze. *New York, Albert L. Hartog Collection*

cerned freedom of fantastic combinations which we found characteristic of the popular, 'flamboyant' style. A rare and excellent example is the bronze handle of our illustration 61,[8] which represents the torso of a man growing from a flower. The metal form of the petals is clearly related not only to the elegantly modelled flower shapes which we encountered in the fine bucchero ware of the last quarter of the century (Chapter 6), but also to bronze work of the time. On the other hand the angular outlines and exaggerated length of the arms connect this piece with the running figures on the large bronze disc at St Louis [54], and in turn with the comparable Villanovan representations on clay vases such as the 'horse tamers' of Narce just cited. The fact may be worth noting that with the Sardinian bronzes, also, the arms are often similarly represented. What keeps this entire group of early Italian sculpture together, in spite of all differences of quality and technique, is the persistence of domestic, ultimately Villanovan, habits of representation.

ORIENTALIZING SCULPTURE

Definition

To this group belong numerous small objects, bucchero as well as ivory figurines created for decorative purposes, which cannot be discussed here for lack of space; I may refer to the statuettes shown above [48, 50] as examples. The Orientalizing trend of these works manifests itself partly in details of iconography like the type of women holding with either hand one of the long tresses of hair which fall over their shoulders [48], and partly in the details of dress and costume which are quite realistically rendered and, as in the iconographical type just mentioned, point to an oriental origin. Thus a fashionable item in the statuettes of women is the long pigtail down the back, which sometimes reaches down almost to the feet of a figure. This mode of wearing one's hair definitely conformed to an oriental, Syro-Phoenician custom. On the whole, this group of sculpture reflects persuasively the strong effect which continuous

contacts with the Syro-Phoenician culture area exercise during the seventh century not only on Etruscan art, but probably on Etruscan society as well.[9]

The Pietrera Group

Although deviating in several respects from these smaller works, the sculpture from the Pietrera Tomb at Vetulonia must be listed with the same group [62, 63].[10] Only fragments are preserved today, carved from the soft local sandstone called *pietra fetida*, but their importance for the history of art is very great: with the exception perhaps of the Daedalic Nicandra statue from the Greek island of Delos, they represent the earliest examples of monumental sculpture discovered in all Europe.[11]

Their style, however, differs considerably from the Greek; equally different was their purpose. For the Pietrera statues were placed inside a tumulus. We must assume that they repre-

sented the dead in their last dwelling place in order to endow the departed with an abiding form such as art alone can provide. They were the substitute bodies for the owners of the tomb. The thought behind this eternization in effigy must have been a good deal more similar to Egyptian ideas of life after death than to anything found in Greek lore: whatever was the background of magic beliefs which by the end of the same century led to the creation of the kouros type of statues in Greece, it did not include the idea that life could somehow resume residence in a personalized image. From their different premises the Greeks developed a far more abstract and generalized concept of statuary; for their statues were not made in the likeness of anyone, nor were they buried in tombs. As funeral statues even, which some of them were, they remained public monuments. The concern of their artists was with the symbolic power and the visible organization of the sculptured form, constituting the upright and forward-stepping

62. Head of a woman from the Pietrera Tomb, Vetulonia, *c.* 650–630. Sandstone. *Florence, Museo Archeologico*

63. Torso of a woman from the Pietrera Tomb, Vetulonia, *c.* 650–630. Sandstone. *Florence, Museo Archeologico*

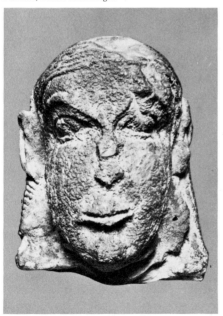

statue as a counter-image, rather than a por-trayal, of life itself; and the accidentals, the physically and socially determining factors which set us up precisely as individual persons, were largely disregarded.

Yet in the Pietrera fragments we find that to these very accidentals, the personal attributes of real individuals, Etruscan art was very much attracted. True, the faces are no portraits; but the placement of the statues in the tomb implies a personal note, and their richness of realistic detail – hair style, necklaces, and personal orna-ment – furthers this illusion. They *are* the dead. Also, they are people of wealth and refinement, an aristocratic lot. The torso of a woman [63] seems to be nude from the waist up except for the necklace; two well-groomed tresses fall over either shoulder, symmetrically arranged. The long skirt which the lady probably wore was held in place by a broad belt with very fine metal decoration, locked at the side.[12] The men of the clan sported loincloths resembling short bathing trunks.[13]

All statues are completely frontal and motion-less; they do not even step forward like the Greek kouroi. The hands of the women are kept between the breasts, rather ceremoniously, in gestures to which a religious significance may have originally attached, but which at that time meant hardly more than a politely educated de-portment. Most of these details are also known from other representations found among the oriental and orientalizing cultures of the time. But a curious speciality of the Pietrera sculp-tures is the way in which they were carved: only the heads are fully rounded; the bodies are rather flat, almost like reliefs. One receives the impression that these figures indeed represent a first attempt at statuary, as if upright stone stelae had only gradually, hesitatingly been transformed into a kind of statues, in order to impart a greater reality to the images. This fact in conjunction with other indications, such as the ornamental detail, makes it advisable to ascribe to these fragments a comparatively early date, within our second stage of Etruscan Orientalizing art: *c.* 650–630 seems best to fit all known circumstances.

The Castellani Statuettes

Sculpture in the round was rare at this early time; not before the end of the century does the number of statues seem to increase noticeably. Then progress was rapid, however. The next milestones in the orientalizing group are the three seated figures of terracotta formerly in the Castellani Collection, and often said to be from Montalto di Castro, the necropolis of Vulci;[14] it is now certain, however, that they came from a tomb at Cerveteri. Two, now in the British Museum, represent women with large earrings; the one here shown, certainly a man, is in the Palazzo dei Conservatori in Rome [64]. The backs of the women's heads have been damaged; we cannot see how they wore their hair. Their earrings furnish the only clear dis-tinction between the three – they are otherwise quite alike as to posture, garb, and size – and we should add that for statuettes their height is considerable: almost a third life-size. All are dressed in a long tunic with short sleeves, and an obliquely cut cloak which is fastened on the right shoulder with a so-called comb fibula. The latter is a typically Etruscan piece of jewellery; actual examples are preserved for instance among the treasures of the Bernardini Tomb. These details must be mentioned because they demonstrate a realism of costume which may well be interpreted as one of the first results of Etruscan naturalism in art.[15] Actually an aston-ishing directness and vividness of observation express themselves in these works, which are unique in our experience, in spite of the typical elements and restrictions of style which they also incorporate. The heads with hair parted in the middle and widely set, oblong eyes have oriental antecedents, such as the 'birdmen' attached to Assyrian bronze cauldrons or their Etruscan imitations. Although not portraits by modern standards, they possess portrait-like freshness and individuality.[16]

In the orientalizing group in which their type of face and soft fluency of form place them, the Castellani statuettes must be regarded as com-paratively late examples. The details of their costume, including the crossbar pattern which

64. Statuette of a seated man from Cerveteri, *c*. 600. Terracotta.
Rome, Palazzo dei Conservatori (formerly Castellani Collection)

makes their heavy garments look like Scottish plaids, have parallels in Greek and Etruscan works around the turn from the seventh to the sixth century. To their maker the solid roundness of sculpture had become a matter of course. Modelling has assumed a naturalistic meaning: notice the way the left arm appears from underneath the cloak. What astonishes us is not the restrictions of style – the blocklike shape or the simple frontality of the seated figures; rather, it is the degree of animation which could be expressed in such restricted language. As we think of these statuettes seated in their tomb, on their chairs of tufa, we associate them readily with the life of men long past. They may be said to receive visitors; does the outstretched right hand expect a gift – a tribute to the dead? Or offer a drinking bowl, now lost, welcoming us to their banquet? Though the meaning of the gesture remains in doubt, the feeling of immediacy remains. In no other art of antiquity, not even the Egyptian, have the dead come so much alive.

GRECIZING SCULPTURE, TRANSITIONAL

Documentary and Archaeological Evidence

In this section we encounter for the first time a literary notice from ancient sources with a bearing on Etruscan art. Pliny tells us that Damaratus of Corinth, forced to flee from Cypselus the tyrant, settled in Etruria, where he subsequently became the father of the elder Tarquin, the later king of Rome. He brought with him three craftsmen who 'introduced' into Italy the art of modelling in clay. As yet the exact date of these events cannot be ascertained, except that they must have occurred during the latter half of the seventh century. Cypselus and Damaratus are indeed historical characters, but the names of the artists, Eucheir, Eugrammus, and Diopus, are either legendary (which seems more likely) or refer to slaves. We cannot even be quite sure what kind of skill precisely Pliny had in mind when he wrote this sentence. Probably he meant terracotta sculpture. Yet, all uncertainties notwithstanding, the passage has its value. In its own semi-legendary way it testifies to the pres-

ence of immigrant craftsmen in Etruria during the seventh century, which seems reasonable; and in addition it gives a hint as to their probable provenance.[17]

Actually, in Etruscan sculpture, grecizing elements do not come to the fore much before the end of the century, but around and after 600 the examples indeed multiply. An important aspect of this acceleration of sculptural activities in Etruria was their increasing consolidation in local centres, in which the practice of sculpture became more or less continuous and where special traditions, types of monuments, and regional styles could be developed. Contrary to expectations which the just cited passage in Pliny might arouse, the south Etruscan terracotta workshops at first give little evidence of Greek infiltration: their famous contributions to Etruscan statuary were all of a later date. Whoever was the master of the Castellani statuettes can have been neither Greek nor Greek-trained. The most striking examples of early Etruscan sculpture in the round, reflecting Greek influence, were works of bronze and stone; and they came from central and northern Etruria, especially the cities of Vulci and Chiusi. Both places were well on their way as centres of sculptural art by the beginning of the Archaic period, and they remained important through the following centuries.

The School of Chiusi

Different from Greece, where marble was in use from the earliest times, all Etruscan stone sculpture was at first made from local limestones and sandstones. From these native materials it derived its special characteristics: opaque, yellowish or grey surfaces, even when levigated; a carving rather than modelling approach to representation; and often simplified, structuralized forms, owing to the brittleness of the stone used. Only the Italian alabaster offered different working conditions; however it was rarely used before the fourth century. From its materials alone much of this sculpture was apt to give an impression of rustic frugality. It lacks the luminosity and transparency of the Greek marbles,

and compared to the somewhat abstract clarity of the latter, is bound often to appear dull, heavy, and earthbound. As was said before, statuary was hardly ever a primary vehicle of artistic expression in Italy; this is especially true of sculpture in stone. Results were different when bronze or terracotta were used, because then the materials differed and, with them, the character of their forms.

The school of Chiusi, which proved the most persistent regional centre of Etruscan sculpture through the centuries, has left us a series of very interesting early stone carvings of statuary character. Many of these are not regular statues, however, but half-length images of women (*xoana*)[18] which may be described as a kind of sculptured busts – the first known predecessors of the later portrait busts of Roman art. In their square-cut frocks and long shoulder tresses the oriental tradition was still alive; the same is true of their type, with hands crossed over the breast [65]. Like the Pietrera statues, the sculptured form of these images still preserved a reminiscence of the flat tomb stelae from which their type was probably developed. The hands and details of the trunks are shown in comparatively low relief, while the heads are fully rounded; most of the figures look somewhat top-heavy. No doubt the emphasis was on the faces with their large, glaring eyes: the seat of life, as it were. Yet, if judged for themselves, these faces differ noticeably from those of the orientalizing group. Their strong, determined outlines and low foreheads overarched by a shallow curve of small curls have their antecedents not in Syro-Phoenician but in Greek Daedalic art. These

65. Bust of a woman from Chiusi, late seventh-sixth centuries. Sandstone.
Chiusi, Museo Archeologico

66. Sphinx from Chiusi, mid sixth century. Sandstone.
Chiusi, Museo Archeologico

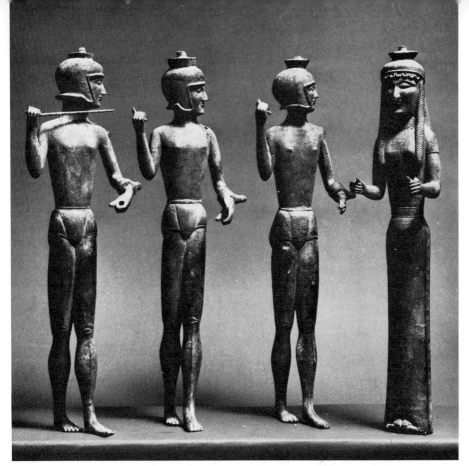

67. Statuettes from Brolio, *c.* 590. Bronze. *Florence, Museo Archeologico*

stones from Chiusi are not unrelated to the Pietrera statues; but we must assign them to a later time, starting about the last quarter of the seventh century and continuing well into the sixth. Soon sphinxes also appear, with similar faces [66]. As to style, this is on the whole a transitional group; it is also the first to show impressively the infiltration of Greek forms into an Etruscan type of sculpture.

The difference between stone and bronze sculpture can be experienced vividly when from the Clusine busts we turn to the find from Brolio, near the northern confines of the same region.[19] Although all the works in this deposit, now in the Archaeological Museum of Florence, were unearthed together, or at least near each other, the material is not quite homogeneous,

and the chronology of the statuettes is still difficult to determine. I should place two plainly orientalizing statuettes first: two women, one of whom in the conventional manner holds in either hand a strand of hair falling over her shoulder. Because both dress and look much like the Chiusi stone busts, they can probably be regarded as local products also. But their style is more in the oriental vein and therefore somewhat exceptional; nothing else known from the same area quite matches their placid roundness. Rather these statuettes may be considered the country cousins of the clan from Cerveteri [cf. 64]. The modelling, if not quite so smooth, aims at a similar softness, even though the ladies from the north still wear their inherited local costumes instead of the more faddish tunic and

the oblique cloak. We may date them around 600.

Perhaps the four large statuettes from the same find are not much more recent. Yet they look like a different race, and not without reason: their style definitely reflects a Greek tradition. This group consists of three warriors and one woman, all belonging together; once they decorated the same, now unknown, piece of furniture. They are the most notable pieces of the whole lot [67]. Again the lady wears the long belted dress which obviously was still the common costume for women in that region. Her elaborate coiffure, with the short curls across the forehead and the two tresses which frame the face, also recalls the Chiusi busts. In their day all these fineries must have looked a trifle quaint; just as the venerable rigidity of the figure with its taut outlines and closed feet seems charged with a sense of Geometric form then already of the past and comparable to much earlier Greek works, like the Naxian Nicandra. Other locally persisting details such as the lady's necklace connect these Brolio figures with the likewise earlier Pietrera statues. The same line of connection can be drawn to the statuettes of the men which, from a critical point of view, are even more interesting. Like the nobles from the Pietrera Tomb they wear a loincloth or 'skirt', though it is differently shaped. The prototypes of this tripartite form of skirt can be traced to Greek, Cretan art of the late seventh century.[20] But in addition the knights from Brolio display more modern kinds of armour, such as Illyrian helmets without nose guards, a form known from Crete as well; they also carried shields, now unfortunately lost, on their left arms. Yet the most stringent reason why we ascribe a comparatively recent date to these statuettes is indicated by their postures. Their left foot is put forward decidedly: the Brolio statuettes are the first indubitable examples in Etruscan art of the type of the stepping kouros. As this type was hardly fully developed in Greece before the turn of the century, a somewhat later date, around or shortly after 590, seems adequate for these Etruscan counterparts.

The same statuettes are important for yet another reason. They are the first representations of the type of spear-throwers which later became so popular in Etruscan art; and in this respect, also, an interesting observation is due. Spear-throwers were quite common among the earlier Greek statuettes of Geometric style. They were then always shown frontally, hurling their javelins forward and standing with feet apart, not in a stepping attitude. When the stepping kouroi became the rule, Greek Archaic art eventually abandoned this old scheme; instead it invented another kind of throwing figure, shown sideways. Actually the new type, like many other figures in action in Late Archaic and Early Classical statuary, was an adaptation from painting, where figures were always seen in side view. Evidently it was felt that the absolute frontality of the standing or stepping statues was not compatible with the representation of specific action.[21]

On the other hand in Etruscan statuary the original, frontal type of spear-throwers was never quite relinquished, and in many later monuments the act of hurling a weapon was still represented as a direct forward movement. One can say that after the Archaic period the Etruscans freely used both types. At least this was the general trend. The interesting observation here is that apparently the artist of the Brolio statuettes was aware of this problem, but that he experienced it as a dilemma which he tried to resolve singlehanded. His spear-throwers are stepping kouroi with heads turned sideways – a very curious break with the rule of frontality in such early works. The explanation, of course, lies in the obvious attempt at representing the kouroi as hurling their weapon towards the left side rather than forward. This change of the ancient pattern, somewhat haltingly performed, resulted in the present, strangely undecided postures. The solution of the statuary problem of the throwing figure thereby proposed was directly opposite to the one which Greek art eventually adopted: the Brolio statuettes combine action to one side in the upper part with a frontal, stepping position of the legs and feet. Instead of expanding the silhouette sideways in the plane, which would have resulted in a unified

direction, the figures keep moving forward into space.

The terse, upright, and somewhat Geometric elegance of the Brolio knights, their elongated forms and precise design, speak for themselves. There is nothing rustic about their style, nothing uncertain about the technical competence of the artist who contrived it. Their exaggerated length represents an apparently wilful departure from a norm, not unlike the elongated meanders of Villanovan art discussed previously (Chapter 2); as such it may be called typically Etruscan. The prevailing trend of the Brolio bronzes is rather formal; and it is as formal experiments, dealing with a problem of statuary to which general importance must be ascribed, that they allow us a glimpse of ancient art at work such as few other creations of their time could afford us.

POPULAR AND PROVINCIAL SCULPTURE

Skirted Kouroi

If from a study of the Brolio bronzes one proceeds to an examination of more popular Etruscan sculpture such as the north Etruscan skirted kouroi,[22] one is apt to find the experience confirmed which was previously recorded in regard to the 'flamboyant' style of folk art: the formal developments in 'high' art and on the popular level seem to move in opposite directions. These bronze statuettes of young men with triangular skirts, in some cases represented as spear-throwers, must once have formed a very frequent type, especially in the region north of Chiusi. Bearded specimens also occur, and some of them may date from as late as the second half of the sixth century. But on the whole the type bears all the marks of a creation of the Late Orientalizing period or the decades of transition around 600 at the latest, when the skirts and parted long hair were still in vogue. All subsequent examples must be regarded as retarded art of a kind which Etruria was always prone to favour, especially in the outlying provinces.

Not only the loincloths made these statuettes look quaint by international standards after 600

but also their stance. For these figures do not walk; at the most some of them put the left foot forward rather timidly [68, 69].[23] Their arms are free to act in a forward direction, whatever it was they held; their bodies form an immovable foil, in the ancient Italian manner. Likewise the concept of form which they incorporate, so remarkably free and detached on the one hand, so much bound to external patterns on the other,

68. Statuette of a skirted kouros, *c*. 600–570. Bronze. *Florence, Museo Archeologico*

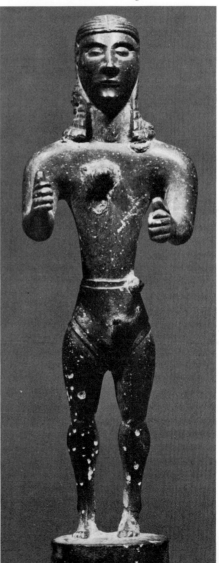

is in the Italian tradition. Because they are so exclusively described as outward forms, rather than creatures with a mind and a will which operate from within, the best among them attain to a passive and quiet air of simple existence,

69. Statuette of a skirted kouros, *c.* 600–570. Bronze. *Volterra, Museo Guarnacci*

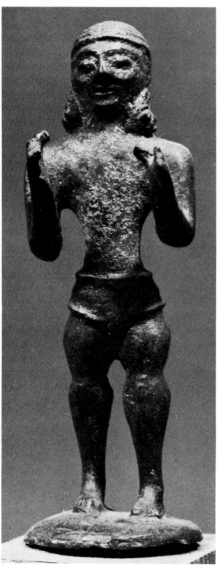

very much in contrast to the active life of Greek statues. Whether their bulging eyes are really open or closed we cannot always tell. Their vitality is stolid and sturdy, if sometimes dreamlike as in Buddhist images; they seem to act like sleepwalkers.

It is important that we notice how their every form differs from the approximately contemporary youths from Brolio. In the popular statuettes of this type all forms are rounded, not straight or taut: shoulders, thighs, calfs. The same tendency to render the human form in swelling and rounded outlines can be observed in domestic vase paintings such as the Etrusco-Corinthian representations mentioned above (Chapter 5). This preference for curving rather than angular, geometric configurations appears to be in keeping with the Etruscan 'flamboyant' style. If in contemporary Greek art comparable tendencies occur at all, as in the limestone statuette in London[24] of a youth from Rhodes, we would call them provincial. In Italy these curving distortions of the human form appear much more consistent in certain local types of monuments. They obviously correspond to a widespread decorative tendency in Etruscan folk art of the Orientalizing period.

The Warrior from Capestrano

I include with this group one of the most remarkable recent finds in Italy, the statue [70] discovered in 1934 near Capestrano in the mountain region called Picenum, between southern Etruria and the Adriatic Sea. As this curious image representing a native warrior in the full regalia of his arms and armour was found outside the Etruscan territory proper, and the inscription on the right pillar supporting the figure is in the local dialect of southern Picenum, it must be the work of an inland school of early Italian art. It cannot properly be classified as Etruscan. Nevertheless its connection with the type of skirted kouros considered in the foregoing paragraph is obvious. The stance, the swelling forms of thighs and shoulders, are all but identical. The warrior from Capestrano is of the same breed, not racially but stylistically. I

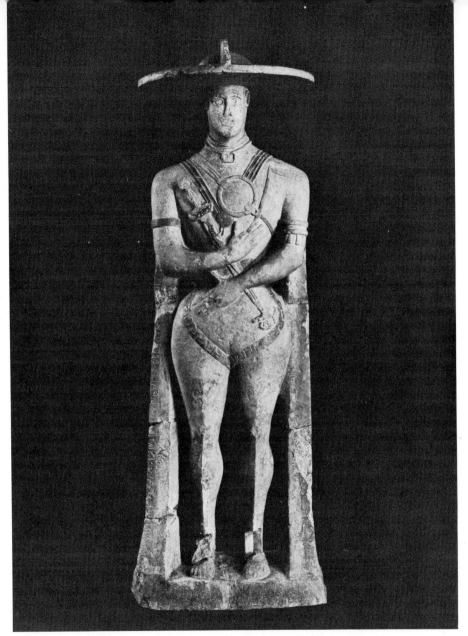

70. Warrior from Capestrano, mid sixth century. Limestone. *Chieti, Museo Nazionale*

regard the figure as a translation into stone of one of the statuettes of skirted warriors, enlarged to life size; hence a more provincial work, dependent on Etruscan art. Whatever echoes of Greek sculpture can also be noticed in it prob-ably reached the local artist, not directly, but through his Etruscan model or models.[25]

Again we are faced with a work which can be called a statue with reservations only; it is not wholly a statue. The two lateral pillars hardly

have a representational meaning. Their function is primarily technical; they were designed, and probably necessary, to give a more stable support than the feet alone could provide. On the other hand they also seem to correspond to the artist's concept of the sculptured image, not yet completely freed from the older idea of the sculptured stele. In this respect his imagination is on a level with that of the artists of the Pietrera sculptures or the busts from Chiusi. His statue therefore has only two, rather relief-like, views fully developed; the two side views are neglected. The figure is neither truly round nor four-sided. Again, as with the Chiusi busts, the hands are held tightly to the body, following the ancient oriental scheme, and not shown with their proper volume but in rather shallow relief. However, one should notice the roundness of the upper arms, and especially the curving outline of the right arm and hand: these bending forms are natural to plastic materials such as clay, and they can also be found among the more primitive early Italian bronzes. But they were not invented for stone. The sharp edge representing the shin bone, which is quite contrary to nature, may seem more in keeping with stone-cutting technique. But actually this detail, also, could have been taken over from bronzes of the type just discussed. It is typical, for instance, of the Brolio youths [67].

The most original contribution of the artist obviously consisted in the local colour which he was able to impart to his work: the realism of costume which so strangely contrasts with the rigidity of his style. The weapons which this warrior chief presses to his body – the tribesman's most prized possessions – are all identifiable as to type. They are shown in every detail, as it were with a feeling of awed sincerity. The pectoral in its iron ring is of the same class as our illustration 54, only smaller. The sword, the hatchet, the armour can all be matched with actual objects. The leaf-shaped garment which covers the abdominal region cannot be a skirt like those worn by the bronze statuettes, but rather served as a protection, perhaps made of leather, forming part of the armour. Only the enormous helmet – it has been explained as a shield, hardly correctly – is quite unique among our stock of early Italian antiques; it must represent a local feature not in use elsewhere.

It has been suggested that the man is wearing a mask and that his ears are covered with metal sheaths; all of which, if true, would indicate that he was portrayed in his burial outfit rather than his live appearance. But this is no more than a hypothesis, though one deserving serious consideration. If one accepts it, one is confronted with a strange question. Can we assume that this artist made a conscious distinction between a natural face and a mask? And that instead of a face he deliberately represented a mask? The trouble is that primitive art does not as a rule stylize consciously. The mask is the form of the face. We can scarcely expect an artist at this level to look at a mask with the same feeling of difference between artificial form and naturalistic representation which a modern observer experiences. The so-called rim of the mask might be the leather strap which holds the headgear in place. It is true that in the rendering of the face the figure deviates appreciably from the statuettes which probably served as its prototypes. But similar round-eyed faces of local style are known to us from other sculpture in this area. The chances are that in the forms of the face the artist followed the native, provincial tradition. When he copied Etruscan models, as he certainly did when fashioning the sandalled feet, his forms turned out more naturalistic. But to the face he imparted the very quality which was missing in the Etruscan bronzes: the expression of a crude but live will. As to date, we must place the Capestrano warrior among the latest of the skirted kouroi to whose series, by type, he belongs. He is a work of provincial early Italian art, retarded in some respects, very original in others. Details, as well as the circumstances in which he was found, point to a date around the middle of the sixth century.

CHAPTER 8

THE RISE OF PORTRAITURE

Various Kinds of Portraiture

Statistically, the prominent fact about early Etruscan statuary is the frequency of funerary art among its products. This Italian peculiarity points to a fundamental difference of purpose from Greek habits, especially during the Orientalizing period and the two transitional decades after 600. At its origin all art serves definite purposes, often of a superstitious or magic nature, before it becomes a matter of custom, prestige, or disinterested pleasure. It is at the beginning of their histories that the contrast of aims appears most sharply in Greek and Etruscan sculpture. For in Greek statuary the human images represented deity, heroes, or man as a dedication and substitute sacrifice to deity. The ex voto and cult image were the two foremost tasks of sculpture in Greece; and, as mentioned before, the Archaic types of standing men and women served both ideas equally well. The underlying magic belief may be sought in a concept of fetish, miraculously charged with the inexplicable energy of life, though at the time here considered the idea was no longer always consciously present. In this sense the quality of being alive became the fundamental, and remained the universal, theme of all Greek statues; and in dealing with Greek art critically, it may be well to remember that this requirement puts before the artist an idea of rather general significance, which regards the species before the individual.

In Etruria, as we have already noticed on several occasions, the evidence points to an entirely different complex of ideas as the cause of statuary. The human images placed in or upon the tombs clearly denoted the persons buried. The dead were made to live in their images, tombs were built and furnished like family houses, and the clans became defined as the community of all their members, past, present,

and future. An art which serves such notions also deals with an idea of life, but on the level of the individual: it deals with people. It must aim at the visible symptoms of the actual and the personal, and it is likely to arrive at a concept of portraiture as its ultimate and logical conclusion. The funerary art of Egypt was led to a similar interest in portraiture, for similar reasons, more than two thousand years earlier. In the West, Etruscan art was the first which by its motivating hopes and beliefs was induced to repeat the experiment of expressing life by personal similitudes.[1]

As with any other theme of art, what matters first in portraiture is the concept and the intention; their realizations may vary, not only in quality but in degree as well. No judgement is possible regarding the degree of similitude incorporated in a portrait if the sitter is not known to us either in person or through other representations; and this, unfortunately, is the case with all Italian portraits before the Roman. The only question concerning which an estimate can be ventured with a chance of success is whether or not the intention to render a personal similitude was at all before the mind of an artist whose work confronts us. Conceivably the chieftain from Capestrano looked like his statue, though this is not likely. The primitive typicalness of his face hardly gives scope for personal features as defined by modern standards. On the other hand it is quite possible that the friends and family of the dead man regarded his statue as a perfectly satisfactory image. They might have exclaimed: 'Look at him, with all his armour! As if he were alive!' For the magic of a mere image impresses primitive people more than ourselves, and the realistic portrayal of costume represents indeed a personal trait which may be taken as a step towards portraiture. Nevertheless, to our way of thinking a portrait means first of all the facial likeness of an individual; and

under this definition the warrior from Capestrano does not qualify.

It is yet another question, even with works apparently intended as portraits, to what degree of similitude the representation of a personal physiognomy was actually carried. It can happen that the addition or omission of a beard makes all the difference required for some people to accept an image as a portrait. On the other hand, even the most photographic portrait cannot give a complete record of a person; every representation of art is selective. Obviously between the minimum requirements which, given certain circumstances, may constitute a portrait and the optimum of naturalistic portraiture innumerable degrees of assimilation to personal likeness are possible and have been essayed, in the long and multiform practice of art.

Therefore we must understand that in the absence of written documentation not only does any definition of an early Etruscan work as a portrait rest on assumption, but also the degree of physiognomical similitude and the concept itself, of what exactly was expected of a portrait, remain hypothetical factors. This is true even in those cases in which the assumption seems justified that a specific likeness, and not a merely typical form, was the aim of the artist.

With the above reservations the well-known female bust of sheet bronze from Vulci, now in the British Museum, can be regarded as a possible portrait [71].[2] It is, however, for several reasons a difficult work to judge. The technique of welding together sheets of hammered bronze which was used to produce this bust is also known from Greek bronze statues of the seventh century. The general appearance of the woman represented in the London bust aligns her with Etruscan orientalizing works of the same century, somewhere between the Pietrera statues and the bronzes from Brolio. Like the Pietrera ladies, she appears to be nude from the waist up, except for her high necklace. Accordingly, one may assume that the broad horizontal band around her waist represents her belt, below which, however, instead of the long skirt, a short, two-tiered base serves as a termination to the figure.

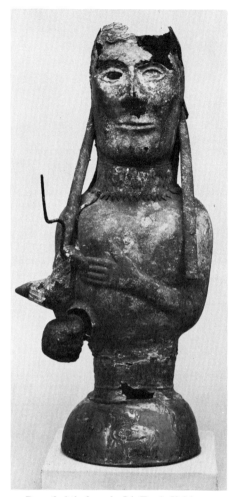

71. Bust of a lady from the Isis Tomb, Vulci, *c*. 600–580. Sheet bronze.
London, British Museum

These details of technique and attire would indicate a comparatively early origin, perhaps in the last quarter of the seventh century. Yet the friezes around the base in comparison to Greek art make a date shortly after 600 more advisable. At that time her costume would constitute an anachronism, but in Etruria a degree of cultural retardation can always be expected. Caution is required, however, because the ex-

tensive restorations which this bronze has undergone make it difficult to arrive at a sound estimate of its style.

The forms of the face can perhaps be evaluated with greater confidence. They do not quite fall in line with the types known for instance from the Clusine busts, but seem rather more individual. This deviation from the norm would not in itself guarantee a true representation of individuality, that is, the portrayal of a definite person, but it may indicate an awareness of the fact that irregularities of form – deviations from the type – are essential characteristics of a human individuality. In this sense the bust evidently does represent 'a person', though it does not necessarily give a true portrait. There is the faintest indication of a smile. Again the likelihood that we are confronted with a personal image, at least by intent, is increased by the circumstance that the bust was discovered in a burial. As regards form, this bust – if the cylindrical base belongs – recalls medieval reliquaries with personalized features in which the relics of a saint were kept as in a new, precious body or a vessel of human shape, wrought of fine metal.

It follows from the foregoing that portraiture based on a concept of 'person' but not necessarily rendering actual individual likenesses must be reckoned with as a possibility in ancient Etruscan practice. While the greater or lesser approximation to the sitter remains a matter of conjecture, the underlying concept of personality, expressed in terms of irregularity and uniqueness, can be shown in visual forms and thus become a matter of evidence. Naturally these problematic cases of portraits or quasi-portraits are characteristic of the popular level of early Etruscan art, because they owe their origin to native religious beliefs and customs.

The large terracotta statuettes sometimes standing on the lids of funerary urns from Chiusi raise a similar question.[3] Their style can be classified as Orientalizing Etruscan, on the popular level. The sample here illustrated [72] represents a woman in a long robe – a kind of girdled tunic – characterized by a chequerboard pattern which covers the entire garment like a net but probably denotes only a similar kind of

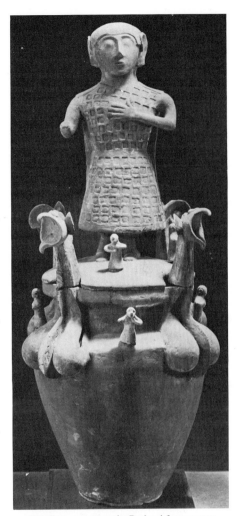

72. Standing woman on the Paolozzi funerary urn from Chiusi, late seventh century. Terracotta. *Chiusi, Museo Nazionale*

plaid material to that worn by the seated figures from the Castellani Collection [64]. A cloak hangs from her shoulders. As in other sculpture issuing from the same domestic tradition, the preserved left hand is held tightly to the body; the curiously long lower arm also is in keeping with Italian habits. Only the right arm was

moving freely forward. In spite of these primitive features the figure cannot be assumed to be much earlier than the Castellani statuettes. It was probably created at some time during the last quarter of the seventh century. This date also fits the orientalizing birds'-heads which surround the urn like so many terrifying defenders of the elysium where the deceased woman stands, as on an island of bliss, in the company of small friendly dancers. In these images the dead rise above their own ashes.

But the greatest surprise comes from the faces of these statuettes. They differ from one another; if they were typical, at least their types were not common in Etruscan Orientalizing art. Neither would we call them portraits in the modern sense. The almost simian face with the low brow of the woman represented in our illustration 72 has antecedents in late Villanovan folk art. A quite unexpected feature is the inclination to the right side, which, breaking the straight axial frontality of archaic statuary, imparts a curious element of spontaneity to the doll-like figure; as if by the wagging of her head the woman were to beat the rhythm of some dance or music. These heads hardly have equals in Etruscan art outside Chiusi. But they are related to a most interesting class of local sculpture, in which the trend towards portraiture created its first recognizable manifestations in Etruscan art: the so-called Canopic urns.

Canopic Urns

The name 'Canopic' (from the anthropomorphic or zoomorphic jars long called Canopic in Egypt) has been given to a class of ossuaries typical of Chiusi, the lids of which are shaped as a human head. All urns of this type hail from tombs, where they served as receptacles for the ashes of the dead.[4]

The religious – or superstitious – origin of this invention cannot be doubted. It is not supported by written testimony, to our knowledge, but the specimens extant and the circumstances in which they were discovered give sufficient evidence of their implied meaning. These vases, assimilated to human form, contained the ashes

as the body contains the life and soul of a person. They were the last and lasting bodies of the dead. The idea behind this practice of preserving the ashes of the dead must have been quite old in central Italy. In their own way the Villanovan ossuaries covered with a helmet [2] already expressed the same thought, for a helmet was the personal attribute and prerogative of a warrior, and therefore a badge of social distinction as well. Apparently the ossuaries so interred were treated as true substitutes of the body. Only they were not shaped as human images. One must assume that the Canopic vases of Chiusi derived from the same Villanovan background of ideas, although their ceramic forms were of more modern design.[5] Frequently the Chiusi urns were placed in the tomb on a throne which obviously represented an important household furnishing. Similarly, the Castellani statuettes had been seated on thrones; and actual thrones of the same form, reminiscent of the leather chairs still used in the American Southwest, were found in some chamber tombs, for instance the Tomba Barberini. This circumstance adds much to the likelihood that the Canopic urns were indeed considered representative of the persons who had a claim to such a seat of honour.

The material of the Canopic urns was bronze or, more commonly, clay. As yet their typology has not been worked out sufficiently. One should begin by classifying the ceramic forms of the vases in which affiliations with other early Italian art as well as the pace of their local development can be more reliably discerned than in the representational details. There can be no doubt, however, that for the history of art at large the most interesting aspect of this group of monuments resides in their portrayals of human faces, which, likewise, exhibit a consistent development. But as their purpose was a special one, so their formal evolution does not entirely follow the overall development of early Etruscan art as we now know it. Peculiar to the Canopic urns was their trend towards physiognomical individualization; and this apparent individualization can hardly be explained as anything other than an attempt at portraiture.

The progress by which these intentions materialized was slow at first; it gained momentum only around and after the turn from the seventh to the sixth century. Actual masks of clay or bronze, attached with bronze wires to the long necks of their urns, seem to have made the beginning [73].[6] The features are very primitive. Peculiar details are the pear-shaped outlines, perhaps derived from the triangular faces of Greek Daedalic art, and a tendency to render eyes and mouths by plastically raised forms. The latter constitutes a provincial mannerism still found in the Capestrano warrior, and was probably grounded in the repoussé technique of the early metalworkers who hammered their reliefs out by raising forms over a wooden core. Together these stylistic habits would indicate a time during the first half of the seventh century as the probable starting date of the type. The next step was to top the neck of the vase with a globular head as lid, on the surface of which a human face could be shown; only at this stage did the jars become truly 'Canopic' [74].[7] Arms and hands were sometimes illustrated in shallow relief around the body of the urn, or attached to its shoulders instead of handles. Even then, the

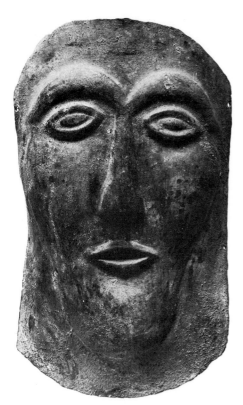

73. Mask from a Canopic urn,
first half of the seventh century. Bronze.
Munich, Antikensammlungen

74. Canopic urn from Castiglione del Lago,
second half of the seventh century. Terracotta.
Florence, Museo Archeologico

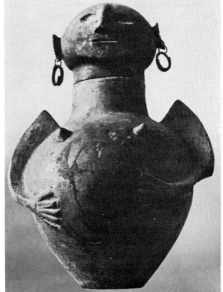

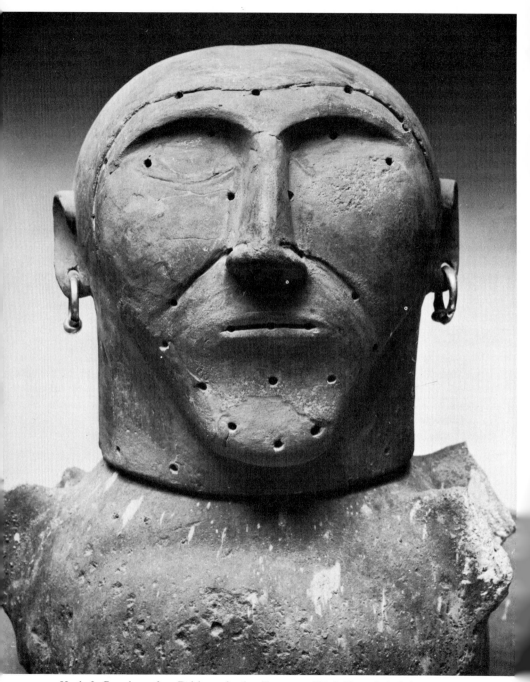

75. Head of a Canopic urn from Dolciano, after 600. Terracotta. *Chiusi, Museo Archeologico*

faces often remain flat and mask-like. Specimens conceived as real heads, the faces of which were integrated with the rounded cranium and in which modelling was used to show the natural differences of depth, are of still later date – hardly before the end of the century. Some of these heads now appear bald, because a wig of natural hair once covered them; paint was used as well, for greater effect. Finally, after *c.* 600, the development assumed a more rapid tempo, and conscious individualization set in [75].[8] These tendencies came to full fruition only during the following, Early Archaic stage of Etruscan art (see below, Chapter 11).

The Canopic urns of Chiusi must be considered as a class by themselves. At their time they had no counterparts, either in Greece or in Italy. Nevertheless their import for the future of Etruscan art must be rated very high. The need for memorial portraits, of which the appearance and subsequent history of these curious monuments bears early testimony, was rooted in the Etruscan way of life. Etruscan art never lost sight of this task, which soon became, if not its exclusive, at least its most special concern. Thus at the close of the Orientalizing period we discover in Etruria the presence of a representational theme which, not unlike events at the same time in Greece, necessitated a break with the earlier, merely generic conception of the human image. It was put to these artists to account for the differences between persons, in visible forms, as something essential to the human experience.

Clearly this development ran parallel to the general Greek trend. But as its motivation in Etruria was a different one, so the outcome also differed. I previously referred to the fact that in Greece the first response to the demand for individualization was to create literary fiction, and that when Greek art made the step from merely generic to more specific representations, it began to tell the stories of gods and heroes; accordingly the anthropology of Greek art came to turn on a concept of character as its descriptive tool – the great fictitious characters of the gods first of all. A critical category was thereby established in the arts in which a knowledge of human

reality could well crystallize and become articulate. In its characters of poetic and religious fiction Greek realism began to analyse the minds and actions of men even before it undertook to investigate the natural world in terms of science, history, and philosophy. To understand humans as characters was indeed a way of accounting for their differences, intermediary between the merely generic and the actual. Naturally the story-telling arts, painting and relief, became the first carriers of these developments. In statuary the critical category of character (*ethos*) was fully realized only much later, in the Classical style of the fifth century.

By contrast Etruscan art, which was not like the Greek a literary art, achieved the transition from generic to specific representations in statuary first. In Italy no less than in Greece the overall result of the Orientalizing period was to open the arts to the manifoldness of the world inhabited by man, and of man himself as a necessary and valid aspect of reality. But in Etruria the artists found themselves confronted with this demand, not on the level of Greek reflective thought and poetic-mythical interpretation, but on the level of immediate presence, charged as they apparently were with the representation of actual men and women. The ensuing Italian development demonstrated that on this level of actuality also the spell of the enormously impressive but relatively undifferentiated generic images of old had to be broken in order to satisfy the new intellectual requirements. In the Chiusi ossuaries individual variety indeed became a theme of art; and an attempt was made to interpret it as a variety of persons with physiognomical differences. In this effort rests the art-historical importance of the Canopic urns, however groping and imperfect the early results may now seem to us. They give evidence of a remarkable new conquest of art; namely, the inclusion within its range of a concept of personality. This concept, aiming at the specific elements which constitute humans as persons – not merely as types – at the same time represents an endeavour very proper to art; for a portrait can never be achieved by verbal description alone: it has to be shown.

PART TWO

THE EARLY AND MIDDLE ARCHAIC PERIODS

CHAPTER 9

INTRODUCTION

The Etruscan Empire

By 600 B.C. there could be little doubt that the new civilizations transplanted into Italy during the previous century had taken root. Two major areas of culture had definitely emerged, one Greek, the other Etruscan; the third prospective centre then forming in Latium had as yet hardly had the occasion to assert itself in a manner noticeable by all. Certainly at this stage the colonial Greek and the Etruscan appear as the two most active exponents of the new Italian culture. Both had then begun to organize and exploit their respective territories; and already it could be seen that each group did so in its own characteristic way. Thus two cultural blocs of unmistakable individuality had come into being and started to move and grow, each on its own momentum. In this respect the resulting situation bears much likeness to the more recent history of the western hemisphere, where a similar colonial drive, originating in Europe, also caused the rise of two quite unequal and in effect novel civilizations in the new continent: one North American; the other Latin, Central and South American. In much the same way it can be said that by 600, when the new civilization of Italy came of age, the domains of the Etruscans and of the Greek colonizers had become two distinct countries. Each owed its existence to the westward expansion of the ancient Mediterranean civilization: this much they had in common. But in the course of time, as each pursued its own political course, they

were destined to counteract each other. Eventually they clashed in overt hostility.[1]

Politically the sixth century marks the height of Etruscan power. In what way exactly this power constituted itself it is now difficult to determine. There was no Etruscan state in the modern sense, but perhaps a network of alliances between cities and ruling families which one might describe as a confederation. But there is no doubt that during the sixth century this organization, loosely knit as it was, reached its maximum extension. By the end of the century it comprised the entire territory west of the Apennines, from Fiesole to Cumae. It possessed important outposts in the Bologna region and at least one Adriatic harbour, at Spina. Attempts were under way at colonizing the valley of the Po, to the foot of the Alps. To all outsiders the Etruscan rule of central Italy must then have appeared as a closed national bloc.

Actually it seems that in many cases this expansion was carried forward by comparatively small, isolated groups which gained control of the foreign communities in which they settled, as did the Etruscan dynasties in Rome. This Etruscan pattern of settlement by pioneering groups was rather different from the more compact Greek colonization. Another significant aspect was its general direction towards the interior. The Etruscan colonization soon came to turn its back to the sea. Evidently the people who promoted it aimed at an intensive exploitation of the land and its resources, rather than clinging to connections with a mother country

overseas. True, the recently opened up woodlands of Umbria enabled the Etruscans to build a fleet, and the waters which they so dominated still bear their name: the 'Tyrrhenian'. But for all we know the chief purpose of this fleet was the protection of the homeland. It also served to maintain Etruscan communications with the nearby metal deposits of Sardinia and Corsica, and to keep the Greeks from sharing in their exploitation. On the whole one receives the impression that initially the Etruscan expansion in Italy met with little resistance. It succeeded, so it seems, owing mostly to a cultural superiority with which its carriers impressed their less civilized neighbours. Its real test came when it collided with equals, such as the Greeks.

In this sense one is probably entitled to say that all major Etruscan wars were defensive. Their aims were not armed conquest so much as the protection of interests previously acquired. Only one of these wars was successful: in 538, after a naval battle near Alalia, the Phocaean settlers from Massalia who had founded a Corsican colony in 564 were forced to abandon this outpost. By this countermove the Etruscans effectively stopped all Greek attempts at gaining a foothold in Italy north of the bay of Naples. However, the end of the sixth century brought the first of a series of reverses which during the following century severely shook, and eventually dissolved, the Etruscan 'empire'. Around 500 the city of Rome revolted and emancipated itself from the rule of the Etruscan monarchy. This proved a decisive event. The Etruscans not only lost their hold on Latium but with it the inland communication which connected their core territory with their Campanian settlements. As a result the Etruscan possessions south of Latium, cut off from central Etruria, became untenable; their final downfall, unavoidable after the rise of the Roman republic, was brought about during the following century.

General Conditions of Art during the Archaic Period

Etruscan art of the sixth century is characterized by a steady and increasingly successful assimilation of Greek standards. This statement holds true both of the borrowed iconography and of the grecizing manner of representation found so very often in the Etruscan monuments. The pro-Greek leanings shown in the arts are further corroborated by other, parallel cultural tendencies such as the approximation of many items of dress and costume to contemporary Greek fashions. Such at least is the evidence of the works of art; no doubt Etruscan society, at least in its upper strata, actually followed suit. These cultural tendencies seem quite independent of the political events in which Greeks and Etruscans are mostly seen in conflict rather than in harmony with each other. Yet there is no reason to be too much surprised at such seemingly self-contradictory attitudes. They can be explained as symptoms of a levelling process which just then began to form the 'western world'. We of the western world still dress, behave, and think basically alike, our wars notwithstanding.

Indeed the very city of Caere which so cruelly suppressed the Phocaeans in Corsica paid tribute to the international authority of the Apollo of Delphi by building a treasury within his precinct, as was the custom of Greek states at that time. There is also other evidence indicating that during the second half of the century Caere became one of the centres of Greek influence on Etruria.[2] The probable immigration of Corinthian artists to Tarquinia has already been mentioned.[3] Not that these Etruscan cities became anything like Greek states: they merely showed, by their actions and attitudes, signs of belonging to a larger commonwealth of culture stretching beyond their own narrow confines, and throughout this commonwealth Greek standards had then begun to direct and equalize numerous manifestations of social life, including the ways of art.

Thus in matters of culture during the sixth century Greece became the adopted mother country of the Etruscan society. Regarding the arts, two results followed immediately from this condition. First, with the general interest now veering in the direction of Greek habits of representation and Greek themes, the previously

noted impact of oriental prototypes on Etruscan art decreased rapidly. It was soon completely replaced by Greek influence. Second, the domestic trends which previously expressed themselves in Italo-Geometric survivals and the Orientalizing folk arts of the flamboyant style became even more isolated than before until, eventually, they also disappeared. The latter development, however, took more time and progressed more gradually than the elimination of oriental reminiscences. Nor did the contrast cease altogether between popular art on the one hand and the more international style of high art on the other. Rather the almost exclusive orientation towards Greek precepts which characterizes the whole country produced a new grecizing art on the popular level as well.

One reason for the last-named development must be sought in the demands arising from purposes not present, or at least not equally active, in the Greek cities. The undiminished importance of local customs and beliefs remained a constituent factor of all Etruscan art. Foremost among these special conditions were the tasks and incentives which the decoration of rich tombs and the care of the dead offered to the Etruscan artists in this as in the preceding century.

Within the general history of art the functions of the Archaic style – the style of the sixth century – must be held to be the same in Etruria as in Greece. Its most important effect was an increased emphasis on the representational potentialities of art which the Orientalizing period had already begun to envisage. During the Archaic period a strict differentiation between representation of subject matter as an end in itself and the more limited idea of decoration became standard practice. Bit by bit the rows of animals and one-way processions of the Orientalizing style disappeared. The human theme came into its own, eventually to become the chief purpose of art. The latter process likewise was initiated in the Orientalizing art of Greece and accomplished during the Archaic period. It definitely established a new concept of art, as a record of human experience and a means of communication in its own right, apart from all

mere decoration. The work of the artist could now make an intellectual contribution of proper value, on a level with such other intellectual endeavours as literature, science, or philosophy, yet separated from them by its special task, which is the creation of images. Art had indeed reached a similar status of independence previously, in other cultures. But its major accomplishments were still to come, and in our western culture the Archaic period of the sixth century opened the road for them.

In a sense the upswing of representational art, as divorced from decoration, strikes us as even more conspicuous in Etruria than in Greece, because there was less preparation for it. The industrial arts which to the end of the Orientalizing period held so large a share in the Etruscan output will occupy our attention less from now on, and hardly at all after the end of the century. Even with mass-produced objects such as ceramics, the emphasis now is on representation rather than abstract-ornamental decoration. Everywhere the pictorial elements take the lead, representing more or less coherent and specified themes. As in Greek art, they were now mostly set in framed fields, apart from other decoration, if any. Within these fields the indiscriminate use of decorative side by side with representational elements soon fell into disuse. A similar process of liberation from decorative purposes can be observed in sculpture. This change from ornament to free representation entirely parallels the Greek development. All in all, the Archaic was the most unreservedly grecizing period of Etruscan art, with the sole exception perhaps of the Hellenistic.

Yet for all the Etruscan acceptance of a Greek manner of representation, there still remained substantial differences between the outcome in either art. These were differences of style and, more significantly, of scope. A simple consideration can illustrate the latter point. In Greek art, the two outstanding achievements of the sixth century were the evolution of the so-called kouros type in statuary, and the black-figure style of vase painting. In both categories the Etruscan contribution remained slight throughout the century. Thus, in general, our previous

diagnosis of Etruscan art will not be changed. The special purposes of Etruscan art continued to provide its most fruitful motivations. Many classes of Etruscan monuments have no Greek counterparts; others, like the numerous bronze statuettes to which we must ascribe a special importance in Etruria, though popular in Greece also, did not there play the same role in the total volume of art. By and large the Etruscans remained outsiders to the methodical approach and strict logic with which the Archaic Greek artists developed and solved their problems of form. Instead, in a manner perhaps less rational but no less consistent, they continued to evolve a quite different idea as to what art was about and what it might accomplish.

Chronology and Periodization

The chronology of Archaic Etruscan art must be based on the more or less parallel Greek development. The early history of Italy yields but few corroborative data. Possibly the evidence of tomb groups can be better utilized in the future than it has been so far, although the character of funeral equipment underwent a noticeable change during the early sixth century. No longer do the Etruscan tombs present us with accumulations of contents as dazzling and variegated as the great funerary treasures which characterized the preceding period. Compared to the tomb furnishings of the new era, the Orientalizing period was a golden age indeed. From here on gold and ivory became relatively scarce; bronze and ceramic objects prevailed. As far as these implements were domestic products, their place of provenance is still of considerable importance for the history of Etruscan art, if it can be established. The relative frequency of certain types of objects in certain regions may then be taken as a clue to their place of origin and their area of distribution. However, in the wealthier burials a steadily increasing percentage of the clay vases was of Greek importation, and not domestic. As depositories of Greek painted vases these tombs have proved invaluable to us, but their chronological value is often impaired by the relative incongruity of their contents, as to type and age.

It was not uncommon for one tumulus to contain Greek vases collected over a century or more.[4] Whenever this happened, the chances are that the contents were composed of several successive burials; but many of the important tumuli were opened during the last century or earlier, under conditions which make the sifting and chronological reassembling of their contents impossible, or at least very uncertain. At any rate, from now on the importance of the Etruscan tombs for the general history of art more often resides in their decoration, especially the wall paintings, than in their furnishings.

The habit of decorating temples with terracotta revetments along the edges of roofs and pediments became common in Etruria about the turn from the seventh to the sixth century. Architectural terracottas of this type are frequently preserved and have proved helpful in determining the styles of local workshops. But no single building of this period can be dated by a historical record, and often the structures themselves to which this decoration belonged are only insufficiently known. The architectural terracottas, also, must be dated by artistic style and other intrinsic evidence.[5]

There is in this situation a considerable difficulty for the reconstruction of an Etruscan chronology, for stylistic comparisons between Etruscan and Greek art are not always stringent. The obstacles are twofold. First, the Etruscan style is rarely, if ever, purely Greek. Not only are the workmanship and formal taste marked by local mannerisms to the point, oftentimes, of outright provincialism, but the very evaluation of Greek art in Etruria, from a buyer's viewpoint as it were, could not do justice to the actual conditions of that art. Greek Archaic art at home developed in specific regional variants which together formed its style. While one of these variants is usually predominant in Archaic Etruscan art also, the Etruscan artists did not often conform to any one standard of style quite strictly. Their work was as a rule not purely Corinthian, Ionian, or Attic: more often than not it fused the dominant characteristics with other stylistic features, either Greek or domestic or both. The remarks made previously about the

style of the Regolini-Galassi vase stand apply here as well (above, p. 57). Etruscan art was still apt to form its own vernacular. Consequently Etruscan and Greek works of Archaic art were not really commensurable. Their styles may be similar but are rarely identical. Even when comparisons reveal close resemblances, contemporaneousness does not immediately follow. Because Etruscan monuments are apt to relate not to one trend of Greek art but to several simultaneously, the chronological evidence is often contradictory. Also the possibility of provincial retardation must always be taken into account in trying to establish the date of an Etruscan work.

The second obstacle to an Etruscan chronology based on stylistic comparisons with Greek art alone lies in the different pattern of evolution which underlies the former. It has long been noticed that Etruscan Archaic art is best divided into three chronological sectors, according to the prevailing variant of Greek style in each consecutive stage. The same divisions will be used here. This does not mean that the Archaic development in Etruria was completely lacking in a coherence or logic of its own: the three divisions merely acknowledge the fact that Archaic art in Etruria received its main impetus from abroad, and that consequently its evolution reflects the accidents of history which delivered the foreign examples to her shores. The Etruscan reaction to imported artefacts hardly differed from the attitude which we noticed during the Orientalizing period. As the superiority of all eastern arts was then accepted regardless of either the Phoenician-Oriental or the Greek style of the chance specimens at hand, so during the Archaic period one has the impression that the Etruscans viewed with comparative indifference the stylistic discrepancies between the various manifestations of Greek art. They merely felt and acknowledged in their own products the superiority of Greek art as they knew it. The stylistic differentiations which we perceive in these materials did not count for so much: what did count were the examples available, be they Corinthian, Ionian, or any other. Everything was welcome to increase the body of art work in far-off Etruria.

In conditions such as these the tentative dates assigned to individual Etruscan works are bound to vary considerably in modern research. They can claim no more than approximate correctness, at best. But the succession of Greek styles which chiefly influenced Archaic art in Etruria is more clearly noticeable, and about this point there is greater agreement.[6] They followed one another, in this order.

Circa 600–550 : Early Archaic. Prevalence of Corinthian art. A period of transition from the Etruscan Orientalizing to the Archaic style, with Corinthian influences in evidence, probably started somewhat before the turn of the century; but no certain dates are available. This is the last time that oriental imports occur with some regularity among the tomb groups.[7] During the same transitional period the following new types of art make their appearance: wall paintings (earliest painted tombs in Caere and Tomba Campana near Veii); Tarquinia door slabs; grave monuments with figure decoration (pillar from Vulci, in Florence); architectural terracottas (frieze from Poggio Buco).

The first fully established Archaic style in Etruria can be traced to stone sculptures from Vulci, not much later than *c.* 590. In Rome, recent excavations uncovered evidence of a local Archaic art around 575 (terracotta frieze from the Forum Romanum). But the most remarkable event of the Early Archaic period was the rapid development of northern Etruria. The inland cities rather than the coastlands took the lead. Chiusi became a veritable capital of regional art, turning out stone sculpture as well as the more advanced forms of her Canopic urns. Heavy bucchero became another of her main industries. From near the end of the period date the first funerary statues of the Chiusi type (hollowed out to serve as receptacles for ashes). At the same time, approximately the decade from 560 to 550, signs of new industriousness can be sensed in other northern centres. The first grave stelae with full-length human figures appear at Volterra. Around 550 the ancient metal industries of the Perugia region began to include works of the highest quality with their ordinary productions, thereby confirming the

final success of the Archaic style by formal as well as thematic innovations, especially a new interest in mythical narratives treated as independent themes of art (bronze chariot from Monteleone di Spoleto, c. 550).

Circa 550–520: Middle Archaic. Ionian influences, always palpable in Archaic Etruscan art, reach their peak.

The paradoxical fact is that among the archaeological finds of the period, imported Ionian objects form the exception. They are not at all frequent.[8] Evidently the strongly Ionian inclination of all Etruscan art at this stage was caused by persons – immigrant artists – rather than by objects imitated. The assumption of direct contact with the Ionian Phocaeans who had moved into the Etruscan orbit during the second quarter of the century still offers the most plausible explanation. Nor must we assume that all dealings between Etruscans and Phocaeans ended with the expulsion of the latter from Corsica. Quite possibly the catastrophe of Alalia had the opposite effect, to drive homeless Phocaean artisans into Etruria after 538.[9] In a similar manner the Etruscan expansion into Campania favoured Etrusco-Ionian contacts, probably involving both trade and exchange of persons.

Most earlier forms of Etruscan popular art died out during this period, or at least before the end of the century. The latest Tarquinia door slabs date from the years around 530. The production of Canopic urns in Chiusi ceased about the same time. Heavy bucchero was manufactured for somewhat longer, but hardly much later than c. 500. A regionally limited industry of rather uncertain duration produced the well known bronze situlae from the province of Bologna.

For approximately the first half of the period the northern regions retained their advantage, a fact demonstrated by the intensity of production at Chiusi and confirmed by the fine metalwork discovered in the environs of Perugia (chariots, vase stands decorated with repoussé reliefs). In contrast to Greece, the Middle Archaic period in Etruria displayed a noticeable disinterest in statuary. Painting and reliefs were the leading

arts throughout. Stone reliefs, mostly of somewhat provincial style, remained popular in the north, as shown by the grave stelae with upright figures from Fiesole. The important class of the Chiusi limestone cippi, with sometimes excellent relief decoration, started some time after the middle of the century.

Gradually, however, the emphasis shifted away from the northern provinces to central and southern Etruria. Vulci, rather than any of the northern towns, eventually became the centre of the bronze industries which made Etruria famous throughout the ancient world (after c. 530). Around the middle of the century an Etruscan tradition of Archaic vase painting had begun to form, probably in the same city, with the creation of the so-called Pontic type of amphorae. Monumental painting flourished, especially in Caere (painted terracotta slabs) and Tarquinia (Tombs of the Bulls, the Augurs, and others). The workshop of the Caeretan hydriae, likewise, must have been founded during this period, c. 540–530.

Circa 520–470: Late Archaic. Gradually increasing impact of Attic prototypes, especially painted vases, on all branches of Etruscan art.

The high level of quality established during the preceding stage persisted during this period, at least in certain places. Concomitantly the divisions sharpened between the more provincial art often turned out by northern centres on the one hand and the standards of the leading workshops in central and southern Etruria on the other. Outstanding in the north were the limestone cippi with reliefs continuously produced at Chiusi. In the south, the bronze foundries at Vulci developed their admirable standards of artisanship; furniture (tripods, candelabra) as well as statuettes can be referred to them. Other classes of importance which cannot always be securely distributed between this and the preceding stage of Archaic art are the Tarquinia 'shields' of sheet bronze decorated with heads of rams or lions or masks of 'Achelous'; and the black-figured Etruscan vases which succeeded the Pontic amphorae, especially those attributable to the so-called Micali Painter. The 'shields' may have started

as early as *c.* 530–520; the work of the Micali Painter around 520. At any rate both classes belong essentially to the last quarter of the century, perhaps continuing for a short while into the next. Simultaneously the workshop of the Caeretan hydriae continued to be active. Last but not least some of the foremost monuments of the period are again found among the wall paintings (Tombs of the Baron, the Lionesses, Hunting and Fishing, and others, all at Tarquinia).

Not before this period did statuary come again into prominence. The production of bronze statuettes, which had never quite ceased, can be seen to increase noticeably in number and quality. Around 520 terracotta statuary resumed its astonishing career in Etruscan art, as manifested by the famous sarcophagi with reclining figures from Cerveteri (Caere). Among the terracotta statues, the Apollo group from Veii constitutes one of the most distinguished examples preserved of all Etruscan sculpture. A date around 500 is here ascribed to it. At the same time terracotta sculpture on a smaller scale was widely practised all over Etruria. Of this fact the Faliscan and Latin sites especially bear ample testimony. All in all, the years between *c.* 530 and 500 rival in productiveness the most flourishing decades of the Orientalizing style in Etruria.

CHAPTER 10

TRANSITIONAL RELIEFS AND WALL PAINTINGS

Tarquinia Door Reliefs

From the art of the transitional period, around the turn of the century, emerged the first examples of a clearly grecizing Archaic style in Etruria. Foremost amongst them are the so-called door reliefs of Tarquinia.[1] They form an interesting class of monuments, but also pose an archaeological problem not yet solved. Almost all examples hail from Tarquinia; all were found in tombs, but in no case has the original purpose been discovered. Some had been used as stone slabs closing the inner doors of tombs, though in circumstances which make it clear that such was not their original destination. Their decoration rather seems to imitate a structural element of architecture, such as the carved beams of a wooden ceiling; but the exact nature of this construction has not yet been explained.

To exemplify the type I illustrate a specimen from Tarquinia, of rather fine workmanship [76]. The decoration of broad bands framed by guilloche patterns is characteristic of the whole group. Usually the horizontal bands are filled with frieze-like, continuous representations: in the example here selected, this part shows two processions facing each other antithetically. The procession to the right (which is the better preserved) represents a woman, a winged griffin, a rider on horseback, and a winged sphinx; one recognizes the echo of a Greek orientalizing vocabulary. The vertical bands, on the other hand, are divided by superimposed squares; each square within its guilloche frame encloses one figure as a rule. Only occasionally are two figures shown in a common action, such as for instance the man leading a prisoner away in our illustration 76. In the same example the remaining squares include an ibex, a lion, and a winged figure in the Greek 'kneeling–running' position, meaning that we are to understand this wondrous creature as shown in hurried flight. Twice a centaur is seen carrying a huge tree over his shoulder, pictured in the early Greek manner as a nude man from whose back grow the body, hind legs, and long curving tail of a horse.

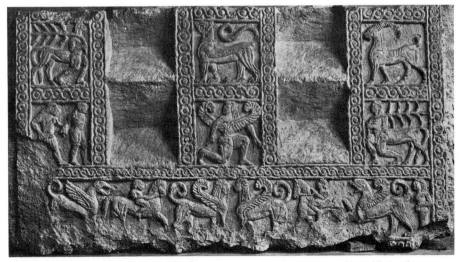

76. Door relief from Tarquinia, first half of the sixth century. Nenfro. *Tarquinia, Museo Nazionale*

In the ornate richness of this decoration the most distinctive feature is the Greek character of its imagery. The centaur was a monster of Greek invention; Greek also is the form of the winged demon.[2] Ionian elements can be observed in all reliefs of this class, for instance in the guilloche or bead-and-reel patterns. But the figural representations remind us mostly of Corinthian vase painting. The stylistic importance of square frames has already been mentioned in connection with the Regolini-Galassi Tomb bracelets (pp. 68–9) and the equally transitional Caeretan red ware (pp. 83–4). More than ever, with the Tarquinia doors, one feels the disciplining effect of these frames; the strictness of the allotted space imposes a geometric rule on the figural representations. Indeed the insistence on a geometric definition will be quite frequently noticed in Etruscan art at this stage.

In the relief before us the tendency towards geometrization operates in the angular structures of the images, as well as their formal relation to the frames. It can even be detected in the freely lined up figures of the horizontal bar, horsemen and animals alike, each of which could just as well be inscribed in a metope. Along the vertical bands the squares are stacked one upon another, as in the Greek embossed shield handles from Argos. No doubt the concepts of composition and formal arrangement underlying these reliefs were indebted to Greek, chiefly Doric, prototypes.[3] But, as often happens in Etruscan art, the reliefs themselves form a type not found in Greek art as we know it. The superimposed panels may have been derived from Argive bronze reliefs and blown up to a much larger size. They represent transpositions rather than copies and are in that sense a novel creation of art. The skill with which this transfer was carried out, from one material to another and from one purpose to another, varied considerably with the individual specimens. Some examples are of very coarse workmanship; the artisans were not always equal to the task. As was said before, possibly the masons who produced these reliefs did not even deal with Greek prototypes directly but imitated domestic woodwork, the decoration of which was in turn based

on the imported prototypes. In the slab here illustrated, the carving technique, which is of very good quality, would be equally suitable for a relief made of wood, and, with some colour added, would produce a quite magnificent example of ornamented woodwork, for instance in a ceiling.

Tomba Campana

The beginnings of monumental painting in Etruria – as distinguished from vase painting – must likewise be ascribed to the end of the Orientalizing period, or rather to the time of transition between Orientalizing and Archaic art which can be identified, approximately, with the decades immediately before and after 600.

The extant examples of Etruscan monumental painting are mostly if not exclusively wall paintings in tombs. The paintings made for the living which also existed in temples and perhaps in private homes have almost all perished. Even with these reservations in mind, the material which survived must be deemed of the greatest importance. It constitutes an indispensable chapter in the history of ancient art. As it is, Etruscan art now offers almost the only available testimony of ancient monumental painting before the Romans.[4] How we would judge the same works if more ancient Greek paintings were preserved it is of course impossible to say. Obviously the condition of all Etruscan art applies to these paintings also: the general standards of representation were set by the Greeks. Yet the wall paintings serve us better than many other monuments to perceive the limitations within which this statement holds. It is easy to see that they stand in some relation to the Greek art of their time, without which they would not have come into existence. The exact nature of this connection is not equally clear.[5] Thus the Etruscan tomb paintings soon developed a characteristic iconography, mostly based on Greek art but adapted to its own purposes. More decisive because more elemental is their stylistic conformity to Greek art, which could only be brought about by an adoption of principles, over and above the imitation of

chance prototypes. Indeed the standards which these Etruscan works shared for instance with Greek vase painting pertained first of all to methods of representation. The reliance on outline design; the expansion of figures in the plane; the sideways action of human figures and the standardization of their postures, all confirm this essential identity of principles. The same close agreement will be observed in the folds of draperies and, come the time, the use of shading in the rendering of solid objects. These are important points indeed: they imply basic attitudes towards principles of painting and the representation of space. Accordingly we must not in this Etruscan art expect approaches to the problems of visual reality on a level significantly different from the Greek; for instance, no concept of space beyond that which contemporary Greek art could provide.

All this means no more than that Etruscan painting, throughout its history, remained on the level of a classical art, broadly speaking. It does not mean that its products can always be accepted as substitutes for the Greek works which are lost: there is a great deal both about their style and their themes which strikes us as properly Etruscan and, to that measure, not Greek. The reason is that the general standards which both arts had in common left much leeway in their specific application. No exact counterparts of the Etruscan tomb paintings have been found in Greece. Nor could wall paintings such as did exist in Greece be easily transported. For this reason alone the prototypes to which the painters of the Etruscan tombs may have had access cannot have been on a scale with their own work. Numerous problems of arrangement, design, and iconography had to be worked out on the spot. It is obvious that this was precisely what happened. No other area of Etruscan art bespeaks a consistent and indigenous development as intelligibly as do the great wall paintings of the Archaic period. The results can scarcely be confounded with Greek art, in spite of the similarities in principle. In their actual effect and Etruscan look these paintings require a description apart from Greek art. The deviations may no more than constitute a difference of degree, not a total contrast; but the history of art must reckon with them. In so far as we call this art Archaic Etruscan, we merely acknowledge that it presents a special aspect of the common Archaic style.[6]

The earliest tomb sufficiently preserved to make critical discussion possible is the Tomba Campana near Veii [77]. The paintings, now

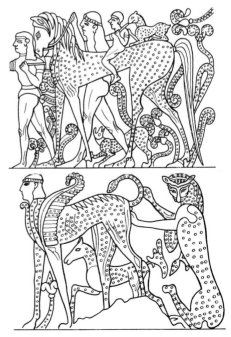

77. Veii, Tomba Campana, details of rear wall of the first chamber, early sixth century

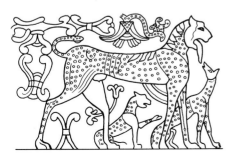

badly faded, surround the rear door of the main funeral chamber.[7] On either side two rectangular fields are stacked one upon the other, each framed by simple lines on three sides but left open towards the corners, where the adjoining walls provide a natural limitation. Thus in effect these paintings appear as four near-square, closed compositions flanking the door. This would constitute a very unusual architectural arrangement in Greek art, though not in the Orient, where decoration by superimposed panels, flanking a door or niche, can be found in both Egypt and Assyria. Yet rather than having recourse to such far-fetched examples one may connect the order of panels in the Campana paintings with the superimposed fields of the Tarquinia reliefs. In this way it can be explained as an enlargement, applied to painted architectural decoration, of a decorative scheme ultimately borrowed from Greek minor arts.

The style of representation in the Campana Tomb appears replete with orientalizing reminiscences not yet fully overcome. Such features are the fabulous zoology shown; the stilted, high legs of the animals; and the habit of filling empty spaces with apparently meaningless ornament. On the other hand the elongated, taut, and somewhat abstract outlines of the humans rather conform to an Early Archaic sense of geometry. In this respect the man behind the horse in the field to the upper right can be likened to the spear-throwers from Brolio (above, pp. 98-9). Whether or not a specific meaning was implied with this imagery it is now difficult to decide. Perhaps the monsters and animals in the lower fields served as guardians of the door. On the other hand the scene on the upper right has been convincingly explained as representing a hunter's departure: if the explanation holds true, this would be the first representation of its kind – a scene from ordinary life, of daily occurrence – in Etruscan art.[8] The man has dismounted from the horse which his slender page is leading; a smaller boy and a hunting leopard ride on the horse. Even the filler ornament may temporarily assume a meaning and stand for the dense forest or underbrush; at any rate, refer to outside nature. That

the hunter denoted the owner of the tomb would be a logical assumption, in accordance with later Etruscan funerary decoration. But here again the ancient Etruscan reluctance to press art into the service of a specific message makes a confident decision impossible. Like a daydreaming child, this art lingers in the twilight between reality and fancy. The possible realism of this one panel dissolves in the adjoining world of fable. Yet, vague though it be, it forebodes an attitude towards the world of man which differs significantly from the mainstream of Greek art.

The colours in these paintings are quite fantastic. Animals are divided into two or more areas of different colour, regardless of natural conditions. However a certain structural value can be discerned in this method: for instance in the representation of a quadruped, the leg nearest the observer may be distinguished from the other, which is farther away, by its colour; or the shoulder joints are of one colour with the leg, contrasting with the neck or rump of the same animal, to clarify anatomical divisions in a manner which had previously become customary in popular Etruscan art. The overall effect of the entire representation must have resembled a decorative hanging. It covered the wall like a large tapestry.

The Problem of Meaning

At first glance it may seem that the adherence to frames in all these monuments entailed at least a temporary regression of content. Compared for instance to the continuous narratives around the ivory situlae from the Pania Tomb [37] the range of subject matter in the Tarquinia doors appears severely restricted. No narratives can be identified among the square compositions; representations of action of any kind are rare. In addition to the prisoner being led away, already mentioned [76], one can cite an erotic scene of a type also found in Corinthian vases in another relief of the same class;[9] similarly, in the Campana Tomb, perhaps the 'Departure for the Hunt'.

All these representations can be classified as genre scenes. As such they form an innovation

in Etruscan art. A certain thematic coherence, however feebly expressed, sets them apart from mere decorative art. Neither is the meaning limited to the most general scope of imagery, the showing only of an example of a species, which was the rule of earlier Orientalizing art. These compositions specify a theme, namely an activity or a situation. But they do not tell a story, or clearly link the situation shown with names of persons either real or mythical. Therefore they must not be thrown together with mythical narratives. The thematic precision of a genre scene rests in the impersonal yet characteristic situation which it represents, such as 'a hunt' or 'a banquet'. It is not vested in a personal character, as would be the case of history, in which the situations and events derive their interest from a hero and his doings. So defined, as a kind of subject matter dealing with activities rather than actions, genre scenes represent one of the important possibilities of art. Their inclusion in the Etruscan repertoire at the start of the Archaic period must be considered a significant event, especially since in Greek art the themes of daily life always remained subjects of lesser importance, mostly confined to minor arts such as vase painting. Etruscan art, which on the whole showed itself more inclined to face life directly, and not necessarily by way of a mythical transformation, evidently was less reluctant to accept themes of this kind in monumental painting. The hunt, especially, forms an example to the point. It was then a subject of old standing, well established in Egyptian and Near Eastern art as a pastime of kings and nobles. Yet in Greece hunting was not often represented as a genre scene. The hunts of Greek art were mostly mythical, even among the vase paintings.[10]

The hunting picture of the Campana Tomb describes its action so indefinitely that doubts as to its meaning may well arise. It obviously assumes an intermediary place between the generic representations of the preceding stage and the specified subjects of Archaic and Classical art. The Tarquinia reliefs, and especially the compositions inscribed in squares, strike an even more conservative attitude in this respect. Most of their imagery continues on the level of

78. Stele from Vulci, first half of the sixth century. Nenfro. *Florence, Museo Archeologico*

generic meaning. Nor was their manner of composition limited to the workshops of Tarquinia alone. A stele from Vulci, now in Florence,[11] presents the same arrangement of superimposed squares, divided by guilloche bands, each containing one single group or figure [78]. Together all these works form an interconnecting group. By style and composition the Vulci stele was obviously related to the Tarquinia reliefs. At the same time the man marching behind his horse in the top field should be compared to the 'page' in the hunting scene of the Campana Tomb.

Nevertheless, regardless of their mostly generic character, all representations in this group look distinctly more modern than their Orientalizing forerunners. This is especially true of the Tarquinia reliefs and the stele from Vulci. Because the frames isolate the figures which they enclose, they also impart to them a new sense of importance. By this emphasis, if for no other reason, the images become special objects of attention and studies in reality with a meaning quite their own; even though there be no action and some of them no more than visualize a make-believe reality of things which the mind may invent. These works address us in a language of art which avails itself of a rudimentary grammar; they speak, as it were, in pure nouns, using verbs hardly at all. Their disconnected pictures resemble illustrations of a primer from which children learn to read. Yet in trying to determine their meaning we recognize them as an elementary exercise, preparatory to an attitude towards subject matter which many arts and artists have at some time required. The isolated representation of a single object, though natural to sculptors, remained rare in ancient painting. It became a matter of increasing interest to painters only after the Renaissance. Dürer's 'Hare' or Rembrandt's 'Polish Rider' of course exemplify infinitely more complex performances, pictorially; but the essential elements of such separate representations we find already present in our Archaic reliefs. Condensed into one simple form, in each framed field, a fact of existence or a mythical phantom come alive. In the clear formal definition of the reality incorporated, rather than a context discursively demonstrated, consists the true meaning of each image.

CHAPTER II

EARLY ARCHAIC ART

SCULPTURE AT VULCI

*Frequency and Quality of Sculpture
in Etruscan Art*

The flow of production was probably never as
steady in Etruscan as in Greek sculpture, nor on
the whole as copious. The higher the level of
quality for which we look, the more this state-
ment is confirmed. It is certainly true that a
great deal of material has perished. But we can
only judge from present knowledge; and accord-
ing to that knowledge the top performances of
Etruscan statuary appear much more isolated
from the average level from which they rose than
was the case in Greece. One can therefore hardly
avoid the conclusion that works of high quality
were always scarcer in Etruria; and the contrast
between popular and leading arts, so typical of
Etruria, expressed itself in terms not only of
quality but also of number.

On the other hand a difference is to be noted
between the Orientalizing and the later stages of
Etruscan art regarding stylistic conformity. One
hardly finds as many unique pieces in Etruscan
art during and after the Archaic period as was
true of the Orientalizing tombs and their often
baffling contents. The obvious conclusion is
that the tradition of style has become firmer.

For this reason the extraordinary fluctuations
of quality within one and the same stylistic or
local group must seem even more surprising. A
sociological factor must be active in this state of
affairs which somehow escapes our knowledge.
Certainly local natural resources often provided
the initial incentive for special industries. The
early occurrence of stone sculpture at Chiusi
and Vulci can probably be so explained. Local
workshops thus formed, but what share itinerant
artists had in their activities can now hardly be
estimated. Did migrants offer their services to
the local public, as the itinerant portrait painters

did in the rural communities of the United
States during the early nineteenth century? The
temporary presence of travelling artists, in addi-
tion to native craftsmen, would make the differ-
ence of quality in certain local schools more
understandable. It would also help to explain
the comparatively short duration of certain
branches of industry in some of these communi-
ties, a fact which constitutes another special
aspect of Etruscan art. Thus stone statuary fell
into disuse at Vulci, while the bronze industries
flourished. At any rate, in most local groups the
outstanding works number very few. But it is
their level of quality rather than the uniqueness
of their formal types and style which isolates
them and makes them look rare.

The Centaur

Statuary in stone seems to have spread from
Vetulonia inland after the middle of the seventh
century. The early examples from Chiusi have
already been mentioned (above, Chapter 7,
pp. 95-7). Sculpture on a comparable Late
Orientalizing level of style was also found fur-
ther south at Vulci, but preserved in conditions
too fragmentary to warrant discussion here. At
any rate there, too, the local workshop tradition
harks back to the end of the Orientalizing
period; but its outstanding products date from
a somewhat later time: the early sixth century.
During that century Vulci reached its flowering,
and must be counted among the Etruscan cities
most receptive to Greek influence. Her tombs
yielded the richest crop of Greek sixth-century
vases found anywhere in Italy. The relief stele
mentioned previously, from the same site, indi-
cates close relations with Tarquinia, which is
not far away; however, stone statuary appears
to have been the speciality of Vulci.[1]

The first important monument of this school,
and indeed one of the finest Early Archaic

79. Centaur from Vulci, c. 590. Nenfro.
Rome, Villa Giulia

statues preserved, is a centaur of local tufa (*nenfro*) now in the Villa Giulia Museum in Rome [79].[2] Centaurs are monsters, hybrids of horse and man. This one conforms to the oldest Greek type, in which the body and hind legs of the horse are quite abruptly joined with the form of a man; the scheme was already in use with the previously mentioned Tarquinia reliefs. In fact the front view shows no more than a stepping kouros whose hands, actionless, hang down to either side: although the legs are now missing,

it is not difficult to reconstruct the type. The face, once bearded, with its low forehead would very much remind us of an earlier Daedalic art if it were not for a new expression of energy, which seems to reside in the bulging forms and protruding eyes. Yet the formal structure is quite abstract, and may be defined as governed by quadrangles. The smooth geometry of the inclining planes which describe the trunk and chest follows a trend which had come to the fore earlier, for example in the bronze youths from Brolio [67]. In the centaur this inherent geometry was more consciously or, to say the least, more consistently employed. Squares determine the proportions. The face on its broad base becomes a squarish mask; a cube seems submerged below the curving contours of the head. Indeed the entire figure, if seen from the side, might be inscribed into a square, not unlike the centaurs of the Tarquinia reliefs; if the missing extremities were added we would probably see before us a rather long-legged creature, moving about with a stalking gait and a good deal of the ancient, orientalizing ceremoniousness.

New, on the other hand, is the firm and compact roundness of the statue. A sense of self-determination was thereby imparted to the image which was lacking in older Etruscan sculpture. Here the human form became indeed defined and shown explicitly, as a material mass come to life. This emphasis on the quality of being alive the Vulci centaur has in common with early Greek statues: he shares their vitality, though hardly their spirituality. He does not even smile like his nearest Greek counterpart, the kouros signed by Polymedes of Argos.[3] But then the centaur may well be the more ancient work of the two. Another circumstance, also, makes comparison with Greek art difficult. We know of no early Greek statues of centaurs. Probably the Etruscan sculptor had a special problem put before him when he fashioned this image, which was found in a necropolis, outside the town proper. A statue of a centaur was not a common thing at that time. Why anyone should want it in this particular spot, we can only guess; the chances are that the friendly monster served as the sentinel of a tomb.

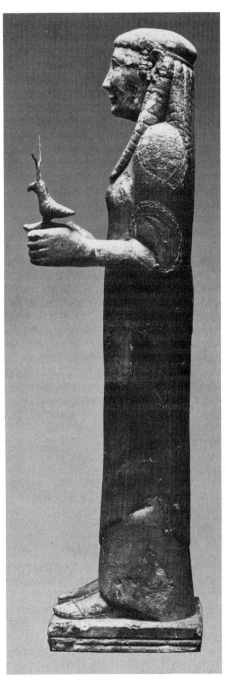

80 and 81. Woman from the Isis Tomb, Vulci, *c.* 580. Alabaster. *London, British Museum*

Other Early Statues

The next landmark of Etruscan sculpture is the alabaster figure of a standing woman in the British Museum which hails from the so-called Isis Tomb near Vulci [80, 81].[4] About half-life-size, this rare and very fine work must be described as a large statuette rather than a statue. It is in excellent condition except for some corrosion in the upper parts, due to weathering. Traces of colour can be seen in several places. The woman had black hair, with two locks falling on either shoulder in front and the rest hanging down her back in a series of long tresses; at about the height of the waist the braids are gathered in a multiple ribbon. The lower edge of her long frock (chiton) was decorated with a neatly painted band of lotus flowers, and another painted border accentuated the straight edges of the open cloak in front. Below the cloak the clasp of the belt was gilded. Every care was taken to present to the observer an image of costly, if somewhat sturdy, elegance.

The style is in line with the then common geometric preferences which simplify all forms but also impart to them their peculiar strength and accuracy, their cubic build. This tendency becomes even clearer in the London statuette than it was in the centaur, because the surface forms, instead of bulging, tend to constitute larger and more coherent masses and planes. Compared to the centaur, the trend has progressed. The broad, angular face of the woman, with its unmoved smile, is quite on a level stylistically with the Polymedes statue at Delphi. It should be dated accordingly: *c.* 590 for the centaur; perhaps 580 for the London statuette. The latter may well be considered the most accomplished work in our possession of Etruscan Archaic art in its Daedalic vein.

Shown full-length on a base, like a sacred image, the figure hardly qualifies as a funerary statue denoting a deceased person, in spite of the realistic costume and the fact that it had been deposited in a tomb. Nor is it always possible in this art to distinguish between a votary offering gifts and deity itself. The strange horned bird which the lady so resolutely holds might decide the question if, as seems likely, it belonged to her originally.[5] So far it has gone unexplained; yet clearly this is not a natural animal. Made of bronze, once gilded, it combines with its avian form the broad horns of the Italian cattle: I should call it a heraldic beast. As such it represents a fitting and meaningful attribute for an Italian goddess, for stories of sacred animals were not foreign to early Italian folklore. A woodpecker led the Picentines; the Italians themselves understood their name as 'cattle-people'. The image of a divine ancestress, or even a mistress of the dead, holding the emblematic animal of a tribe or clan would not seem out of place in an Etruscan tumulus.[6] We may expect that divine ancestry was indeed claimed by patrician families already in early Italy, just as later in Rome the Julians called Venus their common mother, to mention one well-known example. The Etruscan mother deity – if this was indeed her character – represented by the London statuette cannot be so definitely named. Yet the spell of the image can still be sensed: in the firm stance of the sandalled feet set wide apart; the intensity of address conveyed by the outstretched hands; the fixedness of the glare. By signs such as these an art of rigid forms endows its images with an extraordinary power, not of representation but of direct presence. This is why Archaic statuary which deals with existence directly, not with any particular aspect of existence, can in its uncompromising forms incorporate the magic efficacy of deity, to a degree unobtainable by any other art.

We conclude this section by showing a resting lion in the Vatican which, together with several similar animals now in different collections, can be traced to the tomb of a prince or nobleman near Vulci [82].[7] The type with laid-back ears and mane of hair around the face probably derived from Late Protocorinthian models; but the strength and sureness of the sculptured forms point to a somewhat later origin, perhaps in the decade between 580 and 570. The style, geometrized rather than Geometric, agrees with the centaur and related works. Only the forms have grown bulkier and become simplified as well as magnified. Contours and proportions

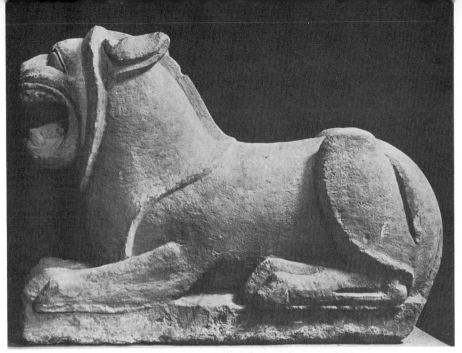

82. Lion from a tomb near Vulci, *c.* 580-570. Nenfro. *Vatican, Museo Gregoriano Etrusco*

are still held to the rule of the squares, straight lines, and right angles. That this style concerned itself not so much with the representation but with the definition of forms can also be deduced from the sharp demarcations which segregate one part from another; notice, for instance, the controlled but quite calligraphic design of the hind legs. The habit of outlining the principal details of a natural object such as the legs of an animal regardless of, and even contrary to, their organic appearance was typical of this entire stage of Etruscan art both on the popular and higher levels.[8] Apparently it met a need for elementary forms. In this respect also these images can be likened to the illustrations of a primer, the office of which is to demonstrate fundamental concepts in rationalized forms. Thus Etruscan art outgrew the wobbling images of its Orientalizing past by geometrization. Obviously this formalism corresponded to a state of transition necessary and proper to the Etruscan development. One receives the impression that its regulative geometry was mostly imposed on the images from the outside; it is not really in

them. It may serve to impart a greater sense of material reality to the sculptured object. But essentially it remains a device for determining boundaries; that is, a framing device. Because Etruscan art was so apt to interpret forms as exterior limitations, it often found it difficult to achieve that unity of form and object which had then already emerged as the main tenet of Greek art. Naturally, the sculptures created from so different an intellectual disposition look different, even when in other respects they appear perfectly assimilated to coeval Greek standards of representation.

SCULPTURE OF THE NORTHERN SCHOOLS

Canopic Urns

The Vulcian statues of the early sixth century had no immediate successors. Indeed the next decades prove rather barren all over Etruria as regards art on an international level. The curious fact is that very few leading monuments of Etruscan art can with good likelihood be as-

cribed to the second quarter of the sixth century; at least not before a time very near the middle of that century. Chiusi alone gives signs of a vigorous production including sculpture of a remarkable standard of quality during these years; but work from there was more in the popular vein.

In Etruria, however, the popular arts bear watching. If they were removed from international standards by intent and practice, they were also apt, for this very reason, to display a high degree of originality. They often tackled problems outside the focus of Greek art. Thus the heads of the Chiusi Canopic urns deserve serious attention in any study of the Archaic period. Origin and purpose of this curious class were explained previously (pp. 106 ff.). What interests us here is the extraordinary development which took place among these monuments during the first half of the sixth century.

Omitting the intermediary examples we turn at once to two representatives of the latest stage, in which the heads are characterized by the peculiar stylization of their bobbed hair [83, 84].[9] Progress compared to older works of the same class is obvious; clearly it is moving in the direction of greater naturalism. The heads are now shown all-round, and the faces have ceased to be mere masks attached to an abstract globular core. Yet, while these improvements may represent advances of sculptural concept in line with the general artistic development, the faces themselves give cause for surprise for another reason: they astonish us because of their atypical character. If in a few instances including our own illustration 84 the modest tomb groups had not become known of which these works formed a part, we could scarcely date them. Present archaeological evidence points to a date somewhat before or after the middle of the sixth century; the entire class cannot long have outlived the first Archaic period.[10] Within the art of that period these heads are quite unique; obviously the process of individuation, operative in the Canopic group from the outset, has led to results far removed from most other contemporary art. The late Canopic heads have no

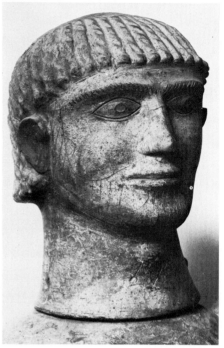

83. Canopic urn from Chiusi, mid sixth century. Terracotta. *Florence, Museo Archeologico*

counterparts outside Etruria, and hardly any outside Chiusi.

To be sure, standard features can be observed, such as the long, protruding chins which perhaps still echo the earlier, pear-shaped Villanovan faces. But individual traits prevail over the typical. At least in this one province of art the trammels of generic representation now appear to be effectively broken. It is obvious that, in their latest stage especially, the Canopic urns have gone far towards establishing a concept of portraiture then entirely absent elsewhere in western art.

How, precisely, are we to describe this concept? Even the latest Canopic heads can scarcely be called portraits in the modern sense. I should call them proto-portraits. There is no certainty that two real persons ever looked like the two heads in our illustrations; but someone might

Therefore the two heads in our illustrations, though they may never have portrayed persons truly, nevertheless incorporate a true concept of personality. This must be called a naturalistic trend. It rests not on analytic categories of understanding such as a description of 'character' but on the immediate and unreflective acceptance of human difference on the level of the actual. It expresses itself in the interest shown in the irrational, if factual, variability of physiognomic forms. The new concept of person as the real condition of man, which was implanted in this class of monuments by their initial personal and memorial purpose, now begins to bear fruit. In this fact lies the incomparable importance of the Chiusine Canopic heads for the general history of art.

Separated from the urns upon which they were once placed as rather incongruous lids, these terracotta heads impress us with a natural vividness which seems to point forward to Tuscan portraiture of the Early Renaissance. A modern observer may feel tempted to ascribe personal characteristics to them. The one with the short, engraved beard [83] we may call impetuous, superstitious, devout; the other [84], active, self-reliant, narrow-minded. Yet these are mere impressions following from the features shown; and one must doubt if anything more than physiognomical variety was originally intended. For together with the personalized forms, one cannot help perceiving also the ingrained rigidity and frozen hardness of their structures. The latter really is a primitive trait, as can be readily seen from the stylization of details, for instance the raised shapeless gashes representing the mouths or the conventionalized patterns denoting ears. At the same time, in some cases at least, the total structure incorporates something of the geometric quality proper to so many works of early Etruscan Archaism. Italian art has time and again reverted to similarly strict structural orders, which never quite fuse with the living appearances. This is why in looking at our illustration 84, where the forms are especially angular, one not only senses the possibilities of a future natural-

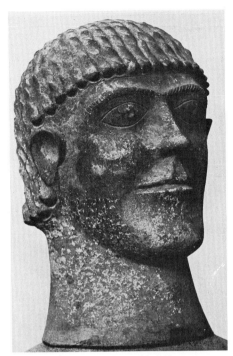

84. Canopic urn from Cetona, mid sixth century. Terracotta. *Florence, Museo Archeologico*

have looked so, or very nearly so. A certain social type of young man has been rendered in both. Yet the features are so varied as to make them look altogether different, for no more apparent reason than because people differ as persons. This is more than Greek art was ever willing to concede to portraiture. Even when Greek portraits became fairly frequent, which happened at a much later time, they dealt with the human exceptions: they celebrated characters of note. The portrait concept which the Canopic urns show in the making does not insist on any comparable distinction of value. It registers differences of appearance as a general mode of human existence: a key to human reality. Attention is focused on the simple observation that faces differ as a fact, prior to all social or moral interpretations one might apply to their differences.

ism; one also receives a foretaste of the formal rigidity incorporated in late Roman portraits. In images such as these the human face turns into an immutable formal fact. The impact of its visible presence and individuality can be felt and taken in at a glance but hardly verbalized.

Anthropomorphic Urns

The inclination to regard the interred urns as the substitute body of the dead can be traced to Villanovan habits, as we have seen. If, as seems likely, the same idea was expressed in the Canopic urns, a progressive evolution can now be recognized, aiming at an ever more complete visualization of the underlying symbolism. The logical end of this development – the complete humanization of the outward shape of the urns – was reached in the cemeteries of the Chiusi region in the ash containers in the form of statues, to which the name of 'urns' can scarcely be applied any more. In contrast to the earlier urns, these figures were made of stone, not terracotta. Their production started towards the end of the first Archaic period, about 560, and lasted to the Hellenistic era. Shortly after this innovation the Canopic vases fell into disuse. The new full-length images had then eclipsed the earlier metaphorical interpretation of the urns as 'bodies' and the lids as 'heads'.

Among the extant examples a statue now in the British Museum seems the oldest [85].[11] It is a very conservative piece of sculpture, representing a man standing, right hand across his breast. In the broad figure without feet, shaped as a flattened cylinder, something of the aniconic quality of the earlier Chiusine busts still survives (above, pp. 96 ff.); likewise the gesture of the right hand signifies an age-old, originally oriental, protestation of modesty and devotion. The bearded head served as a stopper to the hollow in which the ashes were deposited. The arrangement of the hair, which is of medium length, parted in the middle and held together by a string-fillet at the back, also perpetuates the ancient Etruscan fashion. In a statue which, because of its grecizing attire – of almost Ionic appearance – can hardly be dated much before

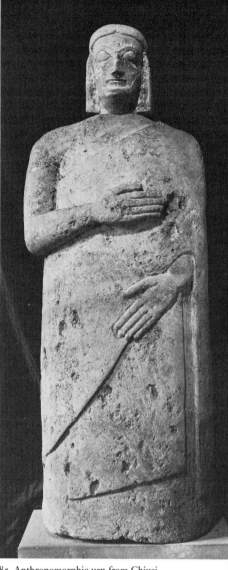

85. Anthropomorphic urn from Chiusi, mid sixth century. Limestone. *London, British Museum*

the middle of the century, these features must appear old-fashioned and provincial. But they also prove that the new type, even though it incorporated some of the more recent Archaic developments, was created by native workmen whose thought, when confronted with this new

assignment, naturally ran along the lines of local tradition. The outcome was a statue novel as to type but unmistakably Clusine in style.

In this analysis the head of the figure turns out to be an interesting document. We cannot doubt that, as with the contemporary Canopic urns, the intention was to give material form to the likeness of a person once alive. But the features do not show it. They are strictly typical and not at all personalized. In this observation lies additional proof that the artists who fashioned the terracotta heads of the latest Canopic vases were out of step with their times. Their colleagues, the stoneworkers, could not at once emulate them, though they learned to do so soon afterwards. Rather the face of this statue, with its broad, angular base, conforms to the abstract and geometric ideal of form which ruled in Etruscan Early Archaic art. The comparative thinness and sharp outlines of details such as the eyebrows, nose, and mouth indeed point to a rather advanced stage of that period. The London statue has this carving approach at least in common with some of the terracotta heads, for example our illustration 84.

Grave Stelae

Avle Tite is the name inscribed on a funeral stele at Volterra which inaugurates a new series of upright tombstones in northern Etruria [86]. All reliefs of this type consist of slabs of stone on which the man commemorated is shown full-length, walking to one side. The sculptured stele was then a novel type of grave relief, even in Greece. Characteristic of the first Etruscan examples are the rounded tops, as shown in our illustration. Later specimens have finials with palmettes. The Volterra stele seems one of the oldest preserved; it is also one of the finest as a work of art.[12]

The knight Avle Tite is seen in low relief. Quietly, composedly, he steps out of this world, to which his polite appearance so much belongs, walking straight up to the narrow frame as if it had no substance for him. His right hand grasps the spear; the left holds a sword resembling a Spanish machete, a form not uncommon in

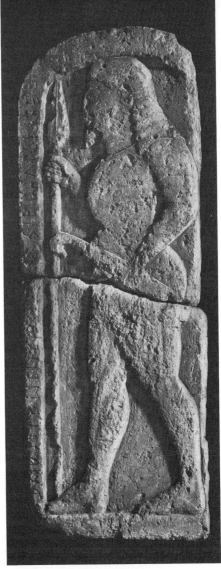

86. Stele of Avle Tite from Volterra, second quarter of the sixth century. Tufa. *Volterra, Museo Guarnacci*

Etruria at this time. The short chiton, too, probably proves him a man of the outdoors to whom the more ponderous civilian garments would be an impediment. This emphasis on the military or sporting prerogatives of his caste should not go unnoticed. It is in contrast to many other

commemorative images, and rather characteristic of this type of reliefs. It seems that the stele placed on the tomb was felt to be a monument in the public eye, and hence one requiring a distinctive attire, different from the images placed inside the tomb, where a man could be a civilian and at home; just as in the feudal Middle Ages a knight will be shown on his tomb in full armour.

The style of the Volterra stone is quite Corinthian. There are no traces of individuation in the large face with the pointed beard, but the well-groomed layered hair has received much attention on the part of the artist. It adds elegance to the military character. One thing is certain: examples were now available in Etruria, ensuring complete mastery of the human figure even in reliefs. The strict side view conforms to Greek standards; it can be defined as the image of a kouros seen in profile and adapted to plane surfaces. A touch of Etruscan Archaism is nevertheless observable in the squat proportions and the slightly overdrawn calligraphy of the curving contour. The likely date is in the second quarter of the century. In the bulky head, with its eyes so close to the surface, one may still read a reminiscence of that intense but not unfriendly vitality which we encountered in the centaur from Vulci; refined, however, by a new sense of cultivation which now controls and permeates the broad inert forms.

INDUSTRIAL ARTS

Architectural Terracottas

Temple building had started in Etruria by the middle of the seventh century. As until Hellenistic times the superstructure of these edifices consisted of rather perishable materials, none is extant above ground. In fact, apart from the stone blocks used for the foundations of the typically Etruscan high podia, the no less typical terracotta ornaments proved in many instances the most durable parts of these buildings. Numerous fragments are preserved. Once, their profuse decoration and gay colours endowed the

temples of early Italy with one of their most distinctive, and most admired, traits.[13]

Yet such use of reliefs was not an Etruscan invention. Two kinds of architectural ornament were especially characteristic of the Archaic period. One consisted in the antefixes, vertical plaques designed to mask and decorate the ends of the topmost cover-tiles above the eaves. In Archaic Etruria the preferred form was an upright disc or shell enclosing the forepart (*protome*) of a frontal human face. The origin of these head antefixes can with high probability be localized on the Greek mainland; more precisely, in the ceramic workshops of Corinth. In the Ionian east the type was unknown.[14]

The other common kind of fictile architectural decoration emerged from the need to cover exposed parts of the roof construction such as the cornice, or the pair of rafters above a pediment, with protective slabs. The habit of decorating these revetments with figured friezes, very popular in Etruria, must derive from eastern Greek, Ionian prototypes; they were not used in architectural decoration on the Greek mainland, but Asiatic sites, for instance the Aeolian Larisa, in the cultural orbit of Phocaea, furnished most striking parallels to the Etruscan examples.[15] Thus the architectural terracottas reflect clearly the two main sources of Archaic art in Etruria: Corinthian and Phocaean. Symptomatic of the Etruscan situation, however, is the indiscriminate combination of Doric head antefixes and Ionian friezes, which in the Greek homeland belonged to separate regional traditions: both types were simultaneously accepted and liberally employed in Etruria.

It is not necessary here to follow the development of the Etruscan terracotta revetments in detail. As a class they must be considered a mass-produced, industrial art. The figured plaques as well as the head antefixes were commonly shaped in moulds which perhaps the workers carried with them to any location where their services were required. For instance fragments of imprints from identical moulds have come to light in Veii, Rome, and Velletri; the original matrices were probably products of the

Veientine workshops whence either the casts
were exported or the moulds themselves trans-
ported for temporary use.[16]

The earliest terracotta revetments preserved
in Etruria belong to the transition from Orient-
alizing to Archaic art. Thus the animal frieze
from Poggio Buco is still quite Orientalizing
[87], on a level with representations like the

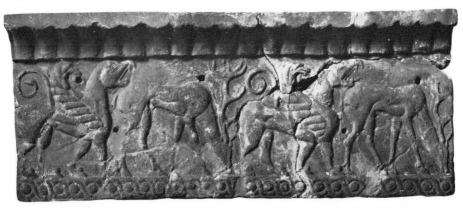

long-legged creatures of the Campana Tomb,
or the ostrich eggs from the Vulcian Isis Tomb.
The galloping riders in other plaques from the
same site look rather more Corinthian [88]. An

87. Animal frieze, revetment from Poggio Buco,
early sixth century. Terracotta.
Copenhagen, Ny Carlsberg Glyptotek

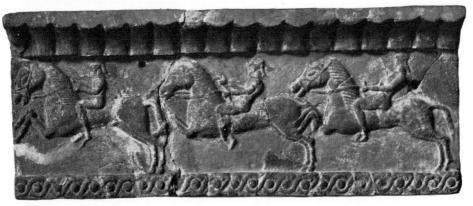

Ionian guilloche band served as base line for
them all.[17] This mixture of stylistic elements,
the imagery itself, and the control of form in its
presentation are well in line with Etruscan art
around or shortly after the year 600.

88. Galloping horsemen, revetment from
Poggio Buco, early sixth century. Terracotta.
Copenhagen, Ny Carlsberg Glyptotek

Early Art in Rome

A recently discovered fragment is included here because of its symptomatic value [89]; the frieze of which it once formed a part represents the earliest manifestation of sculptural art known to us in the city of Rome. Actually several friezes made from the same mould may have been in existence, decorating diverse buildings, because remnants of identical design have come to light not only at three different locations in the Roman Forum but also on the Capitoline.[18] However, the fragment here illustrated is by far the most important. It shows a procession of monsters. Between two panthers which look very large by comparison marches a bull-headed man. In itself this combination of imagery would be interesting enough to require attention in an early Italian monument, for the bull-headed man is not a common fantasy; at least not the way he is shown here, as a quite impersonal monster lined up with other creations of fancy, rather than a specific representation of

myth like the Minotaur of the Greek Theseus story.[19] At this point, however, the style of the relief must interest us even more, for the following reasons.

On the whole a not inconsiderable number of Archaic architectural terracotta friezes dating from the sixth century have been preserved from the city of Rome, at least in fragments. Most others, like the fragments already mentioned, have their close counterparts at several sites in the Latin-Sabine territory or in nearby Veii. Their style is not unusual.[20] But the frieze with the bull-headed monster appears to be unique. In the first place it is older than the other terracotta revetments from Rome; it must be dated very near the year 600, and perhaps even to the last decade before that year. In the second place, no fragments of the same type have thus far been observed outside Rome; nor can its style be matched by examples elsewhere. In fact, it is difficult to find parallels for it at all in contemporary Etruscan art. The chances are that we are dealing with a product of local art in

89. Procession of monsters, fragment of a revetment from Rome, *c.* 610–600. Terracotta.
Rome, Antiquarium Forense

Rome under the first Tarquins – the earliest 'Roman' art.

The freely drawn, calligraphic contours of the animals contrast with the human shape, in which the rectangularity proper to so much Early Archaic art in Italy has been carried to new extremes. Indeed, to characterize this method of representation one requires a special descriptive term, such as 'Neo-Geometric'. The style is rare indeed. It has affinities with the female dancers on the large bronze disc at St Louis [54]. But the examples closest to it, in my opinion, are the peculiarly flat reliefs on three slabs of Alban stone (*peperino*) now in the collection of the Conservatori Palace. Of uncertain provenance, these panels apparently formed part of a funeral couch or 'Totenbett' of a kind well known from the Etruscan chamber tombs.[21] They show animals under, or in front of, a bed of which two legs are shown; the dog here illustrated [90] exemplifies the similarity of style to the terracotta revetments from the Roman Forum. Together, these monuments form a

small group connected, beyond the common Early Archaic traits, by a rigorously geometric principle of stylization. Can this 'Neo-Geometric' manner of design be accepted as a local, Roman or perhaps Latin, variant of the Early Archaic style? On the relief in the Conservatori Palace the dog turning its head sharply towards the spectator looks like an ancestor of the Capitoline wolf, created a hundred years later.

Heavy Bucchero

By the end of the Orientalizing period a new kind of bucchero appears on Etruscan sites, characterized by increasingly thick walls often bearing stamped reliefs. Gradually this new ware took the place of the earlier black bucchero with its porcelain-like vessels and thin, finely decorated walls (above, p. 77). Production in several centres is likely, at least for the first part of the period. Eventually, however, it became more or less exclusively centred at Chiusi where the 'heavy' bucchero (*bucchero pesante*) con-

90. Relief from a 'Totenbett', early sixth century. Peperino. *Rome, Palazzo dei Conservatori*

tinued for a long time as a major local contribution to Etruscan art. There alone the bucchero industries remained active throughout the second half of the century; they died out only when the shift from Archaic to Classical habits of style occurred.[22]

A very fine Late Orientalizing example is a situla – one of a pair – from Cerveteri in the Villa

91. Situla from Cerveteri, c. 600.
Heavy bucchero. *Rome, Villa Giulia*

Giulia in Rome [91].[23] Its form as well as the parallel friezes separated by guilloche bands still remind us of the ivory boxes from Chiusi described on p. 64. The animal rows include winged horses, a male sphinx, and once a human figure: a man marching briskly among the monsters seems to stab – or drag behind him – the lion which follows; the large beast raises its paw as a cat might, in order to hit the instrument of its subjugation. Its upturned face is drawn as if seen from above, in a manner also already encountered on the Clusine ivory box (p. 64). The case is interesting because, in the Cerveteri situla, the violent distortion inherent in this

somewhat strained motif evidently expresses an emotional meaning, and indeed a quite realistic observation. It illustrates the opposition of the animal to masterful man: a small but noticeable episode of drama in the otherwise so indifferent, one-way trot of the monsters. The date is probably slightly later than the Chiusi boxes, around, but hardly before, 600.

The advent of the Archaic period among the bucchero vases is indicated first of all by changes of ceramic form. Owing, obviously, to the chastening influence of Greek taste, the variety of shapes decreases; so does the free play of inventiveness in their design. The only exception to this rule, Chiusi, will require a brief discussion later on. Goblets on a high foot remain a popular form, and during the early decades of the sixth century are often decorated by a continuous stamped frieze of small figures around the rim; similar friezes were in use also with other types of bucchero, and indeed all sorts of industrial art, metal implements as well as the already mentioned Caeretan red ware.[24] Pitchers show the influence of Corinthian models, and perhaps metal ware. But soon the figural decoration begins to grow in size as well as in importance. In the wake of the new trend emphasis now focuses on the representational elements; the decorated vases become 'picture-carriers'. A good and comparatively early example is of interest here: a vase at Tarquinia, perhaps of Caeretan manufacture and certainly still dating from the first quarter of the century [92]. The row of dancers, produced by the repeated impress of an identical mould, can give us an idea of the kind of prototypes which underlay such popular products as the bronze disc at St Louis [54]. Also the absence of a base line beneath the figures in both monuments bespeaks the close relations between these ceramic industries and the popular level of domestic art [93].[25]

Soon the ingrained Etruscan flair for fantastic formal combinations again asserted itself in this class, as it was apt to do especially in the ceramic crafts. As a consequence originally grecizing forms can be found in rather surprising mutations; witness the well-known pitcher in Florence, the muzzle of which is shaped as the head

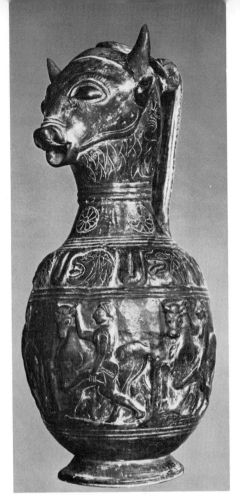

92 and 93. Pitcher, perhaps from Cerveteri, with detail of dancers and gorgons' heads, first quarter of the sixth century. Heavy bucchero. *Tarquinia, Museo Archeologico*

94 and 95. Pitcher with calf's head, with detail of a bull tamer, sixth century. Heavy bucchero. *Florence, Museo Archeologico*

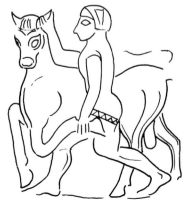

of a calf [94, 95].[26] Yet even here, in a product of definitely regional character, the frieze of young bull-tamers now covers almost the entire height of the body up to the shoulder of the vessel. This part at least exists solely for the sake of the images; it is a true 'zoophoros' after the new, international fashion. Moreover the choice of a specific subject matter imparts a new dimension of meaning to the repetitions of one and the same die, which follow each other in a still 'endless' – in that sense decorative – succession. The result nevertheless resembles a real representation, for instance the procession of a rodeo.

The Popular Style of Bucchero at Chiusi

The calf-headed pitcher at Florence can probably be assigned to the workshops of Chiusi, where the Italian *bucchero pesante* experienced its ultimate and most conspicuous flowering. There, also, the new grecizing ceramic shapes as well as the manner of decoration by figured friezes had been introduced. But of even greater interest to us are the more bizarre, domestic types of vases which remained entirely peculiar to the Clusine centre, for once more in these curious creations the local potteries gave full vent to the unrestrained taste of early Etruscan folk art. On their own, more recent level of style the large bucchero vases from Chiusi exhibit the same exuberance of temperament, love of unorthodox combinations, and abundantly swelling forms which we encountered previously in the popular arts of the Orientalizing period.

This style frequently opposes its own baroque leaning and rustic originality to the contemporary grecizing trends; or rather it demonstrates a radically adverse if highly imaginative reaction to them, just as the exaggerated angularism which we found in the architectural friezes from Rome represented an extreme reaction to the same trends in the opposite direction. From a classical viewpoint this Clusine pottery looks sturdy in some parts, wilfully elongated in others; heavy as well as ornate; and generally distorted. No longer are the vessels reminiscent of the subtle taste of the silver-

smiths, as was true of the earlier 'fine' bucchero: they rather resemble such later manifestations of the potter's art as the colourful earthenware, the gay and heavy-bellied beer and wine tankards of south German and Bohemian make, which suited the hearty taste of the sixteenth and seventeenth centuries. Much bucchero ware on this level is quite un-classical in feeling, just as those later transalpine carry-overs of medieval pottery remained apart from the pro-

96. Urn from Chiusi, sixth century.
Heavy bucchero. *Baltimore, Walters Art Gallery*

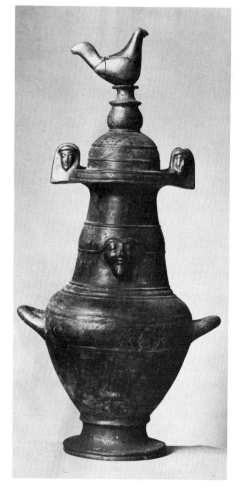

ducts of the Italian Renaissance of which they accepted the lusty detail, but refused the sobering discipline.

Yet even the most extravagant forms of the Clusine *bucchero pesante* are not wholly beyond our understanding. All have recognizable antecedents in earlier art, or so it seems; for instance, in the squat urns with lids which look like large soup bowls, often equipped with stylized handles in a truly baroque fashion, the ancient orientalizing type of the krater on a high foot has clearly survived.[27] Still more interesting is the case of the tall, towering urns with dome-shaped lids on which a bird, sometimes characterized as a rooster, perches like the weather-vane on a church steeple. Their elongated necks betray their origin: before us, obviously, stand the last descendants of the old Villanovan biconical urns. The Villanovan form is quite evident in early specimens; it is more closely approximated to Greek forms but still noticeable in later pieces such as our illustration 96.[28] A spirit of free play, of uninhibited pleasure in formal variation, must be held responsible for these surprising creations. They were the outcome of a popular art, no doubt, with roots in very ancient regional traditions. Their taste is provincial if outspoken; to our knowledge, these bucchero vases represent the ultimate products of that Italian current which I have previously termed the flamboyant style of early Etruscan folk art.[29]

CHAPTER 12

LITERARY ASPECTS OF ARCHAIC ART

THE EMERGENCE OF LITERARY SUBJECTS

Mythical Themes in Greek Art

In Greece poetry preceded every other art. Literature, that is poetic fiction, shaped the concepts in which men learned to recognize themselves as existing in particular social and personal conditions, over and above the great generalities of life and death. For fiction, if not true to fact, can yet be true to experience. Storytelling can dwell on individual happenings and impart significance to the seemingly accidental. It is hardly an exaggeration to say that the Greek mind was first awakened to itself and the world around it by invented narratives.

From the eighth to the sixth centuries the Greek myths went through a decisive stage of their poetic redaction, in the form of the epic. The principal cognitive tool evolved by this mythical fiction, as a key to reality, was the category of human diversity, which was paralleled by the distinct characters of gods and heroes. The concept itself was a Homeric heritage (above, p. 63). In their post-Homeric, Archaic phase most Greek myths were given the shape in which we still know them. From the scattered fragments of ancient folk tales and names dimly remembered the vast mythical fabric was created of the strife between gods and men in which multifarious life became mirrored and events understood as the effect of causes. Never before have the seriousness and reality of human situations been revealed so lucidly; have the crises of decision, the fatal interplay of human wills, and the force of circumstances been so impressively shown. Myth was the given theme of the epic. Under its impact, in Greek thought, the world became narratable even before it became knowable in terms of science. Clearly the grasp of reality in a myth differs from that which descriptive science offers. A myth is not a true statement of fact, nor a direct representation of a reality at hand: it rather constitutes the opposite, namely a transfer of experienced facts into a created fantasy. Yet as such it can be turned into a reasoned account of events, however fictitious; indeed, a guide to reality. In this realistic exploitation of the myth the Greeks went farther than anyone else.

When during the Archaic period the collection, and in a sense rationalization, of the myths became a primary intellectual concern in Greece, a large reservoir of singularly memorable plots and stories came into being. Naturally, in this process the literary arts took the lead. However, mythical themes appear in Greek pictorial arts at a very early time. This interest in a properly literary subject matter must by no means be taken for granted. It is rather distinctive of Greek art, and an obvious reflection of the overwhelming influence which myth exercised on Greek minds. One can well understand the challenge which the mythical narratives extended to the figurative arts under such circumstances. Even to us today these fables appear so charged with human meaning that the attempt to extricate from their often strange and not rarely brutal happenings their recondite messages still remains a worthwhile undertaking. Awareness of myth had indeed become a source of knowledge; myth was a form in which the conditions of human lives and actions could be made explicit. Already by the end of the century the latest, classic mode of these narratives began to appear as a possibility: the Greek drama.

A critique of human personality was clearly implied with this development. The qualities of uniqueness and importance accrue to mythical actions precisely because they relate the deeds accomplished, or the mishaps suffered, by certain personages. In such a scheme of thought the gods, by dint of the very diversity of functions ascribed to them and the powers which

they yield, presented the traits and limitations of definable characters. Zeus behaved differently from Apollo; Artemis differently from Aphrodite. The deities of Greek mythology became subject to the laws of mutual attraction and repulsion which we call love and hatred. As persons they explained themselves through their actions, because each acted 'characteristically'. In short, they became the enormously enlarged proto-images of human character-types, defined by personal temperaments, idiosyncrasies, and social involvements. Therefore on a more human level heroes could be interpreted by the same tokens. In Homer the noble and unforgiving character of Achilles resembles that of Apollo. The theme was given, but the interpretations always remained free.

Our principal point here must be that all these are essentially literary notions; and that in this sense most Greek art which incorporated them was and always remained a literary art. The result was inevitable, not only because so much Greek art actually represented myths or mythologized, that is personalized, religion, but also because with effects even more comprehensive, mythology had generally become a heuristic principle in Greek thought, by which to search out an ever-growing fund of insights into both nature and human conduct. At this stage one can say that the gods were both real as the wielders of forces, and fictional as human metaphors. Myth, of course, must be regarded as a form of literature even though it be handed down only by word of mouth, not in writing; yet most Greek myths were actually committed to writing during the sixth century, if not before. The Greek world simply was a world founded on literature, intellectually, because myth, which is a literary form of narrative, had come to mould the common modes of knowledge. As a matter of course, artists shared these universal interests and experiences, like everyone else. But as a consequence an entire new dimension of meaning and connotations accrued to the visual images of art, beyond that primary symbolism which all images convey by themselves as representations of reality. The power of the artist to bind the ineffable and abstract in con-

crete and visible forms was thus enormously extended. While the art which grew from these notions was literary, it rarely was literal, in the sense of furnishing illustrations to given texts. It contributed freely in its own concrete ways to the common stock of experience, memories, and insights.[1]

Religion and Myth in Etruria

The difference of scope, in spite of the formal similarities, between the early arts of Greece and Etruria becomes strikingly apparent in the light of these considerations. It was indeed fundamental (see p. 64). Nor did the Archaic period in any way alter these conditions: if anything it aggravated them. Virtually none of the statements made just now regarding the place of mythical literature in Archaic Greece would apply to Etruria. The Etruscan was not a society founded on literature. Least of all was its culture – such as it was – based on poetic fiction.

It is greatly to be regretted that so comparatively little is known to us about early Etruscan lore. On the other hand this fact is in itself indicative of the non-literary character of this Etruscan civilization as a whole. Obviously much information, of a kind that would be reflected in Greek poetry, was not recorded or not preserved in writing in Etruria. Yet an important intellectual development undoubtedly took place in central Italy also between the eighth and the sixth centuries. There is reason to assume that, as in Greece, religion was both the original cause and the instrument of this development. However in Etruria religion itself took a different turn; and the same seems true of Rome.

The continuation of an ancient Italian tendency to personify significant actions is especially noticeable in Rome: for instance Consus is the god who hides; Janus the god of transit. Remarkable in these notions is their high level of abstraction. Any 'hiding' may conceivably fall within the province of Consus; any 'transit' – through a gate, crossing a bridge, from one period of time to another – within the competence of Janus.[2] As symbols these abstractions

no less than the Greek myths represent a progress towards a world known more firmly by detail. Yet in their case the mental act of personification was not followed by subsequent personalization. There were no myths worth telling about Consus, Janus, and their ilk. Appearances strongly indicate that in Etruria as well as Rome those divine characters which by origin and concept were capable of assimilation to Greek gods and goddesses, such as Tinia–Zeus, Uni–Hera, Turms–Hermes, and others, received what mythology they later possessed from Greece, together with their human shapes and distinctive attributes.

In a somewhat different fashion, in Etruscan religion the powers which direct cosmic nature and, within the boundaries of nature, human affairs became systematized rather than personalized. The universe was mapped out, in order to learn from it the meaning and origin of portents. Again in this systematic order of concepts, foreign to early Greek thought, a contribution to intellectual progress was certainly included, though one the full impact of which it is now difficult to assess. The books containing this store of superstition and knowledge, the Etruscan *Disciplina*, are wholly lost. There can be no doubt that in their turn they too constituted a case of literature. It is equally certain that the importance of this literature for the arts was negligible.[3]

Yet central Italy was not without its own native myths. Some were definitely religious, though of a type quite different from the Greek. Of such a kind was the story of the prophetic child, Tages, who rose from the fresh furrow of a ploughed field to reveal the Etruscan doctrine. More common was another sort of stories which we may call historical myths and which deal with the divine or semi-divine ancestors and founders of tribes, clans, or cities. The worship of 'gentile' deities assigned to individual families was definitely Etruscan, but what was told about them, if anything, we scarcely know. On the other hand in Roman folklore such tales formed and were preserved possibly at a quite early period; and some of these folk memories, however confusedly, refer to conditions and names

recognizably Etruscan. To this category belong the curious traditions regarding the queen and sorceress, Tanaquil, held to be the mythical ancestress of the Tarquin dynasty in Rome; the stories of Romulus himself must also be so classified. In the end the legends in this vein led to a form of saga rather than true myths; such as the saga of Mastarna and his dealings with the early kings of Rome.[4] Characteristic of all these stories is their avowed aim to explain existing conditions. They are legendary history. Only at a comparatively late date – if at all – did poetry and the arts concern themselves with this mythology, and even then it appears that the astounding events from which history followed mattered more than the plausibility as personal characters of heroes who were after all no more than the fateful tools of providence. The epic of the Roman empire, Vergil's *Aeneid*, expresses this spirit most monumentally. Achilles in Homer is a more interesting character than Aeneas. The reason is not that Vergil lacked insight and realism, but that his emphasis was not directed towards the invention of a human character for its own sake. His hero existed, acted, and suffered for the sake of history. To that extent he was not the principal theme of the poem.

Two conclusions emerge from a survey of early Italian, Roman and Etruscan, intellectuality as we know it. In its progress towards a fuller knowledge of human reality we observe a split rather than a unified tendency. On the one hand deified abstractions become an essential means of intellectual orientation. It is obvious that as a philosophical idea, a 'god of transit' can inspire a great deal of thought. Over the centuries the god Janus indeed became the subject of very subtle speculations, which culminated in late classical theology. But even if a god of this kind be believed in, he merely stands for one prescribed thought. He cannot act as a person, beyond the limits of his abstract function. Neither can he be interpreted as a human character or, on this level, add anything specific to human knowledge.

On the other hand we find universally revered deities whose origin was really in the private worship of individual clans and the home, and

whose functions were often elemental. There was a tendency in many cases to conceive of them also as communal deities, as happened to Vertumnus of Volsinii. Some among their number were in time equated with names of Greek mythology, as the Roman-Etruscan Saturnus eventually appropriated the myths and functions of the Greek Kronos.[5] However these more or less artificial equations were mostly due to later developments, and early Italian art profited but little by them: rather the mythical pedigree and clannish cults tended to confirm the Etruscan propensity to turn to immediate reality as the true locus of human experience while disregarding the cognitive values which may be incorporated with poetic fiction. After all, from the mythical ancestors descended the living families, real institutions, real history. Again the emphasis was on the actual.

Consequently what was lacking in Etruria was not so much literature as that specific trend of literary thinking which in Greece expressed itself so lavishly in mythical fiction. It follows that Etruscan art could not by its own resources become a literary art, as Greek art did. During the Archaic period, under Greek impact, human representations moved into the focus of attention as the most worthwhile subject of art, but even then their purpose cannot always have been the same as in Greece. The mythical foundation was missing. It is a telling symptom of the difference between Etruscan and Greek conditions that down to the middle of the sixth century not one Etruscan representation can be with certainty identified as an image of deity. If the gods were at all human, as some were certainly thought to be, they were not specified as characters and hardly even by standard attributes; hence our difficulty in recognizing them. It seems that it was only with the advance of the Archaic period that the Etruscan pantheon became more articulately humanized. At that time Greek images and pictured narratives brought an awareness of the personal – not merely magic or demoniac – character of deity into Etruria, for the first time in her cultural history.[6] The tendency gained momentum towards 550, but what place these essentially foreign mythologies

came to assume in the general framework of Archaic Etruscan art remains to be seen.

MYTH AND ITS USES

The Chariot from Monteleone

One monument above all calls for attention here: the bronze chariot from Monteleone, now in New York [97–9]. At the threshold of the second Archaic period, it opens the series of Etruscan masterpieces which continues after the middle of the century; it also gives the most impressive testimony of the new interest in mythological subjects then stirring in Etruria.[7] At long last the human theme has come into its own; the Greek influence is obvious. Moreover for composition and execution the chariot easily passes as the most splendid, as well as the most perfectly preserved, example of Archaic metallic art in our possession.[8] Three large reliefs decorate its outer surface. Like all its other ornament they were hammered out from thin sheets of bronze in the common Archaic repoussé technique, with details added by way of sometimes very fine incised design. In accordance with the structural form, which follows a customary Etruscan type of chariot, each relief is contained in an arched frame, the centre panel covering the high, curved front wall being the largest of the three. A smaller frieze around the base of the chariot represents groups of fighting animals, demons, and monsters.

The large reliefs are exceedingly interesting; but they also present certain problems. The centre panel shows a bearded man and a woman facing each other while a spotted fawn lies on the ground between them, obviously dead [97]. Together they hold the large Boeotian shield and the helmet, which form the middle axis of the composition. From the sky birds swoop down, perhaps as lucky omens. There can be little doubt about the meaning of this scene. The woman hands the weapon to the warrior; no other explanation seems to make sense.

97. Chariot from Monteleone (centre panel),
c. 550. Bronze.
New York, Metropolitan Museum of Art

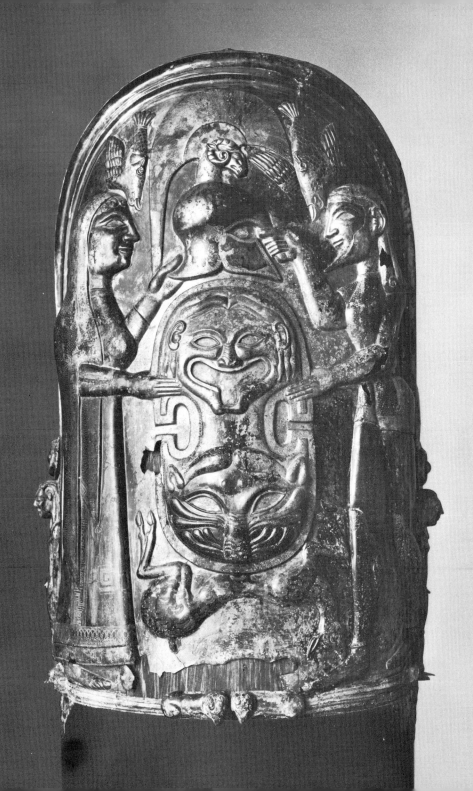

98. Chariot from Monteleone (left side panel), *c.* 550. *New York, Metropolitan Museum of Art*

In the side panel to the left two heroes are duelling over the body of a third, already despoiled of his armour except for the greaves [98]. The victor again wears a Boeotian shield, of the same form if somewhat different decoration as the one featured in the front panel. He receives miraculous aid in the form of a bird apparently interfering with the spear which his unfortunate adversary is aiming at his head; at the same time the tip of the spear bends, deflected by the hard

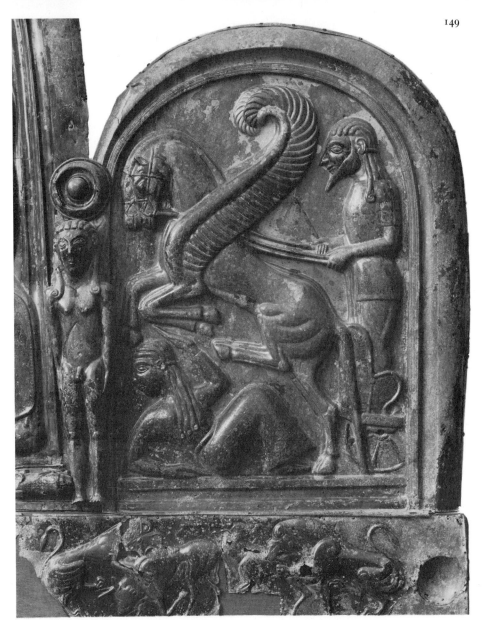

99. Chariot from Monteleone (right side panel), *c.* 550. *New York, Metropolitan Museum of Art*

metal of the seemingly invincible helmet. In the third panel, which sheathed the right wall of the chariot, a hero without armour is represented in a vehicle almost identical to the chariot itself, drawn by two winged horses [99]. The foremost horse is actually flying, in a curious galloping gait;[9] simultaneously it is lifted upward, or so it seems, by the reclining woman in the left lower corner. The other horse still has its hind legs on the ground, but prances ready to take off.

The soliloquizing stage of early Etruscan art has clearly ended here, much later than in Greece. People face each other. There is inter-action and discourse; there is also, as a result, drama and sentiment. From the dreamy soli-tude of mere existence, which was all the earlier one-way compositions could express as long as each creature was restricted to marching behind some other phantom equally incapable of com-munication, these persons have descended to a level of social coexistence. They meet in con-flicts and agreements; they are aware of each other and united by the necessity of mutual action, which is the law governing all human reality. They have consequently begun to repre-sent something other, and more, than the mag-nificently undisturbed pageant of images which was the pride of the Orientalizing decorators, and which from now on will be an obsolete form of art, though one long surviving.

The foremost means by which art makes the dialogistical nature of human situations explicit is antithetical composition, as against one-way processions. This was not in itself a new device, though earlier Etruscan art hardly made use of it. Even Greek art progressed rather slowly in this direction. One reason certainly was that many decorative purposes of ancient art favoured horizontal friezes, which in the classi-cal tradition retained a greater importance as a common mode of pictorial composition than they have ever enjoyed since. Friezes naturally invite that merely enumerating sequence of images which, if living beings are represented, properly constitutes a 'procession'. Neverthe-less in classical art frieze compositions often be-came centred instead of moving evenly in one direction, thus indicating that the idea of the frieze itself underwent changes under the in-fluence of the antithetical concept. The latter principle prevailed entirely in post-medieval art. Emphasized further by the almost universal use of four-sided frames, it largely determines for us today our conception of the nature of a painting.

The antithetical compositions of the chariot from Monteleone are of the utmost simplicity and thus truly Archaic. Moreover they are highly patterned; hence the difficulty of their interpretation. The pleasure in standard for-mulae of course was merely another Archaic trait, and indeed one which art and epic poetry held in common. But the fact that it is so much in evidence here may serve as a reminder that we are dealing with an art still near the border-line between generic and specific representa-tion. Thus to the generic formula 'heroes duel-ling', any desired names can be attached.[10] Which name specifically the artist had in mind we have little way of knowing. Doubts have in fact been raised that these three reliefs represent any mythical action at all.[11] Yet the evidence rather favours the assumption that a definite action was intended. Indeed the panels seem to tell a story in three scenes, as follows: hero re-ceives armour (from divine mother?); he over-comes adversary in duel; he travels to heaven in a chariot with winged horses supported by the reclining earth-goddess. Perhaps we should not try to name him.[12] It is true that the story of Achilles fits this narrative scheme in some ways, but so does the story of Aeneas; and while in the *Aeneid* the tale of Venus providing armour for her son was probably patterned after the *Iliad*, it appears by no means certain that Vergil was the first to add this episode to the life of his Italian hero. It may well have been told accord-ing to the same pattern at a much earlier time. The ascension by chariot certainly constitutes a bit of folklore well established in ancient Italy. Although neither Homer nor Vergil reported this end for their respective heroes, we know that miraculous disappearance taking the place of normal death was in Italy ascribed to Aeneas, as it was to Romulus.[13]

Another question presents itself here, from the point of view of stylistic criticism. If, as seems likely, the events represented in the three large panels of the New York chariot have one and the same protagonist, they obviously con-stitute a continuous whole: they tell their story progressively. Consequently they incorporate an important characteristic of that illustrative method which is now best known from Roman and Early Christian art, and often described by the term 'continuous narration'.[14] Greek art on

the whole was reluctant to accept this form of narrative by progressive episodes: instead it preferred to collect the essential aspects of a story in one single action. For this reason one must doubt that the narrative method of the bronze chariot was derived from a Greek source, even if the story itself was Greek, which is uncertain. On the other hand, in this case as on previous occasions Phoenician metal bowls may well be taken into consideration as possible sources of early art in Italy, for progressive narratives indeed occur on them. They even appear in the manner of a truly 'continuous narration', in which the individual scenes are not divided by frames but lined up in uninterrupted friezes.[15] The occasional use of a 'continuous' method in Archaic Etruscan art is probably best explained by the presence of these oriental examples rather than by Greek ones. On the New York chariot the hero appears three times, though in panels separated by frames. This fact constitutes a modification of the underlying narrative principle. Of greater significance seems another modification which comes to the fore in the sequence of the narrative scenes. One would expect that the warrior received his arms first, the duel followed, and the apotheosis came last. In a continuous frieze things might well have been so arranged. Yet on the chariot, because of the dominant role of the front panel, a different order was indicated. The initial scene, in which the weapons are handed to the hero, was singled out for the middle panel. Therefore in this arrangement one reads the story from the front panel backwards, as it were, by proceeding from the middle to the two side panels. The latter are co-ordinated with, and at the same time subordinated to, the medial relief, thus functioning like the two lateral wings of a triptych. This interruption of the natural temporal order in favour of an abstract compositional principle, and the ensuing emphasis on the compositional centre, represent Greek tendencies, at least in spirit. Similarly in the famous Corinthian krater representing the departure of Amphiaraos, the apparent frieze composition is actually broken up into three parts, with the centre reserved for the hero.[16]

The master of the New York chariot was a very competent craftsman, and an excellent designer. One must assume that he grew up within the orbit of Corinthian art. However, Ionian contacts are not altogether missing, as might be expected in a work which on account of its own style as well as that of the objects found with it must be dated near the year 550.[17] There is a certain grandeur about his figures, an austere monumentality still reminiscent of earlier Etruscan statuary on the level for instance of the alabaster lady from the Polledrara cemetery [80, 81]. His characters move with noticeable restraint, as if not yet accustomed to the freedom of expression which the new art demanded of them; but they act with remarkable decision and clarity nevertheless. The relief of the 'Ascension', especially, shows the virtues of this style to the best advantage, which combines great certainty of form with a keen power of observation. Two strange standing kouroi are placed at the corners between front panel and side walls. Their angular forms exhibit that tendency towards harsh geometrization which sometimes manifests itself in the more provincial regions of Etruscan Early Archaic art; the great bronze disc at St Louis can once more be adduced for comparison [54]. It has been remarked that the kouroi have their closest parallels in north-east Etruria.[18] Be this as it may, the chariot as a whole was most likely produced near the place of its discovery, which is the region of Perugia; the artists may have immigrated, perhaps from different parts. Their work confronts us with an early product of those Umbrian workshops which during the following decades made so outstanding a contribution to the Archaic art of Etruria.

Ornate as it is, this vehicle was hardly meant for service; more probably it was created only for the funeral procession and for deposition in the tumulus. The choice of imagery selected for its decoration may well have been dictated by this purpose. Any story which ends with an ascension to heaven – a moment of abduction as well as salvation – can lend itself to the symbolical expression and mythical confirmation of a belief in existence beyond the tomb.

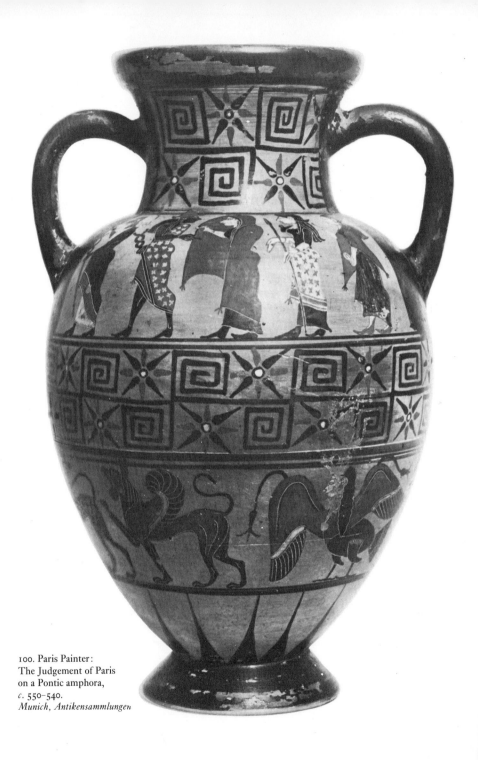

100. Paris Painter:
The Judgement of Paris
on a Pontic amphora,
c. 550–540.
Munich, Antikensammlungen

MIDDLE ARCHAIC PAINTING AND METAL RELIEFS

PONTIC AMPHORAE AND
BOCCANERA SLABS

The Paris Amphora in Munich

The mythological vogue continued after the middle of the century. Perhaps as a consequence of this new interest in subject matter, paintings and reliefs became the preferred arts of Etruria throughout the second Archaic period. Indeed, compared with contemporary Greece, the condition of Etruscan art about this time seems curiously out of balance. The steady progress of Greek statuary attracted little attention. On the other hand narratives in which art rivals the spoken word were eagerly received. Their themes were no less Greek, as far as we can tell, but for the general development of Etruscan art they held a special significance. The freedom to deal not only with images in isolation but with meaningful relations between the images came to Etruria much more abruptly than was the case of Greece.

About the same time the first Etruscan atelier of painted vases in the Greek Archaic manner opened shop. It was probably located at Vulci, where most of its products were discovered. Its output, as we know it today, forms a small but interesting group of pottery which by a misnomer became known as 'Pontic' vases.[1] The finest specimen extant is the famous amphora in Munich with the Judgement of Paris; it is also one of the oldest among the works attributable to the artist who, from this vase, was dubbed the 'Paris Painter' [100, 101]. Different from the Monteleone chariot, the decoration of this fine vessel can hardly be suspected of veiled symbolism; it is a frank piece of story-telling. Employing his clay vase as a convenient painting ground, the artist, unknown by name but certainly Etruscan by style, produced a delightful bit of mythical illustration which, for its fine finish and display of gay detail, might be likened to a book illustration, had such illustrations then been invented.

The ovoid, carefully moulded shape of the amphora with its comparatively short neck at once shows the influence of Greek formal discipline. The ornamental zones are decorated by square meanders alternating with star-flowers in the manner of a chequerboard pattern. Some very fantastic monsters, elegantly drawn, prance along the frieze near the bottom. But the focal point of interest to the artist was obviously the figured representation, for which the two large shoulder fields were reserved. Although the composition is formally broken up into two parts by the interfering handles, it renders a unified context. Actually one 'reads' this vase by turning it round in one's hand: then the antithetical character of the two framed pictures becomes at once apparent. They confront each other like question and answer; the situation, definitely, is in the nature of dialogue.

A conversation is indeed carried on across the handle, between the cowherd prince, Paris, on the one side and an old man with a speaker's staff on the other. The latter is not so easy to name; perhaps Zeus in some disguise more likely than Priam. Young Paris with long, fine curls seems surprised, understandably; he is also a little curious. Behind him throng the royal cattle, in the care of a dog with hanging tongue. A defiant-looking raven perches on the back of the animal nearest to Paris, much in contrast to its master's politely trusting attitude. Meantime on the other side Hermes turns round to give last-minute advice to the contestants. Matronly Hera unveils herself – a gesture which for her is almost an attribute. Knowledgeable Athena argues; and fashionable Aphrodite trips forward gathering her skirt. I agree with those

who find humour in this scene, though I think this lies more in the gestures and the situation as a whole than in the faces.

Yet another peculiar implication of this little painting must not go unnoticed. After all, the meeting of the famous protagonists, which is what we see, relates their story only up to a certain moment. This moment appears rather preliminary. The painting does not really constitute an action but instead marks the beginning of one, namely the exchange of words which will eventually lead to an action. The visit of the goddesses to Mount Ida led to many portentous events. But not even the contest for which they came is truly shown, let alone the war of Troy and all the later happenings. The explanation is that a rather special, Greek attitude has here prevailed. This attitude must be briefly commented upon, because it established a new principle of composition. As such it added an important aspect to the fabric of meaning – the accepted symbolism of visual images – which with us still defines the domain of art.

In these representations, interest switches from the rendering of an event to a merely preparatory moment. Thus the future, suggesting suspense, becomes implied in the present; and instead of a consummated action the work of art stages a situation in the making. Knowledge of the future the observer must supply. To the measure that he is able to do so the situation before him becomes transparent; it is no longer a closed event. Such a method of composition does not require the actual illustration of progressive episodes, because it rests on a principle more subtle than the explicitly continuous narratives. The principle is to visualize the factors which have shaped, and which continue to be active in, one particular situation; as long as we recognize this moment as a consequential one, the dimension of time, properly invisible, falls within the range of its meaning. Because works of art so conceived appeal to a sense of impending future, time really becomes their leading theme; and art can play on the contrast between the apparent present and the eventual outcome, still veiled at the moment shown but already known by the observer.

Nothing indicates that Greek myths reached Etruria in a written form at this early period. Yet somehow they must have spread, as they became propagated by imported Greek art and re-told by Etruscan artists.[2] There are signs that a rise in cultural level, literacy, and refinement indeed occurred about this time among the upper strata of Etruscan society. Artists had an important share in this development, if the monuments can at all be taken as a cultural index. The Paris Painter must be counted among their number. He was thoroughly versed in Greek art; he also knew the Greek stories and could handle them ingeniously. In his style the Ionian element predominates, down to the details of dress such as the pointed caps[3] which from here on for a while were to remain a hallmark of the Etruscan monuments, although their origin was in Anatolian and eastern Greek fashions; the same is true of the pointed boots worn by the women. Fabrics are richly decorated, but folds are not yet shown in the garments. All in all the Munich amphora demonstrates the turn towards an Ionicizing art and Ionicizing culture in Etruria. It may be dated approximately to the decade between 550 and 540.

The further development of the Pontic vases cannot be discussed here, for lack of space. The workshop remained active throughout the next few decades and probably till the end of the century, a period beyond the scope of this chapter.[4] What must be stressed, rather, is the general importance which accrued to painted vases at this time as the prime vehicles for the distribution of Greek myths in Etruria. The vase painters, before others, can be relied upon to represent a story for its own sake: for the entertainment it provides. To them a myth need be neither a metaphor nor a personal allegory, as often happened in funerary symbolism. More often than not their work was story-telling pure and simple; and beyond the events told and re-told, no afterthought was invited.

Boccanera Slabs

Wall decorations of a new kind appear in Caere about the same time. They were painted on

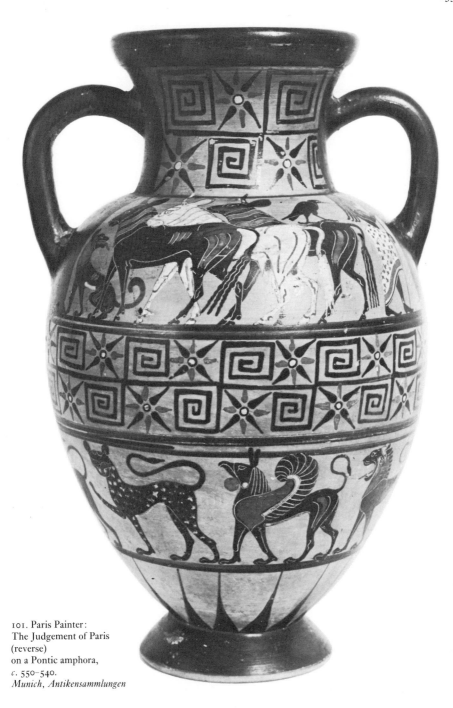

101. Paris Painter:
The Judgement of Paris
(reverse)
on a Pontic amphora,
c. 550–540.
Munich, Antikensammlungen

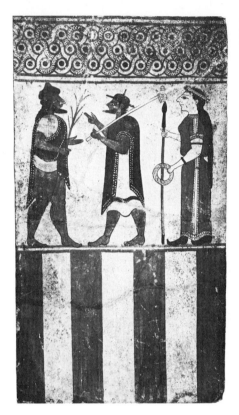 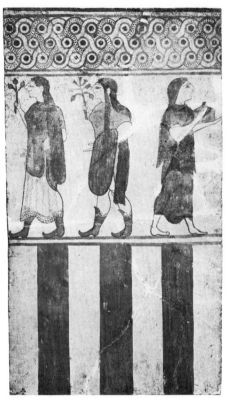

102–4. Boccanera slabs from Cerveteri, *c.* 550–540.
Painted terracotta. *London, British Museum*

terracotta slabs thinly coated with plaster, in
which a design was first sketchily traced, then
filled out with paint. The technique was Greek
– Kraton of Sikyon was credited with its inven-
tion – and known as painting on 'whitened
slabs'; it could be applied to wooden as well as
clay tablets (*pinakes*).[5] The Etruscan examples
on terracotta have come to light in various am-
bients, but the two most interesting sets with
large figured representations both hail from
tombs. Of these, the one now in London[6] and
known from its discoverers as the Boccanera
slabs seems of a slightly older style than the
second, otherwise closely related, which by way
of the former Campana Collection passed into
the Louvre in Paris (pp. 174–5).

The Boccanera set consists of five large up-
right plaques which were originally attached to
a wall. At least three of them appear to have been
placed side by side so as to form a continuous
decoration [102–4]. Clearly they constitute an
attempt at monumental wall painting in the
sense stipulated above (Chapter 10, Note 4).
The principle of decoration itself is interesting.
The figured frieze rests on a decorative zone of
broad, vertical stripes painted alternatingly red
and white. The pattern thus resembles a lattice
fence, much like the one represented on a later
occasion around the interior walls of the Em-
peror Augustus's Altar of Peace in Rome.[7] A
triple guilloche forms the upper frame of the
frieze. Two of its intertwined bands are covered
with black dots, and the whole design gives a
rich effect, anticipating the incrustations of the
so-called Cosmati Style. But, again, the princi-

and an unorthodox bull-sceptre in lieu of the ordinary herald's staff.[8] Behind him Athena is characterized by a spear, though still without the helmet;[9] Hera follows with a branch of flowers or fruits; the eventual winner of the contest, Aphrodite, holding a similar branch, comes last, as in the Munich amphora. She is not afraid to show a leg and does so with gusto, as in the vase painting, if somewhat more generously.

The procession moving to the right is more difficult to explain. Two alternatives are put to the commentator. The first is that this represents an actual event, for instance a procession of women carrying gifts to the dead or the tomb. This assumption might explain the fact that two women hold perfume bottles and the third, barefoot, carries a round covered box; it does not explain the conspicuous figure to the right round whose chiton a snake is coiling. Because her character does not seem at all real, I prefer the second alternative: that this group, too, forms part of a mythological theme. A possible suggestion seems the wedding of Peleus and Thetis. Three goddesses are lined up to bring their gifts; the fourth with no gifts but encircled by a snake may tentatively be identified as Eris, uninvited and determined to start the chain of events which led from the Judgement of Paris to the downfall of Troy.[10]

The level of style in general agrees with the Munich amphora; so does the spirit of the presentation. But the differences cannot be quite discounted. The slabs show heavier forms, a trend towards monumentality perhaps, but they lack the crispness of the vase painting. Both monuments may be ascribed to the same decade approximately, but the Caeretan paintings differ in so far as they exhibit a sense of design slightly more modern and certainly closer to an Ionian point of departure.[11]

pal object of interest was the figures. Two neatly drawn sphinxes, each seated with one paw raised, may have served as guardians on either side of the entrance; the three figured panels probably decorated the rear wall of the tomb. The composition is quite Early Archaic. Something specific was obviously represented, but entirely in the manner of the conventional processions, and doubts about the meaning of the representations are therefore bound to arise. One thing is clear, however: the two processions are moving in opposite directions. One must assume that they render two different actions. Indeed there is a good likelihood that in spite of some obvious anomalies the scene to the left again narrates the Judgement of Paris; or rather it shows Prince Paris in a pointed cap politely conversing with Hermes, who addresses him, wearing a slightly tuscanized hat

METAL RELIEFS FROM UMBRIA

Castel San Mariano

Three Umbrian tombs have notably contributed to our knowledge of mid-sixth-century

art: the tomb of the Colle del Capitano, which yielded the Monteleone chariot; that of Castel San Mariano, the surviving contents of which are now shared by the museums of London, Munich, and Perugia; and Fonte Ranocchia, whence came the so-called Loeb tripods now in Munich.[12] The presence of metalwork of such high standard in the region around Perugia poses a problem for the history of art. Metallic crafts had long been practised in Umbria, but generally on the level of local, popular taste. To our knowledge no earlier works of distinction occurred among her output; nor did anything of comparable excellence again appear in this region, with the sole exception, perhaps, of the Late Hellenistic tomb of the Volumnii. The three Middle Archaic tombs with their precious contents thus form an isolated group as to locale and period, and the question arises how objects which differ so much from the local level of artisanship came to be included with these burials. Apart from their time and provenance, they have further in common that all are of metal, the best amongst them being reliefs in repoussé technique. On the other hand they differ considerably among themselves as to style. Although the technical tradition which produced them might have been local, no corresponding coherence can be detected in their formal characteristics. In this respect they provide no evidence of an 'Umbrian School' but rather appear to us as exceptional performances, showing little contact with their surroundings. One must conclude that either the objects or the artists were imported; and though I find a certain intriguing likelihood in the latter assumption, the other alternative cannot be lightly discounted, and the question must remain undecided for the time being.[13]

The find from Castel San Mariano is the most numerous. Its contents show a great deal of variety, including, as it seems, two different types of chariot, several bronze stands, and other objects; but the whole complex needs re-study. Nor is the group homogeneous as to age: the older objects may be dated shortly after the middle of the century; the more recent ones two or three decades later. This continuity in time also is best explained by assuming that the total complex was collected over the years, from objects locally available and probably locally produced, if with the help of migrant artists.[14]

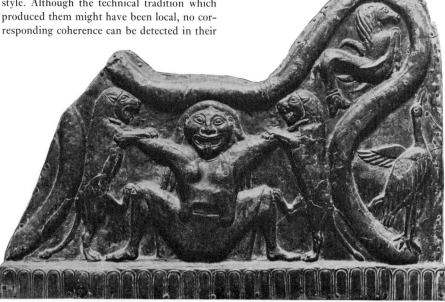

105. Chariot from Castel San Mariano, c. 550–540. Bronze. *Munich, Antikensammlungen*

The most conspicuous item in the earlier group is the bronze sheetings from a chariot in Munich.[15] The chariot must have been of the rectangular type on four wheels. The better part of the long side to the right is preserved, with representations of a boar hunt and sea monsters, and at the opposite end a hero once fighting a now lost centaur; on another fragment, probably of the left railing, two lions devour a stag. The terrible mistress of animals [105] holding two lions at arm's length may be assigned to the rear, where she squatted between the hunters and the hunted, grinning insanely.[16] Eastern Greek formal reminiscences abound in this repertory. Yet one would say that the artist felt strongly, almost personally, about his subject matter, even when he deals with current formulae like the facing demons. His manner of expression is not of the choicest, but what he wants to say he says effectively, and the changes of mood from one set of images to the next are very convincing. His style is solid and lively at the same time; the forms simplify and tend to be somewhat heavy but not excessively so. The whole is on a level with the art of the decade after 550, reflecting the incipient monumentalism of the period but not identical with any other of its known manifestations.

By contrast the relief of Herakles duelling with two opponents (probably Kyknos the giant aided by his father Ares) in Perugia, which is generally ascribed to the second chariot, displays a smooth craftsmanship of almost Attic elegance. It is a very interesting work, certainly among the most recent pieces included with the find from Castel San Mariano. As the folds on the women's garments show, it cannot be earlier than c. 530–520.[17]

Something must be said, however, about another most remarkable part of this find, namely the three silver reliefs in the British Museum, although unfortunately their state of preservation also makes it difficult to judge at present, and imposes a degree of caution on every attempt to discuss them. They are repoussé reliefs worked out in extremely fine detail: the effect of preciousness is heightened by electron plating in places, aided by incised design. Nothing is known about their purpose except that, obviously, they must have been nailed to some piece of furniture.[18] One panel is purely ornamental, a pattern of openwork palmettes in a curving frame. The others have figured decoration. Of the latter two, the smaller one represents two lions assailing a boar. A sphinx looking back, while at the same time propping one raised paw against the oblique frame, was restored into a forward-looking griffin. It seems that originally her posture resembled that of the Boccanera sphinxes (above, p. 157), although the style is later and the execution much finer. There is no certainty that all three fragments came from one and the same object, although they seem to be of the same make and period.

Most interesting is the largest fragment, which shows two young riders on rearing horses [106]. A third figure identically attired lies on the ground, left knee bent, right leg stretched out so that the foot appears behind the rear legs of the horses. The right hand is raised for protection. The riders are young men, not Amazons, and unarmed; therefore the representation cannot be a battle. It could be a horse race, perhaps even continuing beyond the present fragment; or just two young sportsmen displaying their horsemanship.[19] At any rate the subject was not mythological, and our attention focuses first not on history but on the formal aspects of the representation. As a formal composition the fragment is indeed a masterpiece. It far excels anything met with in Etruscan art up to this point by dint of the power and vivacity with which the artist was able to communicate a representation from life. Yet the representational scheme itself was then not unusual; only the quality and expertness of its execution were exceptional. For instance the Ascension panel of the chariot from Monteleone, certainly an earlier work, pictured a very similar situation, with certain variations imposed by its subject matter: the horses had to draw a chariot, the reclining figure had to be a woman [99].

For all that, the comparison reveals mainly the novelty of compositional concept and indeed the altogether new spirit which document themselves in the silver relief. In the new version the

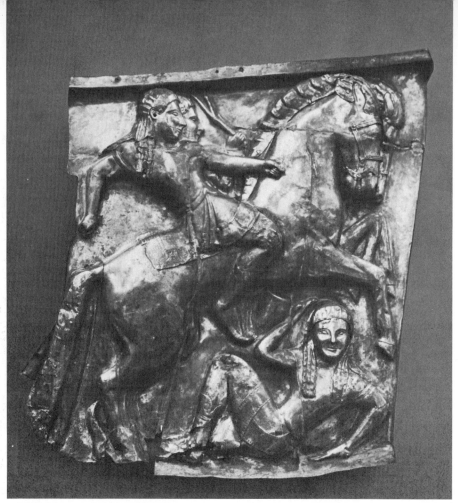

106. Relief fragment from Castel San Mariano, *c.* 530–520. Silver. *London, British Museum*

horses and riders form a chiastic design expressive of effort and tension; the whole group becomes understood as a balance of contending forces. No comparable concept was within the reach of the older artist. His design, for all its strength and directness, appears static by contrast, lacking in that peculiar quality of life so abundantly incorporated in the London fragment. For in this fragment it seems that motion itself has become a theme of art, over and above the representational significance of the figures. Not only the fact that the figures move but the energy of their movement, as a united action, is concretely shown. At the same time the circumstance that they are in motion appears as a qualifying condition of reality, in both men and animals: both exist in their mutual action, not apart from it. Thus the last traces have been eliminated of that insuperable loneliness from which the earlier art could not redeem its images, because it insisted so much on their singleness as signs denoting, each for itself, a discrete thought. Instead in the London silver relief motion appears as the superior thought in which the parts fuse, and to which they surrender their separateness. It is further specified

by mechanical and biological conditions. The riders act like riders, restraining their animals; the horses, racing each other, move in a manner adequate to their species, forceful, tempestuous, yet capable of discipline. Thus an emotional connotation also comes to the fore, as a third element of meaning, in the various forms of movement. It is difficult sufficiently to evaluate today the evident if inexplicable rapidity of progress in Archaic figural representations during the half century from *c.* 570 to *c.* 520. As the drawn figures grew more pliable, the transient nature of their actions also was bound to be more sharply felt. It fell to the artists to invent new patterns in which to fix the transient. Within this process, among the testimonies available, the rider relief from Castel San Mariano may be held a leading monument.

The broader context of these changes must of course be sought in Greek art. The interpretation of life as movement, expressed in the actions of centred organisms, was a Greek tenet. It was this absorbing interest which enabled the Archaic artists in time to overcome the rigid absoluteness of the earlier images, and to replace it by the insight that every living creature is indeed a being in motion; that it is at any moment conditioned by motion; and that stability is not found in reality. Thus the Archaic period first realized in its art a desire, never afterwards quite extinct, to represent motion directly as a general condition of existence and not merely as a symptom of specific actions. The image of the prancing horse was only one of many cases in question. Before the Greeks it had already become established as a handy pictogram of art, both Egyptian and Assyrian.[20] Early Greek Archaism disregarded it; mature Archaism recast it, and gave it a new interpretation. Solutions like the riders and the rearing horses in the London fragment certainly also constitute a patterned image, for motion cannot be properly shown, only hinted at. In this respect they did not differ greatly from their antecedents, for example in Assyrian reliefs. What differs, rather, is the meaning and connotations of the pattern. Firstly, realism now includes the postulate of organic coherence.

Secondly, a new kind of expressiveness, over and above the representational detail, now resides in formal elements such as masses and directions. Thirdly, a new proclivity to abstraction appears in the attitude towards subject matter. The entire composition tends to become as much a visualization of movement as it is the picture of an action. From here a long development of western art took its initial impulse which led in due course to the Parthenon horses, to Leonardo's equestrian monuments, but also to abstractions of motion as in modern art.

In so far as the artist of the London relief complied with these innovations which he well understood but hardly invented, he represented a Greek accomplishment in Italian surroundings. In fact his adherence to eastern Greek standards must be judged to be very close if one regards the build and temper of his horses: strong, curving necks, flaming manes, mouths opened for breathing and teeth laid bare.[21] Nevertheless it appears that this rare specimen of Archaic silver work was at the same time firmly anchored in Etruscan art. Some importance may be ascribed to the fact that the representational scheme of the prancing horses, with or without a reclining figure, occurs in several other more or less contemporary monuments from Northern Etruria; witness, from the region around Perugia, the Monteleone chariot and the mounted archers of Loeb tripod B.[22] Thus the silver reliefs from Castel San Mariano fit into their regional context by iconography if not by style. Their style is best matched with Pontic vases. The somewhat brittle humans recall advanced work of the Paris Painter.[23] The horses are of a different calibre but their design, likewise, finds its parallels among the latest vase paintings of the same class, in which the forms have grown broader and the silhouettes more massive.[24] The folds in the chiton of the foremost rider support this analysis. All the evidence suggests a date in the last decade of the Middle Archaic period, *c.* 530–520, for the London silver reliefs. Clearly by then the human theme had been opened fully, in its triple aspect, to the art of Italy: as description of natural form, as narrative, and as an expression of energies.

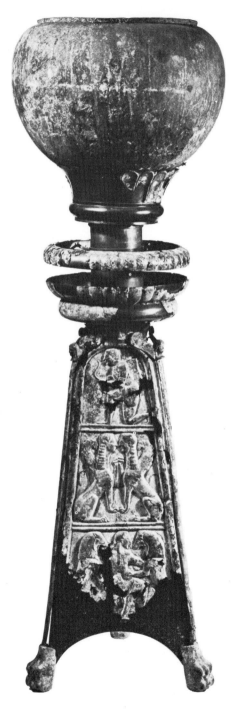

Loeb Tripods

The so-called tripods from the Loeb Collection, now in Munich, are really high stands supporting cauldrons. They consequently constitute a modernized variant of the similar, earlier vase stands of bronze and clay current among the Orientalizing and Early Archaic tomb groups [20, 30, 46]; hence, a traditionally Etruscan type of implement. The Loeb group consists of three stands with cauldrons preserved, all hailing from the same find, and agreeing with the older type in purpose though not in construction [107, 108]. It must be noted, however, that

107 and 108. Cauldron and stand (Loeb tripod C) (with detail) from Marsciano, *c.* 540. *Munich, Antikensammlungen*

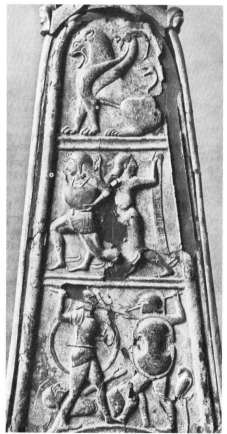

the way in which the vessels are joined to their stands is of modern restoration, not entirely reliable, and that the third cauldron was never recomposed from the existing fragments.[25]

While the earlier Etruscan vase stands had been conical, the form of the new specimens was changed into a three-sided, blunted pyramid. Each side is framed by a raised border line, arched on top. These borders much resemble bronze staffs imitated in relief, and indeed reveal the curious shape of all three implements as derived from a 'rod-tripod' of the common archaic type. The addition of the bronze walls between the rods deprived the latter of their original tectonic function, and transformed them into frames around fields decorated with hammered reliefs. The result was a new form of furniture which so far has but few parallels within, and none outside, Etruria.

Slight differences of style are apparent in the reliefs. The tripod called C, which is the smallest, certainly is the oldest as to style; it is also the most elaborately finished. Its reliefs may be dated to the years around 540, or not much later [107, 108]. Tripod B, the decoration of which includes the heraldic archers mentioned above (p. 161 and Note 22), follows in close order, probably c. 540–530. Only tripod A exhibits decidedly more recent features and must be placed still later, c. 530–520.[26]

The Greek myths were well known in the workshop of these tripods. Some interesting observations can be made about the selection of themes represented, which is limited. Two stories are shown twice: Perseus hurrying with the head of Medusa in his bag, and Herakles strangling the Nemean lion. The story of Peleus pursuing Thetis even occurs thrice, once on each tripod, and like the two Perseus reliefs, all three Thetis stories differ not inconsiderably from one another. The latter fact is remarkable because it shows that each time the myth was represented afresh. The story itself was known and understood by these artists, not merely an iconographic prototype which they might have conveniently copied.

On the other hand the mythological stories of the Loeb tripods must be judged to represent somewhat impersonal if competent performances as regards their interpretation of subject matter. They are clear, articulate, and skilful. But an air of professional detachment spreads about them, and their narratives spring few dramatic surprises. Story-telling has become a matter of course, almost routine, and the mythical recitation shows little more personal participation than is found in the decorative detail, the restive beasts of fable or frozen scenes of battle, which occasionally have been interspersed with the histories. Neither is there much variation of compositional ideas. In their superimposed fields still reminiscent of Early Archaic 'picture-reels', the narratives unfold at an even pace. The fields are closed on all sides, either quasi-metopic or, in the top registers, forming an arched tympanum. Within, the compositions mostly rely on the ancient one-way arrangement: they form scenes of pursuit and flight, rather than of dialogue and confrontation.[27] Antithetical groups which appear among the more decorative representations are severely symmetrical and strictly patterned. Obviously the aesthetic merit of these reliefs consists in their compositional firmness rather than in any subtlety of content. To their artists, form mattered more than subject matter.

Yet such deliberate control of form cannot fail to interest us. It produced a style of calculated monumentality, the comparatively small size of the representations notwithstanding. Similar tendencies could on occasion be observed in other monuments after the mid-century, but never so clearly demonstrated. Figures are styled in a grand manner, with broad and gently swelling forms generously expanding so as to fill with bulk and weight their allotted spaces. It seems characteristic of this desire for a certain formal greatness that most accessory details were engraved, not modelled. In this way they do not break the compactness of the large, sculptured forms. Another interesting observation is that this style develops. It is already present in the oldest tripod (C), culminates in the second (B), and reappears, tempered with a new sense of refinement and elegance, in the latest (A). Evidently one is deal-

ing here with a definite stylistic trend, the sources, duration, and geographical distribution of which still remain to be explored. In this task the contemporary tomb paintings may now prove to be of considerable assistance to the historian.

CHAPTER 14

THE SCHOOLS OF TARQUINIA AND CAERE

TOMB PAINTINGS AT TARQUINIA

Zonal System of Mural Decoration

Shortly after the middle of the sixth century there appears in the Etruscan tombs, notably of Tarquinia, a new system of painted decoration arranged in superimposed zones round the walls.[1] The change had fundamental importance, because it created entirely new opportunities for representational painting. It introduced into Italian art as the common form of mural composition the principle of continuous horizontal friezes which remained in force from then on until the Roman Empire.

In the older tombs, in the manner of the Campana Tomb (above, p. 121 and illustration 77), paintings had been grouped round a door, either real or feigned. Monsters or animals were placed on either side, heraldically; they were the 'guardians' of the door. It appears that this arrangement must be understood quite literally; that a kind of guardian was indeed intended to protect the entrances to the dead, and consequently that this Early Archaic scheme of tomb decoration owed its formal pattern to an idea half real and half magic.[2]

On grounds radically different from the Early Archaic reasonings, the new decorative schemes instead incorporated an abstract concept of architectural order in Greek terms. This does not mean that references to the purpose of the tomb are lacking in the new decoration. But they also now draw on a different context of ideas. Obviously thematic changes came about together with the new decorative system which subjected the representations to a different formal rule. The following are the decisive formal features. All round the funeral chambers the walls are divided into consistently defined parts corresponding to two, or more often four, architectural elements: a dado, the wall space

proper, a cornice or entablature, and above it, in the triangular spaces created by the pitched roof, the pediments. Not all four elements are always simultaneously present, nor are the same parts always selected for painted representations. Indeed it is our contention here that a chronological sequence can be observed in the shifts of emphasis from one of these architectural divisions to another, not unlike the sequence of varying architectural arrangements which form the four so-called styles of Campanian wall painting. Common to all painted Etruscan tombs after the Middle Archaic period, following the division of the walls by horizontal zones, remained the habit of arranging mural representations in friezes or frieze-like compositions. The formation and evolution of this decorative order can best be followed in the tombs of Tarquinia, where, apparently, it began. The outstanding Middle Archaic examples are the two tombs named 'of the Bulls' and 'of the Augurs', in that order.

Tomb of the Bulls

The new type of frescoed tombs at Tarquinia came into being at about the time when Etruscan black-figured vase painting started in nearby Vulci (above, pp. 153 ff.). Interest in Greek mythology was then on the rise all over Etruria. One can hardly regard it as an accident that the oldest known tomb of this kind, the Tomb of the Bulls, also contains the only mythological painting found so far in any Tarquinian tomb. Even beyond Tarquinia, this work, which represents the story of Troilus, has remained a unique example of Archaic mythological painting on a large scale preserved anywhere [109]. Its date cannot be far removed from the Pontic amphora with the Judgement of Paris in Munich [100, 101], though its style differs, and it may be somewhat later.[3]

If one examines the decoration of this tomb, a degree of indecision becomes apparent both in the thematic choices and in the arrangement of the representations. Obviously the artists could not rely on an already established tradition for the work to which they were assigned, although no doubt they were competent craftsmen. Instead they solved some of their formal problems in a rather experimental and preliminary way. We must conclude that the above described comparatively firm tradition of architectural decoration which characterizes the later tombs of Tarquinia formed itself on the basis of experiments such as this. It was then in a still tentative stage. It follows that the Tomb of the Bulls must be regarded as a truly Archaic work, even by the standards of the special group to which it belongs. Within that group it marks the beginning of a consistent, and in that sense original, local development. It introduces what may well be called the second style of Etruscan wall decoration, but by its emphasis on the door areas it betrays the fact that its character is still transitional.

The best preserved painted decoration is found on the rear wall and pediment of the first chamber, or vestibule, which in general layout already follows the common Tarquinian type with pitched roof and imitated rooftree. Two doors, leading into two narrow funeral chambers further back, divide this wall into three sectors of unequal size: two lateral posts and a larger, pillar-like centrepiece. But, different from later custom, the doors do not reach up to the pediment. Instead, a frieze bounded by two striped bands extends above the doors, like an architrave, between wall and pediment. This arrangement provided three distinct areas for decoration: wall, architrave frieze, and pediment [109]. It must soon have failed to satisfy, however. In the Archaic tombs next in order of date we find doors raised to the height of the pediments. As a result only two areas, not three, are set aside for figured decoration: the figured architrave was eliminated, and striped bands took the place of the entablature. Subsequent changes in this decorative scheme will have to concern us later.

In the Tomb of the Bulls the most conspicuous wall space was the central pillar. This is where we find the story of Troilus. Rather schematically designed trees decorate the two lateral posts. The same semi-ornamental motif was carried over to the central field, where, however, the trees had to be subordinated to the main picture and held to a smaller scale. Some are decorated with wreaths and fillets, as for a religious celebration. The figured representation seems to rest on this little grove in a rather precarious manner, giving evidence of a laxity of structural feeling similar to that we encountered previously in Villanovan decoration (p. 35) and shall again observe later, in the Roman Ara Pacis.

In the main painting the precinct of Apollo is represented with its fountain, to which Troilus descended from besieged Troy. The boy is alone. He has just stopped his horse, as if suddenly startled by a noise and seeking cover behind the tree. Achilles leaps forward from his ambush behind the fountain. We would not say that this composition is quite on a level of fluency with the best contemporary mythological scenes discussed in the preceding sections. In order to bring the facts of the story before us, the painter had to battle against a certain rigidity of expression; he was a 'primitive'. But he already adhered to the oncoming Ionian fashions. The horse, as well as Troilus with his slanting forehead and elegantly pointed shoes (*calcei repandi*[4]), gives evidence of the new trend. Other features appear quite retarded. Achilles seems to wear a loincloth similar to those of the provincial type of skirted kouroi. The high legs of the horse still suggest the stilted animals of the Campana Tomb. Yet there is also a fine display of free-hand drawing, especially in the rear portion of the horse. More important still, we witness the endeavour to develop a monumental style of painting suitable for the decoration of comparatively large spaces; and to achieve such a style almost certainly with the aid only of quite small prototypes such as vase paintings.

The outcome of these contradictory factors is a delightful picture, nevertheless. The figures are not nearly as patterned as one might expect.

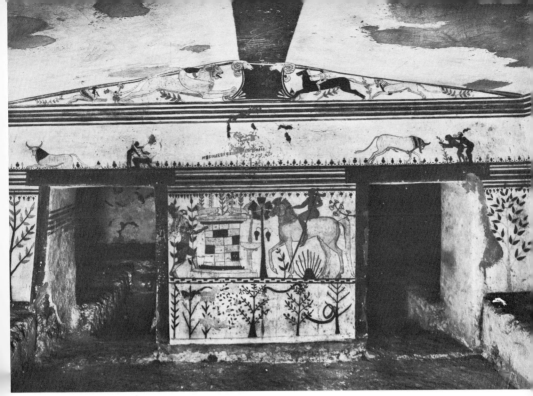

109. Tarquinia, Tomb of the Bulls, *c.* 540, rear wall

There is a great deal of fresh observation in them. The comparative rigidity with which their representation was carried out rather helps their expressiveness: it makes them seem frozen in their posture, as if a sudden spell had fallen upon them, and their very breath been arrested. There is a noiseless terror about this scene, enhanced rather than mitigated by the motley objects which set its stage. The palm tree with a crown like a big stylized carnation, the rusty colour of dried blood, is a beautiful piece of folk art. The fountain is represented by a grand structure in the form of an altar, built of blocks painted white, the same dark red as the tree, and a charmingly transparent watercolour blue. Two lions rest on the light blue top; one spouts water into a basin below.

Surprising in this composition is the equal importance accorded to the human and the non-human elements. The mute things matter as much as the people who move about them; they form a world deemed worthy of attention, as in

a landscape painting. Theirs is an art world to be sure, and quite fantastic. Yet by attitude, if not by scientific knowledge, the painter should be called a naturalist. Hence the originality of his approach, however limited his artistic vocabulary may seem to us. In the scenery which he built, man and objects meet as equals. We seem to witness the first step towards the concept of a world in which man is contained as a part of nature.

Immediately above this picture the frieze remained empty, but further to the sides over each door one finds a small erotic group, each time associated with an image of cattle. The latter are usually held to be bulls (from which the tomb was named), although only the one to the right, which has a bearded face in the oriental tradition, can qualify for the specification. With horns lowered he seems to charge the pair before him; the lovers stay quite unruffled. The recumbent animal on the other side takes no heed of the corresponding group near by, with which

it has no visible connection. Still higher, the pediment is filled with an antithetical composition of a kind which became typical of many Archaic tombs at Tarquinia. It centres in a voluted object with concave outlines, perhaps a painted reminiscence of the kingpost which in this place should support the rooftree. Towards the left side of this object a winged lion and a sphinx are facing; to the right, another bull chases a man on horseback.

There is an odd sense of threat, peril, and flight about much of this imagery. But a more precise connection between it and the tomb which it decorates can hardly be established.[5] More likely we are dealing here with disconnected images in the Archaic manner, each of which must carry its meaning in itself. As far as we can judge there was no connecting system – no more than among the small representations which we found encased in the square frames of the Tarquinia door slabs. In fact the erotic scene over the right-hand door is quite similar to a group in one of these slabs. The small size of these pictures, which make no attempt to fill the height of the frieze, probably indicates that they were taken from prototypes on an entirely different scale, and inserted in their present places rather unconcernedly, like marginals alongside the written columns of an illustrated book. Similarly, the choice of the Troilus episode for a funeral decoration must be considered a tentative one. Whether or not a connection was felt between the myth and the purpose for which it was here used, we cannot say. But undoubtedly there was a need for a definite and meaningful iconography as the frescoed tombs became more frequent in Tarquinia. As it turned out, myth did not fill that need. To our knowledge the experiment of the Tomb of the Bulls was not repeated.

Tomb of the Augurs

The answers to both problems, of iconography and of architectural order, appear fully worked out in the Tomb of the Augurs [110, 111].[6]

This tomb offers one of the best preserved examples of Archaic painting, and one of the finest. Obviously it was the work of a leading artist. The decoration is continuous all round the single funeral chamber. It consists of four distinct parts: a dado painted black; the wall frieze of large figures moving along on a reddish base line; the striped cornice taking the place of an entablature; and the pediments. From now on we may call this the standard arrangement of the Archaic tombs, here for the first time fully developed as an articulate architectural order. The second style of Etruscan wall decoration is now an accomplished fact. The figured friezes to which has been given the greater part of the wall stand out clearly, in well drawn contours, against the lighter buff colour of the ground. Possibly this choice of background was influenced by contemporary ceramics such as the Caeretan hydriae (below, pp. 171 ff.) or the similarly coloured terracotta slabs. At any rate the colour scheme is severely limited. Black, various shades of red, and yellow constitute its dominant triad. Blue was used for the leaves of the stylized trees, and green for the middle band in the striped cornice.

The imagery has turned away from both myth and magic. Instead we are confronted with a set of themes entirely on the level of human actuality. The paintings in the Tomb of the Augurs represent events in honour of the dead: a thematic choice which from then on became standard in the painted tombs of Tarquinia. The large door in the rear wall probably represents the entrance to the tomb. It thus symbolically transforms the funeral chamber into a place in front of the tomb, as if the dead were still part of the world outside, where all the events are staged, designed to please them. Placed on either side like the one-time guardians, two professional mourners now face each other. Then follow the games which form part of the funeral: boxers, wrestlers, runners. Metal vessels – precious prizes – are stacked between the athletes to reward the winner. An umpire to the left of the wrestlers carries a crooked staff; it is the latter insignia which earned him the title of 'augur' from the early discoverers, probably erroneously. Most interesting are the two masked men who play their sinister pranks,

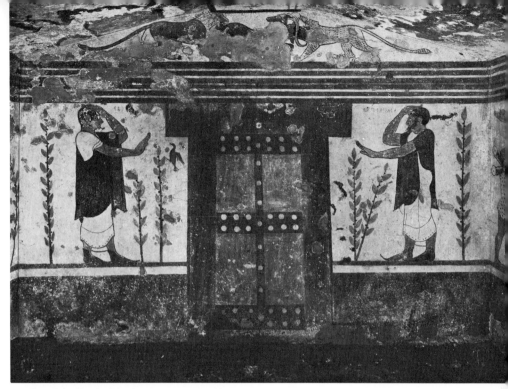

110. Tarquinia, Tomb of the Augurs, *c.* 530, rear wall

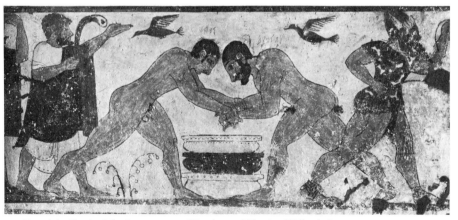

111. Tarquinia, Tomb of the Augurs, *c.* 530, Wrestlers and Umpire. Wall painting

much like clowns in a modern circus, as a side-show between the athletic contests. Their inscribed designation, 'Phersu', suggests that originally they represented characters from the nether world, spooks on the loose as it were, though how literally the idea was then still taken we cannot know. One directs the cruel fight between a blindfolded man and a fierce dog, hold-

ing both on a leash; the other seems to deride the runner who cannot catch up with him. At any rate both Phersu are real people; they only wear the masks of demons. But to the popular fiesta which is in progress around the tomb, they add a sombre and savage touch. In the pediments above, beasts of prey devour peaceful animals.

Here for the first time we find monumental wall painting, understood and demonstrated as a special task of art, involving particular conditions. Every care has been taken to make all shapes appear large and important, and to balance them against one another so that they neither crowd each other nor become lost in the surrounding space. Figures standing upright reach from the base line to the upper cornice. If models on a smaller scale have at all been used here, as one suspects was true of the Tomb of the Bulls, they left no mark on the style of representation. All around, in an even and measured pace, one sees the walls covered with broad, flat forms enclosed in rhythmically curving outlines, enlivened by contrasts of solid colour which result from details such as garments and hair. One may find that this aggregation of somewhat stocky men lacks something of the airy charm conveyed by the naively appreciated world of nature in the Tomb of the Bulls, but it also has outgrown the uncertainties of the latter, and on the whole the advantages far outweigh the loss. The same awareness of the needs of formal order expresses itself in the groupings, which lean towards an antithetical, and even symmetrical, arrangement of figures along each wall.

This style can well be matched with that of the Loeb tripods, especially the intermediary specimen (above, p. 163). It was consequently not limited to wall paintings, though it may well have originated in that branch of art for which it is eminently suited. Comparable tendencies appear in vase paintings, both among the later Pontic amphorae and the Caeretan hydriae.[7] Moreover, parallels can be found outside Italy. There exist definite relations between the Tomb of the Augurs on the one hand, and the fragments of Archaic wall paintings discovered in the Lydian city of Gordion on the other.[8] Even

more interesting, perhaps, proves the comparison with the reliefs from the Pillar Tomb of Belenkli, the ancient Isinda, in Lycia, for in this instance the correspondence is not limited to points of style: it extends to the iconography as well, which in the Lycian tomb not only includes athletic games, boxers, wrestlers, and musicians, quite similar to those represented in the Tomb of the Augurs, but also the theme of the hunt, likewise known from Etruscan tombs.[9] Since direct connections between these widely distant monuments can hardly be assumed, the existing similarities are best explained as the symptoms of an international style which from a Greek Ionian centre radiated to northern Asia Minor in the east, Italy in the west. While the original centre as yet cannot be identified, the evidence being too fragmentary, it still does not seem unlikely that this rather erratic appearance of related stylistic and perhaps cultural traditions in outlying provinces of the ancient Mediterranean came to pass in the wake of enforced migrations such as the evacuation of Phocaea, earlier in the century. In central Italy, Caere may have functioned as the regional centre of distribution, but the new style must have spread rapidly, since its manifestations occur in quite different points of Etruria. The often noted relation between the master of the Tomb of the Augurs and the workshop of the Caeretan hydriae may be so explained.

The date and duration of this stylistic vogue are difficult to determine. In this connection the typological differences already mentioned between the Tomb of the Bulls and that of the Augurs assume added importance, for a certain lapse of time must almost certainly be allowed for the progress from the tentative and experimental decorative system in the Tomb of the Bulls to the fully developed, completely rational arrangement of the decorative elements in the Tomb of the Augurs. The Tomb of the Bulls, where the connections with the past are still so much in evidence, may have been painted around 540. The Tomb of the Augurs followed, perhaps a decade later.[10] The Greek manner of rendering the folds of garments by stylized zigzag patterns apparently was then in its begin-

ning stages. The artist has tried the new device in two places, rather cautiously: in the chitons of the umpire (the 'augur') next to the wrestlers and of the flute player on the wall opposite.

PAINTING FROM CAERE

Caeretan Hydriae

As the Middle Archaic period draws to a close, Caere once again moves into the limelight as an artistic centre. Again, as in Tarquinia, the emphasis is on painting. Reference has already been made to the workshop of the so-called Caeretan hydriae. Obviously in a history which deals with the transplantation of Greek artistic standards into Italy this remarkable class of painted vases must be assigned its part. Just what that part actually was in the general development of art, and how it ought to be evaluated, are still moot questions, however. There is room for doubt whether these vases should be discussed at all in a volume on Etruscan art, rather than in one on Greek art. The answer probably is that they should be included in both. The matter has not yet been settled to everybody's satisfaction.

In many respects the circumstances surrounding the Caeretan hydriae resemble those of the Pontic amphorae. The hydriae, too, form a small group with clearly distinguishable characteristics. All specimens the origin of which is securely known were found at Caere.[11] While this fact cannot prove that they were also produced there, it strengthens the likelihood that such was indeed the case. It is no proof to the contrary that the Greek language was understood in the workshop, as we know from a specimen inscribed in Ionian letters.[12] A considerable fraction of the population appears to have spoken Greek at Caere at one time or another, as can be deduced from various evidence.[13] Certainly the shape of the vessels is purely Greek, following the established type of the 'water carrier' (hydria) with two upturned horizontal handles and one vertical handle; and the excellence of the craftsmanship as well as, in the finest examples, of design meets the best con-

temporary Greek standards. On the other hand there is no other Greek group of vases quite like these hydriae; nor can their style be easily derived from one single Greek school or region. Rather the stylistic analysis uncovers a fusion of various, not homogeneous, Greek sources, as one is wont to find in the Etruscan products of the time. Thus among the contemporary vase paintings of Greece the Caeretan hydriae stand out as an isolated and somewhat mysterious class, because of their unconventional use of style, their iconography, and their rich polychromy. Colour, mostly white and a dull, purple red applied to the underlying black of figures and ornament, was employed so generously that many of the representations can hardly be described as black-figured, in the strict sense of that term.[14] Instead, contacts with the contemporary output of central Italy, both stylistic and iconographic, can be stated quite frequently. Relations to the studio which produced the Pontic amphorae are especially close. The better Etruria becomes known to us as a stylistic province of Archaic art, the more clearly it appears that the Caeretan hydriae fit into the Etruscan development more naturally than into any other. Thus the present evidence indicates strongly that we are faced with a Greek workshop established in the West and indeed most probably at Caere. Nor can the members of the workshop have been complete strangers to the region. If this had been their lot, it would be difficult to explain why their work and outlook are so often in agreement with other art produced around them.[15] Obviously the studio formed an integral part of the Etruscan environment in which it functioned and to which it brought its superior craftsmanship, plus a fresh supply of Greek myths.

A life span of about one generation, approximately from 540 to 500, must be assigned to the workshop on grounds of style. The hands of at least two artists have been distinguished. One whose œuvre includes the earliest specimens may have been the older of the two, perhaps the founder of the shop (the 'Knee Painter'). In the course of time he was joined by a younger companion (the 'Busiris Painter') to whom among

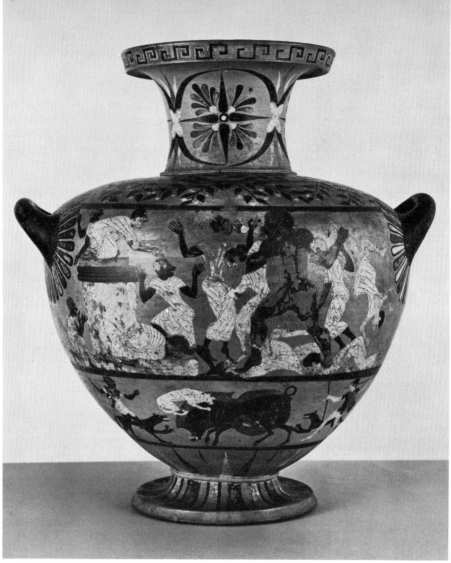

112. Busiris Painter: Herakles among the Egyptians on a Caeretan hydria, *c.* 530–520.
Vienna, Kunsthistorisches Museum

other contributions we owe the most celebrated work of the entire group, the hydria in Vienna representing in its main picture frieze the story of Herakles among the Egyptians [112].[16]

As the Busiris Painter tells his story it becomes a very amusing affair. One may describe it as a kind of boastful travelogue, something like an ancient version of Gulliver's adventure with the Lilliputians. Shipwrecked on a hostile shore, Herakles finds himself surrounded by busy little Egyptians who have decided that according to the law of their land, the stranger must be sacrificed. The king, Busiris, is to officiate. In the Busiris Painter's picture Herakles has regained his strength, and the situation has been thoroughly reversed. Distinguished by a

ceremonial beard, in the fashion of Egyptian royalty, and a curving forelock reminiscent of the royal symbol, the Uraeus, the king himself now lies prostrate on the steps of the altar upon which two of his men have already sought refuge, and towards which another is fleeing. One, kneeling, touches the altar for protection. At the same time the remaining Egyptians, numbering six, are being disposed of by the strong-arm hero. There is much confusion and shrieking, as indicated by the open mouths, and it is amazing to see how effectively the composition deals with the turmoil. Other representations of the same scene can be found in Greek vase painting, though not very frequently. Among them the work of the Busiris Painter exhibits several unusual traits. To its apparent Greekness the composition adds a peculiarly Egyptian flavour. Herakles is always shown to be strong, but not necessarily a giant. Here he has become endowed with that symbolical oversize which in Egyptian reliefs was traditionally reserved for persons of rank, notably the king, while in his turn the king has been reduced to the measure of his subjects. Also in other respects Herakles behaves much as a pharaoh might, in the Egyptian official style: he steps on his enemies, destroying four of them simultaneously. He is supposed to do these things really which a pharaoh would be shown to accomplish symbolically. It is all very funny, and will seem funnier the more one perceives of the details and their implications; but the means employed, a persiflage based on stylistic imitation, were hardly in the tradition of ordinary Greek standards of art.[17]

The master must have been a man of wit; it was a witty idea to present the exploits of Herakles in Egypt in terms borrowed from the Egyptians themselves. He also was a knowledgeable man, able to look at the strange ways of the Pharaonic country with an interest as fresh and independent as did Herodotus some three-score years later. It is possible that he travelled; perhaps he had connections with the Ionian colony at Naukratis, and thus gained a first-hand knowledge of Egyptian art and manners. However, the alternative hypothesis should not be rashly discarded, namely that quite possibly his acquaintance with Egyptian conditions was founded on materials present in Italy. There is reason to believe that of the numerous articles dumped into Etruria by the Phoenician trade during the seventh and early sixth centuries, a sufficient number was still in circulation at the end of the Archaic period to exercise an influence on Etruscan works of art. This would be especially true of the previously discussed Syro-Phoenician metal bowls with their non-Greek iconography which included a rich assortment of Egyptian reminiscences (above, p. 47). The familiarity with Egyptian mannerisms of style which characterizes the Busiris hydria might well have been derived from imports of this kind. The Orient, by its Phoenician extension, was then nearer to Italy than to Greece; and the Busiris Master was evidently in a position to judge its formal manifestations – what he knew of them – with amused detachment. His own drawing style was decidedly Greek, and indeed notably free of provincialism. He was also a most successful representative of that grand manner which just then asserted itself in Etruria, as the preceding chapters have repeatedly shown. It is the latter quality, above all other similarities, which places the Herakles of his chief painting in close stylistic relation, for instance, to the broadly drawn figures of the Tomb of the Augurs.

The other Caeretan hydriae cannot be discussed here, for lack of space. As a group they constitute one of the most undiluted and direct manifestations of Greek style ever produced in Etruria. Their themes are purely Greek, and often Homeric. Yet in the remarkable variety of their representations local features, also, can frequently be detected. Their most general characteristics, across all differences of execution, are a straightforward, even light-hearted, talent for story-telling; an alert attention to natural detail and environment; and not rarely, an amusing slant given to the rendering of a story. After all, the myths have their comical sides. In looking over this small collection of paintings one still today appreciates the freedom of mind which fell to their artists as the fruit of

remoteness when the spell of cultural closeness was broken and replaced by a new independence of judgement, owing to a variety of contacts.

Campana Slabs

The second large set preserved, at least in parts, of Archaic Etruscan wall paintings on terracotta *pinakes* likewise came from Caere. These are the so-called Campana slabs, now in the Louvre [113, 114].[18] Their broadly drawn figures, which move about with a stout and serious dignity, equal in monumentality, if not vivacity, those of the Tomb of the Augurs. Their style is different, however.[19] It is perhaps best described as a continuation of the style seen in the earlier Boccanera series (above, pp. 154 ff.), with which it shares representational habits like the undulating outlines of the long chitons. But now the figures have acquired a greater range of action, and the articulation of details is much more secure. The faces, too, are obviously of a different and more recent cast. Profiles have lost their forward-pointed 'nosy' look, beards are rounder, eyes smaller and more naturally placed. Essentially this is a drawing style, of deliberate flatness and with a flair for selective realistic observation, rendered in firm lines as if especially designed for our instruction: note the fashionably pointed boots, flashy as any ever worn by a Texan cowboy. The shoes are laced and tied together above the ankles, with a leather tongue rising high to protect the shinbones. Evidently they represent the ancestors of the *calcei* which later became a prerogative of the Roman senatorial class. These slabs constitute for us a valuable example of painting carried out in simple, variedly coloured planes and with a multitude of inner design, at a time when most vase painting still adhered to the black silhouettes. I date them to the last Middle Archaic decade, *c.* 530–520.

Unfortunately the Campana slabs are not as well preserved as one would wish; restoration is in evidence in several spots. Moreover, doubts may well be raised as to whether the tomb in which they were found was their intended destination.[20] The question is not without impor-

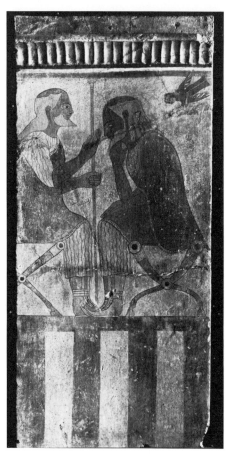

113. Campana slab from Cerveteri, *c.* 530–520. Painted terracotta. *Paris, Louvre*

tance, because on the answer may depend our reading of the subject matter. Evidently five of the slabs formed part of a continuous decoration. One of a more elegant style and framed by different ornament was discovered separately, if in the same location, and must be ascribed to another context. This is the slab representing a man with sceptre seated before a female statuette, perhaps a cult image, at the base of which a snake is coiling.[21] Its explanation is uncertain, but most likely it is mythical. Of the remaining five slabs which belong together, each is crowned by a slightly protruding mould forming a cor-

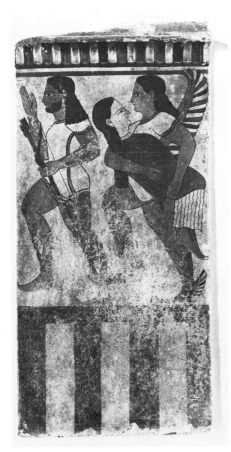

114. Campana slab from Cerveteri, *c.* 530–520. Painted terracotta. *Paris, Louvre*

In the abduction scene [114] Iphigeneia may again be recognized, this time rescued from the sacrificial altar by Apollo (with bow and arrows) and Artemis (winged), who carries her away through the air.[23] If the representation is so interpreted, its presence in a tomb would seem doubly meaningful, for it lends to the myth a special connotation, of salvation from death. Such analogical reasoning occurs time and again in the funeral art of ancient Italy: suffice it here to refer to the much later Etruscan ash urns with stone reliefs on which the same myth is often shown (below, p. 423). The similar frequent mythical allusions to survival in the sculptured Roman sarcophagi of the time of the Empire may also be referred to here as a matter of common knowledge.

nice. The processional pattern of composition still prevails, and the figures move upon a similar podium to the one found in the Boccanera slabs, reminiscent of a lattice fence.[22] About the meaning of these representations general agreement has not yet been reached, though obviously the abduction of a young woman by a winged being calls for some mythological explanation [114]. Thus in one slab one may identify Iphigeneia led to her sacrifice by two men carrying weapons; in another, Calchas the seer and King Agamemnon, seated, deliberating about the means of reconciling the offended goddess, Artemis [113].

115. Head of a warrior from Orvieto, *c.* 530–520. Nenfro. *Florence, Museo Archeologico*

MIDDLE ARCHAIC SCULPTURE IN THE ROUND AND MINOR ARTS

Head of a Warrior from Orvieto

Three regions of Etruria stand out as active centres during the Middle Archaic period: Caere, the closely allied towns of Tarquinia and Vulci, and the Umbrian territory. For although, as we have seen, the local origin of the metallic art discovered in the latter region is not beyond doubt, its presence and high quality testify to the active participation in the general culture of the province in which it was found. By contrast the north-western coastal region from Populonia to Vetulonia, which contributed so much to the Etruscan orientalizing civilization, during the Archaic period appears comparatively unproductive. There remains to be mentioned, however, the cultural middle axis of Etruria which moves from Orvieto – perhaps the site of the ancient Volsinii – in an almost straight line north to Chiusi, Fiesole, and the region round Bologna. The art produced along this geographical line proves on the whole of a more provincial cast, differing in this respect from the contemporary art of the southern centres, which cultivated a rather more international level of taste; nevertheless it is often interesting precisely because it grew in a state of comparative isolation and independence. In many instances it illustrates the adaptation of the Archaic style to the specifically Etruscan themes and preferences better than the more hellenized products of the progressive workshops.

The large tufa (*nenfro*) head from Orvieto, now in Florence, which dates from near the end of the Middle Archaic period, *c.* 530–520, is a fine example of this provincialism [115]. It represents a young man wearing a popular Etruscan variant of the Cretan helmet, arched over the forehead, where it is finished with an outturned rim.[1] Stone statuary was of rare occurrence in Archaic Etruria, and the tradition was carried on only intermittently, in a few places.

Vulci, as we saw, was probably its earliest home, and Orvieto lay within the cultural orbit of that city. The master of the Orvieto head may well have learned his craft in a Vulcian workshop. Ultimately, of course, he followed a Greek precept. One may find the outcome Ionian rather than Attic, but this is neither here nor there; actually it is neither. Instead we shall have to admit that amongst our store of ancient stone sculpture this head constitutes a unique item. Purpose, material, and local mannerisms mark it unmistakably as Etruscan.

The most obvious anomaly of the Orvieto head, namely the circumstance that apparently it was never joined to a statue, may be related to purpose. It is at any rate quite contrary to Greek usage. For this head of colossal size rises not from a neck but from a thick cylindrical base which must be reconstructed as the crowning of a column or a round cippus. Presumably it marked a tomb. However, in Etruria representations of isolated human heads, without bodies, also occur in sanctuaries, where they obviously served as ex votos. Most extant examples are later, and of terracotta. Nevertheless the possibility remains that the Orvieto head also was not a funerary monument but a dedication in a sanctuary. Another deviation from the Greek norm is the armour: no Archaic Greek kouros wears a helmet. Thus the 'kouros' head from Orvieto affords a very ancient illustration of the remark found in Pliny, that it was the Greek custom 'to hide nothing [of the human form], the Roman, to add the armour' (*N.H.* 34.18). The statement is not true without exception, but on the whole it has been shown to be correct, at least as regards large statuary. One should add, however, that, as it is possible to see here, the history of the armoured statue as a type of sculpture began in Etruscan art even before the Roman; indeed, in Archaic Etruscan art.

Last but not least, the sculptural style deserves our attention. A tendency to simplify and enlarge all essential forms constitutes its most obvious characteristic. To some extent this peculiarity can be explained by the material, which is both coarser and softer than Greek marble, and does not lend itself to the rendering of fine detail. For the fine finish the sculptor had to rely on the colour, which probably covered the head entirely, and which has now disappeared. All in all, one must count his work as a product of that formal current of Etruscan art which often surprises us by its emphatic distortions and unexpected combinations of form. It is surprising to see the smiling mask of the Archaic face emerging from the wide open frame of the helmet. The helmet seems overlarge, the chin protrudes too far, the smile is exaggerated, of a mocking expression. As they were once painted, the bulging eyes must have appeared enormous, not blind as they are now but looking straight forward with a steady gaze, though without real aim or target.[2] Yet all these are mere surface forms. There is altogether too much mass unaccounted for inside the abstract, near-spherical shape of the whole. No doubt this head was created in the wake of the monumental style which we observed in other monuments of the period. Again, the sculptural interpretation of the stylistic precept – monumentality understood primarily as solid mass – appears to us quite Etruscan. From the Greek point of view this can scarcely be called a responsible handling of form: it lacks the discipline of a rationalized structure which in a Greek work of sculpture binds the outward forms to a core within, as it were. Here the core remains inert, and the smile materializes on the surface, as on a cloud of stone. The total effect is one of robustness and vitality, where the Greeks show spirit and animation.

Chiusi and the North-West

Further north the city of Chiusi retained its position as a centre of regional art throughout the Archaic period. A degree of hellenization can be observed in her products also, but the

116. Statuette of a woman, *c.* 550–540. Bronze. *Florence, Museo Archeologico*

process appears to be slowed down somewhat by the persistent adherence of the workshops, and obviously the public as well, to the already traditional techniques and native types of objects. Thus the emphasis is still on the indigenous categories. To this period belong the latest Canopic urns; the production of anthropomorphic urns continues, as does the heavy bucchero. All three categories have been described previously, and require no further treatment here (above, pp. 130 ff.; 132–3). One conspicuous fact may be worth mentioning, however. This is the absence, at most of the inland places, of a local tradition of painting. Tombs with painted decoration exist at Chiusi (see below pp. 274 ff.). With this one notable exception Archaic wall paintings have not been found in these towns, nor can a local workshop of painted vases be assigned to them. Their industries seem wholly concerned with metalwork, stone sculpture, and other forms of the sculptural arts. Hardly a work of colour in the Archaic style can be traced to them.

An outstanding bronze statuette, now in Florence,[3] representing a heavily veiled woman can with probability be counted among the products of this region [116]. Its provenance is uncertain, but the type has counterparts, if of lesser quality, in other sectors of the Etruscan north-west. The woman stands erect and immobile; a forbidding image shrouded entirely in her long cloak, of a curiously abstract, ceremonial form. Her only human features are the face, of quite Ionian shape, which looks straight forward, and the upturned shoes which stick out from underneath the flat robe as from a wooden board. Once there were also two hands, stretched forward horizontally. The eyes are large, protruding, lanceolate, and enlivened with short engraved lines all round, representing eyelashes. The latter detail connects our lady with other works of art of the Middle Archaic period, from Perugia and Tarquinia.[4] Clearly this statuette renders a cultic form, inspiring awe just because it is so removed from ordinary human appearance. Ultimately, of course, the type harks back to Greek orientalizing art.[5] But as it lingered on in Etruria at this comparatively late date, it

seems to have become a popular type of *xoanon*, only incompletely humanized. The curious shape of the bronze in Florence, repeated by similar statuettes in other places, well illustrates the strange tales about ancient images still preserved in Roman temples at the time of the Empire, which in the minds of a later generation, no longer versed in the ways of Archaic art, raised doubt whether beneath their veils these venerable objects were intended to represent men or women.[6]

Ivory Tablets from Tarquinia

One rather important class of Chiusine monuments, the cippi in the form of rectangular bases decorated with low reliefs, came into being about the same time, shortly before 520. However, since the great majority of these monuments, including the most notable specimens, belongs to the end of the Archaic period, it seems more practical to deal with them in a later chapter (below, pp. 207 ff.). Here is the place instead to introduce a type of industrial art which for a while enjoyed considerable popularity in Etruria, especially during the last quarter of the sixth century, and which almost certainly exercised an influence on the Chiusi cippi. These are the often very finely carved ivory tablets which are known to us from various Etruscan sites; examples begin to appear towards the end of the Middle Archaic period. Apparently, as a class, they depend on Cypriote prototypes which reached Etruria by way of the still active Cypro-Phoenician trade; evidently by that time the workshops of Cyprus had ceased to furnish the oriental or quasi-oriental objets d'art which this traffic once carried, and had in their turn become converted to the more and more prevailing hellenic-international style. The tablets of this type are normally found in sets. Each consists of a panel enclosed by a rectangular, frequently ornamented frame, within which a figured representation is shown in low relief. While the original purpose of the sets is not certain, the theory that they decorated small jewellery boxes or caskets of a characteristically Cypriote form has much to recommend it. The

tablets found in Etruria, however, are doubtless of local origin and workmanship.[7]

One finds some of the finest as well as earliest examples of this type in four tablets originally hailing from Tarquinia and now in the Louvre. These also formed a set. One tablet, here illustrated, portrays a man in a chariot (*biga*) drawn by two winged horses [117].[8] The driver leans forward with a whip in his raised right hand, furiously racing the horses. He wears a short chiton, Ionian fashion, and his long hair is

have come to light at Vulci proper but also in numerous other localities, among them Orvieto and Chiusi. Exportation from a centre such as Vulci seems the most probable explanation of these statistics.[10] During the Late Archaic period the range of distribution of this interesting class of monuments comprised all Etruria, from Campania in the south to Bologna in the north.

The significance of the tablets for the general history of art obviously rests on their conscious

117. Tablet from Tarquinia, *c.* 530–520. Ivory.
Paris, Louvre

blown back by the opposing wind. All this is very elegantly carved, in minute detail; but the representation itself is neither very specific nor original. It repeats a rather common genre scene of which examples occur, for instance, among the Pontic vases.[9] The bulging outlines of the horses' necks, which form the bases of their short manes, also have parallels there. In the tablet the horses are equipped with wings, probably to indicate their swiftness. The stylistic connections with Pontic vases as well as the workmanship make it likely that the set originated in or near the place of its discovery, the Tarquinia–Vulci area. Other, later specimens

use of the picture frame. As panel compositions they signify a vast step forward from the Early Archaic 'metope' arrangements (above, p. 120). Now the frames enclose a properly understood picture field within which multiple actions are sometimes shown, and which is separated from its surroundings like a modern, framed painting, by broad, sometimes moulded bands. However, the attitude towards the picture field differs from modern habitual modes of composition. One notices a curious desire, almost compulsion, on the part of the artists to have the figures fill as much of the field as possible. Often a figure overlaps the frame; or the latter quite arbitrarily

cuts off parts of a representation which could not be accommodated within the field. That is to say, the interpretation of the field is primarily decorative, not so much as a space in which the figures and objects exist but as their geometric limitation. Yet the tension which arises in any composition designed for a frame, between the frame and the forms within, has begun to make itself felt, even though, at this stage, it is apt to be experienced as a struggle.

Bologna Situlae and Related Material

One group of monuments which is properly characteristic of the Etruscan north must yet be mentioned here: the class of situlae of which the large specimen from the Certosa, now in Bologna, offers the most famous example [118]. Among the other art of its time the group distinguishes itself both by a common, if provincial, style and by a special iconography. Most

118. Certosa situla from Bologna, third quarter of the sixth century. *Bologna, Museo Civico Archeologico*

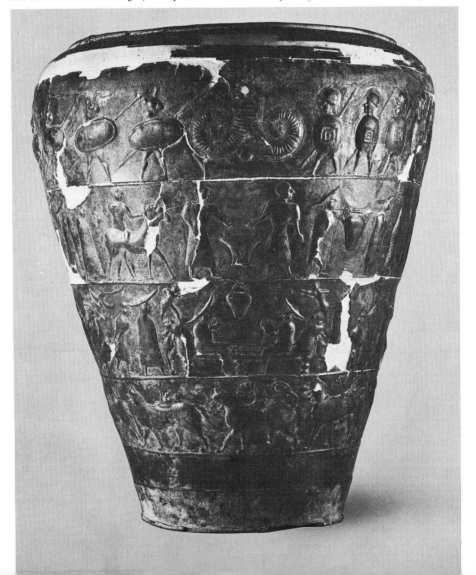

objects in this category are situlae made of bronze with decoration hammered into the thin metal, in the ancient technique of repoussé. The word situla is a Latin term describing a pail with a movable semicircular handle. The form was then not rare in Italy, especially in the north, where it was perhaps indigenous, or at least perfected, possibly under oriental influence.[11] At any rate the area of its greatest frequency lay north of the Apennines, in the regions round Bologna, Este, the Veneto, where the Etruscans never gained a foothold, and beyond, in central and western Europe. Amongst this large body of material our concern here is solely with the comparatively few specimens decorated with figural representations in a coherent style which was probably developed in or around Bologna. Together with these a small number of metal objects other than situlae must be listed, because their imagery drew on the same sources, as becomes evident both by their style and by their subject matter.

The pictured decoration typical of this group is usually arranged in friezes, often superimposed upon one another. All deal with matters of daily life. The presentation of the subject is apt to be highly detailed, almost pedantic. For all that, I would not call these representations true narratives, any more than the reliefs round the funeral chamber in an ancient Egyptian mastaba. Their spirit is epic, on a purely descriptive level. There is no drama, tension, or climactic action. Time passes leisurely in these compositions where every moment seems as important as the next.

Thus on the situla from the Certosa near Bologna one sees, in the top register, a parade of soldiers [118]. A long train of people follows, both men and women, bringing with them the riches of their rural life: fine cattle, a hunted stag, baskets, vessels filled presumably with delicious wine. In the third register a hunter lies in ambush behind a tree, trying to catch a hare in a trap [119]. And, as in the decoration of an Egyptian tomb, we are made aware of the purpose of such lavish preparations: the banquet is the end and climax of the rural epic. Its representation provides the reason why all the good

119. Detail of hunter and hare from the Certosa situla

things shown are being assembled. In the Certosa situla it is placed in the centre of the third frieze from the top, complete with couch, wine, and music.

Banquets, similarly represented, are also rendered on other situlae, though in no other example preserved are the details as vivid and entertaining as in the one at Bologna. Nor is the combination of the banquet with a parade or procession including armed men unique. It is noteworthy, however, that in some instances a third additional theme appears linked with the two already mentioned. This consists in representations of athletic games, usually boxing matches, as far as we can make out. Most commonly two contenders face one another over the prize that will go to the winner, in a symmetrical scheme very like the wrestlers in the Tomb of the Augurs at Tarquinia (above, p. 168).[12] The question arises what context of meaning, if any, binds these three themes together. The problem must seem the more interesting if one realizes that these very themes became the dominant subjects of all funerary art in Etruria after the Tomb of the Augurs: in the Etruscan tombs from now on over and over again we shall be shown banquets, games, and processions. The difference is that Etruscan art in each subsequent period was inclined to give its preference to just one of these themes; precisely as in the Tomb of the Augurs we find the athletic spectacles but neither a banquet nor a procession. From time to time the emphasis shifted from one to another. Only in the circle of the Bologna

situlae do all three themes occur simultaneously.[13]

In the Etruscan tombs there can be little doubt that all three themes represent varying aspects of the same event, namely, the funerary celebration. But what about the Bologna situlae? A banquet may be held for many different reasons. It is not necessarily a funerary feast. Only the realistic character of these representations cannot be doubted. It is amply demonstrated by the details of costume, furniture, and implements. For instance on the Certosa situla metal pails of almost the same type as the vessel itself are carried in the procession. Other vessels represent the familiar form of Villanovan biconical urns. Obviously the documentary value of these monuments is very high. Nevertheless it appears that their iconography, while developed locally for special purposes, was not without foreign prototypes. It shows definite, indeed telling, affinities to the Syro-Phoenician metal bowls which we have found on various occasions to have contributed so much to early Italian art. This observation holds good not alone of the technique, the arrangement of processions and episodes alike in parallel friezes, and the realistic tenor of the genre scenes; it is also borne out by details, especially in the rendering of the banquets.[14] To the imported schemes the native craftsmen added local colour, enlivening their pictures with that peculiar realism of detail, especially of costume, to which the popular arts of Italy so often owe their naive persuasiveness. But the motivation for all this imagery still escapes us. Not all the scenes portrayed on the situlae can be matched by examples from the Phoenician bowls. For instance, it appears that for reasons of their own the native artists freely introduced athletic contests into their representations. One must assume that in their experience contests, parades, and banquets belonged together, because these things happened together in their actual lives.

This coincidence with the iconography of the Etruscan tombs suggests that on the situlae also the same activities, at least upon occasion, represented events in honour of the deceased. When, as often happened, the situlae of this type were used in burials as containers of ashes, a funerary interpretation of their decoration is indeed indicated. In this respect, also, the analogy of the Egyptian tombs does not seem fortuitous. Here, as in Egypt, by the power of images, the joys of the living spilled over into the abodes of the dead. We must conclude that ancient, in fact Villanovan, folk ways such as these provided the background in actuality for the imagery that we see in the painted tombs of Etruria.[15]

Unfortunately no certain date can as yet be assigned to this group. General considerations of style, as well as the history of the region where these objects originated, make it likely that their production began at some time after the middle of the sixth century. The situla from the Certosa formed part of a tomb group which also contained Greek Late Archaic materials. For all that, it may have been in use for several years before reaching its final destination. Actually it gives the impression of being one of the earlier works of its kind. Later examples show a more worn style and a more perfunctory attitude towards the subject matter. The workshops which created these popular implements may well have stayed in business for a considerable time, even beyond the turn of the century, without a major change of style and repertoire.[16] At any rate, as a group, the Bologna situlae and the monuments related to them constitute the last instance known to us of orientalizing art in ancient Italy;[17] just as the rural society which they served and whose customs they so faithfully portrayed, for all the apparent comfort of its material condition, must be regarded as a provincial, belated offspring of the Villanovan culture.

120. Tarquinia, Tomb of the Lionesses, *c.* 520–510, end wall

PART THREE

THE LATE ARCHAIC PERIOD

CHAPTER 16

PAINTING AND METALWORK

TOMB PAINTINGS AT TARQUINIA

Tomb of the Lionesses

At Tarquinia the new period is ushered in by the magnificent paintings of the so-called Tomb of the Lionesses [120–2].[1] For the first time a change becomes apparent in the architectural order which had come into being, as we saw, shortly after the middle of the century. In the Tomb of the Lionesses the decorative divisions of the walls differ in important respects from the Archaic standard scheme exemplified, for instance, by the Tomb of the Augurs (above, pp. 168 ff.). The border zone of parallel stripes which there took the place of an architrave has

been omitted. This leaves two major horizontal divisions instead of the original three: the figured frieze, occupying the upper third of all four walls, and the dado. The latter is separated from the wall frieze by a border not unlike a wooden plank, which supports the figures and is in turn supported by a row of upside-down palmettes. There are also other irregularities. The dado represents water from which dolphins gaily jump; flying birds populate the free air overhead. Stranger still, wooden columns are painted in the four corners of the funerary chamber, and two similar columns divide the lateral friezes about the middle, cutting across the horizontal divisions. Thereby the placement of the frieze acquires an element of structural

121. Tarquinia, Tomb of the Lionesses, *c.* 520–510, Banqueter. Wall painting

unreality even more pronounced than in the Tomb of the Bulls (above, p. 165). On the other hand the pediments are treated as before. In the one to the rear, on either side of the central post, one finds the two animals which gave the tomb its name, although in fact they resemble female panthers more than lionesses.

These changes have symptomatic importance. They demonstrate the strength of the new concept of painting, valued as an art in its own right and growing ever more independent of the architectural order. Quite logically, in the ensuing evolution of Tarquinian mural decoration, the architectural concepts which formed its point of departure could not long be observed and became, in fact, dissolved. With the Tomb of the Lionesses wall painting in Tarquinia has entered into its third phase, or 'style'.

Simultaneously one notices a shift of thematic interest from games to banquets, enlivened by dancers. This change, also, proved symptomatic. The banquet was to remain a favourite theme of Etruscan art, even beyond the Archaic period.[2] Whether, round the walls of a tomb, such frolics represented the actual festivities of the living or a fabled life of bliss ascribed to the dead, it is difficult to decide. The distinction may not have weighed so heavily in antiquity as it would now. Even in real funerary celebrations the dead were easily thought of as silent partners in the joys of the living. Possibly the decoration of the dado contains a clue to the underlying idea. Are these the waters across which the dead were supposed to sail? The thought would add an element of Utopian fantasy to the happenings rendered in the frieze, but the matter is not at all certain. Neither is it unique; for instance in the Tomb of Hunting and Fishing (below, pp. 187 ff.) the upper contour of the dado was also transformed into a stylized representation of water, in a very similar fashion.

In their airy pavilion, open to the sea breezes, the banqueters recline, two on either side, husky young men with fashionably trimmed blond hair and short curly beards. The people on the rear wall, towards which they turn, one must assume to be entertainers. An enormous mixing bowl wreathed with vine leaves stands in the centre of that wall. Its size more than matches the bronze krater of Vix;[3] the ladle hangs near by. Across this imposing vessel two musicians face one another, one a lyre player, the other a flutist. Farther to the right a boy and girl perform a gay and rather suggestive pantomime. On the other side a richly robed and hooded young woman dances a solo to the accompaniment of her castanets.

Together, taken at face value, all this imagery represents genre painting pure and simple. There is nothing mythical about it. Even if the thought of a happy beyond was implied, the enjoyments it offered were earthly indeed. The style fits the mood. Especially in the design of the large and somewhat hefty limbs of the men, the love of broad forms and stout monumentality which we found in the Tomb of the Augurs still lingers on (above, p. 170). I count the Tomb of the Lionesses as a later instance of the same monumental style, closely related to the

122. Tarquinia, Tomb of the Lionesses, *c.* 520–510, Boy Flute-player. Wall painting

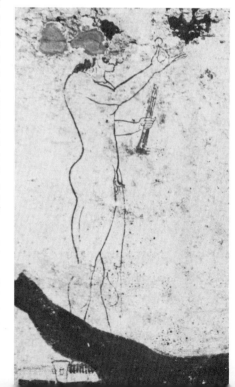

frieze of the Augurs but of more advanced date, *c.* 520–510. A new sense of refinement has been added to the massive forms, expressed chiefly in a much richer colour scale. The figure of the flamenco dancer represents a tour de force of Archaic painting composed of a variety of flat, decorative colour planes. Outline drawing, too, was on a high level: witness the delicate figure of a small flutist who faces the first diner on wall III [122]. I doubt that this puzzling character was intended to look androgynous, as has been suggested.[4] Rather the artist found some difficulty in rendering the childish form of a very young boy. As in other Archaic Etruscan paintings, children add to the fun at the banquet, as do the tame animals.

Tomb of Hunting and Fishing

This tomb consists of two connecting chambers [123–6].[5] In each the decorative order follows the Archaic standard scheme, with an upper zone of parallel stripes in lieu of an entablature. A chain of leaves and buds hangs from the lowest stripe in the first chamber. In the second chamber one finds the dado transformed into a seascape [125], in much the same manner as in the Tomb of the Lionesses.[6]

By far the greater portion of the wall space is given to figured friezes, interrupted only by the doors and, in the second chamber, by a niche in the right upper corner of the rear wall. In addition the pediments are also decorated. Together these representations form a most enjoyable ensemble, remarkable equally for its spirit, execution, and iconography. The pleasures of the banquet are combined with dance and music, as well as with the no less ancient funerary theme of the hunt. Merry-makers dance to the sound of a flute under high trees in the first chamber, on a plinth painted solid red [123]. The trees are hung with all sorts of desirable objects, perhaps prizes to be earned by the dancers. On the rear wall, above the door leading to the second

123. Tarquinia, Tomb of Hunting and Fishing, first chamber, *c.* 510–500, Dancers. Wall painting

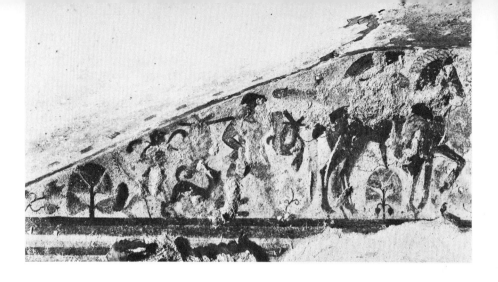

chamber, the pediment shows a hunting party in a forest [124]. Two of the hunters ride on horses; it is likely that they represent the masters. Obviously the same timeless situation which we know already from the Campana Tomb (above, p. 121) has here once more been illustrated. We shall not see it again, however. Apparently this once so popular topic was soon afterwards dropped from the Etruscan funerary repertoire. But certainly the forest had never been portrayed more alive, with so delectable a variety of plants, trees, and undergrowth.

Evidently the hunt above this door preludes the theme elaborated in the inner chamber. But here the sea is dominant, peopled with playing dolphins and little boats from which the boys spear fish or cast their hooked lines [125]. The hunters are striking young men who, one from a promontory and the other on a rock rising abruptly from the water, aim their slings at the crowd of birds which fills the air. From still another cliff – the highest – a boy dives into the sea before a small boat waiting to pick him up. The onlooker is reminded of the steep Tyrrhenian coast, say, below Cosa.

This vast panorama, in which the details follow each other without apparent formal constraint, stretches all around the room. From its upper delimitation, the striped 'architrave', hang wreaths of various design and colour. As in the first room, the coloration is gay and varie-

124-6. Tarquinia, Tomb of Hunting and Fishing, c. 510-500. Wall paintings

124 *(above)*. First chamber, pediment

125 *(opposite)*.
Second chamber, rear wall, lower frieze

126 *(below)*.
Second chamber, pediment, Banquet

gated, in contrast, for instance, to the more severe, more restricted colour scheme one remembers from the Tomb of the Augurs. Blue and greenish tints abound; black is almost absent. Only the outlines which describe the contours of boats, men, and animals range in tone from dark-brown to a near-black.

The convivial wreaths may be taken as a transitional element hinting at the banquet in

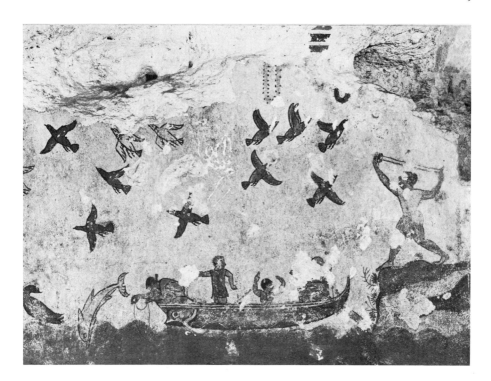

the pediment above the rear wall. Different from the Tomb of the Lionesses, however, the banquet here takes the form of the festive family meal which just about this time seems to emerge as a standard topic of Late Archaic Etruscan art [126]. A bearded man and a richly dressed woman recline on a low bench or mattress. The man holds a finely wrought drinking bowl in his left hand. His right rests on the shoulder of the woman. Her white right arm and hand are extended to touch his chest, while in the other hand she seems to offer him one of the ubiquitous chaplets. Smaller figures, possibly children, wait on the couple. The whole scene is strictly centralized; it is also divided, equally strictly, into a masculine and a feminine half. On the side of the man the younger boys serve as waiters. One is about to fetch a refill from the

large krater in the corner; a lyre hangs on the wall. On the side of the woman one sees a female flute-player and two seated young girls, all perhaps servants. The one near the corner seems to bind a wreath from materials contained in a low basket before her. Here the object on the wall represents a cylindrical box or basket with small feet and an arched handle, of a shape not unlike the later cistae from Palestrina.

Hardly sufficient attention has yet been paid to the diversity of compositional principles embodied in these various representations. The dancers in the first chamber do not form a truly continuous frieze; instead they tend to stage antithetical groups. More important still, the intrinsic continuity of the wall frieze is effectively countered by high trees which grow at regular intervals, thus enclosing each figure in a measured and framed field of its own. A similar ornamental tendency to emphasize 'panel' against 'frieze' composition appeared in Italian art as early as the Villanovan level (above, p. 36). The nearest parallels, however, to the dancers between the trees are found in orientalizing works such as the golden bracelets in the Vatican and their Phoenician prototypes (above, p. 69). To divide a frieze into rectangular panels was not a Greek habit. Therefore it becomes likely that the reappearance of this device in the Tomb of Hunting and Fishing was due rather to a domestic tradition.

The orientalizing scheme of composition cannot, however, explain another stylistic peculiarity of the same frieze, namely, the comparative smallness of its figures. The trees loom large above the human gaiety, conveying the idea of a pleasant grove, if not a forest. The seascape in the second chamber differs from this composition in so far as it forms a continuous, panoramic frieze; but it does share with the frieze of the dancers the small scale of the humans. This distinction by size, between people and environment, constitutes a matter of considerable importance. To have the human protagonists play their parts on so vast a stage of nature implies an interpretation of the human status itself. I should call this interpretation a naturalistic one; not only because in reality trees are often taller

than humans and mountains still higher, but also because an art which reduces human existence to something near its true size is apt, by the same token, to point up the independent character of man's natural surroundings. Every attempt in this direction revises visibly the balance between the human and the extra-human world. It presupposes a naturalistic outlook, even when all the details cannot be termed naturalistic by modern standards. The point is that in compositions of this kind the people, together with all other creatures shown, are contained by one large, wide-open world of nature. The painting makes it clear beyond doubt that this world exists wholly by itself and not only with reference to man, though man may inhabit it. In this impartiality towards the non-human manifestations of existence we recognize a trend which in Etruscan monuments had come to the fore previously, in the Tomb of the Bulls (above, pp. 165 ff.).

Among the prevailingly anthropocentric arts of antiquity the antecedents of this pictorial naturalism are not easy to trace. Certainly these dancers under trees and the hunters by the sea must be counted among the earliest representations on record, in any art, of peaceful people in a setting of landscape that actually contains them. Previously the Assyrian reliefs which narrated the king's wars had attempted something comparable, in their attention to scenery and their tendency to subordinate persons to setting.[7] But they are too far removed in time, geography, and purpose for us to allow any direct connection with the Etruscan paintings. Examples from Greek art are not altogether lacking, and nearer in time,[8] but they are neither frequent nor similar enough to be of substantial help in explaining this emergence of naturalism in Archaic Etruria. The littleness of man in his encounter with nature was not as a rule a theme of Greek art before the Hellenistic period.

There remains the question whether the general concept of naturalism which seems to permeate this imagery did not extend to the details as well, and ought to suggest that their obvious liveliness derived from immediate observation rather than tradition. Many of these

details give a very spontaneous impression; therein lies their charm. But the line between spontaneity and convention is difficult to draw in any ancient art. At least one figure which occurs twice in the second frieze, the striding hunter on a rock, can be recognized as a patterned image well known from yet another tradition of art, namely, Egyptian painting. In fact the entire frieze may be said to reproduce, however freely, a theme of Egyptian iconography: fishing on the Nile and the pursuit of jungle fowl.[9] The coincidence is probably not fortuitous, even though at present one cannot verify the means by which these foreign topics were communicated to Etruria.[10]

Another irregularity yet to be mentioned results from style rather than iconography. If one applies to every unit of this decoration the same criterion regarding the relative sizes of persons and environments, remarkable discrepancies become apparent. Only in the wall friezes does the world appear large, the figures small. In the two figured pediments the proportions are reversed. The hunters in the first pediment are represented taller than the trees among which they march. Moreover, each figure reaches to the full height of the frame. Consequently the illusion of airy space which characterizes the friezes is lacking. The banquet pediment in the second chamber follows the same tendency, even enhances it. In its grand design the drinking couple dominates the centre by mere mass. There is hardly an empty space left round the reclining diners, nor round the other figures which crowd inside the frame. Clearly this composition aims at monumentality at the expense of open space. It defines the pictorial forms as broad, flat areas of colour; zigzag folds appear only once, in the light-green border of the lady's coat. But all these internal differences notwithstanding there seems to be no need to speak of different styles, nor of different workshops in the decoration of this tomb. The smaller figures which populate the cliffs and the sea show the same bulging outlines and belong to the same stocky breed as the large banqueters above them. Nor is an air of spontaneity excluded from the monumentality of the upper painting. We are dealing not with two distinct styles but with two different modes of the same style, simultaneously employed: one more formal and monumental, the other more naturalistic, looser in its approach to composition and in the invention of postures and attitudes, more variable.

There is no ready explanation of this apparent anomaly. We must remember, however, that from early times the peoples of Italy were accustomed to the presence in their midst of competing artistic traditions both native and imported. Precepts of art could be interchanged more arbitrarily in these conditions than was possible in the more integrated societies of the ancient Mediterranean such as the Greek. The master who decorated the Tomb of Hunting and Fishing was obviously capable of more than one manner of composition. But within each unit the mode he has chosen was handled consistently and with full understanding. The unity of style in the resulting variety is maintained by the generally similar build of the human figures, be they large or small. The banquet pediment demonstrates his competence in monumental composition, paired with refinement of detail; it also shows most clearly the origin of his style. The drawing of the human form and the broad planes of colour are obviously related to the paintings in the Tomb of the Lionesses and, ultimately, to the Tomb of the Augurs: the artist may well have learned his trade in the workshop of the latter. We may date this tomb, approximately, to the last decade of the century. Postures and outlines of the figures indicate the Greek, Ionian substratum of this style. Contact with the atelier of the Caeretan hydriae likewise seems probable in a work which proves itself a descendant of the Tomb of the Augurs. Finally, a presumable connection with Caere and the Busiris Master can perhaps shed some light on the Egyptian reminiscences so freely transformed but nonetheless noticeable in the marine frieze. Such references to things Egyptian, possibly based on personal knowledge and utilized with an independent wit, seem to have been in the tradition of the Busiris Master himself (above, pp. 171 ff.).

127. Tarquinia, Tomb of the Baron, *c.* 500, rear wall

Tomb of the Baron

The name refers to Baron Kestner, whose efforts led to the discovery of this tomb in 1827.[11] Round the walls of the one burial-chamber the decoration follows the Archaic standard schema of a quasi-architectural division into three horizontal bands: parallel stripes in lieu of an architrave; in the middle a figured frieze which occupies approximately one half of the wall; and the bottom zone which assumes the function of a dado, although here it is not differentiated by colour from the rest of the wall, and is separated from the piece above solely by two parallel coloured lines. In addition, the pediments are also decorated, showing in the middle the base with concavely curving sides often seen in this place, supposedly supporting the roof-beam; the latter is painted a solid red. Two hippocamps, one on either side, are antithetically arranged left and right of the centre, each accompanied by two sportive dolphins [127].

The paintings, which count among the finest at Tarquinia, were executed in a quite unusual technique. The walls were not coated with plaster, as is the case in most other tombs of this period. Instead the figures were painted directly on the carefully levigated rock into which the tomb was carved, thus preserving the ivory tone of the natural stone. A greyish underpaint was used, however, to sketch broadly the outlines of each separate figure and object. It is still visible in many places, accompanying the final contours as a delicate and cloud-like foil. The colours themselves are solid and opaque, standing out strongly and with still undiminished brightness from the stone ground.

The most evident characteristic of the frieze is the formal, almost ceremonial conduct of all its personages. Instead of the vividness and vital exuberance which most Tarquinian tomb decoration of the Archaic and Early Classical periods liked to display, this artist preferred quiet elegance and a minimum of action. In the centre of the rear wall, the focus of attention, a well groomed gentleman with his arm round a blond boy who serves him as flute player, walks briskly towards a tall standing woman, apparently to offer her the drinking bowl in his outstretched left hand. The lady, likewise, is stylishly dressed, complete with diadem, large

128. Tarquinia, Tomb of the Baron, *c.* 500, rear wall, central group

earrings, and a dark-red mantilla falling over the shoulders from her high cap. She raises both hands in a gesture, most likely of greeting. Of all the scenes shown, their encounter comes closest to a definable action; we may accept it as a reminiscence of the obligatory drinking feast [128].

Two youths on horseback fill the fields left and right of this group, and two more lead horses from which they have dismounted, facing each other, on the right wall of the tomb. An almost identical group is seen on the opposite wall, where, however, the two young men seem to talk eagerly to a woman standing between them. Conceivably this group might portray the Dioscuri with Helen, or perhaps Leda, in the middle. But the context of the frieze hardly favours any mythical explanation. We see polite, courtly behaviour on all sides; not much really happens.

It seems likely that contemporary Greek vase painting set the pace for these unassuming exchanges of conversation: pictures of situations rather than actions. Here the new impact of Attic vases makes itself felt, alongside the persistent Ionian idiosyncrasies basic to this style.

Attic vase painting was then in its stage of transition from black-figured to red-figured representation; evidently the painter of the Tomb of the Baron was *au courant* with this development. Details of his design – folds of garments and the scarce indications of anatomy – are on a level with such Attic masters as Oltos or Euthymedes. The exquisitely painted group of the flute player and his merry master arranges two striding figures parallel to one another in such a way that the nearer almost overlaps the farther. This novel idea of grouping was almost certainly derived from an Attic source, probably a painted vase.[12] There is sufficient evidence, however, to show that for all his Greek borrowings the artist was actually trained in the local tradition. His predilection for rigidly centralized and heraldic composition hardly squares with prevailing Greek tastes.[13] Costumes are Etruscan, not Greek; and the avenue of equidistant trees, now already a familiar mark of Etruscan monuments, again separates and encases groups and individuals. Moreover, an analysis of form, especially of the principal group, can make it quite clear that one is dealing with a work due to a follower of the Augur Master. The differences between

his paintings and other decoration of the Augur group, for instance, the Tomb of the Lionesses, are more apparent than real: more of mood than of style. The Tomb of the Baron is, of course, the later work; I should date it near the year 500. But the contours, the stocky build of the men have not changed, in spite of the obvious refinement of detail. Among the details there appears here a new symptom which bears watching: the curiously decorative, undulating line representing eyebrows [128]. This mannerism seems difficult to match in Greek art, but it can be found in other works of Etruscan manufacture, as we shall soon learn. The chances are that it was also a manifestation of domestic taste. Symptoms such as these are evidence in fact of the progressive consolidation of a western, Etruscan tradition of monumental painting.

THE DESIGNING ARTS

Black-Figured Vase Painting

Even while in all likelihood the older workshops of the Pontic amphorae and Caeretan hydriae were still active, another generation of vase painters moved to the fore in Etruria, replacing with a new, black-figured style of design[14] the more polychrome manner practised by their elders. There can be little doubt that the change followed the example of the contemporary black-figured Attic ware. Nevertheless the relation between the black-figured vases of Etruria and their foreign counterparts is not easily described. Clearly the Etruscan vases were the products of a provincial craft, but many also display a vitality of their own; they represent something more than a mere extension of Greek art into Italy.

The status of vase painting among the competing arts can hardly have been the same in Etruria as in Greece. By Greek standards the history of the painted potteries of Etruria – their rather abrupt appearance at certain times in certain places, their often uneven stylistic development and quality of output – must be judged to be totally irregular. The coherence and logical progress that shaped the Greek tra-

dition are lacking. One may doubt if a continuous tradition of painted vases ever formed in Etruria. Individual ateliers were indeed founded and flourished; sometimes, perhaps, there were local schools comprising several workshops. But for the most part these industries existed one at a time. Connections between them, if any, are now difficult to ascertain. Rather, each new shop received its impulse directly from some contemporary Greek manner of style or technique. Yet we not rarely recognize the personal styles of artists with independent minds, even though their names be lost to us. If one were to list all their works alike as mere imitations, the measure of originality which certainly some of them exhibit would be unnoticed. Etruscan vases often emulate their foreign models successfully and sometimes judiciously. More often than not they relate to their famed prototypes rather freely; not unlike the way in which Delft porcelain is related to the Chinese original, to cite a more modern instance of transplanted crafts.

It follows that the contribution which the Etruscan black-figured vases were capable of making was to Etruscan, not to Greek art. Instances are not difficult to find which show that in regard to form as well as themes, these vases were very much a part of the Etruscan ambience. In turn, they also helped to build that ambience. By the same token they can yield valuable information about special conditions of art in Etruria, which differed from the Greek. In this respect the most obvious is a statistical fact, namely, the relative sparseness of their number, which contrasts conspicuously with the much larger output of the contemporary Greek industries. This is true in the absolute sense, although by itself the number of Etruscan black-figured vases still extant is not inconsiderable. The discrepancy becomes more striking, however, because so large a portion of this material is really no more than routine work, of quite mediocre quality and without much consequence for the history of art at large. The number of examples that matter therefore remains much smaller than the total output. Everything confirms the observation that after $c.$ 525 at the latest, vase painting

in Etruria can no longer be rated as a leading art. The nearest explanation of this anomaly is the circumstance that in Italy the native production competed with the genuine article – the imported originals – which were available even in the rural districts. Obviously there existed a market for the domestic substitutes also, but this was more limited in scope and volume. So it happened that towards the end of the Archaic period the Etruscan vases followed the Greek development at a strangely uneven pace, and often as a spirited commentary on the coveted wares from abroad which trade deposited on the Italian shores.

Another, more subtle factor may nevertheless have contributed, also, to make the history of black-figured vase painting in Etruria a rather special episode in the art of antiquity. For 'black-figured' means a manner of painting which demands that the use of colour, other than black, be severely restricted, if not eliminated. It thereby encourages a distinction between painting with colours and colourless drawing, as two different modes of the painter's art. In this development the art of ceramic decoration soon came to be defined more as a kind of drawing than a true painting. Representations rely on the outlines of figures filled in with black and silhouetted against the red ground of the vase. Etruria adopted the principle rather belatedly, hardly before the last quarter of the sixth century. At that time, to judge by the monuments, mural painting was the leading pictorial art of Etruria. On the side of the vase painters was the advantage that they could show a greater variety of themes. Nevertheless it seems that, compared to their Greek colleagues, they had to be content with a comparatively minor share in the formation of contemporary taste and, concomitantly, with a minor volume of trade.

Once adopted, the black-figured style stayed in Etruria for an extraordinarily long time. This fact again constitutes a significant anomaly, proper to the Etruscan condition. There is no certain explanation for it. By the time the first black-figured vases were made in Etruria, the transition from black- to red-figured represen-

tations was already in progress in the Greek ceramic workshops (cf. above, p. 193). By the beginning of the fifth century the superiority of the new mode had been generally accepted in Greece, and examples began to reach the Italian markets in quantity. Yet only about the middle of the Classical century do we find Etruscan vases in the red-figured technique; till then, most domestic products of Etruria continued in the antiquated black-figured manner.[15] At the same time, however, we find signs of experimentation with intermediary techniques, which tried to match the modern effects by painting figures in red colour on the black background of the vases. These data are difficult to interpret. Perhaps the native craftsmen shied away from a method that merely applied the black colour to areas around the figures represented. They insisted that to paint meant to shape figures *upon* the ground, by applying colour to the images themselves, which they regarded as the positive elements of their representations. For this reason they may have been reluctant to reverse the relation of ground and colour as happened in the genuine red-figured technique, where the images are really representations by default, i.e. areas of ground spared from the colour around them. If this explanation is accepted, the vase painters in Etruria may be said to have simply continued the older precepts which the painters of murals never entirely ceased to practise. In doing so they delayed appreciably the transition from Archaic to Classical habits of work.

The Micali Painter and his Contemporaries

The most interesting artist in this group apparently was the so-called Micali Painter. A considerable body of material has been assembled under this name, which is no more than a fictitious label, now generally accepted in order to refer to a person recognizable by work but not otherwise known to us. In addition to the vases directly attributable to this artist there are others more or less closely related to his production but not made by himself. It seems, then, that he had collaborators and followers. We must assume that for some time after c. 515[16] he

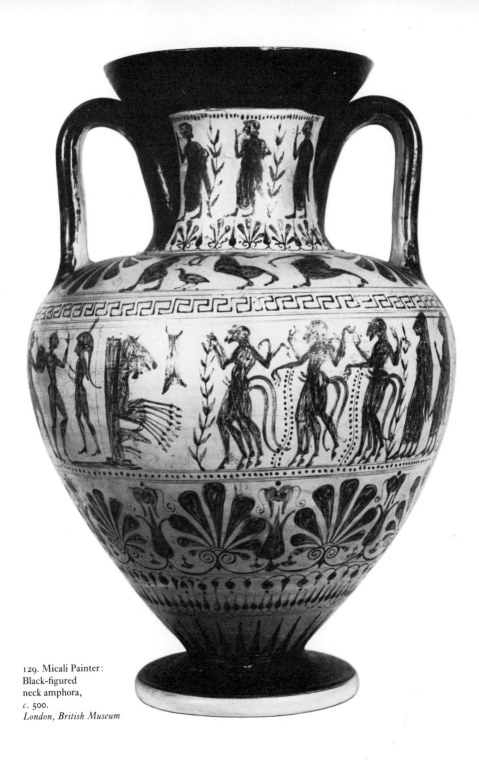

129. Micali Painter:
Black-figured
neck amphora,
c. 500.
London, British Museum

ran a very active workshop, possibly in Vulci, where many of his vases were found; but there can be no certainty about these matters. Some of his vases were exported into northern Etruria, though he himself seems to have been a resident of the south.[17]

Points of contact between his work and the contemporary Etruscan wall paintings are not difficult to spot. This is especially true of the earlier vases which probably mark the beginning of his career. A fine neck amphora in London[18] belongs to that class [129, 130]. The

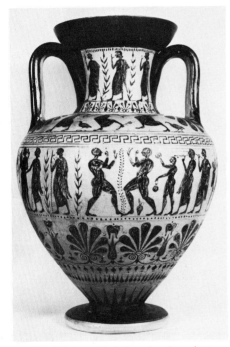

130. Micali Painter: Black-figured neck amphora (reverse), c. 500. London, British Museum

broad frieze around its body contains no less than twenty-nine figures, not counting the ingenious device which represents the forepart of four racing horses passing the winning-post; yet it does not look at all crowded. There is no need here to enumerate details, but it is interesting to observe that the iconography sticks closely to the themes which were also favourites in the

painted tombs: games, athletic contests, dances. The only significant difference results from a chorus of satyrs (or sileni?) which injects a note of mythology into an imagery otherwise of pure genre. Again we meet here the trees and shrubberies that break up parts of the frieze into metopic compartments, as happens so often in mural painting (above, p. 188). The dancers line up in groups of narrowly overlapping pairs. In short, one faces a near parallel to wall decoration, such for instance as that of the Tomb of the Baron, executed, however, in the new mode of black-figured vase painting. The latter comparison also gives a clue to the likely date of the London amphora: about 500 or slightly thereafter. The ladies' dresses boast stylish zigzag folds, and for the first time we encounter a soldier sporting the new form of the long-crested 'Attic' helmet.

The figures themselves are painted with a thin varnish, somewhat like wash drawings. Obviously their pastimes include a good deal of what the artist had actually seen and remembered, such as the highly entertaining sports events, or the parade of the ladies showing off their home-made costumes. Nevertheless, what sets this imagery apart from all possible Greek prototypes is a matter of style, even more than themes. The lilting attitudes, puppet-like agility, dangling stances are not Greek. Form here does not follow structure, as it does in Greek art. It is handled freely, adapted to passing needs and whims and hence exceedingly variable. It also is capable of distortions, a thinning here or a thickening there, as the case may be. These apparent vagaries are not accidents. A glance at the bulging outlines of the boxers or the litheness of the dancers convinces us that their maker knew what he was doing. With him even the calligraphic flourish turns into a happy paraphrase of something in reality.

This attitude towards artistic form, detached, uncommitted, and coupled with a penchant for the humorous, seems in keeping with the Etruscan tradition of painting (above, p. 191). It is indeed likely that the Micali Painter was in contact with the school of Tarquinia, at least at some point of his career. A neck amphora in

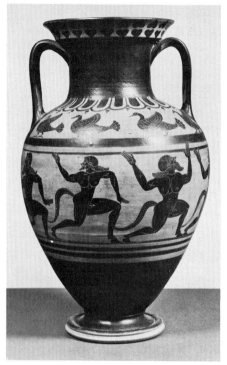

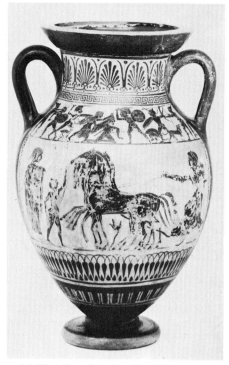

131. Micali Painter: Black-figured neck amphora, *c. 500–490. Baltimore, Walters Art Gallery*

132(A). Black-figured amphora from Vulci, *c. 490. Würzburg, Martin von Wagner Museum*

Baltimore[19] shows this quite clearly [131]. A row of running sileni, gesticulating wildly, fills the frieze. The gay monsters were painted in a different manner, more solidly than the lanky marionettes of the London amphora, and perhaps at a somewhat later time. Yet, the difference of chronology notwithstanding, their sturdy physique resembles nothing as much as the earlier but similarly posed dancer from the Tomb of the Lionesses (above, p. 186). For the ceramic artist, apparently, this was a study in monumentality.

Chiefly for the sake of contrast I conclude this necessarily brief report with a work of different character, and painted by a quite different hand, on an amphora in Würzburg[20] [132]. In the main field of the side here illustrated Athene departs on a chariot drawn by four horses. Above, a frieze: Aphrodite, with wings, rescues Aeneas

from the onslaught of Diomedes by making him invisible. The warriors' armour is like that of the Aegina sculptures. The style, generally, is on a level with the eastern pediment; it is hardly Archaic any more.

The painter, whose identity remains unknown, was well conversant with Greek art, which, however, he translated into a personal idiom of noticeably Etruscan flavour. Remarkable is the almost heraldic symmetry of his friezes, in which the action moves from both sides towards the middle (see above, p. 193). In the painting here selected the framing figures, one at either end, represent standing archers in antithetical attitudes. Further towards the centre striding warriors encounter each other in nearly identical postures. One duellist is shown frontally, while his opponent repeats his action, poised in the opposite direction and seen

132(B). Black-figured amphora from Vulci (detail), *c.* 490. *Würzburg, Martin von Wagner Museum*

133. Engraved mirror from southern Etruria, *c.* 500. Bronze. *Munich, Antikensammlungen*

from the back. This manner of composition with its calculated correspondence was destined for a long history in Hellenistic and Roman art, followed by a revival in the early Renaissance: for an example compare Pollaiuolo's 'Battle of the Nudes'.

Engraved Mirrors

By the end of the sixth century the earliest bronze mirrors with engraved decoration appear in Etruria, introducing a class of monuments which subsequently became one of the most cherished products of the Etruscan metal arts. At first the mirrors were shaped as circular discs, with a peg to be inserted into a handle of wood or bone. Later specimens are rather pear-shaped to provide a smoother transition to the handle. Mirror handles or stands in human form, popular in Greece and especially in Greek south Italy, never found much favour in Etruria. Decoration, if any, was usually engraved on the back of the disc. Occasionally, however, cast reliefs take the place of the more common engravings; apparently they were considered the costlier ornament. Either way, the decorated mirrors seem to have been an Etruscan speciality, unmatched in Greek art.[21]

A mirror in Munich, the design of which probably represents a dancing couple [133],[22] may illustrate these introductory notes. It is a remarkable work, interesting in many ways. Metal engraving as practised in ancient art was an exacting technique. There could be no thought of differentiating forms by any means other than the drawn lines. Colour and shading had to be resigned. These conditions, imposed on the craft by its working stuff, set the metal engravings aside from all other pictorial arts, including vase painting, where the different colours of ground and figures preserved at least one element of chromatic contrast. Engraving design was outline-drawing pure and simple. Its history consisted in the progressive refinement of the drawing itself.

Apparently, for the artists who practised this technique it was not advisable to improvise representations. Errors were not easily corrected,

and the metal on which the artist worked was valuable. We must assume that most of the time the draughtsmen used model drawings of one kind and another, which they transferred to the mirror. Otherwise one could hardly explain the omissions and false interpretations of detail which sometimes occur in their work. Thus the designer of the Munich mirror omitted the left contour of the woman, which one expects to appear between the right arm and leg of her male companion. Neither is it quite clear how he wished the mantle of the latter to be draped. Obviously the use of models helped the assuredness of his design but invited errors of another sort, which one may blame on the mechanics of copying.

The model of this mirror can scarcely have been a Greek work, though it incorporated Greek reminiscences. The adroit arrangement of the two figures in the circular frame is indebted to the tondo compositions on the inside of painted Attic drinking cups. Another reference to Greek art appears to be thematic rather than formal. Similar dances are frequently shown in Greek vase paintings, where, however, the dancers usually represent characters from the retinue of Dionysos. The free dance of individuals, as opposed to the collective discipline of choral dancing (above, p. 186), was then a rather novel theme of art. In Greek art it was from the beginning interpreted as an utterance of Bacchic frenzy. Towards the end of the Archaic period figures of solo dancers, single or in groups, make their appearance among the wall paintings of Etruscan tombs. The connection with Greek Bacchic representations is obvious. In Etruria, however, the performers are not as a rule the nymphs, maenads, or satyrs of Greek mythology. Mostly they seem to represent ordinary persons; they are entertainers, or perhaps the guests themselves, at the festive banquets. Thus in Etruria the Bacchic dances of Greek vases become demythologized and their gaiety part of a secular, not a religious imagery.

To these representations Etruscan art appended yet another innovation: pairs of men and women shown in embrace, as partners in

the dance. Greek art has no precedents for such bisexual groupings. They, also, are the proper symptoms of an Archaic Etruscan iconography.[23]

All available evidence points to southern Etruria as the homeland of Etruscan metal engraving. The closest relations of the mirror in Munich are among the Etruscan black-figured vases and the wall paintings. This is true of the style – figures broadly expanded on the flat surface of the metal disc – which seems directly related to the grand manner of design developed by the school of Tarquinia. It is equally true of the iconography, which falls in line with the Etruscan reinterpretation of Greek Bacchic dances. Possibly the choice of ivy for the ornament around the border reflects an original connection between the representation within and the world of Dionysos. On many other mirrors, both earlier and later, vine is used instead. Thus the running figure on a mirror in London[24] was inscribed into a wreath of vine. This figure compares well with the dancer from the Tomb of the Lionesses (above, p. 187), and may therefore be slightly older than the mirror in Munich. For the latter a date near 500 seems indicated both by details of costume, such as the pointed hat of the girl, and by the composition of the group as a whole.

One other Archaic mirror, now also in London,[25] ought to be mentioned here because of its provenance. It came from Palestrina, and may well have been a local product of this ancient town [134]. Praeneste was famous for its engraved bronze utensils, cistae, and mirrors, mostly in much later times; but evidently the industry was established already during the Archaic period.[26] The mirror in London is a rather curious object. The tall winged goddess attended by two young boys probably represents Aphrodite between Eros and Himeros – Love and Desire – being readied for her journey across the sea. This time the outer border consists of a wave-pattern. The boys are really children, naked except for their open Etruscan shoes. Conversely, the goddess wears her elaborate Etruscan boots, with small wings added. The style is quite different from that of the preceding mirror, and at first glance may look earlier than it probably is. It certainly belongs to another artistic province than the Vulcian or Tarquinian examples discussed above. The three figures do not bend to the surrounding circle; they stand severely vertical, parallel to one another. The forms of the goddess seem surprisingly heavy, almost stout. The apparent sturdiness of her form may be an archaism, or perhaps a provincialism; it was not repeated in the figures of the two boys. Actually the design is very fine. Lines are sensitively drawn, with a taste for curving fluency. The latter quality undoubtedly constitutes the most conspicuous characteristic of style of the London mirror, and contrasts noticeably with the angularity, for instance, of the dancers shown on the mirror in Munich. I should date the mirror from Palestrina somewhat later than the one in Munich, hardly before 490, although, admittedly, the diversity of their regional styles makes a meaningful comparison between these two monuments all but impossible. It may be worth noting, however, that Aphrodite on the London mirror has discarded the pointed hat so fashionable among the Etruscan ladies by the end of the sixth century. Instead she prefers a diadem not unlike the one worn by the Apollo from Veii (below, p. 238). In her strong, by no means inelegant form a sense of archaic monumentality has survived which recalls the older art of Caere, such as the painted Campana slabs.[27] But the apparent archaism can only be an echo of the past, nothing more. All other details place this mirror near the lower border, rather than the higher, of Archaic Etruscan art.

134. Engraved mirror from Palestrina, *c.* 490. Bronze. *London, British Museum*

CHAPTER 17

NORTHERN ETRURIA

Chiusi

Towards the end of the sixth century Chiusi emerged as the cultural and probably also the political centre of the Etruscan north. It is therefore perhaps no mere accident that the new cultural stir in this old provincial capital coincided with the traditional date of her semi-legendary king, Lars Porsenna, who according to the Etrusco-Latin annalists threw his power behind the unsuccessful venture of the Tarquins to restore the Etruscan monarchy in Rome. While the details of his chivalrous exploits must be assigned to saga, the rising wealth and cultural importance of his town, at precisely that period, cannot be doubted; they are well attested by the monuments. From the archaeological evidence alone one would conclude that by the end of the Archaic period, ancient Clusium had entered into a new phase of prosperity and cultural refinement which was to last well into the following, Classical century.[1]

There are also signs of more regular commerce than existed in the preceding period between Chiusi and the centres of southern and central Etruria. The insular aspect which the Etruscan culture of Chiusi presented throughout most of the sixth century derived from the long survival of Villanovan habits and beliefs apparently shared by the local population and expressed in forms and traditions not matched elsewhere. As the Archaic period drew to a close, however, two of the most characteristic and original local industries, the Canopic urns and the heavy bucchero, came to a standstill. Neither, it seems, survived the Archaic period.[2] Hence, Late Archaic art in Chiusi is characterized in part by a negative symptom, the cessation of long established local crafts. At the same time at least one domestic class of monuments, the carved stone cippi, rapidly gained in number and importance. Both developments must be credited to changes of cultural outlook, as well as new manners of style communicated through renewed contacts with other parts of Etruria. That these contacts included the city of Tarquinia, before others, seems by no means unlikely.

Tombs with painted decoration present a somewhat different though probably related problem. At Chiusi large, elaborate burials were at no time as common a luxury as, for instance, at Caere or Tarquinia. The number of painted tombs on record in the Chiusi region is relatively modest.[3] There are signs, however, of periodic fluctuations. At the head of the local series are placed two tombs which, with good likelihood, can be assigned to the beginning of the sixth century. This is as early a date as one may expect almost anywhere in Etruria.[4] But then follows a chronological gap. Not before the end of the Archaic period, at the earliest, can we resume the line of painted tombs at Chiusi. Of this and the immediately following Early Classical period, two important monuments have been preserved: the so-called Tomb of the Monkey and the Tomb of the Hill (below, pp. 274 ff.). Several others not actually preserved but known from sufficiently trustworthy documents can be added to their number.[5] Two fragments from a tomb datable approximately to the last quarter of the fifth century conclude the list.[6] No certain information is available at present regarding tomb paintings later than the fifth century.

The chronological evidence of these finds, incomplete as they are, may yet be of help in reconstructing the cultural history of this northern fortress town. They indicate, firstly, a time of comparative isolation during the greater part of the sixth century. Within this time of concentration on native resources fell the flowering period of the local folk art. Secondly, the finds show a conspicuous renewal of interest in

monumental painting, beginning around 500 and sustained for at least one generation, during the time of transition from Late Archaic to Early Classical art. This revival was apparently in keeping with the standards of the urban societies in southern and central Etruria; it did not arise from a consistent local tradition. In the renewed popularity at that time of tombs decorated with painting, one may recognize another facet of the ambitious and expansive age to which Porsenna lent his name.

Bronze Statuettes

At about this time, the decades immediately before and after 500, a new influx of modern trends makes itself felt among the bronze statuettes attributable to northern centres. It is of course a mere hypothesis, if a likely one, that Chiusi was the seat of the principal workshops which produced the indigenous bronzes of the Etruscan north.[7] The hypothesis is strengthened, however, by the fluctuations of style and quality which one encounters in this material, much as in other Archaic art from the area. Apparently the three chronological divisions suggested above apply to the bronzes as well. The fine statuettes from Brolio represent the first stage, about contemporary with the earliest painted tombs at Chiusi (above, pp. 97–9). They combine international polish with regional traits. The series of Early and Middle Archaic provincial types follows, such as the skirted kouroi which were first produced at Chiusi but spread subsequently throughout the northern territory, retaining their popular appeal almost to the end of the century (above, pp. 99 ff.). Much of this material is of a low and cursory quality, not only in the secondary centres like Fiesole, but also in Chiusi proper.[8] It is, however, typical of the prevalence of folk art in this region, characterized by the persistent repetitions of local types that would appear outdated in parts of the country more sensitive to international changes.

The third stage, reflecting renewed contacts between Chiusi and the world abroad, is represented by Late Archaic statuettes of a clearly

135. Statuette of a kouros from Chiusi, late sixth century. Bronze. *London, British Museum*

different inspiration. To this class belong the standing kouros of our illustration 135, or the javelin-thrower of illustration 136, both from Chiusi.[9] Both are regional works no less than the foregoing; but it is obvious that their makers were aiming at new standards of quality. In their formation the regional habits rather became a source of strength and originality. The foreign reminiscences of style which these statuettes in-

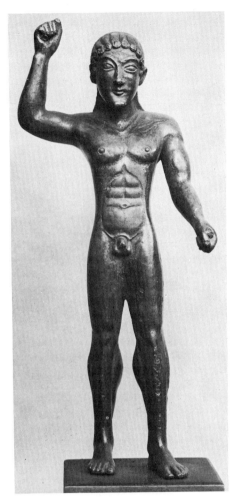

136. Statuette of a javelin-thrower from Chiusi, end of the sixth century. Bronze. *London, British Museum*

of type and detail notwithstanding. Short-legged, with bulging outlines growing thicker below the waist, they face us squarely. Their peculiar proportion bespeaks the local habitude; so does the unwillingness to move forward that is common to both. Their reluctant walk contrasts noticeably with the new expression of alertness in the faces; the result is a contradictory effect, as of pent-up energy. Any Greek figure on the same stylistic level would step more briskly.

The standing youth may be dated near the year 500. Perhaps the javelin-thrower ought to be placed somewhat later, because of details such as the modelling of the knees, and the lighter stance. Indeed his face, with its emphatically outlined and broadly spaced features, seems already beyond the borderline that separates Archaic from Early Classical.[10] But neither statuette appears to copy a Greek prototype directly. We must assume that the new iconographic types were communicated to the northern capital from one of the Etruscan centres farther south, such as Vulci.

Reliefs

A speciality of Chiusi are the finely designed reliefs which have long been recognized as a group by themselves, comprising among their number some of the best examples of early Etruscan stone carving. The number of specimens extant is considerable; their material, with few exceptions, is the local limestone (*pietra fetida*).[11] All examples preserved apparently served funerary purposes. The majority are bases supporting cippi – the more or less spherical or bulbous, aniconic markers of tombs. Some decorate urns: boxlike, rectangular containers of ashes. A very small minority were carved into the outer walls of sarcophagi. Interment still occurred rarely in Chiusi, where, apparently, the persistent Villanovan tradition did not encourage this manner of burial.

The oldest monuments in this group were circular bases, perhaps in some instances stacked one upon another, with diameters diminishing in the higher drums. These strange monuments

corporate are quite unequal, as happens often in Etruria: eastern Greek with the standing youth; Attic or, more likely, Peloponnesian with the javelin-thrower. Etruscan workshops were never choosy about the provenance of their models. The finished product, its formal disposition and temperament, at any rate remained their own. Thus the way both figures are set up is very nearly the same, their diversity

started in the Early Archaic period.[12] By the middle of the sixth century rectangular blocks had become the rule. The workshops turning out these stones remained in business for at least another hundred years. The latest specimens known to us date to the middle decades of the fifth century. At that time or soon afterwards, the custom of erecting these monuments apparently died out.[13] The bulk of the material, however, belongs to the Late Archaic and Early Classical periods, approximately between 520 and 470. It seems therefore appropriate here to insert a discussion of these reliefs, although the chronological duration of the group as a whole transcends the limits of the chapter.

Apparently the rectangular bases constituted the leading form. The circular bases were mostly forerunners; the later urns and sarcophagi, derivative variations. Among the rectangular bases themselves, four types can be distinguished by criteria relating to proportions and decorative detail.[14] The bases which one may count as Types I and II tend to be high and narrow, with slanting walls. Moreover, in the second type the representations on each facet are often framed by vertical borders which interrupt the original continuity of the decoration around the monument. By contrast, the blocks of Types III and IV expand in the horizontal direction, and the last type produced rather low bases with oblong, frieze-like reliefs. Heavy, sometimes elaborate mouldings, with or without decoration, frame the representations above and below. But vertical borders are dispensed with in both types in which the figured reliefs remain open on either side.

In so far as the Early Archaic bases replaced the cylindrical form in vogue before the rectangular blocks, and the latest reliefs by style fall into the category here called Type IV, one may assume that the four types represent a chronological sequence. Nevertheless, in detail the sequence is far from clear. Apparently the types overlapped. The changes of style which one observes, especially within the Late Archaic and Early Classical groups, do not coincide precisely with the typological changes. For instance

the reliefs on the rectangular bases of Type II appear to form a homogeneous group. Their style is on a level, approximately, with the Tomb of the Lionesses at Tarquinia (above, pp. 185 ff.). The imagery is wholly Etruscan, with the dancers and musicians of the funeral feast furnishing the favourite theme. Also in this respect the Tarquinia tombs offer the closest parallel. The relief is uniformly flat. This is true of the entire class; because the surface modelling is often exceedingly delicate, with details designed in an almost linear fashion, the total effect in many cases resembles a drawing. Frequently in the reliefs of Type II the figures appear peculiarly elongated. Their surfaces show a preference for broad planes, interrupted by comparatively scarce details such as folds or borders of garments: again, these characteristics seem related to Tarquinian painting of the last quarter of the sixth century. The elongated figures have their counterparts in late vases, especially the work of the Micali Painter (above, pp. 195 ff.). The monumental style resembles that of the wall paintings. The reliefs may be dated accordingly, between 520 and 500. During the same decades, however, bases of the antiquated cylindrical type continued to be produced in Chiusi, with representations in the then modern manner.[15]

The accompanying relief [137] illustrates this stylistic phase well.[16] It stems from an ash urn, not a base; the long side here reproduced represents a banquet of young men. The bulging torus on which the box sits seems to align it with the earliest bases of Type III, but the style of the reliefs agrees better with the second type. The relief is very flat, of a somewhat soapy quality, and more reminiscent of the contemporary ivory tablets (above, pp. 180–1) than of painting. Tablets were easily transported. Their presence in Chiusi, which is attested, may have aided the local masons to develop this characteristic manner of carving. It can also help to explain the similitude which the reliefs of the urn in Florence, and others like it, bear to the art of Tarquinia and Vulci. This is true of the grandly designed monumental forms as well as

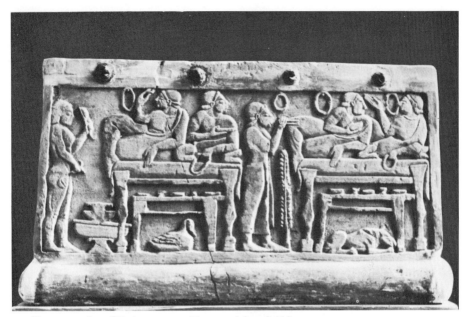

137. Cinerary urn from Chiusi, *c.* 520–500. Limestone (pietra fetida). *Florence, Museo Archeologico*

the predilection for angular outlines. The composition fills the picture field almost to exhaustion; more figures could hardly be accommodated. It obviously is sensitive to the impact a frame can have on the images within; and as was often true of the ivory tablets, the frame, here also, is felt as a constriction. The rectangularity of the design within seems to respond to the angularity of the frame. Thus, each of the two groups of merrymakers on their high benches adjusts itself very nearly to the outlines of a square. Their robust limbs counteract, and at the same time occupy fully, the geometric limits they are allowed. Festive wreaths along the walls are supposed to heighten the pleasure but in fact seem to be in everybody's way, as if hung from the crowded ceiling of a ship's kitchen.

By contrast, the reliefs of the third type give the impression that a new set of artists was at work. For all that, the earlier reliefs in this group were almost certainly contemporaries, not successors, of Type II. The difference between the two groups resides primarily in their iconographies; though differences of style also eventually become apparent. Among the monuments of the third type the variety of themes represented surpasses those of Type II. The dancers continue, but more often than not they are joined by mourners around a body lying in state, shown on another side of the same monument; on still another side young men on horseback perform the memorial games, this time represented as horse races. Even more interesting are two scenes which apparently occur only on bases of Type III. Their explanation is not certain, but it is clear that the situations to which they refer complement each other, especially when they appear on the same monument as they do on the base in Munich [138, 139].[17] Each representation consists of five persons, three standing and two seated, distributed each time according to the same symmetrical scheme. In one scene a lady stands in

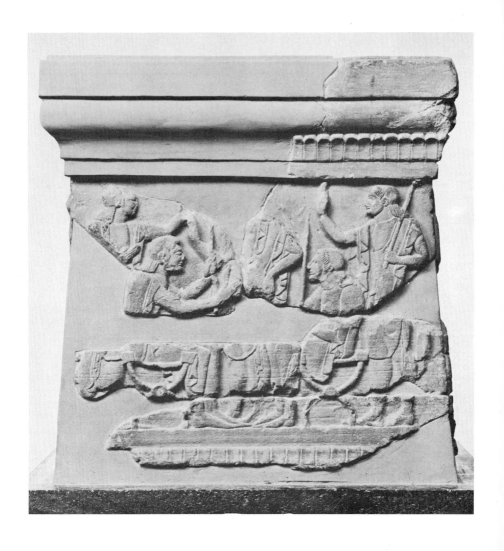

138. Cippus base from Chiusi, *c.* 500–490. Limestone (pietra fetida). *Munich, Antikensammlungen*

the middle of a group of women, to let her companions admire her wardrobe: a trousseau-party for the bride? In the opposite relief a young man holds the centre, two others sit on curule chairs clutching their sceptres, which end in crooked finials (the *lituus*?), and all argue eagerly. Their significance also is not securely known. I share the older opinion, which was lately contested, that the seated personages are magistrates. These scenes transport us into the midst of Etruscan city life. Both possibly deal with aspects of a common theme, that is, wedding and marriage. As home is the ladies' domain, so the place of a man is in the assembly; but his title to it rests on his claim to be the master of a household. On a funeral monument these representations acquire a significance

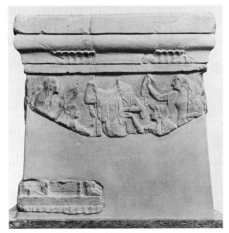

139. Cippus base from Chiusi, *c.* 500–490. Limestone (pietra fetida). *Munich, Antikensammlungen*

comparable to the illustrations of marriage ceremonies and acts of public office on Roman sarcophagi of the second century A.D. They deal with the social conditions of human existence; and in this way, as an accomplishment in society, they describe the fulfilment of a life laudably ended.

The representational style of the base in Munich [138, 139] differs from that of the reliefs of the second type, and even from the earlier

specimens of Type III. It is considerably finer, aiming at elegance rather than monumentality. Details have become more numerous and minute. One notices a fresh interest in Attic vase paintings and, concomitant with it, a sharpened sense of accuracy in the use of forms and lines. The choice of actions has widened, and gestures and postures are freer. Moreover, in the monuments of Type III, of which the base in Munich is the outstanding representative, the mouldings above and below the reliefs often feature a simple tongue pattern.[18] All signs indicate an advanced date for this base and its stylistic relatives, which may tentatively be set in the decade from 500 to 490 or slightly beyond. The looks have changed, of ornaments, figures, and garments alike. With the advent of the novel manner of multiple forms dividing the once broad and almost undivided planes, the hegemony of the Tarquinia wall paintings and the monumental style, then already over a generation old, began to wane.

Characteristic of the entire series of the Chiusi reliefs is the almost total absence of mythical subject matter.[19] Their themes are for the most part mundane, as in so much Etruscan art, and may be classified as genre in the sense considered above, p. 186. Yet, as was true of these previous occasions, we observe here a progress from generic concepts to more specific meanings. In the earlier Chiusi bases the universal theme, death, was not mentioned directly. It was only alluded to by the illustrations of rites which accompany the funeral, such as dances or, less frequently, athletic spectacles. Apparently the tendency was from the outset to emphasize the social circumstances attending human deaths, in a way which differs little from the earlier Tarquinia tomb paintings. Thus the dancers seem quite impersonal beings. It happens that, like the banqueters, they mingle occasionally with mythology. Often they leave the outsider in doubt as to the degree of reality he ought to ascribe to them.[20] Their uncertain status, likewise, recalls the paintings at Tarquinia (above, pp. 185 ff.).

The scenes of lamentation which appear on the Chiusi bases after *c.* 530 are quite another

matter. One sees the dead surrounded by their mourners. The situation is pointedly real, and among the mourners types, if not persons, are often depicted very movingly, by characteristics of age and attitude.[21] Similarly the gatherings of the women at home, and the men in the assembly, illustrate special social situations.[22] In this cultural climate the fact that these are scenes neither of myth nor narrative rather turns to their advantage. Etruscan art, it seems, thrived on themes such as these which face the life at hand directly, without a mythical detour.

The adaptation to this new and local purpose of a Greek Archaic style appears perfect and seamless.[23] Yet it must not be forgotten that Greek art itself at the time of Late Archaism was apt to encourage this Etruscan worldliness. Just then, Greece was going through one of the most naturalistically minded stages of her own intellectual history. One symptom of this condition in the arts was a relatively high incidence of genre scenes – testimonies of a sharpened attention to ordinary human events – also among contemporary Greek vase paintings.

CHAPTER 18

SCULPTURE IN BRONZE AND STONE

THE BRONZE WORKSHOPS
OF SOUTHERN ETRURIA

Tarquinia Shields

In contrast to the northern towns, stone sculpture was on the decline in the Etruscan south towards the end of the Archaic period. The low point was reached around 500, to judge from the extant finds. This observation seems to apply with equal force to reliefs and to statuary. Hardly any stone work of southern provenance can be dated to the decades of Late Archaism. Instead one notices a sudden upsurge of activity in the ancient bronze industries of the region; and large terracotta sculpture attained an all-time height, most obvious in the output of the Caeretan and Veientine workshops.

About the location of the leading bronze workshops in southern Etruria one cannot be so certain, but we can recognize at least some of their characteristic products, and the relative frequency with which these works occur in certain places indicates to us with a fair chance of likelihood the centres of their production. Thus the evidence points to the territories of Tarquinia and Vulci, the two neighbouring cities always closely related culturally, as the home of the most important ateliers which just then began to establish the reputation, soon to spread throughout the ancient world, of the fine Etruscan bronzes. Between these two centres, Vulci seems to take most of the credit for this new development. For the first time, owing to the inventiveness and skill of her bronze artists, a branch of Etruscan art won international recognition.[1]

A class of certainly Tarquinian origin was the so-called shields with masks as their central decoration, many of which can be traced to tombs of the Tarquinia region. Actually, these strange monuments were not shields but circu-

lar plaques of hammered bronze designed, most likely, as ornaments of furniture [140].[2] Their principal purpose, apparently, was funerary. In the tombs they seem to have been attached to the wooden beds of the dead; but occasionally the same types of masks appear to have been joined also to other objects such as wooden boxes, or even the walls of a cart or chariot.[3] Apparently their use was generally confined to the territory of Tarquinia, though isolated cases of exportation are known, for instance from the region of Perugia.[4]

The sizes of the Tarquinia shields vary, but their form is standard. A broad, raised moulding forms the frame round the central mask, which was likewise hammered, but worked separately before being joined to the central field. Some represent the heads of rams or lions, others show masks of mythical beings. Among the latter, one type especially invites attention. It depicts a male face, moustached and bearded, with two small horns growing from its forehead [140]. In Greek art this was the traditional image of the river-god Achelous, and therefore the Tarquinian masks, also, have often been so named. Yet it is doubtful if a mythology so ex-

140. Mask of 'Achelous' on a 'shield' from Tarquinia, *c.* 520–510. Bronze. *Vatican, Museo Gregoriano Etrusco*

clusively Greek applies here. More likely one might describe this demonic face as the bull-horned Dionysos, since other masks belonging to the same class often represent Bacchic company, such as satyrs.[5] But then the Bull-Man had long before this time been established in Italian folklore as a demon or deity in his own right (above, p. 136). His grinning mask may well have been trusted to avert the spirits of evil intention, by whatever name people referred to the owner. On the shields, at any event, it took its place among the guardians of the dead.

Production of the Tarquinia shields seems to have started about 520, though most extant specimens probably belong to a somewhat later time, nearer the year 500.[6] Their style is unmistakably Tarquinian. The well-groomed Achelous masks, especially, are the close cousins of the elegant and frivolous *bon-vivants* gathered around the walls of the Tomb of the Lionesses (above, pp. 185 ff.). The shield here illustrated [140] may be their exact contemporary and hence be tentatively assigned to the same decade, *c.* 520–510.

Tripods from Vulci

The attribution to the city of Vulci of the most outstanding Etruscan bronze industries at work during the Late Archaic and Early Classical periods also is no more than a hypothesis. It is, however, an opinion now commonly shared; and a considerable body of facts can be rallied to its support. Amongst them, an easily recognized group of rod tripods proved of special significance because its members can be ascribed to Vulcian workshops with a high degree of likelihood. As with the Tarquinian shields, actual finds, in this case within the necropoleis of Vulci, have made this conclusion, if not certain, at least very probable.

The monuments at issue are richly decorated bronze tripods of a distinctive type.[7] The following are the chief characteristics [141]. Six supporting rods rise obliquely, narrowing towards the top, to form three high arches. At the broad base the ends of the two oblique rods next to

each other are held together by a low, solid foot. From the resulting three feet grows between the two oblique rods still another, perfectly straight rod which, not unlike a column, carries statuettes or statuette groups on its top. In addition, two more or less horizontal rods issue from the back of each foot towards a central ring, thereby providing a stable, if perforated, base for the entire structure. All supporting rods lean inwards. This tapering, airy scaffolding carries on

141. Tripod from Vulci, *c.* 510–490. Bronze. *Vatican, Museo Gregoriano Etrusco*

its top a heavily moulded round basin. It is special to these Vulcian products that, different from the Greek rod tripods, they do not carry the traditional cauldron or *lebes* but a charcoal basin. They served as portable stoves.

As mere objects these tripods ought to be listed with industrial art. Yet the interest of their

oldest specimen of the series [142]. This tripod still carries the traditional *lebes* on a thin and wiry structure, the only adornment of which are two horse protomes alternating with two lion heads around the double ring on which the vessel was placed. Horse protomes, similarly placed if different in style, can also be found on a tripod of exquisite workmanship in Berlin, discovered at Metapontum in Calabria but probably made at Taranto.[8] The horses' heads on the tripod from Populonia, with their upright rather than hanging manes, are of more recent date and scarcely older than 530. They do indicate a typical relation, however, to the earlier Greek tripod in Berlin and thereby to the art of western Greece. We may then assume that from beginnings such as these the established type of the Vulcian tripods developed within a quarter of a century approximately.

Lyre-shaped spirals hanging from the supporting arches and bordered by a fringe of palmettes and acorns – the latter usually rendered more lovingly than the former – became a distinguishing mark in this class of tripods [143]. Examples like the one here illustrated,[9]

143. Hanging spirals on a tripod of Vulci type, early fifth century. Bronze.
New York, Metropolitan Museum of Art

142. Tripod from Populonia, *c.* 530. Bronze.
Copenhagen, National Museum

details transcends their simple, practical purpose. Besides, the circumstances attending their beginnings ought to interest us. First in importance is the prospect of an initial link to the Greek art of south Italy. If, as seems plausible, the tripod from Populonia, now in Copenhagen, really was of Vulcian origin it would be the

which show the mature stage of this decoration, probably date past the year 500. Apparently the production of these characteristic implements continued into the first Early Classical decade, between 480 and 470 (see below, pp. 221 ff.). With regard to their stylistic development, still another observation is due here. As often happens in Etruscan art, the final products of the local evolution deviate from Greek parallels by their accumulation of ornament; in turn, this special tendency predicates a new and clearly un-Greek order of form.[10] Yet for all their Etruscan exuberance the Vulci tripods gained wide popularity. They were exported far beyond their homeland, even into Greece.[11] Moreover the statuettes invented for their embellishment, as well as those attached to other contemporary metal implements, gave rise to a new interest in small bronze sculpture among the Etruscan workshops themselves. A prodigious output of bronze statuettes, of a hitherto unheard-of variety and freshness, still bears witness to these innovations.

Decorative Bronze Statuettes: Incense Burners and Tripods

The idea of using statues or statuettes for the decoration of practical objects was not new, nor limited to Archaic art, nor particularly Etruscan. Caryatids, that is human figures employed as supporting members of architecture or, on a smaller scale, as carriers of various kinds of utensils, were at this time as later an accepted device of Greek art. One example, the Greek type of standing mirrors held up by human statuettes, has been mentioned previously (above, p. 201). In the Late Archaic art of Etruria, however, the small sculpture put to decorative uses seems to have acquired a special significance. All the independent, that is to say not decorative, bronzes considered in our previous chapters were ex votos, dedicated to deity: they served a religious purpose. Statuettes decorating practical utensils such as a tripod were another matter. They owed their existence to a desire for luxury lavished on things of ordinary use. At least this was their primary purpose. Eventually, some of these objects may well have found their way into sacred precincts also, and certainly most of those still preserved ended their useful lives as gifts to the dead. But essentially they must be regarded as secular, not religious. They also constituted a class of private, not public art.

The variety of themes found among bronzes of this kind, and the variety of ways in which these themes were represented, are astonishing and delightful. It seems reasonable to assume that the new freedom of invention manifested in the small sculpture was somehow dependent on its private character. The principal problem before the sculptors at the end of the Archaic period was probably the same on either side of the Adriatic: to free their art from the constraint of a comparatively few representational types – stepping kouroi, figures enthroned, standing korae, etc. – and to endow their statues with the same agility, and the same variability of a situation, which the painters had long enjoyed. It seems that the lesser public commitment, and perhaps a certain unawareness of the severe formal logic which imparted its unerring firmness to Greek sculpture, made the task easier for the Etruscans. Their price for success was to be eloquent and impressionable and to respond readily to whatever chance brought before them, be it direct observation of reality or another work of art; but rarely to be exemplary.

Three types of useful objects, above others, encouraged this thematic expansion in the plastic arts: in addition to the already described tripods there were the incense burners of bronze (*thymateria*) and the high candleholders (or candelabra, as they are often called).[12] None of these three types constituted a novelty in itself, but all received new shapes, ushering in the Classical period, during the decades between 500 and 470. In the changes of style and attitude to which all these small works testify, the ateliers of Vulci had their incontestable share; though one ought not to forget that the possible contributions of other Etruscan centres can hardly as yet be justly calculated.

First among the many examples we should mention an elaborate incense burner in the

Vatican, which may confidently be assigned to a workshop at Vulci [144].[13] It exhibits a rather surprising combination of forms. The lower base, triangular with curving sides, rises on three feline (or canine?) feet, each supported by a pointed acorn-like object. On each end of its three-pronged surface rests a crouching dog; two are still in place. With heads turned back, they seem to watch the smaller and likewise triangular, solid upper base, from the corners of which sprout three flower buds, rather incongruously. The boy who stands on the upper base carries on his head a high, well-turned stem. The latter, in turn, is divided into three sections by way of two superimposed discs resembling umbrellas, fashioned from overhanging leaves. The uppermost section probably carried the incense bowl, now lost. Only two gracefully bending leaves and, between them, a flower bud in the form of a hanging hook have survived.

Viewed as a whole, this seems very much an Etruscan piece of furniture. Details such as the vegetable umbrellas, or the narrow, overhanging leaves and the bud on top, seem to hark back to earlier local styles of metalwork, including reminiscences of Italo-Orientalizing and even Villanovan decorative habits (above, Chapter 6, p. 82). Actually the type of incense burner shaped as a tripod, on feet formed as animal claws or legs and with a human statuette supporting the bowl on top, had closely related forerunners in the Near East, dating from the eighth and seventh centuries.[14] To this scheme the Etruscans introduced the higher shaft and, especially, a new variety of supporting figure which replaced the earlier caryatids. Thus with the incense bowl in the Vatican, the statuette of the standing boy has been incorporated as a carrier. Moreover it will be seen at a glance that the boy does not act the part of a carrier: he does not appear in the least concerned with the burner placed on his head. A similar independence from the carrying function is characteristic of many other Etruscan decorative statuettes. Obviously their makers thought of them primarily as images in their own right. The final effect is that of a monument put to-

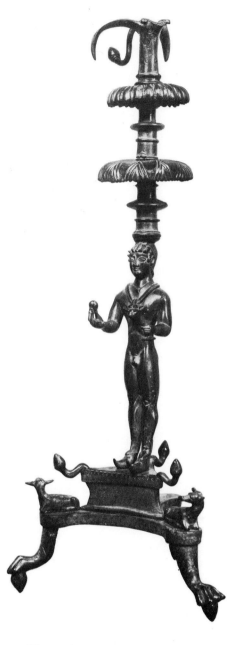

144. Thymaterium (incense burner) from Vulci, end of the sixth century. Bronze.
Vatican, Museo Gregoriano Etrusco

gether from many incongruous parts, some real, others sheer invention, some functional, such as the elegant double base, others representational, and still others decorative, semi-representational. The logic of their sequence is formal but hardly reasonable. So this strange object grows as a man-made tree or plant: an early forerunner of those lightly growing fantasies, the decorative candelabra of Roman and later still of Italian Renaissance art. The fantasy, we may conclude, was Etruscan by origin and temper.

The statuette of the boy serves us as a reminder that the archaic Greek type, the kouros, was indeed well known in Etruria by the end of the sixth century [144]. Yet no less obviously it either was not truly understood or, at least, not accepted as a total commitment. One may describe the statuette under the Vatican censer as a nude kouros in soft Etruscan shoes; which description amounts to a denial of the authentic meaning inherent in the Greek image type which we are wont to call kouros. The young boy stands straight as a votary but holds out a fruit and a drinking vessel, scarcely addressing himself to deity but to some nearer audience. We have no explanation for his oversized necklace, with the animal's head as a pendant.[15] On the whole, he looks and behaves much as an attendant would at an Etruscan banquet. The Greek prototype of kouros was followed, to an extent; but its austere withdrawal from the social nexus was negated. Instead the Etruscan artist turned the statuary situation into one of privacy and social contingency. This work is finer and more formally accomplished than were the northern statuettes considered in the preceding chapter. But the Etruscan idiosyncrasies remain recognizable nevertheless: the hesitant walk, and a certain heaviness, especially of the lower portions, both seemingly remnants of the monumental style. Details are accurately accentuated, in almost a carving manner. One may notice the sharp edges that define the chest, or the mannered stylizations of the angular knees and the V-shaped collar bones. Style and content both indicate close relations to the art of Tarquinia. The politely bobbed hair of the boy

that contrasts so amusingly with his ruddy face, and indeed his entire appearance, is on a level with the paintings in the Tomb of the Baron. I date the censer accordingly, to the last decade of the sixth century.

For contrast and comparison one may turn to another incense burner of the same type, this one in the British Museum [145].[16] Its lower platform rests upon lions' claws poised on tortoises, and this time three small lions guard the upper base. The stem has four sections divided by three leaf-'umbrellas'. The carrying figure represents a female dancer, dressed in a chiton with half-long buttoned sleeves and the familiar pointed Etruscan boots, her cloak tied around the waist in a multiple, artful knot. She, too, has a large necklace, similar to that which the boy wears in illustration 144; but her pendant is a lion's head, apparently in keeping with her other leonine accessories.[17]

The woman may be an acrobat-entertainer. Perhaps in this instance a rational connection did exist between her action and her decorative function. Illustrations of dancers balancing comparable objects on their heads occur in other Etruscan monuments.[18] One notices differences from the censer in the Vatican also, in spite of the obvious agreement of type. The master of the dancer in London had a different sculptural style. He presented his fast-moving figure entirely as a silhouette standing out flatly against the ground, almost in the manner of a vase painting. Moreover, he treated the contours in a curiously ornamental way, for example by letting the hanging ends of the sleeves show the exaggerated elegance of the back-bent hands. The latter represents a gesture as expressive as it is Etruscan. Late black-figured Etruscan vase paintings provide the nearest parallels. The crisp accuracy of the sculptured forms which delights us in the Vatican incense bowl is lacking here, not only in the modelling of the statuette but also in the decorative details of the stem. The master of the London censer wrote a broader, heavier hand. He was probably a contemporary of the artist who fashioned the specimen in the Vatican, and like him may

145. Thymaterium (incense burner), *c.* 500.
Bronze. *London, British Museum*

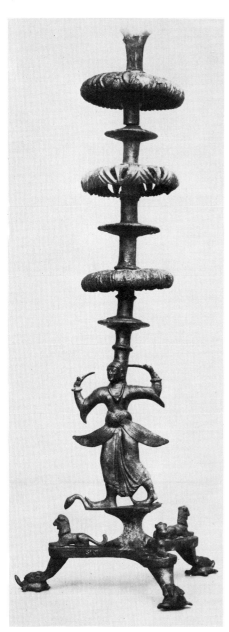

have worked in Vulci; his dancing girl dates
from the very end of the century. But obviously
he represented a different workshop tradition.
His figural style, with its greater dependence on
vase painting, connects him with the ceramic
industries of Tarquinia, where he may have
been trained.

The already discussed tripods likewise are
regularly equipped with figural ornament: one
may notice the groups of lions attacking their
prey which decorate the apexes of the support-
ing arches around the tripod in the Vatican and
others like it [143]. But remarkable as these
animal scenes are, of more immediate interest
will here be the groups of human statuettes on
top of the straight rods which, with the tripods
of this type, rise between the arched supports.[19]
Upon each rod, on a small base stretched across
typically Vulcian bowing leaves and buds which
function as a fancy capital, one sees two figur-
ines: three pairs in all. The first pair represents
Herakles clasping hands with a woman next to
him, both figures running hurriedly towards the
right [146]. The next shows two horse-tailed
satyrs, also in a hurry but moving in the oppo-
site direction [147]. Last follows a pair of young
men who stand quietly, grasping with one hand
their rounded Etruscan togas, and apparently
in no hurry in spite of the wings on their boots
[148]. Together the three pairs form a narra-
tive sequence. Perhaps they were supposed to
tell us how Hera, molested by the satyrs, was
rescued by Herakles; or rather to give us an
Italian version of that myth. Herakles, Hera,
and the satyrs can be identified, but the two
young men, or celestial onlookers, are not so
readily named. They may be the two Dioscuri,
or in some other way not so far known to us
form part of the native tradition, as is certainly
true of their costume. At any rate, the same
story was apparently also represented on a
sequence of metopes from the sanctuary of Hera
Argoa near Paestum, in Lucania.[20] This fact
ought to interest us for several reasons. One
notices the relief-like character of the statuette
groups from Vulci; also, that each pair could be
fitted in a rectangular frame, about the shape of

146. Herakles and Hera, statuettes from a tripod,
c. 490–475. Bronze.
Copenhagen, Ny Carlsberg Glyptotek

147. Satyrs, statuettes from a tripod,
c. 490–475. Bronze.
Copenhagen, Ny Carlsberg Glyptotek

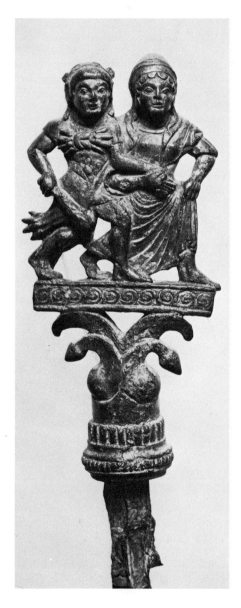

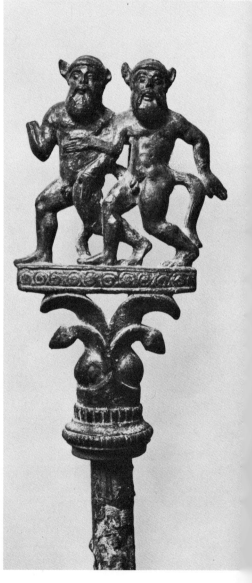

148. Dioscuri(?), statuettes from a tripod,
c. 490–475. Bronze.
Copenhagen, Ny Carlsberg Glyptotek

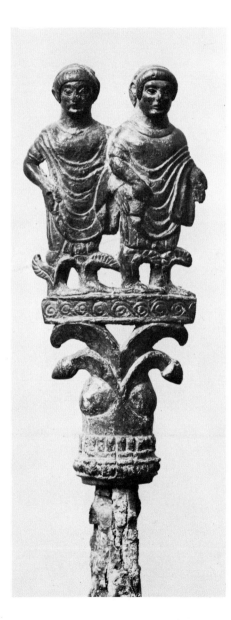

a metope. The statuettes are really small sculpture in the round but arranged like reliefs, as if by someone familiar with Greek temple sculpture. Thus both the subject matter and the manner of its representation indicate an active connection between these small bronze works of south Etruscan make and the cities of Magna Graecia. The validity of this observation is further strengthened by symptoms of style, such as the squarish, sturdy, ultimately Ionian proportions of the figures.

VULCI AND CAMPANIA

Vulci: Chronology and Importance of Small Bronze Sculpture

There remains little that one would term 'Archaic' in the statuette pairs from the tripods just discussed. Their broad, square faces do not smile, nor do their eyes slant. The only obvious archaism is the continued adherence to 'kneeling–running' postures, which apparently the artists of Etruria were loath to abandon. Unusual, if not Archaic, is the almost totally frontal representation – only the feet turn sideways – of the Dioscuri. All the rest, including the folds of garments, bears the mark of a transitional-Early Classical style. The date of the tripods for which these small works were designed may be sought within the years between 490 and 475.[21]

On the strength of preserved materials that can be reasonably assigned to the workshops of Vulci, the flowering of her metal industries has been tentatively set between c. 520 and 470 (above, pp. 214 ff.). Actually their most numerous and impressive output stems from a narrower span of time, towards the end of that period rather than its beginning. One is thus led to ask what is known about the same workshops, beyond the approximately fifty years of Late Archaism. The answer to this question can only be conjectured.[22] Nevertheless it seems possible to set down two observations of principle regarding the interrelations between statuettes, which one may refer to their workshops and formal habits encountered in other media. Firstly, both the decorative and the indepen-

dent bronze statuettes frequently reflect an inclination of their makers to accept inspiration from the pictorial arts such as paintings and reliefs. This may be no more than the Etruscan facet of a general trend in Early Classical sculpture. The same trend operates in Greek art, in statuary on a much larger scale. Secondly, at least for the period that concerns us here, the small bronzes must be considered a leading form of sculpture. This seems to be a condition proper to Etruria. The same claim cannot be made for Greece, where monumental statuary, and from 520 onwards especially the large cast bronzes, were the carriers of progress and innovation.[23]

For some time towards the end of the Archaic period and in the most active places of southern Etruria it appears that the bronze statuettes became the mediators between pictorial imagery and statuary. Since the closing of the traditional gap between independent statuary and the silhouette-bound pictorial arts constitutes a historical process of far-reaching consequences, to call attention to this situation does not seem superfluous. It was exceptional compared to conditions elsewhere. Nothing illustrates more clearly the influence of the bronze workshops on other sculptors than the well known statue from Vulci, now in the Villa Giulia, which represents a youth riding on a marine monster [149].[24] It is a stone monument, probably the guardian of a tomb, carved from the local nenfro. But a statue in the round one can hardly call it. Its frontal view, if not neglected, is little satisfying. Instead

149. Youth riding a sea monster from Vulci, c. 550–540. Nenfro. *Rome, Villa Giulia*

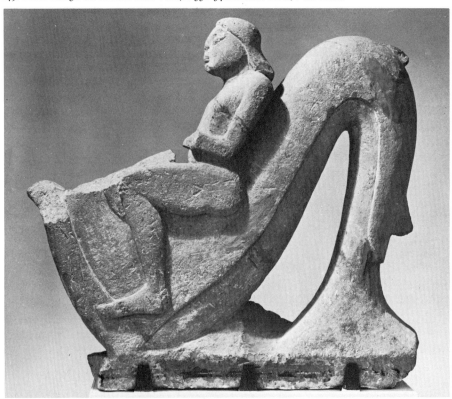

one turns to the two lateral views, which are worked out much more sensitively, in a flat but precisely designed relief. Ultimately the motif may have been a painter's invention. But the immediate source was almost certainly a small decorative bronze of local origin.[25] Thus one is faced with the forms of a bronze statuette, translated into stone and blown up to larger size. The case is unusual. Besides, it holds interesting implications for the local chronology. The Ionic-looking lad on his elegant sea-dragon cannot be dated far from the middle of the century. The decade from 550 to 540 seems the most likely assignation. Thus far, the Vulci dragon-rider represents the latest Archaic stone statue from southern Etruria of which we have knowledge. But since, apparently, its formal design depended so closely on decorative bronze work, it gives us by the same token an early date for the preponderance of the bronze industries in Archaic Vulci. The ascendancy of the latter may have started at precisely that time.

*Vulci: Typical Statuary
versus Free Choice of Motif*

Among the independent – not decorative – statuettes of the late sixth and early fifth centuries a contingent of kouroi and korae in the Greek manner may be expected. Indeed it is surprising that their number is not larger: especially the marching young men of Greek Archaic art have found few if any convincingly represented companions among coeval Etruscan sculpture, large or small.[26] Generally one observes a reluctance to represent the forward step. The difficulty was one of long standing – already the javelin-throwers from Brolio gave evidence of it (above, p. 98). But its motivations are not obvious to us. Perhaps a conservative habit, clinging to an accustomed image, caused the Etruscan artists to depart so late and so cautiously from the ancient types, ultimately of Geometric origin, which kept their two feet firmly on the ground, parallel to each other. Or a predominantly pictorial leaning induced these same artists to think of motion as a sidelong, not a forward, direction, even in a statue. At any

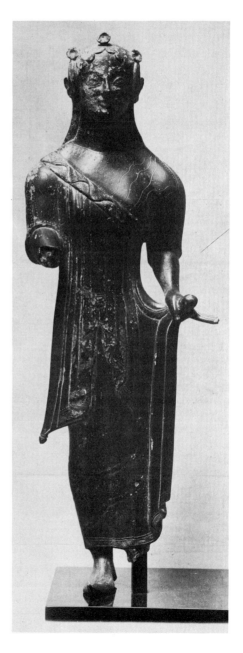

150. Statuette of a girl (Morgan statuette), *c.* 510–500. Bronze. *New York, Metropolitan Museum of Art*

rate Etruscan statuary seems to have made the change almost without a pause from Early Archaic to Classical interpretations of the quiet stance. Frontally forward-stepping male images occur only during a comparatively brief interval. Even then they are not frequent, nor do they step very decidedly.

The case of their female partners, the Greek type of korae, appears to be somewhat different. Examples are not so rare and often follow their imported models more closely. The ladies so represented imitate the stylish dress of their foreign sisters and try to learn the fashionable gesture of lifting ever so slightly with their left hands the unfamiliar chiton. But they hesitate to step forward, even more than do the men. For the most part the Etruscan korae simply stand, with feet rigidly kept side by side, thus defeating the sense of their own action: the garment gathered in the left hand for an easier walk. Their costumes, too, cause trouble to the artists. Misunderstandings of sartorial details often betray the fact that Grecian dress cannot have been a common sight in the towns of Etruria.[27] Perhaps it was not worn at all in ordinary life.

The Morgan statuette in New York[28] provides us with a good example [150]. It is a rather large bronze dating approximately to 510–500. The time was one of affluence, and bronze statuettes of a generous height are among the symptoms of its wealth. It also was a time of active inter-cultural relations. Obviously, the artist of the New York statuette was well acquainted with the newest Greek type of kore, at least with its Attic variety. He rendered the costume knowingly, though he had to combine it with the domestic type of boot. One cannot be quite certain if he understood that the little cloak was a separate garment and different from the long chiton underneath, but he did justice to the folds and the embroidered edges of the mantle. Yet all this finery had to enter into a precarious match with an immoderately heavy neck and a squarish Etruscan face. Even the Etruscan elegance of the left hand with its long curving fingers has in this context a slightly

awkward effect. The incongruous details help us, however, to recognize the local style: south Etruscan, and probably Vulcian.

While the actionless marching and stepping statues standard in Greece were received with caution in Etruria (above, p. 223), ancient domestic types continued, foremost among them the ever popular javelin-throwers (above, p. 207). More important still, the Etruscan bronze statuettes of this time include a growing number of representations which do not fit any standard type. One recognizes an increasing tendency to invent postures freely, as records of a live situation, not variations of a type.

One of the finest bronzes in this class is the statuette of a votary now in the British Museum[29] [151]. The subject is a young man, frontally poised and dressed in a short cloak, the semicircular Etruscan 'toga'. His high boots and the edges of the cloak are embellished by engraved ornament, representing embroidery. His left hand rests on his hip; the right is stretched out with the palm held vertically in a gesture, perhaps, of worship. His left foot advances just enough to suggest a forward step.

Here is a work of excellent quality, in all respects: contours, proportion, modelling, and surface treatment. It has life and dignity and an air of good-natured vitality of a kind Etruscan sculpture of this period often exhibits. One will notice that the V-shape of the collarbone has been somewhat less abstractly rendered than for instance with the boy of the Vatican censer [144]. Nor is the hair curly; nothing reminds us any more of the ancient Tarquinian elegance which, by contrast, now begins to look old-fashioned. Stylistically this statuette represents another breed, more nearly related to the squarely built Dioscuri of the tripods [148] than to the generation that preceded them. It is the finer work, by far, but the resemblances are sufficient for us to ascribe the London youth to a Vulcian atelier and approximately to the same decade as the tripods, c. 490–480.

One other statuette in the British Museum[30] shall be remembered here, to give us a hint at the range of variety which the bronze statuettes

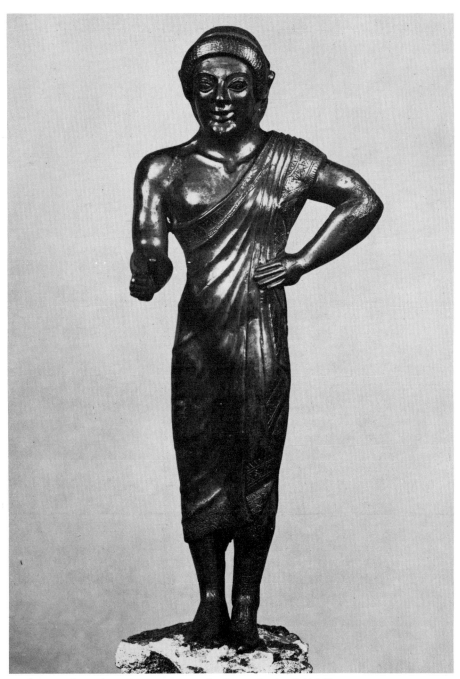

151. Statuette of a youth wearing a toga, *c.* 490–480. Bronze. *London, British Museum*

of this period encompass. The striding woman from Falterona [152] was probably a product of Vulci too, slightly earlier than the standing youth, and certainly from a different workshop. Not only the detail work, but the whole concept of representation differs. The woman rushes

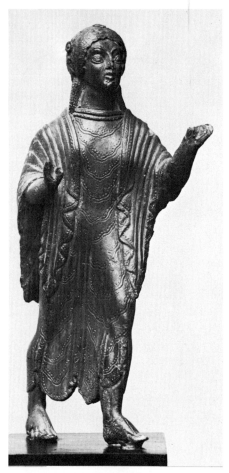

152. Statuette of a striding woman from Falterona, c. 490. Bronze. *London, British Museum*

forward, both hands stretched out, wearing flowers in her hair much like the kore in New York. She seems excited, though what causes her concern we do not know. Although she dresses in the shorter, Etruscan form of chiton,

her footgear is nicely decorated sandals, not the customary domestic boots. Perhaps the lady belonged to the realm of mythology. One will notice, moreover, that she is not represented frontally, as one would expect of an independent figure. Her eager, somewhat stooping walk seems to have been a common characteristic of Archaic Etruscan art, even much earlier than the transitional period about 490 to which the statuette from Falterona evidently belongs. First of all, however, we must comment on the direction of her walk, which is less towards than past the observer, moving from an imagined background as it were into an equally undefined foreground. The image was planned in an essentially pictorial manner: as if the unnamed woman were to form part of a group reminiscent for instance of those in pediments.[31]

Campanian Bronzes

Near the end of the sixth century a new type of bronze vessels, used as cinerary urns, began to appear in Campania.[32] They are large containers of various shapes ranging from ovoid to globular. In general type they resemble Greek *dinoi* (cauldrons), but for the most part their forms, however carefully fashioned, defy definition by the customary Greek ceramic terms. The shaping of the foot or support on which each urn is placed also varies. All urns lack handles. Their distinguishing features are their lids, which are decorated with a variety of bronze statuettes, regularly arranged in the same characteristic order. A large statuette or, in some instances, a statuette group stands in the middle on top of the lid, which is formed as a slightly raised disc. All around the edges of the disc smaller statuettes of horses, or riders on horses, are lined up behind each other in the fashion of a merry-go-round [153–6]. The variousness of the statuettes is entertaining, but it is difficult to account for their ensemble.

Almost certainly the workmanship is local; these are not imported goods. The problem is whether they should be listed as western Greek art, or Etruscan. In the history of early Italian art this is not a new question. In ancient Italy

art did not adhere to national boundaries as reliably as we moderns may be led to expect: it was regional – divided by topography – much more than national. Only in the very south of the country were the Greek colonies sufficiently interconnected, and sufficiently close to the homeland, to build a little Greece – later called the 'Magna Graecia' – within their respective city limits. In the larger part of Italy art grew up by using as models the stray finds at hand. Its growth was fed by local resources, whatever they happened to be, and often profited from intellectual piracy.

In surveying her Late Archaic and Classical art one may consider Campania a province in her own right, open to cross-currents both Greek and Italic. Greek Cumae and Etruscan Capua were rival cities politically, but the artisans seem to have moved freely across the borders. The Etruscan hold on Campania was probably at its strongest around 500. Obviously this condition facilitated the influx of Campanian Greek art into Etruria. As we have already seen (above, p. 215) the effects of these contacts are most vividly felt at precisely this time in the workshops of Vulci and other south Etruscan towns. Vice versa, a kind of local Etruscan art was produced in certain Campanian towns. One may count the cinerary urns as a species of the latter description. Their production was probably centred in Capua, and their artistic dialect may be defined as Campanian-Etruscan.

The carousel of statuettes on the lid bespeaks the Etruscan pleasure in ornament accumulated for plastic effect. Its ornamental function, apart from the meaning of the images, is to show solid objects ordered in space. Essentially this was a very ancient device, inherited from Mycenaean antecedents and Geometric popular art. Similar spatial arrangements can be found in various creations of the Archaic minor arts, both Greek and Italic. But no other known examples resemble the Campanian lids as nearly as the primitive impasto urns from Chiusi where the doll-like images of the dead stand in solid monumentality, on the middle of the lid, surrounded by small figurines of mourners (Chapter 8,

153. Campanian urn, *c.* 500. Bronze.
(West) Berlin, Staatliche Museen, Antikenabteilung

154. Campanian urn, *c.* 500. Bronze.
New York, Metropolitan Museum of Art

pp. 105–6). Also the lid of a Late Villanovan bronze ossuary from Bisenzio may be compared, on which a variety of small statuettes is distributed according to the same schema.[33] In my opinion the Campanian urns can best be explained as revivals of the same ancient Italic funerary tradition. Only the meaning and the quality of the images have changed. The central statuettes indulge in all sorts of activities, scarcely funerary. Cowboys with long, rustic trumpets seem to play the music for a rodeo of marching horses [153].[34] Athletes in the Greek manner, for example discus-throwers, appear around 500 [154].[35] An especially accomplished example in the British Museum[36] has four Amazons, two of whom practise the Parthian shot, on horses trotting around the rim [155]. They are solidly cast little statues looking like toy soldiers. The dancing couple in the centre, on a raised base, was laid out in a more relief-like manner [156]. It compares well with the pair of Herakles and Hera from the Vulcian tripod [146]. Though its details are more Archaic than the latter, and its likely date must be set somewhat earlier, c. 510–500, it illustrates persuasively the stylistic relationships which connected Campania during this period with the bronze workshops of Vulci.

155 and 156. Campanian urn, with detail of dancers, c. 510–500. Bronze. *London, British Museum*

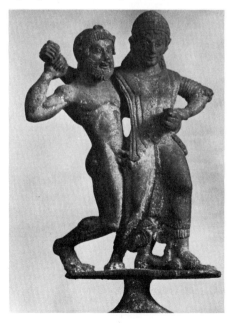

CHAPTER 19

SCULPTURE IN TERRACOTTA

CAERE

Sarcophagi

The history of the Etruscan sarcophagus begins in Caere, and the earliest examples known at present are of terracotta. Just what moved some Caeretan families to adopt this form of burial, or what outside influences persuaded them to do so, it is now difficult to say. As far as one can judge, it sprang from no urgent need. The habit of transforming the simple receptacles of the deceased into stately monuments of stone or some other durable material was indeed common around the Mediterranean, and in certain countries, chiefly Egypt, it had long been a persistent tradition among the upper classes. But

the custom was by no means ubiquitous. In Greece it was rare in the core countries of the motherland, and only around the fringes of the Greek world, especially in the Asian territories, are richly adorned sarcophagi of Greek style found sporadically and at considerable intervals of time and locality. The habit never became continuous. In the mainstream of the Near Eastern civilizations stone sarcophagi were on occasion employed in royal burials, most notably those of Assyrian kings. But such examples as we possess form the exception rather than the rule and came about almost certainly through Egyptian influence. Limestone sarcophagi of the Archaic period have been found in Cyprus. The latter place is about as close to Etruria as we can come, surveying the archaeological evidence

157. Sarcophagus from Procoio di Ceri, mid sixth century. Terracotta. *Rome, Villa Giulia*

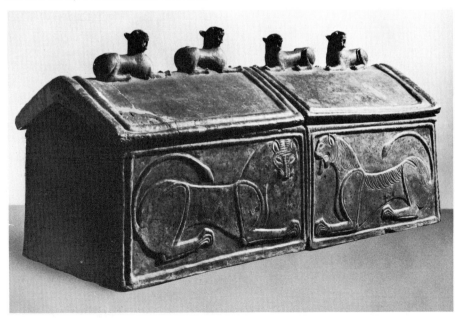

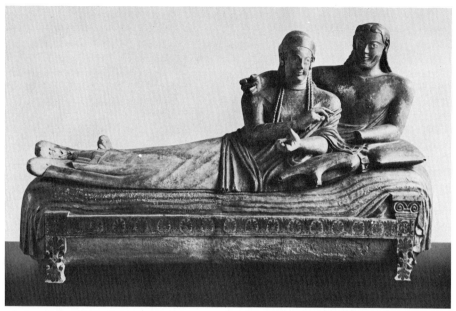

158. Sarcophagus with reclining couple, last quarter of the sixth century. Terracotta. *Paris, Louvre*

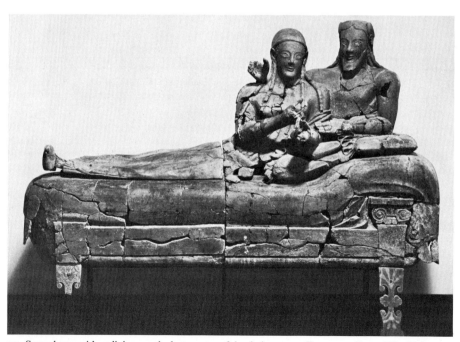

159. Sarcophagus with reclining couple, last quarter of the sixth century. Terracotta. *Rome, Villa Giulia*

together with the trade routes by which goods and ideas are known to have entered ancient Italy.

In Archaic Etruria the prevailing custom was to cremate the bodies, or, in the more ambitious burials, to lay the dead on their stone beds and benches as if to rest. No sarcophagus or even coffin was required. When towards the middle of the sixth century sarcophagi were nevertheless introduced into Etruria, the impulse must have come from abroad. Yet as far as we know, no actual models of foreign type were at first imitated. Be this as it may, the adoption by the Etruscans of this manner of burial proved a momentous step in the advancement and gradual expansion of ancient art. The sarcophagi which from then on in Italy remained in demand almost continuously for many centuries, offered to generations of artists a special and well defined field of activity. Their number comprises some of the finest and most noble works that came from Etruscan Italy until much later the Romans and their Early Christian followers shaped the final chapters of this glorious history.[1]

Caere was a likely place to promote such a novelty. Her communications with the Aegean were then very active, owing chiefly to the Phoenician trade.[2] Moreover, terracotta sculpture had long been a local tradition (above, pp. 93 ff.). Apparently by the middle of the sixth century the engineering skill needed to produce works of terracotta on a large scale had sufficiently progressed to turn out objects as impressive as the sarcophagus from Procoio di Ceri, now in the Villa Giulia Museum[3] [157]. Thus far this appears to be the oldest decorated sarcophagus preserved in Etruria. It is also a work of remarkable craftsmanship. Actually its long box was composed of two sections or, as it were, two adjoining cinerary urns in the form of a house with pitched roof. Its very form, borrowed from the traditional containers of ashes, marks this as a work of transition and initial effort. Statuettes of guardian lions crouch on the ridge of its roof,[4] and a lion and lioness of orientalizing type face each other along the walls. Their large images are in very flat relief, and rather abstractly designed. The whole im-

presses us as a deftly shaped and finely glazed ceramic monument.

About one generation later, in the last quarter of the sixth century, one may place the two

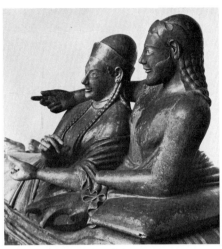

160. Sarcophagus with reclining couple (detail of 158), last quarter of the sixth century. Terracotta. *Paris, Louvre*

masterpieces extant of Caeretan ceramic sculpture, the sarcophagi with reclining couples in the Louvre and in the Villa Giulia Museum [158–60].[5] These are of about equal size and nearly identical appearance. Like their predecessor from Procoio di Ceri they were made in separate pieces, subsequently joined together. But their shape retains no memory of the ancient cineraria, nor indeed any reference to their practical use: it is frankly representational, moulded into the likeness of a banqueting couch on which rest a wife and husband comfortably united, as was the custom in Etruria.[6] In each group the man has placed his right hand on the shoulder of the woman; the gesture is probably symbolic of familial union and possession. To represent a reclining figure with both legs stretched out instead of one knee raised was in keeping with Greek Ionian art.[7] The human form, likewise, bespeaks Ionian taste: comfortably rounded faces, broad shoulders, the blown-up chests of the men, and, generally, an em-

phasis on outer contours rather than anatomical distinctions within, are the telling symptoms. For all that, the work as a whole can scarcely be defined as Greek. It is probably best understood as an outcome of the Late Archaic monumental style which Caere and the Tarquinian wall paintings alike cultivated (above, pp. 174-5, 191). The subject matter, the dining couple on a couch, was decidedly local, Etruscan. For this reason alone its sculptural rendering required fresh observations and decisions: the type to be followed had to be worked out in Etruria. Actually we know that this happened, quite possibly in Cerveteri. Other examples on a lesser scale have been found, dating to about the same period.[8] They can teach us the enormous gap of taste and refinement which on occasion may separate different productions of art, conceived in accordance with an identical pattern.

I assume that our two sarcophagi were works by different artists, though their makers may well have been members of the same workshop. At any event their manner of handling the most obvious formal problems is remarkably similar. Two of their rather Etruscan idiosyncrasies can be readily named. One is the angularity of design which governs, not only the outlines of both groups, but also details, such as the way in which limbs are joined to bodies, arms to shoulders, forearms to elbows.[9] The other formal characteristic, no less conspicuous, derives from the abrupt change of direction at the point where the half-raised torsos turn from the outstretched legs at a full ninety-degree angle, without any assuaging transition. Any ordinary person would find considerable constraint in holding such a position; yet the visitor standing before these groups will accept it without uneasiness, so persuasive are the immediacy and presence of these large figures, their urbanity of manner, the easy elegance of their gestures, their patrician demeanour. Etruscan also is the artist's partiality for selecting aspects of the whole deemed essential, generally the upper halves of the figures including the hands, heads, and faces. By contrast the legs beneath their covering shrouds received a minimum of plastic volume; sculpturally, they appear neglected. Precisely because of the inequality among the parts, certain details stand out with unusual force. I name the emancipated hands; the tube-shaped folds which mark the ends of garments, quite unconventionally designed for the occasion and the medium; and the soft, laced shoes of the ladies. To produce these life-size terracottas must have been a considerable achievement, not only of technical know-how but of artistic inventiveness and discretion as well.[10] They are the earliest large terracotta sculptures preserved from Etruria, and among the most accomplished and original to be found anywhere.

Architectural Terracottas

A considerable number of Late Archaic roof terracottas from the territory of Caere is still extant and dispersed in various museums of Europe and America – remnants of her many temples and their lavish decoration. For the most part this material consists of antefixes in accordance with the established Late Archaic type, common to all Etruria, which shows human faces, rigidly frontal, within halo-like shells variously decorated. Their purpose was to mask the end-tiles along the edges of a roof. The colourful effect which a series of such antefixes produced was peculiar to the Etruscan temples.[11]

Two unusually fine examples, both kept by the Ny Carlsberg Glyptotek in Copenhagen, may serve as illustrations [161, 162]. The face of the young woman [161],[12] now detached from the bordering frame in which it was originally embedded, clearly addresses itself to a taste of daintiness which one notices also in other works of the end of the sixth century. The proportions seem inordinately long, the contours abstractly shaped. Colour, much of it preserved, brings this face to life. On the whitened surface of the flesh, delicate dark arches delineate eyes and eyebrows; wavelets drawn in white add a semblance of lustre to the hair, now of a bluish hue though once probably black. Nor were the accessories of fashion omitted: an ornate diadem and a pair of large, button-shaped Etruscan earrings. From out of this finery the girlish eyes

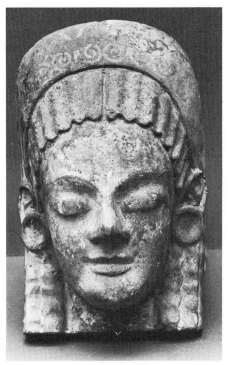

161. Maenad antefix, late sixth century. Terracotta. *Copenhagen, Ny Carlsberg Glyptotek*

deities were revered within – seems to hark back to the Late Archaic period. The other antefix from Caere, here reproduced, testifies to the same trend [162].[13] Its mask portrays a satyr with reddish hair and greying beard. A portion of the surrounding shell and its decoration of palmettes has been preserved. The workmanship of this specimen is not quite as fine as that

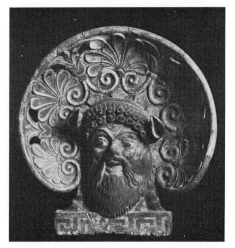

162. Satyr antefix, late sixth century. Terracotta. *Copenhagen, Ny Carlsberg Glyptotek*

give us a fixed stare, and the faintest flutter of a mocking smile. Their irises are painted yellow, as if they were small pearls of amber.

The coherence of the plastic forms is entirely in the Caeretan style and may be judged a fine example of it. But the stretched proportion appears rather exceptional; ordinarily, Caeretan artists prefer forms more fully rounded. The reason is perhaps that we are dealing with a roof terracotta. Seen from below, at some height, the forehead would not seem so steep.

Most likely this head represented a maenad – one among the mythical devotees of Dionysos. When the Bacchic mythology began to infiltrate Etruria, perhaps by way of Campania, some of its earliest reflections in Etruscan iconography appear among the architectural terracottas. The habit of decorating the roofs of temples with faces of satyrs and maenads – regardless of what

of the maenad, and the style also differs: all forms are broader, more robust; evidently the satyr belonged to a different series, and a slightly later date ought perhaps to be assigned to it. In many ways this mask may remind us of the 'Achelous' in the Tarquinian shields (above, p. 213). At the same time the comparison emphasizes the differences: the Caeretan rendering, by its fleshy monumentality, makes the Tarquinian look lean and crisp. Yet both seem possessed of a similar energy and vitality, which each communicates in its own way. This effect resides in the motionless frontality of the masks, and the power of their glaring eyes. A row of antefixes of this kind, of satyrs and maenads alternating, must perhaps be imagined as something more than merely a colourful decoration. That they also were. But in addition, in Etruria, the lusty companions of Dionysos had come to

join the grinning guardians whose task it was to fence the gaily decorated sanctuaries from the intrusion of the profane.

The Pyrgi Columen Plaque

During the excavation of a sacred precinct over-looking the Tyrrhenian sea at a point now called Santa Severa, the ancient Pyrgi, remains of a large, Late Archaic terracotta relief came to light [163, 164]. The find proved one of the most

nished with nail holes for attachment to some wooden surface. At first it seemed part of a pedimental composition, though as such it would have been unparalleled in Etruria at any time before the second century.[14] But the shape of the relief is now clear; it was rectangular, broader than high, with plain finished sides and a shallow base on which all the figures stand. These are somewhat under life-size, and the background plaque reaches only to the shoulders of the standing figures; it could not possibly be

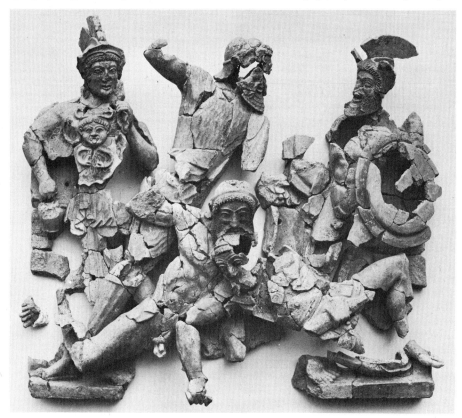

163. 'Gigantomachia' relief from Pyrgi, c. 510–485. Terracotta. *Rome, Villa Giulia*

spectacular discoveries of Etruscan art in recent times. Though the relief was broken into many small fragments, enough has been recovered to show that it was a composition of six figures in high relief against a background plaque fur-

the central group of a pediment of any size. It could be, on the other hand, the revetment plaque for the main roof beam, the columen of a large temple with an open pediment of Etruscan type; and it has now indeed been established

that this was the columen plaque from the front gable of Temple A at Pyrgi.[15]

The subject is clearly Greek, a battle in which the gods take part. Athene is instantly recognizable, and the tall, bearded figure whose head marks the centre-top of the composition, and who is dressed, not like a warrior in helmet and

two episodes, in the war of the Seven against Thebes.[16] The six characters form two groups. The bearded god turns with visible violence to the right, his right arm lifted. Of his two opponents, only the shield of the first is preserved; the second rushes forward, a savage grin distorting his face. This is Kapaneus, whom the

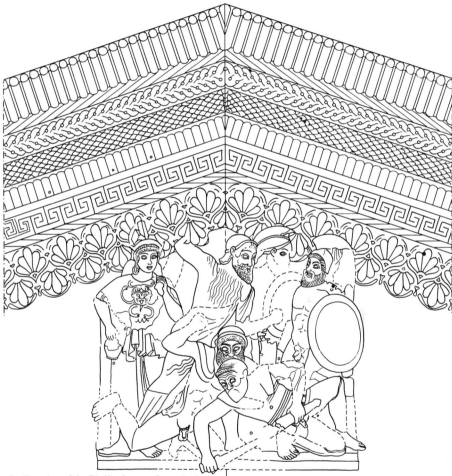

164. Drawing of the Pyrgi columen plaque *in situ*

cuirass, but like a god in chiton and toga (see below, p. 241, the costume of the Apollo of Veii), should by rights be Zeus. Originally, the scene was taken to be part of a Battle of the Gods and Giants; it is now identified as an episode, or

thunder of Zeus is about to destroy. Athene, on the left, is intent on the two bearded men who are struggling on the ground at her feet. Her left hand lifts the edge of the awful aegis on her breast, while from her right swings a little pot

with the ointment of immortality she is bringing to her favourite, Tydeus. But he and Melanippus are at death grips, and Tydeus has sunk his teeth into the crown of his adversary's head. The shock of this horrid sight has stopped the goddess in her tracks; she is utterly disconcerted, and her face is stiff with fastidious distaste.

At first sight the terror of this grim tale may appear remarkably Greek, as was the myth it told. The canon of representational form – postures, folds of garments, faces – relates more closely to Greek than to most Caeretan art that we know. Yet there is much that must be called strange and irregular, if we are to judge this composition by Greek standards. The formal details agree with Greek monuments on a chronological level about equal to the western pediment at Aegina.[17] But when one considers the relief composition as a whole, discrepancies come to the fore. The plaque from Pyrgi represents a compact group of six figures, stacked in depth from the rear towards the foreground. The result is a melee of limbs and faces overlapping each other, fragmented, and so tightly packed that one deciphers their meaning and context not without some difficulty. One may doubt that a Greek relief ever presented the observer with an aspect so bewildering; none can be cited. The designer of the Pyrgi plaque was nevertheless an artist of great skill and ingenuity. He did not, however, conceive this work in the manner of a Greek relief. Instead he produced a scrimmage of figures entangled in knots from which they can scarcely extricate themselves, and of actions built up in fusing planes which seem to move forward towards the observer. Obviously this is not the method of Greek reliefs, where actions mostly move sideways, and planes are clearly defined even if figures are stacked in depth. But overlapping groups similar to the Pyrgi relief, complicated to the point of confusion, can be found in Greek vase paintings at the time of transition from Late Archaic to Early Classical styles. There is reason to suggest that the mode of composition exemplified by the Pyrgi plaque was derived from Greek painted vases rather than from any plastic monument. As so often in early Etruscan art, one is dealing with a transfer of styles from one medium to another.

It seems that in this process of translation the artist developed a new and unexpected manner of relief. The forms do not hold to an even surface or a unified plane. Instead, the surface modelling changes from lower to higher elevations, the highest relief being reached in the forward-thrusting heads, which are worked out almost entirely in the round. Such mobility of surface modelling was not the rule of ancient reliefs, either Archaic or Classical; only the bronzecasters of the Middle Ages (Hildesheim bronze doors) and the early Renaissance (L. Ghiberti) came to exploit these possibilities to the full. Yet in the Pyrgi pediment this method was used; it served admirably to strengthen the emotional impact of the struggle shown. We find the whole scene imbued with savagery, reflected also in the strangely expressive faces. The smiling lips may be Greek and conventional, but the resulting expression is not. The three human faces that have remained seem to render a scale of emotions, of wild directness. The furious Kapaneus yells his defiance into the very face of Zeus; over the last flicker, the ultimate moment in insensate resistance, in the dying Melanippus hovers the savage joy of triumph which is the dying Tydeus'.

The iconography is no more Greek than the composition. In Greek representations it is the severed head of Melanippus that Tydeus attacks with his teeth, not the scalp of his still-living adversary. Nor is it the Greek practice to conflate two episodes in a story into a single composition: The Last Night of Troy, a favourite subject in early red-figured vase painting, is not treated like this. The Kleophrades Painter's Iliupersis shows five simultaneous episodes in a running frieze around the shoulder of his hydria: in the centre Priam, seated on the altar, with the body of his grandson Astyanax on his lap, is attacked by the savage Pyrrhus; this is flanked by the rape of Cassandra, and by a scene of an unknown Trojan heroine who beats off a Greek hoplite with her washing paddle; the two ends of the frieze are 'happy endings', the escape of Aeneas with his father and son, and

the rescue of Aithra by her grandsons, the sons of Theseus.[18] But in the Tale of Thebes the deaths of Kapaneus and Tydeus are not simultaneous, nor do they take place on a single crowded patch of ground. The Greek picture is a narrative, five scenes in a tragic story; the Etruscan relief points a moral – bestial savagery is abhorred by the gods, and its wages are destruction. For all its violence, the mood of the composition is lyric, not epic. This moralizing treatment of Greek myth will appear again in Etruria, particularly in the funerary art of the Hellenistic period.

VEII

The 'School of Vulca'

The case for Veii as an artistic centre in the Late Archaic period rests on similar grounds to those which apply to nearby Caere, though with one significant difference: the claims of Veii to artistic prominence are not only supported by monuments excavated on the spot but also by a written tradition. We learn from Pliny that a Veientine master named Vulca fashioned the cult image for the temple of the Capitoline Jupiter in Rome. The image, of terracotta, was a standing statue, according to Ovid, over life-size, and painted.[19] One may imagine that in execution it resembled the seated statue from Paestum mentioned previously,[20] except that it was probably of larger dimensions and more modern in style. According to the Roman *Fasti* the temple was dedicated in 509, at which time one must expect the cult image to have been in place.[21] In these circumstances the likely date for the execution of the statue was the decade between 520 and 510, the year 509 being the *terminus ante quem* for its completion.

Pliny reports further that the middle acroterium of the Archaic temple, probably rising above its front gable, which represented Jupiter standing on a quadriga, was a work of Vulca also. The correctness of this statement has been doubted, though hardly with sufficient reason.[22] An acroterium of this description must have been a statuary group of considerable dimen-

sions; it must have been difficult to produce so large a group, and even more hazardous to mount it on so exposed a spot. Damage was bound to set in soon, owing to winds and weather and perhaps also the not infrequent fires. Yet it seems that the quadriga survived for more than two hundred years.[23] Finally, we learn from the same literary source that an Archaic statue of Hercules, likewise of terracotta, was still shown in Rome at the time of the Early Empire, and ascribed to Vulca.[24]

In the history of Etruscan art, which is almost totally anonymous, this little cluster of records relating to the name of a single artist constitutes a rare incident; it is very much the exception. Scholarly criticism must of course be applied to it, and perhaps first of all to the name of the artist, known to us only from the comparatively late notices assembled by Pliny.[25] Even if the name should turn out to be fictitious, however, which is by no means certain, illuminating information can still be extracted from the records. According to the Roman tradition the Capitoline temple was built on the behest of two Etruscan kings of Rome who belonged to the Tarquin dynasty. It was ambitiously planned, although the first structure was probably not as large as the rebuilt and aggrandized temple which Vitruvius described. Upon completion it became the largest Archaic temple of the Tuscan style, and indeed one of the largest temple-buildings of its time.[26] In the light of these facts, we must regard as both plausible and valuable the reports that the artist commissioned to create the cult image for this building, and probably to work on the terracotta decoration as well, was a ceramist from Veii. Moreover, it seems to follow from this set of records that a Veientine workshop had to be established in Rome.[27] A project of such magnitude could not be completed by one man, single-handed. Nor is it likely that terracottas of the size and quantity which this purpose demanded were shipped to Rome from Veii, let alone from places still farther away. Ancient practice in similar instances was to call the artisans to the locality where their work was needed, whenever the domestic resources were not sufficient to carry

out a project, especially one of architecture, and when therefore it became necessary to invite talent from abroad.

Veii, situated about 20 km. north of Rome, was a convenient place to look for such help, if for no other reason because it was the nearest. We must infer, nevertheless, that at the time when these decisions were made she also had a reputation as a centre of the then most advanced ceramic industry: large terracotta sculpture. At any rate Veii could provide the skills required. The effect which this turn of affairs may have had on Archaic art in Rome will be matter for a later chapter. Here we must first stress the fact that according to the known circumstances the school of Vulca, if one wishes to call it so, is probably best understood as a Veientine workshop operating in Rome. Since the reason for its presence in the city was a project of long range, the workshop probably stayed in business for many years; how long, precisely, our sources fail to tell. One may expect that its members were recruited from different parts of Etruria, not from Veii alone. The sources tell us so (above, Note 27); besides, this was the common way of organizing a temporary workshop for the erection of a large public building, including the completion of all its fittings and furnishings, under the supervision and with the active participation of an artist in charge. On the whole, the evidence leads us to assume that the work of Vulca and his helpers was in a Late Archaic style, in agreement with the stylistic trends prevailing at the close of the sixth century. Yet, while the Roman tradition thus reflects the enduring fame of the Veientine terracotta studios of the Archaic period, it can tell us nothing about their special manner of style or their local characteristics. For the latter question one must still turn to the finds from Veii, whence Vulca started.

The Portonaccio Group

The now famous Apollo of Veii [165, 169] was found in May 1916, by chance, in a spot called Portonaccio which lies just outside the ancient city to the south. For the first time in the recent

era this discovery drew general attention to the importance of large terracotta sculpture as a special manifestation of ancient art. Subsequent excavations showed that the Apollo formed part of a whole group of similar terracotta statues. The place where their remains came to light, in more or less fragmentary condition, proved to have been the precinct of an Archaic temple, the three cellae of which were evidently dedicated to a divine triad. Originally the terracotta figures stood on the roof of the temple, as one may conclude from the large tiles on which they

165. Apollo from the Portonaccio Temple, Veii, *c.* 515–490. Terracotta. *Rome, Villa Giulia*

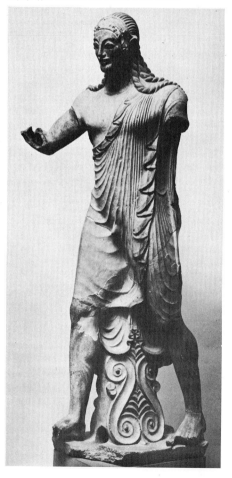

appear to have been mounted. The base portion of each tile was formed as a saddle which enabled it to sit on the ridge of the roof, and at the same time to serve as a pedestal for the statue it was to carry.[28] Thus the group in its entirety was to be viewed from below, sideways, the statues following each other in a straight line along the pitched roof. No other example of this manner of architectural decoration had previously been noted. There could be little doubt that it represented an Etruscan innovation, contrary to Greek architectural taste and not

matched anywhere outside ancient Italy. Perhaps its nearest counterparts within our present experience are the large roof statues of Italian Baroque churches and palaces as we see them, for instance, crowning the façades of St Peter's and the Lateran Basilica.[29]

Fragments of a statue of Herakles, placing his left foot on the torso of a hoofed animal whose feet are tied together as if for easy removal, introduce a narrative element [166]. The story to which this representation alluded was probably the myth of Herakles, who, while carrying away

166. Herakles and the Ceryneian Hind (two views) from the Portonaccio Temple, Veii, c. 515-490. Terracotta. *Rome, Villa Giulia*

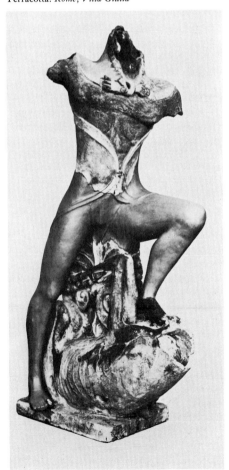
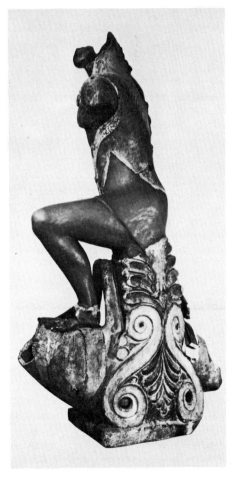

the Ceryneian hind, was stopped by Apollo.[30] It seems that the two protagonists, Apollo and Herakles, moving towards one another, formed the central pair of the group, each followed by a line of various mythical characters. A head of Hermes can still be identified [167]. Others are

The fact that a mythical action was here represented by a group of statues calls for comment. Narratives are not a natural theme of statuary.

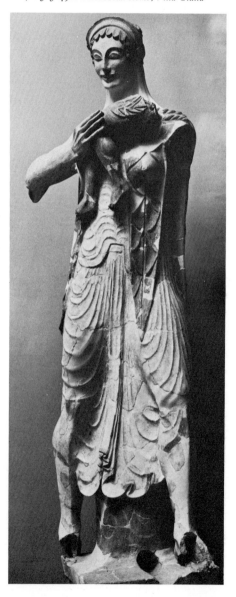

168. Woman and child from the Portonaccio Temple, Veii, *c*. 515–490. Terracotta. *Rome, Villa Giulia*

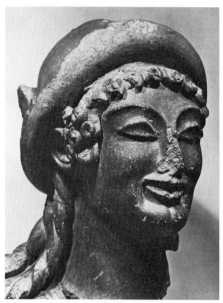

167. Head of Hermes from the Portonaccio Temple, Veii, *c*. 515–490. Terracotta. *Rome, Villa Giulia*

not so easily defined. For the striding woman who tenderly bears a child in her arms no satisfactory explanation has yet been forthcoming [168]. Since the infant cannot be the god Apollo, the suggestion to name its guardian Latona, Apollo's mother, carries little conviction. The figure may represent almost any other name, however, on the multifarious list of mythical mothers and nurses who were so popular, and often venerated, in early Italy. It is even possible that she represents one of the deities of the shrine itself, which the statues were meant to embellish. An un-named *kourotrophos* occurs quite frequently among the artless statuettes which worshippers deposited as ex votos, to please the sacred spirits of the place.[31]

To tell a story was as a rule the domain of painting and relief. In this respect also, as for its placement on the roof of the temple, the Apollo group ranks with the exceptions. The solution of the problem probably lies in the decorative function of these statues. They do not conform to the norm of statuary, which treats the statue as an isolated and self-contained object, because they were from the outset conceived as a unified whole. Therefore they appear to move in a common field of action, as do the individual figures in a relief; and, as in a relief, all the statues which one can ascribe to this group move sideways while at the same time turning towards a presumed spectator, spread out, as it were, against a simulated background. By the same token they prescribe the standpoint the spectator must take; they open up to one side only. Apparently the makers of the group, faced with this rather special assignment, practised the same method of approximating in round statuary relief-like postures which we observed previously on a smaller scale in some bronzes from Vulci (p. 221).

That connections actually existed between the Portonaccio workshop and the bronze industries of Vulci seems likely for other reasons as well. The interest in narrative itself was shared by the ateliers that produced the Vulcian tripods (above, pp. 214 ff.). The lyre-shaped ornament with which the masters of the Portonaccio terracottas masked some of the heavy supports between the legs of their statues [165, 166] resembles the double volutes hanging from the supporting arches of the Vulcian tripods. Moreover, the story of the Ceryneian hind, otherwise rare, was known and illustrated in the workshops of Vulci.[32] These facts are probably not unrelated. Whether actual contact between the Portonaccio workshop and the Vulcian bronze-foundries was brought about by migrant bronze artists employed in Veii, or merely by imported products, one cannot now decide. But it is probable that such relations existed. From Vulci, it would seem, came the concept of statuary; the crisp and linear design of details, such as the folds of Apollo's cloak; and perhaps also the special kind of grecism incorporated in the group from Veii.

For the paradox of the Portonaccio statues is that their Greek ingredient was chiefly one of content, while their looks are patently Etruscan. They re-enact their myth ceremoniously: more like an ordered spectacle than a forthright story. The protagonists have taken their stand. Now one expects a dialogue to follow in which they will uphold their opposing claims. Verbal exposition goes before action; such was the rule of the incipient Greek drama. The characters of the Portonaccio group seem to behave in much the same spirit. Their gestures are explanatory, perhaps threatening, certainly preparatory for action. But as far as we can still read their message the actual moment of violence is yet to come. Reasoned unreason, the mother of strife, still holds the action in suspense. Thus the myth was set up as a dialectic situation. The thought impresses us as Greek, but at the same time eminently suitable for the rectilinear succession of statues which is made necessary by the architecture.

Yet, however ingeniously invented the composition of this group may seem to us, its formal style is still more remarkable. Various hands were certainly at work here. But the outcome in all essential respects is uniformly alike and consistent. To do justice to it is difficult, precisely because the approach to form, also, seems so original. The short cloaks and chitons worn by Apollo and the woman who clutches the child may perhaps be taken as the outward signs of a certain provincialism. We know them also from other monuments; evidently they represented Etruscan costumes.[33] At any rate, they contribute to the characteristics of an art separated from the international mainstream. Though echoes of Greek art abound in details, these original models seem far removed. All Greek reminiscences have been thoroughly transformed: the consistency with which the transformation was carried out becomes the measure of this style. The first statement due about it is that the formal idiom of the Portonaccio group has no parallels among the ceramic sculpture of Archaic Etruria. Of particular importance is the comparison with the terracottas of Caere, its nearest rival. If we see the statues from Veii side

by side with art from Caere, we find no resemblances; instead, we face a total contrast.

There is a quality of harshness about the statues and fragments of the Portonaccio group which may well surprise us; for clay is a malleable material which invites continuous modelling of forms and often leads to softly fashioned, even blurred, surfaces. The artists of Caere infused this kind of modelling – natural to the coroplasts – with their proper sense of monumentality. Inside the firmly drawn and spacious contours the surfaces remain smooth and fluent. Contrariwise, the sculptors of the Apollo group tend to give more detail, and to break up the surfaces into separate compartments of form. The resulting segments are sharply outlined, as if cut with a knife or some other hard instrument. The total effect is one of a glyptic rather than plastic treatment of form.

Clearly, a principle of style is here involved; but so are instruments. The indications are that the statues from Veii were worked with another set of tools than, for instance, the large Caeretan sarcophagi discussed in the preceding chapter. They were the outcome of a radically different workshop tradition. Of course the working methods employed in fashioning the Veii statues cannot at present be reliably described. They can at best be reconstructed from their apparent results. It seems that the figures were first modelled, chiefly by hand, into the desired shapes. Then details were entered into the already moulded surfaces, with the aid of tools. A working procedure such as this can explain the shallow grooves which were equally used to represent the folds of garments, and the veins and muscles upon Apollo's legs.[34] It may also help us to understand the abstract regularity of these details, especially the folds which follow each other in superimposed ranges of parallel curves carved as it were from the modelled surfaces. Similar groove patterns, similarly produced, had long been popular with the native potters, particularly in the Faliscan region (above, Chapter 6, p. 77 and illustration 47). The available evidence therefore leads us to conclude that the Portonaccio artists, in their finishing details, employed tools and techniques which were traditional with the potteries of the Veientine back-country, especially the Faliscan territory. They put ancient devices of the local craft to new uses. Apparently they were craftsmen themselves, schooled in the local ceramic shops, who to their assignment as sculptors brought their training as potters, and the instruments to which they were accustomed. As far as one can judge today, the resulting ceramic style of statuary was wholly their own.[35]

The face of Apollo probably shows better than any other detail the originality and power of expression of which these masters were capable [169]. In power it is the superior of the affable Caeretan couple, coeval with it. Its forms bulge, almost burst, with vital energy. One will notice that the parts within the face – cheeks, eyes, eyebrows, the strong and fleshy lips – are separated from one another by sharply drawn lines as if the clay had been cut away with a modelling knife; probably this had indeed been done. The striated hair appears to have been produced by a potter's routine tool. On the other hand the curious, wing-like ductus of the eyebrows constitutes a much finer trait. We have already encountered the same design in the Tomb of the Baron (above, p. 194). It seems to have been an Etruscan favourite, shared by sculptors and painters. Thus flickers of realism and passages of abstraction are juxtaposed rather than fused here, as in the entire statue. The whole figure appears composed of distinct and not always homogeneous parts. Yet the effect is extraordinary. Where in Archaic art does one find another face quite like this? The rugged profile is most rare. So is the short, receding forehead, below which cheeks, eyes, lips, and chin seem driven to the surface with an air of haste, one is tempted to say. A sense of urgency also issues from the hurried stride of the statue, which stoops forward as do so many other Etruscan walkers. The formal devices from which these impressions derive may be described as a sort of 'abstract expressionism'. Their expressive power culminates in the forward head, the eager smile of the lips, and the avid glare of the eyes fixed on their quarry. The smile on Archaic faces was a conventional hiero-

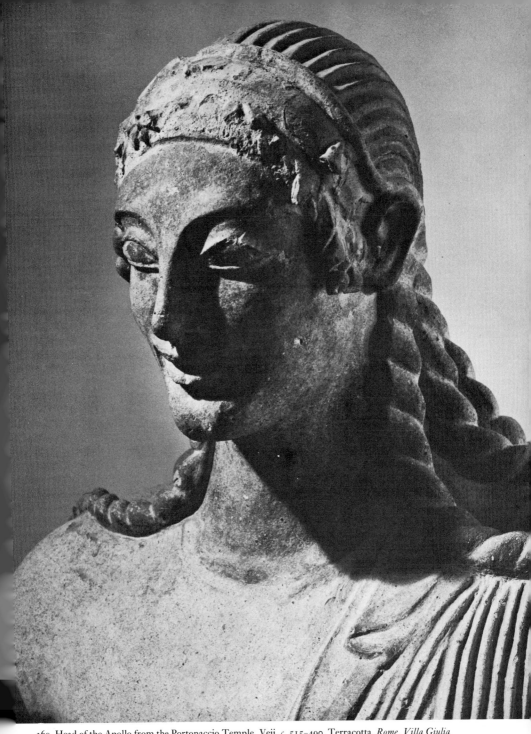

169. Head of the Apollo from the Portonaccio Temple, Veii, *c.* 515–490. Terracotta. *Rome, Villa Giulia*

glyph of rather broad meaning, but the Etruscan artists managed, on occasion, to endow it with some of the weirdest connotations encountered anywhere in its long history. All in all, among the great sculpture of the Archaic age this statue is not the most noble, although a nobility of comportment is not wholly lacking. But as a plastic record of human temperament, it may well be the most uncannily successful.

Antefixes

Several terracotta antefixes can be ascribed to the Portonaccio temple. They are not all in the same stylistic mode, however, and at least one appears to have belonged to an older set that may have preceded the terracotta statues by about two decades. It represents the face of a young woman, probably a maenad, approximately contemporary with the so-called Peplos Kore in Athens. It is interesting to note that the smooth, rounded forms seem closer to Caeretan terracottas than to the Apollo group. There is no trace of the carving manner which characterizes the latter. No visible connection relates this work to the workshop that produced the famous statues.[36]

Quite different is the case of the large antefixes with a mask of Gorgo-Medusa,[37] which may be confidently credited to the masters of the Portonaccio statues [170]. The mask is set deeply in the centre of a shell which consists of broad, leaf-like ribs flaring outward. From this hollow, as from a cave, it greets the visitor with its monstrous smile. The face follows the Archaic type of gorgoneion, but the interpretation of the type is unique. Furrowed cheeks, apple-shaped, surround the voracious gape of the mouth, complete with flapping tongue and boar's-teeth below a pudgy nose. The scornful gaze of the eyes projects from underneath undulating ridges which represent brows, contracted toward the nose. There is no forehead to speak of, only another deep furrow arching below small, parallel rolls of hair. The two ears stand out sideways like two handles, and coiling snakes spring from everywhere, all round the

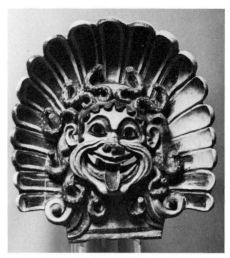

170. Gorgon antefix from the Portonaccio Temple, Veii, *c.* 515-490. Terracotta. *Rome, Villa Giulia*

face. Most of the face was painted white, but the tongue and boar's tusks were red, and the eyes and eyebrows black. The whole may be read as a well planned decorative design of undeniable, if somewhat bizarre, elegance, and though there is room for doubt that it was ever meant quite seriously, the resulting image adds up to one of the most spirited demons in Archaic art.

In this Gorgonic mask the carving style of modelling again is very much in evidence, and in full agreement with the statues of the Apollo group. The same may be said of still another type of antefix from the Portonaccio precinct, of lesser artistry and perhaps slightly later date. The mask represents a maenad; it may have been created as a replacement for some spot that needed repair.[38] A coherent tradition of craftsmanship may be recognized in the preference for sharply delineated forms. But to consider this the proper style of all art from Veii would seem a rash conclusion. Until new finds give grounds for a different judgement, it seems safer to regard this first of all as a working procedure characteristic of the one atelier which is here called the Portonaccio workshop. Nor is there any certainty that the Vulca of ancient fame

worked in the same manner. Even if it were so, there is reason to doubt that he was also the artist of the Apollo group and the other terra-cottas which may be associated with it. The chances are that during the period from 515 to 490, which seems the latest date likely for the group in Veii,[39] Vulca and his men were still fully occupied with their commissions in Rome. We shall have to return to this question in the following chapter.

171. Duelling warriors, acroterion from Falerii, *c.* 480. Terracotta. *Rome, Villa Giulia*

CHAPTER 20

AGER FALISCUS, LATIUM, AND ROME

Architectural Terracottas

Terracotta sculpture was also popular in the extra-Etruscan territories adjacent to southern Etruria. From the 'ager Faliscus', where Etruscan-speaking peoples lived in close communion with Latins, stems the pair of duelling knights in the Villa Giulia here reproduced as illustration 171.[1] Originally it formed the middle acroterion of a temple near Città Castellana (the ancient Falerii), in a locality now known as I Sassi Caduti. Style and workmanship are clearly Etruscan; I should date the acroterion to *c.* 480.[2] It is difficult to decide just what kind of struggle was represented here. One can hardly account for these two fully armoured men as mythical personages. They seem denizens of the real world, contemporaries of their makers; perhaps heroes of a yet unknown saga. Their rich military equipment has been depicted with utmost accuracy. The leg armour consists of two pieces, one protecting the shin, the other the calves. Similar metal plates cover the thighs. The kneeling warrior holds a sword of curious shape, curved like a South American machete. Groups of duellists similarly posed had long been a standard feature of Greek art, and in this respect the imagery falls in line with Greek reliefs or vase paintings, while the taut, freely rounded forms remind us more of small bronzes. But the armorial details are rare and special. Moreover, their maker rendered them with an obvious awareness of their speciality, much as Vergil later described the unwonted pageantry of the Etruscan power rallied to the aid of Turnus.[3] The Archaic artist, likewise, turned reality into a heroic tale, merely by spelling out the details so minutely. If ever Archaic Italy had an epic of knightly exploits, retold with a sense of heraldic precision matching medieval chivalry or Vergil's catalogue of princes, this acroterion might illustrate it.

Isolated Late Archaic and Early Classical antefixes have come from the same building (Temple of Mercury), as well as from other sites of Falerii Veteres. The Archaic finds add little to our knowledge, however; here we may by-pass them. Their iconography is mostly Bacchic, featuring masks or dances of maenads and sileni.[4] The broadly shaped, strongly modelled faces and figures show little relation to the refined products of Caere and Veii: their analogues are found among the terracotta decoration known from Latin cities further south.[5] Evidently the trade along the inland route of the valley of the Tiber (p. 20) propagated a decor-

The almost overexpressive fragment of a silenus

172. Silenus antefix (fragment) from the Capitoline, Rome, late sixth century. Terracotta. *Rome, Capitoline Museum*

from the area of the Capitoline temple in Rome may serve as an example [172]. It is the most accomplished specimen extant among the antefixes of this style which we may well call Faliscan and Latin.[6] The mask with its wrinkled forehead and bulging eyes has a comically stupid look, whereas its cousins from southern Etruria (such as the satyr of illustration 162) strike us as witty rather than funny, and impish rather than stupid.

South of Rome, the largest single deposit of Late Archaic terracotta sculpture hails from the shrine of an enigmatic Latin deity, Mater Matuta, at ancient Satricum (modern Conca, north-east of Anzio). It comprises a rich sam-

173. Silenus and maenad antefix
from the Temple of the Mater Matuta, Satricum,
c. 500–490. Terracotta. *Rome, Villa Giulia*

pling of the materials commonly found among the debris of early Italic sanctuaries, consisting chiefly of terracotta revetments, antefixes, and piles of humble ex votos. There are also fragments of large statuary, similar to the statues from Veii but of lesser quality.[7] The best preserved and most remarkable among these finds is a series of antefixes representing amorous couples of sileni and maenads [173]. They march (or dance?) together in close union, from left to right, broad-faced and heavy-footed. The sileni, mostly nude, have long rounded beards and leafy crowns; the girls wear thin chitons and short mantles. Un-Greek, if interesting, is the apparent variety of facial expressions.[8] The courting capers of the dancers, clumsy and direct, may amuse us as the peasants of the elder Brueghel were calculated to amuse city-dwellers. In both instances, the critical distance between object and onlooker has been set by the artist. The squat forms and the metope-like reliefs of the silenus-maenad antefixes from Satricum reflect Italo-Greek connections, models in the style of the Late Archaic metopes from the temple at the Foce del Sele.[9] But the rustic homeliness of the characters must count as a domestic trait, as is true also of their actions: the boorish advances of the men and the nuances of surprise, acquiescence, or complaisance registered by their companions. A true *fête champêtre*; we find nothing quite like it in contemporary ancient art.

Early Statuary in Rome

In Rome, the approaching end of the Archaic period brought far-reaching changes. It is marked by the incipient urbanization of the city. A boom of public works can be noticed in many communities at this time throughout Latium and southern Etruria, but the corresponding projects in Rome seem to have exceeded the similar efforts of other places, both in numbers and magnitude. The political upheavals of the era, which probably included the expulsion of the Etruscan monarchy and the establishment of the republic (above, Chapter 19, Note 19), do not seem to have interrupted

the cultural process; if anything they helped to continue it. The generation living between *c.* 510 and 480, in addition to the completion of the temple of Jupiter on the Capitoline and the beginnings of such Roman landmarks as the Circus Maximus, saw the draining of the marshland which made possible the architectural reorganization of the Roman Forum, and the rise of new temples all around this newly ordered area.[10] With the temples went architectural decoration, painting, and statuary. Thus the first steps were made to move the future capital of the empire into the rank of the centres which, over the millennia, each in its turn shaped the consciousness of the race.

In this sequence of new projects the Capitoline temple was the first and most ambitious. It can hardly have failed to leave an impact on the public commissions that were undertaken immediately afterwards, likewise involving both architecture and art. Even if the Capitoline workshop dispersed before the end of the sixth century, it had set standards for others to follow. Besides, enough new work was going on or was then in the planning stage to keep people of special skills in the city. Their number may well have comprised former collaborators in Vulca's workshop. At any event signs can be discovered which, at this turning-point of her history, link the art of Rome to southern Etruria. It seems that the presence of Vulca left its mark, even after his work on the temple of Jupiter had ended.[11]

Towards approximately 490–480, there appears among the Etruscan bronzes a new type of Jupiter (the Etruscan Tinia) standing upright, as we see him for instance in the large bronze statuette in the J. P. Getty Museum[12] at Malibu, California: a toga slung over his left shoulder, his left hand pierced to receive a now lost sceptre [174]. Frontally posed and endowed with a severe dignity approaching Greek Early Classical tenets, the figure behaves like a cult statue. The larger prototype, however, which it seems to reflect, must be sought in Etruria. Workmanship and details of the Getty statuette are Etruscan. Archaic reminiscences still linger in the smile on the face, which recalls the lusty

174. Statuette of Jupiter (Tinia) from Piombino, *c.* 490–480. Bronze.
Malibu, California, J. Paul Getty Museum

mien and stylish beards of the Tarquinian dandies of yore.

In Etruscan Late Archaic art a cult image must be regarded an innovation. Therefore it is hardly a mere accident that the first example of this new type of art which comes to our attention shows the Capitoline god in a style on the verge of change from Archaism to Classicism. The early religions of Etruria and Latium required neither temple buildings nor cult images. We are told expressly that in Rome the statue of Jupiter in the Capitoline temple was the first in-

stance remembered of a cult statue set up in a public sanctuary.[13] The standing Jupiter in the Getty collection [174] may well illustrate this famous work, or else it can help us to form a believable idea of the statue in the quadriga on the roof, which also was certainly upright. At any rate it represents an iconographic schema then entirely new, which Vulca may have followed if he did not invent it.

Additional information about art in Rome at this time comes from Pliny. When the Temple of Ceres (dedicated in 493) was built on the slope of the Aventine two Greek coroplasts, probably from Campania, took charge of the terracotta decoration. This fact may denote a shift of policy, entrusting to artists from the Greek-speaking south an official assignment of a kind for which Etruscans had been employed previously.[14] Actually the change was hardly quite so radical. Apparently the artists of the Capitoline workshop had been a mixed crowd, including Campanians (above, p. 238). The difference was that this time the contractors themselves, who signed the decoration with their names, were Greeks.[15] The work for which they were commissioned may nevertheless have been in line with local tradition, since it included painted terracottas in the Italic-Etruscan fashion. That the influx of Greek workmen did not remain without consequences, however, follows from another incident recorded in Pliny. In the same Temple of Ceres a bronze statue of the goddess was dedicated shortly after 485 by the Cassian family. Apparently it was offered as an ex voto.[16] Pliny thought this the oldest bronze statue extant in the city; he cannot have been far wrong. The skill of casting statues of hollow bronze was then a very recent accomplishment: it had developed in Greece hardly more than one or two decades earlier, soon to become the most potent agent of change from Archaic to Early Classical precepts of statuary sculpture.[17]

The Capitoline Wolf

About the statue in the Temple of Ceres not much can now be said beyond the fact that it existed, and that according to written tradition it was a work of the early fifth century. Yet its record provides us with a valuable item in the context of circumstances which one must bear in mind if one wishes to understand the one early bronze statue in Rome still before us: the she-wolf in the Capitoline Museum [175, 176].[18]

The documented history of this famous work reaches back to the tenth century, when its place was on the outside of the medieval Lateran Palace. Its vicissitudes before that time remain obscure, however, and about its original provenance, function, or meaning, no information has so far come to light. The figures of the twins, Romulus and Remus (removed from our photograph), were added in the fifteenth century, probably by Antonio Pollaiuolo. Otherwise, the statue seems remarkably well preserved, except for the bushy tail, which is restored, a broad open rift in either hind leg, and a few repairs of minor importance.[19]

That the animal represents a wolf, if on a scale slightly above the natural, has never been doubted. There is some uncertainty whether or not a monument of such early origin ought to be connected with the legend of Rome's founding, popular rather in later times. Anyhow it seems likely that originally the Capitoline Wolf was a single statue, not part of a group. Even so she was clearly a maternal animal. There was no need to show the legendary children expressly to remind the Romans of her story, provided that story was already current in Rome by the end of the Archaic period. The assumption that this was indeed the case can perhaps be supported by another consideration. The myth of Romulus and his less fortunate brother dealt with memories of the city before the Tarquins. Perhaps the young republic propagated it for precisely this reason: it had an anti-Tarquin ring. The statue in the Capitoline Museum was certainly a public monument, perhaps a dedication exhibited in one of the new sanctuaries.[20] But as a reminder of the distant past and a symbol of Roman origins it may have carried a political address as well, in opposition to the rule recently abolished. The mood of defiance which it so obviously expresses, fits this ex-

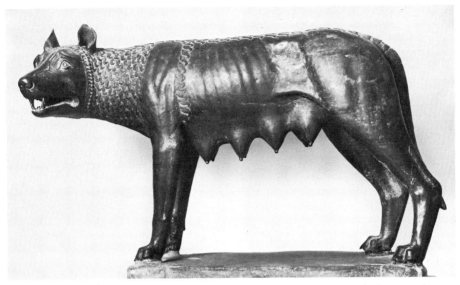

175 and 176. Capitoline Wolf, *c.* 500–480, with detail of head. Bronze. *Rome, Palazzo dei Conservatori*

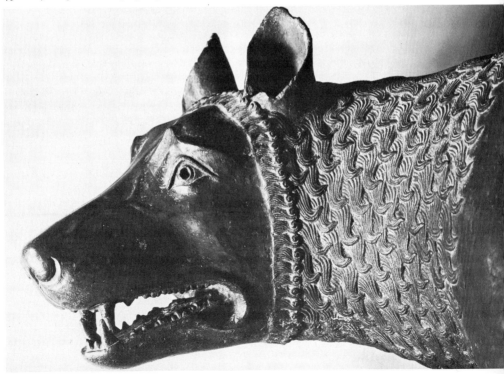

planation well. There is no reason to expect that an Archaic monument such as the Capitoline bronze should conform with the now mostly remembered iconography of the myth, which became standard only much later. A different representation, the group which the Ogulnii dedicated in the Forum, apparently became the prototype of the subsequent Hellenistic-Roman tradition. This group did show the twins, and the motherly care of the animal. The old folk tale was given a human and touching turn. Nothing of the kind could ever have been true of the Capitoline bronze. There the motherly instinct, if it was at all implied, received a more consistent and realistic interpretation. Hostile and wary, the animal snarled at the stranger dangerously, as she still snarls at the curious visitor of today in the quiet *salone* that now houses her.

The effectiveness of the whole work is felt immediately; to judge the parts is a different matter. There exists little agreement as yet about the likely date of this bronze, or its regional characteristics. In its apparent wholeness various, even contradictory, formal traditions and attitudes have strangely fused. Close inspection shows the Capitoline Wolf to be a composite beast, zoologically and stylistically.

Perhaps these inequalities inherent in the work as we see it now can tell us something about the working conditions that produced them. The caster was almost certainly a Greek, though he may have set himself up in Rome as the artists did who about the same time worked on the Temple of Ceres (above, p. 250). The sculptor who prepared the model for the cast was probably a different person, in accordance with a division of labour not unusual in ancient workshops. Be this as it may, it now becomes clear that the required task, to represent a she-wolf, created difficulties which the artists had to overcome, at least in part, with the help of traditional devices. Wolves are canines of a conspicuously lean build, with long pointed noses and a peculiarly stalking gait. That much the sculptor knew, and rendered. There is a surprising amount of direct observation incorporated in his work: not only details, such as the

small head with its short ears, but the entire silhouette, the stance of the animal, which has its slim but strong forelegs planted obstinately on the spot it will not cede, bespeak a keen sense of the natural reality. But wolves also have hairy pelts, and that the artist made no attempt to show. Instead he chose to assimilate the animal he was to represent to the traditional representations of lions after the archaic fashion common in Etruria; hence the long hair locks strung along the spine, the collar of small curls that frame the face, and the curly mane around the neck. Wolves sport no manes.

Because of the manifest originality of this work, one is likely to overlook its many archaisms. They exist nevertheless. The very structure of the statue is archaic. In the geometry of its outline, in the sharp turn of the head which breaks the prevailing profile direction almost at a right angle, we recognize archaic habits long embedded in the local tradition (above, p. 137). The elongated, flame-like locks of hair along the back can be found, similarly designed, in many animals of archaic art, Greek as well as Italic: lions, dogs, and others.[21] More remarkable, if less easily defined, is the peculiar stylization of the mane. This detail was treated evidently as a part by itself, rather incongruous to the rest. It was excellently planned and executed, however. The locks are small; each is shaped as a little hook not unlike a modern question mark. Together they form a decorative pattern, in the manner of oriental designs aiming at an 'infinite rapport'. In fact the nearest parallels I am able to cite are the similar patterns representing manes of lions, or the fur of other animals, in Achaemenid art of the late sixth and fifth centuries B.C. The decades around 500 was a time of near collaboration between Greek and native craftsmen in Persia, especially at Persepolis. One of their number may have brought this device to the West, where the mane of the Roman wolf thus far constitutes its only known occurrence.[22]

For all that, one may assume that the Capitoline bronze was produced in Rome. One ought perhaps not to describe it as an Etruscan work, outright. But clearly it was the upshot of an

Etruscan tradition, adapted to special needs of theme and material, and a partiality for squarish structures that may be called a local trait. Among the Etruscan reminiscences which we can still perceive, most relate to the art of Veii. It has long been noticed that the modelling of the wolf's rib cage much resembles the torso of the hind from the Portonaccio group, though the bronze is the superior of the two. To this observation more can be added, confirming the first. The angry eyebrows, which impart an expression of almost human temperament to the animal face, find their formal counterpart in the mask of Medusa discussed in the preceding chapter (p. 244). Also the sharply expressed outlines which describe this and other details of the head, especially the eyes, appear to be a mannerism in keeping with the ceramic tradition of Veii; while the head as a whole, facing us from out of the wreath of small curls, recalls the lion masks of the Tarquinia shields.[23] It seems reasonable to recognize in these formal specifics the marks of an Etruscan school, active locally. Certainly the artist who fashioned the wax model for the bronze wolf had been so trained. He may have been a coroplast originally, working in the Capitoline shops under Vulca. Bronze casting is essentially a modelling art, and its procedures are therefore nearer to other crafts dealing in plastic materials such as clay than to the quite different professional experience of the stonemasons.

Every available evidence counsels us to place the Capitoline statue at the end of the Archaic period, within the singularly productive decades between *c.* 500 and 480. In that event, one must count the Roman wolf among the very earliest examples preserved of large statuary cast as hollow bronze. Interestingly, the eyes of the beast are fully cast, forming part of the modelled surface. The pupils are shaped as small cavities, and were perhaps filled with coloured paste, as was done with some of the hammered masks in the Tarquinian bronze shields (above, p. 213). This method of casting the eyes with the surface runs counter to the Greek custom, which leaves the eye sockets of large bronzes hollow, for the insertion of eyes made of a different material. It seems to have been practised, however, in Etruscan bronze foundries of the early fifth century.[24] Therefore this detail may be taken as a further confirmation both of the relatively early date and of the local origin of the Capitoline bronze.

PART FOUR

THE CLASSICAL ERA: THE FIFTH CENTURY

CHAPTER 21

INTRODUCTION: THE ATTENDING CIRCUMSTANCES

Political Circumstances: Fifth Century

'Classical era' is a term of art history borrowed from Greek art; and as such it has here been adopted. The most distinctive phases of Greek Classical art encompass the years from 480 to *c.* 330. Because of the parallelism which exists generally between Greek and Etruscan art, it seems practical to apply to the latter the same period term, and to designate by it approximately the same unit of time. In Etruscan art one can in fact discern a 'Classical' period corresponding to the Greek. In many ways the Etruscans continued to follow the Greek direction. Yet a closer examination is bound to reveal radical contrasts as well which separated the Greek Classical development from that of Etruria. Nor did these differences concern art alone. The first statement due here is that during the century and a half which the Classical era comprises the political, social, and intellectual histories of Greece and Etruscan Italy drifted ever more apart.

Different from the Greek, the Etruscan ascendancy culminated about 500. In retrospect, it now appears, Etruria was essentially a power of the preceding Archaic period. After her maximum expansion, around 500, she was not granted a time for consolidation. The first signs of her future decline are clearly written into the history of the same early decades of the fifth century which in Greece brought the victory over the Persians and the consolidation of the Athenian hegemony. It is interesting to contemplate the condition of Etruria at this critical

moment. At first glance her position looks well established and healthy. Etruscan rule seems to stretch from the foothills of the Alps to the Gulf of Naples. But political cooperation among its constituent elements – independent towns and monarchies founded by individuals, in condottiere style – was rather loosely organized, and far from stable. The lack of authentic Etruscan sources probably led historians as early as the later ancient writers, Greeks and Latins alike, often to ascribe to the moves of the early Etruscans a more organized direction than they actually possessed. One can perceive many reasonable objectives in the progress of the Etruscan territorial expansion but little evidence of their coordination on a national scale. During the Archaic period the individual units, which together formed the Etruscan power, had grown ever more articulate. Now, at the end of that period, it became clear that they were all inclined to prefer home rule to concerted action, and the pursuit of interests close at hand to inter-territorial planning.

Etruscan Italy, so defined, at the beginning of the Classical era comprised three distinct territories. In the core land between Apennines and Anio the ancient centres were active, prosperous, and secure. In alliance with Carthage their fleets all but controlled the Tyrrhenian Sea. In Campania, to the south, the Etruscans were organized as a league of twelve cities, after the example of Etruria proper, if the ancient tradition is to be believed. Capua and, for a short time, Pompeii belonged to their number. To the north, a move to found new Etruscan settle-

ments in the valley of the Po was well on its way. This also was to establish a confederation of twelve cities after the traditional pattern, with Mantua and Felsina (the modern Bologna) in the lead. One result of the latter development was a new Etruscan interest in the Adriatic. About 500 the town of Spina began to function as the Etruscan trade centre on the Adriatic coast, built into the sea much like Venice, on a grid of wooden piles. As the harbour of Felsina, it opened up an important new trade route from the interior to the East.

Reverses began in the south, in military encounters with the Campanian Greeks. Until the end of the sixth century not much was heard about Etruscan armies. We find them mentioned more frequently around and after 500: the sign of a new and warlike time. At the start of the new era, in 474, an Etruscan attempt to take the city of Cumae was thwarted with the help of Hieron of Syracuse. The military defeat seems to have been decisive. It left the Etruscans without harbours, Pompeii having been lost also. The control of the sea lanes had slipped from their hands. The inland route to Campania was already imperilled, since it had to pass through Latin territory. Yet for a while at least it seems that Greeks and Etruscans went on living together in Campania, much as before. The history of art must take into account a continuation of the easy exchange and collaboration between them for some time after 474 (above, p. 227). Campania was finally lost to both Greeks and Etruscans at the close of the century, when Samnites from the nearby mountains forcibly installed themselves in the fertile plain, and the local civilization was reduced to a level of rank provincialism.

The Etruscan drive into the Po valley may have gained momentum from the wish to offset the insecurity of the Tyrrhenian trade and the narrowing access to Campania. Conditions in northern Italy at that time must have differed much from those in the south. The land was vast, relatively unexplored, and there were no other peoples of equal cultural resources either to assist or to oppose the settlers. The success of the Etruscans was at first spectacular. The

tombs of Spina reflect the sudden wealth of the town. Her population appears to have been mixed: Greeks, natives, Etruscans; nevertheless the wealthy tomb groups of the fifth century exhibit rather a standard selection, each including one or two large vases by the best Greek masters, some smaller vessels, vases of Etruscan make sometimes, and often Etruscan bronzework. About 450 this ostentatious prosperity seems to have been at its peak, and by 400 the city was still a going concern; but soon afterwards the finds taper off. Around 350 the wealthy burials seem to have stopped altogether. Felsina, though a settlement of quite different character, shows a similar curve of development and decline. These curves are really typical of the whole Etruscan venture into the Po valley. It was fated to collide with the nomadic tribes of Gauls which from the outset prevented Etruscan settlements in the north-west, the modern provinces of Piedmont and Lombardy. During the later fifth century the Gauls infiltrated the central and eastern sectors in growing strength. From the south the *montagnards* of Umbria posed a similar threat, taking over eventually the harbours of Ravenna and Rimini. It seems that the most important Etruscan cities survived the upheavals, as did Mantua and Felsina, which received her present name, Bologna, from one of the Gallic clans that finally occupied her. But all grew poorer, and some of the new settlements had to be abandoned altogether, like the site at Marzabotto. After 400 Etruscan influence was on the wane, and at the end of the fourth century the country had relapsed into a state of barbarism, with hardly a glimmer left of the Etruscan culture.

Political Circumstances: Fourth Century

With Campania lost and the frontier north of the Apennines in dissolution, Etruria was reduced to her original territory. In a state of relative isolation the Etruscans set about mending their fences. This was the time when the large fortifications came into being, often in the so-called Cyclopean manner, of which the imposing remnants are still visible in so many

towns of the region. Rome, also, built her stone wall (erroneously known as the Servian Wall) during this period. Three disastrous events, all of which occurred at the beginning of the century, pointed up the need for such precautions: the destruction of Veii by the Romans (396), the Gallic raids which occasionally went beyond the Apennines, one of them reaching as far as Rome (386), and the sack of Pyrgi by the Syracusans (384). The latter was excused as a punishment for piracy, which apparently some Etruscans at that time regarded as a legitimate way of life. During the fourth century Etruscan pirates operated on both the Tyrrhenian and Adriatic Seas, and complaints were becoming more frequent. But whatever its motivation, the Syracusan raid demonstrated the vulnerability of the Etruscan coasts. That the Gauls, arrogant, restive, and impatient, created a source of serious danger for all central Italy cannot be doubted. What provoked the Roman action against Veii appears less clear. Her destruction marked the end of a long war. The ineffectiveness of the Etruscan defences against the Celtic raiders, and generally the state of uncertainty which resulted from the rivalries amongst the Etruscan cities, may have prompted the Romans to set up their own wards in Etruscan territories, along the roads that led to Rome.

At any rate, the fourth century became the period of Roman penetration into Etruria. Those among the ancient city republics which were not physically harmed became politically crippled. The example of Caere is typical. The city was an ally of Rome in 386; by 270 she was a Roman dominion. Thus in various ways and by varying degrees, one by one, the Etruscan states became dependencies of Rome. Around 300 the process was nearly complete. The decisive steps leading to the final incorporation of Etruria into Roman Italy were all made before the end of the century.

It seems paradoxical that the almost total loss of political influence within hardly more than a century and a half, with all the grave changes these reverses must have entailed, was not followed at once by a corresponding decline of the economy. Yet many signs point to a continuation of Etruscan prosperity during the fifth and fourth centuries. The costly burials of the rich, our principal index of Etruscan wealth, show changes of style and fashion but hardly a loss of either frequency or quality. Etruria was still an acquisitive market and able to pay for the imported commodities with her domestic reserves, copper and iron. Nevertheless, the final balance of the two centuries which saw the zenith of the Greeks was unfavourable for Etruria. She had ceased to be an active force in world politics, which then focused on the contrast between the Greek community and the Orient. To this overall situation her states reacted as an altogether Italian people, without either colonial bonds or interests abroad that might engage them on one side or the other of the larger conflict. Their own problems were immediate and homebound. From 474 onwards dates the gradual transformation into isolated agrarian and mercantile communities of the Etruscan city-states.

Art: Chronology and Period Divisions

At no time did Etruscan art appear farther removed from the Greek than in the Classical period, especially during the early fifth century. The new situation contrasts sharply with the preceding Late Archaic phase, when the Etruscan monuments approached the contemporary Greek more closely perhaps than ever before, although differences resulted, even then, from diverse purposes, traditions, and working materials. Certainly some manner of relation existed perpetually between Greek art and Etruscan. It was built into their histories; they were the two progressive arts of their time. Our problem is to describe how their relation operated at any one period. Until the end of the Archaic phase the pace of progress was mostly set by Greek art. So were the standards of representation, though in the latter regard one must allow for a wider margin of divergence. But Early Classical art casts a doubt on both premises: neither was the pace of progress the same in Etruria and in Greece; nor, it seems, did the direction and meaning of progress converge in both countries.

The political developments of the fifth century cannot fully explain this situation. Another consideration may come closer to the heart of the matter. The step from 'Archaic' to 'Classical' was entirely a Greek intellectual venture. Especially in the formative arts with which we are here concerned, this may well be called a revolutionary event. It fed on dissatisfaction with the past, and delight in innovation. It repudiated the typicality of images on which all earlier art relied, including the Archaic Greek, in favour of uniqueness and variability. Moreover, Greek art had long been accompanied, and to an extent regulated, by theory. Treatises which explain the numerical systems used in the construction of Archaic temples probably constituted the first instances found anywhere of the instructional essay as a form of literary prose. A believable ancient tradition tells us that about the turn from the sixth to the fifth century the sculptor Pythagoras of Rhegium began to apply a similar method of numerical control to statuary, thereby initiating the long series of experimental canons, or treatises on measured proportions, which into the subsequent unfolding of Greek representational art instilled an abstract, guiding element of formal logic. Thus the conversion from Archaic to Classical also implied a change in critical theory and in the modes of rationalization on which rested the critique of the new works of art. On this point the written sources and extant monuments confirm each other. Together they make it amply clear that the Greek progress towards Classical art had a programmatic meaning, and that it followed a rationalized direction. The situation in Greece cannot be discussed here further, but a reminder is in order that the rise of Classicism in Greece meant something far more precise and more radical than a mere turn in the perennial cycles of taste. In the light of these circumstances, a history of Etruscan art must first ask in what way and when these Greek innovations became reflected in the art of the West; and to what extent, if at all, Etruria became acquainted with their theoretical foundations, that is, their literacy.

On the last question more has to be said in the following chapters. As regards the two preceding ones, the answer must be that in Etruria the Classical style was received with considerable delay. Since large statues of stone or bronze were not shipped across the seas in great number one is forced to assume that the workshops of central Italy, then as in the past, had to rely on smaller objects for what knowledge they might have been able to gain of the new art. As once the Phoenician bowls introduced to the West both their themes of art and a manner of their representation, so the Greek painted vases came to fulfil the same communicative function on the eve of the Classical period. The effect of the vase paintings on Etruscan art continued into the subsequent decades. Nevertheless, signs of contact with contemporary Greek art are surprisingly scarce during the period which in Greece produced the exemplars of the Early Classical style. One may argue, with reason, that these exemplars were not accessible to the Etruscans, and that the vases by themselves could not communicate an adequate conception of the Early Classical style, which was primarily sculptural. The argument must be conceded, but it can hardly resolve the problem of Etruscan isolation, which seems more complex. One still asks what caused the sudden loss of outside communication in the Etruscan art of this particular time.

There seems to be no certain answer; only a syndrome of telling symptoms from which perhaps an answer can be deduced. The body of art which can be ascribed to the decades approximately between 480 and the middle of the century is abnormally small, if compared to the Late Archaic output. Of the monuments still extant, a large portion falls into categories which served established local demands, such as tomb paintings. The style is generally conservative and appears to be either a continuation of Archaic antecedents or, in some of the finest examples, a delicate if belated Archaism. The prevailing tenor is restrictive rather than expansive; we may call it isolationist. These symptoms can perhaps be related to the harsher political climate after 500, and especially after 474. Yet regardless of what may have been their ultimate cause, one circumstance emerges from

them which must be deemed of major importance for the history of ancient art. There was no phase of Etruscan art corresponding to the Early Classical or 'severe' style in Greece. In its place one encounters a time of hesitation or, as it will be called in the following, a period of transition, which in turn has no equivalent in Greek art. After so irregular a start, it becomes doubtful if the art of the Classical era in Etruria could at any time be in agreement, as to development and purpose, with the contemporary Greek. At any rate the previously established parallelism between these two strands of ancient art was broken at the point when Greek art began to reshape itself, and prepare for that new union of imagery and reflection which we of today call Classical. What 'Classical' means in Etruscan art thereafter remains to be seen. That its pace of progress differs from the Greek is already obvious. In dealing with the Etruscans, it will therefore be advisable to divide the art of the Classical era into three separate stages proper to Etruria only: Period of Transition, c. 480–450; Response to Greek Classical Art, c. 450–400; Etruscan Art of the Fourth Century, c. 400–300.

Period of Transition (c. 480–450). Some interesting materials fall into this category, all in a lingering Archaic style, although a certain progress nevertheless seems to be noticeable amongst them; but since comparisons with Greek art are of little avail, owing to the different pace of development in the latter, datings of Etruscan monuments in this period are quite uncertain. They can only be based on comparisons between the domestic products themselves.

Tomb paintings were still a leading art in Tarquinia and were also resumed at Chiusi. Engraved mirrors continued, though they are not frequent; the finest specimens date from the last years of the period. Vase paintings, in a routine manner mostly, follow the Late Archaic technique of black figures, or else the imitation red-figured method. Stone sculpture is rare, and limited entirely to reliefs. It was especially popular in the inland towns of the north. The latest Chiusi cippi belong to this period. About

contemporary are the funeral stelae from Fiesole, in a more provincial vein, and also the earliest carved tombstones of the Felsina group.

There is little to report about terracotta sculpture. Apparently moulds of the preceding period were still in use, or closely imitated, for architectural decoration such as antefixes. The finds at Veii include statuary that perhaps dates from this period, but only fragments are preserved.

In contrast, bronze sculpture testifies to an undiminished, perhaps even intensified, activity. Bronze statuettes and utensils, often on a high level of quality, continued to be much in demand. Cast reliefs decorating mirrors and other small objects seem to have been an Etruscan innovation at this period. Still more important are the preserved examples of large statuary harking from the same decades. Evidently Etruria took to the new technology of hollow casting at an early time. The large bronzes in Rome, mentioned in the preceding chapter, cannot be considered an isolated instance, for they were matched by similar statuary in the Etruscan cities. It seems that at first the production of large bronze sculpture was concentrated in southern Etruria. The metal came from the mining areas of the north, chiefly Populonia, and was shipped along the coast to the southern harbours. Most likely the ancient ateliers at Tarquinia, Vulci, and perhaps Veii, which had long been the chief producers of Etruscan fine bronzes, also undertook the development of this new branch of their industry.

Response to Greek Classical Art (c. 450–400). The prolonged adherence to Archaic traditions in Etruscan art lasted until the middle of the fifth century, when signs of impending change become noticeable. At some time between 460 and 450 appear the first Etruscan vases painted in a regular red-figured manner. Another symptom is a negative one: from c. 450 onwards, the number of painted walls in the tombs of Tarquinia decreased sharply, almost to the point of cessation. The few paintings which perhaps ought to be assigned to the second half of the century, all poorly preserved, give an impression of mediocre workmanship and slackening invention. Tarquinian mural painting thus

ceased to be a guiding art in Etruria. Even when a revival finally took place about a hundred years later, the muralists never quite recovered the places of leadership which they held during the Archaic period.

The production of fine bronzes and bronze utensils went on as before, with the exception perhaps of the incense burners supported by caryatids (above, p. 216), the taste for which does not seem to have outlasted the Archaic period. On the other hand the famous bronze lamp from Cortona which freely mixes Classical elements with Archaic reminiscences probably dates from the beginning of the new era of renewed contacts with Greek art (below, p. 288).

Extant examples of terracotta sculpture, though still not numerous, include some exquisite works in the new style. The best finds came from inland sites along the median axis of central Italy: Veii, Falerii, Orvieto. In general, the growing cultural importance of the inland cities, and their active participation in the renewal of Etruscan art, are worth noting. No longer were the western harbours the sole recipients and distributors of the fresh impulses derived from Greek imports: the new Adriatic trade, and perhaps easier communications, evidently tended more than was the case before to equalize the cultural levels in the separate Etruscan territories.

A renewed interest in stone sculpture becomes noticeable towards the end of the period. The ancient ash containers in anthropomorphic shapes, a class long dormant, underwent a significant revival in the territory of Chiusi during the last quarter of the century. One or two decades later, near the close of the fifth century, the first Etruscan carved stone sarcophagi made their appearance in Cerveteri.

Etruscan Art of the Fourth Century (c. 400–300). Etruscan art attributable to the fourth century is more frequent than are the materials which we may ascribe to either stage of the fifth. Considering the inevitable, if uncertain, percentage of works lost, we must conclude that the original production was even larger, thus approximating the peak level which Etruscan artistic production had reached during the Archaic period. Yet apart from quantity, the new art of Etruria had little in common with the Archaic. Its general mood and social significance were quite different. Chiefly, the art of the fourth century carried out and expanded trends begun during the fifth. Almost all the principal classes of monuments with which we especially connect the name 'Etruscan' were in existence before the year 400. The century that followed elaborated and enriched the various types of art given to it by inheritance. The engraved cistae from Praeneste, which started about the middle of the fourth century, constitute the only innovation of note. The principal classes of monuments and their uses, in which Etruscan art was wont to express itself, had by then become a fixed and common canon, rooted in the public consciousness. Their sum total, at the close of the fifth century, may well be called a national tradition, over and above the regional divisions still valid within the artistic and intellectual commonwealth of Etruria.

A survey of the most important classes of monuments and their geographical distribution yields the following list. Wall paintings in tombs are known from Orvieto and Tarquinia. From the latter city also stems the famous sarcophagus with a painted Amazonomachia, now in Florence. Red-figured vase painting flourished. In the course of the century this industry moved from the southern coastal cities where it probably started further inland and north; first to the Faliscan territory and to Orvieto, later to Chiusi, and finally to Volterra. The production of the popular bronze objects decorated with engraved designs, chiefly mirrors, seems gradually to have become concentrated in Praeneste. Nevertheless it is likely that mirrors were also produced in other cities, for example at Tarquinia; the metal engravers had long been at home in the Etruscan south. Outstanding among the stone reliefs were the grave stelae from Felsina–Bologna (cf. pp. 373 ff.). In Chiusi the anthropomorphic ash urns were turned into a class of monumental stone sculpture; in one surviving instance, bronze was used. For bronze remained the preferred material, and bronze casting the highest art of statuary. Remarkable for the sake

of this survey are the provenances of the few examples that have survived: the 'Mars' from Todi; the Chimaera from Arezzo. The comparatively high number of statuettes still in our collections must make up, as best they can, for the losses of large statues. Meanwhile the craft of the coroplasts continued; it had long been an Etruscan speciality. Finally the stone sarcophagi of Tarquinia have to be mentioned which during this century developed into a characteristically Etruscan and very numerous category of monuments. Though they form one homogeneous class as to use, the habitual repertoire of their decoration will have to be discussed under three separate headings. Their sides are often decorated with representations in relief. The persons shown reclining on their lids must be classed as a kind of statuary; but their faces require a study in its own right, as a special manifestation of portraiture.

Three points of fact emerge from this survey which determine the condition of Etruscan art in the new era. First among them is the conspicuous multiplicity of places which participated in the increase of works of art, either by producing or receiving them. Evidently the whole of Etruria was involved in this venture. The cultural equalization which began in the preceding century (above, p. 260) has progressed considerably. If a disparity between the various territories can be discerned at all, it is not in favour of the coastal regions. In the statistics of finds the localities inland and north show a slight advantage.

Secondly, one recognizes a significant contrast between this state of affairs and the conditions of the Archaic period. The latter favoured the Tyrrhenian coast. At any one time from the seventh century to the end of the sixth the Etruscan centres of highest activity were fewer and more isolated from each other. Also, the differences of level between their various artistic traditions and skills were more apparent: the lines were more sharply drawn between those founded on the direct overseas contacts which then were the monopoly of the western harbours, and others that grew up in comparative remoteness; so was the distinction between the leading arts and folk art. From the fifth century onward the cultural condition of Etruria as expressed by her arts seems to have grown more solid and unified. The regional differences, which still count, seem less separative. Thus the paradox resulted that, at the time when Etruria ceased to be a nation politically, she acquired a national identity culturally, in her institutions, social traditions, and art.

The third point regards the relative significance of the chronological subdivisions which we here propose. Different from Greek art, in which the Classical style arose with the suddenness of a personal resolution and a fresh beginning, the change from Archaic to Classical occurred in Etruria, as a gradual transition. This observation, if accepted, implies that the decisive chronological division between the old and the new in Etruria lay at the end and not at the beginning of the transitional period; not about 480 but one generation later, near the middle of the fifth century. A further change, as between two stages of a continuous process, may be acknowledged about the turn from the fifth to the fourth century. The latter division however seems of minor importance if compared to the conclusion of the preparatory period, accomplished fifty years earlier. From c. 450 to the Hellenistic period, the advance of art in Etruria can be regarded as a coherent progress. In this development Greek Classical art had a certain share. But how far its impact reached, and what precisely the hypothesis of a Classical era may signify in Etruscan art, neither traditional history nor mere opinion but only the monuments can tell us.

CHAPTER 22

WALL PAINTINGS AND STONE RELIEFS

POST-ARCHAIC WALL PAINTING AT
TARQUINIA

Decorative Systems and Zonal Divisions

Among the wall paintings at Tarquinia which
are here assigned to the interval between Late
Archaic and Classical art, two are outstanding:
those in the Tomb of the Chariots, and in the
Tomb of the Banquet [180-5]. The recently
discovered Tomb of the Ship,[1] though not of
the finest execution, attracts attention also, be-
cause of its unusual subject matter [187]. These
are exceptions, however. In general an unmis-
takable standardization of themes as well as of
their presentation was taking place throughout
the period. A series of closely allied wall paint-
ings, a few among them of the first order but all
enjoyable, resulted from this competent if some-
what conventional art.[2]

The decorative systems into which the figural
paintings were fitted require a brief examina-
tion. They mostly correspond to the manner of
arrangement classified above as the third phase
of Tarquinian wall painting (pp. 185 ff.); that is,
they follow the example first set in the Tomb of
the Lionesses, to our knowledge, rather than the
basic Archaic scheme (the 'second style') as ex-
emplified by the Tomb of the Augurs. The dis-
tinguishing symptom is the decoration of the
upper margins of the walls. In the tombs of the
second phase one finds in this place a broad
band of parallel stripes which functions as an
upper cornice, perhaps in imitation of a beam or
wooden plank painted with various colours. The
device is continuous around the chamber and
thereby, quite logically, also serves as a base for
the pedimental triangles above the small walls.
The underlying rationalization, as explained
previously, was of an architectural order. By
contrast, in the Tomb of the Lionesses the upper
third approximately of the walls was reserved

for the representational decoration which thus
moved into the place of a large, figured upper
frieze. The logical consequence was that the
striped band which might be expected above
the frieze was omitted; the figured frieze itself
replaced the geometric decoration of the upper-
most zone [120]. Thus far an architectural
reasoning might yet apply to the revised ar-
rangement. But the illusionistic representations,
which on all sides seem to depict a locality tran-
scending the actual bounds of the chamber, cast
doubt on any interpretation of the decoration as
a consistently rendered interior architecture.
The thin frame-line which separates the frieze
from the gable would in a real structure provide
an intolerably tenuous foundation for the pedi-
mental group. The painter's first concern was
with the spectacle he set out to illustrate, not
with a sham architecture for the room in which
he painted it.

The trend thus begun outlasted the Archaic
style. During the decades around 500 one can
observe a growing tendency to place figured
representations in the upper third of a wall;
sometimes the traditional striped architrave was
simultaneously shown, as in the Tomb of the
Baron [127]. The decorative system employed
in the Tomb of the Chariots, which heads the
list of Tarquinian wall paintings after 480
(below, pp. 266 ff.), is probably best explained
by the same Archaic antecedents. A smaller
figured frieze runs on top of the main zone,
which represents dancers [183]; again, the com-
bination impresses us as pseudo-architectural.
The arrangement apparently was an innovation
in its own time; it yielded two zones of figures
instead of one, and peopled pediments in addi-
tion. The thought was ingenious, but apparently
failed to set an example. We know of no attempts
at repeating it.

Instead, the majority of zonal systems in this
period falls in line with the third style as above

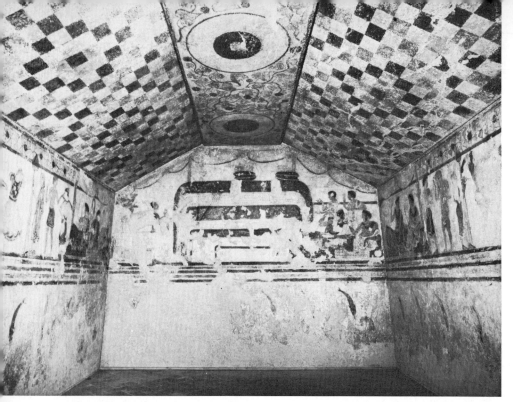

177. Tarquinia, Tomb of the Funeral Couch,
c. 470–450, rear wall

defined, the principles of which they vary with
considerable freedom. Gradually the striped
cornices either disappear from the upper bor-
ders of the walls or else are turned into orna-
ments of a different form and function. The
wish to save more wall space for the pictorial
elements probably instigated this rather experi-
mental approach. Thus in the Tomb of the
Funeral Couch,[3] which I should date near the
end of the transitional period [177], one still
recognizes the after-effects of zonal divisions in
the manner of the Tomb of the Lionesses [120].
But the proportions have changed and, in a
sense, become distorted. The figured frieze now
occupies about half the height of the lateral
walls, and still more of the rear wall. The action
represented, not wholly explained so far, is con-
tinuous, but it has lost the character of a frieze in
favour of that of an entablature. A striped band
topped by a laurel garland on which the figured
zone rests serves as a divider between the upper

half of the wall and the dado; in this location it
can hardly have carried a reference to normal
architecture. Dolphins and the sea reappear in
the dado, as we saw them in the Tomb of the
Lionesses; and just as was true there, in the
Tomb of the Funeral Couch the upper cornice
has also been omitted. The undulating drapes
hanging from the ceiling or, on the rear wall,
from upright posts, form part of the representa-
tion, not of the architecture of the tomb. They
belong to the building wherein the banquet and
ceremonies take place which the paintings illus-
trate. At one point, however, the liberty which
the later decorator took with tradition far ex-
ceeds the example of the Tomb of the Lionesses.
In his design the rear wall has been entirely sur-
rendered to the representational paintings, with
the enormous funeral couch – if this is indeed
the explanation – occupying the centre.[4] No
space was left for the customary architecture of
a pediment, supported by a kingpost. In the

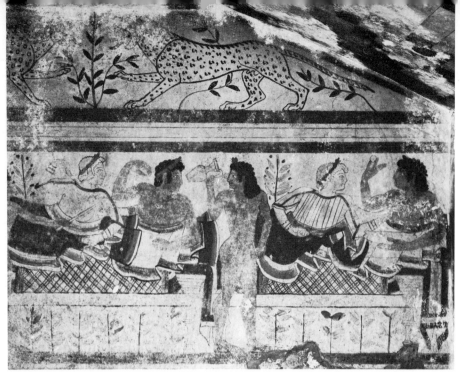

178. Tarquinia, Tomb of the Leopards, *c.* 480-470, rear wall, Banquet. Wall painting

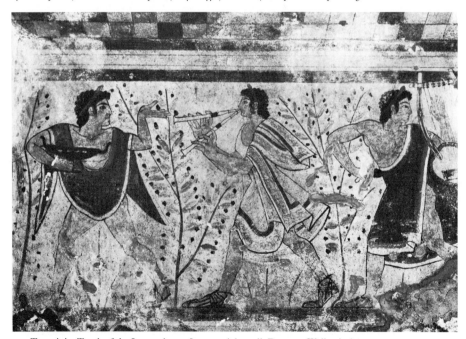

179. Tarquinia, Tomb of the Leopards, *c.* 480-470, right wall, Dancers. Wall painting

progressive dissolution of the Archaic architectural schemata which appears to be the essence of the third phase in the evolution of the Tarquinian murals, this omission of the traditional pediment marks a final and most radical step.

Not all mural decoration of the transitional period was so revolutionary, however: a different and seemingly more conservative scheme became popular after 480, and was frequently repeated during the following decades. The standard iconography that went with it, banquets and dances, will be discussed below (pp. 269 ff.). Probably the earliest example of this kind of decorative system is preserved in the Tomb of the Leopards [178, 179].[5] Large, many-figured friezes fill the walls. Above them runs a narrow band, effective as a framing device, though only a poor remnant of the erstwhile entablature fasciae. A somewhat broader border of parallel stripes sets the main zone off from the low, dark-painted dado. This system seems rather in keeping with earlier usage, because it permitted the persistence of traditional pediment compositions. Nevertheless it also changed the character of the superimposed zones in the direction shared by almost all mural systems at this stage, by substituting freely ornamented borders for the former architectural divisions. Thus in the Tomb of the Banquet[6] [184] the narrow band on top of the main zone contains a trailing vine of ivy between two dark-red, parallel lines. In conjunction with the triple-striped lower border this design creates an elegant and efficient frame for the representational frieze; but in terms of architecture, the resulting order has lost all meaning. The architectural triad of socle, intermediary wall space, and architrave (or cornice) no longer applies. In effect, only one of its members survived: the figured frieze, now securely settled in the main zone of the walls and emphasized by the horizontal framing ornament. As with other decoration of the third style, the upper edge of the dado forms the traditional wave pattern, thereby referring to the billowy seas; it too has become part of the representation. Occasionally among the decoration of the transitional period one encounters more conservative ensembles which

seem to revive the tectonic Archaic schemata, as in the Tomb of Francesca Giustiniani [186].[7] On the whole, however, these instances seem to have remained a minority. The prevailing trend was to give up the architectural analogues and turn the zonal divisions into freely adjustable ornament, as a setting for the pictured friezes.

Tomb of the Chariots[8]

The special character of this monument – its zonal system – has already been noted (above, p. 263). The representations which fill the zones are no less unusual. Even in its present state of ruin the Tomb of the Chariots commands attention [180–3]. Much must be called unique: the richness and scaling of the decoration, the thematic choices, the subtle use of colours.

One enters a lightly painted chamber. The broad ridge-pole is decorated with large, starlike circles, perhaps intended to represent carved ornament, while the slanting sides of the roof are covered with a chequered pattern, probably in imitation of woven hangings.[9] The paintings round the walls show three sets of figured representations. Added to the main zone are the small frieze along the upper edge of the wall and the rear pediment with two large, reclining banqueters who look truly colossal by comparison with the rest [180].

The small frieze provides entertainment for the crowds. It renders athletic contests and all sorts of sport, presumably in honour of the dead but clearly for the pleasure of the living as well. Everything seems to happen simultaneously, as in a three-ring circus. Wooden stands covered with canvas are shown in the two corners of the rear wall, facing each other, from which gesticulating spectators follow the boxing matches and other spectacles in the arena [181]. Two similar stands are placed in the adjoining corners of the lateral walls with their backs to the stands on the small wall, to make it clear that the onlookers can really see all that goes on in the stadium, in all directions. Unfortunately many details have now faded beyond legibility and can only be reconstructed from earlier drawings.[10] The genteel audiences, including ladies, are seated on

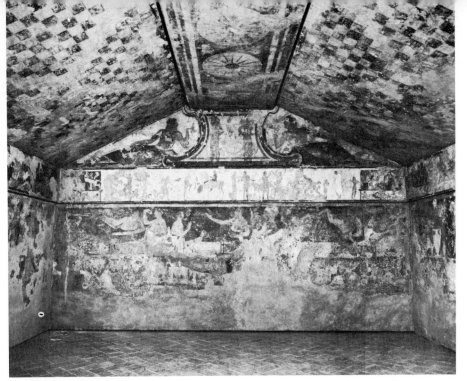

180. Tarquinia, Tomb of the Chariots, after 480, rear wall

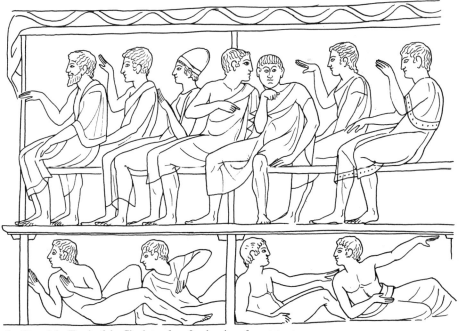

181. Tarquinia, Tomb of the Chariots, after 480, drawing of spectators

raised platforms. Below, in the interspaces between the supporting posts, their pages while the time away playing the *morra* game, making love, or just looking at the contests. In the same frieze, upon the right wall, one finds the chariots from which the tomb took its name. Chariot races were the most noble of funeral games, in the Homeric tradition. At Tarquinia the Tomb of the Olympic Games represented a chariot race in full progress, including the accident of an up-turned car. Apparently the latter theme was special to Etruscan art, as it later became a standard item in the circus races represented on Roman sarcophagi.[11] In the Tomb of the Chariots, however, the races have not yet begun. Instead of the event itself one sees the preparations that precede it, from the point where the unruly horses are led into the arena to the moment when the first two bigae are ready to parade past the grandstand. In this part of the frieze the actions form a sequence, with a connotation of progressing time, much as in the frieze of the Parthenon. The Athenian procession can be viewed as a progress from departure to arrival, contained in a unified composition. It follows that in the small frieze of the Tomb of the Chariots the preparations before the races constitute a compositional unit in its own right, like a small pictorial epic within the larger context. The antithetical group of the trainers who harness two horses to the chariot between them

adopted this manner of narration from the early dramatists (above, p. 241). The entire frieze, on a white background, is most delicately drawn and coloured. The flesh tones are light, not stark brown or red as was customary in the earlier, Archaic paintings. Some of the horses are red, others appear to be painted a light blue, at least in their present condition; originally they may have been black.[13] In the main zone below the frieze, dancers on a larger scale stand out in light colours against a ground of red. This, also, was an unusual combination. Perhaps the red ground was due to reminiscences of Greek red-figured vases, or else to the fact that empty walls were often painted red in ancient buildings. The dancers, men as well as women, seem rather mannered beings, moving ceremoniously. They follow each other in equidistant fields, each framed by two straight trees [183]. This arrangement corresponds to a domestic habit of long standing (Tomb of Hunting and Fishing, above, pp. 187 ff.; cf. p. 190). In combination with the red backdrop, however, the ancient device produces a novel effect. Within their framing fields the stylized figures appear more as ornament than as a representation of reality. They seem to render a row of pictured tapestries, images twice removed from life, dimly outlined on the faded red of the ground into which they might as well have been woven, not painted.

182. Tarquinia, Tomb of the Chariots, after 480, chariot frieze

[182] functions as a key motif, as in a centred frieze of the Classical style.[12]

In its Etruscan setting this section of the frieze forms a conspicuously grecizing episode. The emphasis on surrounding circumstances, before or after an action, was a Greek trait, especially in Classical art, which probably

The spirit of the whole as well as many details, such as the variety of postures and frequent foreshortenings in the small frieze, force us to place the Tomb of the Chariots beyond the range of Etruscan Archaic art. The dancers even look archaizing rather than truly Archaic. We may compare their design, the puppet-like ele-

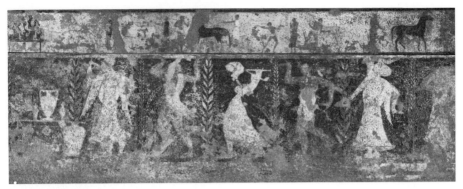

183. Tarquinia, Tomb of the Chariots, after 480,
superimposed friezes

gance of their movements as well as the stylized
folds of their garments, to the mannered ar-
chaism sometimes found in Greek red-figured
vase paintings of the Early Classical period, for
instance in the work of the Pan Painter. A tenta-
tive date shortly after 480 seems to do justice to
this remarkable monument.

The Eternal Banquet

During the period of transition after 480, ban-
quets became the standard subject matter of
funeral painting at Tarquinia. Usually their
representations include two themes which are
often treated separately: reclining banqueters,
and rows of dancers. Apparently, they were held
to be related subjects: they belong together.
The setting is either outdoors or, as has also been
suggested, a tent erected for the occasion.[14] A
place in the green would be well suited for the
dancers, and seems indicated by the trees and
shrubbery traditional in these representations.
Banquets on the other hand were more likely to
be set up in a covered structure such as a tent.
The probable answer is that one is dealing with
a fusion of two themes that were originally
separate, as they had been in the Tombs of
Hunting and Fishing and of the Lionesses
(above, pp. 187 ff., 185 ff.). When they finally
became merged into a unified event, one may
doubt whether its setting was ever quite ration-
ally defined. It bears the features, for the most

part, of a vision of some unworldly garden of
Eden.[15]

During the transitional period it became cus-
tomary to assign the banqueters to the rear wall
and distribute the dancers along the lateral
walls. Such was the case in the Tomb of the
Leopards [178, 179]. Trees and flowers grow
from the ground, even below the couches of the
symposiasts. The latter are engaged in a drink-
ing bout; but instances are not lacking where
the banquet offers food along with the drink.[16]
When the theme of the banquet first appeared
in the iconography of the Tarquinian tombs it
seemed to portray a rather solemn occasion,
reserved for the master and mistress of the
house (above, p. 189). In the Tomb of the
Leopards three couples are shown on their
couches, ostensibly as a picture of gay company:
the meaning of the theme has changed, together
with the times. It is not clear what part the
dancers play on this occasion; again, they are
lined up in rows, separated from each other by
the scanning rhythm of trees in the Etruscan
manner. The figures are well preserved, and
their style is interesting. Yet by Greek standards
one can hardly date them: while they seem to
follow Late Archaic patterns of silhouette draw-
ing, there is also an air of spaciousness and
liberality about their motions which sets them
apart from genuinely Archaic design.[17] Details
confirm this impression. A comparison between
the outlines of faces in the Tomb of the Leopards

and the Tomb of the Baron [128] for instance shows the difference; so will a glance at the hands of the flutist in the Tomb of the Leopards [179]. A change of style has occurred, and it moves in the direction of Early Classical forms. Yet, different from Greece, this change did not come to Etruria as a sudden and total renovation; it appears to us rather as a steady progress feeding on, and expanding, existing resources. The anonymous artist of these murals lacked neither originality and variation of detail, nor a sense of monumental form; attention ought to be paid to the folds of garments, rendered in grandly designed, flat, broken forms. All in all, the Tomb of the Leopards marks an early stage in the Etruscan transition from Archaic to Classical tenets (cf. above, p. 259). We may assign to it an estimated date in the decade from 480 to 470.

same pattern [184, 185]. Three couches with banqueting couples – the *triclinium* – fill the rear wall, together with a flutist, a boy attendant, and a cat stalking a domestic fowl below the tables. Wreaths hang from the ceiling: the scene is indoors. The dancers along the lateral walls must be thought to be in the open, however; the customary trees divide them: birds flutter in the free air. Interestingly, the Etruscan paradise-fantasy here became mixed with Dionysiac memories. A woman dances in frenzy, like a Greek maenad [185]. Ivy decorates the upper border, and the altar-shaped kingpost in the rear gable is overgrown by the same plant. The religion of Bacchus evidently made an inroad on this painted Elysium. Its advance in Etruria may be counted among the signs of the new time.

Very likely these murals, like others in Etruscan tombs, were executed by a workshop group.

184. Tarquinia, Tomb of the Banquet, *c.* 470–460, right wall, Dancers. Wall painting

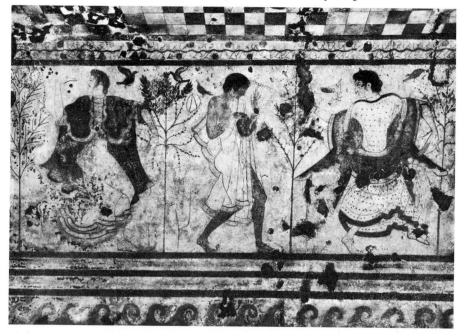

In the Tomb of the Banquet, which was perhaps painted about ten years later, the large figured friezes are arranged according to the

Different hands can be detected in them. The decoration followed a unified plan, however, with an obvious taste for subtlety, finely drawn

outlines, and light, delicate colours. No doubt the leading artist knew Greek art, probably from vase paintings, and he was familiar with the problems that interested the new generation of painters, for instance the advances made in the rendering of thin garments. But the work in its entirety represents an Etruscan, not a Greek fantasy. A parting glance at the ecstatic dancer can make this clear [185]. Her short dotted frock – the material resembles modern printed calico – and the dark stole worn reversed, as it were, with the collar hanging down in front and the loose ends fluttering at the back, are decidedly Etruscan; so is the studied bend of her trained hands. Her artful step is rendered by the distinction between one foot set sidelong and the other put forward, in perspective. This rendering was certainly in keeping with the most up-

185. Tarquinia, Tomb of the Banquet, c. 470–460, Dancer. Wall painting

to-date Greek drawing skill, but the feet that perform the step are shod in soft Etruscan shoes; a display of provincial elegance at which an urban Greek may well have smiled.

About this time a new iconographic element makes its appearance among the customary representations of feasting, music, and dance. In the Tomb of the Funeral Couch, a bridled horse is led into the place of gaiety.[18] A biga with a coachman in it halts abruptly behind the woman who plays her double flutes so emphatically among the dancers of the Giustiniani Tomb [186]. Another biga, now almost indistinguishable, was once shown on one of the long walls. It is difficult to account for the presence of these silent guests. They have been explained as participants in the funeral games.[19] But the trouble is: they do not participate. It is exactly their stillness and inactivity which cause us to wonder. They strike a disquieting note. The horse seems to await its rider, the coachman his passenger. The likelihood is that in these strange interspersions between the dancers and the banquet one encounters early hints at a quite different funeral metaphor: death as a journey. Apparently at Tarquinia this was then an unaccustomed turn of thought. One is led to believe that it became introduced into the familiar Tarquinian imagery only tentatively, almost shyly. Yet this idea with its more sombre allusions to the ultimate fate of man was destined soon to replace the hospitable company of the diners and symposiasts in many representations of Etruscan funeral art. The means of the journey may vary; horse and chariot can serve equally well.

I am inclined to count the newly discovered Tomb of the Ship among the same category of early elaborations on the image of uncanny travel [187]. The banqueters are present, as usual. Turning his back to them, a man stands behind a rock [188]. He strains to look out over the sea before him, with one hand raised to shelter his eyes from the sun. On the other side of the cliff follows the seascape with the ship from which the tomb received its name. Among the crew one still recognizes a frantic mariner; the ship may be in trouble – running into the

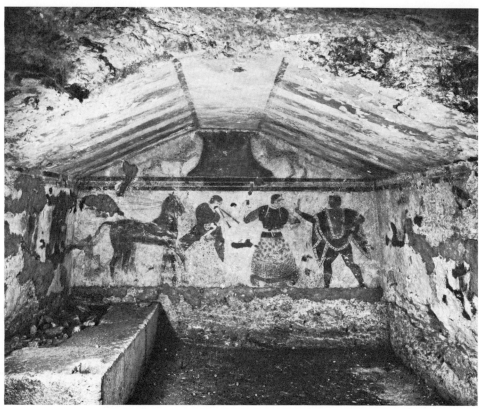

186. Tarquinia, Tomb of Francesca Giustiniani,
c. 470–450, rear wall

cliff, for instance? It is not clear whether or not
the artist assumed a connection between this
unusual scene and the symposium, just as it is
difficult to decide, here and in many other re-
presentations of the funeral journey in later art,
whether the moment illustrated is one of de-
parture from the living, or arrival among the
already departed. In imagery, as in the circum-
locutions of language, the thought of the human
finale invites vagueness, wherever precision is
beyond our reach.

It seems that at Tarquinia the Archaic tradi-
tion of painting and its long epilogue in the tran-
sitional period ended shortly after the middle of
the fifth century. The Tomb of the Ship ap-
pears to have been one of the latest examples

preserved. Together with the Archaic tradition,
the themes of the eternal banquet and the
dancers on their blessed meadows all but dis-
appear from the funeral monuments of Etruria
– at least temporarily. Their memory was not
wholly extinct, however. Actually the sundry
themes of funeral art – the iconography of death
– which the Archaic period established in
Etruria survived in ancient Italy for a long time
to come. The representations of the hunt, the
career of the noble which includes a man's
marriage and civic offices (above, p. 211), the
circus races and athletic contests, all will be
found anew on the Roman sarcophagi of the
second and third centuries A.D. Banqueters will
again rest on the lids of coffins, both later Etrus-

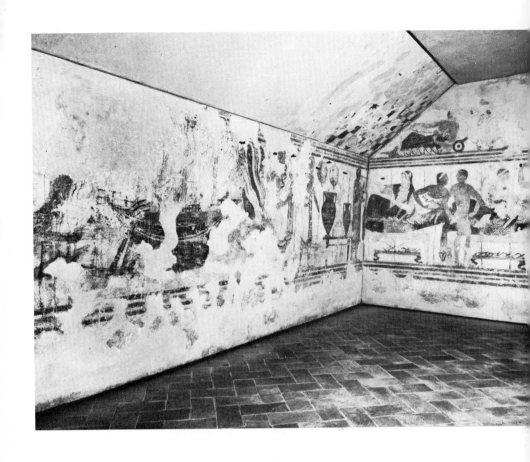

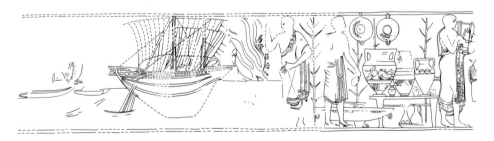

187 and 188. Tarquinia, Tomb of the Ship, *c.* 460–450, left wall, with drawing

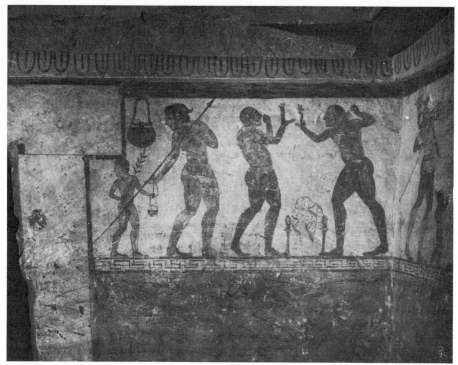

189. Chiusi, Tomb of the Monkey, c. 480–470,
corner of main room

can and Roman, and on Etruscan ash urns; dancers and music transmuted into mystic celebrations of Bacchic revels will again find a place on the sculpted walls of Roman sarcophagi.

PAINTINGS AND STONE RELIEFS
IN NORTHERN ETRURIA

Wall Painting at Chiusi: Tomb of the Monkey

Tombs with painted figural decoration begin to reappear in the city of Porsenna about 480, after a lapse of almost a century (p. 205). One may doubt, however, that their number was ever considerable. Among the examples on record only two are sufficiently well preserved to warrant discussion here: the tombs called 'of the Monkey' and 'of the Hill' (or 'the two Chariots'). The other Late Archaic and post-Archaic tombs

of the region must now be judged chiefly from second-hand sources such as verbal descriptions and drawn illustrations. Most seem to stem from the decades around 450, though the latest may date near the end of the century. On the whole they form a unified group of predominantly local character but with unmistakable Tarquinian reminiscences.[20]

Characteristic of both the Tomb of the Monkey and that of the Hill are the figured friezes which sit below the cornice, where they occupy slightly more than the upper third of the wall. This arrangement resembles the Tomb of the Chariots at Tarquinia, except that in Chiusi the walls below the friezes were left entirely without decoration. Both tombs were carved into the natural tufa. The chambers are arranged crosswise, with the largest room in the centre, like the atrium in a Roman house; the

190. Chiusi, Tomb of the Monkey, *c.* 480–470,
drawing of corner of main room

191. Chiusi, Tomb of the Monkey, *c.* 480–470,
Seated Lady, Games, and Dancer. Wall painting

figured friezes were reserved for this room. In the Tomb of the Monkey the walls below the frieze are painted in a blackish green, thus giving the effect of an irregularly high dado. The ceilings are shaped as a three-stepped sequence of sunken panels which diminish in size, the uppermost being the smallest. They seem to imitate an elaborate wood construction. This form of ceiling differs radically from the Tarquinian tombs; so does the painted cornice which in the Tomb of the Monkey sets the frieze off from the architecture. It consists of a broad band, with a tongue pattern sketchily outlined in red. A smaller band below the frieze shows a thinly drawn meander between two red lines. Only the black and red stripes immediately below the cornice that includes the tongue pattern can be read as a residual reference to the striped cornices which were customary in Tarquinia. Clearly the new tombs at Chiusi were not unrelated to Tarquinian antecedents; however they were not wholly dependent on them [189, 190].

In the Tomb of the Monkey, the frieze represents athletic events shown as separate episodes rather than as a continuous action: the traditional games in honour of the dead. A lady in Etruscan costume – the only onlooker – seems to preside. She may portray the sponsor of the games and, if so, is most likely the widow of the deceased. She is seated on a four-legged chair, her shod feet resting on a footstool. With both

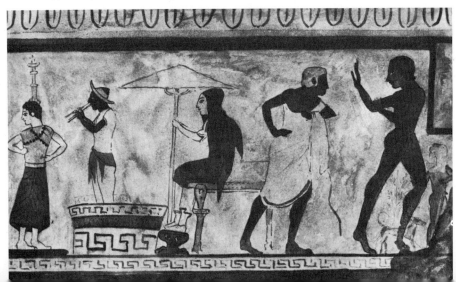

hands she clasps a large umbrella; ostensibly this serves to protect her from the sun, though it may also denote a sign of social distinction. The meaning of a low, angular, decorated piece of furniture in front of her is likewise still uncertain; it may be a chest or basket in which travelling mountebanks transported their costumes and equipment.[21] A hatted flutist stands behind, not upon, this podium-like object. Presumably he plays for the dancer before him, who balances on her head a tall object, perhaps an incense stand [191] (cf. pp. 216 ff.). The games which follow illustrate a rich variety of sports. The programme features chariot races and young riders who jump from a running horse, or perhaps change horses in full gallop. The Archaic aristocracy held this skill in high honour, as a sport as well as an art of battle; similar races on two horses occur on the Chiusi cippi and elsewhere in Etruria (p. 209).[22] With this one possible exception, however, most participants in the show appear to be professional performers and entertainers. Different from Greece, athletics tended to be a spectator sport in Etruria. As a piece of by-play, near the door to the rear chamber (*tablinum*) one sees chained to a tree the little monkey from which the tomb took its name.

The style of these paintings is conspicuously uneven, apparently because different models were used for individual episodes. The group with the seated lady was probably improvised. It looks like the direct record of a local event, of the kind the Micali Painter liked to show. The chariot races remind us of earlier terracotta revetments with similar representations. Among the athletic exercises, the pair of boxers [189] was surely drawn from south Etruscan, perhaps Caeretan or Tarquinian, prototypes, while the spear-thrower with his page next to this group reflects an Attic design – most likely a vase painting in the style, for instance, of Phintias. Attic reminiscences, adapted from Greek palaestra scenes, are frequent among these gymnastic groups. They also connect the frieze with the pronounced Atticism of the then leading domestic art at Chiusi, the cippi of the third and fourth styles (pp. 208 ff.; also below, pp. 279 ff.).

The ceiling of the rear chamber has only a single large coffer, which however contains a curious painting [192]. Within the square frame a red rosette encloses a diagonally placed cross of four pointed leaves, green in colour. Two narrow decorated zones surround this disc; the inner zone is filled with short rays, the outer is shaped as a scalloped band. Outside the rosette four sirens of the Ionic-Etruscan four-winged

192. Chiusi, Tomb of the Monkey, *c.* 480–470, rear chamber, ceiling coffer

type rise from the four corners, again arranged diagonally. They are drawn *en face*, as if seen from below. Sirens are rapers of souls, and air is their element. Their presence in a tomb, and indeed in the loft of a funeral chamber, draws its meaning from common Etruscan lore. The system of their arrangement is not so easily explained, however. It was hardly invented for this one occasion; the principle which it follows – a circle contained by a panel – had a significant history afterwards. The painted coffer in the Tomb of the Monkey must be regarded as the earliest example extant of a ceiling decoration which gained prominence in much later Roman and Early Christian art. The mosaics in the vaults of the apse of San Vitale and the chapel of the Archbishop's Palace, both at Ravenna, where four angels carry the heavenly roundel,

became the most renowned elaboration of the same schema. Here we should note that the Etruscan painting already associated this diagrammatic design with thoughts of air and sky; late antiquity developed it into a symbolic cosmography.[23]

Wall Painting at Chiusi: Tomb of the Hill

The Tomb of the Hill, like that of the Monkey, was laid out on a cross-shaped plan, though only the atrium and the narrow tablinum at the rear were completed. But the interior decoration adheres to the Tarquinian tradition, in principle if not in all details. The ceiling of the central room imitates a pitched roof supported by a broad ridge-pole; however, in the place of the kingpost one finds a painted palmette, flanked

by two double volutes. The figured frieze occupies the top of the wall, but here it is framed by coloured stripes after the Tarquinian manner [193]. The iconography also is standard: a banquet of young men on couches, attended by busy waiters and a woman flutist. It is not clear if the banqueters were also the audience of the funeral games which fill the other half of the frieze, though it seems possible that they were so interpreted. The games include gymnastics, dancer-entertainers plus musicians, and a chariot race [194]; the chariots (*bigae*) racing past little trees – perhaps the markers of the track – have near parallels among the Chiusi cippi.[24]

A varied team of artists was obviously at work here. The master of the chariots was a colorist of cultivated taste, in a tradition that may hark

193. Chiusi, Tomb of the Hill, *c.* 460, main chamber

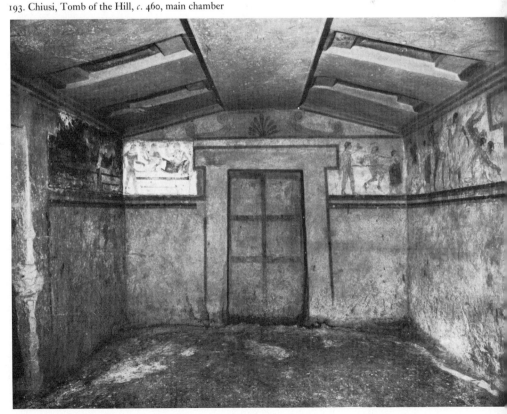

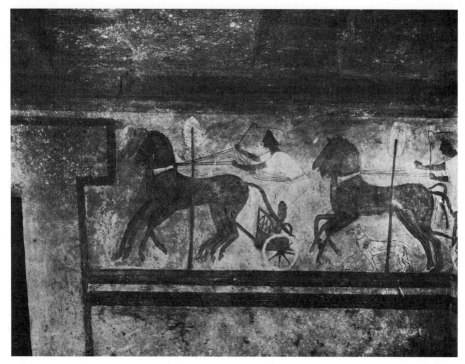

194. Chiusi, Tomb of the Hill, *c*. 460, Chariot Race.
Wall painting

back to the school of the Paris Painter (pp. 153 ff.). He achieved his decorative effects *à la* Matisse by flat planes, evenly coloured and elegantly silhouetted, without boundary lines and with a minimum of inner design. More interesting still is the painter of the nude figures, who apparently was less of a perfectionist but also less given to routine. The traces which he left, rather unconcernedly, of his preparatory drawing deserve a special study. The group of the two waiters is his finest piece [195]. Different from his colleague, he was primarily a draughtsman. It is a pleasure to recognize his ease of hand and command of form in the straight lines that build a man's torso from an intrinsic triangle; or the delicacy, firmness, and concert of outlined shapes in the still life of the vessels. The entire group resembles a master drawing of the Renaissance. There hardly exists another sample of ancient draughtsmanship that tells us

so much about the forming process – method and personal intuition combined – underlying a painter's finished work in the Early Classical style.[25]

The banqueters seem to be by a different hand, and do not require discussion here. They look like a rather decorative version of the same subject in the Tomb of the Leopards (illustration 178 and p. 269). Only the young attendant who enters from a corner to wait on the guests may again be ascribed to the 'master of the nude figures'. His massive forms are those of Early Classical statuary.[26] Compared to the Tomb of the Monkey, the paintings in the Tomb of the Hill appear to be the later works – well within the period of transition. Tentatively, one may assign to the former a date between 480 and 470; the Tomb of the Hill, to judge from the most advanced elements of style among its various art, must be closer to 460.

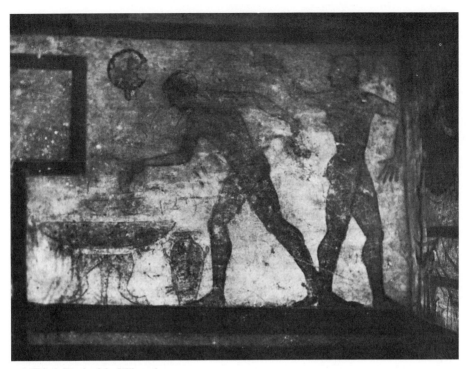

195. Chiusi, Tomb of the Hill, c. 460,
Preparation for the Banquet. Wall painting

Chiusi Cippi

Typologically, the monuments that count as the fourth phase of the Chiusine cippi all date from the transitional period after 480, and for the most part nearer its end than its beginning; they also represent the latest class of these uniquely Chiusine objects. The tongue patterns that frame their pictured fields had already been introduced during the preceding phase, to which the decoration of the new type is obviously related.[27] The chief difference consists in the dimensions of the block, which among the specimens of the fourth class tend to be low and oblong, in contrast to the rather high and straight proportions of the earlier monuments. Thus the cippi of this type resemble the statue bases decorated with reliefs which occur in Greece about the same time. The reliefs extend horizontally, more like friezes than panel compositions. A special feature is the spiralled columns on either end which were common, if not obligatory, in this class. Comparable lateral dividers had previously been used in the second type of cippi but were omitted in the third.[28]

The *chef d'œuvre* of this class is the large cippus in Palermo, of excellent execution.[29] Two sides are preserved. Both deal with the games which were the favourite themes of funeral art at this period, in Chiusi as in Tarquinia. One side refers to dance and athletics; the other shows the chariot races [196, 197]. The games in this instance must have been a public event of considerable splendour. Spectators, or perhaps judges, sit on a specially built scaffold; one man keeps the score on a tablet [196]. The prizes lie on the ground beneath them: six jars, or skins, filled with wine or oil. Performers line up in front of the scaffold. We are to understand that the programme featured a Pyrrhic dancer,[30] a

dancing girl with flutist, who possibly stood for a whole troupe, not shown; and athletics, represented by a discus-thrower with trainer. The other side needs no description [197]. It renders the races in the now familiar scheme, with one exception: there are three horses instead of two for every chariot. The composition on this side is extremely formal. The horses prance strictly in line; the tops of trees alternate with the heads of the drivers to divide the length of the course into measured sections. Yet from the very repetitiousness of the types that portray the racers, set against the static rhythm of the background, an impression of forwardness arises, as if car after car was passing with rapid speed before our fixed eye.

The obvious concordance between cippi and funeral paintings, especially the murals in the Tomb of the Hill, is a remarkable fact. It confirms the essentially local character of Chiusine

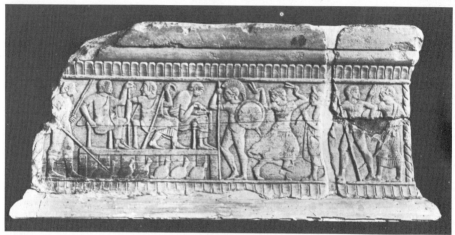

196 and 197. Cippus base from Chiusi, *c.* 460. Limestone. *Palermo, Museo Nazionale (Collezione Casuccini)*

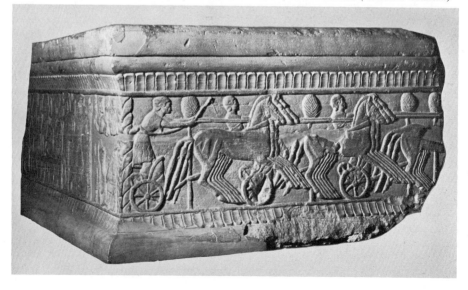

art, in spite of the impulses which its makers absorbed from abroad. Artistic production at Chiusi retained at all times a distinctly local quality, though often it did so on a level of provincialism remote from the main stream of Etruscan art. In the Late Archaic and post-Archaic periods this changed. The works here before us meet the contemporary standard, even though we must describe them as highly individual contributions to the total of Etruscan art. One curious circumstance regards the priority of wall paintings, in relation to other local art. It has already been pointed out that the peculiar ornament which in the Tomb of the Monkey delimits the frieze along its upper edge has no match in Etruscan mural decoration elsewhere (above, p. 275). Yet it does have a counterpart in the tongue patterns of the latest cippi. We must conclude that the painters followed the reliefs. Evidently wall painting was not the leading art in Chiusi, as it had been at Tarquinia. The tastemakers of Chiusine art in the early fifth century were the studios that designed the cippi.

Fiesole and Bologna

Two other special types of north Etruscan reliefs must briefly be mentioned. One of them, the stelae and cippi from Fiesole (anc. Faesulae), was already on the wane in the early fifth century. It consists of a small group of funeral monuments which were made of local sandstone between *c.* 520 and 470; only twenty-six specimens are now known.[31] Their artistic value is modest; they are of interest, however, as an example of Etruscan provincial art at the threshold of the Classical era. The region that produced them was open to many cross-currents from both south and west. Yet it retained its proper, somewhat insular character. The customers for this art apparently were a landed aristocracy – a class whose security of living and social importance must have dwindled fast under the impact of the Gallic raids into their territory. Nowhere else has the Archaic type of the upright stele which within its narrow confines portrays a person of rank or title survived

so long. Prototypes came from Volterra (above, p. 133), and ultimately from Greece, via the Tyrrhenian harbours. Eventually even the Attic type of stele, with a crowning palmette, was thus introduced into Italy [198]. Variants of a tongue pattern are used frequently, especially as a framing arrangement. This preference the artists of Fiesole shared with their colleagues at Chiusi; but otherwise there is little evidence of contacts between the two places. At Fiesole the

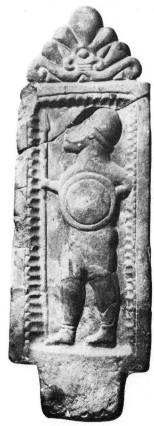

198. Stele from Fiesole (S. Agata nel Mugello), *c.* 510. Sandstone. *Florence, Museo Archeologico*

human figures have a stocky build. Their images exhibit symptoms of a certain primitivism, especially in the curtailed rendering of the upper extremities, the arms and hands; the neck also

is often suppressed. It is nevertheless clear that the local craftsmen drew on southern, most likely Caeretan, models. Their work can be dated accordingly; though the representations bear primitive features, there appears to be no reason to assume a time-lag. As in the earlier examples from Volterra, the first purpose of each stele was to show the image of the deceased. The choice of themes is therefore limited. The more conservative type renders the dead in full figure, walking; the noble is portrayed as a knight in armour, or with other insignia of rank. Only among the later stelae does one also encounter allusions to the eternal banquet.

About the same time, 510 approximately, the stelae of Felsina (the modern Bologna) begin to assume their characteristic horseshoe form, which later made them one of the most distinctive classes of monuments in ancient Italy.[32] Their peculiar shape may have been due to a fusion of local, Villanovan menhir forms with the Tuscan tradition of stelae with rounded tops.[33] Like those of Fiesole, the tombstones of Bologna were fashioned from a brittle domestic sandstone. Perhaps due to this material and the local habits of working it, their decoration was carved in flat relief. Images and ornament were outlined by sharp edges but hardly modelled inside; they resemble drawings or vase paintings more than sculpture. Unlike the Fiesole group, however, which died out about 470, the Felsina stelae lasted for approximately 150 years. Their production gained momentum during the period of transition which followed the Archaic; it reached its full vigour in the late fifth and the first half of the fourth century. Around or shortly after 360 the workshop seems to have been discontinued.

The later material will have to be discussed subsequently, in its proper place. Those early stelae to which one can assign a likely date between 480 and 450 make a rather provincial impression as to style and workmanship. They represent a mixed assortment of themes, including the standing or walking image of the deceased; the stones of this type are obviously related to stelae from Fiesole. Yet the Bolognese stelae show a greater variety of themes even at this stage; the impending changes in the iconography of death make themselves felt. Already one finds allusions to death as a journey. In at least one instance the journey is clearly indicated: a man travels in his cart.[34] More often it seems to be hinted at by the image of a lonely horseman. The wave pattern along the edges of the horseshoe – the regular framing ornament in this class of stelae – leaves little doubt that the goal of the voyage must be sought beyond the sea.[35] One may recall that the thought of a billowing sea was expressed by the same pattern in the tombs of Tarquinia. It does not occur there as regularly, however, and not necessarily with the same connotations (p. 266). Vice versa, the Archaic standard subjects of the banquet and games, which were the favourite funeral themes of Tarquinia, are conspicuously rare among the Felsina stelae.

Nevertheless, the history of funeral iconography in Etruria seems to have been a continuous one, as we observed before. It now appears that this continuity included repeated exchanges between the land north of the Apennines and the ancient centres in the south. The thematic primer of funeral art in Archaic Italy was a monument of the northern region, the Certosa situla (pp. 181 ff.). Its catalogue did not include the metaphor of the last voyage which will dominate the second, post-Archaic and Classical stage of the Etruscan imagery of death. Yet, when the representatives of this novel thought first appeared among the banquets and gay dances of the Tarquinian tombs – strange and unexpected guests – they may well have come from the north this time also.[36] Certainly the Felsina stelae give us the greatest number and the most explicit examples of the interpretation of death as a journey to be found anywhere in the Classical period. The rudiments of a new symbolical poetry, without parallel in contemporary letters, were assembled in these mute yet persuasive images. The traveller beyond the ranges of time, the lone rider in the valley of death, to us today have a Celtic flavour. Have they not survived, as literature, in the Arthurian legend?

CHAPTER 23

PROTO-CLASSICAL ART

DRAWING, GRAPHIC ARTS.
AND CAST RELIEFS

Vase Painting

While the tomb paintings were held to the thematic restrictions of their purpose, and the painted terracotta slabs in the Archaic manner went out of use, free representation of mythical subjects, narratives, and secular themes continued in the minor arts. If indeed Etruria possessed an equivalent of Polygnotan painting, on a monumental scale but free from the sepulchral confines, it has hardly left a recognizable trace.[1] Instead the present evidence suggests that the mythical imagery of the post-Archaic period developed chiefly in three closely allied crafts: vase painting, engraved mirrors, and cast metal reliefs. All three must be considered special skills, working for a limited demand only. The relative prominence of vase painting in the total output of domestic art remained considerably less than in Greece throughout the period;[2] the two other industries – engraved mirrors and cast reliefs – were typically Etruscan, and apparently not represented in Greece at all.

In these three branches, however, the number and variety of mythical themes increased noticeably. During the first half of the fifth century, interest in narrative themes and Greek mythology was on the rise. At the same time one encounters in the arts the signs of a growing literacy. On the engraved mirrors the names of gods and heroes are not rarely inscribed near the images that portray them. After the middle of the century the legends often give the Etruscan names rather than the Greek form: indications that the myths had been translated and were perhaps read as well as listened to. It has been remarked, correctly, that the mirrors on which such inscriptions occur were designed for

women. We must conclude that during this period central Italy became progressively a province of that Classical, intellectual culture which based itself on the humanistic interpretation of Greek myths; that the formation of an Etruscan literate society was in progress simultaneously; and that in this process, educated women had an important share.[3]

Yet in other respects the same workshops that promulgated the Greek myths display a curious independence of – or perhaps remoteness from – Greek prototypes. The various ways in which the artists handled their media often reveal a remarkable originality. For instance vase painting either carried on in the ancient black-figured manner, or else used the imitation red-figure technique (above, p. 195). Neither technique was much practised in Greece after *c.* 500. Thus the Etruscan artists had to rely on their own resourcefulness, adapting their working procedures to new representational demands, if they wished to meet the new formal standards. Early Classical vase painting was understood, more consistently than ever before, to be a designing art – a manner of representation by drawn lines rather than coloration. At the same time the new style called for more detail, especially of the inner design, following the Greek red-figured examples. The speciality which the Etruscan black-figure workshops developed in dealing with these demands was drawing by means of incised lines – a technique that may be described as a kind of engraving. Indeed, during the Proto-Classical period engraving became the guiding principle of all designing arts in Etruria. A recently acquired colonnette-krater in Bern,[4] the main picture of which represents Theseus battling with a centaur [199], illustrates the changes, both of content and style. The Theseus myth was an Attic import; so, probably, was the broad monumentality of the design. The unknown artist worked in the black-

figure technique, but he strove to replace the ancient flat silhouettes by a suggestion of volume and weight in his rendering of corporal forms.

199. Theseus battling with a Centaur on a black-figure colonnette-krater, second quarter of the fifth century. *Bern, Historisches Museum*

200. Detail of false red-figure stamnos, *c.* 470-460. *Schloss Fasanerie bei Fulda*

The figures remained black patches bordered by thin lines, scratched into the clay and filled with white; the inner design was produced in the same manner, sufficiently detailed to achieve a patterned image of the chest and abdominal muscles. Greek Early Classical reminiscences abound; in contemporary Etruscan art, the nude figures in the Tomb of the Hill (above, p. 278) seem near relations.

Design by engraving, be it on metal or the hardened glazes of ceramics, was essentially an archaic technique, and its long survival in Etruria may have been due ultimately to regional conservatism. Nevertheless fresh generations of artists came to rejuvenate the ancient skills. From vase paintings of the second quarter of the century such as the Theseus amphora in Bern one may gauge the success of these experiments. Most interesting in this respect is a large stamnos in Schloss Fasanerie near Fulda [200][5] which was worked in the false red-figure technique: the figures were not reserved from the black background but painted upon it, with a rather heavy red paste. A variety of methods was used for details. Some lines were drawn with a brush in a thinned red colour, slightly darker than the dominant red; others were scratched lightly into the red surface. All decisive outlines, however, consist of deep furrows in which the black glaze of the ground reappears. The effect is extraordinary, resembling the raised outlines of Greek vase painting, though the working procedure was actually the reverse; an air of sturdy strength results, as in a woodcut. Obviously the artist was an ingenious craftsman as well as a fine designer. A taste for broad folds in the rendering of garments connects him with the school of Tarquinia, especially the workshop that decorated the Tomb of the Banquet.

Mirrors, Engraved and Cast

Mirrors with engraved decoration – an Archaic invention (pp. 201–2) – maintained their place

in Etruscan art throughout the fifth century, though the peak of their production was reached only later when, in the fourth century and the Hellenistic period, they counted among the most popular articles of the domestic industry.[6] Moreover, after *c.* 480 the mirrors became the

201. Herakles and Atlas (Aril) on an engraved mirror, *c.* 460–450. Bronze.
Vatican, Museo Gregoriano Etrusco

principal carriers and distributors in Etruria of the imported Greek myths, in addition to the native histories they also told. For this reason, from here on, they may be regarded as a continuous index of Etruscan literary taste over the centuries. Thereby they took over an illustrative function which in Greece was chiefly reserved for vase paintings.

Another type of mirror, decorated with flat reliefs, makes its appearance about the same time. They are solidly cast discs, shaped just like the engraved mirrors with a peg at the base for insertion into a handle of wood or bone. To cast reliefs solidly – rather than hammering them out over a mould – was not a Greek habit, and the antecedents of the Etruscan reliefs in this technique, if indeed they had antecedents elsewhere, cannot now be named. Most Etruscan examples date from the Proto-Classical period, before *c.* 450. Their representations and ornament are obviously akin to the engraved mirrors. The reliefs are flat and resemble drawings, notwithstanding the slight elevation and delicate modelling of the representational parts. They seem to have been conceived as engraved images, but produced in a reversed technique which aimed at raising the deeply outlined forms ever so lightly above the ground. Apparently the interest in this rather special fashion of the metallic arts was of short duration. It does not seem to have lasted much beyond the fifth century. From the art historian's point of view, the mirrors of this rather rare class may be considered a variant of the more common engraved examples.

Exploits of Herakles, long popular in Etruria, are preferred themes on the mirrors; so are Paris and Helen of Troy, as indeed all romances of Greek mythology. Clearly the tales of amorous union or separation appealed to the users of these objects. Herakles, the golden apples of the Hesperides in his hand, taking leave from Atlas (Aril), is the subject of the finest mirror engraving preserved from this period [201], now in the Museo Gregoriano Etrusco;[7] the incised drawing, classical on the level of about 460–450, attains a Polygnotan dignity. Flowers and a tree on the right suggest a magic garden, and a lusty

202. Herakles and Mlacuch on a mirror, *c.* 480–470. Cast bronze relief.
London, British Museum

203. Eos and Kephalos on a mirror, *c.* 470–460.
Cast bronze relief.
Vatican, Museo Gregoriano Etrusco

vine, growing from two stems at the bottom, forms the frame. Atlas, who on his shoulders carries the cloud-shaped cosmos with all the stars, faces outward, plaintively: he who has returned to his eternal burden seems the protagonist here, more so than the victor, joyously departing Herakles. The dialogue, a brief interval of hope, has ended, and the giant finds himself alone again with his toil.

Clearly the tondo form prescribed by the object does not invite crowded compositions. In most Etruscan mirrors of the fifth and early fourth centuries action is restricted to two or three persons; the tendency is to condense the epic narrative into rather still pictures of a single situation. Thus in a splendid relief mirror in the British Museum[8] of somewhat earlier make, *c.* 480–470, Herakles (Herecele) abducts – or merely carries – a lady named Mlacuch [202]. The two broadly drawn figures fill the roundel to its limits with the struggle of their angular limbs and their swirling garments; the design was consciously, and most skilfully, adapted to the surrounding circle. Yet in this older work, different from the Aril mirror, monumentality was still realized in the terms of the Late Archaic vase painters, as was the framing ornament. The same may be said of another relief mirror, now in the Vatican, which renders the radiant Eos carrying off young Kephalos [203].[9] Its relief, drawn more loosely, may be a decade later than the foregoing; the frame of ivy compares well with the ivy scrolls in the Tomb of the Banquet (above, p. 266). Like the Aril mirror, this one came from Vulci. It is likely that cast reliefs were a speciality of Vulci altogether; but some engraved mirrors probably ought to be ascribed to Vulcian workshops also, especially among the earlier materials, before the engraving industries tended to become concentrated in Praeneste.

Miscellaneous Cast Bronze Reliefs

Cast reliefs were used not only on mirrors but also on other implements, such as armour. Occasionally helmets have been so decorated. The cheek-pieces of a cast helmet from Todi,

now in the Villa Giulia,[10] illustrate duels between two pairs of armoured knights [204] – a theme of the heroic saga which in this instance was probably borrowed from Greek Late Archaic vase painting. The manner of relief is doubted masterpiece of early Etruscan craftsmanship [205]. Its purpose was most likely to light a tomb. The large circular container, shaped as a flat basin, has a diameter of *c*. 60 cm. It could be filled with oil and hung from a ceil-

204. Duelling warriors on the cheekpiece of a helmet from Todi, *c*. 470–460. Cast bronze relief. *Rome, Villa Giulia*

similar to that of the mirrors, however, and quite obviously domestic. Interesting is the foreshortened left leg of the succumbing warrior of illustration 204: clearly a designer's experiment, not a sculptor's. The representational forms, though slightly raised, produce nearly plane surfaces; in this style, flatness rates as a virtue. One may date the Todi helmet in the sixties of the century, about contemporary with the mirror [203], if by a different hand.

Here I insert the famous lamp from Cortona (now in the Museo Civico there),[11] a rather abstruse implement aesthetically but an un-

ing by way of the sizeable conical shaft that rises from its centre; the entire work was cast of bronze, in one piece. Only by looking at it from below can the relief decoration be fully appreciated. One sees: in the centre a mask of Medusa, surrounded by small coiling snakes; around the central medallion a circular frieze, containing pairs of wild animals who attack or devour animals of different species; following this inner frieze an outer zone consisting of the familiar wave pattern, enlivened by friendly dolphins. These three circles form the bottom of the cup-shaped container. There follows a

205. Lamp, mid fifth century.
Cast bronze.
*Cortona, Museo
dell' Accademia
Etrusca*

ring of sixteen lamps, each connecting with the master container from which they all jut out; thus they shared the oil needed to feed their sixteen wicks. Their lower sides are decorated alternately with winged sirens and crouching Sileni; the latter play flutes. Finally, in the intervals between the lamps masks of 'Achelous' appear peeping out from the shadows behind the flames; one remembers that the bearded and horned face of the bull-man was a spook of certified Etruscan ancestry (above, pp. 136–7, 214). It is hardly possible to say what all this imagery was about, though it certainly appears well thought out; perhaps we should understand it as the tripartite image of a world comprising earth, sea, and an airy realm beyond the sea, at which Etruscan sepulchral symbolism so frequently hinted. The ring of lamps with their small images – weird, protective, or friendly as the case may be – recalls the circles of symbolic figures around the lids of the much earlier funerary urns from Chiusi (pp. 105–6) or their Campanian descendants (pp. 226 ff.). It looks as if the same native scheme had here been revived once more, in a different language of myth. Style and workmanship date the Cortona

lamp to the end of the Proto-Classical period, about the middle of the fifth century or even somewhat beyond. It is at any rate a very un-Greek, un-Classical object, in spirit as well as formal organization. We may consider it a late manifestation of that flamboyant taste which has so often come to the fore in the more insular and remote reaches of inner Etruria. On this evidence one must ascribe it to some unknown, if highly skilled, atelier of the central region, perhaps one located at Chiusi.

BRONZE AND TERRACOTTA SCULPTURE

Hellenizing Tendencies

The exceptional condition through which the art of Etruria passed immediately after the Archaic period can be most clearly noted in her bronze statuary. In this category the Etruscan reaction to the changing standards of art appears unsettled indeed – spurred by the Greek evolution but also in contrast to it. For a critique of the paintings we lack the Greek equivalents; moreover, the school of Tarquinia maintained for more than a century so high a degree of coherence that to the modern surveyor its progress may well seem to follow its own inherent logic, touched only remotely by the emergence of the Classical style in Greece. No comparable coherence becomes apparent among the Etruscan bronzes of the same period. Together they form a variegated lot in a diversity of styles, owing to causes either regional, workshop-conditioned, or simply personal; yet for their critique as a group, the well documented parallel evolution of Greek sculpture can be currently consulted. The material for such a study is plentiful. It includes remnants of statues, and an abundance of statuettes. Among the latter one finds many of excellent quality; but the more provincial examples are also often entertaining and almost always interesting. From a set of monuments so large and various it is difficult to make a meaningful selection. It does seem possible, however, to discern certain characteristic tendencies among them, over and above the variousness of formal manner and

content that distinguishes the whole group. These primary symptoms we may attempt to name and illustrate, even while the study of detail, and especially the division into separate schools and workshops, is still in progress.[12]

A grecizing tendency is much in evidence. To this sector belong many, if by no means all, of the statuettes, as well as the surviving examples of larger, hollow cast bronzes. Decisive is the adherence, in all members of this class, to Archaic Greek statuary types, chiefly the nude kouros or its feminine counterpart, the Attic kore. Even action figures such as the popular throwers – of a javelin or other weapon – ceased at this time to represent the erstwhile knights who, like the statuettes from Brolio [67], were realistically costumed and armoured. Instead, they now often appear as nude athletes after the Greek fashion. One may observe here, as a general remark, that the representation of nudity had no certain place in early Etruscan art, probably because the latter, in the main, was rather socially and civically orientated. The few female nudes known in Archaic Etruscan art almost certainly represent deity; nude males, unless expressly designated as mythical characters, mostly portray young boys – children or adolescents, below the age of maturity.[13] Evidently in Etruria nudity lacked the heroic and athletic connotations which had accrued to it in the Greek tradition; neither the native lore nor the social reality offered a sufficient basis for such connotations to form. We must conclude that nudity as a style of art was a Greek import into Etruria.

Another critical point among the Etruscan bronzes of this period of transition regards the forward step of standing statuary figures. Next to the spear-throwers from Brolio, who in the Etruscan art of their time remained a lone exception, the first cautious signs of renewed interest in forward-stepping figures in Etruria date to the years around 500 (pp. 223 ff.). The paradox is that among the Etruscan bronze statuettes the two standard types of Greek Archaic statuary, kouroi and korae, occur in appreciable numbers only at a time when, in Greece, the same types were already falling into

obsolescence. To refer to this somewhat perplexing state of affairs as a time-lag is justifiable, but it is hardly enough to account for all the facts before us. Particularly, the vicissitudes of the stepping kouros type in Etruria suggest a different reading of the adaptive process that evidently took place. If the Etruscan kouroi had come to look and act exactly like their Greek forebears, the time-lag between them and their elders simply would not be noticed, because it would be beyond recognition. Actually the Etruscan statuettes look different in detail as in conception; and as a rule the details reflect the current advances of sculptural fashion even when the chosen type of action remained, in a sense, archaic. The large statuette of a spear-thrower in the Louvre,[14] which counts among the most accomplished Etruscan bronzes of the period, illustrates this point [206]. One notices its harsh movements and stocky build. In these qualities one may look for a mixture of elements, or a fusion of the old with the new, if one measures the data by Greek standards. Yet the validity of all such observations regarding an assumed imbalance of stylistic elements remains in doubt, since the statuette shows so clearly that it was not a Greek work. In the Etruscan context where it belongs, almost everything about it must be deemed an innovation, the stepping posture included. For the first time the indecision and uncertainty of direction which we found so often in the Etruscan spear-throwers has been overcome. A comparison with the somewhat earlier statuette in London shows the difference at a glance (pp. 206–7 and illustration 136). The athlete rendered in the Louvre statuette faces the observer squarely; his target lies straight ahead, his step follows the path of his weapon. Among the loosely jointed Etruscan bronzes such collected energy is much the exception. It must be regarded as a Greek trait, as one would also look to Greek statuary of about 470 for stylistic parallels to the heavy forms and the elongated torso. Thus, formal analysis of detail confirms, even deepens, the aforementioned estimate of a chronological paradox. Apparently the Etruscan bronze-workers perfected the forward step, in the Greek

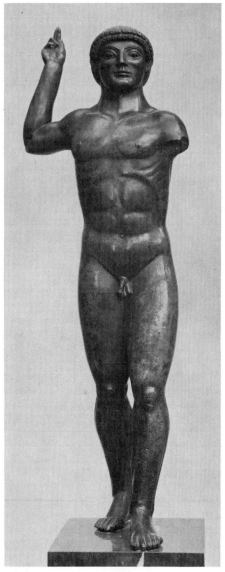

206. Statuette of a spear-thrower, c. 470. Hollow-cast bronze. *Paris, Louvre*

Archaic manner, only after 480 or thereabouts. At the same time in Greek statuary action-figures such as a spear-thrower were likely to be shown sideways, as in a relief, while the fashion-

ing of frontal upright statues turned on the problem of organizing not the active step but the quiet stance.

Comparisons between actionless standing kouroi of Etruscan origin yield similar results. They persuade me, for instance, to date the fine statuette in Frankfurt am Main[15] [207] some

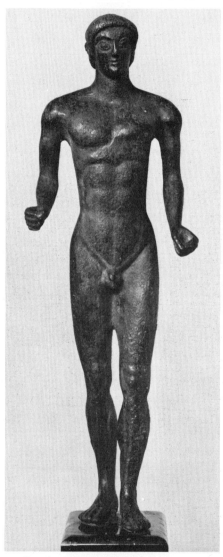

207. Stepping kouros, probably after 480.
Frankfurt am Main, Liebighaus

time after rather than before 480. Earlier examples of the same general type, like our illustration 135,[16] make it sufficiently clear that their differences are not due to the obvious diversity of workshops and regional traditions alone, but also to a different comprehension of the statuary type itself. The latter changed with time. The lesson of the evidence seems to be this. The Greek Archaic type of the frontally posed, marching male statue was not introduced into Etruscan art at once, nor can its reflections among the Etruscan statuettes be recognized as faithful copies of specific models. Instead it was absorbed into the domestic tradition by a gradual process, equal to a progressive evolution. This process of assimilation began late in the sixth century, and went on for about thirty years – approximately the span of one generation. By *c.* 470 it was complete. The result was an Etruscan – or perhaps Italic – variety of the original kouros type, Proto-Classical rather than Archaic, to which we must allow a proper history, in accordance with its proper purpose. For the progressive – and belated – acceptance of the Greek kouros in Etruria evidently signifies something more than a chronological anomaly.

It seems significant for yet another reason. Most earlier Etruscan adaptations of foreign art served immediate and practical ends. The primary problem of artists in ancient Italy was to produce an acceptable imagery, in line with international standards, to satisfy needs of domestic custom, cult, and luxury; in the latter category I count the communicative value of the Greek myths. None of these incentives explains the appearance in Etruria, at this late date, of nude kouroi after the Greek fashion. Their subject matter had no place in the domestic social scene. We must assume that the attraction of this foreign iconographic type was specifically aesthetic, detached from practical reality and unaffected by the pleasures found in narratives.[17] The growing popularity of this manner of statuary can probably be set down as the first Etruscan manifestation of a critical appraisal of Greek art for the sake of its Grecism alone. It

marks the rise of an intellectual philhellenism in non-Greek Italy and, concomitant with it, of a special strand in Italic art: hellenizing on principle.

Hollow Cast Bronzes

During the fifth century the Etruscan towns began to assemble that wealth of bronze statues for which they remained long famous. There is no reason for doubt that this reputation was grounded in fact, even though the later Roman accounts of booty taken from conquered towns such as Veii or Volsinii have to be accepted as more symptomatic than real.[18] On the basis of the same records we must assume that a great deal of this art was taken to Rome, where it eventually perished. The history of the Etruscan Proto-Classical and Classical large bronze statuary must be reconstructed from accidental finds, isolated examples, and stray fragments. In this task the literary sources are of little help. Different from Greece, the bronze artists of Etruria remain for us anonymous, their names forgotten, their works untitled.

Hollow cast bronzes extant from the Proto-Classical period are mostly statues or heads stemming from statues; the smallest, a head in London[19] [209], is about half life-size. All represent young men. The early examples sport longish hair and well-groomed rows of curls, variously arranged in fashions one also meets in contemporary Greek art and Etruscan small bronzes [206]. Near the middle of the fifth century, however, this still half-Archaic elegance gives way to a simpler bearing. The hair becomes shaped like a tight cap, with more or less straight parallel strands falling artlessly from the apex to the margins all round the head; curls, bands, and tresses are discarded. But neither does one find well designed, small locks of hair as in Early Classical Greek bronzes, for example the charioteer at Delphi. The new manner which prevailed in Etruria has a more rustic look. It may have spread to Etruria from south Italy; Doric, especially Argive, Greek bronzes seem the nearest relations.[20] Ever after, Etrus-

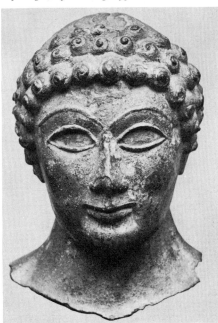

208. Head of a youth from Nemi, c. 480. Hollow-cast bronze.
Copenhagen, Ny Carlsberg Glyptotek

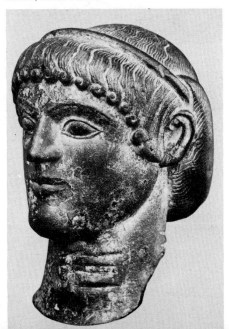

209. Head of a youth, c. 470. Hollow-cast bronze.
London, British Museum

can art maintained a preference for such boyish heads capped by a pelt of thick, hanging hair.

In the early hollow casts of Etruria the eyes are of one piece with the face (Capitoline Wolf, p. 253). This technical detail runs counter to Greek habits. Yet in Etruria it persisted beyond the Archaic terminal date of *c.* 480. A head at Copenhagen[21] [208] is of particular interest here: not only the cast – rather than inset – eyes but also their sharply drawn, raised contours resemble those of the Capitoline bronze. By workshop tradition, the Copenhagen head, which was found at Nemi, seems the closest associate thus far of the Capitoline Wolf; it may well have come from the same Roman shop. The somewhat smaller and more broadly built head in London [209] appears to be a distant relative: it may be a provincial offshoot of the art of Vulci due to a local foundry in the Etruscan north, perhaps Chiusi. The parallel wrinkles below the chin would ordinarily be held a feminine attribute, but the features rather fit a young man, and the hair tucked into the diadem corresponds to a Greek Early Classical male fashion. The carving style of design seems related to that of our illustration 206, though the forms are flatter and the details of the face more widely spaced. I should date the Copenhagen head close to 480; the head in London slightly later, nearer to 470.

210. Head of Minerva from Sant'Omobono, Rome, late sixth century. Terracotta. *Rome, Antiquarium Comunale*

Terracotta Sculpture

One senses the new hellenizing impulse not alone in the bronzes but among the large terracotta sculptures as well. The finds in Rome have proved especially instructive in this regard. A still Archaic head – perhaps Minerva – from the temple precinct around Sant'Omobono,[22] which dates from near the end of the sixth century, gives every sign of Caeretan authorship, or at least of a Caeretan workshop tradition [210]. By contrast the torso of a mortally wounded Amazon from the Esquiline,[23] near 480, looks remarkably Greek; it has the crispness and decisiveness of form which we associate with the Greek tradition [211]. This observation is in keeping with the influx of Greek, probably south Italian, artists at the close of the Archaic

211. Torso of a wounded Amazon from the Esquiline, Rome, *c.* 480. Terracotta. *Rome, Antiquarium Comunale*

period, as recorded by Pliny (cf. p. 250). Perhaps the Amazon from the Esquiline should be defined as a Greek work created in Rome for a Roman building. Similar reflections of new contacts with Greek art can be observed in the Etruscan towns north of Rome. The splendid protome of a winged horse in the Vatican, which hails from Cerveteri, fits into this current.[24] The horse's head has near counterparts in the spans from the east pediment of the Temple of Zeus at Olympia, with which it seems about contemporary. Such close formal coincidences hardly resulted from the study of vase paintings alone: more likely in this instance also a Greek Early Classical Type was transmitted to Etruria by immigrant sculptors from the south of Italy, possibly Campania.

Generally, as the fifth century progresses, one notices in Etruria a trend away from painting and reliefs, balanced by a corresponding increase of statuesque imagery. This preference for three-dimensional sculpture may also be credited to the impact which the new Greek statuary art made on Etruria. Even among the terracotta revetments, which continued to be a popular part of Etruscan temple decoration, one

finds about the middle of the century representations in very high relief, almost totally round, instead of the customary bas-reliefs in the Archaic manner [212].[25]

Bronze Statuettes: Domestic Themes

Under this heading one may list those Proto-Classical bronze sculptures which differ from the hellenizing group because of their attire, action, or decorative destination. Here, for instance, belong the two large statuettes from the find of Monteguragazza, in the Apennine mountains near Bologna, now in the Museo Civico [213, 214].[26] Like most Etruscan statuettes which were not decorations of useful implements such as the frequent lampstands, both figures represent votaries. But unlike the grecizing statuettes discussed before, which habitually served as ex votos also (above, p. 290), the two statuettes from Monteguragazza really behave as worshippers in the sanctuary. Originally both were mounted on stone bases, or perhaps one common base, to be seen as a pair. The young woman brings gifts: a flower and a fruit, most likely a pomegranate. Her companion offers the

212. Terracotta revetment, mid fifth century.
Arezzo, Museo Archeologico

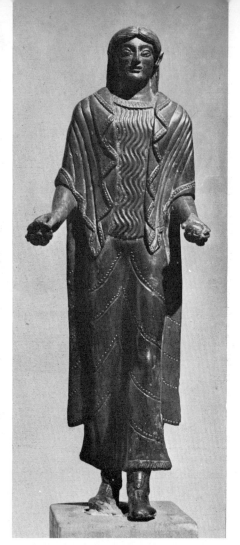

213. Statuette of a male votary from Monteguragazza, c. 470. Bronze. *Bologna, Museo Civico Archeologico*

214. Statuette of a female votary from Monteguragazza, c. 470. Bronze. *Bologna, Museo Civico Archeologico*

ritual libation, his left palm held open and downward, addressing the nether deities. He steps forward in the Archaic fashion; unlike any Greek kouros, however, he wears a short cloak around his waist, the ends of which are slung around his left arm. Thereby he becomes the earliest representative, to our knowledge, of a new statuary type of half-draped youths, interpreted as votaries or sacrificers. The new image was to reach the peak of its popularity in much later Etruscan art, during the fourth century

and the Hellenistic period; Roman art of the Early Empire continued it, as a suitable iconographic schema for the portraits of imperial princes. His female partner keeps pace with him, in the eagerly stooping gait we already know from Vulcian bronzes (pp. 224–6) and the Portonaccio statues. Her short dress reveals the heavy Etruscan shoes; it seems to emulate a Greek fashion, though one can hardly describe it as either truly Greek or truly Archaic. Moreover, her broad face shows clearly that the

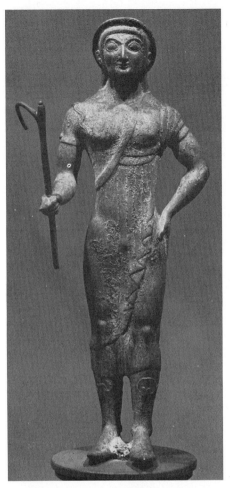

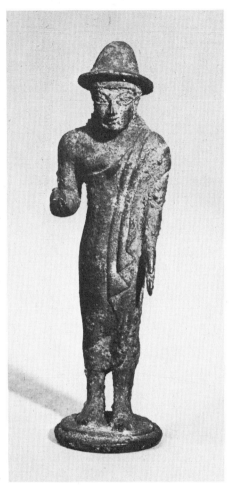

215. Statuette of 'Vertumnus' found at Isola di Fano, *c.* 480. Bronze. *Florence, Museo Archeologico*

216. Statuette of a votary, *c.* 490–480. Bronze. *London, British Museum*

borderline of Archaic art has been passed. We may date both statuettes in the Proto-Classical period, around 470, and assign them to a workshop of northern Etruria which inherited its glyptic style from the bronze and terracotta sculptors of Vulci, Veii, or the Roman school of Vulca.

The sizeable statuette in Florence,[27] often if erroneously cited as Vertumnus [215], likewise represents a human worshipper or dedicator, who enters the sanctuary ceremoniously. Its

subject, perhaps, was the grateful winner in a race of horsemen or chariots. The foppish boots and small pointed hat are quite Etruscan, but for an adequate understanding of the short, apparently sleeved chiton-like garb we lack parallels. Like the two preceding statuettes, with which it has much in common, this bronze, found at Isola di Fano, seems a product of northern Etruria. Certainly its provincial elegance agrees well with an urban, if culturally somewhat insular, environment, of art as of

manners, such as Chiusi provided about the start of the Classical era. A smaller statuette in London,[28] related to the foregoing by subject matter more than style, may conclude this hurried selection of Etruscan types [216]. The little man in boots, heavy Etruscan cloak, and high conical felt hat, bows devoutly before the deity to whom he offers what appears to be a pomegranate in his right hand. Again the left points downward in reverence, presumably, towards the nether powers. He is an image of awe: perhaps a countryman come to town in order to redeem a vow. Clearly this is a scene of genre, culled from life. Its maker matched the accuracy of observation with a lean, formal neatness, in the Vulcian tradition. It is worth noting also that he cast this figure in one piece with a circular stand. Similar circular bases will from now on be found a frequent characteristic of Etruscan small bronzes, especially among the decorative statuettes discussed in the following pages.

BRONZE UTENSILS
AND APPLIED SCULPTURE TO c. 400

Incense Burners

From the period between c. 470 and c. 450 date the last Etruscan *thymateria* of the customary Archaic type, mounted on shafts built up in sections that resemble pieces of turned wood or bone; the sections are separated by horizontal discs which, in the earlier specimens, were shaped as abstract plants or flowers with hanging leaves (p. 217). Here I cite an example of slightly different and probably more advanced design, privately owned, in New York [217].[29] The earlier flower-shaped 'umbrellas' have yielded to flat discs, and a single circular platform on three feet provides the base; the new trend restricts the non-representational decoration. This simplicity benefits the statuette, which serves as a caryatid: in the present instance, a hoofed Silenus pouring wine. His type may have been Campanian in origin, though the workmanship is more likely Etruscan and due, possibly, to a northern studio.

217 *(below)*. Thymaterion, *c.* 470–460. Bronze. *New York, The Pomerance Collection*

218 *(opposite)*. Candelabrum, *c.* 480–460. Bronze. *Rome, Villa Giulia*

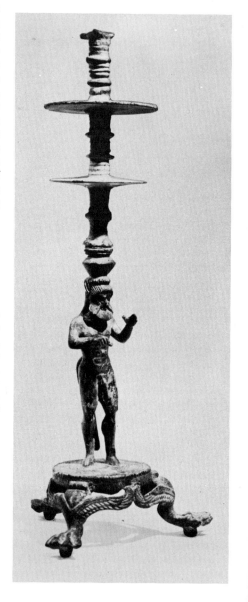

Candelabra

During the same decades of the fifth century a new type of high candleholder – usually called a candelabrum – comes to the fore which became one of the most distinctive contributions of Etruria to the art of its time [218]. From a low tripod on curving legs that finish in animal feet rises the slender stem – smooth, polygonal, or fluted, as the case may be. A small disc with overhanging rim sets the stem off from the top part. The latter, measuring about one fifth of the total height, consists in the early examples of small cylinders and rings stacked upon one another, similar to the shafts of the Archaic incense burners; later this element was treated more variably. At any rate it constitutes the most special characteristic of the Etruscan candelabra, in contrast with the contemporary Greek as well as later Roman light-holders; the latter, on similarly high shafts, sustained oil lamps instead of candles. Four horizontal arms, often imitating birds' heads on craning necks, branch out broadly from this top part; the candles were stuck to the spiked ends of the arms. In the centre a statuette or statuette group on a round moulded base is placed as a finial: it marks the middle of the circular space defined by the surrounding hooks. Once more, as with the lids of the Campanian urns, we find statuary enclosed within a calculated spatial order. All this seems much in the Etruscan taste and quite different from the Greek, which rather emphasizes the independence from spatial commitment of all statuary in the round. In the Etruscan ensemble the outer circle suggests a gyrating motion; by contrast, it enhances the stillness of the figure at its centre.[30]

Although the Etruscan candelabra deserve attention as fine furnishings in their own right, their chief importance for the history of art rests on the variousness of the bronze statuettes which formed a regular part of their design. The early finials display the same mixture of lingering archaisms with stylistically progressive traits which characterizes so much Etruscan art around 470. But the majority dates from the second half of the fifth century and the early

decades of the fourth. The Etruscan candelabra must be regarded an essentially Classical type. In the absence of so many other testimonies undone by time and greed for metal, their crowning figurines provide us with a primary source of information about Classical sculpture in Etruria.

Military subjects, which were rare among the Late Archaic bronzes – it is not certain that the spear-throwers were always understood as warriors, rather than athletes – appear more frequently and in greater variety among the candelabra statuettes. One recognizes them because their protagonists are shown in full armour, on

foot. Perhaps their popularity at this particular time reflects the recent ascendancy of the new military class, the heavily armoured infantry (hoplites), though some at least may represent heroes of saga. The latter explanation possibly applies to a finial in the Metropolitan Museum, New York[31] [219], which renders a rather innovative theme. An older soldier supports a younger comrade who is wounded and visibly limping. The older man wears a beard in the Late Archaic fashion, with a small apron below the lip, and a Corinthian helmet, though his leather armour, held in place by two broad shoulder-flaps, represents more modern equip-

219. Warrior and wounded companion on a candelabrum finial, c. 480–470. Bronze. *New York, Metropolitan Museum of Art*

220. Man and woman embracing, statuette group, c. 480–470. Bronze. *London, British Museum*

ment. The Archaic details notwithstanding, the spirit of free invention incorporated in forms freely handled is Early Classical. Within the series of the extant candelabra statuettes one will assign a relatively high date to this group: between 480 and 470 approximately.

Here is the place to refer to two remarkable statuettes which are related to the New York group chronologically, if not by destination. The splendid Ajax from Populonia, now in Florence, certainly was a work independent of any decorative purpose.[32] The statuette group in London,[33] though hardly the finial of a candelabrum, may have been designed for the decoration of, for instance, the lid of an urn or box [220]. Both appear to be south Etruscan; the execution is very competent, on a level with the finial in New York but due to artists of a different taste and schooling. Their themes, too, are unusual. The suicide of Ajax is Greek, Homeric. In the statuette group in London we are shown a pair of lovers; they have been called Nymph and Satyr. Yet among this popular mythical race they represent an unusually decorous breed: a satyric pair so neatly attired is difficult to find. The girl resembles a well-behaved Attic kore, and her bearded companion is a variant of the benignly smiling image which perhaps also rendered the Jupiter of Vulca (p. 249). In Etruscan iconography, their case seems unique: rather than members of the satyr family they must portray deity, perhaps the archetypal pair of Jupiter and Juno.

Small Bronzes
of the Second Half of the Fifth Century

About the middle of the fifth century Etruscan small sculpture assumes a different look: it has entered into its Classical phase. The Archaic reminiscences to which the preceding thirty years clung so tenaciously fade into the past, and make room for a new crop of images. The apparent turn of styles was not limited to art. As happens often when the transition from one generation to another touches the deep reaches of the cultural edifice, the change in Etruria from Proto-Classical to Classical announces

itself, among other symptoms, by a different manner of dress. After c. 450 one can expect the men in armour to wear the so-called Attic form of helmet, usually with upturned cheek-pieces and combined with a scaled leather cuirass over a short-sleeved tunic [221]. This equipment remained standard, as a military uniform, for the rest of the century. At the same time the ladies resign all claim to the former Grecian fineries and instead present themselves, rather sturdily, in long embroidered tunics and mantles with decorated edges, slung over the left arm or

221. Warrior and woman, statuette group
from Marzabotto, c. 440–430. Bronze.
Bologna, Collection Countess Aria Castelli

shoulder [221, 227, 228]. Heavy necklaces, with or without the round golden pendants called bullae, and high laced shoes with pointed tips complete the native costume.[34] On occasion the domestic outfit appears to have been assimilated to its Greek equivalent, the long chiton worn underneath a himation [221]; but, on the testimony of the monuments, the Greek peplos with its characteristic overfold remained foreign to Etruria even in its Classical period. In general, the prevailing trend favoured regional over international modes of costume, both male and female; we may register this phenomenon as an index of increasing cultural isolation (cf. above, p. 258).

In this development of a Classical type of bronze statuettes, the Etruscan candelabra had a considerable share. The new style probably formed in the old centres of the Etruscan south, although a considerable portion of the total output, especially candelabra, actually stems from northern sites; best documented among the latter are the tombs of Spina (above, p. 256). The workshops that created these implements have not yet been sorted out; it seems likely that the ancient seats of metallurgy in the north such as the realm of Chiusi, or the cities of Populonia, Bologna, and possibly Perugia, contributed to this industry. One must add, however, that the quality of workmanship and execution differs greatly among these bronzes, as among so many other products of Etruscan art.

As a fine and relatively early example of the new Classical mode one may cite a statuette group from Marzabotto near Bologna [221], dating from about 440–430.[35] In this group, which was certainly designed for a candelabrum. a soldier is joined by a standing woman on whose left shoulder he rests his hand. She offers him a drinking cup – whether of welcome or farewell we cannot say. Her apparel and hairstyle follow the new fashion, and the artist took pains to impart to her a semblance of Greek demeanour, in a Classical vein. For the same reason, I assume, he omitted the customary Etruscan boots, preferring to leave the lady barefoot.

Suspended Statuettes

One other closely related class of decorative statuettes, turned out for uses so far undetermined, seems to have been a characteristically Etruscan product of the second half of the fifth century. The handsome discobolus in a New York collection[36] [222] might have been the

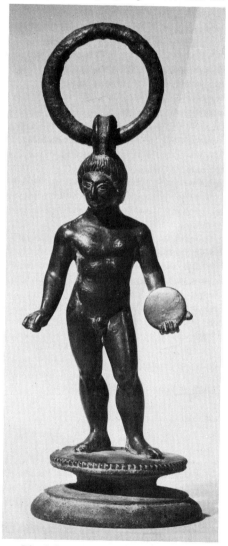

222. Discobolus, c. 450–425. Suspended bronze statuette. New York, The Pomerance Collection

finial of a lost candelabrum, were it not for the
large ring attached to his head. It has been sug-
gested that hooks were fastened to the moulded
base, perhaps to hold implements such as ladles
for the banquet. The whole contrivance could
be carried about or suspended from its ring. Be
this as it may, the statuette, its most important
member, is remarkable not only for its fresh
modelling but also for the athletic theme which
just about that time invaded Etruscan sculpture.
Comparable representations and the free stance
date this sturdy young athlete with his un-
glamorously striated hair after the middle but
probably still within the third quarter of the
century.

While the domestic implements of the time,
such as the candelabra, were mostly standard-
ized as to form and function, the styles and sub-
jects of their statuettes vary greatly. A statuette
from Spina[37] which represents a young boy,
likewise with a ring attached to his head [223],
illustrates the range of variety one may expect
within a single class of objects. It is larger than
most bronzes of its kind, and its stylistic lineage
differs clearly from the equally suspensible dis-
cobolus [222]. Its subject matter is rare too. The
boy cuts a lock from his hair. His action more
probably renders a subject of genre than myth:
it may allude to the hair offering due from a
young man upon reaching maturity. The statu-
ette was perhaps coated with silver, traces of
which have been noticed; on any count it ap-
pears to be a precious and carefully-thought-
out work. The styling of hair and face indicate
connections with south Italian Greek, possibly
Tarentine, art. I date the Spina statuette some-
what later than the similarly poised discobolus,
because of its more eccentric posture: near 400.
Its maker may have been an exiled Campanian
who settled in the north. At any rate his work
does not seem Vulcian. Both the Tarentine
reminiscences and the eccentric stance are
symptoms of a new turn in Etruscan art, about
which more will have to be said in the following
chapters.

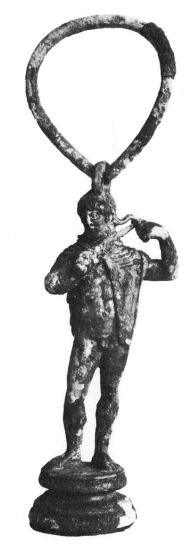

223. Youth from Spina, *c.* 400. Suspended
bronze statuette. *Ferrara, Museo Archeologico*

CHAPTER 24

THE CLASSICAL STYLE IN ETRURIA

BRONZE STATUARY:
STANCE, STRIDE, AND MOTION

Upright Statues: Stance and Step

It is now clear that contacts between Greece and central Italy, though continuous, were not equally close at all times; nor did they affect all parts of the social fabric with equal strength. On the whole the acceptance of the Greek cultural model in Etruria proved increasingly selective and often subject to prolonged processes of assimilation which noticeably altered the initial paradigm. One must stress the fact that, in spite of its habitual connections with Greece, the art of Etruria is really very little Greek. Especially on the Classical level the differences of range and temper between Greek and Etruscan weigh more heavily than the concordances: we perceive them not only in the apparent results but also in the conditions under which both arts matured. A penchant for rational guidance, verbally expressed, accompanied the progress of art in Greece.[1] In Etruria one faces a prevailingly practical, craftsmanlike organization of the artist's work. The verbal rationalizations of its aims, preferences, and dislikes have not reached us; but the silent witness of the impact which an essentially mercantile workshop organization had on all Etruscan art, even in its Classical phase, is the continuing anonymity of that art. An inquiry into the Classical style in Etruria must wholly rely on symptoms deduced from the examples at hand. Since it cannot be supported by authentic statements, it must perforce be diagnostic.

Bronze statues and statuettes supply the representative monuments. During the Classical period bronze casting emerged as the most renowned domestic industry, and bronze statuary as the leading art: her bronzes made Etruria famous. Marble sculpture occurs sporadically; for reasons unknown, the working of marble never attained a regular place in the Etruscan repertoire.[2] The latter circumstance constitutes the most consequential single difference between the conditions of art in Etruria and those in Classical Greece. In Greece the great marble temples became the showcases of the new art and the training centres for generations of artists. In Etruria the decisive circumstance was precisely the absence of marble architecture and hence of that concentrating effect which the large building projects in Greece exercised on the other arts rallied to their embellishment. 'Classical' in Etruria is a variety of art that grew in a state of comparative decentralization, mostly beyond the controlling influence of architecture, and with common denominators that often differ totally from the Greek.

Since the parallel tendencies that nevertheless continued to connect ancient Italy with contemporary Greece operated under conditions so different, the results differ also. Thus the upright, essentially actionless statue was a theme that Greek and Etruscan art shared. Clearly this was a special instance of the broader proposition, the human theme: in Greece, at the start of the Early Classical style, the quietly poised statues came to replace the Archaic scheme of upright figures that set the left foot forward. The promoters of this formal change, from step to stance, can hardly have been unaware of its human meaning. For to step, to walk freely, are primary actions in which the person asserts itself. When in its progress Greek art discarded the Archaic stepping images in favour of others that merely stand, it thereby turned to a different and more subtle condition of the human self-consciousness. The balance of the quiet stance then took the place of explicit action; it became interpreted and shown as action in abeyance.

The review of Proto-Classical bronzes (pp. 290 ff.) has already made it clear that Etruscan art reacted to these Greek developments with

reluctance, and perhaps with a degree of misunderstanding. In Etruria the Archaic kouroi rarely walk; their Early Classical successors rarely stand at rest. It is obvious that the canonical postures of Greek statuary – stepping, standing, walking – were met with uncertainty.

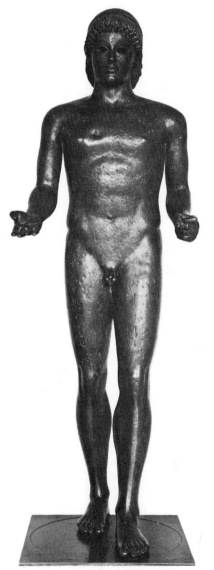

224. Apollo from Piombino, *c.* 460(?). Bronze. *Paris, Louvre*

Two much discussed bronze statues may illustrate this situation. The very youthful Apollo – he seems a child – from Piombino, now in the Louvre, cannot with any certainty be declared Etruscan [224].[3] He was however most likely a work of Italy; the possibility that he originated in an Etruscan workshop ought not to be excluded from consideration, even though near comparisons are at present lacking. At any rate he is the latest in the series of Archaic kouroi to which he belongs by type, but from which he detaches himself by style.[4] The other statue, now in Copenhagen[5] but formerly in the Palazzo Sciarra in Rome, probably represented a youthful votary who once in his outstretched hand offered a gift, now lost [225, 226]; it is hollow cast in the south Etruscan tradition, of about 460–450. Eye-sockets and lips are open, the former to be filled with eyes of coloured materials after the Greek fashion, which contrasts with the earlier Etruscan habit (p. 253). One formal detail still connects this statue with the native past, however: the steeply arched eyebrows are each shaped as a raised ridge, like those of the more archaic head from Nemi which we related to the workshop of the Roman wolf [208] (p. 294). The chances are that the Sciarra statue indeed originated in Rome, where it was found. One can regard it as a regional attempt in the manner of an incipient Etruscan classicism. I mention two formal traits in particular: one is the discrepancy between the squat, heavy torso and the agile, slender limbs which look out of context, as if borrowed from another person of different build. The second is the relatively shallow relief of the chest and abdomen, which seems to cling to the surface, avoiding depth. These contradictions are no accident. They reflect an intended pattern that produces a characteristic silhouette, not wanting in elegance. As the eye follows the tapering outlines, from the broad shoulders to the lean hips and gently curving thighs, one realizes that the structural contrasts of heavy volume and rippled or mellow surfaces, and the staccato effect of the lithe extremities must be taken to be the makings of a style.

The Apollo from Piombino shares these traits with the Sciarra statue, his archaic conduct notwithstanding. We must conclude either that the new style reached Etruria from some undisclosed centre of southern Italy, or that the Apollo was himself an Etruscan work, in spite of his different detail and workmanship. On the strength of the formal data I am more inclined towards the second alternative, and to ascribe the bronze from Piombino to an Etruscan am-

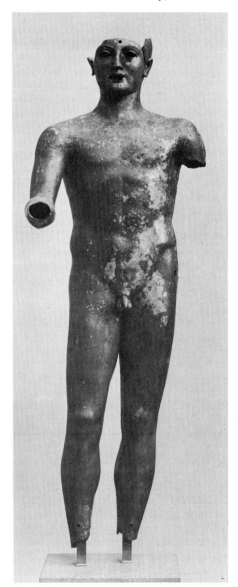

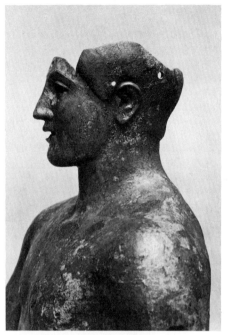

225 and 226. Votary (with detail of head), formerly in the Palazzo Sciarra, Rome, *c.* 460–450. Bronze. *Copenhagen, Ny Carlsberg Glyptotek*

bience of *c.* 460: only in Etruria did Archaic image types maintain themselves so long, in a time of change, to make a belated kouros statue plausible which, on the other hand, shares so many formal traits with a representative of the new, hesitant, local classicism.[6] Both statues aimed at high technical standards; yet the manner in which they were constructed – part for part, as it were – denies them that firm union from within which was the concern of all classical imagery in Greece. The statue from Piombino, within the limits of its adopted Archaic schema, achieves greater assurance in rendering the eager step. Conversely, the Sciarra bronze

betrays the newness of its enterprise by the in-
decision of its adopted stance. A distinction be-
tween the side which carries and the free leg was
intended but hardly realized. The prevailing
impression remains one of motionless frontality.
Neither does the head turn; only the right eye-
brow, raised, gives rise to a lively, slightly im-
pudent, expression.[7] Thus, however warily, the
Sciarra statue ushers in the Classical phase of
bronze sculpture in Etruria.

During the second half of the century the rift
between Greek and Etruscan art widened
further. Already before this date sculptors in
Greece had begun to experiment with statues
that lift the heel of one foot from the ground.
This innovation completely altered the quiet
contrapposto poses of images standing at rest.
It not only led to a less stable and more variable
balance of stresses and support, involving the
whole figure; it also demonstrated a new con-
cept of organic motion. The outcome was a dif-
ferent image type: a different action. The *uno
crure insistere* of the Polycletan statues cannot
truly be described as a state of rest; it represents
in fact a precarious intermediate between stance
and walk. Thus, paradoxically, the Classical
revolution in Greece ended by standardizing
another kind of step – one very different from
the Archaic. Its new images do not march for-
ward. They seem to have arrived from a space
behind them, and come to a halt. Their en-
trances into the world of men are epiphanies,
their actions frozen moments, eternally tran-
sitory.

In view of the extraordinary impact which
these developments had on the future course of
art, it is surprising that Etruria did not follow
them more closely than was apparently the case.
In part, at least, differences of purpose account
for their separation; the range of an art must
necessarily reflect the needs and expectations of
the society that supports it. The principal
themes of Greek Classical statuary, in addition
to architectural sculpture, were images of the
gods or victorious athletes. Etruria had little
room for either. Perhaps we would know more
about Etruscan representations of deity if more
large statues were preserved; among the statu-

ettes only a few can be so identified with confi-
dence.[8] Athletes after the Greek model were
eventually accepted in the Etruscan repertoire
of statuettes. Thus young discus-throwers be-
came a favourite subject among the applied
bronzes [222], though among the ex votos
athletes, other than spear-throwers, remain rare.
Vice versa, a large contingent of the Etruscan
bronzes deals with two classes of people that
were rarely portrayed by Greek statues: ordi-
nary votaries – not victors – and armed hoplites.
The former are quite unheroic personages who
enact the religious tasks incumbent on their
civic status. It is possible that the representa-
tions of hoplites include characters of heroic
saga or even deity; if so, they lack distinguishing
attributes. Since all these statues and statuettes
wear arms of common use, they appear all
equally deheroized: they behave according to
their calling, as soldiers.[9] The leading charac-
teristics of either group are the narrow range of
their typical actions, and a realistic rendering of
dress and equipment. Thus by definition these
prevailingly domestic thematic divisions also
became the two classes of Etruscan statuary
farthest from the Greek.

The progress from a Proto-Classical to a
Classical phase of style is nevertheless also
recognizable among these materials. It took
place, however, in terms that tended to stress
rather than mitigate the particularism of Etrus-
can art. Its foremost symptom was the change
from step to stance which, as has been shown,
happened very belatedly. But this innovation,
once it had been adopted, was in Etruria not
followed by a further development towards
lighter and more flexible interpretations of the
standing figure. The remarkable fact is that
Etruria mostly ignored the Classical Greek for-
mula of statues standing at rest, with one foot
half lifted. The Etruscan versions of such sculp-
ture keep their two feet on the ground – a habit
which persisted, if with exceptions, into the
Hellenistic period. When reflections of Poly-
cletan schemata occur, which is not often, they
are modified accordingly. The domestic tradi-
tion decided what behoves a quietly standing
statue.

This departure from a Classical norm was not a mere matter of detail. The stance influences the entire statue. The manner of standing chosen by the Etruscan sculptors about the

227. Statuette of Turan (Aphrodite), second half of the fifth century. Bronze. *Cambridge, Mass., Fogg Museum of Art, Harvard University*

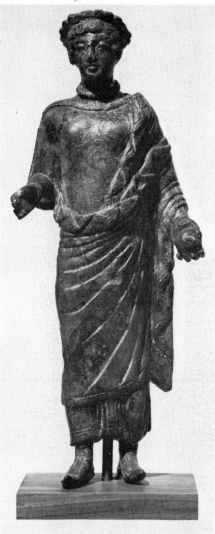

middle of the fifth century was from the outset unfavourable to the loosened contrapposto poses towards which Greek Classicism strove. In this regard the Sciarra statue [225] looks a stranger vis-à-vis any Greek statue of comparable type; yet in many other respects it was a grecizing work, in a tradition that began with the Kritios boy. When one turns to somewhat later Etruscan examples the stylistic distance grows. The so-called Turan (Aphrodite) in the Fogg Art Museum[10] [227] stands resolutely on her two feet, clad in upturned Etruscan shoes; moreover the feet are placed almost parallel. The Archaic step was indeed discarded, but the stance that replaced it seems a return to the pre-Archaic, timeless form of a severely frontal statue. For all that, the statuette, which is of rather generous size and conceived in a statuesque vein, is not devoid of a Classical quality. But this quality resides in properties other than its stance, which is non-Classical. One ought to consider also that in the Etruscan monuments of this period 'Classical' need not be equivalent to 'Greek': we are dealing with a regional reaction to the Greek Classical style. This reaction may be described in three ways: as a detachment from Archaic formal clichés, as a new liberality in the spacing of broad areas of form, and as a sense of monumentality expressed in material bulk. The last point – the tendency to equate monumentality with massiveness – must be held a recurrent phenomenon in Etruscan art, especially stone sculpture (p. 178).

One senses in this Etruscan attitude towards the maturing Greek Classicality a latent conservatism, or an atavistic aesthetic, that felt drawn to very ancient principles of imagery and hence reluctant towards the new. Yet in the psychology of Etruscan art this reluctance itself seems a new component; early Etruria used to welcome all foreign inspiration without shyness, and almost indiscriminately. If, as it appears, the Classical evolution was received with reservations, the cause may be sought in the more self-conscious and sophisticated evaluation of Greek art which we have already noticed (p. 258). Especially on the Classical level the en-

counter with Greek sculpture seems to have fostered a notion of essential difference on the Italic side. On these grounds Greek art could be accepted more knowingly and with a consciousness of choice (pp. 258-9), while by the same token it could also be opposed and resisted. Certainly the advance of the Classical style did not go unnoticed. An interesting large statuette in Baltimore,[11] dating from near the end of the century, shows beyond doubt that its maker was familiar with two special concerns of Greek contemporary sculpture: contrapposto, and the transparency of garments [228]. He dealt with both in a quite original way. Yet he subordinated either interest to the aboriginal stance and the traditional action of a woman votary who lifts her skirt with one hand like a kore of old, although obviously the new fashion of dress lent itself only with difficulty to this prescribed gesture.

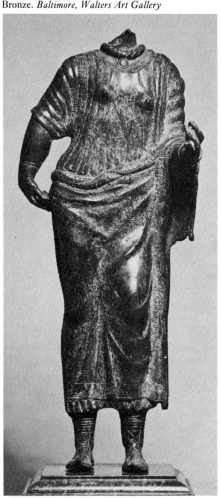

228. Statuette of a votary, late fifth century. Bronze. *Baltimore, Walters Art Gallery*

Elongated Figures

At the same time surprisingly sharp contrasts of style come to the fore internally, between the coeval artistic relics of Etruria proper. The principle of bulky monumentality in sculpture was challenged by its antithesis: the appearance of attenuated and elongated figurines, which comprise a sizeable contingent of the bronzes extant from the Classical period.

This peculiar contradiction of principles had earlier antecedents. Among the skirted kouroi likewise some were squat and bulky; others were excessively lean (above, Chapter 7, p. 99). So, on a different level of quality, were the spear-throwers from Brolio [67]. A large kouros statuette in Berlin[12] carries its abnormally stretched trunk on stilted legs [229]. It stands and acts as if it were a reincarnation of the skirted type, though actually it is a Late Archaic work, hardly older than *c.* 480. Among its contemporaries this statuette seems a freakish exception; yet, since it probably came from Chiusi, its master may well have remembered the dapper bronze soldiers of a bygone age, once so popular in this region, and from one of them have drawn his idea of elegance. If so, he perfected it. One ought to notice the grooved elliptical line that joins the hips with the trunk into a continuous design: such calligraphic readings, imposed on the living form, reach deeply into the history of the Geometric style in Etruria and beyond. We cannot account for these survivals, if indeed one must call them so. But the penchant for abstract configurations sets the Berlin kouros up as an intermediary between the native past and the novel type of elongated

figures that became the antipodes of the Classical style.

The new statuettes render spear-throwers, or persons in similar aggressive postures.[13] Some portray Menrva (Minerva) with her familiar attributes. Whether the far more numerous men – usually armed hoplites – were intended as images of the indigenous Mars or merely as human warriors remains undecided; apparently all of them were ex votos in sanctuaries. They seem impersonal beings, bent only on their warlike action – their invariable destiny. With time these statuettes became increasingly standardized, until by the end of the fifth century the last specimens reached the ultimate stage of a routine stylization. Thus their history follows the typical course of a popular and regionally limited Italian industry: a development in reverse, which must not necessarily be viewed as deterioration but which certainly implies a loss of meaning, as the point of departure moves progressively out of sight.

The most remarkable circumstance about these statuettes is the fact that chronologically they constitute a distinctly Proto-Classical and Classical group of monuments. The images of Minerva follow a Greek Late Archaic type of Promachos.[14] Among the men the large bearded statuette from Apiro perhaps reflects aftereffects of the Athenian Tyrannicides.[15] Of the Etruscan models that probably launched the type and set its pattern the tall armoured statuette in Florence[16] can be considered representative [230]. This minutely detailed, curious work of c. 450 also renders a striding hoplite. Its style is characterized by occasional touches of archaism, such as the small folds of the chiton, combined with a somewhat manneristic, fastidious simplicity of all forms including the pose itself; the violence of the action becomes muted by the unmoved expression of the large face, the unseeing eyes, and the affected rigidity of the stride. From images such as this the new popular type of spear-throwers inherited not only its often repeated action but also the formal mannerism from which resulted the excessively attenuated bodies. Apparently the fashion thus to elongate the human form for the sake of ele-

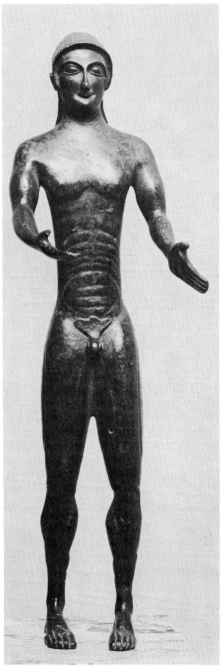

229. Statuette of a kouros, c. 480. Bronze.
(West) Berlin, Staatliche Museen, Antikenabteilung

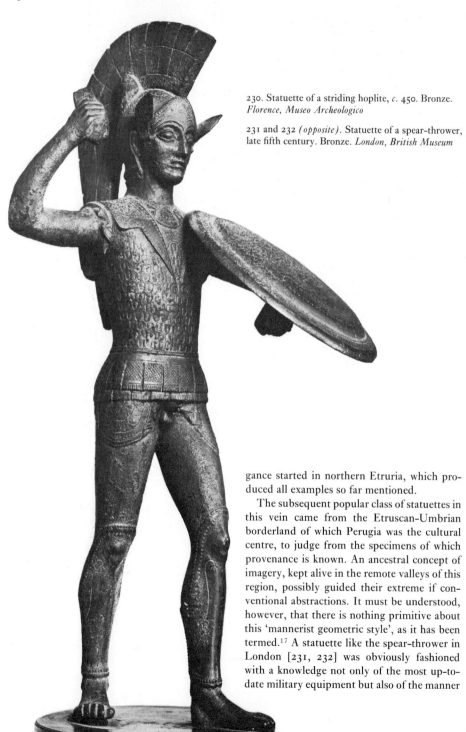

230. Statuette of a striding hoplite, *c.* 450. Bronze. *Florence, Museo Archeologico*

231 and 232 *(opposite)*. Statuette of a spear-thrower, late fifth century. Bronze. *London, British Museum*

gance started in northern Etruria, which produced all examples so far mentioned.

The subsequent popular class of statuettes in this vein came from the Etruscan-Umbrian borderland of which Perugia was the cultural centre, to judge from the specimens of which provenance is known. An ancestral concept of imagery, kept alive in the remote valleys of this region, possibly guided their extreme if conventional abstractions. It must be understood, however, that there is nothing primitive about this 'mannerist geometric style', as it has been termed.[17] A statuette like the spear-thrower in London [231, 232] was obviously fashioned with a knowledge not only of the most up-to-date military equipment but also of the manner

of representation which the Etruscan bronzes had then adopted for the portrayal of this particular action: brutally frontal.[18] Nevertheless the view from the side was not neglected. In some regards it even appears to be the preferred aspect; the same remark holds good of many other statuettes in this category. Their silhouettes are often a captivating sight. With limbs and torsos reduced almost to wiry staffs, the contours succeed better than the frontal view in making the simple geometry of the sculptural construction explicit. In some instances their bodies rise straight from the broad triangle of the striding legs, as with the London statuette [231] whose angular arms and shoulders are surmounted by the profile of a face, steep as a mountain ridge; the enormous crest of their helmets tops these figures as a flag tops its pole.

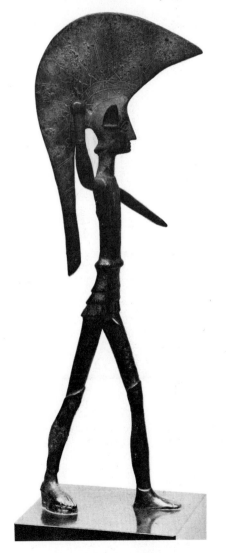

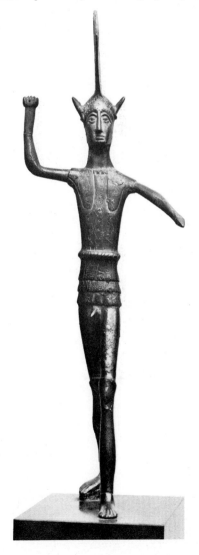

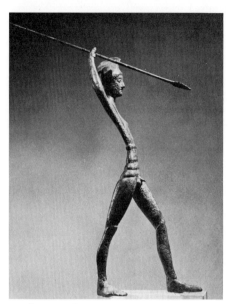

233. Statuette of a spear-thrower, late fifth century. Bronze. *Perugia, Museo Archeologico (Collezione Mariano Guardabassi)*

Again in other examples the silhouette may form resilient calligraphic curves, as is the case of the statuette in Perugia which leans back for the throw [233].[19]

Common to all images of this class, regardless of quality, is their determining factor: geometric abstraction. The means to accomplish this formal aim was a deliberate use of attenuation and elongation of the representational detail. At a time when all art around them was striving towards the fullest possible expression of humanism, the appearance in northern Etruria of these semi-geometric statuettes poses a problem. For different from primitive conditions where superficially similar results may be credited to an effort of shaping images not otherwise attainable, other choices were within the reach of fifth-century Italy. The founders of the new style must have been aware of them. Whatever were the motivating reasons, their abstracted images violated norms then valid; their manner of styling amounted to wilful alteration,

i.e. distortion, of the human form. This must be the verdict even if one realizes that no live model but a pre-established type of art was so transmuted. The observations on the psychology of Etruscan art which in this account were set down on a much earlier occasion (Chapter 2, pp. 35 ff.) are probably just as applicable to the anti-Classical tendencies within the Classical era. Then, as before, the Etruscan was not on the whole a naturalistic art – as little as was the Greek. Its method of representation was prevailingly formal, though it made allowance for selective realistic interspersions, as did all ancient arts in varying degrees. The attitudes which determined 'form' in each case must be held responsible for the different outcome.

In Greek art the verity of form may be described as twofold. It was at the same time intellectual and existential – hence capable of that high degree of rationalization which the artists, and by the end of the century the critics, pursued consistently. Etruscan art, from the start, lacked a theoretical schooling comparable to that which Greece inherited from her own Geometric style. It was never committed to so close a nexus between artistic form and reason. As an explanation *ex eventu* one may here recall that the Villanovan-Geometric phase of Italic art never came to maturity because it was too soon superseded by the imported oriental or orientalizing models. But neither, owing to the same circumstances, was it so thoroughly assimilated and absorbed by the subsequent development as was the Geometric style in Greece. In Etruria, geometric abstractions remained a possible way of art *per se*, long after the same abstractions had ceased to be an obvious factor in the creation of art in Greece. To the Etruscan artists form was something given; hence something to be found ready-made, be it in a work of art from abroad, in a regional tradition at home, or else to be derived from a natural object directly. As such it might be accepted and imitated freely, without reservation; it could also, as man's plaything, be varied and abstracted beyond any semblance of the natural order, to a point which by Classical tenets must seem an unjustifiable excess.

The Eccentric Stance

Thus the paradox came to pass that simultaneously with geometric images of a then rare rigidity, the statuettes of the late fifth and early fourth centuries include some of the happiest small sculptures of all Etruscan art. These also have a lesson to teach concerning the spirit that infused their makers; upon closer study one may find them no less instructive than enjoyable. A little discobolus in Detroit[20] makes ready for action, right foot forward [234]. As the swing of his body gathers energy for the release of the discus he moves easily, without constraint; the left heel is slightly raised, preparing for the forward leap that must accompany the final step. With the face and the striated

hair the artist dealt sketchily: his object was the action, not the person. The raised heel is an interesting detail. It shows that an Etruscan sculptor did make use of this device after all, when he thought it in keeping with the action represented. So did others among his countrymen, as we learn from the statuette of a young page pouring wine in the Nelson-Atkins Museum of Kansas City [235].[21] It seems that the reluctance (p. 308) to adopt this Classical schema chiefly concerned the quietly standing figures. In the latter instances, however, the uneasiness which caused the Etruscan sculptors to avoid the Greek canonical postures reveals a critique of that canon itself. To walk and to stand are distinct acts; no man can do both at the same time. Yet the Polycletan model contracted

234. Statuette of a discobolus, late fifth century. Bronze. *Detroit Institute of Arts*

235. Statuette of a boy holding a patera, late fifth century. Bronze. *Kansas City, William Rockhill Nelson Gallery of Art and Atkins Museum of Fine Arts*

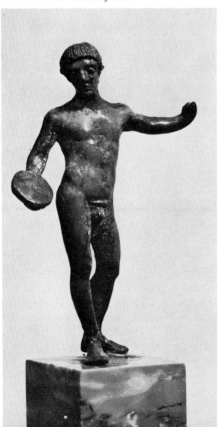

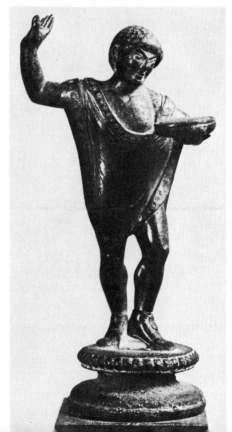

these two incompatible actions into one, in a manner visually acceptable but contrary to natural experience. The hesitation of the Etruscan artists to recognize this compound scheme may therefore be interpreted as an implicit objection which practical sense raised against an ingeniously invented, if highly abstracted, image-type.

Nevertheless the problem made an impact, or so it appears; an answer had to be found. I suggest that the increasingly eccentric postures which characterize the quietly upright statuettes and statues of Etruscan art towards the end

of the fifth century, and in much fourth-century art as well, represent a response to the Polycletan dilemma. We may regard them as the Etruscan equivalent of the Greek Classical contrapposto stances. Not that this solution was found without considerable experimentation; nor was it monotonously applied. It proved on the contrary capable of much variety. For instance, the statuette of a nude young athlete from Monte Capra now at Bologna [236] seeks to approximate the Greek formula.[22] The left foot was slightly raised, but since at the same time it was put forward in the Archaic manner,

236. Statuette of a young athlete from Monte Capra, late fifth century. Bronze.
Bologna, Museo Civico Archeologico

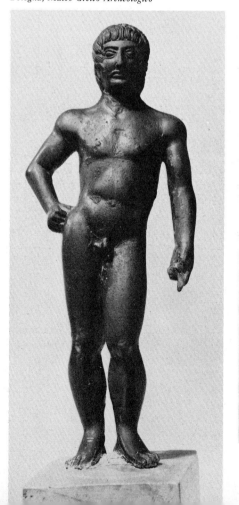

237. 'Mars' from Todi, early fourth century. Bronze. *Vatican, Museo Gregoriano Etrusco*

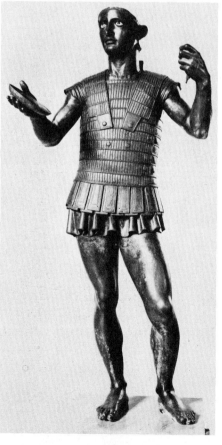

however cautiously, instead of moving up from the rear, a precarious imbalance resulted in the figure as a whole. One senses the difficulty caused by the conflict between an inherited iconographic conception and a new ideal, insufficiently comprehended.

By contrast, the armoured statue of the so-called Mars from Todi [237] now in the Vatican[23] shows the completed evolution of a Classical formula in the Etruscan style. The feet are wide apart, almost parallel, and placed firmly on the ground. In these conditions the contrapposto stance after the Classical prescript turns into a peculiarly limber, dancing gait. It is clear that this posture, though it differs from Greek statuary, constitutes a hardly less abstracting schema, and one no less difficult to justify on naturalistic grounds. In every respect this armed hoplite with his large, empty face presents himself as a thoroughly formal, even studied, work. One misses the spontaneity found in so many lesser statuettes: the pedantic accuracy which its makers lavished on the inanimate detail of armour and tunic strengthens this impression rather than mitigating it.

Yet the decisive difference between the Etruscan Mars and any Greek upright statue lies neither in the formalism nor in the realistic equipment of the former, but in the lack of a firm inner structure. In Etruscan art at any stage form was likely to mean little more than the outward appearance of things concrete. There is hardly ever a sign that an illustrative form was the calculated effect of an inbuilt proportionate order, or the natural expression of an organism moved from within by a personal will. The eccentric variant of a Classical posture which developed in Etruria after c. 450 accords with this fundamental habit. Form continued to be understood as a function of two exterior variables: contours and surfaces. The hip-shot stances of much Etruscan statuary on the Classical level resemble nothing more than the spineless, question-mark-like posture of the Late Gothic International Style. In either type of image, animation was rendered symbolically and with similar results by the same outward sign; the sway of an excessively curving outline.

The Detroit Rider

One other component of the Classical style in Etruria must still be mentioned, namely the emergence of a new naturalistic strand. The large statuette of a horseman, now in Detroit,

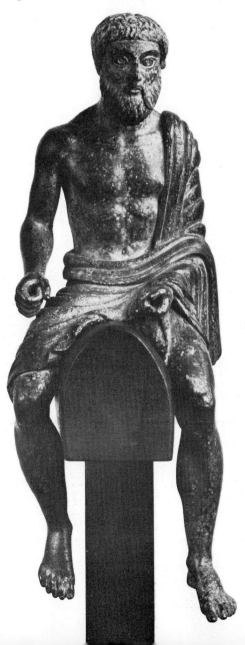

238. Statuette of a horseman, shortly after 430. Bronze. *Detroit Institute of Arts*

Michigan, illustrates this aspect well. Nothing quite like it was encountered among the bronzes assembled in this chapter to which, in spite of that fact, its date and origin refer the Detroit rider [238].[24]

The difference is chiefly one of temperament and attitude. The horse which the man once straddled is lost. It must have been walking staidly while its master held the reins in his left hand; what object the right hand clasped one cannot make out. He has the appearance of a knight on horseback. At any rate we recognize him as a person of reality, not myth; most likely a votary who dedicated his likeness to some shrine in or near the town of Spina. The maker of this ex voto may have been a local artist, settled in Spina though trained elsewhere. His glyptic style of modelling, especially apparent in the thorax and abdomen of his statuette, reminds us of the carved forms which characterize the Vulcian tradition (see above, p. 241). More important is another fact: here for the first time we find a reflection of the art of the Parthenon in Etruscan sculpture. The telling symptoms are not only details such as the easy folds of the mantle, but the whole bearing of the figure, which is rendered in broad and solid forms, comfortably spaced but sparsely detailed. Altogether, the evidence points to a date shortly after 430.

Among the competing tendencies of Etruscan art I consider this style an innovation. All art is formal, by definition; but art also has ways to play down its inevitable formal role to a point almost of deception: we then accept the result, as we accept nature itself. The Detroit rider is such a work. As he meets us squarely, his earnest face bowed slightly to the left, he shows himself equally remote from the eccentric mannerism as from the forced abstractions that hallmark so much Etruscan imagery of this time; instead, he is calm and collected. One may apprehend these attributes as moral qualities, residing in the man so portrayed. But in fact they also bespeak a certain attitude of art which favours understatement, avoids exaggeration, and tends to minimize the artist's interference with natural appearance. Hence, its interpretation of the human form is realistic but deliberately undramatic; it also is apt to stress social and personal diversity. We perceive here the incipience of a reflective naturalism of a kind hardly found in any earlier art. The proto-portraits of the Chiusi urns can perhaps be regarded as remote antecedents (above, pp. 129 ff.); portraiture remained the principal domain of all naturalistic art throughout antiquity. The Detroit statuette is not a portrait yet; but it does mark the start of a new naturalism, and a more subtle understanding of the human person. Its dignity, which seems so artless, is a stylistic trait; it represents the most mature response to Greek Classicism of which the Etruscan tradition proved capable. Eventually this trend will lead to character portraits like the so-called Brutus (below, pp. 399-400). For its grasp of the natural object it must be called a naturalistic art, but it also carries an element of character evaluation (*ethos*) as its Classical heritage. We should here recall that during the fourth century the first equestrian statues were set up on the Roman Forum.[25] The Detroit rider may give us a hint as to their looks and manners.

TERRACOTTA SCULPTURE, CHIUSI URNS, STONE SARCOPHAGI

Terracotta

Some of the most nearly hellenic Classical sculpture from Etruria was due to the ceramists. Grecizing male statues – wearing the long mantle (toga) without a tunic underneath – occur among the ex votos of Veii before the middle of the fifth century.[26] Soon after 430 should be the date of a large bearded head of excellent execution from a temple at Orvieto [239].[27] We cannot name it with certainty; it may but need not portray the Etruscan Jupiter (Tinia). Its well groomed long hair, tied at the back, is held together by a broad wreath of laurel; the leaves, stacked in three rows, were probably gilded, the flesh parts of the face painted a rusty red. The beard consists of shorter locks that tend to curl inward at the tip, as if continuing the semi-Archaic tradition of

239. Bearded head from the Via San Leonardo Temple, Orvieto, shortly after 430. Terracotta. *Orvieto, Museo dell'Opera del Duomo*

240. Male head from the temple at Lo Scasato, Falerii, late fifth century. Terracotta. *Rome, Villa Giulia*

the question-mark curls of the Roman wolf (above, Chapter 20, p. 252 and Note 22). But the head from Orvieto is Classical sculpture altogether. Below the deep brow, the eyes recede with an inward slant under heavy lids. The mouth with its full lower lip bespeaks a volatile temper: at once easily aroused, quick to respond, and still. The streaming forms of hair and beard flow about the stable order of this face as the restless ocean circles the world of man on the shield of Achilles. Attic, and perhaps Tarentine, reminiscences may have helped to shape this extraordinary work.

A somewhat smaller head in the Villa Giulia from Città Castellana (Falerii)[28] has often been cited as a possible copy of the Olympian Zeus by Phidias [240]. More likely its maker merely varied a type depending on Phidian models; the head seems to date from near the end of the fifth century. At any rate, this neatly modelled terracotta shows the continuing strength of the Greek

tradition in the Faliscan region. It also exhibits the ancient virtues of the Faliscan craft: compactly rounded forms, exactitude of small detail, deftness in the handling of ceramic colour (pp. 247 ff.).

Of a quite different order is the famous Malavolta head, also in the Villa Giulia,[29] from the precinct of Minerva at Veii [241], which originally formed part of a lost votive statue. It represents a young man with short, curling hair, in a style about contemporary with Greek statuary from the last quarter of the century. Its generally Polycletan character has often been pointed out; nevertheless its nearest relative does not seem to be a work by the Argive master himself but a derivative such as the 'Idolino' in Florence. Actually the Malavolta emerges from all comparisons with related art as a very independent creation. Its maker – an artist in his own right – seems to have had Tarentine connections, and he knew Greek art well. Yet he carved

from a Classical schema an emphatically non-conformist, personal face. The boy whom he portrayed, or whose countenance he invented, looks at us wistfully; there is in his expression a tinge of melancholy, which one sometimes

241. 'Malavolta' head from Veii,
end of the fifth century. Terracotta.
Rome, Villa Giulia

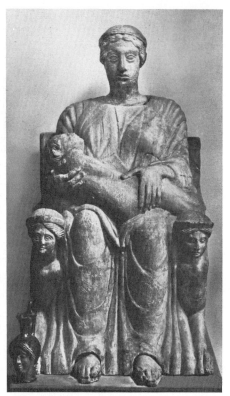

242. Mother and child from Chianciano, *c.* 400.
Limestone cinerary urn.
Florence, Museo Archeologico

notices in the young when they think themselves unobserved. The sharply cut outlines that fashioned this face accord with the indigenous Veientine manner; the result, a near-portrait, foreshadows the crisp individualism of Florentine Quattrocento sculpture, in form and spirit.

Chiusi: Cinerary Urns

At Chiusi and in the Chiusine territory the second half of the fifth century witnessed a renewed interest in the anthropomorphic containers designed to hold the ashes of the cremated dead (pp. 132-3). The novel versions of this ancient local product were wholly humanized figures, about two-thirds life-size, and

formally quite unrelated to their intended function as burial vessels, though actions and meanings appear to refer to their funerary destination. Since the majority of the examples extant was carved by local sculptors from local limestone, they signal as a group a remarkable revival of stone statuary in Etruria after a lapse of nearly a century.

There are two distinct types: seated figures and reclining banqueters. The former are women on sturdily built thrones, often flanked on either side by a sphinx whose wing serves as an arm rest. The heads of the enthroned figures were worked separately and are removable. Details such as the thrones with supporting sphinxes clearly echo Greek art, as do the

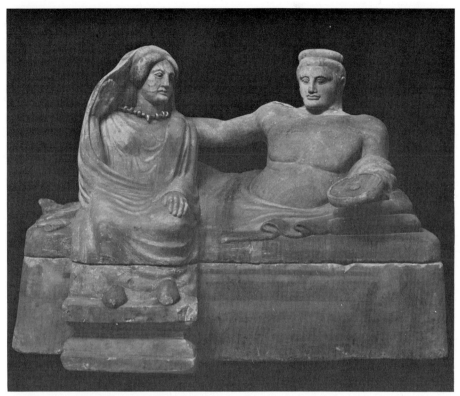

243. Banqueter and wife from Città della Pieve, late fifth century. Polychrome alabaster cinerary urn. *Florence, Museo Archeologico*

sandals the ladies wear. But the total effect is anything but Greek. Encased in their broad, stolid forms, staring at us impassively, these statues create awesome images. One from Chianciano, now in Florence,[30] holds a child in her heavy hands [242]: she is a mother. The child seems to sleep in her lap, but the woman does not heed. She gazes in a void before her – gloomy ancestress of Michelangelo's sadly prophetic Madonna at Bruges. Whoever fashioned this image, near the year 400, was a craftsman of moderate skill, but he stated the Etruscan understanding of the Classical style in sculpture very clearly. He was susceptible to its monumentality, which in the native vein he interpreted as massiveness of form; and to its look

of self-contained serenity, which he read as earnestness.

Banqueters appear among this class of statuary about 400. They soon became the rule, thus reviving the ancient Etruscan fantasy of the feasting dead. But here too the mood has become more subdued. The banqueters of the Classical cinerary urns are young men resting on their couches, as the happy couples on the Caeretan sarcophagi did before them (p. 231). If they are given a feminine companion, she sits at the foot end of the bed. She may be wife or bride, lifting her veil as does the fashionable young woman of the group in Florence[31] from Città della Pieve which dates from near the end of the fifth century [243]. But in another, slightly

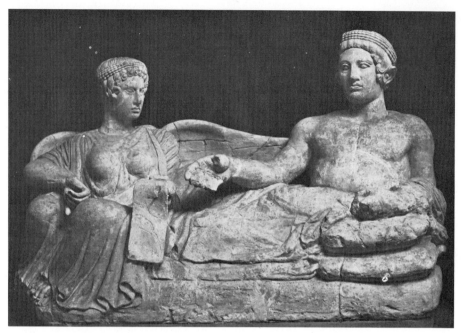

244. Banqueter and Vanth, *c.* 400. Limestone cinerary urn. *Florence, Museo Archeologico*

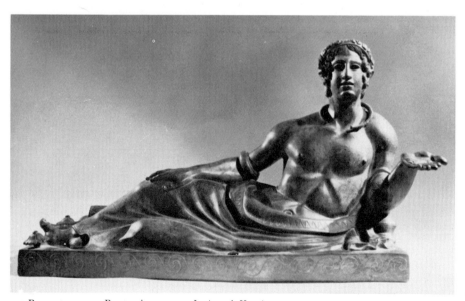

245. Banqueter, *c.* 400. Bronze cinerary urn. *Leningrad, Hermitage*

later instance a winged demon takes this place. The apparition opens a scroll as if it were a book of accounts, looking sternly at the deceased; her wing touches his shoulder in a gesture of silent claim [244]. For the first time we meet the enigmatic image of Vanth, which from here on was destined to become the most frequent symbol in the expanding Etruscan demonology of death.

Like much Etruscan art, the Classical Chiusine ash urns were a regional speciality. But they were also an ambitious group of monuments artistically, without a match in contemporary art. With time, their material became more variable. Among the second type – the banqueters – one finds use of alabaster [243] as well as bronze [245], in addition to the ubiquitous limestone. The finest among the preserved bronzes, the statue in the Hermitage in Leningrad [245], marks the zenith of the group.[32]

Two observations of style apply to the group in its entirety. Its Greek contacts seem to lead to south Italy, especially Tarentum; this assumption explains the characteristic small locks of hair, ending in spiral curls before the temples, which frame so many of the faces. Similar curls occur in other Etruscan statuary of the time, such as the 'Mars' from Todi [237]. Their nearest counterparts are Tarentine terracottas, which however treat the same detail more freely. The Etruscan fashion may have been derived from south Italian models by progressive stylization.[33] Another matter altogether is the general build of these figures, the banqueters especially. Their heaviness, the inordinate width of their chests and shoulders, expresses grandeur of form at the expense of the natural order. The functional context of limbs and body becomes neglected; these inert shapes were not calculated ever to rise from their couches. Such single-minded emphasis on the sculptured surface amounts to a denial of all interior structure. The tendency was a heritage of the Etruscan past, as we have seen. In the Etruscan tomb sculpture of the late fifth and the fourth centuries it was carried to its logical end. Bodies and garments are described as sheer physical mass or, with the ash urns, they actually cloak a

hollow vessel. The wish for a Classical monumentality probably even guided this most radical externalism of the sculptural form, however unclassical the outcome may seem to us. Concomitantly, one notices a growing sensibility to the specific properties of the stone which was chosen as a working material. Thus, in the urn from Città della Pieve [243] one witnesses the formation of an 'alabaster style' of sculpture which differs markedly from the contemporary treatment of form in other stone or in bronze. For the first time we meet here the *obesus etruscus*.[34] His type was foreign to earlier Etruscan art. For this reason alone one must doubt that portraiture plays any part in the colossal lethargy of many later Etruscan funeral images; more likely the new art over-played a highly concrete sense of monumentality, or an admired quality of the mere materials – their bigness, polish, or durability.

Early Stone Sarcophagi

About the same time, towards the end of the fifth century, the large class of stone sarcophagi with carved decoration came into being which count among the foremost monuments of Etruscan art in its later stages. Only a small initial group falls within the scope of this chapter, however. Its four known members hail from Cerveteri, which had also produced their domestic antecedents, the Archaic terracotta sarcophagi with banqueting groups on their lids (p. 231). Again, as with the Archaic examples, life-size images of the deceased occupy the lids, but their condition has changed. The new Caeretan stone sarcophagi show only a single person on each lid, not a couple; and in all known instances these persons – bearded men, apparently of rank – lie supine, stretched out flat on their pillows [246].[35] Art has made no attempt at restoring to them the semblance of active life; instead it has resolved to face death directly, renouncing allegory. These listless figures either seem to lie in state, without a stir, or, if a metaphor was at all suggested, they are likened to sleepers on their beds. Their open eyes must be

accepted as a representational convention rather than a natural symptom. The chances are that both meanings were implied simultaneously: the persons so rendered are sleeping, and they are also dead.

Clearly the iconography of death has taken a new turn, towards a more factual and less poetic description than ancient memorial art would as a rule admit. To portray the deceased as lying on top of their tombs, either in state or in perennial sleep, was a custom of late medieval and Renaissance art, where examples are plentiful.[36] Yet the Caeretan sarcophagi of the type here at issue must be recognized as remote ancestors of the Christian monuments which date from nearly a millennium later. One would like to know the origin of an idea of such impact; so far there is no certain answer. In time and concept the nearest relatives of the Caeretan sarcophagi are a small number of Punic sarcophagi likewise made of stone.[37] The rigid, recumbent figures on their lids may be a humanized reminiscence of the Egyptian mummy form, as it is

indeed shown on some earlier Phoenician sarcophagi from Sidon.[38] Yet both the Punic and the Caeretan samples presuppose an eastern Aegean domatomorphic type of lids shaped as pitched roofs. To mount on their ridge the desired statuesque double of the buried person presented difficulties; the problem was solved separately in every instance. The device was foreign to Greek thought, and no formal counterparts exist in Greek art, though the images, especially the faces of the Punic group, presuppose acquaintance with Greek Classical tomb sculpture. Whether the initiative to compose this novel type of sarcophagi from such various elements lay with the Phoenician or the Caeretan artists is a moot question. Owing to the close commerce between Caere and the Carthaginians, the formal scheme as well as its ideological motivation might have travelled in either direction.[39]

The most frequently cited example of the Caeretan group is now in the Vatican[40] [246]. It is also the oldest fully decorated stone sarco-

246. Sarcophagus from Cerveteri, late fifth century. Campanian limestone.
Vatican, Museo Gregoriano Etrusco

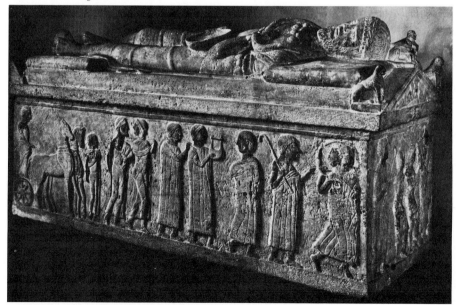

phagus in western art, providing us with an early model of the type which Etruscan funerary art was to retain henceforth. It combines the two standard features of all later Etruscan sarcophagi: figured friezes in relief decorate the box, and the more or less fully carved likeness of the deceased occupies the lid. Ample remains of the original paint are still visible. The material is a hard Campanian limestone closely resembling marble, with which it is sometimes confused. This circumstance is interesting, because it aligns the Caeretan sarcophagi with a short-lived attempt by local masons at cultivating sculpture in hard stone. The experiment, which is without precedent, appears to have been centred in southern Etruria; almost certainly it was a regional Etruscan reaction to Greek Classical marble sculpture. As an example of a different kind I insert a rare head in Toronto, Canada,[41] which may have been part of a votive statue, not quite life-size [247], representing a young boy. The workmanship is clearly Etruscan; one may date it near such bronze statuettes as our illustration 222.

247. Head of a young boy, end of the fifth century. Marble or hard limestone. *Toronto, Royal Ontario Museum (formerly L. Curtius Collection)*

The experiment in hard-stone sculpture was soon abandoned; so, eventually, was the severe iconographic type *à la lit de parade* of the Caeretan sarcophagi. On the Etruscan sarcophagi of the following centuries the dead came to life again, and references to the eternal banquet are frequent. Already the recumbent owner of the Caeretan sarcophagus in the Vatican must not be wanting his most obvious implement: the drinking cup [246]. Attention must also be called to the frieze of sharply outlined flat figures on the walls of his coffin.[42] Journey is its theme; but in this version, it seems, the journey has ended. The traveller is solemnly welcomed by his smiling wife, a band of musicians, and a speaker ready to address him. In Roman terms, we read this pageant as a scene of *adventus* rather than *profectio*; the funeral procession has turned into a picture of arrival and reunion.

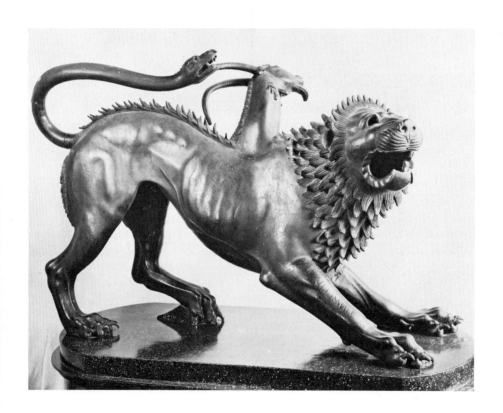

248. Wounded Chimaera from Arezzo, second quarter of the fourth century. Bronze. *Florence, Museo Archeologico*

PART FIVE

THE CLASSICAL ERA: THE FOURTH CENTURY

CHAPTER 25

SCULPTURE

BRONZE AND TERRACOTTA

The Chimaera of Arezzo

A balanced appraisal of Etruscan art in the fourth century is seriously impaired by the almost total destruction of the large bronze statuary. In Greek art, which suffered similarly, the loss is to some extent offset by the surviving marble sculpture and the auxiliary evidence of literary sources and Roman copies. But Etruria by-passed marble as a suitable working material, and Etruscan sculpture in stone other than marble was reserved for rather parochial uses, chiefly funerary. Yet our judgement of a past art is contingent on the accidents of conservation. Since the lost bronze statues of Etruria have left few discernible traces, and only scant echoes in written records,[1] a top level of Etruscan fourth-century sculpture – an upper horizon of skill and taste – was withdrawn from sight with their disappearance.[2] Hardly anything is now left by which to gauge its erstwhile accomplishments.

The wounded Chimaera from Arezzo [248], now in Florence,[3] is a rare survivor of this once famous but now nearly extinct class of ancient sculpture. Unlike the armed Mars [237] or that radiant spirit, the Leningrad banqueter [245], who attain comparable perfection while dealing with domestic themes, the Chimaera renders a Greek beast of fable in a Greek iconic scheme. Outstanding works of a noticeably Greek bent, when found in Etruria, always raise the question if they were not in fact of Greek origin.[4] The Chimaera, likewise, has invited classification with Greek art, chiefly on the presumption that

Etruria has no bronzes of similar worth to show.[5] Yet the Etruscan context in which she finds her rightful place is not wholly lost; we can still trace it. The dog-like zoology of the animal has its counterparts among Greek lions; by the end of the fifth century this manner of representing lions was a standard recipe of the Classical style.[6] But with the Chimaera the pseudo-naturalism of the anatomy contrasts with the ornamental styling and artificial order of the hair and mane. It is also at odds with other patterned details of the head, in which the native tradition appears conspicuously alive. The V-shaped, raised muscles above the bulging eyes have a long history in Etruscan art, reaching back to the Capitoline Wolf and beyond (p. 253). Though modernized in form, the device still serves its ancient purpose: to signify a physiognomical danger signal. It denotes anger. By this means the fierceness of the wounded beast was given quasi-human expression, as a facial distortion, for the visual formula which produces this effect can hardly be credited to a genuine observation of animals. On the contrary, it humanizes the animal by an act of empathy. Her adversary, Bellerophon on his Pegasus, need not have been shown. The onlooker towards whom the Chimaera turns takes the place of her enemy. More likely the animal enacted its story alone, much as did the Archaic mother wolf.[7]

Bronze Statuettes

The triple division among the statuettes of the fifth century (pp. 290 ff.) – hellenizing, domes-

tic, and attenuated – remained in force through the subsequent Late Classical and Hellenistic stages of Etruscan art. As regards the hellenizing and domestic categories, their differences continued to be chiefly thematic, though their separation may also lead to stylistic differences, as style often follows subject matter. From the fourth century onwards, the hellenizing group includes a growing quota of Greek gods and heroes, while the domestic subjects mostly deal with human votaries and sacrificers. At the same time the class of attenuated statuettes became enriched by a new type which consists of thin, flat bronze rods, made in the likeness of frontally standing, inactive humans. All are excessively long, and details are indicated with minimal modelling except for the small heads, which are finished in the round. Their themes are deity, votaries, and sacrificers. The new type shares with the earlier striding warriors (above, pp. 305 ff.) the wilful distortion of the human form but not their action and temperament. Incidentally, a diminishing interest in matters military seems a characteristic of all Etruscan statuary at this stage: the spear-throwers and armed soldiers have all but receded from its catalogue of topics.

Herakles, whose popularity continued widening, in Greece as in the West, still occurs in the old Etruscan schema of a fighter, launching forward [249].[8] But the prevailing tendency was to regard him as the heroic achiever who, his labours past, grasps the prize – the Hesperian apples – already in his hand. A statuette in London[9] [250] which so shows him illustrates the grecizing current among Etruscan bronzes about the second quarter of the fourth century. The stance is not unlike that of the Mars from Todi [237], but less outré; the forms are sturdy and possess that material firmness which is often the *interpretatio etrusca* of a Greek Classical model. For a contrast one may turn to a statuette in Florence[10] [251] which portrays a young votary about to perform a libation. The offering gesture of the right hand, accompanied by the open palm of the left, is typical; so is the brief mantle slung across the hips and around the left arm (cf. pp. 295–6). Although no certain

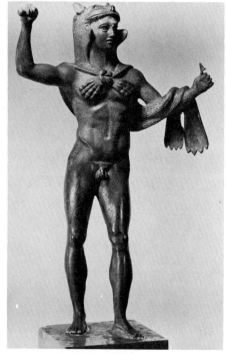

249. Statuette of Hercules, early fourth century. Bronze. *Paris, Bibliothèque Nationale*

indicia of data and origin are now obtainable, it seems in order on the visible evidence alone to place this statuette well into the second half of the century. The stance, this time with raised left heel, is eccentric to the point of mannerism. Yet the statuette as a whole achieves a pleasing air of litheness, even naturalness. It also teaches us the substance of the domestic theme on this level of style: to create not portraits but images sufficiently personal to answer the condition of

250. Statuette of Hercules,
second quarter of the fourth century. Bronze.
London, British Museum

251. Statuette of a votary, second half of the
fourth century. Bronze. *Florence, Museo Archeologico*

human diversity. This postulate affects alike the faces and the bodily details of the figurines so conceived. It explains their un-heroic simplicity, and it justifies their often improvised, and hence un-Classical, appearance.

252. Statuettes of 'haruspices',
fourth century or later. Bronze. *Rome, Villa Giulia*

The new rod-shaped, elongated statuettes differ sharply from those in either the hellenizing or the domestic manner, because of their rigid formality; though their realism of themes and costume moves them nearer to the domestic group [252, 253]. The sacrificer reappears as a haruspex, clad in a long robe and pointed hat, with a huge bulla hung from his neck [252]. Other similarly styled specimens represent young boys and women, some of whom may be deities.[11] Action, if any, is limited to sparse gestures of cult or devotion; only the hands move. That their formal abstraction was carried out methodically one cannot doubt. But the origin and meaning of the formal scheme which they all follow are quite uncertain. One is here dealing with a popular art of decidedly ritualistic character used, it seems, for ex votos in certain rural sanctuaries; finds are known from northern Etruria (Chiusi and Volterra) and Latium (Nemi).[12] Apparel and hair styles suggest an approximate chronology reaching from about the middle of the fourth into the second century. The formal model which guided these strange inventions, so clearly out of step with their times, seems to stem from much more remote strata of Italic art. It recalls the menhir form of stelae from northern Italy, or the Archaic *xoana* shaped as flat wooden boards (p. 179); some instances resemble herms, fantastically lengthened [253]. At any rate the statuettes of this group – the last abstract sculpture of antiquity – revived an Archaic image-form which was remembered only in isolated districts or sanctuaries. Possibly they replaced wooden ex votos of similar shape.[13] We understand them as testimonies of a rustic religious conservatism; their very primitivism hallowed them.

Terracotta

A series of half-life-size terracotta figures apparently dating from the middle decades of the fourth century comes from the Belvedere Temple at Orvieto, where they probably served as revetments to the columen and mutuli of its open pediment. Best preserved are two standing

253. Statuette of a goddess(?)
from the Sanctuary of Diana at Nemi,
second half of the fourth century. Bronze.
Paris, Louvre

figures, a youth and a bearded man, both projecting in high relief from upright slabs which were nailed to a wooden background, like the figures on the columen plaque from Pyrgi [163]. Both look intently to their left, presumably towards the centre of the gable. The impressive head of an older man turning to his right and stroking his beard probably belonged to the opposite half of the same gable. His gesture denotes surprise, wonder, or thought. All three are onlookers who react in various ways to some stirring event, once perhaps shown on the columen. We can only comment on the immediacy of their reactions; the cause of their amazement remains untold.[14]

IMPLEMENTS AND APPLIED SCULPTURE

Candelabra and Censers

By the close of the fifth century the private demand which had been a mainstay of Etruscan art all along was still on the rise, and continued so throughout the entire fourth century. Witness is the growing number and variety of ornate bronze utensils among our finds. The Classical type of candelabra and candlesticks on a high stem, often shaped as an attenuated Ionic column, persisted with few alterations through the Hellenistic into the Roman era.[15] Finials datable to the fourth century exist in quantity; statuettes serving as caryatids for the shafts of incense burners, which are rarer, may be added to the number of applied statuettes. The ease and spirit of invention which from the outset made this one of the most delectable classes of ancient small sculpture did not fail the new crop. Yet one notices amongst them an increase of workshop repetitions and near-replicas of identical inventions. The quality of the statuettes varies greatly; one misses a unified standard of workmanship and finish. Even among the less perfect or merely sketched ones proof of freshness and talent can often be found, though a few may strike us as dull or incompetent. At any rate enough handiwork went into the shaping of all, the mediocre examples not excluded, to escape the monotony of a mass-

fabricated product; we judge them as individuals, each by its own faults or merits.

Athletes, especially the long popular discus-throwers, yield a preferred subject matter; but one also encounters a prize-winning musician in this company of victors [254].[16] Several

groups represent a man struggling with a rearing horse: a modernized variant of one of the oldest Etruscan themes, the horse tamer (Chapter 2, p. 40; Chapter 7, p. 90). The struggler is either an armoured soldier or a youth whose mantle slides from his hip in the heat of action

254. Finial statuette of a citharist,
mid fourth century. Bronze.
Paris, Bibliothèque Nationale

255. Statuette group of youth and rearing horse,
late fourth century. Bronze.
Florence, Museo Archeologico

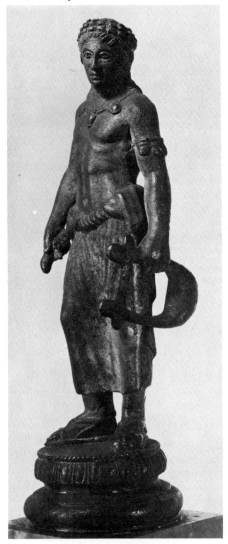

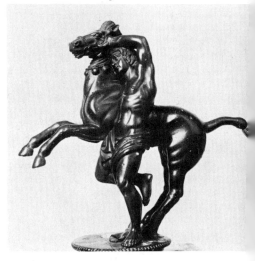

[255]. The second version seems an improvement on the first, dating from near the end of the century, to judge by the type of horse and the unconventional modelling.[17] Neither version is likely to represent myth. The noble art of horsemanship, rooted in ancestral tradition, probably provided the motivation and the subject; we set these statuettes down as an exercise of genre, not of history.

Love of genre, in a more bizarre vein, also produced a new type of incense burner which seems to have lasted throughout the century, into the Hellenistic period. Evidently these implements, all similarly constructed and decorated, replaced the Archaic and Early Classical types of censers. While the principal divisions of base, shaft, and cup remained, the new stands altered the shape of these elements, and often the meaning as well. All rest on a three-legged

256 *(below)*. Censer base (triskelion) from Vulci, last quarter of the fourth century. Bronze. *Vatican, Museo Gregoriano Etrusco*

257 *(right)*. Statuette of a discobolus on a censer base, mid fourth century. Bronze. *Rome, Villa Giulia*

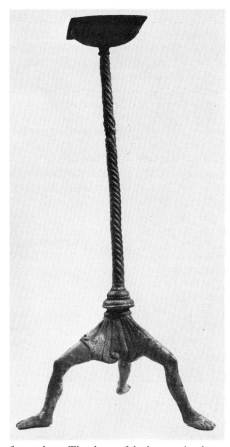

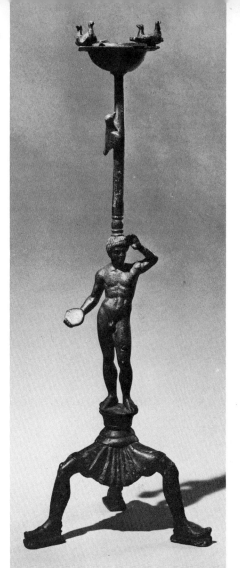

foot or base. The shape of the base varies, however, in several characteristic ways. Two variants especially seem to have set the standard. One consists of three human legs, bent at the knee, often issuing from a short garment which represents the lower hem of a tunic; frequently the feet are clad in soft shoes [256].[18] This surrealistic triskelion may contain a reminiscence of the jugglers on earlier censers (pp. 218 ff.). The other variant forms a tripod of lions' hind legs which emerge from the beaks of three griffins; the lions' paws rest on round mouldings, placed each on a flat, square base. From the centre of the tripod rises the shaft. Both variants were in use simultaneously, though the second seems to have outlasted the first. Both were probably products of Vulci.

Reminders of the past are also the human carriers which in some instances kept their places between the tripod base and the shaft, for instance the excellent statuette of illustration 257, which renders a discobolus about to start

his motion.[19] Carriers may be combined with either kind of base. In any event the shafts of the new censers are higher and more slender than were those of the older type. Often they are twisted, or wound with a spiral band like a may-pole. There is life around these poles. Small birds – perhaps doves – perch on top of the shallow bowl as if it were a water basin; a snake or a cat might climb the pole, to catch the birds;

or the cat chases a cock up the tree.[20] All in all one receives the impression of a light-hearted imagery, standardized though variable, which would logically seem more suited for the holders of a liquid than of coal fires.[21] Its variations, always entertaining, are often cursorily exe-cuted, but special and more carefully worked combinations are not lacking. One of the most surprising, which hails from Todi, rests on three winged caryatids supporting a wheel; on this uncertain platform stands a satyr bent over a basin on a high foot, who on his back balances the stem with the cup on top [258]. The familiar birds hover about the cup, and still another winged demon – a smaller sister of the caryatids – glides down, or perhaps up, the pole. I men-tion this censer expressly because of its Etrus-can cachet; no Greek tale we know explains its meaning.[22]

Bronze Handles

Early in the fourth century the Praenestine cistae came into existence, adding a new luxury item to the familiar household goods of Etruria. We lack the information to make out what special meaning these implements held for their former owners, except that they served them as toilet boxes in life and that most were found in graves, the last and most personal possession of a deceased woman.[23] The earliest exemplars were oval wooden containers within a bronze sheeting with geometric or floral ornament either hammered or executed as openwork, and mounted on four feet representing feline claws. Their lids were sometimes attached by hinges; commonly the handles were shaped as human figures bent backwards, lifting their bodies with hands and feet. The oval form soon gave way to a low cylinder on three feet, with small rings around the middle for chains or other means of suspension. At this stage engraved representa-tions appear on the lids. By mid-century a defi-nitive standard shape was established, consist-ing of a high cylinder on three feet with separate lid and statuette handle, and engraved decora-tion round the wall of the cylinder; it remained in demand to the end of the Hellenistic period

258. Satyr and winged caryatids on a censer from Todi, late fourth century(?). Bronze. *Rome, Villa Giulia*

in Italy, about 100 B.C.[24] The decoration of these cists must be discussed in three different parts, according to its diverse elements. The engraved friezes which constitute their chief attraction belong in the graphic arts (below, pp. 353 ff.). The small figural representations which often surmount the separately worked feet are cast reliefs. The handles – their third typical feature – are statuettes but form a class by themselves, marked off from others by their special function and typical motifs. Different from the engraved decoration, they must be described as a mostly provincial family of Etruscan small sculpture. The history of art would have little reason to tarry with them if it were not for the information they offer regarding the so-called retardation of style which is similarly known from other separate groups but often generalized too readily as a condition of Etruscan art as a whole.

After the gymnasts doing the 'bridge', in the second stage ensembles of two nudes either fighting or wrestling, or of two armed soldiers carrying a dead comrade, were added to the stock motifs of the cistae handles [259].[25] The last-named triads are especially interesting because they probably started from an epic narra-

tive: Death and Sleep costumed as winged knights remove the corpse of slain Memnon or Sarpedon. Greek black-figured vase paintings of about 500 were the likely models.[26] At what time this Archaic schema first reached Etruscan art is unknown. The Praenestine statuette handles incorporating it are for the most part non-mythical genre scenes. They can hardly antedate the second quarter of the fourth century, though some reflect prototypes of the mid fifth and, with them, the Archaic traits which these prototypes inherited from the preceding transitional period [259; cf. 219]. If, as seems likely, the workshops that furnished the handles used such early models, this practice explains sufficiently the anachronism – rather than retardation – of much of their work. It also explains the contrast to the engraved drawings which were made by different masters under different conditions and show no sign of a comparable retardataire tendency.

When at the third stage, about 350, the Praeneste cistae attained their definitive shape, the statuette motifs that had been used for the lids during the two initial stages were retained. They did undergo changes and variations, however, both formally and thematically. Thus the armed men who carry their slain companion became young soldiers or nude athletes,[27] as the relative frequency of nude figures increased generally after the middle of the century. With the groups of two, this change sometimes entails new mythical interpretations. The wrestlers stage the match between Peleus and Atalanta, or a satyr is paired with a nude maenad; at this time the Bacchic element advances noticeably in all Etruscan art.[28] But special and original creations remain the exception. The bulk of the material, from the late fourth century onwards, is mass-produced ware. It repeats and varies a limited and sometimes hackneyed repertoire to which, it seems, little was added after c. 300. Because of this longevity of the representational schemata and their cursory finish, the single handles are difficult to date. Their chronological order has yet to be established.

Thus it happens that some of the finest Praenestine statuettes come from objects outside the

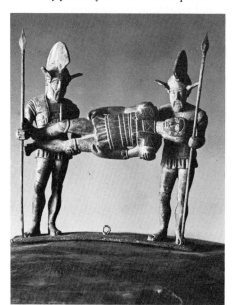

259. Two soldiers carrying a dead comrade. Cista handle from Palestrina, mid fourth century or later. Bronze. *Rome, Villa Giulia*

range of the cistae. Anthropomorphic handles, which till then were used sparsely in Etruria and for vessels only, became very much the vogue after the middle of the fourth century. One finds them attached to all sorts of utensils including metal pans, strigils, and many others. One example: the young man of illustration 260 perches on the edge of a charcoal shovel, at the point where the long, straight handle joins the scoop.[29] He wears boots and a traveller's hat; his mantle is spread across the ram's neck in which the pole terminates. Sheltering his eyes with his right hand he looks down into the deep, searchingly: he is Phrixus, looking for Helle who fell into the waters that bear her name. The handle has been turned into a mythological pantomime, ingeniously invented; it probably dates from the third quarter of the century.

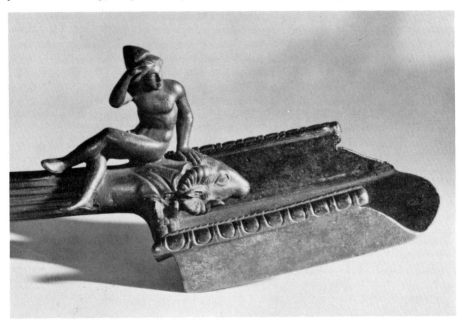

260. Statuette of Phrixus on a fire shovel
from Palestrina, third quarter of the fourth century.
Bronze. *London, British Museum*

CHAPTER 26

PAINTING

Wall Painting: Tarquinia and Orvieto

After a lapse of nearly a century during which the tomb paintings at Tarquinia offer little more than persevering routine (Chapter 22),[1] the decoration in the Tomb of Orcus first evinces a new spirit and sense of quality. The tomb has two originally separate chambers which are joined by a corridor, dug as an afterthought. The first chamber, through which the visitor enters today, was the oldest (Orcus I).

Just when and why the second tomb (now Orcus II) was connected with the first are moot questions. The enlargement seems in keeping with the consolidation of large patrician families, which created a need for extended burial places; the process continued far into the Hellenistic period. It is reasonable to regard the Tomb of Orcus as an early, comparatively modest, manifestation of this trend. All suggestions of a more precise chronology within these broad archaeological guide posts are tentative and must be based on observations of style. The urgent problem lies with the modes of transition from Etruscan Late Classical to Hellenistic painting, about which too little is known; in this matter the Greek example is of small help. Since, however, the paintings of Orcus I and II, in their diverse styles, display a remarkable coherence of sense and temper, it seems best to treat them together, despite the chronological gap of uncertain length which divided them.[2]

Only fragments of the murals around the first chamber are now visible. The one best preserved is the famous head of a woman with the family name, Velc[ha], inscribed before her [261]. Such legends, added for personal identification, are characteristic of the new tomb paintings. Yet the head is not a portrait. Only the accessories are shown realistically: wreath, bandanna, gold necklaces. The face was drawn as a motionless side view, its spacious form

filled with flat colours and firmly outlined details, without shading, though a slight turn is to be observed in the shoulders, indicating per-

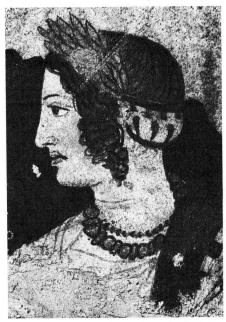

261. Tarquinia, Tomb of Orcus I, *c.* 350, 'Velcha'. Wall painting

spective. Whoever designed this head was trained in a Classical tradition of Greek late-fifth-century descent. The novelty of his work resides less in the drawing, which seems standard, than in the colours, for which Greek parallels are missing. Originally the lady was seen at a banquet, next to her husband, Arnth Velcha; both reclined on a common couch, in the ancient Etruscan fashion. Near by stands a pale, greenish-blue Charun.[3] Time has obliterated much of the other paintings, which repeated the customary Tarquinian banquet schema, with small trees separating the couches.

In accord with a long noticeable tendency to de-emphasize the architectonic character of the decorative elements (cf. p. 263), the frieze of figures occupied the main zone between a wave pattern below and a vine of heart-shaped leaves above. We are thus faced with an essentially conservative decoration which included interspersions of a new mythology and was carried out in a decidedly Classical taste. The date which at present seems most widely accepted for Orcus I, around 350, is probably not far off the mark.

The presence of the demon (Charun) requires a comment: it is the first time that we meet this infernal phantom, whose gruesome image was soon to become a frequent addition to the Etruscan demonology of death. As in medieval Christian art the devil split into a host of devils, so in the Etruscan monuments of the fourth century a multitude of Charuns begin to busy themselves with the job of the Greek Charon, their original parent, to whisk the dead away. They and their spectral relations, the Vanths, Lasas, and their ilk, have caused much modern speculation about an alleged change of mind and mood in the Etruscan community.[4] The facts point to a less sweeping explanation. The

banquet of the blessed still remained the popular metaphor of death in Etruscan art; in this respect not much was changed. But the locale of the banquet which the older monuments represented with gentle vagueness (p. 269) has now been made explicit by the attendant demon: it is a nether world, abode of shades. In this point a change has indeed occurred, but it marks hardly more than the inroad of a Greek concept into an already existing Etruscan iconography.[5] The banquet goes on as before, but the gay dancers have left; there was no room for them in this hellenized subterranean world. The thought of it commanded darkness; and this even the painter had to contemplate. Thus he chose a subdued palette, and showed blackish clouds creeping up behind guests and ghosts. One such cloud provides the dark foil from which, by contrast, the profile of the young woman [261] derives its unworldly luminescence. This handling of the chiaroscuro, unwonted in ancient art, is remarkable because it reverses the customary relation between light ground and solid objects. It thereby anticipates in principle the kindred demonstrations of modern painting, for example Leonardo's 'Ginevra de' Benci'.

262. Tarquinia, Tomb of Orcus II, early third century, Hades and Persephone. Wall painting

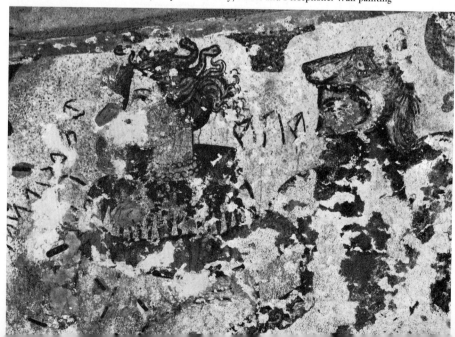

The decoration of the adjoining chamber (Orcus II) enlarges and elaborates the stage set by the first: the realm of the dead. A table with luxurious vessels, and a serving page standing by, connect the themes chosen for the annex with the banquet which prevailed in the older tomb. In the new murals Hades with wolf-cap and his queen Persipnei, her flaming hair intertwined with snakes, preside [262]. Before them stands the giant, Geryones, in Etruscan armour. Here are three characters of Greek myth transposed into the vernacular. The group is silhou-

busy around heated ovens; and kitchen boys at their jobs [263]. One of them bends over a large bowl, working with two pestles [264] like the satyr beneath the censer [258]; in the painting the forward bend becomes a neatly designed perspective. Both in concept and detail these decorations seem a show of provincial realism

263 and 264. Kitchen scene from Golini Tomb I, Orvieto, last quarter of the fourth century. Wall painting, with drawing. *Florence, Museo Archeologico*

etted in cool, muted tones against the surrounding light-grey haze, more in the manner of an illuminated drawing than a painterly work; it is of notable elegance. A drawn model may indeed have been used; but the style is not Classical Greek and a connection with the Polygnotan 'Nekyia' unlikely. The list of the persons who inhabit this mythical inferno was common property of the heroic tradition. Their portrayals are not equals stylistically, however. Theseus, held on his rocky seat by the spell of a demon inscribed 'Tuchulcha', probably represents the most advanced, if not the finest, level of style in this unusual decoration: Hellenistic, early third century.[6]

From not much later than the paintings in Orcus I date the murals of the so-called Golini Tomb I, near Orvieto. Again the subject is the Avernian banquet; Hades (Aita) and Persephone (Persipnei) join the diners in the right rear chamber.[7] But the interpretation of the banquet is unique. Before the traditional guests on couches unfold the preparations for the promised meal. These include the store room with slaughtered animals, game, and fowl; cooks

265. Tarquinia, Tomb of the Shields, c. 280, Banquet of Larth Velcha. Wall painting

pitted, as it were, against the urbane literacy of the school of Tarquinia: a praise of the good life on the plantation. As the self-expression of an opulent agricultural society they resemble the similar topics in the tombs of ancient Egypt. But in every way the nearest parallels were the themes of the nearly contemporary Greek realists, painters like Pauson or Antiphilos.[8] The date of the Golini Tomb is probably closer to the latter: last quarter of the fourth century.

The Tomb of the Shields in Tarquinia inserts itself here, despite many disparities, for the following reasons. Like the Tomb of Orcus it belonged to the Velcha clan, and its major theme was the banquet in the presence of the nether deities. On either count it represents the last stage known to us of the ancient Tarquinian tradition which its decoration follows in arrangement and spirit, though not without significant alterations.[9] In the anteroom, on the way to the inner chambers, one passes two paintings of dining couples in a broad, almost showy manner. The familiar wave pattern rises from the dado. Two lengthy inscriptions specify the situation. One cites the *cursus honorum* of Larth Velcha, who commissioned the tomb [265]. The other names his parents; the father was Velthur Velcha. The metaphorical interpretation of the tomb shows a new facet: the grave, though an Acherontic place, is also the house where the departed members of the clan arrive and assemble. The shields in the rear chamber from which this tomb took its name belong neither to the blessed meadows nor to the Stygian realm; they are the decoration of a patrician home.

In both dining groups the women sit at the foot ends of the couches, as they did on the Chiusine urns (p. 321); the new mode was accepted at Tarquinia. At the same time the couples exchange the traditional symbolic gestures; one spouse places a hand on the other's shoulder, or an egg is given and received.[10] Servants and musicians attend, and the tables are laden with food. The painting style, too, is peculiar. Details differ in manner and quality; one recognizes different hands. But the overall effect is one of sturdy firmness, down to the

gaily coloured ornament of the wooden furniture, the bed covers and pillows, the things to eat or the ladies' boots. This style derives its strength from a simple, rectangular geometry – each dining pair can be inscribed into a square – and a liking for large, strongly outlined, flattened forms. At first sight it may give the impression of a folk art, but soon one notices its finer points: faces in half-profile, shoulders drawn obliquely, the plane, almost Byzantine, perspective of two feet on a footstool [265]. Rather, in surveying the particulars, one discovers a deliberate emphasis on regional characteristics which has much in common with the bronze statuettes in a domestic vein listed above (pp. 295 ff.). The attitude, rare in painting, seems a calculated contrast to either the Classical Grecism of the murals in the Tomb of Orcus, or the hellenizing realism of the Golini Tomb. The striated hair and stubbly beards of the men are in keeping with this analysis. Yet the artists who tried these new ways were probably of the local school. The flat ornamental elegance of folds, as in a Japanese woodcut, had long been a hallmark of the Tarquinian tradition (p. 270). Only the often noticed pseudo-impressionistic manner in which the face of the mother was painted introduces a foreign note. Although it clearly differs from the prevailing drawing style, this detail must not be regarded as a chronological symptom.[11] The rivalry between linear and illusionistic representation was endemic to Classical painting, from the days of Parrhasios and Zeuxis; the coloristic method was no novelty when the Tomb of the Shields was painted. I think it probable that the latter decoration was about contemporary with that of Orcus II, to which it opposes its own domesticity of style: not later than *c.* 280.[12]

Amazonomachia

Apart from the few murals of Classical style in Etruscan tombs, the only Classical painting to have survived is a battle of Greeks and Amazons round a sarcophagus of Greek island marble found at Tarquinia.[13] The sarcophagus, with gabled lid, was certainly imported. The paint-

ings were probably executed in Etruria. The Amazons wear the soft, laced shoes of Etruscan women; some sport rather capricious long chitons [266]. Excepting such irregularities of detail, the battling groups look predominantly Greek. One asks whether they rendered a specific and unified Greek composition. Copies of famous paintings apparently circulated in

266. Amazon sarcophagus from Tarquinia, *c.* 350. Painted Greek island marble. *Florence, Museo Archeologico*

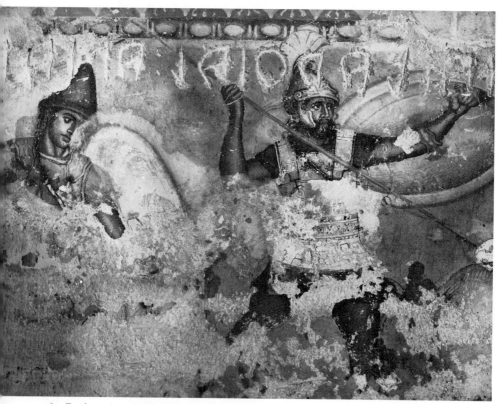

267. Greek warriors, detail of Amazon sarcophagus

Italian workshops long before the commercial copying of Greek statuary began, and may be expected at any time after the middle of the fourth century (p. 355). But the Tarquinia sarcophagus gives a more divided impression. For instance, while the wide angular boxes of the two chariots which race into the battle, each with four white horses, were not of Greek design, the passengers, Amazons in either case, and the animals might have derived from Greek art. Similarly most other groupings, however lively, were staple motifs of heroic action in Greek art of the advanced fourth century. This also argues against an undivided model. More likely we have to deal with an anthology of choice episodes, culled from various prototypes.

The artists who painted these episodes around 350 were performers, not inventors. Their first concern was professional virtuosity: a skill in shaping the likeness of anything – a shield, an arm, a tanned and bearded face – from shades of colour. In this ambition the best among them succeeded supremely [267], in spite of the fact that they may have followed a script. But it is difficult to see how, in this manner, they could have copied a large object, such as a mural, directly. Their copying methods would be more easily understood if the immediate models had been small paintings, perhaps on wood, that were kept in the workshop. This assumption also accounts for the miniature character of their work – its illustrative character, its accuracy of detail and colour, all on a relatively small scale. About the ultimate source of these prototypes one can only speculate. Not all of them need have come from Amazon battles. Thus a triple group from one end of the chest well nigh repeats the composition of the Death of Pentheus from the House of the Vettii, in Roman Pompeii; if it were an adaptation of the same original from which the Roman painting also descended, this connection would explain the long garments of the two Amazons.[14]

Vase Painting

The Etruscan line of authentic – not simulated (cf. p. 195) – red-figured vase painting probably began in Vulcian workshops, about the middle of the fifth century. The new manufactories may have been started by immigrant potters, though the painters appear to have been trained locally, as their designs and thematic propensities often demonstrate. Greek models were available, and copied. This we know from a kylix in the Musée Rodin in Paris: its outside duplicates parts of the outer frieze of an Attic cup which is still extant.[15] The Rodin kylix can hardly be dated much later than its Attic prototype: about 450. It is one of the earliest Etruscan vases to show full mastery of the red-figure technique.

Subsequently the taste for home-made painted vases in the new manner spread fast across the country. Nothing illustrates as keenly the decentralization and the ensuing leapfrog pattern of progress in the arts of Etruria as does the history of her indigenous vase painting in the fourth century. While the initial workshops at Vulci and perhaps other places in the southwest continued, new studios opened in the early fourth century at Falerii and soon afterwards at Chiusi. During the last third of the century local potteries started at Volterra. Finally, near the year 300, sundry classes of late red-figure ceramics of a popular type began to circulate, chiefly in the north-east; some may have been manufactured there, for example at Ferrara (Spina). One generation later all these industries were withering; none, it seems, long survived the mid third century. The time was past when ceramics were valued carriers of painting.

Historically and topographically this expansion of one single branch of Etruscan art opens interesting prospects. Its route suggests a trend away from the ancient Tyrrhenian centres in the south: it moves from Vulci inland towards the east, then northward along the spine of central Etruria to Chiusi and Volterra, and eventually to the north-eastern fringe territories. Thus the path of the migration confirms the growing commercial strength of the inland towns; it must not be taken to mean a commensurate weakening of the old cultural centres in the south-west, however, for which there is no archaeological evidence. Rather it indicates a

change of direction within the industries which, groping for different ways of ceramic decoration, founded new shops to meet the demands of new markets. A brief review of their products shows the gist of these changes.

The leading Vulci group strictly follows the Attic rule of red figures reserved from the black varnish. Its drawings are generally done in relief lines, not lines of flat colour, approximating the Greek model; and it relishes a repertoire of Greek stories. Some of the finest works in this vein are due to artists of the early fourth century, the 'Settecamini Painter' and others near him. Yet their pictures often surprise us. On a cup in the Vatican, who is winged 'Zetus', carrying away a listless 'Phuipa' (Phoebe)?[16] Lovers exchange glances also in Greek art; but in what Greek work has one seen two eyes so wildly

268. Settecamini Painter:
Pasiphae and the Infant Minotaur
on a red-figured cup, early fourth century.
Paris, Bibliothèque Nationale, Cabinet des Médailles

rolling, and answered by a face so frozen? We are treated to a new variation on the age-old theme, abduction by the avid wind: a ballad of love and death. The medium and the shape of the cup are Greek; the characters are Greek in name only; and the action, probably, was not a Greek myth at all. In the roundel of another cup in Paris[17] which belongs to the same class Pasiphae holds in her lap the infant Minotaur [268]. The absurdity of the maternal idyll serves as a reminder: even the monster was once a dear child. Such readiness to dwell on the less obvious side of a familiar tale – a special sense of the ferocious or the comic – easily comes to the fore when Etruscan art deals with Greek mythology. We found it in the Pontic vases and the Caeretan hydriae (pp. 153–4, 171 ff.); here we find it on the Classical level. Apparently this mood of detached scrutiny was an answer to the imported myths by a society of outsiders. That the inventors and buyers of these mythical fantasias and asides were people of literate tastes may be safely assumed, not only because they benefited from inscribed legends: they must have known their Greek stories well, to perceive so astutely the veiled address to the ever-present in the fabled happenings. This critical ability is itself an indicator of an Etruscan literary culture, then concentrated in the cities of the south (below, p. 408).

About the same time, around 400, the Faliscan red-figure vases made their entry into Etruscan art, though their most important contribution came somewhat later, in the second quarter of the century, with the work of at least two Greek-trained, ambitious artists dubbed, respectively, the 'Aurora' and the 'Nazzano' Painter.[18] The *chef-d'œuvre* of the former is a large volute-krater in the Villa Giulia[19] which on its front features Aurora united with a young lover – presumably Kephalos [269]. The picture unrolls in a grand sweep, from right to left. The goddess of dawn has risen from the sea, holding the reins of her Greek four-in-hand, which is led by the wide-winged morning star. We see the bottom of the chariot from below: the course is skyward. Aurora is an apparition of light, haloed, her body half revealed by a flutter-

ing mantle; the boy leans against her, looking up, and their glances meet. Two birds chasing each other in flight are the only hint at pursuit and seizure. Concepts and composition are clearly Greek, ultimately Attic, though probably transmitted through Apulian intermediaries. The drawing achieves superb passages in the perspective of the chariot or the turning form of the boy. It all seems a far cry from the Vatican mirror [203] which illustrated the same story about a century earlier. The native traits of the Aurora krater point to the future, not the past. The tendency to crowd the pictures and the corresponding density of the ornament are

269. Aurora Painter: Aurora and Kephalos on a Faliscan red-figure volute-krater, c. 375–350. *Rome, Villa Giulia*

Etruscan symptoms. Moreover, large portions of the figures and decoration were painted white. Not much is left of the red ground; gradually the red-figure rule gives way to a more pictorial and colourful manner of vase painting.

The Nazzano Painter likewise seems to have had contact with Apulian ateliers and access to Greek exemplars. His extant masterpiece is a kalyx-krater in the Villa Giulia[20] with a remarkable 'Iliupersis' [270]. The fall of Troy is shown by a variety of episodes, arranged on two superimposed levels. The order is interrupted, however, by the giant figure of Neoptolemos about to smash the child Astyanax. This gruesome image, of Classical origin, thereby becomes the compositional centre in a dual sense: it occupies a middle ground between the upper and lower rows, and at the same time a central place along the vertical axis of the picture. In principle this arrangement was Greek, perhaps

270. Nazzano Painter:
Iliupersis on a Faliscan
red-figure kalyx-krater,
c. 375–350.
Rome, Villa Giulia

Polygnotan. Only the straight base line below the archer in the upper left seems a novelty; it transforms the otherwise loosely aligned rows of persons, imagined as co-existent in an irregular terrain, into two separate registers. To represent narratives in stacked zones was not a Classical device, but instances occur in Etruscan wall painting (see Chapter 14, Note 18); on the Nazzano krater the straight line isolates the bowman above from the Helen episode below. It ends before Neoptolemos because in this place another, more Classical, compositional idea prevailed; with the result that old Priam, king of Troy, is attacked by a fellow Trojan rather than by Neoptolemos, who ought to be his murderer according to tradition. The prosopographical confusion suggests firstly that the painter worked from drawn models; secondly that these models were lined up horizontally, as in a scroll. It is not clear whether he always understood the episodes which in his model probably comprised three persons each. He certainly did understand the encounter of the irrepressible Helen and her vengeful husband, Menelaos, disarmed by a rather matronly Aphrodite. This story he retold with gusto and a personal flair; though fair Helen should not trip into Priam, as here she does. White is used, if more sparingly than in the vases of the Aurora Painter. The Nazzano Painter evidently was the more conservative of the two, nearer to Classical tenets, whence came his strength and his troubles.

Thus far we have only been dealing with one, rather elevated, stratum of Etruscan red-figure vase painting, which conspicuously announced the Etruscan bid to partake in the international standards set by the Greek ceramists. One must not, however, overlook the varied lot of the more homely vases which trailed this new Etruscan enterprise from the start, content with a simpler level of skill and a lesser sense of competition with the Greek. It is difficult to assess their contribution to the store of art at large. We recognize them by symptoms which range from carelessness or provincialism to the hastiness of mass-produced, popular wares. A loss of technical quality may, but need not, accompany

these characteristics. Perhaps the foremost importance of this popular art lies in the fact that it existed at all in such variety. One may ask what caused the inequality of artistic standards which in Etruria seems constitutional; and why corresponding divisions are all but absent from Greek art before the Hellenistic period. In Etruria, where the impetus of change came more often than not from abroad, diverse factors, especially of communication, certainly contributed to this condition. But I think that the primary cause lay in the predominantly private status of Etruscan art. The diversity of its aesthetic levels reflects the social diversity of the persons who took an active share in it, either as craftsmen or buyers. The even broader range of variability in Roman art, which grew from a related social order, was an Etruscan heritage.

The variety of artistic idioms in Etruscan red-figure vase painting cannot be fully illustrated here, for lack of space.[21] A few general observations must suffice. From the latter part of the fifth century onward, painted wares of a more or less parochial, rustic character continually parallel and emulate those of the leading levels. As a rule they seem linked to the same centres, sometimes even the same workshops, which also produced the vases approximating to the contemporary Greek more closely. Apulian and Campanian connections are noticeable on either level.[22] Among the earlier materials, before the middle of the fourth century, the symptoms separating the popular from the more finished products are mostly differences of degree or detail, rarely of principle; there are few fixed criteria on which to ground distinctions of kind, or to judge quality. One such criterion – design by relief lines (above, p. 344) – enabled J. D. Beazley to divide Etruscan red-figure techniques into three successive periods. In the first stage one finds mixed technical habits: some painters use relief lines, others flat lines (period I). During the following period, starting shortly before the turn from the fifth to the fourth century, drawing by relief lines prevails (period II). In the last period, from the third quarter of the fourth century onward, the relief-line technique is abandoned, and design

is carried on in flat colour (period III).[23] This criterion pertains to vases of all kinds, on every level of quality. In many respects the second period seems the happiest. It includes the mythical intermezzi of the Settecamini Painter and his circle, and the large Faliscan vases. This is also the time when a knowledge of Greek paintings other than vases reached Etruria, by copies either drawn or coloured, but at any rate portable (this chapter, pp. 341 ff.). Reflections of such models in Etruscan vase painting begin early in the fourth century and continue throughout the middle period. We find them on vases painted in local, experimental techniques, such as the famous 'Argonaut' krater in Florence,[24] and in the work of declared hellenists like the Settecamini Painter[25] or, later, the Faliscan Nazzano Painter (p. 346). The presumptive Greek prototypes were probably about contemporary, or not much older. The selection used by the south-western and Latin Etruscan workshops (Tarquinia, Vulci, Praeneste) seems to differ from the Faliscan, however; we shall touch this problem once more, in connection with the Ficoroni cista.

In the final stage, from c. 330 onwards, the Greek Classical element recedes. Even with those potteries which continued a traditionally hellenizing bent, shape and decoration often assume a homely Etruscan look. The Greek connections have not broken but their origin becomes ever more remote, vanishing in an evolution totally alien to their start. This is true generally; the modes of change and their results may be found varying in the different schools and geographic regions. Thus the late Vulcian vases retain their inherited interest in Greek narratives and a flair for the monumental and tragic. They also display a preoccupation with the infernal demons whose unlovely likenesses we know from the Tomb of Orcus (this chapter, p. 338) at Tarquinia. Here, as there, these phantoms function as the messengers of death and the custodians of shades. They wait for Admetos taking leave of Alkestis, or the prisoner slain by a bearded Achilles.[26] The themes are Greek, Etruscanized; the manner of their assimilation, however clearly and forcefully the story may be told, leaves the impression of a provincial and insular art. The upper level of quality which the same shops once fostered is missing.

In the Faliscan group, which reached its acme about a generation after the Vulcian, the eventual qualitative regression took a different turn. It was accompanied, perhaps motivated, by changes of subject matter. From the early fourth century, when the fine atticizing cups of the 'foied' Painter repeated three times the same representation of a girlish Ariadne, leaning back in the arms of tall Dionysos,[27] Bacchic themes were favourites at Falerii. During the last quarter of the century a new Bacchic imagery of more popular character began to adorn the Faliscan pots, probably in response to the new Bacchic cults and rites which then moved north from Campania. For the most part this was a generic iconography, dealing with the typical plays of maenads and satyrs: the Bacchic dreamland. Only rarely does a picture hint at more specific meanings, for example when Hermes defends a maenad from a death-dealing Etruscan Vanth.[28] The Faliscan vases of the preceding stage, about the middle of the century, bespoke a different temper. Their themes were myths of persons re-enacted: poetic narration and allegory, even contemporary battle with the Celts interpreted as heroic action.[29] In retrospect this interval, which produced the most classical native vase painting, appears as a lone episode between two periods of rather static imageries; the first refined to the point of mannerism, the second homespun, downright, and terminal. If the Boston skyphos[30] [271] is indeed Faliscan, it must be considered a solitary latecomer, telling its tale in an unfamiliar manner of drawing. On the obverse is a group of three: Admetos delivers his farewell speech, Alkestis listens, a death-demon hovers over both. The monuments on either side I take to be markers of tombs. The scene is Euripidean but staged in the native milieu, whence come the demon, Admetos' patrician shoes, and Alkestis' fineries. It misses the pitch of tragedy; the painter, perhaps not without a trace of mockery, insisted on a paraphrase in the vernacular, as if he were illustrating an imaginary 'Euripides Tuscus'.

271. Admetos and Alkestis on a red-figure skyphos, late fourth century. *Boston Museum of Fine Arts*

The red-figured vases of Chiusi came forward at a relatively late date, not long before the middle of the century. The first examples so far recognized are a series of finely wrought cups in the Attic tradition.[31] Bacchic themes and women laving or dressing are their common topics. The Acherontic spooks are absent; evidently they did not fascinate all parts of Etruria alike, or else had not yet reached the Etruscan north. The best pictures are found in the roundels of the cups, which are drawn in relief lines; within the limited scope of their themes they communicate a refreshing spirit, variety, and invention. This contrasts with the outside decoration, which appears to have been treated as secondary, and was drawn in flat colour; ornament and human representations both indicate a loss of meaning and incline towards over-stylization and stereo-

types. Yet, the differences of quality notwithstanding, the roundels share with the outer friezes the Etruscan look, and a preference for poses which by then had become the properties of Etruscan art: dancing gaits and fluttering hands, crosswise steps and eccentric stances.[32]

That nevertheless the atelier of the Clusium cups had room for a purer hellenist we know from one surviving fragment in Florence[33] which I here reproduce: a relic of art of rare value [272]. The roundel tells a story: Hermes delivers to Leda and Tyndareos, as foster parents, the egg from which Helen shall be born. The drawing is not faultless; it is important because it shows the garments and ground fully shaded in a delicate pictorial manner. The cup cannot be dated far from the mid fourth century. This is the earliest authentic example pre-

272. Fragmentary red-figure cup of the Clusium group, mid fourth century. *Florence, Museo Archeologico*

served of a new manner of drawing, perhaps related to the efforts of Parrhasios and his followers, painters who at just that time undertook to include with a plane design a semblance of corporeal reality, modified by light and dark.

Among the late Clusium wares the duck askoi deserve attention [273] because they introduce a new, highly standardized class of Etruscan ceramics. Iterative practices had been on the increase for some time, especially in the early Faliscan and Clusine workshops; but to base a whole ceramic series on a single model seems another matter. Serial production means iteration on principle, not only on occasion. It presupposes a different attitude towards the objects

so produced, the crafts that produced them, and the market for which they were produced. The changes of outlook and commercial organization which this method implies characterize the last phase of ancient vase painting in Etruria. Repetition, or variation within a narrow range, of a standard shape combined with a standard decoration became the working rule and concurrently the trademark of specific ceramic factories, much as the same rules determine the types of most modern table ware. The Clusine askoi in the shape of a duck constitute such a class. They vary in quality, but on the whole one would describe them as very pleasing objects. The painted plumage covers the bird with a

patterned ornamental net, from which only neck and head are exempt. On either side vertically extended figures, usually winged, interrupt the stylized wings and feathers. Most represent naked Lasas – dainty and impersonal spirits, attendants of Turan, who from the mid fourth century onwards populate the Etruscan fantasies of the divine paradise. They hardly serve a single determinable function. Their business is to delight; thus in many respects

Potteries from Chiusi which emitted branches to Volterra about the last quarter of the century probably laid the ground for the local ceramic industry of that town. The red-figure ware of ancient Volaterrae, like the late Clusine, has a strong regional flavour, in the character of a popular art. Its leading forms are kraters with column handles and high necks covered with ornament either abstract-geometric or, if floral, similar to the Clusine palmettes. The repre-

273. Red-figure duck askos from Chiusi, late fourth century. *Paris, Louvre*

they resemble the heavenly damsels of Hindu mythology, the equally ubiquitous apsarases. On the askos in Paris[34] [273] the Lasas fly with wings spread, at the same time beating the air with their feet, as swimmers do. They hold long sashes; one grasps a perfume flask with a firm hand. How much meaning one ought to expect from these ostensibly decorative images it is difficult to say. As a class the Clusium duck askoi seem a popular product, not without a certain ornate elegance, but in the manner of folk art, with a taste for strongly designed and gaily crowded decoration. The folklore, if any, of their image associations has not yet been investigated.[35]

sentational subjects are contained by these ornaments in near-square, metope-like fields. Mythical narratives occur, but are rare; the funeral demonry was passed by, as in Chiusi. Preferred themes are Bacchic scenes, isolated mythical creatures such as a Lasa or a centaur, and conversation groups without much specific meaning. Pigmies in sundry situations – fighting a crane, miming a mythical character, or battling with a Gallic enemy – seem another and novel favourite choice; so were horses' heads.[36] The isolated, portraitlike human profiles which became a trademark of the latest Volterra workshops in the first quarter of the third century must be discussed later (pp. 393 ff.).

352

274. Chrysippos cista from Palestrina, *c.* 350. Bronze. *Rome, Villa Giulia*

METAL ENGRAVING AND CARVED RELIEFS

CISTAE AND MIRRORS

Praenestine Cistae

Etruscan metal engraving reached its height during the fourth century, as an appendage to two classes of useful objects: the bronze mirrors habitually so decorated, and the incised decoration of the bronze cistae. By that time it had become a very demanding art which vied with painting and painted vases in complex, multi-figure compositions, although its medium allowed drawing by line only. The engravers could not avail themselves of a contrast of colour between ground and images, as the vase painters were able to do (p. 346), but they could whiten the grooves cut into the metal, to make the lines stand out more clearly, and generally did so. To this severe discipline are owed some of the finest examples of pure drawing in the Classical style.

About the middle of the century the high bronze cylinders of the Praeneste cistae (pp. 334 ff.) opened up new opportunities for engraved design.[1] They provided space for large figurative friezes, framed by smaller bands of abstract or plant ornament; contrary to the rule of the vase painters, the designers of the cistae usually omitted the dividing lines between figures and ornamental zones. Engravings round the lids, mostly of ornament, occur frequently. The decoration round the cylinders appears to have been incised on the straight metal sheets, before bending. Separately worked attachments – feet and chains – were added later and often disrupt the engraved designs: the craftsmen who put the parts together were thinking of the implement which they were to complete, and treated the engraved adornments as dispensable frills.

Nevertheless, for their contribution to the whole of art the large figurative friezes first claim our attention. Their primary themes were Greek myths. Italic elements mingle with the Greek-inspired representations; inscribed legends in Latin are no rarity, Praeneste being a town of Latin speech and lingering Etruscan traditions. Non-mythical subjects are scarce; the few extant examples date among the latest products of the local bronze industries, probably not long before the siege of Praeneste by Sulla early in the first century B.C. It was common practice to render two or more mythical episodes in a single frieze. One example is the large cista of illustration 274, now in the Villa Giulia,[2] which presents the following sequence. First, abduction of a boy by a luxuriously dressed young man who drives a four-horse span: Chrysippos carried off by Laios, future king of Thebes. Next, the familiar Judgement of Paris, and a not so easily named bearded hero in armour before Apollo – possibly Laios again, receiving the oracle which predicts his death by the hand of his son, Oedipus. This assemblage of topics may be thought odd, but it is not necessarily meaningless. The verdict which Paris rendered on Mount Ida was the prologue to the abduction of Helen, a crime which in execution and impact equalled the rape of Chrysippos. It set the series of calamities in motion which ended with the destruction of Troy: 'saeva facta, tristia dicta'. This causation – abduction and rape – the otherwise different histories of Paris and Laios had in common, and the artist could have remembered the coincidence. Similar matchings of myths by formal analogies that one might deem superficial until one perceives their human moment can be found in other Etruscan monuments after the mid fourth century. In these instances the myth has ceased to be a self-contained narrative; it points to a moral which transcends the contents of a single story. Thus paired for comparison and interpreted as meaningful counterparts, the mythical images assume an allegorical function; like poetic allusions,

they can be grouped at will. The device is essentially literary. One recalls the indicative uses of myth in Latin poetry from Propertius to Ovid; the latter's *Metamorphoses* provide the most explicit example. In visual art implied meaning cannot always be made so clear. If we fail to find it, the fault does not necessarily lie with the Etruscan artist, who may have followed a consistent thought, however unwonted his reasoning or imagery appear to us now.

The Chrysippos cista probably belongs near the beginning of this series of cistae, close to 350. Like the Aurora Painter who was his contemporary, its designer emulated Apulian vases (above, p. 345). He did so most successfully in the abduction scene and the adjoining judgement of Paris; both resemble vase paintings in the manner of the so-called Darius Painter. Actual vases, or more likely preparatory workshop drawings brought from Apulia, where perhaps he was apprenticed, may have been his models. The Laios episodes – if the visit at Delphi indeed represents Laios – might have been lifted from a scroll illustrating the story of Oedipus; but the ravishment of Chrysippos looks more like a separate picture, as if a vase painting had been rendered in line drawing. The next alternative, that the Laios scenes copied a mural, I consider the least probable. Reflections of Greek, south Italian vase paintings appear properly characteristic of the cistae from the third quarter of the century. This observation leaves the question open: by what means and in what medium did such prototypes reach the executing artist? It seems reasonable to assume that the engravers worked from a predesigned copy, though we may wonder why in their friezes demonstrable iterations are so rare, in contrast to the cast attachments which repeat each other often. At any rate we must insist that the presumptive models were of manageable size. The latter argument all but excludes large wall paintings. The one notable exception to this rule, and at the same time the biggest and most accomplished cista preserved, seems to be the so-called Ficoroni cista [275-7] in the Villa Giulia.[3]

275. Drawing of the Ficoroni cista from Palestrina, signed by Novios Plautios, later fourth century

We by-pass the details of this uncommonly rich monument in order to comment briefly on its pride, the large frieze. A single myth is represented. The Argonauts in the search for fresh water have come upon a spring in the territory of the savage king Amykos. The king denies the use of this water to any stranger who cannot beat him in a boxing match. Pollux (Polydeukes) accepts the challenge and wins. Amykos is bound to a tree and left to his fate; the Argonauts depart. The frieze, a continuous band, unrolls from right to left. First we see the spring with a lion as fountain-head, in a rocky and wooded terrain. A man drinks from a cup; another (Polydeukes?) practises boxing. The aft of the ship Argo appears behind rocks, with men lounging. A ship's boy descends on a ladder; he carries a small barrel and – rather surprisingly – a round basket much like a Praeneste cista. Then the principal group: Amykos being bound to the tree. Onlookers, amongst them Athena; further left a mysterious demonic being, winged and bearded, visibly thoughtful. A group follows of two men conversing; a young man rests in the hills, farther back. Empty amphoras wait to be filled; and a youth who lifts an amphora concludes the action, thus restoring the connection with its first cause, the fountain.

I think it likely that this pictorial sequence implies a progress of time, in the sense of 'continuous narration'. Polydeukes is shown thrice: training on the punch-bag, punishing Amykos, standing quietly with his twin brother. In the last group he holds a victor's fillet in his hand, and the hat on his head tells us that the Greeks are making ready to leave. The tripartite division which allows so much room for by-play on either side of the dramatic centre follows a Greek, ultimately Polygnotan, precept; certainly in this instance the model before the engraver was a painting in the heroic key. It may have been the 'Argonauts' by Kydias; that is to say, a work by an artist of the mid fourth century.[4] The cista probably dates nearer the end of the century. It has been shown that scattered references to the same work occur on both mirrors and Italiote vases; the original must have been accessible in Italy, and equally popular among the ceramic and graphic workshops of Etruria and Latium.[5] Evidently the suffering, forward-leaning form of Amykos was its most admired detail; rightly so, we may add, as witnessed by Renaissance painters such as Sebastiano del Piombo who used the almost identical motif to represent Christ bound to the column.

The Ficoroni frieze contains Greek, south Italian particulars: a flying victory, almost unclothed; a 'Papposilenus', guardian of the spring; the barrel carried by the ship's boy.[6] But on the whole its original seems to have been a Classical monument in the Attic tradition. The history of Kydias' painting cannot be traced so far back. We first hear of it when Hortensius, the Roman orator, bought it for a fabulous price and installed it in a building constructed for this purpose, in the grounds of his villa at Tusculum. This happened early in the first century B.C.; perhaps the same painting was later exhibited in the Porticus Argonautorum in Rome.[7] It is not known where and for what destination Kydias' work was commissioned originally; it could have preceded Hortensius in Rome. As regards the Ficoroni cista, one can only say that a famous painting answering the description of 'Argonauts' was reproduced in its large frieze, and that about the turn from the fourth to the third century details of the same painting were circulating in the studios of south Etruscan artists. It is likely that this work was then indeed in Rome; hence the unusual signature on the cista. The engraver, Novios Plautios, made his drawing within sight of the original: 'in Rome'.[8] His work relates to the original as the engraving in Inghirami's book relates to Leonardo's *Battle of Anghiari* cartoon, now likewise destroyed. Whether Kydias or another was the author of this lost model, Novios' engraving is the only surviving reproduction of a Classical Greek painting which gives indications of having been copied from the original directly by a master draughtsman, himself a near-contemporary.[9]

Within the general periodic progress from Late Classical to Hellenistic tastes the art of the Praeneste cistae seems to have taken a course of its own. Towards the end of the fourth century

276 and 277. Ficoroni cista from Palestrina, signed by Novios Plautios *(left)*,
with detail of the Binding of Amykos *(above)*, later fourth century. Bronze. *Rome, Villa Giulia*

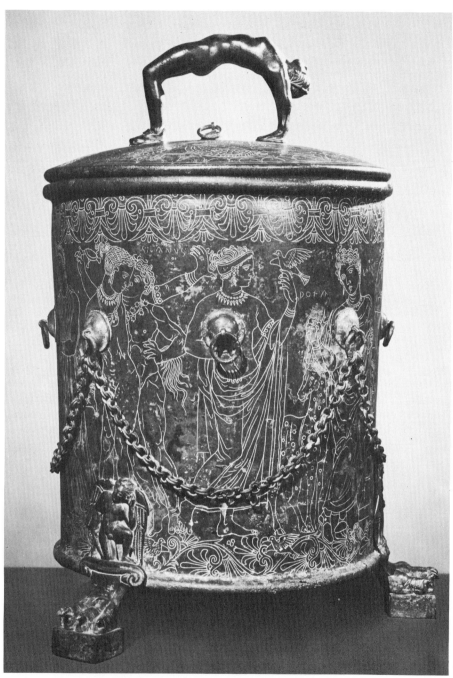

278. Assembly of mythical figures on a Praenestine cista, early third century. Bronze.
New York, Pierpont Morgan Library

the reminiscences of Apulian vase painting recede; this observation holds true alike of the mythical themes and of such representational formulae as the obliquely drawn, stormy quadrigas. A quieter, less active imagery takes their place. The designers still know their craft; although their work varies, the differences of quality are not as drastic as in much other Etruscan art. But their reception of the new Hellenistic styles poses a problem. The vivid modes, Pergamene-Asian or Alexandrian, which to modern eyes constitute the foremost characteristics of Hellenistic art, hardly left a mark in the friezes of the cistae. Instead, the designers of the latter seem to cultivate a brand of Atticism of their own devising. Mythical characters are shown, but rarely their actions; occasionally one finds revived a Classical theme which had fallen into neglect, such as the battle of the centaurs. The material has not yet been sorted, and dates assigned to individual cistae are notably uncertain: especially so after *c.* 300, when comparanda are often lacking. At least with this rather special class of Etruscan monuments, the Hellenistic development appears to have been a smooth transition from Late Classical to incipient 'neo-Attic' attitudes.

For an example I add a cista in the Pierpont Morgan Library in New York [278].[10] Among the large, well designed figures of its main frieze two are Homeric: Ajax and Agamemnon. Two others seem personages of Greek myth, but the sense of their translated names escapes us. Matronly 'Lavis' turns towards the Homeric heroes; 'Ladumeda' leans on a bearded herm while holding a fawn on a leash. Next to her stands the central figure of the obverse side, an Aphrodisian character called 'Doxa'; a dove settles on her raised left hand. To her right an amorous couple: 'Silanus' and a nude maenad. In this frieze each element is treated as an entity by itself, separate from all others; no story is told. Though each name appears to tell its own tale, as far as we understand it, the bearers of these names seem unable to communicate among themselves. Lavis and the Homeric heroes may form a group of three; another group is Doxa between the Bacchic couple and

Ladumeda. But we cannot press their meaning, if any was intended. Again the underlying principle appears Polygnotan; it recalls the silent company of the departed great in intimate groups or alone, in the Delphic 'Nekyia'. The designer who imposed this aloof order on his protagonists did so in his own modern manner, though not without hints at Greek Classicism. His visual world was Hellenistic, Neo-Classic. He liked frontal representation and tricky foreshortenings; pending future finds, the early third century seems a likely date for his work.

Mirrors of the Fourth Century:
Style and Development

The bulk of the engraved Etruscan mirrors dates from the fourth and the Hellenistic centuries. Preserved examples are abundant, but, compared with the cistae, the differences of quality are greater. Many small mirrors seem mass-fabricated objects, carelessly drawn and repetitive in their choice of motifs. Yet even if we discount the cheap and the mediocre, a surprising variety of work stands out for deftness of drawing, invention, and scope of subject matter. This vast material has not yet been sufficiently collected and sorted, though important initial studies are available.[11] Its chronology must rest on stylistic and typological criteria; external, historical or archaeological data, apt to corroborate the stylistic evidence, so far are few. The chronological dilemma is aggravated by a scarcity of references to contemporary vase painting among the mirrors. Shared motifs like those connecting the cistae of the mid fourth century with other art of their time are infrequent. One receives the impression that the designers of the mirrors developed rather independently. Their relations with contemporary art can be recognized generally, within the broad limits of period styles, but they are not easily detailed.[12] During the third century, when ceramic painting declined, the mirrors continued as an autonomous and vigorous branch of pictorial art; this may have been due to no small degree to their early independence from the vases.

In the absence of close comparisons with objects outside their own group, the temporal sequence of the mirrors cannot be lightly established, let alone ascertained. It seems that they shared with the Praeneste cistae the even passage from Late Classical to Hellenistic levels. Evidently in Etruscan art the year 300 was not an overall epochal divider. Yet while in either category the rate of change appears to have been gradual rather than abrupt, the results differed. Many mirrors look more Hellenistic – or less Neo-Classical – than the engraved cistae which we think to be of equal date. But the mirrors are a much more numerous group. Unlike the cistae, which apparently were all Praenestine, the mirrors pose a problem of origin. They probably came from different workshops, in different localities; and their styles diverged accordingly, even among the approximately coeval specimens. While Praeneste remained to the end one of the busiest production centres of the mirrors, and the only one about which we have certain knowledge, the chances are that there were competing shops in other towns, not yet identified.[13]

I conclude this rapid review of questions attending the Late and post-Classical Etruscan mirrors with a note on the scarcity of analogues among their surviving coevals in other branches of art. The progressive separation of mirror design from vase painting seems to have been the main cause. It began late in the fifth century; by the last third of the fourth it was an established fact. Before this time the mirrors posed no such problem, because they did not differ essentially from the roundels of painted cups. When the vase paintings fail us, our ideas of Greek representational art must depend on sculpture: reliefs and statuary. This has been the case with Hellenistic art especially. But the mirror engravings are pictures, and with the years their compositions veered ever more decidedly towards painting pure and simple – not ceramic painting or sculptured relief. If we seem to lack the standards by which to measure their temper, it is because their nearest relations were lost works of painting, about the making of which we know very little. Under these condi-

tions, barring new finds, it follows that the Etruscan mirrors must themselves be accepted as the only authentic pictorial art of the Late Classical and Hellenistic periods which is now with us in quantity; hence their unique interest and their apparent isolation.

The pictures on Etruscan mirrors are all compositions within a round (pp. 201 ff.), and variations are possible only within the prescribed circle. Early in the fourth century appears a new kind of three-figure group. A seated – or somehow smaller – figure on either side, in profile, turns towards the middle figure, which often represents a deity standing between them, more or less frontally. The pictures that follow this scheme do not usually show much obvious action, though their quiet groupings can convey a sense of muted stress. On a mirror in New York[14] [279] laterally placed Helen (Elinai) and Paris (Alexandros–Alcsentre) balance each other, and the standing third acts as the tongue of the scale: Aphrodite (Turan). The play of hands between her and Helen has Greek counterparts, though here it was more likely a fresh invention; Helen is reluctant, Aphrodite beseeches, and we know that she will succeed. In bearing and attire these images mix Greek with domestic traits. On the whole the Etruscan look prevails, however, and with it the sturdy dignity which so often expresses the Etruscan conception of the Classical: Turan in the centre is hardly more than a generation removed from the statuette in Cambridge, Mass. [227].

Such quiet three-figure compositions seem properly characteristic of the first quarter of the new century. But there were other ways to fill a round, and the time was ready to exploit them. A few examples must suffice to describe the ensuing variety of styles and themes in the later Etruscan mirrors. A fine engraving from Vulci portrays solitary, winged Calchas [280].[15] The Greek seer bends searchingly over the liver of a victim, as an Etruscan haruspex might strain to read the same oracle. The inscribed name suggests a theological equation: Kalchas of the Homeric myth and the legendary founder of the Etruscan doctrine are one. Their offices to humanity are the same; and they are demons,

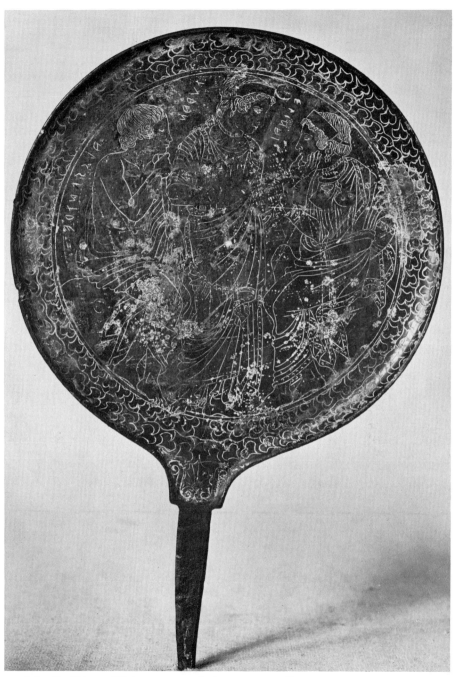

279. Aphrodite, Helen, and Paris on an engraved mirror, *c.* 400–375. Bronze.
New York, Metropolitan Museum of Art

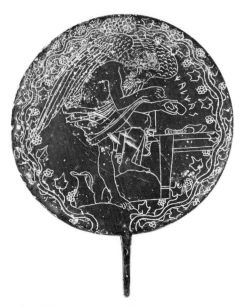

280. Calchas on an engraved mirror,
mid fourth century. Bronze.
Vatican, Museo Gregoriano Etrusco

both. The question of possible prototypes must be raised here, as it was asked with the cistae; but for the mirrors the answer points to somewhat different conditions. Repetitions, which constitute the clearest evidence of motifs borrowed and shared, are frequent only among the pieces of lesser quality. The more ambitious compositions are usually singular, though other copies may once have existed. The preserved material gives the impression that many engravings were original designs. On occasion, models were copied repeatedly – often by subordinate helpers – and perhaps shared by several related shops.

Cross-connections between mirrors and other crafts are rare, however. An outstanding exception is the mirror in East Berlin, likewise from Vulci, which shows young Fufluns reunited with his mother, Semla, in the presence of Apollo [281].[16] The Fufluns group cannot be separated from the Faliscan cups of the 'foied' Painter which represented the same god, paired

with Ariadne (Chapter 26, p. 348 and Note 27); in this instance the mirror engraver and the ceramist certainly used the same model. The mirror was probably the later work, nearer the middle of the fourth century. Instead of three figures it renders four, arranged so as to bisect the circle: opposite Dionysos and Semele, Apollo (Apulu) and a satyr boy who plays the flutes; Apollo's laurel sets the dividing line.

A stippled row near the clavicle of Apulu perhaps denotes an attempt at shading; if so, it was an innovation, as were the minute crosshatchings that in the Berlin mirror render the hems of garments. The Etruscan mirrors were then about to enter into their Late Classical phase, which reached its summit shortly afterwards, in the third quarter of the century. A heightened visual sensibility is the outward sign, and perhaps was the cause, of the change. It expresses itself in a new sense of balance, a liberal variety and pliancy of surface elements within the rounds, and a previously unknown delicacy, even sweetness, of design. At the same time one notes a tendency towards more painterlike effects. The new taste favours shading of details, both of draperies and anatomy; human hair is drawn as narrow, parallel lines. When all this lineament was filled with white, contrasts of light and dark resulted which may well be said to rival painting. This becomes especially obvious in compact areas such as thick hair, striated or bobbed; or when the ground was closely stippled with white dots, to create a different hue.

The borders around the pictures call for attention too. On these new mirrors they often turn into sizeable exercises of the decorator's art. Some reflect contacts with the flowery ornament of south Italian Greek vases; this observation seems to contradict the centre pictures, in which south Italian relations, if they existed, can rarely be verified. Other borders elaborate earlier Greek motifs, or the simpler vine or ivy wreaths of the local tradition. On occasion, however, one finds amongst them quite unconventional devices. A mirror in Leningrad shows Turan, upright and richly adorned, embracing

363

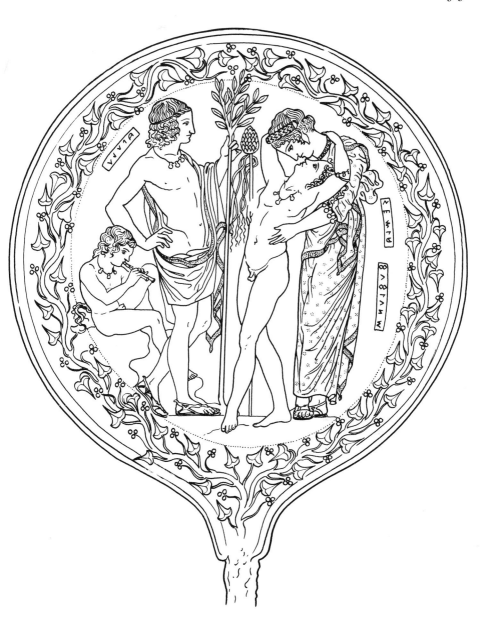

281. Apulu, Semla, and Fufluns
on an engraved mirror, mid fourth century. Bronze.
(East) Berlin, Staatliche Museen

Adonis (Atunis) [282].[17] The lover is a young boy, the goddess tall and maternal: a favourite Etruscan version of Greek myths which pair mortals with deity. Behind Turan sits an attendant, ready with perfume and a rod to apply it; her beautifully feathered wings fill the segment above, as does the craning neck of Aphrodite's giant goose on the opposite side. The border is a heaven filled with airy spirits; the entire mirror the illumination of a dream, in a taste

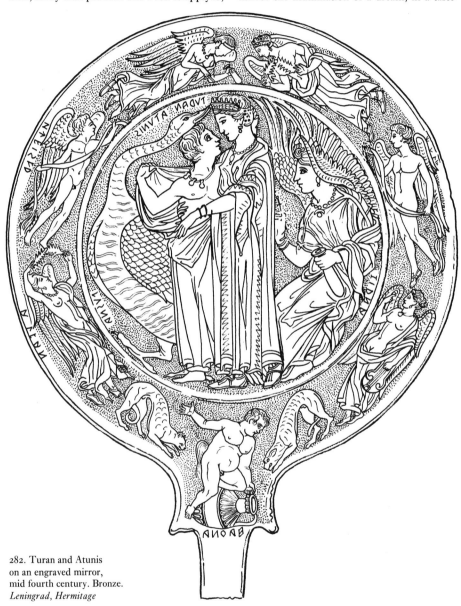

282. Turan and Atunis
on an engraved mirror,
mid fourth century. Bronze.
Leningrad, Hermitage

that matches the best manifested in the Pre-Raphaelite school.

The themes of the Etruscan mirrors require a short discussion. Most were taken from Greek mythology. Myths have neither author nor copyright; they are common property, ready for everyone to reshape or vary their plots and decipher their meanings. They grow or wither, as the case may be, by collective action. The Etruscan contribution to Greek myth, from the Archaic period onward, must be held to be considerable; but at no time were the Etruscan variants conceived more freely or expressed with greater ease and originality, their range as wide or their insights as keen, as in the art of the advancing fourth and the early third centuries. The engraved mirrors were the foremost vehicle of such intellectual leanings; this fact alone sets them apart from all other Etruscan art, as a special class.

The customers for these objects were women. We must presume that the mirrors of quality appealed to an elevated social stratum; the women who bought them must have been sensitive to the subtleties they chose. It was no accident that stories of love and romance rate high among the mythical repertoire. The less frequent non-mythical events likewise turn to matters of feminine concern, for example the toilet of a bride.[18] Even the forthright genre scenes found on Praenestine mirrors at about the same late stage as on the cistae (this chapter, p. 353) play with amorous allusions.[19]

It seems characteristic of the mirrors, however, that within this broad human interest the mythologies are often selected with a taste for the rare and the recondite, or for episodes well known but seldom illustrated. These pictures clearly address themselves to an informed clientele. Quiet if significant situations have preference over dramatic action. Though almost all the myths are Greek, their protagonists mingle lightly with the fashionable Etruscan fantasies, especially the eternally changeable, eternally attractive Lasas. Native Etruscan myths occur occasionally, perhaps supported by a concurrent literature; they are given equal status with the Greek.[20] Women are conspicuously frequent,

and often the centre of a story. Female nudes are a standard part of this imagery, as we also found them in contemporary Etruscan vase painting. They constitute a symptom of style specifically Etruscan and different from most coeval Greek art, though shared to some extent by the western Greeks. This is true not only of Aphrodite, who in many scenes appears as a popular bystander, or the Lasas who in Etruria take the place of the male – and equally plentiful – Greek Erotes, but also of heroines such as Helen of Troy, or Atalanta, whom Greek art will not ordinarily show so unveiled.[21]

In the art of the Etruscan mirrors the Greek myths appear altogether absorbed into a native culture about which we would have scant knowledge if it were not for these iconic testimonies. The transfer of civilizations from the Aegean to the Tyrrhenian, which began in the eighth century, now seems nearly completed; and the time approaches when the ultimate fusion of its dual heritage – the Greek and the Italic – will be accomplished in Latin letters.

Late Classical Mirrors

In the disc of a mirror in Florence[22] which brings us to the last third of the century, seated Atunis embraces a winged Lasa [283]. Beside

283. Atunis and a Lasa on an engraved mirror, last third of the fourth century. Bronze. *Florence, Museo Archeologico*

284. Atropos, Aphrodite and Adonis,
Atalanta and Meleager
on an engraved mirror,
end of the fourth century. Bronze.
(West) Berlin,
Staatliche Museen, Antikenabteilung

the hunter is his dog, tongue hanging from the gaping mouth. Above, a wild goose in flight holds a flower in its beak: attribute or hypostasis of the heavenly apparition? Yet the figures are classically styled in a grand and ample manner; the inner design includes shading by dotted lines, not only in the nude parts of the youth but in those of the woman as well.[23] The inscribed name of the Lasa, 'Achununa', might tell us the story if we could translate it. She executes a nimble Etruscan step to perfection: does it denote arrival or departure? A sense of suddenness and rapture springs from the large unbending faces, profile gazing into profile; their glances seem more persuasive still than the grasp of hands. We must recall the mythical destiny of Adonis: a predicated fatality, inseparable from the present. It warrants, if it does not define, the passionate seriousness of the moment. A related masterpiece in Berlin[24] – 'the grandest of all Etruscan mirrors' (Beazley) – has Atune seated, this time next to Aphrodite, in accordance with the common myth [284]; she stands and looks down at him sadly, her hand on his right shoulder. Opposite is a similar pair, Atalanta (Atlenta) and Meleager (Meliacr). The huntress's spear leans idly against her shoulder, and her head turns outward to face the beholder; Meleager stands farther back, head bent to the other side. The subject of this mute assemblage cannot be narrative; rather, we may call it a morality. Two principles apparently governed the association of these four persons: their future destiny and the similar accidents that were to strike them. Atalanta, Meleager, Adonis were hunters; they were also the heroes and heroines of mythical romances. A boar felled Adonis; the Calydonian boar caused the end of Meleager. Their stories differed in detail, but the outcome was the same, and the boar's head on top is at once their trophy and memorial. In the centre between them towering Necessity (Athrpa, the Greek Atropos) hammers a nail into a timber, as of a roof: a symbol of finality, record of time fulfilled. She is nude and winged like a Lasa, which she may well be if indeed Lasa, 'the Lady', was the Etruscan

ancestress of the Latin Fortuna Primigenia who presided over the oracle at Praeneste. Horace's 'saeva necessitas' (Odes I, xxxv, 17) could hardly be illustrated better; nor could Horace in Odes III, xxiv, 6 f.[25]

This engraving may be somewhat later than the Atunis mirror in Florence [283]. The near-frontality of the persons shown is its formal characteristic, which also causes the sombre mood, as in certain group portraits, where everyone looks outward and all action is suspended. Greek equivalents can be found among Attic grave reliefs about 320; the hieratic character of this formal arrangement was already noted by Beazley.[26] But its intellectual style opens still another perspective. The moralizing allegory and elliptical use of myth were in line with other Etruscan art, especially mirrors, about the start of the Hellenistic period. But they also had effects upon the future. The habit of mythical allusion and variation as a means of binding thought to sentiment laid the ground for an erudite tradition of long duration. We count this Etruscan hellenism among the sources that shaped the imagery, taste, and methods of the subsequent Latin Classical poetry; chiefly the latter's free use of myth, but not rarely the direction of its thought as well.

There are other examples of this uncommon art. An Etruscan mirror from Volterra now in Florence represents Herakles, his earthly labours completed, receiving the breast of Hera [285].[27] The ceremony equals an adoption rite; the son of Zeus and Alcmene thus becomes a legitimate member of the Olympian clan. The myth is rare but the representation is not unique. Zeus, Apollo, and two goddesses stand round the middle group as witnesses, their sturdy forms merged into a solid wall. Thus to pack the round with figures, grouped in a half-circle which opens toward the observer, was a further elaboration of the earlier, more loosely arranged centred groups of three or five. Among the Etruscan mirrors this seems a high Hellenistic style; if so, the Florence version of the 'Adoption of Herakles' ought to be dated near the middle of the century. We note also that,

unlike the ominous and prophetic allusions im-
plied in the two preceding pictures, the story
here refers to events of the past; it signifies a
moment of annulment, the reward of long en-
durance. For the wrath of Hera has been
assuaged; now the hero bends down to her
though he avoids a genuflection – a detail which
the designer was eager to explicate. It is a cere-
monious action, and the intent clearly is to put
an end to strife, to resolve a discord deeply
rooted. At the same time a strange by-play goes
on in the upper register. I cannot believe that

the bald-headed Silenus in that sector was quite
unrelated to the main action. Like Herakles, he
is drinking – not the milk of Hera, but the wine
of Dionysus. Milk and wine were opposites in
ancient cult – the active side of religion; and
Hera and the Sileni were enemies of old.[28]
Surely the onlooker was counted upon to notice
this secondary contrast; here we cannot follow
it up, lest we stray from our subject.

One example more, different but equally out-
standing. Two pictures of myth in superim-
posed registers decorate a famous mirror in

285. Herakles adopted by Hera
on an engraved mirror from Volterra,
mid fourth century. Bronze.
Florence, Museo Archeologico

Paris[29] [286]. In the upper Herakles again appears, before the enthroned Zeus. A winged child, Epiur, appears to guide him. We do not know the story of the child, nor why Hera is absent. But the locale is Olympus, the meeting friendly. Turan on the left looks attentive, Thalna on the other side, who usually deals with the care of infants, seems curious and eager; so does her pet fowl, a swan or goose. The whole scene evidently renders an otherwise unattested version of Herakles' entry into Olympus, enacted by a predominantly Etruscan cast.

Even stranger doings take place in the lower zone. Helen of Troy, also on a high throne, turns to shake hands with Agamemnon. Yet if the names were not inscribed, who would recognize them? Helen is costumed as an oriental princess, with Phrygian cap, and bearded Agamemnon has the back of his head covered with the end of his rich Greek himation in a ceremonial manner. A facing youth who looks down on their linked hands is named Menelaos, evidently rejuvenated. Paris, on the other side of the throne and equally youthful – a study of the

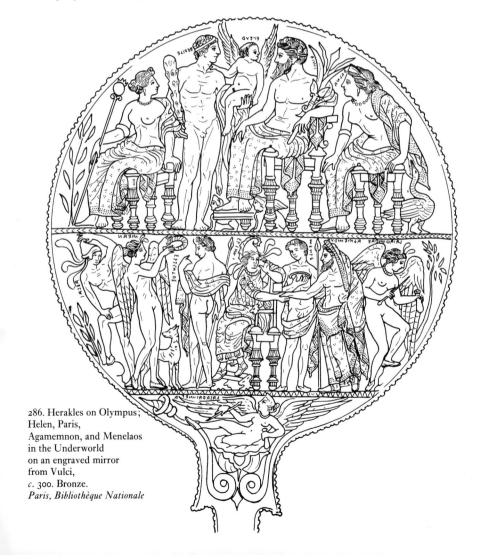

286. Herakles on Olympus;
Helen, Paris,
Agamemnon, and Menelaos
in the Underworld
on an engraved mirror
from Vulci,
c. 300. Bronze.
Paris, Bibliothèque Nationale

'crossed step' seen from the back – moves to-wards a winged Lasa who offers him a chaplet. Both youths hold spears: they had once been warriors. Thus the four who caused the Trojan War and all the misery in its wake – Helen between her two husbands, and Agamemnon – now meet in an Elysian place, a realm of spirits.

We cannot fully comprehend the thought involved; for instance, why Helen was given her regal part, as of a queen of Troy concluding a pact with the Greek commander-in-chief. That the moment is one of reunion and reconciliation is obvious. The same can be said of the Olympian meeting above; in both instances Hera was appeased: old enmities were ended. The comparative citation of myths and their free handling for inductive purposes have a literary flavour, though for the time which concerns us, about 300, the most we know about this lore we learn from these Etruscan engravers. The artist of the Herakles-Helen mirror belonged to the Neo-Classical group of his generation (this chapter, p. 359). He favoured Classical interspersions (Zeus), but he also knew Apulian vase paintings and made Helen look like a Greek theatre-queen. Conversely his Paris, drawn from the back, seems an early example of a neo-Attic type which lived on in Roman versions such as the dancing maenad in the Villa of the Mysteries.[30] The unusual arrangement by stacked tiers could have been derived from Apulian theatrical scenes, but the lines that divide them were an Etruscan addition. A close parallel in Roman Neo-Classical art, without the straight base lines, however, is the Augustus cameo in Vienna.[31]

I emphasize these formal elements which combined forward-looking traits with others more retrospective because the content invites similar remarks. The futile necessity of strife, the resolution of contrasts by mutual accord, were the themes of Greek tragedy. In the Elysian meeting of the Homeric heroes, with enthroned Helen in their midst, these musings assume a wider sweep and a different direction. Now their stuff is historical legend, the contrast one between East and West; but in the new lands of the West the tide of sympathy has begun

to turn, and to favour the Trojans. The change was decisive: the sense of the Latin *Aeneid* still depended on it.[32] But it also signified an act of reconciliation in its own right, which was carried out symbolically in erudite fables based on vague historical memories. Of this intellectual bent the mirror in the Bibliothèque Nationale seems the earliest preserved testimony. As Helen, queen for whatever reason, there receives Agamemnon, she seems a prefiguration of Dido queen of Carthage receiving the Trojan Aeneas; and the peace which she concludes, a pre-Vergilian variant of Juno's hedging agreement to a consequent if different halt of discord on Italian territory.[33]

RELIEFS: CAST AND CARVED

Cast Reliefs

The mirrors with cast reliefs never were frequent (cf. p. 286) and became even scarcer during the Classical period. The theme of one in Berlin[34] may have a bearing on the winged demon of the Ficoroni cista (p. 354). The chances are that it represents Talos wrestling with the two sons of Boreas, the North Wind [287]; the same subject appears on an engraved mirror of almost identical composition. Talos was thought to be a giant wholly of bronze, who heated his brazen chest to smother his adversaries. The story was part of the Argonaut saga, and in the better documented versions the Dioscuri are his attackers; in the present variant, which outside Etruria seems unknown, the aggressors are less familiar twins who might be the Boreads: outlandish-looking, wild and bearded as Boreas himself. Novios' Sosthenes, though more nobly shaped, seems of this family too. That the brothers struggle to free themselves from the grip of Talos is confirmed by still another Etruscan mirror which renders his attackers in the same formal scheme but as young, without wings, with names added: Castor and Pollux. In the cast mirror, was the strange triangular object above the right heel of Talos meant to plug the giant's only vulnerable part?[35] At any rate all three Etruscan Talos mir-

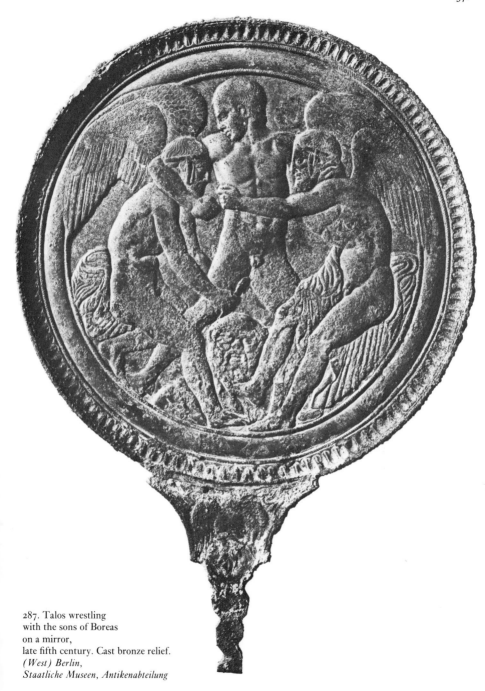

287. Talos wrestling
with the sons of Boreas
on a mirror,
late fifth century. Cast bronze relief.
(West) Berlin,
Staatliche Museen, Antikenabteilung

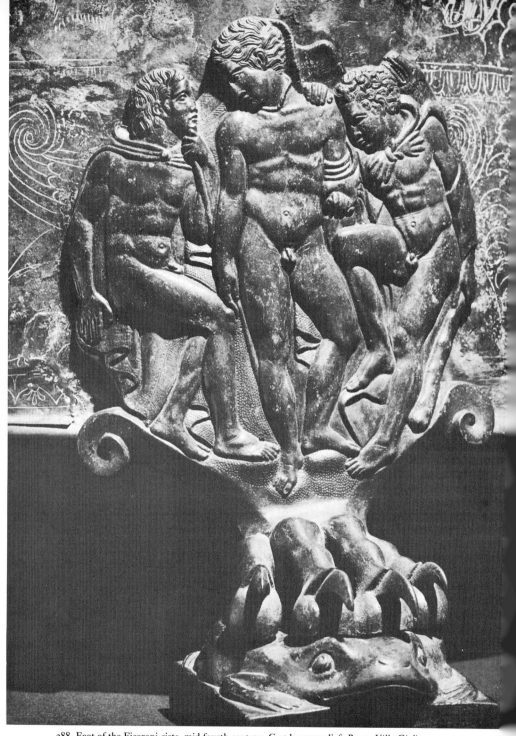

288. Foot of the Ficoroni cista, mid fourth century. Cast bronze relief. *Rome, Villa Giulia*

rors agree in depicting the precarious contest as a triad with facing centre figure, like the triple groups in vogue about the early fourth century (p. 360). The cast mirror is the best piece of the series, and probably the oldest as well; the angular contours, and the abrupt turn of Talos' head, suggest a late-fifth-century date. Whether or not an imported exemplar was used, the head of the Silenus on the ground was certainly an Etruscan interpolation.[36]

A new class of cast reliefs was the separately worked feet attached to Praenestine cistae. Their chronological sequence, hardly established yet, must be gauged from their own style and that of the cistae they supported (pp. 334 ff.); existing types of feet could be variously applied or repeated, and thus survive for a considerable time. Three feet of the same cast were required for each cista. Among those we know, the feet of the Ficoroni cista (Rome, Villa Giulia) excel for their subtle invention and workmanship [288].[37] Again we meet groups of three: the arrangement is not unlike that of the Talos mirror [287], though the outlines have softened and the lateral figures are placed semi-frontally, with shoulders extended. Among the other decoration of the cista they seem the work of an older master whose art formed near the middle of the century; it is not in the manner of Novios.[38] The young man in the centre has wings. I should call him a personification, Thanatos rather than Eros; but then, what story binds these three together? The clue, I think, lies in the action of their feet. The myth is about Peirithous in the nether world. The winged guide of the dead starts to return upward. Herakles, if it is not Theseus after all in spite of the Herculean lion-skin, looks dejected but ready to be led back. Peirithous, whom Herakles must not redeem, remains. He appears prepared for the journey, all ready with cloak and walking-stick; but he cannot move from his seat. Now he stares at the parting companions in horror and disbelief. The winged spirit, Death, looks back in sorrow; he, too, obeys orders. Drama, tragedy, in the shortest, most subdued terms: neither Greek nor Etruscan art ever again told the story more movingly, or more succinctly.

The article of which this relief was the crowning part deserves notice as an object in its own right; it is a remarkable bit of industrial design. A well-modelled feline claw squeezing a frog on a small, square slab serves as base. From the claw sprout two firmly shaped volutes; these provide a curving hold for the figures above to sit or to step on. In function if not in form they are comparable to the inverted volutes in the corners of the so-called Boston Throne.[39] The relief has no other frame; the contours of the three-figure group are its outer limits. This may seem a bizarre device by Greek rules; nevertheless the feet of the Praeneste cistae, the present example not excluded, have antecedents in the openwork handles of south Italian Greek mirrors, and the unorthodox volutes, also, might be best understood in this context. Evidently the volutes were the result of a reductive process which started from Ionic capitals, used as bases for the representational section which was originally distinct from them. The feet of other Praenestine cistae offer sufficient examples of the same device and its ever freer variations.[40]

Felsina Stelae

The Etruscan stone reliefs of the Classical and Late Classical periods are, like their predecessors, all funerary and almost all non-architectural.[41] The large stone sarcophagi which Caere introduced to Etruria (pp. 323 ff.) remained a speciality of the Etruscan south, though in time the type spread northward as far as Chiusi and Volterra. Throughout the fourth century and beyond the sarcophagi constituted the leading class of Etruscan stone reliefs (Chapter 28); upright grave stelae, the proper heritage of the northern region, were then almost extinct. The only stelae still perpetuated locally were the horseshoe-shaped monuments of the Felsina cemeteries (p. 282), whose production reached its peak during the first half of the fourth century; it ended rather abruptly about the middle of the century. In general the new Felsina stelae retain the horseshoe outline which was by then their hallmark; proportions vary, however. The horseshoe can approximate

the form of a disc [291]. But the prevailing trend lengthens the horseshoe and gives it greater height, while at the same time broadening its base and straightening the lateral contours [292]. As a rule each stele had sculptured decoration on front and back, framed by broad bands in which the wave-like running-dog pattern continued to be the most cherished ornament. Inside the frames these fields are commonly divided by superimposed zones, not unlike the engraved mirror discussed above [286] (pp. 368 ff.). In the history of the stelae this seems a timeless device, residual from Archaic habits – as with the mirrors, however, the question arises whether the separate representations are unrelated, or whether in some way they complement each other. After the late fifth century a sequence of three stacked zones was standard practice, though human representations may appear in only one or two of them. The latest examples include attempts at increasing the number of zones to four. But simultaneously with these expanded specimens appear the numerous small and ungainly stelae which signal the end of the whole class – and probably demographic changes in the city as well – shortly before the Gallic capture.[42]

Like their shape, the carving of the horseshoe stones remains traditional. The Felsina reliefs of the Classical period preserve the stencilled look which was their characteristic from the start. Contours are sharply drawn and raised from the sunken ground; surfaces remain flat, or almost so; inner details are mostly indicated by engraving (p. 282). Paint was used, as one knows from occasional traces, now mostly vanished. Even when a modicum of surface modelling was employed, the overall effect of the reliefs is always closer to design than to sculpture. A handy craftsman could put this technique to good use with results that may please us, as in the two reliefs reproduced [291, 292]. There are others like them, but not many. The artistic quality of the more than two hundred preserved Felsina stelae and fragments is modest, on the level of a folk art often using primitive devices. We should pay attention to

them not so much for their formal qualities as for their iconography.

Most Felsina stelae deal in funeral symbolism; a voyage is their preferred image of death. This partiality was apparent early (cf. p. 282); it seems still growing after 400. Other items in the Etruscan catalogue of memorial themes were neglected or forgotten. One finds few reminiscences of the funeral games, hardly any references to the banquet, and even less evidence of dancers. The Avernian spectacle of fourth-century cast is also missing, although Charuns occur among the latest specimens. Instead, on the stelae of Felsina, the dead travel: by chariot, on horseback, on foot. The chariots are two- or three-horse spans; very rarely quadrigae. Men drive themselves; ladies sit behind a coachman on cushioned benches, balancing their umbrellas. A precursor often runs before or with the horses to clear the way, but where the journey is headed we are not told. The wave pattern in the frames may still hint at some unnamed big water to be crossed. Occasional details support this idea; thus one stone, of nearly circular shape, renders in the main zone a woman in a chariot which is drawn by two winged horses, between a youthful swimmer in the exergue and a dolphin in the upper sector.[43] These trips as such often look harmless and easy, especially for the women, who are so comfortably provided, as if they were taking an afternoon ride into the country.

It is the collateral imagery that sounds the weird tones. A young man proceeds quietly on his horse, but before him rises a monster: a man's body, head, and arms grow from two upright serpent tails which, intertwined, give the tall creature a wavering stance [289]. The dog below, which moves upward in the opposite direction, as on a hairpin bend, may belong to the rider, but the same can hardly be true of the child that trails the dog. This 'braided-serpent man' must have been an old folk fantasy in Felsina; we have also an amusing Archaic stele where he confronts a foot soldier. After the fifth century his image occurs more often and in various places, though only in decorative by-

289 and 290. Journey on horseback to the other world on Felsina relief steles, early fourth century. *Bologna, Museo Civico Archeologico*

play, as if Etruscan art had to come of age before dealing more freely with its childhood dreams.[44] In Felsina the serpent man seems to be understood as a friendly demon with a calling; he stops the wayfarer, and perhaps advises him of something he ought to know: half fairy tale, half earnest saga. Etruria was always prone to expect wisdom and instruction from a demon. But the child has no reasonable explanation: how it fits the adventure – the journey into the unknown and the unexpected – we cannot tell.

Stranger things follow. In another Felsina relief the traveller rides along the bent arm of a giant, as if he were riding up a hill [290]. One only sees the shoulder, arm, and face of the giant; the outlines resemble a valley bordered by a high and steep mountain. The mountain is in fact a huge mask of Silenus – the giant's face in profile – which from its height watches the Lilliputians as one would watch a toy. Yet this rider seems no different from many others who trail across the main fields of Felsina stelae, except for his present predicament. He, too, is a traveller into the unknown, but again the meaning of the adventure escapes us. A head of Silenus can, as we have seen, assume special meanings in Etruria (this chapter, Note 36), but in no other instance is it joined to a giant who toys with mortals. The folk tales that nurtured this fantasy seem to come from outside Greek myths; in ancient art the theme is unmatched.[45]

On the famous stele of illustration 291,[46] a man riding in a biga occupies the main field; a normal subject. But in the field below a gigantic beast – wolf or lioness – nurses a human child. Again, the choice of imagery is baffling. There can be no thought of the Roman founding legend in this frontier town of the Etruscan north; but a parallel saga may have been current there, or familiar to the artist from older illus-

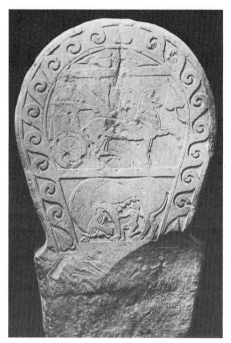

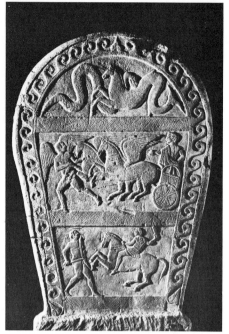

291. Journey on horseback to the other world; baby nursed by a wolf or lioness on a Felsina relief stele, early fourth century. Sandstone. *Bologna, Museo Civico Archeologico*

292. Sea monsters; journey on horseback to the other world; fight between Etruscan horseman and Gaul on a Felsina relief stele, mid fourth century. Sandstone. *Bologna, Museo Civico Archeologico*

trations. This group is one of the best Felsina reliefs we have. It also seems unique in the art of its time, for its style as well as for its subject matter. The stele itself must be dated by the central relief, which seems a competent if not outstanding work of the early fourth century. The way the animal in the lower zone turns back to its nursling also seems in keeping with a fourth-century date; the same trait reappears not much later on coins illustrating the Roman wolf (pp. 250 ff.). Yet the wide bow of this beast's neck and its broad head, drawn as a frontal mask instead of sideways, follow Archaic prescripts. We must conclude that the animal group was intended to differ from contemporary styles: it is an archaistic work. Possibly the artist had an Archaic model which he adapted with more than ordinary skill. At any

rate he created a design of pent-up power, rare in the ambient in which he worked; the alien style emphasizes the strangeness of the event he showed. How this uncommon sight fitted into the habitual imagery of the stelae remains a riddle: one cannot say that the man on the biga was even expected to notice it. It may stand for nothing more specific than a miracle by the wayside, in the wilds through which he must pass. The child reared by the protective animal may anyhow denote a friendly sign.

Our last Felsina relief holds to a different key. It is one of the latest in the series, dating from about the mid century.[47] The obverse is divided into three registers [292]. In the lowest an armoured horseman duels with a Gaul who goes to battle naked, as we are told was the Gallic custom. Myth has given way to contemporary

history: the perennial frontier war with the roaming Celts. In the main field a man in a mantle drives a biga; he could be the same who fought the Celt below. His horses and fore-runner are winged, and the span does really fly, while the wheel of the chariot still touches the ground. Greek art reserved this type of miraculous ascent for mythical heroes, particularly Herakles, but the Felsina relief need mean no more than 'disappearance from sight', perhaps in agreement with an older Etruscan tradition (Chapter 12, p. 150 and Note 13); Roman art applied the same image-formula to the imperial apotheosis. The large snake biting a hippocamp in the upper sector was a popular ornament among the Felsina stelae;[48] it seems an ominous emblem, if a conventional one. The back of this stele renders a man on foot, clad like the one in the biga of the front. A winged youth has taken him by the hand.

I think it likely that all these images hang together somehow; for instance, that the reference to combat adds a biographical note to the reliefs of the obverse side.[49] The mantled man of the back relief probably represented a separate person, but he must be a near relative. He appears older, and finds himself in a different situation. An altar behind him indicates the tomb; a basket with a high handle was placed on it, for offerings or provisions.[50] Though the winged genius is a more rustic character than the kindred spirit of illustration 288, his office here cannot have been very different. He has come to greet, to receive, to lead away; now we learn that the voyage starts from the tomb. It may continue as it started, on foot. The lone walker, however awkwardly drawn, has long been a familiar sight on the Felsina stelae; only in the latest examples is he sometimes joined by emissaries from the spirit world – messengers of ultimate arrival. Their appearance at that time was probably due to contacts with southern Etruria.

It is regrettable that we know so little about the folklore which these stelae try to communicate. In their proper iconography the dead travel alone, unaided. The metaphor is poetic rather than mythical: a 'voyage au bout de la nuit'. This differs sharply from the banquets – Elysian or Acherontic – which gave the tomb paintings and sculptures of southern Etruria their content and formal range (pp. 269 ff.). For the banquets were sociable; they also presupposed a locality – an abode where the departed assembled. The travellers of the Felsina stelae rarely keep each other company, and they never seem to arrive anywhere. On either count – their loneliness and their uncertainty of goal – we should also distinguish them from the processions of the sculptured sarcophagi, which in other respects look like a variant of the voyage theme. To this matter we must return presently.

CHAPTER 28

STONE SARCOPHAGI: RELIEFS

Preliminaries

By *c.* 400 the Etruscan stone sarcophagi had attained their standard form. Caere apparently ceased to produce them, but other towns took over, led by Tarquinia and, somewhat later, Chiusi. The statuesque images of the reclining dead on the lids and the decoration of the boxes either by coloured reliefs or, less often, paintings (p. 341) remained their essential feature. Details vary, however, as do size and execution; most Etruscan stone sarcophagi give the impression of an individually planned work. In the present chapter our concern is with the reliefs; but a few prefatory remarks must be set down regarding the type of objects for which these reliefs were designed.

The working material, with few exceptions, was the opaque limestones of the region, and the common nenfro. The lid often feigns a sloping roof, or at least its two gables, as was true already of the prototypical example from Caere in the Vatican [246]. The companion pieces from the same tomb make it clear, however, that their makers did not truly plan in architectural terms; rather their mental model was a chest on four sturdy feet.[1] Even when the feet are omitted, no architecturally designed base replaces them as a rule to answer the pitched roof of the lid. In this respect the Etruscan sarcophagi differ from the type which the Greek workshops devised for their foreign patrons, such as the so-called sarcophagus of Alexander. The Greek design is deliberately architectural and therefore apt to favour high, richly moulded or stepped bases, while the much more numerous Etruscan sarcophagi look more like carpenter's furniture, imitated in stone.[2] An Etruscan lid may simulate a roof in considerable detail, complete with tiles, antefixes, and guardian lions or sphinxes on the ridge; the box can nevertheless represent a wooden chest – an object *sui generis* – and be

accordingly decorated with applied or sunken reliefs in a wood-carver's style. Among this furniture, architectural consistency was not required and rarely found.[3] Express references to either wood-working or building in stone remained the exception.

Most Etruscan sarcophagi emphasize the figural reliefs at the expense of ornament that would curtail the narratives. An oblong, low-walled chest not unlike a Renaissance *cassone* was their guiding form. This leaves the walls free for reliefs, but not all four sides are always fully decorated. Practical rather than aesthetic considerations (for example the intended location in the tomb) probably account for sides left empty, especially among the sarcophagi of the fourth and third centuries, when four-sidedness was the rule.[4] On the earliest extant example [246], the reliefs fill only one long and one short side, but they already indicate a persistent tendency to single out one long wall as the front. By contrast the short ends right and left are often treated as parts of minor importance. If the reclining figure on the lid shows any motion at all, the side towards which it turns becomes the main aspect of the whole monument.

Themes: Myths and Battles

As a rule the long friezes and the panel compositions of the short sides form separate units; even when they deal with related themes, they rarely represent a continuous action.[5] Greek mythology furnishes most of their subject matter; the 'processions', as they are often called [246], are next in frequency. The mythologies form a clearly hellenizing group, perhaps less subtly retold here than in the best painted vases and contemporary engravings but rather more literal in relation to their Greek sources. Yet in these reliefs, too, the familiar stories may be applied to a special purpose,

though the message may seem slow and dreary if compared to the freer range of thought which the designing arts invited. A monument to the dead posits a theme by itself. If the mood of the message be sombre, even monotonous, it is also stately, and this also we certainly owe to the mythology of the Etruscan sarcophagi. Their images pass by, almost as one; in all their apparent variety they each evoke the same memory, pronounce the same sentence: death is a rover, man his victim. So Achilles slaughters the Trojan prisoners; Polyxena is sacrificed to the shade of Achilles; Cassandra and Iphigeneia must die at the altar; Clytemnestra lies slain on the tomb of her murdered husband; and two winged Vanths – taking the place of Greek Apollo and Artemis – destroy the children of Niobe.[6] In some instances episodes culled from various contexts of epic or tragedy are lined up in a single frieze.

These choices point to an underlying method not to be explained by the alleged Etruscan penchant for violence; the stories were Greek in the first place.[7] More likely the excerpts from myth, wilfully collected for a funerary memorial, must be considered an Etruscan addition to the iconography of death. This time the crucial reference is couched in a simile, not a metaphor: the deceased are likened to the fictive victims of death and disaster. The same method – elliptical use of myths – we have observed in Etruscan art before. The thought – emphasis on the finality of death – could be learned from the Greeks. It is in keeping with this attitude that the decoration which features Greek myths omits the popular allusions to a life after death. There is no hint at a journey to the beyond, nor at arrival. The patrons of this more demonstrative than narrative art evidently were a literate group, with a taste for the heroic. On the walls of their sarcophagi the slain are remembered next to their slayers, and often sympathies seem divided between them; the end of tragedy becomes a *memento mori* for all.

Among the not infrequent representations of battle, the fights between Greeks and Amazons must be classed as mythical; in these compositions, too, defeat and victory are usually dispensed with equal justice.[8] Not all scenes of battle are so easily defined, however, though all seem to deal with specific circumstances. When Greeks fight Persians the same encounters might be about Troy, or recall facts of political history not on the heroic level. One such relief, at Chiusi, possibly renders episodes of the battle of Marathon – perhaps a reminiscence of the once famous work of Mikon in the Painted Stoa of Athens.[9] Fighting the Celts became another popular subject, at a time when their violent thrusts must have been a matter of concern to all Etruria (see p. 257). But while in these instances history replaced the myths and sagas of old, it also gave occasion for new myths of a different brand.

Two types of historical legend especially seem to have interested the arts. The first recalls local deities, heroes, or demons rising from their soil to take part in battle as Theseus, Echetlos, and the eponymous Hero were said to have done at Marathon; the other type reports on a shrine or sanctuary violated by barbarous intruders but saved by the offended deity, as Apollo allegedly saved his oracle at Delphi from marauding Gauls. The first story may explain the naked giant in the centre of the sarcophagus at Chiusi, if indeed this relief refers to Marathon. The second may have a bearing on several representations of Gallic battles which take place in a sanctuary.[10] Their locality need not be Delphi, though it might well have been so intended; if it was not, the reliefs still tell us that the Delphic legend had spread to Italy.

Processions

The so-called processions pose a different problem. They represent neither Greek mythology nor specific history; yet their actions, which at a glance seem so much nearer the domestic and private domain, are by no means easy to read. The earliest Etruscan stone sarcophagus we know has a relief of this sort, though there the people do not all face in the same direction, as one might expect of a marching procession. Tentatively, I named the moment thus represented an arrival or reunion [246] (p. 325). This

presupposes a journey, and a place at which to arrive. In this new funerary imagery the notion of a voyage, which we know best from Felsina, seems to fuse with the conceit of the blessed meadows which the tomb paintings of Tarquinia liked to elaborate. But different from the Felsina stelae, the processions either signify a farewell at the start or the welcome at the end of the journey; and different, likewise, from the Tarquinian gaieties, they allude not to Elysian frolics but to a place where the departed members of a family reassemble. The patrician household, formally represented by its master and mistress, as on the large terracotta sarcophagi from Caere (p. 231), was the foundation of the Etruscan city societies; the pomp that surrounded these households, we may now observe, underlay much of their funeral art as well. From the games and banquets in honour of the dead – actual institutions – grew the paradisiac fantasies of Etruscan painting (pp. 186 ff.).

Similarly the reliefs of the Etruscan sarcophagi turned semblances of a real procession into a phantasm, the sense of which their silent images guard only too well. Thus in the relief of illustration 246, the musicians and the speaker who perhaps delivers a funeral oration certainly belong to this side of reality: ceremonies honouring a deceased person of rank. But the biga and driver are ambivalent images. They may mean no more than the obvious; or they

may connote a fabled voyage to a land of no return, as the similar travellers did on the Felsina stelae. The meeting of husband and wife in this context seems a rather unexpected addition. If we understand it as a reunion, it must mark the end of the journey; it hardly represents the farewell before the start. But since these images all deal in mixed allusions – while the couple meets, the funeral service continues near by – logic fails us. We must weigh the probabilities, but there can be no proof. Therefore a possible reference to wedding scenes cannot be excluded either, although the young woman acts as a blithe spirit rather than a conventional bride.

In the splendid sarcophagus at Boston[11] [293] the allusions to wedding and marriage are much more overt. Two processions move towards the still group of wife and husband, in the middle. Her left hand rests on his shoulder, and he holds her right at the wrist, as was the Greek custom. The mantle without tunic, which all the men wear in the procession on his side of the frieze, probably was a Grecism also. But if this were a simple illustration of a wedding, and he the groom, then why the walking-stick? In Etruscan art a cane rarely means a mere article of fashion: it mostly announces travel, either contemplated or completed, and travel is indeed represented on the short sides. On the left, a lady on a cushioned wagon with coachman and

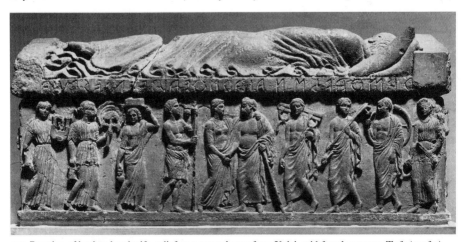

293. Reunion of husband and wife, relief on a sarcophagus from Vulci, mid fourth century. Tufa (nenfro). *Boston Museum of Fine Arts (on loan from the Boston Athenaeum)*

maid who holds the umbrella is received by a Vanth; on the right, a bearded gentleman mounts his biga. All this is very like the Felsina stelae. In the front relief, we are led to conclude, the travellers are reunited. Journey's end is indicated, which the stelae would not make known (pp. 374 ff.); it is not shown as a certain place, as in the contemporary paintings, but merely hinted at as a nondescript beyond. Two different ideas have prevailed instead, and become combined: the simile of the voyage, and the reassembly of the family.

Processions of this type – essentially a realistic and private theme – introduce the latest stage of Etruscan funerary iconography. At the same time they reinstate tenets and sentiments of the Archaic society about which Etruscan art had long been silent. In the broadest sense they deal with the serene order, splendour, and etiquette which a new generation of wealthy householders ascribed to, or borrowed from, its ancient forebears. In this revival Caere took the lead; Vulci and Tarquinia followed. The allusions to wedding and marriage were soon discarded. Ultimately there developed a standard iconography of funeral processions, but whence they come and where they go remain unanswered questions.

Chronology and Iconographic Sources

Other difficulties arise from the uncertain chronology of these reliefs and the variety of their sources. Ideally each Etruscan sarcophagus ought to be judged as a unit comprising its overall shape, the decoration of the lid, and that of the box. Actually it is often impossible to satisfy all these critical requirements at once; they involve three genres of art, and these have quite different histories, not always sufficiently explored. At present most Etruscan sarcophagi must be dated by the reliefs for which Greek stylistic parallels are available. The demonstrable changes of overall shape have yielded too few clues – so far, at least – for us to base a continuous chronology on this criterion. The third formal element of the sarcophagi, the reclining figures on the lids, also gives us little

certainty. The chronology of the lids must be grounded for the most part on the putative dates assigned to their respective boxes. Their iconographic types and the problems of their portraiture are peculiar to Etruria; abroad one finds little material suitable for comparison, or for verifying contemporaneousness.

The material at hand suggests that the greatest number of extant stone sarcophagi, including the best and most interesting, originated within the century and a half from c. 350 to 200: it seems that during the early fourth century the production of stone sarcophagi advanced only intermittently.[12] The two Vulcian sarcophagi in Boston usher in the new era; even then, as far as we can tell, the increase at first was slow. The Boston sarcophagus of illustration 293 takes up the already established theme of marital reunion, thereby connecting the new phase with the start of the series. Its counterpart features an Amazonomachia on one long side [294] – at that time a new theme of memorial art. In the back relief two antithetically placed horsemen do battle with two Greeks, with a single Greek posing in the middle. The modelling is very precise, in a somewhat rigid classical style. The frames also introduce a new formal type which places the reliefs between corner pilasters or columns carrying rudimentary capitals – definitely a hellenizing device. This 'portico type' did not expel the older 'wooden chest type'; both remained in use into the mid-Hellenistic period.[13] The combatants on either long side are grouped in pairs, with a taste for symmetrical order. I should not date these two sarcophagi far apart, in spite of their differences of themes and outlook: about the mid fourth century. Full evidence should include the lids also, but since their discussion requires a different set of data I reserve it for the following chapter.

After this new start the production of stone sarcophagi gained momentum, chiefly in Tarquinia and her neighbouring towns (Vulci, the Orvieto region, Tuscania); in the north, Chiusi took the lead. The work next to be mentioned is another product of Vulci, now at Copenhagen.[14] A Lasa in low relief covers the front half of the

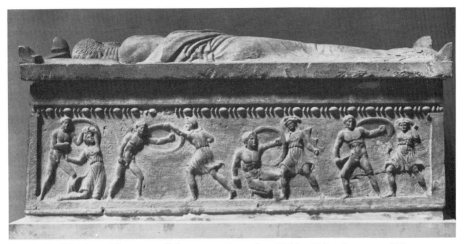

294. Battle of Greeks and Amazons, relief on a sarcophagus from Vulci, mid fourth century. Alabaster. *Boston Museum of Fine Arts (on loan from the Boston Athenaeum)*

roof-shaped lid, one large undulant wing spread over the far side. Her delicately cut face has a serious look; a bird nests in the instep of her foot – an attribute, or her double? In the relief below a bearded man guides his biga, followed by two horsemen; a horseman on the left short side closes the procession. Vanth lights the night with a torch, to show that the way is dark. On the right side of the front relief three motionless women on a chariot await the traveller: they and their attendants have come to meet the new arrival, with Charun at their side [295]. Whoever they are, we must count them as Acherontic phantoms: uncanny sisters, three Fates perhaps. Here for the first time all the elements are assembled which shaped the last Etruscan periphrasis of death in the image of a procession.

The train of companions – in this instance knights on horses – was fitted into an allegory which suggests not only the journey on the biga, as in the Felsina stelae, but the terminal locale as well. In the left corner of the long side stands a tree: at the entrance of Avernus, as in Vergil, *Aeneid* VI, 282–4. Beyond this point the procession fades into myth. The Lasa on the lid is of good Etruscan Late Classical design, and the mood of the reliefs is in keeping with the poetic bent of Etruscan art at that time. A date somewhat after the Boston sarcophagi, late in the third quarter of the fourth century, seems most likely.

The pace and sense of development among the Etruscan sarcophagi from here on to the end of the third century are not at all clear. One

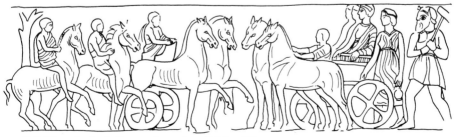

295. Relief from the front of a sarcophagus from Vulci, *c.* 330. *Copenhagen, Ny Carlsberg Glyptotek*

reason is the variousness of their decoration, which often reflects the iconography and styles of disparate sources. It must also be remembered that an iconographic model can be adapted to many modes of style, with incalculable results. This interaction – or amalgamation – of borrowed elements with local contemporary changes of taste often makes it difficult to define and date their apparent styles. Again a product of Vulci,[15] now in the Villa Giulia, Rome, can serve us as an example [296]: a sarcophagus of

Vulcian also; beyond their subject, however, the two monuments have little in common.

At first sight the sarcophagus in the Villa Giulia gives the impression of rendering a Greek Early Classical model. But as the Amazons are represented nude, the design from which it was carved must have been Etruscan.[16] Nevertheless Greek Early Classical reminiscences abound. They come to the fore in standard motifs such as the Amazon dragged by the hair from her faltering horse; or in semi-archaic

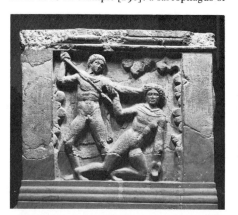

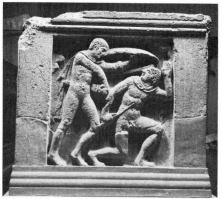

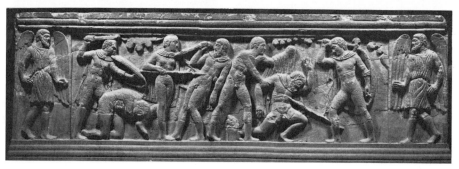

296. Battle of Greeks and Amazons, reliefs on a sarcophagus from Vulci, c. 300. Tufa (nenfro). *Rome, Villa Giulia*

the *cassone* type with exceptionally fine reliefs that emulate woodcarving, framed by horizontal mouldings. A battle of Greeks and Amazons covers all four sides. The theme is the same as on the Boston sarcophagus [294], which is

devices like forward shoulders drawn sideways. Also the curious scalloped shapes interspersed with the battle – a Vanth hides behind one of them – may be a Classical memory. I take them to represent clouds which appear wherever death is near: 'the nether darkness came down on his eyes,' as the Homeric phrase has it (e.g. *Iliad* v, death of Sarpedon).[17] The stifled movements and heavy build of many figures probably de-

note Classicality, as massiveness often did in Etruria. But the work itself is post-Classical: hardly before 300. This date accords with the Neo-Classical leanings which we observed in other Etruscan art of the early third century (pp. 355 ff.). The artist of this Amazon sarcophagus revived a Classical mode in a spirit of mannerism.

The principle of order in both Amazon battles, Boston and Villa Giulia [294, 296], is a paratactic arrangement of separate units. Groups of combat, mostly duels, follow each other in a horizontal row, though in the Villa Giulia reliefs the groups are more tightly packed. This method must be distinguished from the tripartite and continuous compositions which apparently were standard in Classical painting (p. 355) but are rare among the Etruscan sarcophagi. One must conclude that few sarcophagus reliefs were based directly on such paintings. Most of their mythology – a genre in which reminiscences of Greek art are common – in-

to be inserted wherever there was a formal need for them.

An example is the sarcophagus in London, British Museum D 21,[18] where one long side represents a battle, perhaps between Greeks and Trojans; the other presents within its apparently continuous frieze the following five, discrete actions [297]. From left to right one recognizes: Cassandra seized at the altar; two Trojan prisoners led to the same altar; Vanth, or rather a half-draped Lasa posed as a silent observer (Atropos?). The three groups on the far side of the central Lasa ought to be read, in my opinion, from the right corner towards the middle: Jocasta dying; Oedipus being led away, blinded; the fratricide of Eteokles and Polyneikes. The small sides show the wrangle between Ajax and Odysseus and the sacrifice of Polyxena or, less likely, Iphigeneia. It all adds up to a formidable array of arguments on death and destruction wrought by agents both human and divine. The examples came from the sagas of two lost cities, Troy and Thebes. Of these the Trojan battle fills one continuous frieze. All other illustrations are episodes requiring a few figures each. The second long side, which combines five episodes

297. Relief from the front of a sarcophagus from Tarquinia, late fourth century.
London, British Museum

stead of showing a unified action by multiple compositions, features select and separate episodes which rarely involve more than two or three persons. Often these small groups seem traditional combinations of ready-made types

of the latter kind, presents a unified composition because its frame is continuous and lacks divisions within. Yet its formal unity is made up of the separate fragments of five diverse stories. Only on still another level of meaning, as

allegory, do the isolated references become reconciled; the fateful Lasa who divides the Trojan from the Theban stories also unites them.

This programme, relying on literary knowledge and visual memory alike, presupposes preformed iconographic formulae which can be put together at will, in paratactic order. It coincides with parallel developments in two other branches of ancient art, namely moulded ceramic decoration and early book illustration: the two were not unrelated, as we know from the so-called Megarian bowls.[19] The reliefs of the London sarcophagus reflect two unequal illustrative sources: a frieze of battle in the tradition of epic narratives; and isolated episodes of Greek drama. We may reasonably assume that drawn or moulded models were used for either kind; that they were available in sufficient quantity for the members and patrons of the workshop to make appropriate selections; and that consequently they were handy objects, not too costly and of manageable format. In this respect the workshop conditions of the sarcophagi with mythical representations do not seem greatly different from those of the Praeneste cistae (pp. 353 ff.), though the models employed were not the same. The earliest mythographic sarcophagi, including London D 21, may date from the late fourth century. The majority seems later, and must find its place in the art of the third century. This Etruscan material, because of its comparatively pristine origin, may yield information about Classical literary illustration in its formative stage which is difficult to come by otherwise. I mention three observations, at random: scenes of the Iliad differ by style and staging from illustrations of drama; Euripides appears the preferred dramatist; and why are tragic scenes that the drama merely relates chosen so often for explicit visualization? There is more to ask and answer, but here we cannot pursue these matters further.

Filling a frieze with disconnected groups was not limited to illustrations of theatre. We find the same staccato effect in the Amazon battle on the sarcophagus in Boston [294], where it was probably due to the use of small, distinct exemplars similar to the dramatic illustrations; in this instance the models – sculptural rather than drawn – may have come from Tarentum. The Boston Amazonomachia seems the oldest preserved example of its theme on a sculptured sarcophagus, and perhaps the earliest incidence of any battle among the decoration of Etruscan sarcophagi. Most sarcophagi with battles rather date from the third century; some are probably still later. Their formal vocabulary, however, often includes older elements. It remains a task for the future to distinguish among their stereotypes – postures and motifs of action – the fourth-century elements from those of later origin. Apparently in these representations of battle the principle of the inviolate human form long remained in force, even when two or three combatants are shown as one interacting group; the same observation holds for the paratactic order in which the groups and single fighters follow each other lengthwise. Only one formal element vacillates: the distance between individual figures and groupings. In certain instances it tends to narrow, a tendency which may prove to be a chronological symptom. With time, as the interstices grow less, the battle friezes become more tightly crowded, the action more packed. We may check this conjecture against the one chronological hint that political legend affords us. In 278 the Gauls would have sacked Delphi, had not Apollo driven them away. The miracle made popular history, even in Latin Italy; witness Propertius II, 31, 13 f., among others. As mentioned before (p. 380), several Etruscan battle sarcophagi show fights with Celts in a sanctuary. If any of these indeed refer to the Delphic legend, they must be dated after 278.[20] The Pergamene manner which subordinates individual form to a continuous context of lines, lights, and shadows marks the next and latest stage of this evolution.

STONE SARCOPHAGI: PORTRAITURE

The Lid Statues: Postures

The demi-figures which top most Etruscan sarcophagi are of one piece with the lids. They are not wholly round, but even when in fact they are high reliefs, their bearing is statuesque. Their postures differ within the narrow limits of a few guiding types which bound their formal variety and their range of meaning as well. All were evidently intended as representatives, in effigy, of the persons on whose sarcophagi they seem to rest. We must accept them as portraits, though it is an open question what precisely a portrait meant to their makers and patrons. The occasion called for personal likenesses; but the expectations which an image must meet in order to qualify as a portrait are not everywhere the same.[1] It may be easier to discuss the postures first, because they imply actions and situations; their problems are of a more familiar scope.

The statues on the Etruscan stone sarcophagi form a continuous group of sculpture spanning about three hundred and fifty years, from the end of the fifth to the middle of the first century. The series starts with flatly extended recumbent figures like medieval *gisants* (p. 323). It ends with half-reclining, half-seated images, the upright torsos and faces of which turn outward; their postures often require a strained, sometimes tortuous motion to make the half-reclining figures sit up vertically, in the manner of a perpendicular high relief. The visitor does not look down on them from above, as he must look at a *gisant* of the first type. By contrast, the statues of the last type are frontally conceived and more or less flush with the front of the boxes to which they add the crowning element. It has been observed that they resemble sculptured façades, and hence they were nicknamed the façade type.[2] If one musters the available material – the number of preserved stone sarcophagi may well exceed three hundred – there can be small doubt

that between the initial *gisant* model and the final façade type an evolution has taken place. But this general observation leaves two questions open. One regards the sense of the evolution – its rationale; the other, the pace of its progress – its chronology.[3]

The two questions interlock. It seems that two diverse allegories vied from the start in shaping the lid statues of the Etruscan sarcophagi: sleep and banquet. The topic of the banquet has accompanied this account of Etruscan funerary art ever since we found it expressed in the uncouth idiom of a Villanovan urn (Chapter 15, pp. 182-3 and Note 15, and Chapter 16, pp. 186 ff.), while the analogy of death and sleep is a poetic commonplace which Greek art rendered as the fraternal action of two separate personifications, 'Hypnos' and 'Thanatos' (p. 335). In contrast to either habitual euphemism, the flat, supine images, which appeared on the Etruscan stone sarcophagi for the first time in the late fifth century, seem to take issue with all metaphor and to mirror the raw fact of death directly (p. 323). If so, we must expect them to look rigid and motionless, as many indeed do. But already the archetype of the series [246] wears the garland and holds the drinking cup of a symposiast, and his head is ever so slightly tilted towards the visitor. In a single image, symptoms of death and sleep mix with the memory of the banquet. There is evidence that the subsequent development of this memorial statuary was chiefly iconographic, and that it turned on the contradictory nature of its given theme. The shifts between the conflicting aspects of this theme determined its history, more than did formal considerations.

We may call the *gisant* Type I of this evolution. Its characteristics are demi-figures laid squarely on their backs, with legs straight and arms at rest; a good if rather late example, of about 300, is in Florence.[4] This severe pattern

388

leaves little room for variation, though one notes a tendency to include indications of a balanced stance which contradict its actual state of recumbency. The heads likewise are often lightly bent or turned; a drinking cup may be placed in one hand. But such inconsistencies notwithstanding, an impression of lifelessness was intended and prevails in most instances. The type remained long in vogue – from approximately the late fifth to the end of the third century. Since it is evident that in this class of monuments, as often in Etruria, subsequent innovations did not at once displace the earlier standards, the statues of Type I competed for a considerable time with the succeeding Types II and III. We must assume that throughout the fourth century they provided the leading model for all memorial statuary on the sarcophagi; most preserved examples seem to date from the second half of that century.[5] When *c.* 330 the Parthunus family at Tarquinia ordered a marble sarcophagus with a *gisant* lid from a foreign, probably Phoenician, atelier, the fashion must have been at its height.[6] The monument of the so-called Poet in the Museo Gregoriano, with its rich mythologies in portico frames (Chapter 28, p. 379 and Note 4), may date from not much later – still within the last quarter of the century.[7]

Near the end of this iconographic line one finds two exceptionally fine works, both images of women. One is the lid of a Tarquinian sarcophagus now in Copenhagen;[8] its approximate date lies around 250 [298]. The silent expressiveness of mien and the soft modelling that suggests clouds rather than human flesh recur in another portrait statue, on a lid in East Berlin,[9] from Chiusi. This young woman lies on elaborate bedding; a hide or pelt serves as mattress-cover, and her languid head rests on two high pillows, one of them fringed. The sarcophagus is shaped as a couch, carved in a flamboyant high Hellenistic style. The vegetal vitality of the decoration contrasts with the frail image it supports, an intended dissonance of

298. Portrait of a woman on a sarcophagus lid from Tarquinia, *c.* 250.
Copenhagen, Ny Carlsberg Glyptotek

mood and occasion which strikes a romantic note. The date must be improvised: late third or early second century; at any rate I count the Copenhagen and Berlin lids as variants of Type I, although it is clear that their makers disobeyed the model not only in form but in spirit. Both statues move as persons, sick perhaps or simply dormant, but alive; the image of death has given way to that of sleep.

Meanwhile the reinterpretation of the recumbent statues as persons sleeping or resting had already produced a formal canon of its own, dif-

ferent from the first; this led to the second redaction – here called Type II – of the lid statues on the stone sarcophagi. Forerunners appear soon after the mid fourth century. The two sarcophagi in Boston [299, 300; cf. 293, 294] with lids transformed into marital beds (the *lectus genialis*; cf. Chapter 22, Note 4) already belong to this category: the couples lie asleep[10] in mutual embrace. The motif – a variant of the banqueting pairs on the Archaic terracotta sarcophagi from Caere [158, 159] – was not repeated on any post-Archaic Etruscan

299. Reclining couple on a sarcophagus lid from Vulci, mid fourth century. Nenfro. *Boston Museum of Fine Arts*

300. Reclining couple on a sarcophagus lid from Vulci, mid fourth century. Alabaster. *Boston Museum of Fine Arts*

sarcophagus now known, or on any other memorial monument of antiquity; Pilon's tomb of Henry II and Catherine de Médicis in the abbey of Saint-Denis, however differently motivated, is the nearest parallel.[11] All other lid statues of the second type, like their forebears, are lonely figures, each by itself in its own place. But, different from the initial model, while still recumbent, they bend and usually cross their legs. Simultaneously they lean the left cheek on the left hand to indicate sleep, or, with head slightly raised, to express thought and, perhaps, melancholy. The general trend is to place the head high, adding an extra pillow or elevating the shoulders by some other device; also, to turn the torso and the further shoulder towards the front. Thus the upper contour is apt to rise gently from left to right.

To this type belong the sarcophagi of Velthur Partunus (the so-called 'Magnate') and the resting 'Thinker' from the Parthunus tomb: ambitious and evidently related works of hard limestone which approximates marble or alabaster instead of the common nenfro.[12] Velthur Partunus was perhaps the son of the priest Laris Parthunus, but this is not certain (above, Note 6). I should date his monument not far from the 'Poet' (above, p. 388), whose cap of hair is similarly cut: first or early second quarter of the third century. The pelt with jagged edges on which he rests seems an ingenious rendering of this novel luxury if compared to the orderly scallops of later Hellenistic specimens. One should also note the abstract design of his right arm, recalling the old Etruscan penchant for angularity which now seems out of tune with the up-to-date realism of the surrounding detail.

The 'Thinker' [301] probably dates latest in this short but precious series of hard stone monuments; his sarcophagus, 2·38 m. long and 0·79 m. high, is uncommonly large, but the walls remained unadorned except for the multi-coloured veining of the stone – a kind of breccia – and a painted cymatium along the upper moulding. For the statue stretched on the lid, cheek in hand, a greyish-white marble was used. The finish is superb, in the Etruscan manner: all mass, surface, and contour, with no hint at a supportive structure within (p. 178). A middle-aged man's flabby chest and abdomen was thus turned into a heaving expanse of lucid stone, bordered by the multitudinous folds and wavelets of his silky cover. The sculptor left some patches unfinished amidst all the polish, as Michelangelo was later to do. The mournful face beneath loosely modelled – not merely striated – hair, though not averted, seems lost in meditation, ignoring the visitor. One must hold this man a person of distinction, and a thinker rather than a doer. I regard his monument as the best stone sculpture we still have by an Etruscan hand; its date may be set, tentatively, about the middle of the third century.[13]

The 'Homeric' sarcophagus in Tarquinia[14] which is next in line chronologically, though related by type, is of a later style. With the

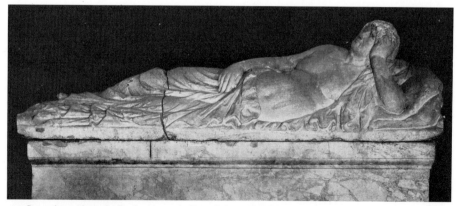

301. Sarcophagus from the Parthunus tomb, Tarquinia, mid third century. Breccia.
Tarquinia, Museo Nazionale

statues of Type II – especially the more ambitious and hence more original ones – the folds of the mantles often disclose interesting fluctuations of taste. On the 'Homeric' sarcophagus the drapery follows a mannerist design, discontinuous, with archaistic innuendoes. Such capricious misreadings of a Classical form suit the closing more than the initial part of the third century; they presage the archaistic experiments of Roman art 150 years later.[15]

Lid statues of Type III appear earlier in the third century, perhaps before 250; we cannot be precise about this, lacking firm data. The statues of this category act more determinedly than those of Type II, with which their first exemplars were probably contemporary. Leaning on the left elbow, their shoulders and heads rise high and freely. Not only details but the theme itself has changed: the new statues render neither sleep nor the aimless gaze of the former group. They look awake; consciousness has returned to their faces. The convivial cup in their hands – that never quite forgotten attribute of the dead – regains its active meaning, and it is also met with more frequently. In these instances the reference to the familiar iconography of the 'blessed banquet' is quite obvious. Even when the bowl is omitted the images leave

little doubt that a live and active situation was intended – repose but not sleep, either true or metaphorical. The only condition which this thematic metamorphosis did not change is the loneliness of the statues; the social pleasure of the banquet was not recovered, or at least not explicitly illustrated.

Among the preserved Etruscan stone sarcophagi Type III forms a small transitional group. It was soon absorbed by Type IV, the façade type, which signifies the last stage of this evolution, from c. 200 onwards. The only reason why the statues of Type III should be separated from those of Type IV is a sculptural one: their determinedly three-dimensional layout.[16] Their limbs spread broadly across the couches; their rising torsos, heads, and shoulders avoid the foreground plane, to pit their bulk against surrounding space. Their finest – perhaps earliest – exemplar is the badly weathered statue of a bearded man in the garden of Villa Bruschi at Tarquinia [302].[17] Once he may have held an open scroll: a reader, rather than a banqueter. The style is hellenizing with Classical overtones: so, it seems, the man has styled himself as a Greek sporting the scholarly beard. Yet his wreath appears to have been the Etruscan *corona frontalis*, and what is left of his face –

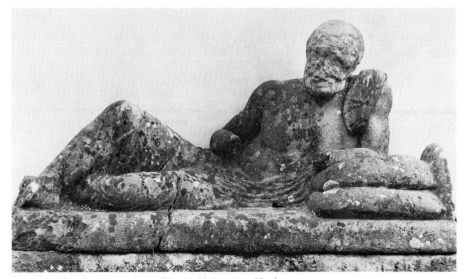

302. Bearded man on a sarcophagus lid, mid third century. Nenfro. *Tarquinia, Villa Bruschi*

glaring eyes close to the surface – suggests a domestic manner of stone carving not unlike the already mentioned later head from Palestrina (Chapter 24, Note 16). The thinning strands of hair at the back remind us of the Hellenistic 'Ageing Sophocles'.[18] Our uncommon Etruscan may date from the same period, about the mid third century.

Prefatory Remarks on Portraiture

Apart from their thematic problems, the images on the lids of the sculptured sarcophagi raise two questions of portraiture. One regards the portrait value of their faces; the other, the apparent individualization of the whole statues ('total' portraits). As a premise we assume that a portrait must render the specific likeness of a named or nameable person. Unless both conditions are met, at least in intent – names become easily lost through the accidents of time – no image qualifies as a bona fide portrait. If for instance a genre work renders a live model as an 'Old Beggar', the result might not differ in substance from a true portrait of the same model,

but the intent does, in so far as it supplants the emphasis on name and person with a generic social and supra-personal classification. Conversely, if an artist purports to represent a specific person without knowledge of that person's actual physical appearance, or without either the ability or the will to render it truthfully, we may doubt whether the outcome ought to be termed a portrait. Current opinion now expects from a portrait close fidelity to the sitter; more often than not attention focuses on the head alone, which becomes an object of representation *per se*. It follows that a critique of Etruscan portraiture must find its way between modern habitual definitions and the different circumstances of ancient art – not the Etruscan alone but all ancient art, and especially the nearest Etruscan relatives, the portraits of Greece and early Rome.

The lid statues of the Etruscan stone sarcophagi provide the following data. They deal with individuals whose names are often inscribed. The majority of their faces are clearly – often impressively – diversified. Many invite description as portraits, true to life, and thereby

303. Profile 'portraits' on both sides of a Volterra column-krater, late fourth-mid third centuries. *(West) Berlin, Staatliche Museen, Antikenabteilung*

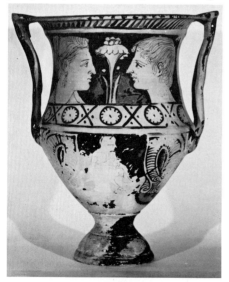
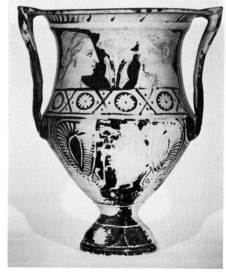

seem to support the claim that a genuine concept of portraiture, equal to the modern, materialized in Etruscan art for the first time in history. The crux of the matter is the unanswerable question of personal similitude.[19] The subjects of this stony portrait gallery are beyond our reach: nothing can be known about their real countenances. In no circumstances can the portrait likeness of their images be taken for granted; in some instances that thought must be dismissed as altogether unlikely.

Recent studies have cast considerable doubt on the portrait value of various other imagetypes of Etruscan make, similarly individualized. One example is the profiles of men and women all painted with the same impressionistic flourish on the high necks of a Volterran group of column-kraters which date from the late fourth to about the mid third century [303].[20] These routine pictures, however vivid in appearance, can hardly mean specific persons; yet their simulated physiognomies seem to pretend (or ape?) portraits. An even more numerous and varied group of equally ambivalent imagery is found among the host of

approximately life-size terracotta heads which between the fourth and first centuries were deposited in so many popular shrines of Etruria, Latium, and Campania.[21] Their mass-fabricated, moulded faces most probably stood for the devotees who dedicated them; possibly they served as a symbolic substitute for the whole person – a *pars pro toto*, not unlikely in Etruria. At any rate one receives the impression that their makers approached their task in a spirit of realism which tends to describe persons as a special offshoot of the common stock, each distinguished from others by his own native looks; a frank interest in the external aspects of personality is unmistakable. Yet it has been shown that in the workshops which produced these heads the same mould was used, with a few hurried changes, to shape the faces of young men resembling those of the Volterra columnkraters, or an old man with a stippled beard, or a woman [304].[22] Since this rather superficial manner of adapting a preformed model to individual needs was standard procedure and by no means exceptional, we are confronted with a paradox. One ingredient of naturalistic por-

304. Two votive heads, third century. Terracotta.
Vatican, Museo Gregoriano Etrusco

traiture was certainly active here: we see the human face accepted as the irrational work of nature in union with age and temperament, and thus deemed a distinctive property of the human individual. But in practice we now find that the concept was not carried to its logical end. In the workshop procedure the model – a multipurpose abstract – was prepared first. If personal likenesses were indeed intended, the ceramist added to the already moulded form what special traits he thought most apt. The latter were an afterthought; in no way, under this piecemeal procedure, could a living face be conceived and rendered in its wholeness. We may still consider the outcome a portrait of a kind; but its claim to personal similitude and exclusiveness must fall far short of modern expectations.

One should note here the close resemblance between the feigned individuality of these votive heads and the 'proto-portraits' of the Late Archaic Canopic jars of Chiusi (p. 106 and pp. 129–32). The simple portrait which deals with the variety of human faces as a natural fact and a matter of interest on its own merits, regardless of social status, hardly had any place in ancient art before the Romans; yet it seems to have been a recurrent theme in the art of Etruria. This circumstance lends credibility to the assertion that the roots of modern portraiture indeed lie in ancient Etruscan custom. The claim is consistent with at least some of the facts before us. It is not wholly acceptable, however, because the alleged portraits may have been – and often were – fictitious rather than true likenesses. The paradox is that, simultaneous with a declared bent for the atypical and the real, one senses in much Etruscan portraiture a widespread indifference towards the unique and unrepeatable qualities of human physiognomies. The Late Classical and Hellenistic terracotta ex votos hardly differ from the Archaic Canopi in this attitude, which treats seemingly individual likenesses as an interchangeable ware.

For a better understanding of this conflicting evidence a brief look at the parallel course of Greek art may be helpful. I have argued previously that on the Archaic level the rise of portraiture required a turn from the generic image of 'man' towards the multifariousness of 'people', from the species to the specific (pp. 130–1). Greek art, obeying the same evolutional law, arrived at a concept of portraiture midway between a broadly generic and a rigorously personal interpretation of man; namely, portraits defined as exemplars of social behaviour or types of character (in the sense of Polygnotus' *ethos* or Theophrastus' *characters*). The habit of reserving portraiture for persons of public renown strengthened this trend. Greek portraits tend to be studies of physiognomy rather than plain likenesses. We may call them synthetic (as in 'Synthetic' Cubism) portraits: free compositions that merge topical with personal traits, either true or imagined. Every Greek portrait of note includes an artist's judgement of its subject.[23] Many, especially the not infrequent posthumous portraits, may have been wholly invented; as throughout antiquity the biographers of the great thought nothing of styling their narratives in accord with preconceived moralizing schemata, lightly mixing fact and fiction for their intellectual ends.

That the Etruscan portraits differ from the Greek can be seen at a glance. Their history started from other premises – less selective, since their first task was to memorialize people of various stations – and thus was guided to a more empirical evaluation of the human physiognomical variety. Instead of a moralizing interpretation it favoured the immediate approach to the visible data which distinguish one human face from another. Nevertheless, as now becomes evident, the representation of persons in Etruria passed through an intermediary stage not unlike the Greek, between a primeval archetype of 'face' and that variousness which is the proper field of portraiture. A gnomic reasoning, such as 'persons differ by their looks', may have moved the Etruscan artists at that stage to invent the self-contradictory concept of a 'typical portrait' incorporated in 'all-purpose portraits' like the Italo-Hellenistic terracotta ex votos and their antecedents: images with the attributes of personality, designed to serve an unspecified number of people as satisfactory likenesses of themselves. Thus 'typical' went before

'individual', in Etruscan portrait art as in Greece; the definitive condition of portraiture – that fidelity of similitude be the record of a specific person and name – came later.

Portraiture: The Stone Sarcophagi

A survey of the sculptured sarcophagi confirms this estimate. Their range of variety and quality much exceeds that of the terracotta ex votos; yet, while the gap between the good and the ordinary often proves surprisingly wide, in this, as in other special groups of Etruscan art, qualitative judgements should be made with caution. The sculpture of this class – reliefs and statues alike – evinces much clumsy workmanship owing to lack of skill or diligence, or both. But there is also an air of ingenuousness about many of these modest carvings, the privilege of an imperturbable folk art; occasionally a face reminds us of the terracotta ex votos.[24] The Etruscan tendency to understand monumentality as massiveness (above, p. 309) is apt to lead with the sculpture of lower quality to an indistinct and inert density of form, from which the heads, also, are not always exempt. It must be admitted, however, that we cannot know how the same figures looked when new, with their overlay of plaster and garish colours. Signs of serial production appear relatively late, around 200, chiefly in southern centres (Tarquinia, Tuscania); monotony of motifs and neglect of detail is their sorry mark. But even among these materials, simple repetitions of a common pattern are rare and mostly limited to large heraldic decorations which often adorn – and guard – the boxes.[25]

Finally I want to mention here a group of lid statues whose peculiar style places them apart from the rest. They represent young men of a most rigid *gisant* type, draped after the Greek fashion in mantles without a tunic. The nude sections are treated with notable firmness and decision, in abstract shapes; they seem an assemblage of globes, hemispheres, and cones, with the semidome of the bloated belly in the centre.[26] Such abstractions of the human form, familiar to the moderns – Léger may be cited,

among others – are rarely seen in ancient art after the Archaic period (cf. p. 278). I understand them as a late reflection of the earliest known Etruscan stone sarcophagi, the Caeretan group of the late fifth century (pp. 323 ff.). Not only are the statuary types related; details bear comparison also, such as the club-shaped arms. The oldest lids of this survival-type perhaps date from the end of the fourth century, but other examples may be much later.[27] All indications point to a decidedly conservative series of monuments which preserved the older model in a frozen style that was quite their own. Their workmanship is competent, if provincial, their apparent primitivism the result of a reductive process which over the years stabilized and restyled the richer forms of a prototype that grew ever more remote.

The unmoved, unmeaning faces of these statues cannot be portraits. They are freely designed formal devices: the rule of all Etruscan portraiture – to hover between the abstract and the natural – applied to the sarcophagi too. A critical review of the latter makes clear not only the remarkable diversity of visages but also the varying gradations of personal traits. Physiognomically indifferent pieces – both men and women – may be expected at all times; their number increases notably among the Mid-Hellenistic material, where a grecizing period style must often make up for loss of personality, or indigenous types are repeated with only slight individual modifications. Neither the typicalness of many heads nor the groping for individuality within the limits of a preconceived type ought to surprise us.[28] We must realize that a large part – perhaps the majority – of the evidently personal likenesses among the stone sarcophagi were in fact quasi-portraits, not essentially different in concept and practice from the mass-produced materials turned out by other contemporary crafts.

The singular importance of the Etruscan sarcophagi for the general history of art stems from the factor which was most special to their class – their material. Stone resists easy repetitions such as those which the malleable clay invited, and from this circumstance arose the oppor-

tunity to create, on occasion, sculpture on a rare level of excellence, beyond the reach and ambition of the less liberalized artistic industries. The large Tarquinian sarcophagi carved from hard, marble-like limestone, such as the 'Magnate' and the 'Thinker', are of this order (this chapter, p. 390). So are the sarcophagi at Boston [299, 300], though one of them [300], like the sarcophagus in Villa Bruschi [302] and a few others in this select category, was made of the less noble nenfro. Common to all, in addition to their superior workmanship, is a wide range of spontaneity and inventiveness, even in the handling of traditional motifs. The faces, which here concern us first, no less than the make-up of the statues testify to this sense of the novel, special, and unique. For example, the facial features of the 'Magnate'[29] are not only rendered with uncommon delicacy; they also seem to meet every condition of a personal portrait. No such pronouncement can of course hope for a definitive confirmation, as we do not know the person portrayed; nor can we judge the veracity of the likeness. But we can estimate the singularity of the image before us by its remoteness from the median level of the contemporary output. There appears to be a serious possibility, not to be disregarded, that a turn from 'typical' to 'real' portraits indeed happened in Etruria about or shortly after 350. If the workshops of the sculptured sarcophagi led this change, they merely brought the old Etruscan insistence on facial differentiation as a mark of the human reality to its ultimate conclusion. Henceforward portraits in the modern sense, i.e. genuine likenesses of specific and nameable persons, may be expected in Etruria, though we will have to regard them as special and perhaps as exceptional. The new descriptive and realistic method was not at once accepted as a binding rule. Other less stringent interpretations of portraiture, of both Greek and domestic derivation, continued in use simultaneously.

The two sarcophagi in Boston illustrate this situation strikingly. On the lid in illustration 300 the husband is a bearded gentleman of a rather Greek type; I find the head of Zeus on a Locrian stater, about or soon after 380, a convenient parallel.[30] A good deal of aristocratic pride and conservatism seems implied in this show of elegance; the man's tersely trimmed beard may be one of their outward signs, as perhaps was also the broad zigzag edge of the blanket, which reminds us of Archaic Tarquinian painting. At the time of the stone sarcophagi beards were becoming rare in Etruria; this one seems to link its owner with the generation that started the stone sarcophagi [246] half a century earlier. But it does so in a way notably refined, far from ancestral rusticity; and the head of the woman beside him belongs entirely to its proper time, if to a Greek fashion. All in all one receives the impression of a consistently styled grecizing work – a monument of Late Classical Etruscan philhellenism. Whether we may ascribe any portrait value to either head is doubtful. The faces show the tastes, feelings, perhaps principles of their makers and patrons; but they can hardly be considered straight likenesses of real persons. The companion nenfro sarcophagus contrasts with this mode in every way [299]. Details of costume are rendered in accordance with domestic manners; so are the faces, which could be portraits. The design of the group, apart from the faces, includes native traits such as the cross step of the lady resting on the marital bed: a concession to local style, and to local ideas of feminine daintiness as well (Chapter 24, Note 42).

Important as these diversities are, they cannot be attributed to a chronological interval. The two sarcophagi are closely allied by their unique set-up and subject; if they were made at different times, the difference cannot have been considerable. It is more likely that their inequalities of style stand for separate principles, active in more or less contemporary monuments; that is to say, the declared philhellenism of the alabaster sarcophagus [300] opposes the equally principled domesticity of its nenfro counterpart [299]. The ancient contrast of attitudes towards the Greek model, which grew more urgent during the Classical period (pp. 308 ff.), has now evolved to a clear dualism between two self-conscious and competing currents in ripe Etruscan art: one home-bred, the other Greek-international.

305. Head of a boy, late fourth century. Bronze. *Florence, Museo Archeologico*

Independent Portraits

I add here a small selection of portraits not from sarcophagi but made for sundry purposes in various materials and styles; each reflects in its own way the range of possibilities which the Late Classical period opened up to the portraitists. Clearly the evolution of portraiture among the sarcophagi was no isolated phenomenon, limited to a group of specialized workshops; it was an event within the whole context of Etruscan art.

The head of a boy in Florence [305][31] gives proof that the bronze casters still held their advantage, though the scarce remains of their work allow only casual glimpses of their accomplishments. This one is a masterpiece: a young boy on the verge of adolescence, about fourteen years old. Once it was part of a votive statue, probably looking up and turned to the right shoulder not unlike the 'Mars' in the Vatican [237] but with a more spirited motion. Its size is about natural: the old rule that human statues keep to a measure below life-size no longer holds (Pliny, *N.H.* 34.11). We cannot discuss how well the image resembled the sitter; but a portrait was certainly intended. It renders the youthful face tenderly, in crisp and somewhat angular forms. The child's open look meets with the strength of set lips: a foreshadowing of the man he is fated to be. Modelling and execution, with cast eyes though with pupils inserted, roughly chiselled strands of hair, and bushy eyebrows, are Etruscan art of the finest; the humanistic interpretation, personal and moody, may be tempered by a touch of Grecism. In style and appearance this head seems a more noble contemporary of the kitchen boys in the Golini Tomb (p. 339); the comparison recommends a putative date in the advanced fourth century.[32]

Another bronze portrait, now in Paris[33] [306], although of more domestic character and later date, seems a member of the same stylistic family. It also compares well with portraits among the sarcophagi, especially the 'Poet' in the Gregoriano (this chapter, p. 388) or the husband on the nenfro sarcophagus at Boston [299]. All four heads share one prominent formal symptom: the short lanceolate locks of hair that start from a whirl upon the crown, whence they move forward to fall artlessly down the forehead. Like the bronze head in Florence, the one in Paris once belonged to a statue. Its subject was a burly, temperamental young man – unless we read the two steep folds above the nose, which cause the angry look, as a conventional addition by the portraitist heralding the Hellenistic storm after the Late Classical calm.

306. Portrait of a young man, mid third century. Bronze. *Paris, Louvre*

In this series the angry young man in the Louvre must be placed last, perhaps as late as the middle of the third century. He and the boy in Florence represent two subsequent generations; the same seems true of the artists who portrayed them. Yet for all their diversity certain standardized details are common: the design and texture of the chiselled hair, the bushy brows, the shape of the cast eyes. These I take to be the marks of a domestic bronze workshop which straddled the transition from Classical to Hellenistic.

Bearded portraits pose a problem in this period. The men on the stone sarcophagi are almost all shaven; only about one in fifty wears a beard (for example the 'Reader' at the Villa Bruschi [302]). The Roman antiquarians, on the authority of Varro, tell us that beards went out of style in Etruria about 300; on the whole their estimate agrees with the modern finds.[34] A curious bearded nenfro sculpture at Tarquinia[35]

307. Portrait of Arnth Paipnas, before 300. Nenfro.
Tarquinia, Museo Nazionale

308(A) and (B) (p. 401). Portrait of a bearded man
('Brutus'), *c.* 300. Bronze.
Rome, Palazzo dei Conservatori

[307] certainly preceded this date and may even
be older than the Boston sarcophagus of illus-
tration 299. Like the latter it was a grecizing
portrait, echoing a still earlier Classical model,
however. The eyes are incised, as they sometimes
are in ceramic sculpture: their maker may have
been trained in a terracotta workshop, with
scant experience of work in stone. At any rate
he did better by the head than the clumsy base,
on which the name of the defunct is inscribed:
Arnth Paipnas. The whole object, put together
so primitively, suggests an improvised construc-
tion not yet sufficiently tried, and prompted by
the Etruscan fascination with isolated human
heads. Three centuries later the Roman por-
trait busts offered a smoother solution of the
identical problem – to put a sculptured head on
a suitable socle.

The much debated 'Brutus' in the Palazzo dei
Conservatori[36] [308] may conclude this section:

in more ways than one he marks a terminal
point. Martin van Heemskerk drew the head be-
tween 1532 and 1536; it was then already in
Rome and famous, though not yet mounted on
its present Baroque bust. G. von Kaschnitz-
Weinberg and R. Bianchi Bandinelli first noted
its kinship with Etruscan portraits such as our
illustrations 305 and 306; their argument is now
generally conceded.[37] The design and treatment
of the hair, bushy eyebrows, and short clipped
beard fit Etruscan bronzecasting and portraiture
from *c.* 350 to the middle of the third century.
But the Etruscan comparisons also reveal irregu-
larities. The head surpasses life-size; we must
conclude that the statue of which it once formed
a part was on a scale above the ordinary.[38]
Statuary of excessive size was in ancient Etruria
a rare preserve of deity (Capitoline Jupiter,
Chapter 20, pp. 249-50 and Note 13; colossal
Apollo in the library of Augustus, Chapter 25,

Note 2); human statues designed as ex votos tend to be on a scale below (this chapter, p. 398), or at least not above, the natural size. It follows that the measurements of the 'Brutus' are special and require explanation. While they do not seem compatible with the common dedications by private persons, they might suit a public monument or honorific statue.

The habit of erecting such monuments in public places reached Italy from Classical Greece; the first examples on record stood in Rome, but since the chroniclers who mentioned them were Romans concerned with the antiquities of their own city, their silence does not preclude similar practices in Etruscan towns. Even in Rome the new custom took hold slowly until, towards the end of the fourth and during the third century, the civic honours of publicly displayed bronze statues begin to follow each other more rapidly.[39] Many were equestrian monuments: I suggest that the statue to which the head now known as 'Brutus' once belonged was one of their kind. As the preserved part of the neck shows, the head was bent slightly downward, turning to its left;[40] the unassuming motion accords well with the posture of a man on horseback, such as the Detroit rider [238].

Both the statuette in Detroit and the Capitoline 'Brutus' are Etruscan art in a grecizing mood; so it seems were most bearded Etruscan heads from the fourth century onward. The agitated modelling of the 'Brutus' may answer a Hellenistic taste, but the crystalline shapes into which the fleshy surfaces break up derive from Etruscan, not Greek antecedents. They are subject to the steady, cubic frame of the face and a purposely undramatic presentation of personality, recalling, once more, the Detroit rider (pp. 317-18). We assign the 'Brutus' to a line of

Etruscan portraiture in a Classical vein which reached from the late fifth into the early third century (p. 396). His Greek counterpart is the Attic Demosthenes with whose images he shares formal details of hair and beard and the expression of a contained will beneath a mien of calm.[41]

But the 'Brutus' is really a work of many facets. In his stern and clear-eyed countenance has been seen Roman *virtus* more often than Greek reflectiveness, let alone signs of Etruscan origin, though so far only the latter have been defined with a measure of certitude. His *romanitas* is more difficult to establish; but the question must be kept open in spite of the demonstrably Etruscan formal particulars, especially if this head was indeed found in Rome, as seems likely. That a large bronze statue cast in Rome about 300 should exhibit Etruscan characteristics is not improbable. Etruscan foundries appear to have been active in the city during the first half of the fifth century (p. 294); we must allow for a continued Etruscan cultural presence in Rome after the Tarquins, neither the scope nor the duration of which is as yet sufficiently known. There is a good chance that the man whose likeness suggested to its discoverers the fancy name of Brutus was a Roman, after all; nothing in his physical and intellectual make-up induces us to call him Etruscan. But then we face the portrait of a Roman by an Etruscan artist. For the first time we see Etruscan art at a point near its evanescence: the point of its becoming absorbed by the alien object it was to portray. There is no split here, no firm separation between Etruscan and Roman. One only senses a beginning confluence, or metamorphosis, in which for a moment the past and the future seem to overlap.

308(B). Portrait of a bearded man

PART SIX

THE HELLENISTIC PERIOD:
LAST MANIFESTATIONS AND LEGACY

CHAPTER 30

PROFILE OF THE PERIOD: THE ETRUSCAN CONDITION

The Price of War

The Hellenistic period witnessed the last notable spurt of Etruscan creativeness, and its less obvious finale. Near the end of it Etruscan art became extinct; what caused its sudden cessation, or what happened to its erstwhile makers and patrons, are moot questions. The Roman conquest, with its notorious acts of destruction, pillage, and violence, would seem the readiest answer, had not the Roman ascendancy over Etruria been well-nigh established about 300, approximately two centuries before the presumed termination of Etruscan art. By about the middle of the third century three Etruscan capital cities had been definitely destroyed: Veii (396), Volsinii (265), Falerii (241);[1] but many others, including some of the oldest and most renowned, such as Caere, Tarquinia, and Chiusi, continued more or less unharmed. In the northwest, after a temporary lull, Populonia reactivated her mining and metallurgical industries, while Volterra, an agricultural centre farther inland, reached the acme of her history in the Hellenistic period.[2] One ought to remember also that in the ancient topography of Etruria many settlements and towns were recorded which today we cannot locate, just as, vice versa, extant remnants like the rock tombs of Sovana and Norchia have not yet been connected with any certain city.[3]

Evidently the Etruscan landscape was then considerably more populated than it is now – more like Ambrogio Lorenzetti's Tuscany: a land of cities in a countryside busy with rural towns, hamlets, estates, and high fortified strongholds. The record of martial ravages in the rural districts is scant and rather incidental, but field explorations show their traces. The harm done by Roman soldiers, in addition to warfare among the Etruscans themselves and the continuing raids of Gallic intruders, must have been serious throughout the Hellenistic centuries.[4] At no time during this period, however, did the damage seem irreparable. There is no evidence – outside the unfortunate communities which took up arms and lost – that large territories were devastated; nor was Rome at war with all Etruria. In keeping with the existing territorial divisions, Roman aggression was aimed at individual cities or alliances of cities, but not at the whole country. The eventual destruction of some of the proudest city-fortresses was deplorable and no doubt caused grave human and material losses; but in no way can it be said to have caused the end of Etruscan art, which survived these disasters.

Etruria and Rome

The fall of Veii may have settled an ancient conflict of opposing claims, the control of the upstream trade of the then navigable Tiber, but it also foreshadowed the unrest which the intrusion of migrating Gauls in the Italian north began to arouse in central Italy. Ten years later

occurred the Gallic assault on Rome. From then on the foremost purpose of the Roman thrust into Etruria was probably to keep open the roads which an army must use in order to intercept potential invaders in the plains north of the Apennines (pp. 256-7): the shocking events of the year 386 revealed the need of far-flung defences. The primary Roman targets were Etruscan cities which might block northbound passages deemed vital for the protection of Rome; thus, it seems, Volsinii came to grief. But the same highways – chiefly the three later known as Via Amerina, Via Clodia, and Via Cassia – while serving the military, also helped the traders.

In either case the Roman choice of routes along the axis of central Italy proved the consequential decision.[5] It favoured the inland cities, as did the previous migrations of Etruscan industries (p. 343). The rising prospects of the Adriatic trade, the first upshot of which had been the meteoric success of Etruscan Spina (p. 256), may account for the latter: industry follows its markets. But the new northeast orientation of much Italian traffic met specifically Roman, not Etruscan, needs. The inland routes offered Rome a natural passageway giving upon the valley of the Po, equally useful as a gate for military sorties and for the transport of goods. During the Roman northward expansion after 310 they bore the brunt of the attack; the most embittered clashes between Roman armies and Etruscan cities took place along these highways in the third century. By that time Spina had ceased to function as a port of entry to north Italy. All important roads to the north now issued from Rome; the new Adriatic harbours at Rimini and Ancona began to operate for the speedier dispatch of Roman troops to eastern battles.[6]

In retrospect these changes appear to be a part of the new order which the Hellenistic era was to establish in the Mediterranean, preparatory to the Roman empire. But our concern is not their outcome so much as their immediate impact on middle and upper Italy, namely, the progressive separation of Etruria from international trade. The Tyrrhenian harbours still served the seaborne commerce between south Italy and the Italian north, if now under a Roman protectorate. But the economic foundation of the Etruscan cities and their function in the new Italian community could never be the same as before: the Etrusco-Latin complex, an Archaic heritage but still a live reality in the Classical period, dissolved, however slowly, when Rome set herself up as a power in world affairs. Etruria, ill equipped or unwilling to follow suit, was left behind – and this at a time when Rome was acquiring new friends and enemies abroad and a new outlook upon herself, in a changing world whose powerful and untried energies were on the move and had already begun to involve Italy. Consequently the resources and powers of Italy, including her human geography, became adapted to Roman policies: the ensuing system of traffic and road connections forced the north-east orientation of the land routes upon middle Italian populations who had been traditionally west-orientated.

Thus history began to bypass the Tyrrhenian shore, and indeed the greater, most civilized section of the Etruscan core-land.[7] In the third century the definitive Romanization of the Etruscan territories still seemed far off, yet for all we know it was completed by the close of the millennium, less by armed enforcement than by administrative measures: the foundation of new Roman colonies (starting along the west coast, from Pyrgi to Cosa, 273); alliances with individual cities; conditioned grants of citizenship (Caere).[8] Eventually the process which incorporated Etruria with Roman Italy fulfilled itself by its own momentum.

Social Change and the Arts

It seems that the autonomous cities of Etruria held out for a considerable time, even when they could not always defend their territories against Roman pressure and the harassments of the Celts. Many, with altered names and revived vigour, resumed a leading role in the medieval history of Italy: Viterbo, Volterra, Siena, Perugia. Among the less fortunate, some of the oldest and proudest were permanently deserted (Veii,

Falerii); still others were ultimately reduced to a state of insignificance – the lot of Caere, Vulci, even Chiusi.[9] The isolation from world affairs evidently affected hardest the Etruscan south-west. When ancient Pyrgi and the adjacent Tyrrhenian harbours became romanized and the mines of Tolfa passed into Roman management (274–273), the once leading cities of the region – Caere, Tarquinia, Vulci – found themselves cut off from international traffic and deprived of their former industrial initiative. In little more than a century Etruria became an agrarian country and a Roman tributary. Even then her free cities could not evade involvement in the wars that were fought in Italy: they still were active republics. Thus we have lists of their contributions to the invasion of Carthage which Scipio Africanus planned towards the end of the Second Punic War (205): six of the cities mentioned, including Caere, furnished grain, sundry viands, and/or timber. Three cities were vari-

ously levied: cloth for sails – Tarquinia; raw iron – Populonia; arms and machinery (in addition to grain) – Arezzo. Evidently Etruria was regarded as a predominantly agricultural area, half ally, half dependency, and taxed accordingly.[10]

At the same time the upper-class tombs, always the most telling index of Etruscan prosperity, do not cease to parade wealth, ambition, and art. In Tarquinia the local tradition of decorating tomb chambers with murals persists. Departure, journey, and Charuns are the common themes, though the blessed dancers of old are also on occasion remembered.[11] In a different vein the François Tomb at nearby Vulci, probably best dated in the mid third century, has left us the grandest wall paintings in a heroic Hellenistic style that are preserved anywhere (below, pp. 412–14). It also introduces us to a new type of grave architecture – the last in Etruscan history – which started its short

309. Cerveteri, Tomb of the Painted Reliefs, early third century, rear wall, centre

career some time in the third century. The most elaborate example of this type, and one of the earliest, is the Tomb of the Painted Reliefs at Cerveteri (Caere) [309].[12] The customary chambers, separate and relatively private, have given way to an undivided interior; heavy, square pillars carry the low, almost flat ceiling, as in most late Etruscan tombs. Niches and stone benches throughout provide for as many interments as the place will hold. An ornate bed in the central alcove of the rear wall stands ready, presumably, for the owner and his spouse. Two badly battered sculptured heads jut forward from the pillars on either side. They turn towards one another, like the similar heads that sometimes flank contemporary Etruscan city gates; beneath them hang milord's walking-cane, his lady's fan, and other personal belongings proper to their rank and comfort. All objects are rendered in stuccoed relief; there are no wall paintings. Stuccoed arms and armour fill the upper zone; drinking cups, working tools, and a rich array of kitchen utensils are suspended on the walls of the middle pillars, crowded but in the neatest order. The whole room has been converted into one of art's strangest still lifes – truly a *natura morta*; one walks into it, from post to post, with amazement.

Nothing in the Etruscan cemeteries quite matches this decoration; we must consider it a fresh attempt at recreating the reality of life in the abode of the dead. It should be pointed out, however, that the innovations are not limited to the pictorial equation of tomb and home. The substance of the allegory, which combines the current concepts of the family community with the prevailing ideas of existence after death, has also undergone changes. The description of the place – the first part of the equation – is remarkably detailed, realistic, and non-mythical; humans are not represented at all. The method underlying this mute imagery differs about as radically from the humanized fantasies of the Tarquinian tradition as a still life by Chardin differs from the academic precepts of his time: it shows the furnishings but does not show their users. Yet the room was plainly provided for

many guests; the thought behind this puzzling layout was made overt in the large tombs of the outgoing third and the second centuries, especially in the Etruscan north, where the halls are filled with cinerary urns of stone or terracotta, shaped as miniature sarcophagi with reclining banqueters on the lid.[13]

This last version may well be the most consistent, in a realistic sense, among the various banquet mythologies in Etruscan art since the Late Archaic period. But we must also note that the gatherings staged by the small lid figures of the urns, as by so many puppets [310],[14] are a rather unexpected departure from the formal pairs of a squire and his lady on a shared couch whose portrayals launched the theme in Etruscan art (Tomb of Hunting and Fishing, Tarquinia; p. 189). To state this contrast briefly: (1) each participant occupies a separate couch (this rule holds for men and women alike; exceptions are rare); (2) the number of participants is variable – in principle unlimited – and distinctions of rank are rarely, if ever, discernible; (3) the burial locale feigns an undivided hall comparable to a Roman atrium; the participants assemble under one roof, in a common room.

A trend to make the homesteads of the deceased more capacious and hence more companionable comes to the fore after *c.* 400; this trend reached its peak in the grand banqueting halls of the Hellenistic tombs. We may reasonably assume that the new make-believe architecture reflected actual changes in the social order, and that the increase of participants corresponded to the rising number of dependants – freedmen, adopted persons, serfs, and foreign labourers of still lesser status – whom large rural households assembled under the paternal authority of a master with powers comparable to those of a Roman *patronus*. A new class of landowners and lords of large estates has taken its place beside the more urban aristocracies of the great merchants and seafarers.

In many respects this development ran parallel with the accumulations of arable land (*latifundia*) in the hands of a wealthy few which in Rome, after 133, the legislation of the Gracchi sought to redress and divide into small farms

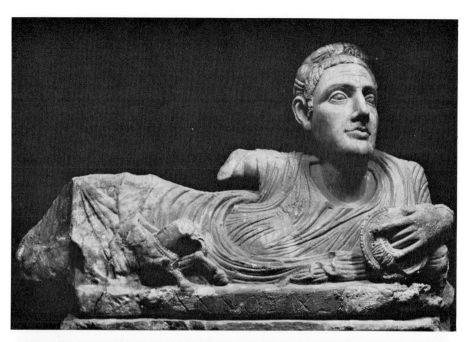

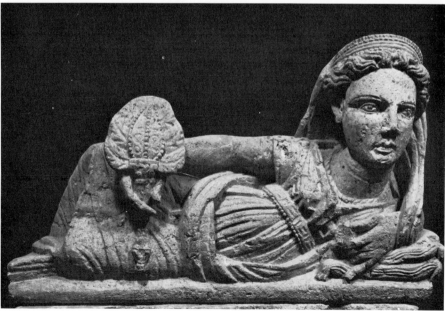

310. Lids of two ash urns from Volterra, second century. Alabaster. *Volterra, Museo Guarnacci*

worked by free owners rather than slaves. Thus in the country, if not in the cities, the social destinies of Etruria and Latium coincided once more. The Roman Senate apparently recognized this community of interest, and hence tended to support the rising landed nobility among its northern neighbours whom many members of this illustrious body may indeed have regarded as their equals. Yet there are signs that relations between master and slave were easier in Etruria than in Rome – though reverses occurred, as at Volsinii, where in 265 a populist faction assumed the government, thereby provoking Roman intervention. It is interesting that a decree of the rebels forbade the former owners to organize convocations and banquets. The edict evidently curtailed a right of assembly: the banquet carried political overtones.[15] Whoever designed the homely opulence of the Tomb of the Painted Reliefs [309] at Caere preserved, in effigy, the memory of a manorial household of this sort – with a sense of the idyllic, however, not forgetting lapdog and cat.

The cultural ties between Rome and Caere must have been very close. Livy tells us that by the late fourth century Roman families of rank were sending their sons there, to be instructed in Etruscan (ab urbe cond. IX, 36, 3). What precisely the young visitors from Rome read in Caere is not so clear. There were the 'libri Tusci' and the lore of devotions and ceremonies, much of which seems to have left an impact on Roman customs, for example the often-cited processions of noble funerals and the famous triumphs;[16] but in Etruria this was also a period of vivid philhellenism, and very likely some of the earliest Roman contacts with Greek letters

came about in the same way: through Etruscan intermediaries (p. 344). At any rate Caere appears as the giving partner, Rome as the receiver.

The evidence of Etruscan art and culture does not always fall in line with the political history of the period. In Roman politics Etruria functioned as a mainly agrarian auxiliary long before she became culturally countrified. One factor in this ambiguous situation was the Roman nobility, which continued to regard the patrician classes of the then reforming, often restless Etruscan society as its geographically nearest connections and natural allies. This rather parochial state of middle Italian interdependence did not fully end even during the third century, when Rome, but not Etruria, became an active bidder in the Hellenistic struggle for power, and her semi-archaic socio-economic order began to approach the hellenic and hellenized nations with whom she was to deal. Still, her innovations came late, hesitatingly. I name three, at random: hiring of mercenaries, i.e. a professional soldiery, besides the regular citizen armies; starting a Roman mint, a conspicuous late-comer in ancient international trade; the rise of a literature in the vernacular which included Greek with native themes, in direct contact with immigrant Greeks chiefly from south Italy. By c. 200 the cultural balance of Italy thus began to favour Rome, as the political shifts did earlier in the century. 'In the Second Punic War the winged Muse descended amongst the rough and bellicose people of Romulus.'[17] We accept the chronology but hedge about the allegory. Her wings may yet have been borrowed from an Etruscan spirit: Greek Muses have no wings.

CHAPTER 31

ETRUSCAN HELLENISTIC

Time of Transition: The Early Third Century

In the decades around 300 Greece embarked on that ultimate extension of her intellectual heritage which gave its name to the nearly three centuries of Mediterranean history now called Hellenistic. For the arts this means, first of all, a step beyond the Classical: the Hellenistic was Greek art in a new key. In Etruria during the same decades a corresponding search for change can hardly be detected. Apparently she entered into her own Hellenistic stage without an ostensible hiatus or turn of taste (pp. 355, 360, etc.). Among the various provinces of the then coalescing pan-Hellenistic community the Etrusco-Hellenistic sector thus occupied a separate place from the start. Its evolution, which was clearly irregular, calls for a brief commentary.

Once more I refer as the root of the matter to the special character of the workshops to which so much extant Etruscan art is owed. Their products – things designed for use, in typical shapes – favour the anonymity of the artists. On these grounds the Etruscan condition contrasts sharply with Hellenistic Greece, where the new art started from the studios of artists (especially Lysippus and his followers) who made themselves known as persons and whose work was much in the public eye. This fundamental inequality between two manners of organizing the artist's work must not be taken lightly. We found it deeply imbedded in the two societies which supported them, and the ensuing diversity of development in the arts of Greece and Etruria proved ineradicable. At no time did Etruria attempt to match the publicness of Greek art and artists, not even in the only domain of art which was public in fact: the decoration of temples. However ambitious and refined some of the Etruscan artistic industries had grown in

the Classical era, as happened with the Praeneste cistae and engraved mirrors, they all produced standardized classes of objects, each with its own characteristic shapes and uses, valued at home but hardly marketable abroad. In this regard the stone sarcophagi, cistae, and mirrors were alike: they all produced separate classes of standard furnishings. Room was left for variety, and often splendidly exploited, in the execution and the decoration, but the basic shapes of the objects stayed fixed by tradition. Not that the awareness of international standards had dwindled in Etruria – quite the contrary; in many instances it appears to have strengthened, sometimes to a point of total assimilation with imported models, as we shall soon see. Rather the sense of competition with the prevailing Greek or Greek-inspired art had become less keen among the local artisans, allowing the latter to follow their own devices in a more relaxed and self-confident mood than often in the past. The quality of their products differs as drastically in these last phases as it had in most earlier Etruscan art; but the more skilled workmen give us the impression of going about their business with remarkable ease, the ever-present Greek comparison notwithstanding.

Thus the split between two ways of art, one internationally orientated and hellenizing, the other more homebound, inclined towards the nearer realities of life and their depiction in a more domestic vein (pp. 290, 305), also enters into our diagnosis of the Etruscan transition from Late Classical to Early Hellenistic. During the fourth century (p. 396) the division hardened; the presence of this internal dualism, and its significance for the last stages of Etruscan art, were already recognized by Furtwängler.[1] In order to trace the gradual acceptance of Hellenistic styles in Etruria one must recall that during the critical decades about 300 Etruscan hellenizing work shows little contact with that em-

phatic Asianism which later found its paragon in the Pergamene school. Instead in Etruria the hellenizing art of the late fourth and early third centuries took to a different, tranquil, and Neo-Classical mode, perhaps a reflection of Early Hellenistic Atticism (p. 359).

Since much of this Etruscan art – sculpture and design alike – is combined with objects of long standardized form and function, its Neo-Classical bent is apt to confirm that semblance of formal stability in a time of transition which causes the problem here at issue. Within the large standard classes such as the stone sarcophagi or engraved mirrors, formal continuity is often more apparent than are the symptoms of change. The pace and visible signs of the formal progress which nevertheless took place are not always equally obvious. Hence, chronological distinctions between Etruscan objects of the outgoing fourth and the beginning third centuries which are based on style alone are even more precarious than elsewhere in Hellenistic art. Moreover, hellenizing and domestic trends can easily find a place within the same standardized series, and may indeed be found side by side in a single monument. Even so, it does not seem unreasonable to describe some of these typical classes either as prevailingly hellenizing, like the engraved mirrors; or as essentially domestic, which might be said of the sarcophagi. But as the century advances, the formal development from which neither camp was exempt tends to approximate, each in its own way, the dominant Hellenistic traits. This was not done, however, without a certain discrimination: appropriateness for special themes – battle, procession, mythical idylls, etc. – now often provides the grounds for adopting a more grecizing or a more homely manner of representation in keeping with the subject. Thus during the final two centuries of Etruscan art, style and subject drew nearer together. Simultaneously in the formalization of set thematic schemata, style surrendered its pristine absoluteness to the rule of particular and often generic subjects, shown as habit expected to see them. We are approaching the generic styles of the future art of Rome.

Sculpture, Large and Small

Etruscan works of about 300 include a rising contingent of large sculpture beyond statuette format, made either of terracotta or of native stone. The stone sculptures are funerary monuments; the finest of them are the later sarcophagi from Tarquinia, discussed above (pp. 395-6, illustration 302). The terracottas are votive; the most popular sort are life-size heads, sometimes complete and freestanding, sometimes merely a mask or a profile in relief (above, Chapter 29, p. 393, illustration 304, and Notes 20-2). These mass-fabricated proto-portraits were dedicated in many parts of central Italy: in southern Etruria, Latium, Campania, and in the new Roman colonies in Samnite territory.[2] Apparently the popularity of this kind of ex voto spread with the widening influence of Rome. But the finest heads were still produced in Etruria. Some of them approach true portraiture; a few may be actual likenesses.[3] A shoulder bust from Caere, now in the Vatican,[4] which is generally dated in the first century B.C. but has recently been assigned to the third, is an outstanding example of the Etruscan ability to individualize an object produced mechanically. The front of the head is mould-made, but the features are so retouched as to portray a haggard woman with a scarred face and anxious eyes, her thinning hair swept back severely from a high and bony forehead. Hafner compares this head with some of the unflattering 'portraits' on Volterran urns (above, illustration 303); it is also an anticipation of the veristic Roman style of the first century B.C.

To turn to smaller sculpture, the bronze ex votos of the Early Hellenistic period are something of a problem. Apparently the Classical types of the male and female worshippers, the men sometimes apparelled as warriors in full panoply [237] but oftener as civilians wearing the semicircular toga [216], the women dressed in the Classical Etruscan fashion [227, 228], continued to be popular. A handsome example of the female type was found at the site of the Latin colony of Norba in a votive deposit con-

taining material of the third and second centuries.[5] Her dress, like that of the Classical ladies [227, 228], her face, and the arrangement of her hair in stiff locks brushed in a wide sweep to either side resemble the Dionysos figure on the lid of the Ficoroni cista [276], and her hipshot pose is an exaggeration of his. The figure is still completely frontal. A youthful *togatus* in a private collection in Switzerland is perhaps slightly later in date.[6] His pose is the reverse of the lady's: left hip out, right knee bent. His face is framed by the arching locks of Alexander the Great, and his head is tilted to the side, his eyes rolling soulfully upward in an emotional way new to Etruria. He too is a frontal figure, and both heels are fixed firmly on the ground.

In contrast to the votive bronzes, decorative figures are often new types used in new ways. The lively figures or groups that crowned the candelabra of the fifth and fourth centuries seem to have gone out of fashion by the beginning of the third; the boy with the rearing horse [255] must be one of the latest. Figured censer bases, like those of illustrations 257 and 258, became rare, and disappeared in the course of the third century. Cista handles, however, two- and three-figure groups like those popular in the fourth century [259, 276], were still made at Praeneste, all but a very few designed in a late version of the Classical Etruscan style.

The cista handle of illustration 311[7] illustrates handsomely the new hellenism in Italy at this time. It is a two-figure group, Dionysos supported by a young satyr whose eager, muscular body is vividly contrasted with the tall, delicate and sinuous figure of the young god. They move forward, intent on each other, their arms about each other's shoulders, their heads turned in a romantic meeting of eyes. Dionysos crosses right leg over left in the time-honoured Etruscan 'eccentric stance'; otherwise the complicated triangular composition with its moving, turning figures is a new thing in Italy, a reduction, one must suppose, of some lost Hellenistic monumental group, curiously successful, resting almost weightlessly on the curved top of its polished cylindrical base.

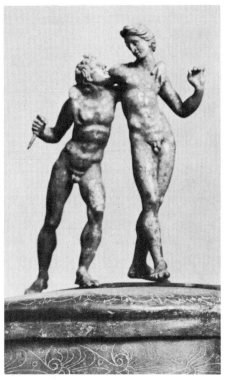

311. Dionysos and satyr, cista handle from Praeneste, late third century. Bronze.
Palestrina, Museo Archeologico Prenestino

The thick clustering locks of hair, rough and tousled on the satyr's head, swept into a soft, heavy roll to frame Dionysos' face, are also new. Windswept, trailing across a cheek or the nape of the neck, massed in heavy, drooping clusters on the forehead, the hairstyles of the Hellenistic period are a far cry from the neat, tight locks of Classical Etruria.

Other bronze utensils, strigils, dishes, jugs of various shapes also used figurines as handles.[8] Winged figures were particularly in demand as supports for the wide, shallow bowls of paterae.[9] Illustration 312 in Cleveland[10] shows one of these handles, the figure of a young girl, nude except for sandals and jewels and a clinging scarf knotted on the right shoulder. Her wings

312. Lasa, patera handle,
late third–early second centuries. Bronze.
Cleveland Museum of Art

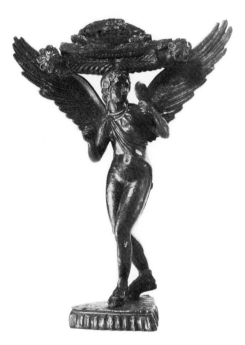

are spread wide; she stands, half crouching, left leg crossed once more over right in the 'eccentric stance', her head turned to the left and raised. She holds a small mirror in her left hand and is evidently admiring her silver necklaces and the linked chain that binds her hair. Clearly she is a Lasa, one of the winged beauties who appear with Aphrodite–Turan on engraved mirrors (above, p. 362 ff.) or float on the Chiusine duck askoi [273]. Her pose and her passion for jewellery are Etruscan; the soft modelling of the young body and the dreaming oval face are echoes of contemporary Greece.

Painting

The paintings from the François Tomb at Vulci (above, p. 405) rank with the finest from Etruria. They covered the walls of the central chamber

of a princely tomb whose many rooms contained burials dating from the mid fifth to the early second century. The paintings themselves have been variously dated, most convincingly to this transitional period between the Late Classical and the mature Hellenistic.[11]

The room is T-shaped, the cross-bar a broad rectangle at right angles to the dromos, the stem a wide anteroom leading to the main burial chamber. Its walls are crowned with a rich polychrome cornice; its upper member, a half-round carved in relief, is covered with a scale pattern in blue, red, yellow, white, and black; a woman's face breaks this pattern in the centre of each cornice; beneath these, in the main chamber, a knot of red and blue morning glories is painted on a white ground. Below, the architectural members are painted in perspective – an egg-and-dart moulding, white with shadings of blue and red, and a running meander. These are all elements taken from Greek experiments in perspective of the fourth century.[12] Beneath the meander runs an animal frieze, an undulating chain of lean, sinuous, mannered creatures whose nature and style are also fourth-century Greek.[13]

The figure scenes which cover the wall below are not part of the normal cycle of tomb painting as we have seen it in Etruria; they are divided between scenes from Greek mythology and scenes from Etruscan history (or legend) and Etruscan daily life. Except for the front wall, where the scenes that flank the door represented Ajax and Cassandra and Sisyphos and Amphiaraos in the underworld, the division is strictly axial: Greek to the left, Etruscan to the right. Flanking the door in the left wall are the wise old men of the Greek army before Troy, Phoenix and Nestor; balancing them on the right wall were the portraits of Vel Saties, one of the family whose tomb this was, and a woman. Her portrait has not survived, but his is one of the best preserved figures from the tomb [313]. He is shown with his dwarf Arnza, who carries a leashed bird perched on his left hand; the fleshy body with its big head and hands and stunted legs is tucked under the corner of the

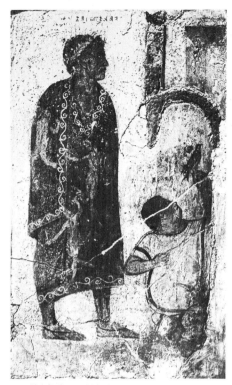

313. Vel Saties and his dwarf Arnza, detail of a wall painting from the François Tomb, Vulci, mid third century. *Rome, Villa Albani*

right wall's painted door jamb, a bustling figure, lurching forward. Vel Saties himself walks slowly behind him, wearing Greek sandals and an embroidered purple cloak, the rectangular himation, not the toga; his head is crowned with leaves. Both heads are highly individual; the faces are modelled in strokes of colour which gives them a real look of life and atmosphere, though the chiaroscuro is still entirely within the outline of the figures – they cast no shadow.

The balance, or contrast, between Greek myth and Etruscan tradition is emphasized by the two compositions that flank the door of the anteroom. On the left, the duel of Eteokles and Polyneikes: Polyneikes, crouched close to the ground under the corner of another painted door jamb, stabs upward at Eteokles, who leans

over to thrust his sword down into his brother's throat;[14] both naked figures spout blood; the interlacing of legs and arms, the twist of Eteokles' body create a closed, spiral composition of considerable ability. This group is balanced by another, less well composed and less evenly matched. Marce Camitlnas, a naked bearded warrior armed with a sword, springs forward with that cross-legged leap characteristic of Etruscan Classical figures;[15] he seizes by the hair the unarmed and cringing Gneve Tarchunies Rumach – a Tarquin of Rome whose name is unknown there. Tarchunies, huddled in his toga, white with the red border of the toga *praetexta*, seems to have been roused from sleep to face death at the hands of his Etruscan enemy. Marce Camitlnas is otherwise unknown; was he perhaps an ancestor of Vel Saties, and was this murder of an unarmed man one of his memorable deeds?

This scene is often associated, perhaps correctly, with that on the right-hand wall of the antechamber, which also shows a series of attacks on sleeping men. The scene on the left-hand wall shows the slaughter of the Trojan prisoners at the tomb of Patroklus, that on the right the rescue of Caile Vipinas by his comrade Macstrna, while three more of his companions, among them his brother Avle Vipinas, deal with his captors. Alföldi has brought out vividly the contrast between the fate of the Trojan prisoners and that of the Etruscans;[16] again one may wonder whether Vel Saties numbered one of his ancestors among the followers of the great condottiere Caeles Vibena who gave his name to the Caelian hill at Rome.

The Slaughter of the Trojan Prisoners is one of seven illustrations of this scene, all taken from a single original, all found in Etruria, and all of the fourth century or a little later.[17] The version in the François Tomb, the fullest and best, is mostly made up of simple, standing figures, the turn of whose heads rolls the scene inward towards its central focus, the savage Achilles, who leans forward to slit the throat of the young Trojan seated on the ground in front of him. These two are framed by Charun, blue-

314. Vanth, detail of a wall painting from the François Tomb, Vulci, mid third century. *Rome, Villa Albani*

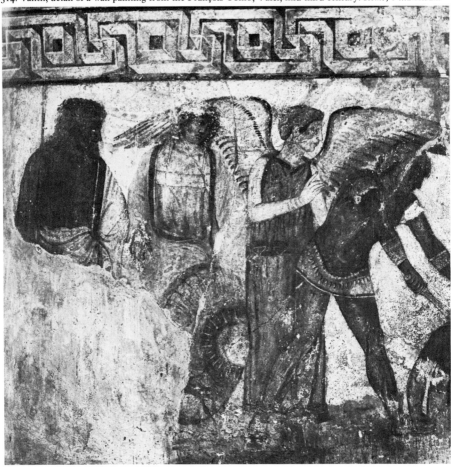

faced and sneering, and Vanth, surely the loveliest of all Vanths, with yellow hair and a compassionate face [314]. Her rainbow-coloured wings are spread wide; one shelters the ghost of Patroklus, who stands beside her, the other shadows Achilles himself, fated to die so soon.

The rescue of Caele Vibenna by Macstrna has no counterpart in Etruscan art; the composition, merely a series of two-figure groups lined up along the wall, may have been designed especially for this tomb. But another exploit of the Vibenna brothers has been preserved in four copies, the oldest of which, like the François

Tomb, belongs to this Early Hellenistic period (below, pp. 415–16). It is surely no coincidence that the first paintings in Rome of men in triumphal dress and the first painted battle scene set up on the wall of a public building in Rome also date from the first quarter of the third century.[18]

Engraving

Engraved mirrors and cistae were as popular in the third century as they had been in the fourth. The scenes tend to be crowded, with many overlapping figures and a prolixity of detail. On the

mirrors the figures are often packed into the circular space almost without head room, the outermost of the group bent uncomfortably to fit the curve of the mirror's rim.

A mirror from Bolsena, now in London[19] [315], manages to include, besides the actors in the scene, a certain amount of background: a rocky landscape where gnarled trees grow, its remoteness and wildness emphasized by the head of a little satyr who peers over the top of a cliff at the action taking place below, a brother of the satyr boy who plays the pan pipes behind the throne of Arcadia in the painting from Herculaneum of the discovery of Telephus.[20] In the foreground sits an Apollo-like youth solemnly playing a lyre, and a boy listening with bent head

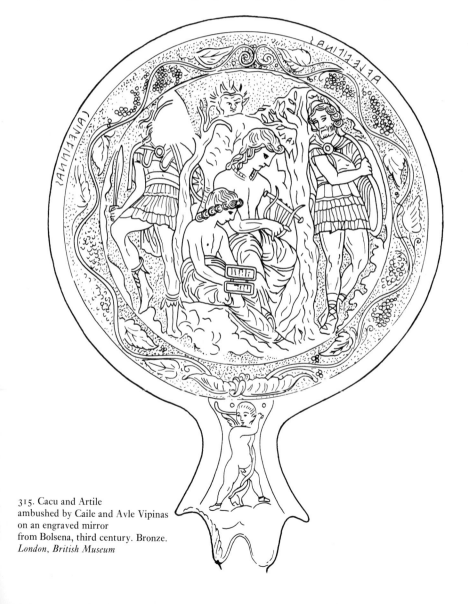

315. Cacu and Artile
ambushed by Caile and Avle Vipinas
on an engraved mirror
from Bolsena, third century. Bronze.
London, British Museum

while he holds an open diptych on his knees. On either side stands an armed warrior, half hidden by the trees that frame the seated pair; the musician's name is Cacu, the boy's Artile, the warriors are the brothers Caile and Avle Vipinas. The same scene is illustrated on three ash urns from the Clusine region.[21] Details vary considerably, but the general meaning seems clear. Artile has come to the sacred grove of a musician-seer, Cacu, for advice or help; the Vibenna brothers have tracked him down. But what action they will take when they have heard the response of Cacu – they are obviously listening to it, in the mirror's version of the scene – is quite unclear. It is the picture of an instant, of a moment of decision rather than of physical action; but, not knowing the story, we cannot tell what the decision was to be.

This mirror and the urns that resemble it must be echoes of an Etruscan historical painting. Perhaps the subject should be called legend rather than history, but it is not myth and not Greek. Like the rescue scene in the François Tomb, where the Vipinas brothers are also protagonists, the subject is Etruscan; even more than the painting, the mirror and the urns prove that the stories of the two brothers were not regional, not confined to Vulci: the Vipinas were, in effect, national heroes. For the first time one gets the impression that the Etruscans thought of themselves, not as a league of separate states, but as a single people.

Another Etruscan scene is engraved on a mirror from Tuscania [316] now in Florence.[22] Again it is set in a wild, rocky landscape, at sunrise, for Dawn gallops her chariot overhead and the sun's spiky rays stick up from behind a hill. But the landscape is almost blotted out by the five massive figures of the central composition. To right and left a male figure, nude except for a cloak, looks towards the main scene. They are divinities; the bearded god on the right is named Veltune (Voltumna, Vertumnus, *deus Etruriae princeps*). His presence indicates that the moment is one of great importance. A young man wearing a tunic and cloak and a cushion-like cap with a high conical projection bends forward over a liver which he holds in the left hand and

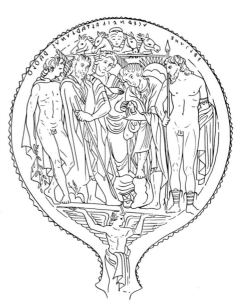

316. Scene of haruspication on an engraved mirror from Tuscania, third century. Bronze.
Florence, Museo Archeologico

317. Triumph on a Praenestine cista, third century.
(West) Berlin, Staatliche Museen, Antikenabteilung

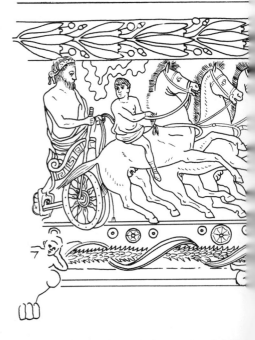

fingers with the right, while a lady and a richly dressed, bearded man listen intently to his explanation. The bearded man is Tarchon, the legendary founder of Tarquinia; the youth with the priestly cap is clearly a haruspex; his name is Pava Tarchies. One would expect Tages, the miraculous boy sprung from a furrow in the fields of Tarquinia who taught the *disciplina etrusca* to the princes of Etruria (Cicero, *de divinatione* II.23.50; Censorinus, *de die natali* IV.13); but Tages' story comes to us from sources considerably later than the mirror, and this may be an alternative version of the revelation of the *disciplina etrusca*. It is at any rate our only illustration of a haruspex in action.

Among the later Praenestine cistae there is one that shows a scene which is neither Greek nor mythological, though at least one divinity is present [317].[23] This is the representation of a triumph, though its details do not entirely coincide with those of the Roman triumphs of imperial times. The action takes place outdoors, on a rocky ground brightened by a huge morning-glory, apparently under a cloudy sky – the wavy lines that loop down from the upper border are very like those used to represent the darkness of the underworld in some Etrus-

can tomb paintings [261, 262]. The victorious general, wreathed with laurel and carrying an eagle-topped sceptre, is pouring a libation over a tripod censer; he wears a long-sleeved tunic, curiously embroidered trousers, and the general's *paludamentum*. His clean-shaven face is middle-aged and fleshy, with heavy calliper lines running from the nostrils to the corners of the mouth. Behind him stand a *camillus*, a priest, and a *victimarius*; the bearded priest's torso is bare, though he covers his head with the edge of his great cloak as Aeneas is to do later on the Ara Pacis: the sacrifice is to be performed *capite velato* in the Roman manner. In front of the general a young man with flowing hair, helmeted and wearing a cloak slung around his hips, leaps forward to grasp the harness of the leading horse of a four-horse chariot. A stately, bearded personage stands in the chariot; he is nude except for his voluminous cloak, and his hair is bound with a heavy fillet like the bearded head from Orvieto [239]. This is altogether a Classical figure and may well represent the god Jupiter himself in his chariot. The youthful warrior at the horses' heads may also be a divinity: Roma leads home the chariot of Titus on his arch, and apparently a Lar Militaris leads

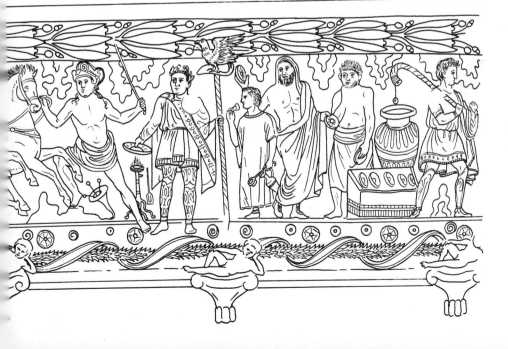

the triumphal chariot of Septimius Severus at Lepcis.[24] Perhaps this is a Lar Militaris too. Two young boys ride the trace horses of the chariot, and behind it walks a soldier wearing a tunic and wreathed with laurel, like the soldiers of Titus' triumph but carrying a *lituus* over his shoulder like the attendants of Etruscan magistrates on their sarcophagi [246]. The combination of Greek, Etruscan, and Roman details is fascinating and puzzling; apparently the 'triumph' has not yet jelled iconographically. Possibly this is not a Roman triumph at all, but a Praenestine celebration. One must remember that the Praenestines were redoubtable soldiers who late in the third century held Casilinum against Hannibal himself (Livy, 23.17.19), and proud men who refused Roman citizenship when it was offered them as a reward for their courage (Livy, 23.17.20).

THE SECOND CENTURY AND LATER

At the end of the Second Punic War, Rome was recognized by the Hellenistic world as one of its great powers, and the dominant power in the West. The second century was to prove her dominant in the East as well. The enormous booty from that century's wars enriched the state and enlivened the city; familiarity with the elegancies of life in the great Hellenistic cities introduced new tastes (usually denounced as vicious), new types of buildings, new styles in architecture, sculpture, and painting.[25] And much of Italy shared in Rome's prosperity and dynamic exuberance. The beautiful tufa architecture of Samnite Pompeii may serve as illustration.

There was wealth in Etruria, too. Tiberius Gracchus, on his way to join the army at Numantia in 137, found southern Etruria a region of great estates cultivated by foreign slaves (Plutarch, *Tib. Gracchus* 8.9), the *latifundia* that everywhere in Italy were replacing the smaller independent farms of an earlier day. The owners of the estates that Tiberius describes were the noble families of Caere and Tarquinia, such as the Pumpu of the Tomb of the Typhon (below, p. 419). It must have been

the heads of such families who marched on Rome in 91 to protest against the agrarian laws of M. Livius Drusus 'because they thought that the Roman public domain which they were cultivating, would at once be taken away from them and that in many cases they might even be disturbed in their private holdings' (Appian, *Bell. Civ.* 1.36, tr. E. I. Robson).[26] Etruscan society apparently still recognized only two classes, masters and dependants; whether the latter were slaves, or serfs, or clients is not always clear. The terrifying slave revolt of 196 which the Roman legions had to put down, 'flogging and crucifying the leaders, returning the others to their masters' (Livy, 33.36.1), was probably, like the earlier slave revolt at Volsinii, a desperate bid by these dependants to gain independence.[27] Archaeological and epigraphical evidence suggests that the line of demarcation between master and bondsman was at least growing fuzzy (see above, p. 408). Particularly in the north, it seems, a middle class – of freedmen? – was demanding a certain elegance in its surroundings, a demand met in part by the industrious manufacture of cinerary urns at Chiusi, Volterra, and Perugia (above, illustration 310).[28] Most of these urns, among them the finest, are products of the second century and reflect, like Pompeii's architecture, the renewed economic vigour of Italy after the close of the Second Punic War.

By 88, at the end of the Social War, all Etruscans, whether they liked it or not, were Roman citizens, and Latin was the language of law and commerce in the Etruscan cities. Etruscan inscriptions grow rarer, though sometimes a single great family will be stubbornly divided on the proper language to use in its funerary inscriptions, and bilingual epitaphs are not uncommon.[29] At this point, perhaps just because Etruscan gentlemen were now accustomed to talking Latin, Romans began to take a scholarly interest in Etruscan subjects. The Sasernas, father and son, were agronomists of the second century whose works are quoted by Varro, Columella, and Pliny. More important to the Romans were the ritual books of the *disciplina etrusca*, translated into Latin by Cicero's friend

Aulus Caecina, and into Latin poetry by a Tarquitius Priscus, apparently a member of a distinguished family of haruspices.[30]

The art of Etruria in these last centuries was greatly affected by contemporary Greek art; it could scarcely help being so, considering what a lot of this was now domiciled in Italy. But Greece's influence was not felt alike in every category. In particular the world of the dead was still an Etruscan domain, where the dignities of the departed were painted and carved and inscribed in their tombs to remind the creatures of the underworld how important they had been in life, and how they expected to be treated in their new home.

Funerary Painting

The latest Etruscan painted tombs seem to be no later than the second century. They are all of considerable size, with a single chamber whose roof is supported by a central pillar and around whose walls are carved stepped benches to receive the members of the family and its dependants, a simplification of the scheme of the Tomb of the Painted Reliefs at Caere (above, illustration 309). The most elaborately decorated is that of the Pumpu family at Tarquinia, called the Tomb of the Typhon [318].[31]

Above the three broad benches that run round the room, the walls are painted with a frieze of dentils in perspective, their shadows falling to the right on the left-hand wall, to the left on the right; the doorway, the true source of light, is treated as if it were the painted source. Above this runs a frieze of yellowish rosettes on a red ground, also shadowed as if the light fell on them from the doorway. Above these, a running wave pattern, painted black, represents the sea, for above it red and white dolphins are leaping. All this belongs to the earlier repertory of tomb paintings: perspective architecture in the François Tomb (above, p. 412), the sea and its dolphins in the much earlier Tombs of Hunting and Fishing and of the Lionesses (above, illustrations 120 and 125). But here their meaning is reduced to mere ornament; the painted architecture is no cornice, the sea is no longer

the stream of ocean over which the dead must pass.

This frieze is broken in the centre of the right wall by a processional scene. Lictors and musicians surround two important persons whose names are inscribed above them, Laris Pumpu cechase, Laris Pumpu zilath, magistrates of Tarquinia. Moving with them are a Fury and two Charontes, the traditional guides and herdsmen on the road to the underworld. But the composition is new: the figures are crowded together, overlapping so that the heads of figures in a second file appear behind or above those in the foreground; faces are seen in three-quarter view or frontally; poses and gestures are varied. This composition, as Pallottino says, looks towards the Ara Pacis.[32] Its direct source must have been some large Greek figure composition of the Hellenistic period. If we can take any of the paintings or mosaics from Pompeii for trustworthy imitations of Greek works, the Alexander mosaic from the House of the Faun is our best candidate,[33] but there must have been

318. Tarquinia, Tomb of the Typhon, second century, Typhon. Wall painting

quieter compositions as well. The dark faces of the figures in the tomb painting have glittering white eyeballs and vivid highlights, very like the heads in the mosaic.

In addition to old motifs treated cursorily and old motifs in a new style, this tomb offers new, modern motifs as well. The central pillar is painted on two sides with the figure of a winged demon whose legs end in twisting snakes [318]. His torso leans forward, boldly foreshortened, while his arms are raised to hold up the pillar's moulded and painted cornice. Shaggy hair, wings, and serpents are blue, the muscular body is red-brown with highlights of pale brown and rose. Though the body is outlined and a few interior details are drawn in black, the modelling is almost entirely achieved in colour, a painterly approach to foreshortening that suggests a painted rather than a sculptured original.[34] The frontal pose, the pathos of the upturned head, the exuberance of the splendid torso, all lead one to suppose that the prototype was Pergamene.

The frieze above the Typhons is made up of a row of dentils, a row of lions' heads in arched recesses which anticipate decoration of the Second Style at Pompeii,[35] and a crowning egg-and-dart moulding. The back of the column also anticipates the Second Style: a caryatid figure of a winged lady whose dress falls in narrow, archaistic folds, and whose legs curl up in acanthus tendrils [319].[36]

Funerary Sculpture

The ash urns of this period have already been mentioned (above, illustration 310).[37] The rite of cremation became popular again in central Italy in the Hellenistic period, not only in northern Etruria but in Latium and even in Rome. These southern urns, like a number of the Etruscan examples, are shaped like a footed box with a gabled lid, descendants of the earlier house- and hut-urns [320].[38] But in Etruria the 'banqueter' urns are still the most popular. Most of them are the work of artisans rather than artists. The effigies make no attempt at realistic portraiture; at best they are 'ethical portraits'

319. Tarquinia, Tomb of the Typhon, second century, painted caryatid from the central pillar

in the Greek sense – the middle-aged man whose weight has overwhelmed him, the young man with springing locks of hair, the fashionably dressed lady. But the finest urns, like the best of the votive terracotta heads (above, p. 410), push ethical portraiture almost to likeness. Far more

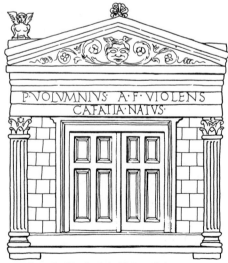

320. Perugia, Tomb of the Volumnii, house-urn of P. Volumnius, late first century. Marble

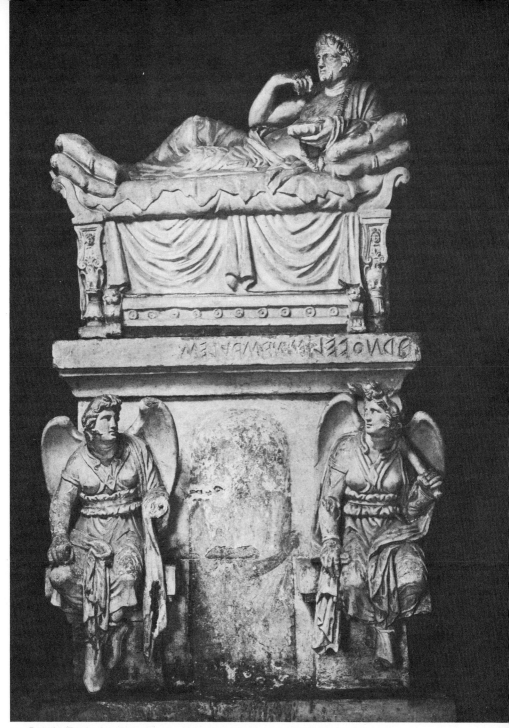

321. Perugia, Tomb of the Volumnii, urn of Arnth Velimnas, second half of the second century

than any of the sarcophagus figures of the earlier Hellenistic period, the effigies of these urns strike us as personages, and personages of a particular sort: widely cultivated philhellenes. The elderly man on a terracotta urn in Worcester from Vigna Grande near Chiusi, the middle-aged man on the cover of an alabaster urn at Volterra, the young Larth Sentinentes Caesa from the Tomba della Pellegrina at Chiusi are all such;[39] Arnth Velimnas, son of Avle, from the Tomb of the Volumnii at Perugia [321][40] is another. In these figures, which date from the second half of the second century, the peculiar hellenism of Etruria is illustrated at its best. The bodies are as carefully designed and finished as the heads. The fleshiness of middle age is taken as an opportunity to create smooth convexities that melt into one another and contrast with the smaller, livelier facets of the drapery that covers shoulders and lower body. The heads are individual, if not true portraits – Larth Sentinentes prematurely bald, serious, with sunken eyes and parted lips; Arnth Velimnas half frowning, full lips pressed together, thinking.[41] They all have the deep-set eyes and romantically handsome features of Hellenistic ruler portraits – Arnth Velimnas also has their thickly clustered heroic hair – but they lack their rather hectic passion and theatricality. These gentlemen are more self-contained than the Hellenistic princes, closer in character to Roman portraits of the next century.

The banqueting couch of Arnth Velimnas is carved in the round, with elaborately turned legs and swans' head finials. It is heaped with cushions and strewn with a richly hanging cloth over which is spread a beast's pelt. One remembers the scandalously luxurious dining couches that Manlius Vulso brought back from Asia in 186 (Livy, 39.6.7). The couch stands on a high base, this too perhaps a Greek innovation, but the base's decoration is thoroughly Etruscan in its content. On either side of an arched doorway sits a muscular Vanth, dressed in the Vanth's characteristic costume of short skirt, crossed baldrick, hunter's boots. The hair of the one on the right is wreathed with snakes, and she carries a lighted torch over her left shoulder.

Both sit with crossed legs and feet dangling; they lean forward and bend towards the doorway, the outer shoulder and wing dropped; their heads are turned sharply towards one another, chins lifted, deep-set eyes rolling upward. Here the passion and pathos of the tradition of Scopas is permitted. The figures are carved all but in the round, and their massive bodies make a grim contrast to the doorway they guard. It is a painted door, and out of it peer painted ghosts. Are they hoping to escape, or waiting to welcome Arnth Velimnas?

One of the few late sarcophagi, from Chiusi (now in London[42]), may be compared with this urn from Perugia. It is of terracotta, and on its lid reclines a lady of heroic size, Seianti Thanunia Tlesnasa [322]. She seems to be in her boudoir, for she holds a mirror in her left hand while she adjusts her veil with the right. This is the ritual gesture that proclaims the bride; the lady on the ash urn from Città della Pieve lifts her veil with much the same gesture [243]. It often identifies the goddess Hera, as for example on the Pontic vase with the Judgement of Paris (above, illustration 100). Seianti Thanunia is wearing bridal finery: a soft, loose, sleeveless dress, fastened on the shoulders to form a V-shaped neckline, girdled high under the breasts; over it a himation that covers her head and shoulders and is wrapped around her lower body. The dress is white with purple borders; girdle and brooches are gold; there are pendant earrings in her ears, a necklace of pendants around her neck, two bracelets on her right arm, six rings on her left hand, and a diadem in her hair. The jewels betray the Etruscan taste for finery but the dress is Greek, the Hellenistic peronatris and himation. In Greece the peronatris was usually worn over a sleeved chiton, but in Italy, where it became very popular, it was worn without one.[43] It is the characteristic dress of later Hellenistic votive bronzes, Etruscan and Latin [325], and became the stola of the Roman matron, as the himation became her palla.

The lady herself has the massive contours of the Vanths from Arnth Velimnas' urn; her broad face, framed by classically parted and waved hair, is impassive except for the intense,

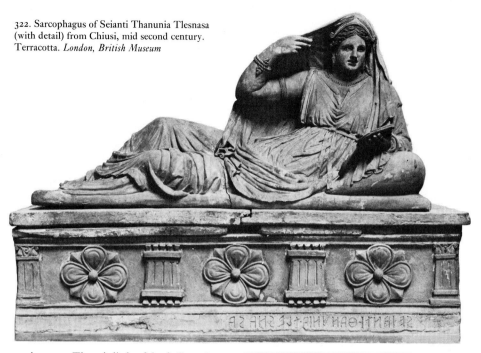

322. Sarcophagus of Seianti Thanunia Tlesnasa (with detail) from Chiusi, mid second century. Terracotta. *London, British Museum*

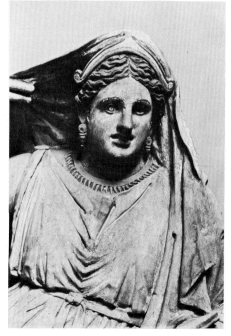

staring eyes. There is little of the feeling of personality and intelligence that Arnth Velimnas' head generates. Her head is Neo-Classical, but the twist of the over-long torso and the delicate ripples of the peronatris contrasted with the heavier folds of the himation are derived from Greek art of the second century. For all their great differences, one can see that Seianti Thanunia Tlesnasa and the Aphrodite of Melos are contemporaries.

Funerary Reliefs

Most ash urns were decorated with a relief on the front, like the fronts of the Classical sarcophagi. Sometimes this showed a journey, or a magistrate's procession recalling the scene on the limestone sarcophagus from Caere [246], sometimes it showed the gate of the underworld and the demons that guard it [321], oftenest it was a scene taken from Greek mythology, by preference a myth of tragic violence: the death of Oenomaos or Hippolytus, the Sacrifice of Iphigeneia, the murder of Aegisthus and Cly-

temnestra. Our illustration 323[44] shows the sculptured front of the alabaster urn of Avle Cneuna of Volterra. The rectangular composition is framed above and below by architectural mouldings; the upper is a triglyph-rosette frieze like that on the front of Seianti Thanunia's sarcophagus [322]. At either end, a figure on a moulded base acts as a caryatid, framing

each carries a blazing torch in the left hand. Not maenads, nor Lasas, but Vanths, as suits the grim central composition, the Curse of Oedipus.[45] The blind king kneels in the centre foreground, dressed in the long-sleeved tunic of stage royalty, with a king's staff in the left hand. His face is stern, and his right hand is raised in the gesture of one taking an oath – this is not the

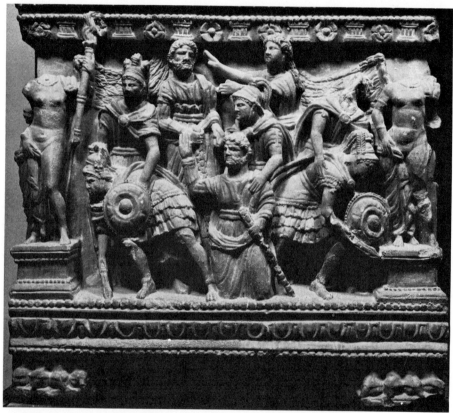

323. Oedipus and his sons, relief from the ash urn of Avle Cneuna from Volterra, mid second century. Alabaster. *Volterra, Museo Guarnacci*

the composition vertically. These Venus-like women wear torques and twisted bracelets; their cloaks are bunched on the left shoulder and caught between the legs like those of the maenads of the Ariadne pediments from Cività Alba [324]. They are winged, their wings stretched out behind the central figures, and

sorrowing Oedipus of the Talamone pediment or of certain other urns that illustrate the same story.[46] Behind him stands a young man, his squire, leaning forward a little, his left hand protectingly on Oedipus' shoulder; to either side his sons are falling, collapsing in death, their backs turned to the father who cursed them,

their squires helplessly trying to support them. Behind and above them all stands Creon, also in royal robes, imperturbably waiting while the distracted Jocasta, with dishevelled hair and arms outstretched, rushes towards him. This is a scene from Euripides rather than Sophocles;[47] yet it is not actually a picture of a single episode. The curse and its fulfilment, the menace of Oedipus' banishment and the threatened dishonour to Polyneikes' body, are all together in a single frame.

The figures, blocky and square-headed, are arranged in a carefully balanced pattern which covers almost the entire background. The brothers' bodies curve strongly out to the sides, away from the central pair, Oedipus and his squire, the arched line of their backs repeated by the sweep of the Furies' wings above them. The wedge-shaped central group, Oedipus, squire, Creon, and Jocasta, is turned outward, not completely but enough to give an illusion of forward movement. The figures are packed close together in three overlapping planes: Oedipus and his sons low in the foreground, their attendants standing behind them, Creon and Jocasta on a higher, invisible level, their heads projecting above and in front of the triglyph frieze that marks the upper frame of the relief. This kind of relief composition, in which the more distant figures are put on a higher level so that they can be seen above the figures in the foreground, seems to have been invented in Etruria at this period. By no means all ash-urn friezes are designed in this way, but many are.[48] This is the scheme of Roman historical reliefs from the time of Trajan and later; how it may have come about will be discussed in the next section.

Architectural Sculpture

Many new temples were built in Etruria during the second century, and many more were refurbished then with up-to-date terracotta decoration. Sometimes the old scheme of acroteria, antefixes, and revetments was retained: for example in the decoration of a little shrine at Vulci and another at Bolsena, or in the first decoration of the Capitolium at Cosa.[49] But oftener a new system appears. The decoration is of a different order – the place of the statues is in the pediments. In Etruria this form of architectural decoration is an innovation. Thus far no Archaic or Classical Etruscan temple has been found to have a figured pediment in the Greek manner; the domestic pedimental ornament was the relief plaque nailed to the head of the ridge-pole above the entrance [163]. When, at this late hour, we see Etruria turn to the Greek canon, we feel faced with a historical paradox. As long as the figured pediments were the pride and glory of Greek temples, from Archaic times to the mid-fourth-century pediment at Tegea, their Etruscan coevals had consistently disregarded them. So indeed did most of Italy, including the Greek south. Yet, in the middle of the Hellenistic period, when in Greece the interest in sculptural pedimental decoration was extinct, figured pediments became popular, rather suddenly, in middle Italy.[50]

The figures in these pediments are half-statues, raised as a high relief from a background slab which could be nailed to a wooden frame, like the earlier columen and mutule plaques (above, pp. 234 ff., illustration 163, and p. 330). The subjects shown in these new pedimental groups were of two kinds: one represented assemblies of divinities or a solemn sacrifice in the presence of the gods; the other showed a scene from Greek mythology. 'Assembly' pediments have been found so far only in Rome or in Rome's colonies; this continued to be the preferred type under the Empire.[51] Mythological pediments were more popular in the Hellenistic period not only in the old Etruscan cities but in Rome's colonies in Etruscan territory.[52] This type also appeared in imperial Rome, if rarely.

Only two mythological pediment groups are well enough preserved to give an idea of their composition: the Seven Against Thebes from Talamone and the Discovery of Ariadne from Città Alba [324]. Both are made up of a large number of small figures, all of a size, modelled on plaques designed to fit together like a jigsaw puzzle and form a continuous background. Over this surface the actors are disposed in over-

lapping groups which fill all the available space so that the action takes place on many levels.[53] This seems also to have been the compositional scheme of the imperial mythological pediments,[54] and it must certainly have been the inspiration for the overlapping compositions on urns such as our illustration 323.

Though something like this scheme was used by such Athenian masters as the Niobid Painter or Aison, and by later south Italian vase painters and their Faliscan follower, the Nazzano Painter [270] (above, p. 346),[55] it was not a kind of composition favoured in Greek relief sculpture. There, if a figure is shown standing behind and above someone else it is because he really is above him, on a mountainside or a cliff, or the walls of a city.[56] The device is Etruscan (above, p. 425 and Note 48), perhaps an adaptation of the vase painter's scheme, but, I think, rather a sort of explosion of the composition of large Greek Hellenistic figure paintings. The Alexander mosaic (above, p. 419) must again be put to use. Its action takes place on a single level which slopes upward in normal perspective, while the heads of those in the background are lower than, and sometimes obscured by, those in the foreground. But if one wanted to use this composition to fill a triangular pediment, one could leave the foreground figures, the fallen horse and his wounded rider, the frightened horse and his groom, on the lowest level, and push up Alexander and Darius into the middle level with some of those spearmen and perhaps the tree at the peak. A scene with a rocky landscape or a walled city in the background would be still easier to make into a triangular composition. I believe that a Greek composition of the Alexander sort was responsible for the arrangement of the Seven Against Thebes in the Talamone pediment, which was then imitated on such urns as our illustration 323, or on the relief on the urn from Perugia in the Villa Giulia where Kapaneus and his ladder are squeezed in above Oedipus' head.[57]

There is good evidence that the designer of the Città Alba pediments (not pediment)[58] drew on Greek Hellenistic paintings for his compositions. In them the sleeping Ariadne is discovered twice. Once she is seen in back view, her almost nude body framed by a cloak that swings round her buttocks and is lifted and drawn away from her torso by the hand of some lost discoverer. Above her stands a nude female figure whose cloak falls from the left shoulder and is caught between the legs; slenderer and more graceful than the Vanths of the Volterran urn [323], she is otherwise of the same type. Here, presumably, it is intended for a maenad. Behind her and higher up stands a gesticulating satyr. Both these figures are now headless. The satyr's background plaque joins that of the left-hand figures of the pediment's central composition: three winged creatures, Eros and two bejewelled Lasas who hold out a veil to serve as a canopy for some personage of supreme importance, now lost, presumably Dionysos himself. The other Ariadne [324] sleeps facing the audience, her right arm thrown over her head whose heavy, tumbled hair frames a sorrowful little face. Her slender torso is again framed by her cloak, which a satyr is lifting to reveal her to the god. Behind her, again, stands a half-nude maenad; above and behind is a running satyr, while to the right a third satyr is apparently dancing with excitement on one foot as he gestures wildly for Dionysos to approach. Both these schemes, the sleeping Ariadne seen from in front and from behind, are found in Campanian wall paintings.[59] Her cloak, lifted sometimes by Eros, sometimes by a satyr, always makes a dark frame for her torso, and when she is seen from behind, it sweeps in a caressing arc around her buttocks. This particular motif was popular in Hellenistic Italy. Two examples, from graves at Taranto and Canosa, must be close contemporaries of the Città Alba reliefs: one is a terracotta figure of a sleeping maenad, the other a parcel-gilt mirror back with a relief of a nereid riding a sea creature.[60] Both have the slender torso with narrow shoulders and rather broad hips of the ladies on the Città Alba reliefs and of the later, painted Ariadnes from Pompeii and Herculaneum. Perhaps the originals of these paintings and the inspiration for the pedimental reliefs were due to south Italian Greek painters. The central group, Eros and the Lasas, from

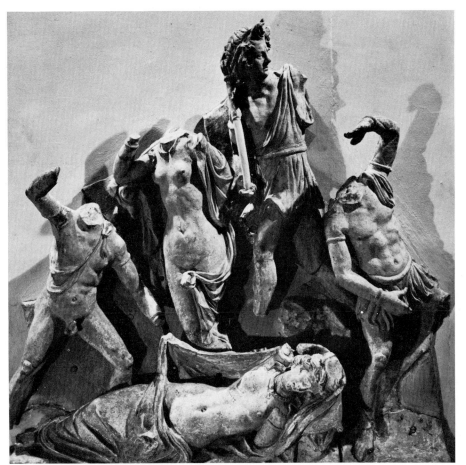

324. Ariadne discovered by the companions of Dionysus, pediment from Città Alba, late second century. *Bologna, Museo Civico Archeologico*

Città Alba should be counted as an interpolation. Slavish copying was a virtue nowhere in the Hellenistic world.[61]

Votive Sculpture

Some time in the third century, probably towards its close, the votive types inherited from the Classical period (above, pp. 410–11) began to look old-fashioned, and a new repertory took their place. This differs from the earlier figures in a tendency to imitate Hellenistic Greek types

and costume, and in a predilection for twisted figures that stand with the weight on one leg, the heel of the other foot raised. Most of the new types are illustrated by the bronzes from a votive *stips* excavated in 1950 at Carsoli,[62] a Latin colony founded in 292 in Samnite country. It may be that these new types were not Etruscan inventions but were introduced to Italy by way of Rome; however, they were popular in Etruria too.

A far handsomer set of votive bronzes than the provincial little figures from Carsoli was

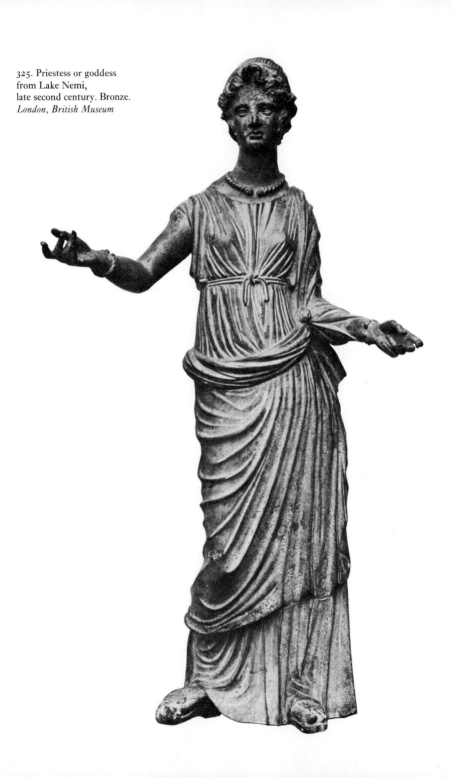

325. Priestess or goddess
from Lake Nemi,
late second century. Bronze.
London, British Museum

found at Nemi in the Alban Hills in 1895: a half-life-sized figure of a woman [325] and seven smaller bronzes.[63] The lady wears the Hellenistic dress of Seianti Thanunia Tlesnasa [322], but her jewels are more restrained: a torque around the neck, a twisted bracelet on each wrist. Her small head is set on a long neck above narrow shoulders; the tall, slender body is too long from waist to knee, like Seianti Thanunia's, and broadens at the hips. This is the stylish figure for ladies in the late second century (see also Ariadne [324]). Her pretty face, framed by short, springy curls that arch over the forehead almost like Alexander's, is very solemn, the full lips almost pouting. She stands easily, the weight on the left leg, right knee bent and foot drawn back, head turned to the right; the graceful arms swing outward, the right from the shoulder, the left from the elbow only – the elbow keeps her cloak from sliding off her hips.

This bronze is the prettiest of a number of similar figures. One from the sanctuary of Juno Lucina at Norba shows how the type stiffened into a stereotype; proportions and costume are the same, the pose very similar, but the grace and lightness are gone.[64]

The smaller bronzes from Nemi represent diademed ladies pouring a libation and young men who wear the *toga exigua*, draped so that it leaves most of the torso bare, also pouring a libation. Their thick, curly hair is crowned with a wreath of vine leaves; they have the same solemn expression as the lady of illustration 325, and they stand with the weight on one leg, the other knee bent and foot drawn back, heel raised, the torso slightly twisted and the head more or less sharply turned to the right.[65] Both types were as popular in Etruria as in Latium. An example in the Louvre [326] wears a tunic under the *toga exigua* and thick-soled sandals; his head is lifted and his eyes upturned, his forehead pulled into a frown.[66] The baroque face is framed by curiously stylized curls, each individual lock a shallow, convex plaque covered by sinuous parallel ridges. The tunic's folds are expressed by incised lines; those of the toga are sharp, stiff ridges that look as if they had been cut with a knife. Here, as in the locks of hair, is a

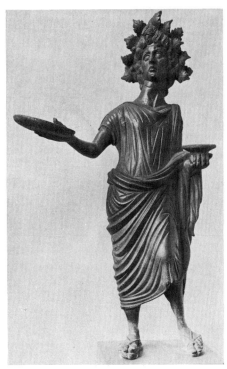

326. Youth sacrificing, late second century. Bronze. *Paris, Louvre*

late reappearance of the ridged patterns of the Orientalizing and Archaic periods.

These libation-pourers (priests and priestesses?) are types created in Italy. For all their hellenism they are not Greek: the male figure has the clustering locks and the vine leaves of Dionysos, but he is a *togatus* holding libation bowl and acerra; the 'priestess' wears a Greek dress but an Italic diadem, and she too holds patera and acerra. The earliest examples of these types may date from the end of the third century; the last, a sadly debased figure of the 'priestess' type, comes from the lararium of a house in Arezzo whose other bronzes are of imperial type.[67]

Another type, one that first appears in the second century, was based on a contemporary Greek subject: the young child, apparently made popular by the Boy with a Goose of the

Greek sculptor Boethos. There had been, in Italy, earlier terracotta figures of seated women holding swaddled babies,[68] but suddenly a quantity of figures (bronze and terracotta) appears of chubby little boys, usually naked, sitting on the ground, smiling or pensive, playing with some toy or pet, or just thinking things over. Illustration 327 (Vatican[69]) shows a bronze found near Lake Trasimene, a pretty child with his smooth, fine hair brushed forward into a neat curl on the forehead. He wears a very large bulla on a chain round his neck, a bracelet on

gentleman named Avle Metele, called l'Arringatore (the Orator) [328, 329].[70] He wears a short-sleeved tunic and the semicircular *toga exigua*, wound tightly around his body, muffling the left arm but leaving the right arm free; on his feet are high boots, intricately bound, the characteristic boots of the Roman senator. He stands erect and steady, both feet firmly planted, the left arm easily at the side, the right stretched out and raised, the body twisted a little to the right, head up, lips parted. Gesture and expression are compelling; he is, indeed, an orator. The

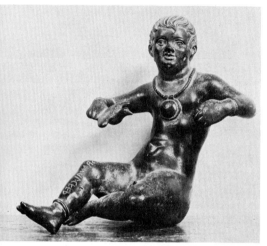

327. Boy playing with a bird, late second century. Bronze. *Vatican, Museo Gregoriano Etrusco*

each wrist, and an anklet on the right leg. In the left hand he clutches a ball, and in the right the tail of a tame – or toy? – bird. He leans back a little, left foot under right ankle, head and shoulders turned to the left, arms raised, elbows out, as if to show off the bracelets. The apparently easy pose is in fact a fine three-dimensional composition: the backward pull of the torso is balanced by the weight of the hips and the thrust of the right leg; the outflung elbows and tilted head seem to be twisting the torso to the left as you watch. Such a pose could hardly have been achieved before the advanced Hellenistic period.

A second bronze from Lake Trasimene, now in Florence, is the largest and the last of the Etruscan togate figures, the life-size statue of a

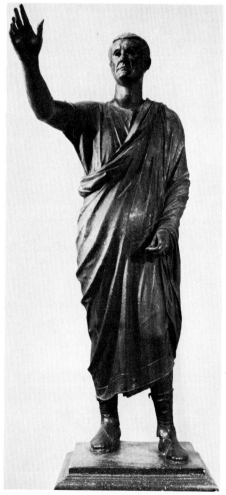

328. Statue of a *togatus* (l'Arringatore), *c.* 90–50. Bronze. *Florence, Museo Archeologico*

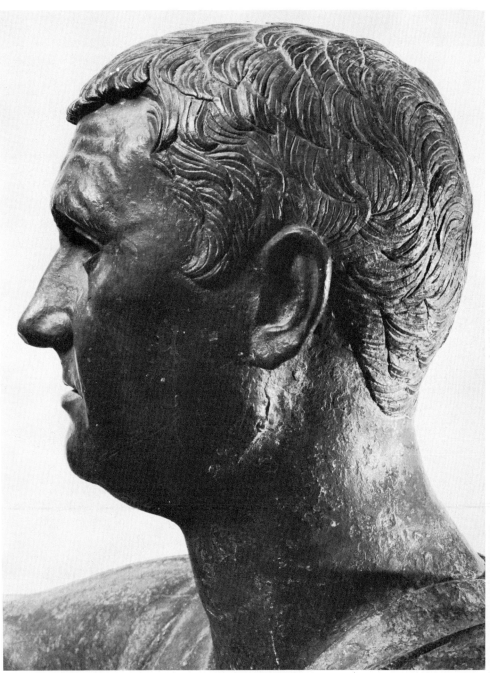

329. Detail of illustration 328

head is like none other from Etruria, round and tight, with close-cropped hair that frames the forehead in a sharp little ridge. The broad face is fleshy and wrinkled: the sagging cheeks and the loose jowls betray the man's age. There is a permanent frown between his eyebrows; deep calliper lines run from the nostrils to the corners of the mouth; the lower lip protrudes and twists to the side. This is a Roman face.[71] If it were not for the Etruscan inscription on the lower border of the toga one could take the figure for one of the Roman *togatae effigies*, the honorary statues of distinguished civilians described by Pliny (*N. H.* 34.10.18). Roman verism had reached Etruria when this bronze was cast. The twisted torso and momentary pose of the Hellenistic 'priest' [326] have been stiffened and quieted; the romantic hair and features of Arnth Velimnas [321] are replaced by a business-like cut and an alert expression. It is perhaps the gesture and expression that make this figure look so un-Etruscan; he is up and doing, he has even shed a good deal of the obesity of earlier Etruscan gentlemen (above, pp. 390, 422).

The recurrent question 'what became of the Etruscans in the end?' is answered here. They became Roman citizens and began to think and act like Romans. A Roman, however perverse his activities might be, was always a man of action, a soldier, an administrator, a lawyer, a politician. He was expected to be a man of physical stamina, with a certain amount, at least, of athletic ability.[72] The career of Aulus Caecina Alienus under the Flavians (Tacitus, *Hist.* 1–3, *passim*) is evidence that an ambitious Etruscan had quite as much stamina and could be quite as active as any Roman-born Roman.

None the less, these new-made Romans were proud of their Etruscan past. Maecenas enjoyed being addressed as 'Tyrrhena regum progenies', and 'eques, Etrusco de sanguine regum'. Suetonius tells us that the Emperor Otho also claimed descent from the princes of Etruria. One of the descendants of Arnth Velimnas [321], the last to be buried in the Tomb of the Volumnii at Perugia (above, p. 422), was a contemporary of Maecenas. His ash urn – a marble house urn decorated in the classicizing style of the Augustan age [320] – is inscribed, in good Roman formula, P. VOLUMNIUS A(vle) F(ilius) VIOLENS, but he has added what no purely Roman funerary inscription carries: the name of his mother, Cafatia. And that is a good Etruscan formula.

LIST OF ABBREVIATIONS

A.J.A.
American Journal of Archaeology

Andrén
A. Andrén, *Architectural Terracottas from Etrusco-Italic Temples* (Skrifter utgivna av Svenska Institutet i Rom, VI). Lund, 1940.

Banti
L. Banti, *Il mondo degli Etruschi*, 2nd ed. Rome, 1969.

Beazley
J. D. Beazley, *Etruscan Vase Painting*. Oxford, 1947.

Dohan
E. Hall Dohan, *Italic Tomb Groups in the University Museum*. Philadelphia, 1942.

Ducati
P. Ducati, *Storia dell'arte etrusca*. 2 vols. Florence, 1927.

Giglioli
G. Q. Giglioli, *L'arte etrusca*. Milan, 1935.

Helbig, *Führer*
W. Helbig, *Führer durch die öffentlichen Sammlungen klassischer Altertümer in Rom*, 4th ed., 3 vols. Tübingen, 1963–72.

Hencken
H. Hencken, *Tarquinia, Villanovans and Early Etruscans*, 2 vols. (American School of Prehistoric Research, Peabody Museum, Harvard University, Bulletin no. XXIII). Cambridge, Mass., 1968.

Herbig
R. Herbig, *Die jüngeretruskischen Steinsarkophage*. Berlin, 1952.

Huls
Y. Huls, *Ivoires d'Étrurie* (Études de philologie, d'archéologie et d'histoire anciennes publiées par l'Institut Historique Belge de Rome, IV, 1967).

J.D.A.I.
Jahrbuch des Deutschen Archäologischen Instituts

J.H.S.
Journal of Hellenic Studies

M.A.A.R.
Memoirs of the American Academy in Rome

Pallottino
M. Pallottino, *Etruscan Painting. The Great Centuries of Painting*. Geneva, 1952.

Pareti
L. Pareti, *La tomba Regolini-Galassi del Museo Gregoriano Etrusco e la civiltà dell'Italia centrale nel secolo VII a. C.* Città del Vaticano, 1947.

Riis
P. J. Riis, *Tyrrhenika. An archaeological study of the Etruscan sculpture in the archaic and classical periods.* Copenhagen, 1941.

R.M.
Römische Mitteilungen

Santangelo
M. Santangelo, *Musei e monumenti etruschi*. Novara, 1960.

S.Etr.
Studi Etruschi

Teitz
R. S. Teitz, *Masterpieces of Etruscan Art, Worcester Art Museum April 21 to June 4, 1967.* Worcester, Mass., 1967.

NOTES

Bold figures indicate page reference

16. 1. For an introduction to the historical sources see the *Cambridge Ancient History,* VII (Cambridge, 1928), chapters 10-13. A good survey of the more recent archaeological research is to be found in A. Furumark, *Det äldsta Italien* (Uppsala, 1947). Southern Italy and Sicily already lay within reach of the Mycenaean civilization of Greece. Traffic across the Adriatic Sea is the most likely explanation: Furumark, *op. cit.,* 52-8. For the subsequent history of navigation in the eastern Mediterranean see Rhys Carpenter, *Folktale, Fiction and Saga in the Homeric Epos* (Berkeley and Los Angeles, 1946), 102-10. Also *idem,* 'The Greek Penetration of the Black Sea', *A.J.A.,* LI (1948), 8. Herodotus, I, 163 claimed that the penteconters built by the Phocaeans of Asia Minor about 700 were instrumental in the exploration of the west. This observation may well be true. The new oared ships could move under their own power and thereby free themselves from the 'tyranny of the winds' (Carpenter).

17. 2. The chronology of the Phoenician colonization in the west is still much disputed. The comparatively early, traditional date of the foundation of Carthage, 814, has been defended by W. F. Albright, *Studies in the History of Culture presented to W. G. Leland* (Washington, 1942), 40-1.

3. In the chronology of the Greek colonies in the west the crux is the foundation date of Syracuse: 734, if one follows Thucydides. On this depend the dates of other, slightly younger colonies such as Catania and Leontini. Nor did Syracuse come first. Strabo, 5.245, declared Cumae the oldest Greek colony in the west. The time difference with Syracuse cannot have been considerable, however, and therefore *c.* 750 is given in our text as the likely date for Cumae. The question is in what way – if at all – the archaeological data can be harmonized with this historical tradition. Two styles of pottery represent the earliest strata in these cities: Greek Protocorinthian and domestic Geometric. In Greece one would assume that Geometric comes before Protocorinthian, but the same sequence is not necessarily true of Italy. The likelihood at present is that in Italy the bulk of the native Geometric ware belongs to the seventh century, and

a great deal of it near the middle of that century rather than the beginning. But the earliest Protocorinthian vases of Cumae and Syracuse represent a Greek importation which probably started around 710. Thus the paradoxical situation arises that they are older than many native vases with geometric decorations. Actually during the following century Late Geometric and Protocorinthian vases are often found side by side in Italian tombs. This fact indicates no more than that, in Italy, the Geometric style of decoration remained long in use. For the art-historical significance of this fact see below, Chapter 2.

The need for a fresh synchronization of the Geometric and Protocorinthian styles in Greece and Italy has increasingly come to the fore in recent studies. See for further discussion: Å. Åkerström, *Der geometrische Stil in Italien* (Uppsala, 1943); A. W. Byvanck, 'The Chronology of Greek and Italian Art in the Eighth and Seventh Centuries B.C.', *Mnemosyne,* XIII (1947), 241-53; Pareti, 483-95; T. J. Dunbabin, *The Western Greeks* (Oxford, 1948), especially 435-71; F. Villard, 'La Chronologie de la céramique protocorinthienne', *Mélanges d'archéologie et d'histoire,* LX (1948), 7-34.

4. For a comprehensive presentation of the Etruscan problem, including the outline of an 'indigenous' solution, see M. Pallottino, *Etruscologia,* 6th ed. (Milan, 1968), and bibliography. Other select readings on the protohistory of central Italy must include the following: D. Randall-MacIver, *The Iron Age in Italy* (Oxford, 1947); F. von Duhn and F. Messerschmidt, *Italische Gräberkunde,* 2 vols. (Heidelberg, 1924, 1939); J. Whatmough, *The Foundation of Roman Italy* (London, 1937); G. Kaschnitz-Weinberg in W. Otto and R. Herbig, *Handbuch der Archäologie* (Munich, 1954), 311-402; D. H. Trump, *Central and Southern Italy before Rome* (New York and Washington, 1965); H. Hencken, *Tarquinia, Villanovans and Early Etruscans,* 2 vols. (American School of Prehistoric Research, Peabody Museum, Harvard University, Bulletin no. XXIII) (Cambridge, Mass., 1968).

The first strata in all early Etruscan settlements are Villanovan: M. Pallottino, 'Tarquinia', *Monumenti Antichi,* XXXVI (1937), 149-54; cf. *idem,* 'Nuovi orientamenti sulla cronologia dell'Etruria protostorica', *Rend. Pontificia Accademia,* XXII (1946),

31-41, and A. Boëthius, 'Osservazioni riguardante la cronologia del materiale villanoviano proposta da Åke Åkerström', *Eranos*, XLI (1943), 169-75.

19. 5. A survey of the founding legends side by side with the ethnographical and archaeological evidence of early Rome: I. Scott Ryberg, 'Early Roman Traditions in the Light of Archaeology', *M.A.A.R.*, VII (1929), 7-118, plates 1-7.

20. 6. Villanovan and Fossa ceramics in Latium: the distinction is due to G. Kaschnitz-Weinberg, who also coined the term Fossa Civilization; see *S. Etr.*, VII (1933), 135-95, and his article in Otto and Herbig, *op. cit.* (Note 4).

New Iron Age materials from Rome have since come to light in excavations on the Palatine Hill and in the Roman Forum: cf. S. M. Puglisi, P. Romanelli, A. Davico, and G. De Angelis d'Ossat in *Monumenti Antichi*, XLI (1951), cols. 1-134; E. Gjerstad, *Early Rome*, IV (Lund, 1966).

For the south Italian antecedents of the Latin Fossa ceramics, especially the sites of Torre Galli and Canale, both in Calabria, see Furumark, *op. cit.* (Note 1), 72-6.

CHAPTER 2

25. 1. Possibly the biconical form was indigenous to the so-called Fossa cultures in south Italy; see Furumark, *Det äldsta Italien* (Uppsala, 1947), 72-6. The first purpose of these vases was probably to serve as water-carriers, like the Greek hydriae (Ducati, 25-6, 50, note 87). Cf. also a biconical pitcher of the Apennine Bronze Age from Monte Cetona (U. Calzoni, *S. Etr.*, XVI (1942), 565-7; D. H. Trump, *Central and Southern Italy before Rome* (New York, 1965), 232, no. and figure 48). For a possible central European origin for the biconical shape see Hencken, 492.

2. Ceramic techniques in early Italy: Dohan, 3-5.

3. Origin and purpose of the Villanovan hut urn: the differentiation between female burials, marked by the model of a house, and male burials, marked by a phallic pillar or cippus, is well known from later Etruscan usage, e.g. at Caere. See F. Altheim, *Italien und Rom*, 2nd ed., I (Amsterdam and Leipzig, n.d.), 106-7; G. Bendinelli, *Rend. Pontificia Accademia*, XXII (1948), 43-59.

26. 4. That the painted Geometric vases of Etruscan manufacture depended on Greek Late Geometric models was plausibly demonstrated by Å. Åkerström, *Der geometrische Stil in Italien* (Uppsala, 1943), especially 87-96. According to him, the production of painted Geometric vases started at Tarquinia, *c.* 725. Similar industries began somewhat later in the Greek territory of south Italy. I follow Åkerström in his

criticism and approximate datings of these materials, but I feel that in central Italy the stylistic distinction between painted and engraved (Villanovan) decoration must be drawn more sharply than appears from his discussion, *op. cit.*, 141. Actually we know less about the decorative style of the engraved ossuaries than about the painted ware. The reason is that the stylistic relations of the former are more difficult to trace.

27. 5. A fundamental investigation of the chronology of Villanovan art is found in Åkerström, *op. cit.*; see especially his summary, pp. 147-9, and the bibliography cited. Cf. also Furumark, *op. cit.*, 68-89. The discussion about the Early Iron Age in Italy is characterized at present by an almost universal divergence of opinion between the earlier and the more recent research regarding the start and the subsequent chronology of the Villanovan culture. This contrast of opinions chiefly stems from two recent developments. One is the collapse of Pigorini's once widely accepted theory that the Villanovan civilization was an outcome of the Bronze Age culture of the so-called Terramare settlements in north Italy. The other lies in the recognition of the fact that the Villanovan style appeared in southern Etruria as early as, or earlier than, in the region of Bologna; cf. Furumark, *op. cit.*, 134-43; Åkerström, *op. cit.*, 129-30 (the Villanovan of Etruria earlier than that of Bologna); Hencken, 11, 631-2; H. von Müller-Karpe, *Beiträge zur Chronologie der Urnenfelderzeit, Römisch-Germanische Forschungen*, XXII (1959), 53, 83 (the two regions contemporary). Thus the previously presumed direct connection or transition between the Terramare culture and the Villanovan has failed to appear; nor was the latter carried to Etruria from the north. As a result of these studies the chronology of Villanovan art had to be revised and put on a new basis. This Åkerström attempted to accomplish by comparing the Villanovan style of decoration to Greek Geometric art. But the evidence thus obtained is not wholly conclusive. In the first place, the absolute dates of the Greek Geometric and Early Orientalizing styles themselves have not yet been sufficiently established. In particular the chronology of Greek art during the eighth and seventh centuries hinges almost entirely on the foundation dates of the Greek cities in Italy, which are still disputed. The most recent investigations do not seem to bear out the rather late datings of Åkerström, *op. cit.*, 153-8, and Furumark, *op. cit.*, 101, with 94, figure 39. In the second place, it cannot be taken for granted that all Villanovan ornament is alike dependent on Greek Geometric art. In my opinion, such direct dependency can indeed be assumed for the painted Geometric wares of Italy; it cannot with equal confidence be postulated for the engraved decoration of the typical Villanovan ossuar-

ies, which may include Greek borrowings but which, on the whole, can hardly be explained as Greek derivatives. What remains uncertain especially is the origin of the Villanovan style, both as to time and to immediate sources.

On the other hand it is now an established fact that Villanovan and Greek Orientalizing vases – the latter mostly Protocorinthian imports or domestic imitations – often occur together in central Italy. For the later stages of the Villanovan production, after the last quarter of the eighth century, roughly speaking, a synchronization with Greek art seems therefore feasible. On the whole, in our scheme of Italian protohistory the time available for the Geometric period is narrowing down. Most Villanovan art indeed seems to belong to the eighth and early seventh centuries; the conventional dates '*c.* 1000 B.C.', still found in many handbooks, are almost certainly too early even for its beginning (cf. Furumark, *op. cit.*, 100).

6. G. von Merhart assumes that the Villanovan meanders developed directly from Balkan forerunners (*Bonner Jahrbücher*, CXLVII (1942), 35–6). In that event the Geometric development in Italy was parallel to, but separate from, that of Greece. Actually the history of the meander, before and outside Greek Geometric art, is not yet very well known. The motif was however introduced to Italy before the Villanovan civilization, as evidenced by meanders found on Apenninic pottery of the Bronze Age: cf. the examples illustrated by U. Calzoni, *S. Etr.*, XII (1938), 228–9, plate 40, and the already mentioned biconical pitcher from Monte Cetona, *idem, S. Etr.*, XVI (1942), 565–7. Besides, special forms of meander pose special problems. A point in question is the so-called stepped meanders, which were very popular in Villanovan art: see Åkerström, *op. cit.*, 131–6. Stepped meanders were also common in Greek decoration from the mature Geometric period, especially on vases from Argos. In Villanovan art they are frequently found on the engraved urns but not the painted ware (see above, p. 25). Evidently they passed into the engraved decoration from a – possibly earlier – source that had no effect on the painted vases. This source may well have been a trans-Adriatic, Balkan centre, probably located in present-day Hungary. The pattern does not seem to have been native to Italian art; it probably came from abroad but not necessarily from Greece directly; see Furumark, *op. cit.*, 89–99, especially 96.

7. There can now be little doubt that, apart from possible Greek interspersions in the decorative vocabulary of early Villanovan art, relations across the Adriatic between the Villanovan culture and the countries of central and eastern Europe must likewise be taken into consideration. Both the Villanovan and the Fossa cultures of southern Italy in their industries exhibit traces of contact with the prehistoric civilizations of the Balkan countries on the other side of the Adriatic. See for this question von Merhart, *op. cit.* (Note 6), 12–20; Hencken, chapters 23 and 25.

29. 8. Åkerström, *op. cit.*, 105 and 111–13. Bronze urn in a tomb group of *c.* 650, E. Franchini, *S. Etr.*, XX (1948/9), 29, plate 3, figure 2.

9. For a useful survey of ancient metallurgy and technical procedures, see H. Maryon, 'Metal Working in the Ancient World', *A.J.A.*, LIII (1949), 93-125, plates 16-20.

31. 10. See von Merhart, *op. cit.*, 5–8. For a comprehensive survey of types and chronology cf. J. Sundwall, *Die älteren italischen Fibeln* (Berlin, 1943) – the two types here illustrated: 177-95 and 136-69.

11. Ducati, 36; Åkerström, *op. cit.*, 115; Dohan, 96, no. 23; A. Talocchini, 'Le armi di Vetulonia e di Populonia', *S. Etr.*, XVI (1942), 33-5, plate 6, figures 35-6.

32. 12. There is no monograph on the Italian bronze discs with geometric decoration. For similar discs with orientalizing decoration, see below, Chapter 6, p. 85, and bibliography. A closely related piece to our illustration 13 (London, British Museum, Catalogue of Bronzes no. 368) comes from Norchia; it is now in Perugia (M. Guardabassi, *Notizie degli Scavi* (1880), 208 and plate 11; U. Calzoni, *Il museo preistorico dell'Italia centrale in Perugia* (Rome, 1940), plate 65). For discs in Perugia with similar decoration to our illustration 14 (London, British Museum no. 375, from Perugia) see Calzoni, *op. cit.*, plate 66.

35. 13. For the oldest Protocorinthian vases from Cumae and Syracuse, see especially A. W. Byvanck, 'The Chronology of Greek and Italian Art in the Eighth and Seventh Centuries B.C.', *Mnemosyne*, 3rd series, XIII (1947), 246–80.

14. Benacci and Arnoaldi: brief descriptive survey in Furumark, *op. cit.* (Note 1), 134–43. From the seventh-century Subgeometric workshops in southern Italy a rather colourful style of Geometric pottery spread to the outlying provinces – Apulia, Messapia – where it enjoyed a long and self-contained existence; in some rural centres this Geometric folk art continued until the third century.

37. 15. For parallels in Balkan art see Furumark, *op. cit.*, 91; A. Roes, 'Der Hallstattvogel', *Ipek*, XIII/XIV (1939/40), 57–84; Hencken, II, 514-30.

16. Åkerström, *op. cit.* (Note 4), 86, figure 2.

17. Birds inscribed in metopes: krater, Vatican, Museo Gregoriano Etrusco no. 16321 (here illustration 16): C. Albizzati, *Vasi antichi dipinti del Vaticano*, fasc. I (Rome, n.d.), 9, no. 37, plate 2; Åkerström, *op. cit.*, 97, plate 27, figure 6. Birds inscribed in squares in Greek Subgeometric art: cf., for example, the bowl from Delos, *ibid.*, 26, figure 6.

18. The same device (representing a goat) occurs in

Geometric vase painting: Åkerström, *op. cit.*, 43, figure 14, no. 5, from Canale. Greek examples are common. For the earlier history of this interesting motif, which apparently started in Mesopotamia, consult the bibliography in Dohan, 45, no. 3.

38. 19. Giglioli, plate 36, figure 2, and bibliography p. 12; Åkerström, *op. cit.*, 98, figure 41. Different from Greek Geometric principles is not only the design of the dancers but also the decorative – not naturalistic – use of three colours. The ground is white. The dancers are divided in groups of three, one group painted black, the next red, etc. Greek Geometric painting used only one colour for figure and design. For the scheme of representation cf. the similar dancers on a bronze shield from Tarquinia, *Staatliche Museen zu Berlin, Führer durch das Antiquarium* (Berlin, 1924), plate 3; their style is Etruscan Orientalizing, probably not much later than the Bisenzio vase. Of the same type are the dancers around the so-called throne of the Barberini Tomb (Giglioli, plate 17, figure 1). These examples show that the facing dancers indeed represent an Italian Geometric, or at least Geometric and Orientalizing, type; they must not be interpreted as a mere whim of the painter from Bisenzio.

40. 20. Dohan, 68–89, Narce Tomb 7F, no. 3. Like the dancers, the 'acrobat' was a typical figure in the early art of central Italy. We find him balancing on two Geometric horses in the stylized design of a perforated handle of bronze, as illustrated by Calzoni, *op. cit.* (Note 12), plate 60. Cf. the still more simplified stylization on a disc of similar design in Berlin in G. Hanfmann, *Altetruskische Plastik* (Würzburg, 1936), 61, note 7, and 124, figure 13.

21. Museo Gregoriano Etrusco no. 15328: Banti, plate 24b. The design resembles the man standing between the two horses on the vase carrier in Philadelphia. But here the horses are kneeling down: the man is a 'horse tamer'. Similar representations were common in Italian Late Geometric art: cf. Hanfmann, *op. cit.*, 85–7. Statuette groups of the same motif occur in Narce: Dohan, 36, nos. 5 and 6, plate 18. The heraldic scheme of the facing figure between two animals in profile was ancient-oriental. It usually represented a deity – a 'Lord' or 'Mistress' – of animals; but the famous Lion Gate of Mycenae, where a sacred pillar takes the place of the anthropomorphic form, may be cited as another example. In Italy the animals represented in these groups are mostly horses. Cf. the fine, if somewhat more recent, bronzes in Berlin (H. Mühlestein, *Die Kunst der Etrusker* (Berlin, 1929), plate 153) and Pesaro (H. Jucker, *Bronzehenkel und Bronzehydria in Pesaro* (Pesaro, 1966), 11–16, 31–52, plate 2).

CHAPTER 3

43. 1. G. Dennis, *The Cities and Cemeteries of Etruria* (2 vols., 3rd ed., London, 1878) is still a classic in this field. For a more recent study consult Å. Åkerström, *Studien über die etruskischen Gräber* (Lund, 1934).

44. 2. For conditions in the ancient Aegean see J. L. Myres, *Who Were the Greeks?* (Berkeley, 1930), 380–400; for early Italy, the vast collection of materials in F. K. von Duhn and F. Messerschmidt, *Italische Gräberkunde*, 2 vols. (Heidelberg, 1924, 1939). However, the line between cremating and inhuming 'Italici' can hardly be drawn as sharply as von Duhn first assumed. For the change from cremation to inhumation in Etruria see Åkerström, *op. cit.*, 186–90. The development began in the coastal area, whence it spread inland. In certain inland centres, e.g. at Chiusi, cremation was the rule for much longer. Forms of burial and religious beliefs: Myres, *op. cit.*, 385–6; H. L. Lorimer, 'Pulvis et Umbra', *J.H.S.*, LIII (1933), 177–9.

3. Forms of tombs in Etruria are determined by practical considerations rather than stable traditions: Åkerström, *op. cit.*, 157–9. Chamber tombs developed from the earlier trench tombs in the coastal regions, after inhumation was adopted. The trench tombs, in their turn, were originally characteristic of southern Italy, where the custom of burying the dead intact was maintained from prehistoric times. Cremating and inhuming groups began to live side by side in Etruria as in Rome during the eighth century. In this respect, too, Etruria presents the picture of a nation in its formative stage. In Chiusi, where cremation remained the rule much longer, early trench tombs are lacking. Chamber tombs began together with inhumation, sparingly, as late as the end of the seventh century. They became frequent near the beginning of the fifth century, when a rather sudden departure from the customary rite of cremation can be observed locally. Family burials: Åkerström, *op. cit.*, 193–5. The tendency to provide room for numerous burials in one tomb increased towards the Hellenistic period. It is obvious that these tombs were used collectively by the members and dependents of large *gentes*, whose common 'houses' they represented. In Rome, too, the *gentes* maintained common sepulchres at which regular ceremonies were performed: *Cambridge Ancient History*, VII (Cambridge, 1928), 417.

45. 4. The only effective methodical means at our disposal of determining the cultural and artistic developments in Etruria during the seventh century consists of a painstaking examination of all articles found to form part of a single burial; for in many burials implements of uncertain date occur together with implements of a style more accurately known. The assured contents of a single burial form a 'tomb

group'. As yet comparatively few tomb groups have been adequately published. For a fundamental example of method see E. Hall Dohan, *Italic Tomb Groups* (Philadelphia, 1942), an investigation of a series of comparatively simple burials from Narce and Vulci. Other studies: G. Matteucig, *Poggio Buco, the Necropolis of Statonia* (Berkeley and Los Angeles, 1951); M. Bizzari, 'La necropoli di Crocifisso del Tufo in Orvieto', *S. Etr.*, XXXIV (1966), 3-109; M. Cristofani, *Le tombe da Monte Michele nel Museo Archeologico di Firenze* (Florence, 1969). Among the famous chamber tombs, the contents of only two have recently been critically examined on similar methodical terms: L. Pareti, *La Tomba Regolini-Galassi* (Città del Vaticano, 1947), and G. Camporeale, *La Tomba del Duce* (Florence, 1967).

46. 5. Egyptian art: imported originals found in Italy are limited to products of the minor arts, such as little figures of Bes, etc. See the series of studies published by W. Freiherr von Bissing in *S. Etr.*, III (1929), 491-5, and subsequent volumes. Phoenician importations: this material includes somewhat larger items, like the famous silver bowls, and the faience vases in Egyptian style. The first systematic investigation of these problems, by F. Poulsen, *Der Orient und die frühgriechische Kunst* (Leipzig and Berlin, 1912), though no longer up to date, should still be consulted. See also the articles by von Bissing, above, as well as references listed below in Note 6. Cypro-Phoenician metal bowls: E. Gjerstad, 'Decorated Metal Bowls from Cyprus', *Opuscula Archaeologica*, IV (1946), 1-18, plates 1-16. The majority of the bowls found in Etruria probably belong to another, closely related but perhaps rather Syro-Phoenician group: Gjerstad, *op. cit.*, 18; for the latter group cf. W. Freiherr von Bissing, *J.D.A.I.*, XXV (1910), 193-9, and XXXVIII-XXXIX (1923/4), 180-241. Especially see the brief iconographical survey included with the last-named article, pp. 221-33.

47. 6. Schemes of synchronization. As explained previously, the same general sequence of stylistic changes can be recognized in Etruscan as in Greek art; it seems justifiable to apply to the former such Greek period divisions as Archaic, Classical, and Hellenistic. Above I have tried to show that, likewise, the conventional term of a Geometric phase has a meaningful place in the description of early Etruscan art. Still under discussion remains the question where, precisely, all these stylistic phases started and ended. Their popular currency in Etruria coincides only approximately with the similar developments in Greece, and the actual time of their duration may often have been quite different. Moreover these period divisions are of a very general nature, and in order for instance to make the history of the Orientalizing style in Etruria intelligible, finer subdivisions

are required which cannot always be borrowed from the Greek development. In such cases the chronological divisions must be deduced from the extant materials alone. One will therefore find that, as with other critical categories needed for the description of Etruscan art, there does not as yet exist a stable basis of agreement regarding the periodization of Etruscan art within the larger art-historical periods. The literature on the subject shows that so far each writer has had to devise – or improvise – significant time sectors in which Etruscan art is to be understood. This condition characterizes especially the seventh century, which, roughly speaking, was the period of the Orientalizing styles in Etruria and elsewhere. Regarding the establishment of stylistic periods in early Etruscan art, recent research has been guided by the following considerations. It is generally recognized that the materials which we call Orientalizing in Etruscan art are not homogeneous. Some, if not all, differences between them can be interpreted as resulting from differences of time. The modern discussion of a stylistic development in early Etruscan art starts from the survey by G. Karo, *Mitteilungen des Deutschen Archäologischen Instituts Athen*, XLV (1920), 106-56. This study distinguishes between two chronological levels. The contents of the so-called Warrior's Tomb at Tarquinia, and other burials related to it, represent the first group, which, according to Karo, should be considered Late Geometric. The famous tombs called respectively Bocchoris, Regolini-Galassi, and in Praeneste Bernardini and Barberini, form the nucleus of the second group. This is the later group, in which the Orientalizing style reaches its peak.

Actually it appears that the date assigned by Karo and others to the Warrior's Tomb was too early. A later date, around 680, would seem more adequate; see Dohan, 105-6. Nevertheless the advantage inherent in Karo's chronological scheme was that it cleared the way for a better understanding of his stipulated first period, which from his analysis emerged as a true time of transition, linking the local Geometric style with the Orientalizing. Instead of an abrupt change we find a gradual absorption by the local crafts of oriental and orientalizing motifs.

A relative chronology had thus become demonstrable in early Etruscan art. The next question was – and still is – if an absolute chronology can also be built on these observations of style.

In the latter respect great hope was placed on the Bocchoris Tomb, for the discussions of which see the bibliography in Note 7. The vase inscribed with the name of King Bocchoris indeed furnishes a valuable piece of information, because it links the contents of this tomb with quite a different set of chronological data, namely the list of the Egyptian kings. But while

the tomb must therefore be dated after the reign of Bocchoris, it could be, and apparently was, considerably later. Recent investigations have shown that in problems of chronology comparatively modest, single burials often give us more reliable information than the great chamber tombs which include several burials, the contents of which may stretch over long periods of time. For instance the examination of the famous Regolini-Galassi Tomb demonstrates beyond doubt that the contents, far from forming a homogeneous group, belonged to a series of successive burials, the oldest of which may be nearly a century earlier than the last; see Note 7. This tomb can therefore no longer be cited as representing a single, unified period within the Orientalizing style; and similar statements are probably in order regarding other great tombs, such as the famous tombs of Palestrina.

Most students of Etruscan art now distinguish between a Geometric phase, ending about 700; an Early Orientalizing phase; and a Late Orientalizing phase ending around 575. The dividing line between the latter two would be somewhere between 650 and 625; see Riis, 188, with bibliography; also C. Hopkins, 'Etruscan Chronology', *A.J.A.*, LVIII (1954), 146. An important change of style must indeed be recognized around the middle of the seventh century. However, a further division in approximately 630 becomes necessary in order to make the overall development intelligible. According to the theme employed here, Etruscan Orientalizing art falls into three successive stages of development.

7. The famous faience vase with the name of Bocchoris is certainly Phoenician, not Egyptian: Dohan, 106-7; cf. Å. Åkerström, *Der Geometrische Stil in Italien* (Uppsala, 1943), 142. A similar specimen was found at Mozia (the ancient Motye, a Phoenician trading centre off the west coast of Sicily); E. Gabrici, *Notizie degli Scavi* (1941), 261-302. Date of the Bocchoris Tomb: around 675, see A. W. Byvanck, *Mnemosyne*, IV (1936), 181-8; Dohan, 108; Hencken, 376.

48. 8. The principal publication, by L. Pareti, was cited above, Note 4. The tumulus itself dates from the first half of the century, but it remained long in use. Only one burial, the so-called 'right niche', seems as old as the Bocchoris Tomb. Most of the other contents stem from later burials whose dates may well be several decades apart, as assumed by Pareti, 123, 347-8, and 510-11. It seems that the principal burials belong to the second half of the century; the latest objects must be ascribed to the end of the century or even to a time somewhat beyond this mark - the decades immediately following the year 600.

9. Survey and catalogue of the funerary deposits: C. Densmore Curtis, *M.A.A.R.*, III (1919), 9-90,

plates 1-71. Recently the objects of this tomb have been carefully cleaned, with excellent results.

10. Survey and catalogue of the funerary deposits: C. Densmore Curtis, *M.A.A.R.*, V (1925), 9-52, plates 1-43.

CHAPTER 4

49. 1. Å. Åkerström, *Der geometrische Stil in Italien* (Uppsala, 1943), 104, plate 29, figures 1-3. Cf. Dohan, 106.

2. For another specimen, similar to our illustration 24, see Dohan, 76, no. 11.

3. Hencken, I, 369, figure 362a and b.

50. 4. Pareti, 233, no. 164. This amphora belonged to the household silver from the so-called cella. The word 'Larthia' inscribed on it probably refers to a man called Larth, as proprietor; M. Pallottino, *S. Etr.*, XX (1948/9), 342. Therefore the woman buried in the 'cella' - a burial already belonging to the beginning of our second Orientalizing stage, *c.* 650-630 according to Pareti - was not the first owner of that set of silver. Pallottino's observation tallies with the fact that the ceramic type of the spiral-amphora was certainly older. The Bocchoris Tomb itself yielded an example (Hencken, 367-8, figure 367b). Spiral-amphorae made of impasto constituted a leading form of native Orientalizing pottery in Etruria and Latium, both before and around the middle of the seventh century. The latest examples occur in tombs with Late Protocorinthian vases, around 630-615. See L. A. Holland, *The Faliscans in Prehistoric Times* (Papers of the American Academy in Rome, V, 1925), 95-100, figures 10-13; Dohan, 61, no. 9.

51. 5. Museo Gregoriano Etrusco no. 15325; Giglioli, plate 41, figure 1.

53. 6. Herodotus, 1.164. These were the same Phocaeans who later joined their countrymen at Alalia on Corsica, and thereby caused the fatal conflict with the Etruscans and Carthaginians in 538. See also below, p. 112.

7. Domestic wares in the Protocorinthian and Corinthian manner: C. Albizzati, *Vasi antichi dipinti del Vaticano*, fasc. II (Rome, n.d.), 48-63; G. Kubler, 'Some Etruscan Versions of Corinthian Ceramics', *Marsyas*, II (1942), 1-15, plates 1-10; J. G. Szilagyi, 'Le fabbriche di ceramica etrusco-corinzia a Tarquinia', *S. Etr.*, XL (1972), 19-73, plates 1-10.

8. G. Q. Giglioli, 'Materiali per un corpus della ceramica etrusca', *S. Etr.*, XX (1948/9), 241-5, plate 13.

54. 9. Oriental imports: R. D. Barnett, *J.H.S.*, LXVIII (1948), 3-4; *idem*, *A Catalogue of the Nimrud Ivories . . . in the British Museum* (London, 1957), 129,

134. Oriental craftsmen in Etruria: Huls, 134-7. An example possibly showing transfer of motifs from Greek (Corinthian) ceramic decoration to Etruscan ivory carving: the Chiusi situlae discussed below, Chapter 5, pp. 64-6.

10. See above, Chapter 3, Note 5. For the significance of Phoenician crafts as portable prototypes of iconography, and their possible influence on Etruscan painting of the Archaic period, cf. F. Poulsen, *Der Orient und die frühgriechische Kunst* (Leipzig and Berlin, 1912), 67-72.

55. 11. Pareti, 304-5, no. 303, plate 39. This stand was found in the so-called *anticamera*, the contents of which, in the opinion of Pareti, belonged to the same burial as that of the left niche (*op. cit.*, 100-4). However, the furniture of this section is conspicuously lacking in stylistic unity. It includes pieces certainly antedating the middle of the century, like the Villanovan bronze amphora no. 325 (Pareti, 321, plate 44), with others of much later date.

12. Pareti, 234, no. 196, plates 20-1, who (103-4) ascribed the cauldron to the furniture of the so-called cella. The workmanship is not quite the same, but the similarity of style to the stand was already observed by A. Furtwängler, *Olympia, Die Ausgrabungen*, IV (ed. E. Curtius) (Berlin, 1890), 125. Accordingly, I date both pieces to the time of the 'cella', approximately 650-640.

For the history of this type of cauldron see E. Kunze and H. Schleif, 'Bericht über die Ausgrabungen in Olympia, II', *J.D.A.I.*, LIII (1938), 107-15; F. Matz, *Geschichte der griechischen Kunst*, I (Frankfurt am Main, 1950), 396-400. In Greece, only the earliest cauldrons were decorated with lions' heads; later the protomes were shaped as griffins. The passage in Herodotus, 4.152.4 which mentions 'Argive' cauldrons refers to the latter type.

A complete investigation of the Italian material is lacking. U. Jantzen, *Griechische Greifenkessel* (Berlin, 1955), puts the Barberini griffin-lion cauldron in his earliest group of hammered bronze protomes, pp. 33-4, and the Vetulonia cauldron in his second, pp. 34-5. H.-V. Herrmann, *Die Kessel der orientalisierenden Zeit* (Olympische Forschungen, VI) (Berlin, 1966), associates these cauldrons from Praeneste and Vetulonia with one found at Olympia (B 4224, pp. 84-9, plates 1-6). Cf. also E. Akurgal, *Die Kunst Anatoliens* (Berlin, 1961), 55-6, figures 35, 39-42. These cauldrons have good claim to be imported pieces. Those from the Regolini-Galassi Tomb were made locally. Their development seems to differ from the Greek; e.g. the lions' heads remained longer in use. Two specimens, Pareti nos. 307-8, have cast lions' heads, turning outwards, attached to their cauldrons by hammered neckpieces. According to Greek standards a date within the second quarter of the century would

be assigned to them. The cauldron here under discussion, no. 196, seems to represent a later stage, even from the technical point of view: the lions' heads are turning inward and are entirely cast, not hammered.

13. Pareti, 175-80, no. 1, plate 5. From the same burial as the vase stand no. 303 [30]. For the form of the fibula ('Blattbogenfibel' with transverse staff and foot disc) see J. Sundwall, *Die älteren italischen Fibeln* (Berlin, 1943), 125-7, no. 22. How this giant pin was employed is quite uncertain. Pareti's idea that it formed part of the lady's headgear cannot be maintained. See the review by M. Pallottino, *S. Etr.*, XX (1948/9), 342.

14. Cf. Akurgal, *op. cit.*, 56-69.

57. 15. A. Rumpf, *Die Wandmalerei in Veji* (Leipzig, 1915), 38-60.

16. See W. von Bissing, *J.D.A.I.*, XXXVIII/XXXIX (1923/4), 224-6; W. L. Brown, *The Etruscan Lion* (Oxford, 1960), 28, 31, 34; G. Camporeale, *La Tomba del Duce* (Florence, 1967), 103-4.

58. 17. Rumpf, *op. cit.*, 43.

18. Types of lions: Poulsen, *op. cit.* (Note 10), 124-5 and figures 134-6, gives a brief account of this zoology. The mane along the back is also found in Protocorinthian lions, e.g. on the Chigi vase. But to transfer this detail to other animals, such as bulls, against all evidence of natural history, seems a habit of Etruscan art.

19. Regional characteristics: in addition to the points discussed in the text above, it should be mentioned that vases with incised decoration continue into this period. A good example of their rather popular style of drawing is the black impasto *olla* in the Vatican: J. D. Beazley and F. Magi, *La raccolta B. Guglielmi nel Museo Gregoriano Etrusco*, I (Città del Vaticano, 1939), 111-19, figures 1-6, and plate 36. Reflections of Corinthian art are clearly present. The curious vase from Tragliatello, of Late Protocorinthian form, uses engraved decoration in a similar style. Again one recognizes the Corinthian motifs, e.g. the row of marching soldiers. The drawing is on a level with the Guglielmi vase, or slightly later; probable date, around or a little after 600. G. Q. Giglioli, 'L'oenochoe di Tragliatello', *S. Etr.*, III (1929), 111-59, plates 22-7; cf. also F. Slotty, 'Manin Arce', *S. Etr.*, XVIII (1944), 164-80.

20. The absence of base lines in the Regolini-Galassi bronze stand was first observed by Poulsen, *op. cit.*, 124; cf. p. 14, Phoenician examples of the same anomaly.

The matter cannot be discussed here, but a reminder is in place that, while base lines are the rule in Egyptian art, conspicuous exceptions can be found in the art of the Empire: cf., e.g., the wooden chest with a representation of the king's hunt from the tomb of

Tutankhamun, the famous reliefs of Sethos I at Karnak, and others (H. Schäfer and W. Andrae, *Die Kunst des alten Orients* (Propyläen Kunstgeschichte, 11) (Berlin, 1925), plates 336 and 376; pp. 101-3). Absence of base lines in Cypriote art: in the orbit of Classical art the representation of figures without base lines becomes a provincialism. Interesting examples occur in the Archaic art of Cyprus. In the hunting scenes of the famous ivory box from Enkomi the animals are superimposed as in the Egyptian representations mentioned above (H. T. Bossert, *Altsyrien* (Tübingen, 1951), 11, no. 166). The after-effects of this style in provincial Cypriote art can be seen in the limestone box from Tammassos, *ibid.*, 21, no. 54. Cf. with these representations the hunters and animals on the granulated gold bulla from Vulci, H. Mühlestein, *Die Kunst der Etrusker* (Berlin, 1929), figure 80. Greek art: base lines are the rule; exceptions are very rare. Among the early Greek monuments only the engraved Late Geometric and Subgeometric Boeotian fibulae show a tendency, as a class, to omit base lines from their representations: R. Hampe, *Frühe griechische Sagenbilder in Boeotien* (Athens, 1936), plates 1-6, 11, 13, 15.

60. 21. C. Densmore Curtis, *The Barberini Tomb, M.A.A.R.*, v (1925), 37-9, no. 73, plates 19-21, figure 1; Mühlestein, *op. cit.*, figures 127-130.

22. Curtis, *op. cit.*, 29-30, no. 36, plate 13, figures 1-3; Mühlestein, *op. cit.*, figures 27, 28; Huls, 46-7, no. 27, plate 17, figure 1. Fluted bowls, without foot: the form was probably Assyrian in origin, see Matz, *op. cit.* (Note 12), 445 and note 573. A quite different attempt at combining flat bowls on a high foot with caryatids was made in early Greek art: *ibid.*, 382-4, plates 246, 247. Instead of supporting the rim of the bowl, the caryatids are gathered around the stem. The form represented by the Barberini goblet and similar specimens of ivory or black bucchero seems to have been properly Etruscan, but its antecedents are not yet well known; cf. below, illustration 48, and Pareti, 311 and bibliography. Date and workmanship of the Barberini goblet: Etruscan under Syrian influence, G. Hanfmann, *Altetruskische Plastik*, I (Würzburg, 1936), 24-6; Huls, 137-51. The caryatids resemble those from the antechamber in the Regolini-Galassi Tomb, and from the Tomba Calabrese. A date towards the end of the century seems indicated for both burials: Pareti, 459. It would also fit the horsemen portrayed on the companion piece of the Barberini goblet: Curtis, *op. cit.*, plate 14.

61. 23. Curtis, *op. cit.*, 24-6, nos. 22-4, plates 9-11; Mühlestein, *op. cit.*, figures 31, 32; Huls, 44-6, no. 25, plates 13-15, 16, figure 1.

CHAPTER 5

63. 1. To illustrate this point further, one may refer to the famous description of the shield of Achilles in the Iliad. The passage gives the impression of rendering not a real, but certainly a possible, work of ancient art; cf. W. Schadewaldt, *Von Homers Welt und Werk* (Leipzig, 1944), 280-302, especially 287, notes 1-5, with reference to the Phoenician bowls. The *ekphrasis* of Achilles' shield must therefore be regarded as the first authentic statement on art in Greek literature, and perhaps any literature. The interesting point is that, while the Homeric poem itself constitutes a highly developed and individualized example of character-fiction, this particular description still reflects an earlier, quite generic, level of art criticism. Its outstanding characteristic is the wholly impersonal, merely classifying, approach to subject matter. No personal name, no definite myth; only diverse if representative examples of human life and labour. Such themes were actually shown on the Phoenician bowls, but hardly in later Greek art, as, for instance, the men working the fields. Like the shield, more often than not this Phoenician art was conceived as a direct – not mythical – mirror of the world, expressed in terms of generic categories.

2. Varro recorded an ancient tradition which Plutarch thought in agreement with Pythagorean rules: that no images of deity existed in Rome before the statue of Jupiter by Vulca in the Capitoline temple – *c.* 500. See testimonia in O. Vessberg, *Studien zur Kunstgeschichte der römischen Republik* (Lund and Leipzig, 1941), 5-6; Riis, 198. The story probably refers to images designed for public worship – cult images. With this proviso, it may well be correct. Cult images were indeed regarded in Rome as a Greek, or rather Greco-Etruscan, innovation.

3. Early names of deities in Italy: for Rome and central Italy see F. Altheim, *A History of Roman Religion* (New York, 1938), 182-7, 229.

The popular groups which I called 'acrobats' and 'horse tamers' (see Chapter 2, illustrations 20 and 22) perhaps constitute the first Etruscan types of deity, or at least demoniac characters, in human form. The horse tamers, especially, follow a pre-Greek heraldic scheme, widely distributed in the eastern Mediterranean. Their appearance in Italy was therefore not necessarily due to Greek importation; the type may have reached the Italian peninsula across the Adriatic, by way of the Balkan route. For additional examples see P. Marconi, *Bollettino d'Arte*, XXX (1936/7), 58-75. An interesting sidelight falls on these conditions from the study of Latin names given in Italy to deities and mythical personages who were known by different names in Greece. Thus the goddess Artemis was first understood in Italy in her older, eastern Aegean

function as a 'Mistress of Animals'. The idea of the virgin huntress developed later. Her Etruscan name, Aritimi, likewise came to Italy in a pre-Homeric form, perhaps transmitted by Illyrian peoples across the Balkans (Altheim, *op. cit.*, 41). It seems that the idea of divine horsemen and twins, called 'Dioskuroi' by the Greeks, was brought to Italy in a similar manner, by way of Illyrian connections, long before it became thoroughly grecized through the influence of the Tarentine cult (Altheim, *op. cit.*, 40). I therefore connect the early Etruscan representations of horse tamers with this equally ancient relic of pre-Homeric demonology in Italy. But then the fact must be emphasized that in art one horse tamer usually stands alone between two horses: in other words, the horses are doubled but he himself is not a twin. This fact may have some bearing on the other, no less peculiar circumstance that when, eventually, a temple was built on the Roman Forum for the Dioskuroi the new building was actually dedicated not to the twins but to only one of them: it was the 'Temple of Castor' (Altheim, *op. cit.*, 244-5).

64. 4. From Tumulus I della Pania. Huls, 62-4, nos. 61 and 62, plates 27-30; Ducati, 175-8, plate 59, figure 180; H. Mühlestein, *Die Kunst der Etrusker* (Berlin, 1929), plate 53, pp. 162-6 (in need of revision); Giglioli, plate 81, figure 2. The companion piece is illustrated in Giglioli, plate 81, figure 1. Italo-Corinthian vases and other objects found together with both boxes indicate a date near the end of the seventh century: G. Karo, *Athenische Mitteilungen*, XLV (1920), 149.

5. The Italian form of the name, Ulixes, like the names of the Dioskuroi and others, probably reached Etruria from an Illyrian, Balkan source even before the Homeric name, Odysseus, became generally known (Altheim, *op. cit.*, 39, 128, 154). This observation tallies with the early popularity of the story of Odysseus in Etruscan art.

6. Both soldiers on the march and a knight mounting his chariot represent standard motifs of Greek Orientalizing art. No specific significance was ascribed to them as a rule, but they could be used for mythical representations on occasion; for instance, the 'Departure of a Warrior' could be turned into an 'Amphiaraus going to war against Thebes'. Cf. the roughly contemporary terracotta frieze from Crete in F. Matz, *Geschichte der griechischen Kunst*, I (Frankfurt am Main, 1950), 491-2 and plate 288b.

65. 7. The iconographic scheme, rear part of a horse attached to an upright human figure, is in accordance with early Greek habits. The long garment is unusual, however. The only example known from Greece represents a female figure, Medusa, in the form of a centaur: the Cycladic (rather than Boeotian) pithos in the Louvre (Matz, *op. cit.*, 414, plate 251). For early types of centaurs see also below, Chapter 10, Note 2, Chapter 11, Note 2.

67. 8. Oriental iconography in grecizing monuments: Etrusco-Corinthian vases, Rome, Villa Giulia [38], M. Pallottino, *Bollettino d'Arte*, XXXI (1937), 149-53, figures 1-3. Provenance unknown, perhaps Cerveteri. Parts restored, but the representations here at issue seem intact. Birds feeding on the dead: there is a chance that oriental representations of this kind gave rise to the Greek myth of Prometheus and the vulture: see E. Kunze, *Kretische Bronzereliefs*, 2 vols. (Stuttgart, 1931), 250-1.

68. 9. Pareti, 182-4, nos. 3-4, plate 6; Mühlestein, *op. cit.*, figures 90, 91; Giglioli, plate 28, figures 1-2. Another pair, of similar make and design, is in the British Museum: F. H. Marshall, *Catalogue of the Jewelry, Greek, Etruscan and Roman in the Department of Antiquities, British Museum* (London, 1911), 123-4, nos. 1356-7, plate 18. The dancers are almost identical, but differences occur in the terminal reliefs, not discussed here: the Vatican bracelets show a 'Mistress of Animals' between two lions each of which is being attacked by a man; London has as central figure a 'Lord of Animals', and the lions are winged.

69. 10. I cannot see that the women hold the trunks of the trees, as most descriptions maintain, including Pareti, 183. They hold hands in front of the trees: consequently they represent dancers. The dancing 'chorus' was a distinct subject of Greek Orientalizing art and also included in the representations on Achilles' shield, according to Homer: Kunze, *op. cit.*, 212-13.

11. Side view versus frontality: from the end of the Geometric period onwards, most dancing figures in Greek paintings and reliefs turn not only their feet but also their heads to one side: cf. the early Attic *loutrophoros* in Paris, Matz, *op. cit.*, 11, plate 193. The dancers on the Cypriote bowl illustrated by E. Gjerstad, *Opuscula Archaeologica*, IV (1946), plate 1, are likewise drawn with heads turned, not facing; this detail is probably due to Greek influence. Otherwise the bowl affords a good comparison to the Vatican bracelets. The figures have the same 'Phoenician' curls, and every second dancer wears a dress like the women on the bracelets, divided by a vertical fold in the middle. The trees are also found behind the dancers. Once again the evidence leads to the Cypro-Phoenician bowls, or some similar portable object from the same stylistic province, as the likely source of the subject matter and even of the iconographical scheme.

12. L. Curtius, *Die Antike Kunst*, II, 1 (Potsdam, 1938), 111-12.

13. See the interesting terracotta relief in Naples representing the lower part of a female figure in a

long garment illustrated in Matz, *op. cit.*, plate 279b. Her dress is decorated by a vertical ribbon, embroidered or woven, which consists of panels stacked one upon another. In the middle panel, a female chorus is represented, with heads facing. The style seems to be local, Italo-Greek, dependent on Peloponnesian prototypes. Vertical rows of panels are even more characteristic of another early Greek type of art: the bronze bands with embossed reliefs which reinforced the leather handles of Archaic shields. These bands can be referred to Argive workshops. Production started before the end of the seventh century: E. Kunze, *Archäische Schildbänder* (Olympische Forschungen, 11) (Berlin, 1950), 204–5, 242.

14. It is indeed likely that the panels of the Vatican bracelets were derived from an original frieze composition, cut to panel size: cf. the almost identical decorations on the oblong pendants, perhaps from a pair of earrings, from the same tomb, Pareti, 187–8, nos. 15–16, plate 7.

70. 15. Pareti, 205, no. 66, plate 12. Most objects of this deposit probably date from near or after the middle of the seventh century (*c.* 650–630, according to Pareti). Individual items may nevertheless be somewhat older, especially precious objects like this necklace, which I date to the first half of the century rather than the second, because of its purely Villanovan Geometric character.

71. 16. Pareti, 180–2, no. 2, plate 5; G. Pinza, *Materiali per la etnologia antica toscano-laziale* (Milan, 1915), 177–85, plate xxiv; Mühlestein, *op. cit.* (Note 4), figure 82; Giglioli, plate 26, figure 2. The present reconstruction of the parts, by G. Pinza, can be accepted as the most probable.

17. Pareti, 185, no. 5, plate 7. For the date, see Note 15; cf. J. Sundwall, *Die älteren italischen Fibeln* (Berlin, 1943), 57.

18. Both techniques had a long history in the eastern Mediterranean, especially Mesopotamia and Egypt. On the other hand, granulated work appears to have been comparatively rare in Phoenician art, as well as in the Geometric art of the Greek mainland (but cf. E. Smithson, *Hesperia*, xxxvii (1968), 113–14, nos. 77a and b, plates 30, 32, a pair of gold earrings decorated with granulation).

The technique may have been introduced to Etruria from eastern Greek, Orientalizing, workshops. See for the difference between filigree and granulation M. Rosenberg, *Geschichte der Goldschmiedekunst* (Frankfurt am Main, 1907–16), 11, 3–4. Granulated work in Etruria: *ibid.*, 111, part 2, 43–69; Ducati, 1, 134.

72. 19. A. Minto, *Marsiliana d'Albegna* (Florence, 1921), 196–8, plate 11, figure 1; Sundwall, *op. cit.*, 246, no. 19. Made from a strong sheet of gold over a silver core. The small birds, sometimes termed

'ducklings' (*anitrelle*), are related to Villanovan Geometric rather than to Orientalizing art: Ducati, 1, 133. Rosenberg, *op. cit.*, 111, part 2, 43–56, distinguishes between two kinds of granulated work in Etruscan art: one in which granulation is applied to small figures in the round as in the present example; another in which granulation is used to create a flat design. The 'sculptural' was probably the older manner. The 'pictorial' design delineating flat figures – as in a vase painting – by lines of extremely fine golden globules is the more exacting technique. Rosenberg tentatively called it 'Vetulonian'. Its chief monuments, generally of a more advanced Orientalizing style, hail from Vetulonia and Vulci.

20. See above, Chapter 4, Note 13.

21. Circolo dei Monili: Giglioli, 8, plate 21, figure 2. For other examples from Vetulonia and observations regarding the origin of this style – possibly based on Mesopotamian antecedents – see G. Karo, 'Vetuloneser Nachlese', *S. Etr.*, viii (1934), 49–57.

22. Victoria and Albert Museum: Mühlestein, *op. cit.*, figures 97–8; Rosenberg, *op. cit.*, 111, figures 107, 108.

CHAPTER 6

75. 1. Bibliography, above, Chapter 4, Note 11. For the history and distribution of Orientalizing hypocrateria in Italy cf. Dohan, 20, no. 2 (comparanda).

76. 2. A certainly Oriental form, of which examples have also been discovered at Olympia, is represented in Etruria by the stands from the Bernardini and Barberini Tombs at Praeneste; cf. H.-V. Herrmann, *Die Kessel der orientalisierenden Zeit* (Olympische Forschungen, vi) (Berlin, 1966), 161–74, plates 65–75. The decoration in large, hammered reliefs is in the style of Assyrian art. The form of the Regolini-Galassi stand differs from these examples. With its two spheres between the conical foot and the flaring top it probably represents a domestic, Etruscan elaboration of the general type. Terracotta versions of the same form as the Regolini-Galassi stand appear first in Etruscan Early Orientalizing tombs of the first half of the seventh century. One specimen formed part of the Bocchoris Tomb: G. Karo, *Athenische Mitteilungen*, xlv (1920), 109, figure 1, no. 13, and p. 111; Hencken, 372, figure 366. For another example hailing from a tomb of the same period see L. Marchese, *Notizie degli Scavi* (1944), 14–15, figure 2.

3. In the south Etruscan and Faliscan territories, where the stands were especially popular, their type was fully developed by the second quarter of the seventh century. Cf. the material from Narce discussed in Dohan; and L. A. Holland, *The Faliscans in*

Prehistoric Times (Papers of the American Academy in Rome, V, 1925), 88–91, plate 8 figure 6, plate 13 figure 15. Possible use of the stands in religious ceremonies: N. Orsi, 'I cosidetti "calefactoria"'; contributi dalle Tavole Iguvine VIb, 24–42', *S. Etr.*, XV (1941), 127–39. Cf. also Holland, *op. cit.*, 91.

4. Origin of the 'flamboyant' form: a date later than the middle of the seventh century was given to the Regolini-Galassi stand because of its decoration; as to form, it is a rather conservative work. The flamboyant forms found in other, similar, stands were obviously not developed in bronze but in terracotta. The tendency appears already in the impasto stands of the second quarter of the century; for instance the curious vertical, connecting links between the chief structural points occur as early as in the stands from Narce (Dohan, plate 28 no. 1, plate 35 nos. 1 and 3). A formal parallel to the Regolini-Galassi stand: an interesting example of similar decorative design, in Greek art, on the lower frieze of the Early Attic Nessos amphora in New York (J. Boardman, J. Dörig, W. Fuchs, M. Hirmer, *The Art and Architecture of Ancient Greece* (London, 1967), plate 74); second quarter of the seventh century. The black silhouettes of upright cones, each supporting two superimposed spherical shapes, look like so many abstractions of a vase carrier with cauldron.

77. 5. A monograph on Italian bucchero is still wanted. For basic information see P. Mingazzini, *Vasi della Collezione Castellani*, 2 vols. (Rome, 1930), 1–4; G. M. A. Richter, 'The Technique of Bucchero Ware', *S. Etr.*, X (1936), 61–5; M. Del Chiaro, 'Etruscan Bucchero Pottery', *Archaeology*, XIX (1966), 98–103. Bucchero appears in tomb groups only after 650: L. Marchese, *Notizie degli Scavi* (1944/5), 20.

6. Dohan, 3.

7. A. W. Van Buren, 'Antiquities in the American Academy', *M.A.A.R.*, XIX (1949), 119–21, plate B. A recent study of the transformations of a single type of vessel from impasto through *bucchero sottile* to *bucchero pesante*: M. Verzár, 'Eine Gruppe etruskischer Bandhenkelamphoren. Die Entwicklung von der Spiralamphora zur nikosthenischen Form', *Antike Kunst*, XVI (1973), 45–56, plates 3–6.

79. 8. Pareti, 423, no. 528, plate 67. Other examples in Giglioli, plate 47. The caryatids: for the origin of the type, see G. Hanfmann, *Altetruskische Plastik*, I (Würzburg, 1936), 23 and note 46. At first, a religious or ritual significance was probably implied by the gesture of holding a strand of hair in either hand. Though this gesture may have originated in the east – Syro-Phoenician according to Hanfmann, *op. cit.*, Cypriote according to S. Haynes (cf. *Antike Kunst*, VI, 1 (1963), 21 and note 9) – it is oftenest found in Etruria.

80. 9. Vatican, Museo Gregoriano Etrusco; Pareti, no. 530, plate 68; others without caryatids, Giglioli, plate 47, figures 2, 5, 7–9.

10. The interior and at least one handle of the fine skyphos of Corinthian form (Pareti, 361, no. 396, plate 52) were coated with silver (from the Peripheral Burial no. 2, in the Regolini-Galassi tumulus).

11. Pareti, 367, no. 400, plate 54. The prototypes probably came from Cypriote art; Hanfmann, *op. cit.*, 21–3.

82. 12. Pareti, 399, plate 54. For the shape of the similar specimens of silver: *ibid.*, 224–5, nos. 165–6, plate 17, from the 'cella' of the Regolini-Galassi Tomb. This is an interesting type of vase; numerous examples are preserved, of silver, bronze, or *bucchero sottile*; the type is represented in all the great tombs but also in the Faliscan area, at Narce and Cumae (cf. Dohan, 78, comparanda no. 2, and examples enumerated in Pareti, 224–5). This type, and many of the metal examples, is Phoenician, or Cypriote; G. Camporeale, *Archeologia Classica*, XIV (1962), 61–70; *idem, La Tomba del Duce* (Florence, 1967), no. 70, pp. 107–8, plate 21a. Its fundamentally biconical shape, very like that of the contemporary spiral amphorae (above, p. 50, illustration 26) and reminiscent of the Villanovan ossuaries, is probably responsible for its great popularity in Etruria.

13. Flower decoration: the ornament on the jug of illustration 51, which resembles a 'tree' of lotus flowers, was traced to Cypriote art, and beyond to Egyptian art of the Empire, by W. von Bissing, *S. Etr.*, II (1928), 19–38, plate 2.

14. A. Minto, *Marsiliana d'Albegna* (Florence, 1921), 290–3, figure 30, plate 52; Giglioli, plate 39, figure 5.

83. 15. A comprehensive survey in Mingazzini, *op. cit.*, 70–96. The technique of red impasto was not new; it had been practised in Etruria since the first Orientalizing phase along with ordinary impasto and early bucchero. New to Etruria was the technique of decoration which is distinctive of this class of vases. Castellani no. 258 precedes all other specimens of the type in that collection; approximate date: last third of the seventh century. It is a storage jar (*pithos*) decorated with two stamped friezes; most such jars have 'metopes'. On the other hand, the flat basins seem always to be decorated with friezes. The oldest basins date from *c.* 600, but most belong to the middle decades of the sixth century (Mingazzini, *op. cit.*, 88–96, nos. 273–87). Not all dies were equally flat; the flat reliefs appear among the earliest pieces, but occasionally also later. The technique of decoration with stamped reliefs was Greek; see for instance with regard to the famous Rhodian pithoi, F. Matz, *Geschichte der griechischen Kunst* (Frankfurt am Main, 1950), I, 478.

16. Pareti, 439, no. 654, plate 70; *ibid.*, 438, no. 647. Cf. the characteristic group of red ware in the Louvre – platters, basins, and jars, all from Cerveteri – in Giglioli, plate 44.

84. 17. Description and complete set of illustrations in C. Densmore Curtis, *M.A.A.R.*, v (1925), 37-9, no. 73, plates 19-21. For an interpretation cf. the somewhat extravagant discussion in H. Mühlestein, *Die Kunst der Etrusker* (Berlin, 1929), 216-19, plates 127-30. Form: the same form of skyphos is well known from Protocorinthian ceramics, see H. Payne, *Necrocorinthia* (Oxford, 1931), 294 and note 3. Date: in spite of its rather provincial style the Barberini cup, because of its grecizing form and iconography, can hardly be dated much before the end of the seventh century. Pareti, 460, is probably correct in classifying it among the most recent items of the Barberini Tomb.

85. 18. Cf. my article, 'Three Archaic Bronze Discs from Italy', *A.J.A.*, XLVII (1943), 194-208, figures 1-3. The three discs in St Louis have meantime been cleaned with excellent results. Our illustrations 54 and 55 show their present condition; especially in the large disc [54] many details have appeared which were not visible before the restoration.

19. The manufacturing centre or centres are yet to be determined. Like the earlier bronze belts the discs were very popular in the interior provinces, especially Picenum. But they were also well known in the coastal towns of Etruria, and their decoration, at any rate, incorporated Greek orientalizing elements which must ultimately have been derived from prototypes shipped into Etruscan harbours.

20. The distribution of two pairs of figures on the four quarters of a circle – each pair consisting of two identical figures facing one another – in the large disc [54] corresponds exactly to the composition of a disc from Vetulonia (A. Talocchini, *S. Etr.*, XVI (1942), 72-4 and figure 18). Moreover, the two lions in the St Louis disc and those of the disc from Vetulonia are of almost identical design; and all four are in turn closely related to the crouching bronze lions of the Bernardini Tomb (Curtis, *M.A.A.R.*, III (1919), 84-5, nos. 92 and 93, plate 67, figures 1-4). Likewise, the anatomy of the running women in the large disc at St Louis can be compared to the 'huntress' on the Barberini bronze skyphos [34], which, though less precise, represents a similar type. An original connection between all these types – humans as well as animals – can hardly be doubted. However provincially distorted, the bronze discs still fall within the orbit of Etruscan art.

CHAPTER 7

88. 1. Some of the best examples of Villanovan sculpture come from tombs at Vetulonia, which seems to have been a centre of their production: Riis, 145. All served decorative purposes, attached to implements such as bronze cauldrons and other furniture. An especially interesting class is the so-called 'candelabra', in reality stands of bronze with hooks on which drinking bowls and similar household implements could be hung. See, for the latter class, F. Messerschmidt, 'Die "Kandelaber" von Vetulonia', *S. Etr.* v (1931), 71-84, plates 5-7.

89. 2. Illustration 56 represents one of a pair of standing women from the Tomba del Duce, Vetulonia, now in Florence, Museo Archeologico. Cf. Messerschmidt, *op. cit.*, 71, no. 2; G. Camporeale, *La Tomba del Duce* (Florence, 1967), 92-6 no. 51, 136 no. 113, plate 18a-e. For the date of the tomb, see Dohan, 106, and Camporeale, *op. cit.*, 163 (contemporary with the Regolini-Galassi Tomb at Caere).

3. Illustration 57, a warrior with sword and bow found at Monte Arcosu (Uta), is now in the Museo Archeologico Nazionale at Cagliari; C. Zervos, *La Civilisation de la Sardaigne* (Paris, 1954), figure 195. This class, not being Etruscan, cannot be discussed here. Relations with Villanovan bronzes, some of which may well have been fashioned under the influence of Sardinian models, still need elucidation.

4. Cf. the concurrent observations on the Greek art of south Italy in E. Langlotz, 'Die bildende Kunst Grossgriechenlands', *Critica d'Arte*, VII (1942), 89-105, plates 33-43. The peculiar forward action of the arms in early Italian bronzes, while the body remains in the flat, was probably due to oriental, Syrian or Phoenician, prototypes: G. Hanfmann, *Altetruskische Plastik*, I (Würzburg, 1936), 65-6, 89, and note 195.

5. *Ancient Art in American Private Collections*, exhibition catalogue (Cambridge, Mass., 1954), 42, no. 367, plate 98.

90. 6. P. Ducati, *S. Etr.*, v (1931), 101, note 2, and plate 8, figure 2; *Mostra dell'Etruria padana* (Bologna, 1960), 87, no. 179, plate 6.

7. From the Second Circle delle Pelliccie; Messerschmidt, *op. cit.*, 71, no. 1, and plate 5, figure 1.

91. 8. *Ancient Art in American Private Collections* (*op. cit.*), 32, no. 224, plate 69.

92. 9. For imitations of oriental motifs (posture and costume) see Hanfmann, *op. cit.*, 17-23 (bucchero), 66-7 (ivory). Cf. also the caryatids, Chapter 6, p. 79, illustration 48, and Note 8. The bronze statuette from the Tomba del Duce [56] represents an early instance in Italian art of a woman wearing the long oriental pigtail; see above, pp. 88-9 and Note 2.

10. No comprehensive account has yet been published. For the archaeological evidence see R. Pincelli, 'Il tumulo vetuloniese della Pietrera', *S. Etr.*, XVII (1943), 47-113, plates 6-11.

11. Hanfmann, *op. cit.*, 37-51; Riis, 144-6; A. Hus, *Recherches sur la statuaire en pierre étrusque archaïque*

(Paris, 1961), 100-34, plates 1-3, 17-18; A. Minto, *S. Etr.*, XXI (1950/1), 21-3.

93. 12. Type and costume of the female statues: Hanfmann, *op. cit.*, 44-6; Hus, *op. cit.*, 117-26; S. Ferri, *Atti del I congresso internazionale di preistoria e protostoria mediterranea* (Florence, 1952), 442-53.

13. Type and costume of the male statues: cf. the Phoenician kouros from Marsala, P. Mingazzini, *Bollettino d'Arte*, XXI (1937/8), 505-9.

14. This seems to be due to an error. Cf. G. Q. Giglioli in *S. Etr.*, XX (1948/9), 277-82. There were more fragments, apparently of other, similar statuettes, but too badly broken for reconstruction; see *idem, ibid.*, XXII (1952/3), 319-28.

15. The complete identity of costume in the male and female figures seems to bear out the statement of Servius (*Aen.* I, 282) that in early times the toga was worn indiscriminately by men and women, contrary to later Roman usage. Similarly Varro, in *Nonius* 540.31.

16. Style: Hanfmann, *op. cit.*, 15-17; Riis, 73-4.

95. 17. Damaratus of Corinth: Pliny, *N.H.* 35.16 and 152, on the authority of Varro; also Cicero, *De Republica* 2.34, cf. Riis, 200 and note 7. The story which connects Damaratus with the clan of the Tarquins does not necessarily imply that Tarquinia was the place where he and the artists who came with him settled, although the later Roman tradition generally assumed that the royal family came from that town. Actually Tarquins are known from other Etruscan cities also, e.g. Caere. It may be said, however, that the stylistic analysis of the monuments rather favours the assumption of a strong Greek influence in central Etruria at the turn from the seventh to the sixth century. The local output of southern Etruria appears at this time less Grecizing than Orientalizing, in addition to the regional 'flamboyant' style likewise characteristic of that region. Tarquinia, on the other hand, in her local art definitely falls in with the central Etruscan centres, especially Vulci; and here the progress of Grecizing art, reflecting the impact of evidently Peloponnesian and Corinthian sources, becomes very noticeable about 600. Cf. Riis, 64-7, 106-7.

96. 18. D. Levi, 'Sculture inedite del museo di Chiusi', *Bollettino d'Arte*, XXVIII (1934/5), 53-6; Riis, 113-15; Hus, *op. cit.*, 57-67, plates 29-35. Explained as goddesses by M. Pallottino and H. Jucker, *Art of the Etruscans* (New York, 1955), 138-9, nos. 35 and 37. Syro-Hittite antecedents, B. Segall, *A.J.A.*, LX (1956), 169-70.

97. 19. H. Mühlestein, *Die Kunst der Etrusker* (Berlin, 1929), plates 180-5; bibliography in Riis, 120-1; cf. also G. Camporeale, 'Le figurine di Brolio', *Bollettino d'Arte*, XLV (1960), 193-201.

98. 20. Cf. the statuette in Berlin, said to be from Crete: K. A. Neugebauer, *Katalog der statuarischen*

Bronzen in . . . Berlin, I (Berlin and Leipzig, 1931), 61-2, no. 158, plate 19; G. M. A. Richter, *Archaic Greek Art* (New York, 1949), figure 56.

21. Statuettes of javelin-throwers: the frontal type, not striding, was very old in Etruria and even older in Hittite and Phoenician art. It may have been first introduced to Italy from oriental prototypes. This subject requires fresh investigation; see, for example, E. H. Richardson, 'The Ikon of the Heroic Warrior', *Studies presented to George M. A. Hanfmann* (Mainz, 1971), 161-2.

For the later Greek type, which is shown sideways, see below, Chapter 23, p. 291.

99. 22. These statuettes are typical of provincial Etruscan workshops, particularly in the north-east. Cf. Riis, 120 and note 2; F. Magi, 'Due bronzetti arcaici del territorio fiesolano', *S. Etr.*, VIII (1934), 413-18, plate 45. They are explained as gladiators by K. A. Neugebauer, *Berliner Museen*, LXI (1940), 7-17. Skirted statuettes were still produced in the third quarter of the sixth century; characteristic of the earlier specimens is the rotundity of the limbs, resulting in a curiously undulating outline. Statuettes of this style also occur without the skirt; cf. G. Monaco, 'Le statuette bronzee del R. Museo di Antichità di Parma', *S. Etr.*, XVI (1942), 521 no. 7 and plate 31 figure 2.

23. Illustration 68, Florence, Museo Archeologico no. 40: Riis, 120, note 2. Illustration 69, Volterra, Museo Guarnacci no. 18; A. Hus, in *Mélanges d'archéologie et d'histoire, École française de Rome*, LXXI (1959), 10, note 1.

100. 24. British Museum B330: G. M. A. Richter, *Kouroi*, 2nd ed. (New York, 1960), 57, no. 27, figures 126-8.

101. 25. Earlier discussions, including the preliminary report published by this writer in *Archäologischer Anzeiger*, L (1935), 572-81, tended to overrate the direct impact of Greek art. The Italic bronze statuettes now provide the missing link. Publications: G. Moretti, *Il guerriero italico di Capestrano. Opere d'Arte*, fasc. 6 (Rome, 1936); A. Boëthius, 'Il guerriero di Capestrano', *Critica d'Arte*, IV/V (1939/40), 49-52, plates 20-1; S. Ferri, 'Osservazioni intorno al guerriero di Capestrano', *Bollettino d'Arte*, XXXIV (1949), 1-9; L. A. Holland, 'The Purpose of the Warrior Image from Capestrano', *A.J.A.*, LX (1956), 243-7.

CHAPTER 8

103. 1. For early concepts of portraiture in ancient art, cf. B. Schweitzer, 'Studien zur Entstehung des Porträts bei den Griechen', *Berichte des sächsischen Akademie, philologisch-historische Klasse 91*, fasc. 4 (Leipzig, 1930), 1-67, plates 1-4.

104. 2. H. B. Walters, *Catalogue of the Bronzes, Greek, Roman and Etruscan in the* . . . *British Museum* (London, 1899), no. 434; Riis, 88, note 3; most recently, S. Haynes, *Antike Plastik*, IV (1965), Lieferung 2, 20-4, plates 9-11. Said to come from the so-called Isis Tomb in the Polledrara cemetery near Vulci. For the archaeological evidence see F. N. Pryce, *Journal of Roman Studies*, XXV (1935), 246-7. He distinguishes between two burials, and possibly two tomb groups of slightly different date, one including a scarab with the name of the Egyptian pharaoh Psammetichus II (593-588). But the distribution of the finds between the two burials is now quite uncertain. We do not even know for sure that the bust was really included in this tomb; cf. Å. Åkerström, *Studien über die etruskischen Gräber* (Uppsala, 1934), 67-8. Moreover, the bust has undergone considerable restoration. The right hand, which is cast, may have held the horned bird of gilded bronze which, with Pryce, I would rather give to the alabaster statuette found in the same tomb (below, illustration 81). A recent examination in the museum made it seem doubtful that the cylindrical band which now forms the base originally belonged to the bust; the hemispherical band representing the skirt may well have served as a base prior to the present restorations. At any rate, the cylindrical band with the horses represents a somewhat later style than the animal frieze in the zone above; the latter would fit the presumed date of the bust better. The pieces are fitted together rather poorly. Was the pastiche due to a nineteenth-century hand? (cf. Haynes, *op. cit.*, 21-2).

105. 3. Riis, 109-10. The Paolozzi vase, here illustration 72: Giglioli, plate 64, figure 3, plate 65, figure 1; Riis, no. 8. The small figures around the shoulder and lid of the vases are often called mourners; I should rather take them to represent dancers, in anticipation of the elysium idea so frequently illustrated later around the funeral chambers of Tarquinia. To the birds' heads growing from what appear to be human testicles a phallic connotation must be ascribed. The likely explanation is that two apotropaic symbols were combined, to ensure maximum protection.

106. 4. R. Bianchi-Bandinelli, 'Clusium', *Monumenti Antichi*, XXX (1925), cols. 445-54; D. Levi, 'I canopi di Chiusi', *Critica d'Arte*, I (1935/6), 18-26, 82-9, plates 8-15, 56-9; outline of a typological series in chronological order, Riis, 108-9. Only the specimens listed by Riis under types 1-5 are definitely older than the year 600. The examples assigned to his group 6 may, for the most part, be dated to the years around 600 and the first decades of the sixth century. For his group 7, which is later, see below, p. 131.

5. Ceramic forms: the leading form is an amphora with vertical handles. Greek influence is likely and in the more developed examples quite evident. However, because of the special purpose of these vases, which from the shoulder upward are interpreted as human likenesses, the handles do not connect with the neck as in the Greek amphorae. Symbolically, they take the place of arms: indeed, realistically modelled arms and hands are sometimes inserted in them; cf. Giglioli, plate 61, figures 1 and 2. Experimental forms, e.g. with horizontal handles, are apt to appear among the earlier ossuaries, cf. *ibid.*, plate 60, figure 1. The older vases also are often more nearly globular, and sometimes placed on a comparatively high foot, cf. *ibid.*, plate 60, figure 2. Bronze ossuaries usually preserve the nearly globular form and emphasize the high foot, as in *ibid.*, plate 62. Reminiscences of Villanovan forms occur, as in the quasi-biconical ossuary, Levi, *op. cit.*, plate 56, figure 30. A very fine example from Solaia, now in Florence, shows a head of triangular and almost geometric form placed on a vase evidently related to late Villanovan, Arnoaldi products, not unlike our illustration 15: Levi, *op. cit.*, 19, and plate 14, figure 20. However, among the majority which adhere to a more or less elongated amphora type, such cases constitute the exceptions. For transitional forms between the Villanovan and the truly anthropomorphic Canopic urns, outside Chiusi, cf. A. Minto, 'I clipei funerari etruschi', *S. Etr.*, XXI (1950/1), 44-9.

107. 6. Illustration 73, mask from a Canopic urn, Munich, Antikensammlungen. For a bronze example in Chiusi, Museo Civico, see Bianchi-Bandinelli, cols. 447-8, figure 61.

7. Illustration 74, Canopic urn from Castiglione del Lago, Florence, Museo Archeologico; W. Zschietzschmann, *Etruskische Kunst* (Frankfurt am Main, 1969), XXI, plate 14; in colour, M. Moretti, *et al.*, *Kunst und Land der Etrusker* (Zürich and Würzburg, 1969), 114, 117, no. 117.

109. 8. Illustration 75, Canopic urn from Dolciano, Chiusi, Museo Archeologico: Bianchi-Bandinelli, *op. cit.*, col. 368, figure 50; Giglioli, plate 60, figure 1; head only, in colour, Moretti, *et al.*, *op. cit.*, figure 121.

CHAPTER 9

111. 1. Cf. above, Chapter 1. For the later history of Greeks and Etruscans in Italy see M. Pallottino, *Etruscologia*, 6th ed. (Milan, 1968), chapters 3 and 4.

112. 2. Riis, 194-6 and note 6 on p. 194, note 1 on p. 196. A typical instance is the group of vases known as Caeretan hydriae, for which see below, pp. 171-4.

3. Above, Chapter 7, p. 95.

114. 4. To name one outstanding example: the Tomb of the Attic Vases, the richest find of Greek imported ceramics in the necropolis of Cerveteri (Caere),

contained materials dating from the first half of the sixth to the end of the fifth century; R. Vighi, G. Ricci, M. Moretti in *Monumenti Antichi*, XLII (1955), cols. 241-310.

5. Below, Chapter 11, pp. 134-5.

115. 6. For the problems of periodization in Etruscan art and its synchronization with Greek art cf. also the chronological survey in Riis, 188-204.

7. Among the tomb groups illustrating the transition from the Late Orientalizing to the Archaic period, the most notable is the so-called Isis Tomb from the Polledrara cemetery near Vulci. Possibly the bust of a lady of sheet bronze (above, Chapter 8, illustration 71), formed part of its contents. Certainly the large Early Archaic statuette of alabaster discussed by F. N. Pryce, *Catalogue of Sculpture in the . . . British Museum. Cypriote and Etruscan*, I (London, 1931), D1 (below, Chapter 11, illustration 80), came from this tomb. Other items are the elaborately decorated ostrich eggs, painted like modern Easter eggs, shown in Ducati, 11, plate 74, figures 220-4. Imported objects from the south-eastern Mediterranean include a scarab with the name of the pharaoh Psammetichus II (593-588) and three balsam flasks in the British Museum (Pryce, *op. cit.*, D2-4; see also *idem, Journal of Roman Studies*, XXV (1935), 246-7; P. J. Riis, 'Sculptured Alabastra', *Acta Archeologica*, XXVII (1956), 25 no. 3, 28 nos. 1 and 2; S. Haynes, *Antike Kunst*, VI, 1 (1963), 4 and note 9). Other oriental imports in tomb groups of the early sixth century: Camera degli Alari in the Tomb of the Dolia at Caere, R. Vighi and F. Minissi, *Il nuovo museo di Villa Giulia* (Rome, 1955), 47; G. Ricci, *Monumenti Antichi*, XLII (1955), cols. 337-8 figure 69, col. 342 figure 71; Tomb of the Attic Vases, *ibid.*, cols. 295-6 figures 49-50; Vighi and Minissi, *op. cit.*, 49.

116. 8. Excellent specimen of a Clazomenian hydria from Caere: G. Ricci, 'Una hydria ionica da Caere', *Annuario della Scuola Archeologica di Atene*, XXIV/XXVI (1946/8), 47-57, plates 3-6. Caeretan hydriae: above, Note 2. For both classes of vases cf. the bibliography in A. Rumpf, *Malerei und Zeichnung* (Munich, 1953), 67-9.

9. The theory of Phocaean influence on Etruscan Archaic art was first expounded by A. Furtwängler, *Antike Gemmen* (Leipzig and Berlin, 1900), 111, 89-90. Bibliography in Andrén, cxlix, note 4. The Ionic phase of Etruscan Archaic art outlasted the Phocaean colonization of the Tyrrhenian Sea: Riis, 148.

CHAPTER 10

119. 1. P. Romanelli, *Notizie degli Scavi* (1943), 239-42, 240 note 1. List of specimens preserved: M. Pallottino, *Monumenti Antichi*, XXXVI (1937),

cols. 197-207 and note 4 on p. 197. Possible use of these reliefs: Å. Åkerström, *Studien über die etruskischen Gräber* (Lund, 1934), 57-9; Pallottino, *op. cit.*, cols. 202-3; G. Ricci, *Notizie degli Scavi* (1952), 224-31. For the duration of the type, which continued somewhat beyond the middle of the sixth century, see Riis, 160.

120. 2. Centaurs: G. Dumézil, *Le Problème des centaurs* (Paris, 1929). Early Greek representations: P. V. Baur, *Centaurs in Ancient Art. The Archaic Period* (Berlin, 1912); Andrén, lxxxvi, note 3. For the winged demon see next note.

3. Argive bronze bands with embossed reliefs: above, Chapter 5, Note 13. The winged demon in a square can also be referred to Dorian art: Perseus on the metope from Thermon, H. Payne, *Necrocorinthia* (Oxford, 1931), 80, figure 23D. Cf. the stamped terracotta reliefs from Argos (S. P. Karousou in *Annuario della Scuola Archeologica di Atene*, XXIV/XXVI (1946/8), 40, figure 3 in note V 21(1)), and the observations made above, pp. 83-4, with regard to Caeretan red ware with stamped decoration. Both the kneeling-running figure and the centaur with human forelegs, framed by 'metopes', are found in this ware around 600; cf. P. Mingazzini, *Vasi della Collezione Castellani* (Rome, 1930), 11, plate 9.

4. 'Monumental painting' is here to be understood as meaning wall painting on a sizeable scale, or paintings designed for architectural use on a scale similar to wall painting. Most extant examples of Greek painting are not monumental in this sense. Hardly any are architectural. Notable exceptions are the fragments of wall painting in an Archaic, eastern Greek style discovered in 1955 at Gordion in Phrygia (R. S. Young, *A.J.A.*, LX (1956), 255-6, plates 85-6); for the more recently discovered painted tombs in Lycia see M. Mellink, *A.J.A.*, LXXIV (1970), 251-3, plates 59-61; LXXV (1971), 246-9, plates 50-2, 250-5, plates 53-5; LXXVI (1972), 263-8, plates 58-60. The Tomb of the Diver at Paestum is the first painted Greek tomb found in the West: M. Napoli, *La Tomba del Tuffatore* (Bari, 1970).

5. For a comprehensive survey of ancient painting including Etruscan, primarily in chronological, not regional, order, see A. Rumpf, *Malerei und Zeichnung* (Munich, 1953); *idem, A.J.A.*, LX (1956), 78.

121. 6. Development of Etruscan wall paintings: M. Pallottino, *Etruscan Painting* (Geneva, 1952). Their technique, *ibid.*, 18-19.

122. 7. A. Rumpf, *Die Wandmalerei in Veji* (Leipzig, 1915), 61-5; also *idem, Malerei und Zeichnung*, 29; Å. Åkerström, *Studien über die etruskischen Gräber* (Lund, 1934), 16. Arguments in favour of a date about, or somewhat after, 600: Riis, 158-9; G. Bovini, 'La pintura etrusca del periodo orientalizante (siglos VII, VI a. de J.C.)', *Ampurias*, XI (1949), 76-87; L. Banti,

'Le pitture della Tomba Campana a Veii', *S. Etr.*, XXXVIII (1970), 27-43.

8. Rumpf, *Die Wandmalerei in Veji*, 64-5. The tympanum in the Tomb of Hunting and Fishing, representing a 'Return of the Hunters', offers the nearest thematic parallel; Ducati, plate 79, figure 229, and below, pp. 187-8.

9. Riis, 66-7.

123. 10. Hares, hounds, and hunters occur both on Protocorinthian and Attic black-figure vases, probably owing to Ionian influence: Beazley, 1, note 4; P. Ducati, *Pontische Vasen* (Rome, 1968), 13. For a much more elaborate example in Ionian art see the Clazomenian sarcophagus, Rumpf, *Malerei und Zeichnung*, 69 and plate 18, figure 5. Here the theme, hunting on horseback and chariot, is quite oriental, and probably recalls the sports of Persian nobles.

124. 11. Museo Archeologico no. 75840: Riis, 77, plate 13, figure 4.

CHAPTER II

125. 1. Early statuary from Vulci: A. Rumpf, *Katalog der etruskischen Skulpturen. Staatliche Museen zu Berlin* (Berlin, 1928), 11-13; Riis, 75-6.

126. 2. A. Hus, *Recherches sur la statuaire en pierre étrusque archaïque* (Paris, 1961), 44; M. Pallottino and H. and I. Jucker, *Art of the Etruscans* (New York, 1955), 139, no. 38; Riis, 75, no. 2, and, for the iconographical type, p. 190; also above, Chapter 5, Note 7, Chapter 10, Note 2. Comparable, the somewhat later north Etruscan - not Vulcian - bronze statuette in Hannover; see G. Q. Giglioli, *S. Etr.*, IV (1930), 360, plate 27, figures 1 and 2; Riis, 88 note 2 and 120 note 2.

3. G. M. A. Richter, *Kouroi*, 2nd ed. (New York, 1960), 49-50, nos. 12A and B, figures 78-83.

128. 4. British Museum D1: F. N. Pryce, *Catalogue of Sculpture . . . Cypriote and Etruscan* (London, 1931), 155-8; Riis, 75, no. 3; S. Haynes, *Antike Plastik*, IV (1965), 15-18, plates 6-8.

5. Pryce, *op. cit.*, 156, note 1; however, his description of the bird as a dove does not account for the curious horns.

6. Woodpecker (*picus*), bird of Mars but also of tribal groups like the Picentini: F. Altheim, *A History of Roman Religion* (New York, 1938), 226; connected with the nether goddess, Feronia, *ibid.*, 262. For the Italian bull-god and the name of the Itali see *ibid.*, 64-8; cf. also below, pp. 136, 214. It appears that features of two ordinarily distinct, 'martial' animals have been combined in the composite form of the horned bird from the Polledrara tomb. At any rate the form has Villanovan antecedents: H. Hencken, 'Archaeological Evidence for the Origin of the

Etruscans', *Ciba Foundation Symposium* (London, 1959), 38; *idem, op. cit.* (Chapter 1, Note 4), 11, 585.

7. Hus, *op. cit.*, 45-6, no. 18, plate 24; Riis, 75, no. 8. For stylistic relations see W. L. Brown, *The Etruscan Lion* (Oxford, 1960), 70-2, plate 25.

129. 8. Other examples: Late Orientalizing bronze discs, above, pp. 85-6 and illustrations 54 and 55; also the animals from the Campana Tomb, above, p. 122. The Greek antecedents must be sought in Early and Middle Corinthian pottery. The stylization of the mane as an upright ring around the face conforms to the type termed Helladic - in contrast to eastern Greek - by F. Matz, *Studies presented to D. M. Robinson*, 1 (St Louis, 1951), 756-7.

130. 9. Riis, 109, type 7; cf. D. Levi, *Critica d'Arte*, 1 (1935/6), 18-26, 82-9, plates 8-15, 56-7. Our illustration 83: Levi, *op. cit.*, 20, plate 11, figure 8. Our illustration 84: *ibid.*, 85, plate 56, figure 31, and plate 58, figure 36.

10. Tomb group including the Canopus for which the head of illustration 84 served as a lid: Levi, *op. cit.*, 85-6 and notes 67, 68, plate 56, figure 31.

132. 11. British Museum D8: Pryce, *op. cit.*, 162, figure 7 and plate 2. For the entire class cf. Riis, 115-18, series B. Our illustration 85: *ibid.*, 115, no. 1.

133. 12. Giglioli, plate 69, figure 2: A. Minto, 'Le stele arcaiche volterrane', *Scritti in onore di Bartolomeo Nogara* (Città del Vaticano, 1937), 307-8, plate 42, figure 1; Riis, 140, no. 1.

134. 13. Critical catalogues and discussions of the Etruscan architectural terracottas: A. Andrén, *Architectural Terracottas from Etrusco-Italic Temples* (hereafter Andrén); *idem, Opuscula Romana*, VIII (1971), 1-16, plates 1-32; Å. Åkerström, *Opuscula Romana*, I (1954), 191-231.

14. Andrén, cxlii.

15. Andrén, cxxxix; Å. Åkerström, *Die architektonischen Terrakotten Kleinasiens* (Lund, 1966), 1, 45-66, 11, plates 22-9.

135. 16. Andrén, 325, and cxx-cxxi, figures 13-14. In the fragment from Velletri, figure 13, 3, the similarity between the walking figure and representations from the Tomba Campana (above, Chapter 10, illustration 77) further corroborates the Veientine origin of the terracotta slabs.

17. Friezes from Poggio Buco (probably the ancient Statonia): Andrén, 77-9, plate 25.

136. 18. See P. Romanelli, *Bollettino d'Arte*, XL (1954), 204; Andrén, *op. cit.* (1971), 7, plate 27, figure 61.

19. According to Romanelli, *op. cit.*, 204-6, this figure does not represent the Minotaur but the bull-headed Dionysus. However, in ancient Italy the bull-god was apt to refer to the native Mars rather than to Dionysus; cf. Altheim, *op. cit.* (Note 6), 64-79. Moreover, in the case of the Roman terracotta frieze

one must doubt if the facts favour any explanation so specific. The bull-man merely behaves as a monster among others, no more personal than a nameless centaur. About the general Mediterranean background of the Minotaur idea in relation to the frieze from the Roman Forum, see also B. Schweitzer in *Charites* (Bonn, 1957), 175-81.

20. Above, Note 16. On the chronology of the Roman terracotta fragments see Andrén, 325-7, 409. For the architectural terracottas found in Rome see also E. Gjerstad, *Early Rome*, IV, vol. 2 (Lund, 1966), 452-89.

137. 21. H. Stuart Jones, *Palazzo dei Conservatori* (Oxford, 1926), 187-8, plate 74 (Sala Castellani nos. 1, 3, 5); Giglioli, plate 157, figure 5; Herbig, 96-7.

138. 22. A monograph on the Etruscan *bucchero pesante* has yet to be written. Still indispensable are the lists of tomb groups containing much *bucchero pesante* in S. Gsell, *Fouilles dans la necropole de Vulci* (Paris, 1891), 451-79. Additional bibibliography above, Chapter 6, Note 5; Riis, 110-11. For the chronology, which spans the entire sixth century, cf. Riis, 158. Observations on technique: R. Sunkowsky, *Österreichische Jahreshefte*, XL (1953), 117-26.

23. Inv. no. 20513: R. Vighi and F. Minissi, *Il nuovo museo di Villa Giulia* (Rome, 1955), 52, plate 26 upper left.

24. Above, Chapter 6, pp. 83-4. These reliefs crowded with very small figures were an Etruscan fad: cf. G. M. A. Hanfmann, *Art Bulletin*, XIX (1937), 463-84.

25. Bucchero pitcher from Tarquinia, Tarquinia, Museo Nazionale Tarquiniense: *Corpus Vasorum Antiquorum Italia*, XXVI, *Museo Nazionale Tarquiniense*, II D, plate 2 no. 2 [92, 93]. For the problem of base lines see above, Chapter 4, Note 20. Several almost identical variants of this vase are preserved: M. A. Johnstone, *S. Etr.*, XI (1937), plate 48, figure 2; Riis, 111, no. 4. The ascription to Chiusi is not certain. Early Caeretan head antefixes like those illustrated by Andrén, plate 6, nos. 13-18, offer closer parallels to the rounded face over the handle of the Tarquinian pitcher of illustration 92 than anything Chiusi has to show.

140. 26. Giglioli, 14 (bibliography), plate 51, figure 3.
141. 27. Examples in Giglioli, plate 50, figures 1 and 2.
28. Baltimore, Walters Art Gallery, inv. no. 48, 436. Additional examples in Giglioli, plate 51, figures 1 and 2.

29. Above, pp. 75-7. Interesting in this context is the sympathetic description of Etruscan bucchero vases by D. H. Lawrence: '[they] open out like strange flowers, black flowers with all the softness and the rebellion of life against convention' (quoted in P. J. Riis, *An Introduction to Etruscan Art* (Copenhagen, 1953), 32).

CHAPTER 12

144. 1. For general information, see H. L. Lorimer, *Homer and the Monuments* (London, 1950); also above p. 442, Note 1.
2. Religion in Rome and early Italy: F. Altheim, *History of Roman Religion* (New York, 1938); G. Dumézil, *Archaic Roman Religion*, 2 vols. (Chicago and London, 1970). Consus and Janus: Altheim, *op. cit.*, 194-7.

145. 3. Etruscan religion: R. Bloch, *Les Étrusques* (Paris, 1954), 91-109; Dumézil, *op. cit.*, 593-660.
4. Age of Roman myth: Altheim, *op. cit.*, 200-17. Story of Tages and possible representations: R. Herbig in *Charites* (Bonn, 1957), 182-6, plate 32. Tarchon and the royal legends of Rome: M. Pallottino in *Rendiconti Lincei*, series VI, 6 (1930), 49-87.

146. 5. Etruscan gentile deities: Altheim, *op. cit.*, 114-18.
6. No representations of deity were included with the rare examples of myth in earlier Etruscan art, such as the 'Flight of Ulysses from Polyphemus' on the ivory situlae from the Pania Tomb, above, illustration 37.
7. A few other myths should be mentioned here, though they cannot be discussed in detail.
1. Theseus killing the Minotaur. Polledrara hydria in London: Ducati, I, 202-3, II, plate 75, figure 223; probable date, first quarter of the sixth century. *Bucchero pesante* pitcher in Basel: W. Zschietzschmann, *Etruskische Kunst* (Frankfurt am Main, 1969), xxviii, 52.
2. Perseus and Medusa. *Bucchero pesante* pitcher, much restored, from Chiusi, Palermo, Museo Nazionale (Collezione Casuccini): Giglioli, plate 53, figures 1 and 2, cf. E. Gabrici, *S. Etr.*, II (1928), 80, no. 17, plate 14; some details need clarification, especially the dog-headed monster often called Anubis, cf. V. Tusa, *Archeologia Classica*, VIII (1956), 147-52, plates 35-40; probable date of this and the pitcher in Palermo, mid sixth century. The composition of these friezes and of the earlier Polledrara vase retains the ancient scheme of the procession. In this manner specific action can be only very casually shown. The relief frieze around the pitcher in Palermo resembles a kind of ballet, or dance of demons, rather than the depiction of an event.
3. Story of Amphiaraos, in three episodes: bronze relief, decoration of a chariot, from tumulus of Montecalvario near Castellina in Chianti: I. Krauskopf, *Der Thebanische Sagenkreis* (Mainz, 1974), 14-17, bibliography note 67, plate 1. This relief is of more than common interest; it forms a frieze in which scenes of small figures are continually repeated, fashioned over dies in the manner of the Etruscan stamped ware mentioned above (p. 84). Every three of these scenes constitutes a narrative. In this way they

present an important example of 'continuous narration' in early Etruria, especially as the individual episodes are not separated by frames as in the New York chariot. Consequently they illustrate the kind of artistic raw material from which compositions like the New York chariot have been derived; see below, Note 14.

8. A. Furtwängler, *Brunn-Bruckmann's Denkmäler griechischer und römischer Skulptur* (ed. P. Arndt) (Munich, 1906), text to plates 586–7; G. M. A. Richter, *Greek, Etruscan and Roman Bronzes* (New York, 1915), 17–29, no. 40; Ducati, I, 279–80, II, plate 108, figures 286–7; Giglioli, plates 88–90.

149. 9. This unusual version of the 'flying gallop', with legs drawn under, seems properly Etruscan: terracotta frieze from Caere, in Copenhagen, Ny Carlsberg Glyptotek H174 (Andrén, I, 18, no. c; II, plate 5, figure 10). Similar representation on an Etruscan black-figure bowl: M. A. Johnstone, *S. Etr.*, XI (1937), 402, figure 3 on p. 401.

150. 10. Furtwängler, *op. cit.*, made a similar statement about the warrior receiving armour from a woman. His remark is true as regards the subject matter but not the formal composition, examples of which are not frequent and which did not constitute a common formula, such as the 'duelling heroes'. A nearly identical composition, likewise from Etruria, probably Chiusi, is the bronze relief in Florence: Ducati, I, 194, II, plate 69, figure 209, evidently derived from the same prototype. 'Duelling heroes': Richter, *op. cit.*, 22. Cf. also the Clazomenian hydria mentioned above, Chapter 9, Note 8.

11. Richter, *op. cit.*, 20–2.

12. This was also the opinion of Furtwängler, *op. cit.* For a different opinion, see R. Hampe and E. Simon, *Griechische Sagen in der frühen etruskischen Kunst* (Mainz, 1964), 53–67.

13. The miraculous end of heroes is apt to take one of two forms in ancient lore: the hero either disappears in a cloud or ascends to heaven with the aid of some carrier. I have dealt with the first idea in 'Origin and Meaning of the Mandorla', *Gazette des Beaux Arts*, XXV (1944), 5–24, especially 18–19; with the second in 'Classical Ariels', *Studies in Honor of F. W. Shipley* (St Louis, 1942), 75–93. For the miraculous disappearance of Aeneas and Romulus see A. S. Pease, 'Some Aspects of Invisibility', *Harvard Studies in Classical Philology*, LIII (1942), 14–16; for the ascension by chariot in Roman religious thinking, E. Strong, *Apotheosis and After Life* (London, 1928), 226–8. The story of Aeneas came to Etruria early, perhaps owing to the Phocaeans: F. Boemer, *Rom und Troia* (Baden-Baden, 1951), 11–49, especially 36–7.

14. A critical discussion of the term, coined originally by F. Wickhoff, is found in K. Weitzmann, *Illustration in Roll and Codex* (Princeton, 1947), 17–36. In Weitzmann's own terminology the New York chariot and the bronze relief with the story of Amphiaraos, above, Note 7, no. 3, exemplify the 'cyclic method', a more comprehensive term than Wickhoff's 'continuous method'. Sufficient evidence is now at hand to assert that continuous narratives existed in early Italian art long before the Hellenistic period generally assumed to be their origin. For possible examples in Greek art of the fifth century cf. E. Bielefeld, *Archäologischer Anzeiger* (1956), cols. 29–34.

151. 15. Cypro-Phoenician (or Syro-Phoenician) metal bowls: above, Chapter 3, Note 5. A most interesting case of narratives of this class is 'The Prince and the Ape Man', sufficiently popular to occur twice among the extant materials. Both renditions follow the same prototype. One is found on a Syro-Phoenician bowl from the Bernardini Tomb at Praeneste (C. Densmore Curtis, *M.A.A.R.*, III (1919), 38–43, no. 25, plates 20–1); the other on fragments of a bowl from Cyprus, New York, Metropolitan Museum, Cesnola Collection, no. 4556 (E. Gjerstad, 'Decorated Metal Bowls from Cyprus', *Opuscula Archeologica*, IV (1946), 10, plate 8; cf. H. G. Güterbock, *A.J.A.*, LXI (1957), 69–70, plate 26a, where the Ape Man is called an 'ape'). The occurrence in two monuments from such distant places of a nearly identical composition throws an interesting light on the migrations of iconographical types during the seventh century, in the wake of Phoenician trade. This iconographical transfer by portable prototypes resembles the travels of Byzantine and early medieval illustrations in books.

16. H. Payne, *Necrocorinthia* (Oxford, 1931), 139–40, 329 no. 1471; E. Pfuhl, *Masterpieces of Greek Drawing and Painting* (London, 1926), plate 9, figure 14.

17. For the tomb see Furtwängler, *op. cit.*, 1–5; Richter, *op. cit.*, 27–8, 177–80. The type of the chariot, though native, was developed with a knowledge of Ionian models: E. Nachod, *Der Rennwagen bei den Italikern* (Leipzig, 1909), 44–7; Richter, *op. cit.*, 25–7. The date indicated by the tomb group, hardly later than 560–550, is confirmed by the absence of folds from the representation of the garments.

18. Riis, 132.

CHAPTER 13

153. 1. P. Ducati, *Pontische Vasen* (Berlin, 1932); Beazley, 12, with bibliography. Localization in Caere rather than Vulci does not seem warranted to me; but see arguments to the contrary in Å. Åkerström, *Opuscula Romana*, I (1954), 231. Illustrations 100 and 101: Ducati, *op. cit.*, 7–9, plates 1–2.

154. 2. For this question cf. also G. M. A. Hanfmann, *Art Bulletin*, XIX (1937), 481–2.

3. The Etruscan pointed cap should not be called 'tutulus'; in some instances it may be called 'mitra', the Greek kerchief which was also used by Etruscan women (A. Rumpf, *A.J.A.*, LX (1956), 75).

4. For the four painters active in the workshop, their chronological order and stylistic development, see T. Dohrn, *Die schwarzfigurigen etruskischen Vasen* (Berlin, 1937), 78-82.

156. 5. G. Lippold, 'Kraton', in *Pauly-Wissowa*, XI, 1660. Painting on wooden tablets remained a current practice from then on, throughout the Middle Ages and beyond. It played a decisive part in developing and preserving the tradition of detachable easel painting in contrast to wall paintings. For the Etruscan paintings on clay, see bibliography below, Chapter 14, Note 18.

6. R. P. Hinks, *Catalogue of Paintings and Mosaics* (London, British Museum, 1933), 3-5, plates 1-2, nos. 5-5e, for bibliography, description, and restorations; also F. Roncalli, *Le lastre dipinte da Cerveteri* (Florence, 1965), 69-77, plates 12-15. F. Messerschmidt in *Archiv für Religionswissenschaft*, XXXVII (1941/2), 364-90 is not convincing; the woman with the snakes cannot be an object of cult. Colour reproductions of London 5b (seated sphinx) and 5e (three women to the right) in Pallottino, 26, 27.

7. M. Moretti, *Ara Pacis Augustae* (Rome, 1948), plates 8-9; E. Simon, *Ara Pacis Augustae* (Tübingen, 1967), 10, plate 8.

157. 8. The animal on the sceptre represents a small bull rather than a horse, as suggested by Hinks, *op. cit.*, 4, no. 5c, cf. A. Neppi Modena, *Emporium*, LXVII (1928), 99; a suitable emblem for Mercury, god of herds, and fit for the occasion, one herdsman speaking to another. For supposedly Trojan sceptres and heralds' staves kept in Italian sanctuaries, see bibliography in F. Boemer, *Rom und Troia* (Baden-Baden, 1951), 60, note 20. Further to Mercury's *petasos*, see the one H. Payne drew from a Corinthian sherd, *J.H.S.*, LXXI (1951), plate 29d. The Etruscan painter added the 'apex' on top, as a sign of greater dignity.

9. This outfit corresponds to earlier iconography which, in Greece, was the rule till the middle of the sixth century; cf. R. Hampe, in *Festschrift B. Schweitzer* (Stuttgart, 1954), 79. In explaining the representation as a 'Judgement of Paris' I agree with C. Clairmont, *Das Parisurteil* (Zürich, 1951), 46-7.

10. All Boccanera slabs are heavily touched with modern patches of paint, but hardly sufficiently to alter their significance and attributes, as far as one can tell at sight. The question if the set is complete or if there were additional slabs, now lost, cannot be decided at present. The procession to the right seems to lack a goal. If the above interpretation proves correct, the relation between the two processions was similar to the frequent combination on vases of the with some other pertinent story; cf. Clairmont, *op. cit.*, 97-100.

11. The pair of antithetical sphinxes with raised paws (not illustrated here) has counterparts in related Etruscan monuments, e.g. Loeb tripod C; G. H. Chase, *A.J.A.*, XII (1908), plate 18. The Pontic amphora in Paris, Bibliothèque Nationale 173 (Ducati, *op. cit.*, plates 22-3), may be about a decade later. Relations between the Boccanera slabs and Greek paintings on vases from Chios were observed by A. Rumpf, *Malerei und Zeichnung* (Munich, 1953), 46.

158. 12. A. Minto, *S. Etr.*, IX (1935), 401-11. It is likely that the find of Castel San Mariano also came from a tomb, as did the two others in this class: E. Petersen, *R.M.*, IX (1894), 255.

13. Some of the solidly cast statuettes from Castel San Mariano are almost certainly local products: e.g. Giglioli, plate 85, figures 1, 3, 6; plate 86, figures 6 and 7 (of the latter type three specimens are preserved, two in Perugia, one in Munich; decorations of a three-cornered object?). Their style indicates connections with Chiusi and Vulci: Riis, 127-36, especially 131. L. Banti, in the paper cited below, Note 25, concluded that both the Loeb tripods and the bronzes from Castel San Mariano were Caeretan imports. Yet at Caere, also, they have no certain counterparts.

14. The first and so-far only survey of the material attributable to this find was published by Petersen, *op. cit.*, 253-319. The find itself was a chance discovery made in 1812, in circumstances now unknown. The earliest inventory, incomplete, was by G. Vermiglioli, *Saggio di bronzi etruschi trovati nell'agro perugino* (Perugia, 1813) (cited by Petersen, *op. cit.*, 253, note 1). Most but not all fragments now in Perugia are included; the pieces in London and Munich are missing. The latter two had already been restored to their present looks when acquired by their respective museums: Munich, Glyptotek and Antiquarium (fragments of four-wheeled chariot) before 1820; London, British Museum (silver reliefs), bequest from the Payne Knight collection in 1824.

159. 15. Furtwängler, *Brunn-Bruckmann* (*op. cit.*, Chapter 12, Note 8), text to plates 588-9. Additional bibliography: Giglioli, 19, plate 87, figures 2 and 3. M. Pallottino and H. Jucker, *Art of the Etruscans* (New York, 1955), figures 50-1, 66-7, 70. The construction of the chariot probably resembled the light chariot from Vix (R. Joffroy, *Monuments Piot*, XLVIII (1954), 36-42, plate 30). The comparable chariots from Etruscan tombs have not yet been collected systematically, but see Pareti, 286-8, regarding the somewhat earlier specimen (*c.* 600) from the so-called antechamber of the Regolini-Galassi tomb, no. 237, plate 31. A parallel to the curving outlines of

the railing reliefs in Munich was pointed out by H. Brunn: Petersen, *op. cit.*, 256, figure 1. Petersen's own reconstruction of a chariot with low front railing and a throne is hypothetical and in parts certainly incorrect; see below, Note 17.

16. The squatting type of figure – not always a gorgon – probably reached Etruria from Corinthian art at the time of the Tarquinian door reliefs; Riis, 66, note 9. For a chronological division into four groups of the material from Castel San Mariano see H. and I. Jucker, *Kunst und Leben der Etrusker*, exhibition catalogue (Zürich, 1955), 72-9, where the fragments of the four-wheeled chariot are listed as Group C: nos. 152-61.

17. The reconstruction of this chariot is utterly uncertain. Suggestions by Petersen, *op. cit.*, 274-96, with drawing; supplementary observations, H. Nachod, *Der Rennwagen bei den Italikern* (Leipzig, 1909), 74-5, no. 87. The large Hercules relief, fully illustrated in photographs and drawings by R. Hampe and E. Simon, *Griechische Sagen in der frühen etruskischen Kunst* (Mainz, 1964), Beilage, and plates 20-1, and interpreted by these authors (*op. cit.*, 11-17) as the fight between Herakles and the Amazons at the mouth of the Thermodon on the Black Sea coast, is explained by Nachod (*op. cit.*, 75) as the front wall of a two-wheeled chariot with arched open railings. This seems possible. Two of the reliefs used by Petersen for the presumed throne of the four-wheeled chariot (above, Note 15) have recently been ascribed to this: Jucker, *op. cit.*, 76-7, nos. 149, 151; good engravings in G. Micali, *Monumenti per servire alla storia degli antichi popoli italiani* (Florence, 1832), plates 30 figure 3, 31 figure 1. Their style differs noticeably from the probably earlier reliefs of the four-wheeler. Thus Petersen's throne is eliminated. But their connection with the large Herakles relief cannot be taken for granted, either. The latter still seems more recent, stylistically. On the other hand, the two interesting female heads (Jucker, *op. cit.*, 76 nos. 147, 147a, figure 24) can more confidently be assigned to the workshop of the Herakles relief. Together with the drapery fragments to which they seem to belong (Petersen, *op. cit.*, 300, figures 7-8) they may even have formed part of the same chariot, flanking the front wall like the kouroi of the chariot from Monteleone, above, p. 151.

18. H. B. Walters, *Catalogue of the Silver Plate, Greek, Etruscan and Roman* (London, British Museum, 1921), 1-3, nos. 2-4, plate 1; S. Haynes, *J.D.A.I.*, LXXIII (1958), 9-17. Cf. H. Maryon, *A.J.A.*, LII (1949), 122, plate 19; O. Brendel, *Magazine of Art*, XLII (1949), 233. I have since convinced myself that my previous doubts were due solely to the uncertain state of preservation, especially of the fragment with the two riders. I now take the three

reliefs to be Etruscan, in all likelihood either indeed belonging to the Castel San Mariano find or at least closely related to it. In the animal group (Walters, *op. cit.*, no. 2) the modern restorations are fairly obvious; only the right lower corner raises questions. The supporting leg of the sphinx seems missing, and the back and hind leg of the monster present a surface of rather unruly modelling distinctly different from other surfaces, e.g. the lion's body to the left. The case of the larger fragment with the two riders is similar if more complicated. Several breakages are apparent. The parts between them must be divided into two, or perhaps three, different categories.

1. Smooth, probably ancient surface. The left leg of the reclining figure seems a good example; the delicate, soft leather boot may be compared with other contemporary specimens, e.g. the shoe of Aphrodite in the Boccanera slabs, above, p. 157. 2. Possibly minor modern additions. What has happened to the right lower arm, or the horse's tail, of the rider in the foreground? 3. Ancient parts, with surfaces somewhat retouched when the fragments were soldered together, before 1824. Between the latter two categories no certain distinction can be made at present. The rider group as a whole is ancient and so, I think, are most details, especially the parts which combine the electron plating with cold engraving; also the foreparts, heads, and manes of the horses, though hardly their tails, or the gilded hoofs of the hind legs. Other parts I still distrust, notably the face of the reclining figure. Whether the doubtful details fall into the second or third category of restorations, only future investigations can show.

19. Similar: cippus from Chiusi in Munich, Giglioli, plate 146, figure 4; another, formerly in Berlin, Giglioli, plate 147, figure 3, with reclining male figure beneath the horses. The explanation of neither scene is certain, but especially in the Berlin cippus the sequence of the funeral episodes makes the interpretation of the riders as sportsmen rather likely; lamentation, dancers, banquet, horse race (with the jockey falling off his horse?). For the class of the cippi see below, Chapter 17, p. 207 ff.

161. 20. Prancing horses drawing chariots: H. Frankfort, *The Art and Architecture of the Ancient Orient* (Pelican History of Art) (London, 1954), 152, notes 69-70. The 'rider on the rearing horse' constitutes a related if special theme which begins in Assyrian reliefs but owes its long and variegated career in later art chiefly to Greek classical formulations. The type came to Etruria from Ionian sources: Åkerström, *op. cit.* (Note 1), 227, note 3. In passing it may be noted that the development from Archaic to Classical concepts in Greek art often advances more clearly in the representations of horses than of humans.

21. Typologically the horses of the London silver relief must be placed somewhere between the terracotta reliefs from Thasos (G. M. A. Richter, *Archaic Greek Art* (New York, 1949), figure 161) and the frieze from the Siphnian Treasury at Delphi (*ibid.*, figure 163).

22. Tripod B, side 2, antithetical representation of two archers (Amazons?): Chase, *op. cit.* (Note 11), plate 14. Notice the characteristic angular design of the horses' forelegs, drawn close to the bodies. Cf. Fragment 18f, Herakles chariot from Castel San Mariano, Petersen, *op. cit.*, 275 and figure 3. Similar: Chiusi cippus with horse races, above, Note 19.

23. E.g. the archers of the amphora Vatican 231: Ducati, *op. cit.* (Note 1), plate 9a; Dohrn, *op. cit.* (Note 4), 146, no. 65.

24. Amphora at Reading, P. N. Ure, *J.H.S.*, LXXI (1951), 198–202, plates 43–4, especially the prancing horse to the right of the fleeing Troilus, plate 44d. Cf. Åkerström, *op. cit.*, 202, figure 15; 227. Likely date: 530–520.

163. 25. Chase, *op. cit.*, 287–323, plates 8–18. Discovered in a chamber tomb near Marsciano, Umbria (Fonte Ranocchia); Minto, *op. cit.* (Note 12), 401–11. Fragments not utilized in the present restoration are still kept in Florence; Minto, *op. cit.*, figures 2 and 3. For additional details and bibliography see the exhaustive study by L. Banti in *Tyrrhenica* (Milan, 1957), 77–92, plates 1–9.

26. A decisive symptom are the folds descending from Thetis' gathered skirt, tripod A, side 3: Chase, *op. cit.*, plate 11; Banti, *op. cit.*, plate 6, figure 1.

27. One of the interesting exceptions: the dialogues between Zeus and a goddess(?) in the tympanum of tripod B, side 1: Chase, *op. cit.*, plate 13. The composition compares with the 'Introduction of Herakles into Olympus' on the terracotta revetment from Velletri, Giglioli, plate 99, figure 1; Andrén, I, 412, 11, plate 128, figures 449–50; Åkerström, *op. cit.*, 205–6, figures 4:1, 4:2 on p. 195.

CHAPTER 14

165. 1. O. Brendel, *A.J.A.*, LXII (1958), 241.

2. In the Campana Tomb the animal groups of the two lower fields may be said to have retained the character of guardians. For the similar arrangements in Early Archaic tombs at Caere (Tomba degli Animali dipinti, Tomba dei Leoni dipinti) see G. Bovini, *Ampurias*, XI (1949), 63–90, plates 1–3. Arrangements of this type may be labelled the first style of Etruscan wall decoration. It is not yet represented at Tarquinia.

3. Pallottino, 29–32; L. Banti, *S. Etr.*, XXIV (1955/6), 143–81; dating, 179–81; H. Leisinger, *Malerei der Etrusker* (Stuttgart, 1954), plates 12–19.

166. 4. Ducati, 191 and note 96. They are already worn by the ladies of the Boccanera slabs [102–4], and by the recently discovered seated terracotta 'divinities' from Murlo (I. Gantz, *Dialoghi di Archeologia*, VI (1972), 172, figures 29, 31, 33–4).

168. 5. Possible chthonian connotations of the bullman, and representations of obscene character in funerary contexts: F. Altheim, *A History of Roman Religion* (New York, 1938), 69–71, 489–90, notes 113–15; cf. above, Chapter 11, Note 19.

6. Pallottino, 37–42; Leisinger, *op. cit.*, plates 34–42. Detailed publication: G. Becatti and F. Magi, *Le pitture della Tomba degli Auguri* (Rome, 1956); review by this author, *A.J.A.*, LXII (1958), 240–2.

170. 7. Pontic amphorae, above, pp. 153–4. In comparison with related vase paintings, the Tomb of the Augurs appears as the earlier and leading work: T. Dohrn, *Die schwarzfigurigen etruskischen Vasen* (Berlin, 1937), 82–4, gives a list of comparisons between the Tomb of the Augurs and the style of the Tityos Painter, the most advanced among the artists in the presumably Vulcian workshop of the Pontic amphorae, whom he thinks a follower of the Tarquinian master. Caeretan hydriae: below, pp. 171–4.

8. R. S. Young, *A.J.A.*, LX (1956), 255–6; even details may be compared: e.g., the indication of eyelashes by radiating lines in the wrestlers of the Tomb of the Augurs and the fragment, *ibid.*, plate 86, figure 20.

9. E. Akurgal, *Griechische Reliefs des VI. Jahrhunderts aus Lykien* (Berlin, 1942), 52–97, plates 7–14. For connections between this tomb and the style of the Caeretan hydriae see also the review listed above (Note 6), 242. A very similar relief, combining, as was the habit in Etruria, athletic games with musical accompaniment, has come to light at Xanthos: M. Mellink, *A.J.A.*, LX (1956), plate 122, figure 11.

10. In determining the date of the Tomb of the Augurs the following points should be considered: closely related typologically (with respect to the system of decoration) are the Tombs of the Dead Man and of the Inscriptions. See illustrations in F. Weege, *Etruskische Malerei* (Halle, 1921), plates 44–6 and 73–5, especially plate 73, showing the rear wall of the Tomb of the Inscriptions with centrally placed, painted door as in the Tomb of the Augurs. Yet stylistically both tombs appear to be somewhat later. The quite developed zigzag folds over the right arm and shoulder of the woman bending down to the dead man (*ibid.*, plate 46) can hardly be dated before 520. As in the previously mentioned comparisons with Pontic vases, the Tomb of the Augurs seems to stand at the head of any series of comparable monuments. For the zigzag folds in the Tomb of the Augurs see Becatti and Magi, *op. cit.*, plates 4 and 9.

171. 11. Monograph: J. M. Hemelrijk, *De caeretaanse*

Hydriae, diss., Leiden (Amsterdam, 1956): the catalogue, pp. 109-15, lists thirty items. Recent articles: F. Devambez, 'Deux nouvelles hydries de Caere au Louvre', *Monuments Piot*, XLI (1946), 29-62, plates 5 and 6; M. Santangelo, 'Les nouvelles hydries de Caere au Museo de la Villa Giulia', *Monuments Piot*, XLIV (1950), 1-43, plates 1-3; V. Kallipolitis, 'Une nouvelle hydrie de Caere', *Monuments Piot*, XLVIII (1956), 55-62, plate 6. For the latter specimen, now at Dunedin, cf. also J. K. Anderson, 'A Caeretan Hydria in Dunedin', *J.H.S.*, LXXV (1955), 1-6.

12. Nestor hydria, Paris, Louvre: E. Pottier, 'Fragments d'une hydrie de Caere à représentation homérique', *Monuments Piot*, XXXIII (1933), 67-94, plates 7-8, and Santangelo, *op. cit.*, 8, note 1.

13. Santangelo, *op. cit.*, 37 and note 3.

14. No chronological argument can be based on the development of this polychromy: T. B. L. Webster, 'A Rediscovered Caeretan Hydria', *J.H.S.*, XLVIII (1928), 196-205.

15. For details see bibliography above, Note 11, especially Hemelrijk, *op. cit.*, Comparisons with contemporary Etruscan art: N. Plaoutine, 'Le Peintre des hydries de Caere', *Revue Archéologique*, XVIII (1941), 8-9. Also Dohrn, *op. cit.* (Note 7), 128-31, 141. In this connection it is perhaps not without interest that a Villanovan favourite, the 'horse tamer', recurs on the Caeretan hydriae, transmuted into a youthful page; see Kallipolitis, *op. cit.*, 56 and note 4 for Greek antecedents; for the earlier Italian examples see above, Chapter 2, Notes 20 and 21.

172. 16. A. Furtwängler and K. Reichhold, *Griechische Vasenmalerei* (Munich, 1906), 5-6, plate 2. Distinction between the Knee Painter and the Busiris Painter: Hemelrijk, *op. cit.*, 17-25.

173. 17. Egyptian reminiscences in the Busiris painting: R. Herbig, 'Herakles im Orient', *Corolla L. Curtius* (Stuttgart, 1937), 206 and note 2.

174. 18. The monograph of F. Roncalli, *Le lastre dipinte da Cerveteri* (Florence, 1965), provides detailed information on this whole body of material, with earlier bibliography. The Campana slabs, discovered in 1856: *ibid.*, 15-24, nos. 1-9, plates 1-8; Boccanera slabs, 28-33, nos. 16-20, plates 12-15. A fragment in Berlin, unexplained (abduction of Helen?), *ibid.*, 25, no. 10, plates 9 and 10, may be placed between the London and the Louvre series. The style is closer to the Tomb of the Augurs than to either set, before, rather than after, 530. Caere was evidently a centre of Archaic painting: Pliny saw some of her old wall paintings still in their places, *N.H.* 35.17. Not all fragments were discovered in tombs: some stem from temples or public buildings in or near the town, such as the fragments from the Temple of Hera (Roncalli, *op. cit.*, 33-7, nos. 23-9, plates 16-18), and the last set unearthed, broken in numerous small

pieces but not beyond reconstruction, which represented the death of Medusa at the hand of Perseus (*ibid.*, 42-6, nos. 43-8, plates 23-7). The colour scheme is unusual: red ground instead of the yellow found in the Boccanera and Campana slabs; mostly white, black, and red in the figures. The style differs from that of the Boccanera slabs but seems about coeval with them. The *bucchero pesante* pitcher now in Palermo, above, Chapter 12, Note 7 (Giglioli, plate 53), should be compared for the type of Medusa as well as the composition. The only case so far of Etruscan painted terracotta slabs from outside Caere may conveniently be mentioned here, although it belongs to a later time, towards the end of the Archaic period: the set from the Portonaccio Temple at Veii (E. Stefani, *Notizie degli Scavi* (1953), 67-80). The much damaged series decorated a wall inside the building, with sundry representations arranged in superimposed zones (*ibid.*, 69, figure 48). According to this reconstruction one must regard them as the earliest example extant of a system of wall decoration which in due time produced the friezes of the synagogue of Dura, or later still Giotto's Arena Chapel at Padua.

19. The nearest Greek parallels are Corinthian: A. Rumpf, *Malerei und Zeichnung* (Munich, 1953), 53.

20. Pallottino, 33.

21. Giglioli, plate 108, figure 1; Roncalli, *op. cit.*, 22, no. 6, plate 6.

175. 22. Above, p. 156.

23. See Pallottino, 35, for the slab with the two seated old men. As to the abduction scene, the posture of the two principal characters running with one foot lifted would not ordinarily signify anything more than swift movement; cf. the black bodyguard of King Busiris on the back of the Caeretan hydria discussed above, pp. 172-3. However, in conjunction with the wings it may denote running through the air or, in other words, flying. In the famous Pompeian painting which for us constitutes the *locus classicus* in ancient art of the sacrifice of Iphigeneia, Artemis still appears in the sky: G. Lippold, *Antike Gemäldekopien* (Munich, 1951), 53-6, plate 8, figure 39.

CHAPTER 15

177. 1. Well preserved except for the crest of the helmet, which is missing. Bibliography: Riis, 102, no. 3; *Mostra dell'arte e della civiltà etrusca* (Milan, 1955), 44, no. 158, plate 27; M. Pallottino and H. Jucker, *Art of the Etruscans* (New York, 1955), 142, no. 60; A. Hus, *Recherches sur la statuaire en pierre étrusque archaïque* (Paris, 1961), 84-5, no. 2, plate 38. For the Cretan helmet, cf. A. M. Snodgrass, *Arms and Armour of the Greeks* (London, 1967), 63-4,

plate 32; an Etruscan bronze hoplite wearing a helmet like that of illustration 115 comes from Ravenna: Leiden, Rijksmuseum van Oudheden c.o. 1, cf. W. Hausenstein, *Das Bild*, 11; *Die Bildnerei der Etrusker* (Munich, 1922), plate 22; E. Hill, *Journal of the Walters Art Gallery*, VII/VIII (1944/5), 106-7, figure 5.

178. 2. Cf. the relief stele of a warrior, likewise from Orvieto: Ducati, 11, plate 110, figure 292.

179. 3. Museo Archeologico no. 27: Giglioli, 19, plate 85, figure 5; Riis, 142; M. Pallottino in *Mostra dell'arte e della civiltà etrusca* (*op. cit.*), 25, no. 79, plate 17.

4. Above, Chapter 14, Note 8, the wrestlers from the Tomba degli Auguri [111], and O. Brendel, *A.J.A.*, LXII (1958), 242. Cf. also Pallottino, *op. cit.*, 25, no. 79.

5. Apparently the type survived in the Greek workshops of southern Italy. A fine example, of even later date, went with the krater of Vix: R. Joffroy, *Monuments Piot*, XLVIII (1954), 19-21, plates 17-18.

6. Statue of an enthroned Fortuna, of gilded wood, in the Forum Boarium: H. Lyngby, 'Fortunas och Mater Matutas kultur pa Forum Boarium i Rom', *Eranos*, XXXVI (1938), 47-9. Cf. A. H. Griffiths, *Temple Treasures. A Study based on the Works of Cicero and the Fasti of Ovid* (Philadelphia, 1945), 61-2.

180. 7. Catalogue and bibliography: Huls, 66-9, nos. 67-8; polychrome ivory caskets and their Cypriote derivation: *ibid.*, 176 and note 2.

8. Huls, 67, no. 67a; pp. 180-5.

9. See detail, Pallottino and Jucker, *op. cit.*, 42; also representations in the recently discovered Tomba delle Olimpiadi, also Tarquinian: R. Bartoccini, C. M. Lerici, M. Moretti, *La Tomba delle Olimpiadi* (Milan, 1959), 75-6, figure 4.

10. Riis, 93.

182. 11. M. V. Giuliani-Pomes, 'Cronologia delle situle rinvenute in Etruria', *S. Etr.*, XXIII (1954), 151-94; XXV (1957), 39-85; J. Kastelik, *Situla Art* (New York, Toronto, and London, 1965). For a possible relation between early Etruscan situlae and Egyptian prototypes, transmitted through Phoenician imitations, such as the famous Bocchoris vase from Tarquinia, above, p. 49, cf. Giuliani-Pomes, *op. cit.*, 162-3.

12. For the iconography of the situlae and the monuments related to them see I. Scott Ryberg, 'Rites of the State Religion in Roman Art', *M.A.A.R.*, XXII (1955), 6-10. The following are the most important examples:

1. Silver vase from Chiusi (Plicasnas Vase), Florence, Museo Archeologico: Ryberg, *op. cit.*, 6, no. 3, plate 2, figure 3. Procession, games, 'Pyrrhic' dancers.

2. Certosa situla, Bologna, Museo Civico: *ibid.*, 8, note 13; Kastelic, *op. cit.*, plates 12-25; here illustrations 118 and 119. Procession (including victim and 'victimarii'?), banquet.

3. Situla from Vače (Watsch), National Museum, Ljubljana: J. Kastelik, *La situla di Vače* (Belgrade, 1956); *idem, Situla Art*, plates 1-8. Procession, games (pugilists), banquet.

4. Situla, Museum of the Rhode Island School of Design, Providence, Rhode Island: G. M. A. Hanfmann, 'The Etruscans and their Art', *Bulletin of the Museum of Art, Rhode Island School of Design*, XXVIII (1940), 14-15, figures 2-7; Kastelik, *Situla Art*, plates 72-80. Procession, games (pugilists), banquet.

5. Arnoaldi situla, Bologna, Museo Civico: A. Grenier, *Bologne villanovienne et étrusque* (Paris, 1912), 375-7; Kastelik, *Situla Art*, plates 50-5. Procession, games (including chariot races).

6. Sedia Corsini: Ryberg, *op. cit.*, 9-10, plate 3. Roman imitation in marble of an Archaic Etruscan bronze chair decorated with bands of relief. The decoration, though not reliable stylistically, includes genuine motifs related to the Bologna situlas - games, processions, sacrifices.

183. 13. The recently discovered terracotta friezes from Murlo (Poggio Civitate) illustrate the same three subjects: procession, games (horse race), banquet, cf. A. Andrén, *Opuscula Romana*, VIII (1971), plates 18-19, 21-2. The fourth subject found at Murlo, an assembly of divinities (*ibid.*, plate 20; T. Gantz, *S. Etr.*, XXXIX (1971), 1-22, plates 1-12), does not form part of the repertory of Etruscan funerary art.

14. Banquets (cult meals) on proto-Cypriote bowls, with dancers and musicians, eighth-seventh centuries: E. Gjerstad, *Opuscula Archeologica*, IV (1946), 4-8, plates 1-3. For the combination of banquets with erotic scenes on couches, which occurs in the later Cypriote bowls, as, e.g., *ibid.*, 8-9, plate 5 (first half of the sixth century), cf. the engraved mirror of Castelvetro: Ducati, 11, plate 153, figure 397. In turn, by its style this mirror is related to the decoration of the Bologna situlae.

15. For a 'Villanovan banquet' see the late biconical ash urn from Volterra, Florence, Museo Archeologico: seated banqueter, three-legged table, footed krater, and servant: M. Moretti, G. Maetzke, M. Gasser, L. von Matt, *Kunst und Land der Etrusker* (Zürich and Würzburg, 1969), plate 147. But see above, Chapter 14, Note 9, for the Lycian parallels for the groups of wrestlers, boxers, and musicians.

16. Characteristic of the progressive standardization of style and content are the situlae from Vače, the closely-related situla at Providence, and the Arnoaldi

situla, above, Note 12, nos. 3, 4, 5. Regarding the late date of both the Vače and the Arnoaldi situlae, see the following note.

17. Date of the Certosa situla, Giuliani-Pomes, *op. cit.*, 185. Situla from Vače, probably late fifth century, *ibid.*, 165. See also Kastelik, *Situla Art*, xxii–xxiv.

CHAPTER 16

185. 1. P. Ducati, *Le pitture delle tombe delle Leonesse e dei Vasi Dipinti* (Rome, 1937), 1–9, plates A–B, 1–3; Pallottino, 43–8.
186. 2. The representations of athletic contests were not altogether discontinued; but from now on they become less frequent. Cf. the discussion of Etruscan funerary iconography above, pp. 182–3, and Banti, 108–12.
3. R. Joffroy, 'La Tombe de Vix', *Monuments Piot*, XLVIII (1954), 6–18, plates 1–15.
187. 4. Ducati, *op. cit.*, 7–8. The drawing style reminds one of early red-figured Greek vases such as the Nicosthenic amphora painted by Oltos, Paris, Louvre G.2: P. E. Arias and M. Hirmer, *A History of Greek Vase Painting* (London, 1962), 321, no. 99, plate 99.
5. P. Romanelli, *Le pitture della tomba della 'Caccia e Pesca'* (Rome, 1938); Pallottino, 49–52; R. Ross Holloway, 'Conventions of Etruscan Painting in the Tomb of Hunting and Fishing in Tarquinia', *A.J.A.*, LXIX (1964), 341–7.
6. On the whole this arrangement corresponds to the wall decoration classified above as Style Two. The majority of the Archaic tombs at Tarquinia fall into this category. I name the following examples, in the order of their likely date of origin.
About 530–520: 1. Tomb of the Olympic Games, discovered 1958 by C. M. Lerici: R. Bartoccini, C. M. Lerici, M. Moretti, *La Tomba delle Olimpiadi* (Milan, 1959); M. Moretti, *Nuovi monumenti della pittura etrusca* (Milan, 1966), 106–20. 2. Tomb of the Dead Man: F. Weege, *Etruskische Malerei* (Halle, 1921), plates 44–6.
About 520–510: 3. Tomb of the Bacchants, *ibid.*, plates 41–3.
About 510–500: 4. Tomb of the Baron, above pp. 192–4, below, Note 11.
Characteristic of all these decorative schemes is the broad upper zone of parallel, diversely coloured stripes taking the place of an entablature. Other details may vary; the matter requires further investigation. Throughout the entire group one sees a degree of indecision regarding the architectural function of the figured frieze, which may occupy the upper section of the wall as if to decorate an imaginary entablature, or be defined as a wall frieze proper, placed between

a low dado and the striped architrave. Among the monuments of Style Two the Tomb of Hunting and Fishing constitutes an exception in so far as in the decoration of the second chamber the dado itself has become a part of the painted scenery, thereby losing its original architectural function, while the striped zone above has been retained.
190. 7. H. Frankfort, *The Art and Architecture of the Ancient Orient* (Pelican History of Art) (Harmondsworth, 1954), plates 100–7.
8. Cf. for instance, the Little Master Cup, eastern Greek, in the Louvre, G. M. A. Richter, *A Handbook of Greek Art*, 4th ed. (London, 1965), 300, figure 419.
191. 9. Hunting and fishing on the Nile, with the hunters standing on boats, were standard subjects in Egyptian art. Cf. for example a relief of Ti hunting the hippopotamus, from Sakkara: H. Schäfer and W. Andrae, *Die Kunst des alten Orients* (Propyläen Kunstgeschichte, 11) (Berlin, 1925), 247.
10. As in other instances mentioned previously, the Phoenician bowls may have contributed details of iconography. Certainly the type of the hunter on the rock could have been derived from them. Disguised as the Hunter-King in the story of the ape-man, he appears on two bowls still preserved, one of them from the Bernardini Tomb at Praeneste: see above, Chapter 12, Note 15.
192. 11. Weege, *op. cit.*, 106–8; Pallottino, 55–8.
193. 12. In Greek vase paintings overlapping groups of this kind have a continuous history extending from the Amasis amphora in Paris (Arias and Hirmer, *op. cit.*, plates XV and 57) to the amphora in Berlin by the Berlin Painter (*ibid.*, plate 151). The latter vase, *c.* 490, shows a group of satyr and Hermes overlapping as closely as, later still, the famous monument of the Athenian Tyrannicides probably presented itself to the observer. The group in the Tomb of the Baron finds its place in this evolutional series near to, but somewhat before, the work of the Berlin Painter.
13. See I. Scheibler, *Die symmetrische Bildform in der frühgriechischen Flächenkunst* (Kallmünz, 1960), especially p. 87, regarding Clazomenian sarcophagi.
194. 14. T. Dohrn, *Die schwarzfigurigen etruskischen Vasen aus der zweiten Hälfte des sechsten Jahrhunderts* (Berlin, 1967), 89–128; Beazley, 11–24.
195. 15. Beazley, 3. For the status of vase painting among the other arts, see M. Robertson, 'The Place of Vase-Painting in Greek Art', *The Annual of the British School of Athens*, XLVI (1951), 151–9.
16. P. Bocci, 'Pittore di Micali', *Enciclopedia dell'arte antica*, IV (Rome, 1961), 1103–4; Beazley, 1–3, 12–15.
197. 17. Riis, 69–70; Banti, 129.
18. British Museum B64. Beazley, 2–3, plates 2, 2a, gives a full description of details; cf. Banti, 110.
198. 19. Walters Art Gallery 48.7: Beazley, 2, 14, plate 3, figure 2.

20. Martin von Wagner Museum no. 799: E. Langlotz, *Griechische Vasen, Martin von Wagner Museum der Universität Würzburg* (Munich, 1932), 142-3, plates 232-4.

201. 21. Ducati, I, 291-5: J. D. Beazley, 'The World of the Etruscan Mirror', *J.H.S.*, LXIX (1949), 1-17; G. Mansuelli, 'Gli specchi figurati etruschi', *S. Etr.*, XIX (1946), 9-137; I. Meyer-Prokop, 'Die gravierten etruskischen Griffspiegel archaischen Stils', *R.M.*, *13. Ergänzungsheft* (1967). See also Chapter 27, Note 11.

22. Munich 2971: M. Pallottino and H. Jucker, *Art of the Etruscans* (New York, 1955), 147, no. 89, figure 89.

202. 23. Etruscan dances: J. Heurgon, *La Vie quotidienne chez les étrusques* (Paris, 1961), 252-5; cf. Pallottino and Jucker, *op. cit.*

24. British Museum 545: Beazley, *op. cit.* (Note 21), 2 and plate 1a.

25. British Museum 543: Beazley, *op. cit.*, 2 and plate 2b.

26. G. Matthies, *Die praenestinischen Spiegel* (Strasbourg, 1912).

27. Connections between the local art of Palestrina and Caere: Riis, 31-4; also below, Chapter 27, Note 13.

CHAPTER 17

205. 1. K. A. Neugebauer, 'Aus dem Reiche des Königs Porsenna', *Die Antike*, XVIII (1942), 18-56. The much fabled tomb of Porsenna probably existed, though the description by Varro in Pliny, *N.H.* 36.13, gives ground for much controversy: summary in F. Messerschmidt, 'Das Grabmal des Porsenna', *Das Neue Bild der Antike*, II (1942), 53-63. It may, nevertheless, have been a genuine monument in the local Archaic tradition: cf. J. L. Myres, *The Annual of the British School at Athens*, XLVI (1951), 117-21.

2. See above, pp. 130, 179.

3. R. Bianchi Bandinelli, *Le pitture delle tombe arcaiche*, sez. 1, *Clusium*, fasc. 1 (Rome, 1939).

4. *Ibid.*, 29-30, nos. 1 and 2. No. 1, the Tomba della Pania, probably had painted ornaments but no figures. No. 2, now lost but known from a detailed description, showed winged monsters, apparently in the manner of the Campana Tomb near Veii, above, p. 122. Still earlier painted tombs existed certainly in southern Etruria; for instance, the 'Tomb of the Ducks', discovered at Veii in 1958, dates from the middle of the seventh century (A. De Agostino, *Archeologia Classica*, XV (1963), 219-22).

5. Bianchi Bandinelli, *op. cit.*, 30-3, nos. 3-8. The oldest in this group was probably the tomb of Poggio

Renzo (no. 3) with details related to Late Archaic tombs at Tarquinia.

6. *Ibid.*, 33-5, no. 9 (Tomba Paolozzi).

206. 7. Riis, 120-2.

8. Above, p. 100.

9. Illustration 135: kouros, British Museum bronzes no. 510. Illustration 136: javelin-thrower, British Museum bronzes no. 512, both feet restored. Cf. Riis, 121-2.

207. 10. The patterned rendering of the abdominal muscles is clearly Archaic. It derives from mid-sixth-century Peloponnesian bronzes such as the statuette in Vienna, N. Himmelmann-Wildschütz, *J.D.A.I.*, LXXX (1965), 124-37. But the face gives a different impression. The eyes are placed on a straight, not curved, line which contrasts with the curving ductus of the lower lip. Though somewhat harshly drawn, this disposition of forms resembles Greek faces of the transitional period. For the hair, see the still earlier large terracotta head from Taranto, E. Langlotz and M. Hirmer, *L'arte della Magna Grecia* (Rome, 1968), plate 29.

11. E. Paribeni, 'I rilievi chiusini arcaichi', *S. Etr.*, XII (1938), 57-139, and XIII (1939), 179-202. The catalogue, *ibid.* (1938), 66-137, lists 207 pieces extant or recorded by trustworthy sources. Eleven additional pieces and fragments are separated from the rest as likely forgeries, pp. 137-9.

208. 12. *Ibid.* (1938), 66, no. 1: Palermo, Museo Nazionale, no. 205, plate 6, figure 1.

13. *Ibid.*, 110-22, nos. 118-73; rectangular bases, Type IV. Cf. *ibid.* (1939), 201-2.

14. *Ibid.* (1938), 61-4.

15. A stylistic study of the Chiusi reliefs is still a desideratum to complement the typological findings. Elongated figures on bases of Type II: Paribeni, *op. cit.* (1938), 78-80, nos. 31 and 34, plate 14, figures 1 (Perugia) and 3 (Chiusi). Notice the angular movements, apparently typical of the reliefs of this type. Dancer, Tomb of the Lionesses [120]: cf. the dancers on a base in Copenhagen, Helbig Museum, Paribeni, *op. cit.* (1938), 83, no. 42, plate 15, figure 1. Late Archaic fragment of a cylindrical base: *ibid.*, 69, no. 10, plate 9 (Palermo). Its style is about contemporary with the banquet in the Tomb of Hunting and Fishing, above, illustration 126.

16. Illustration 137, cinerary urn, Florence Museo Archeologico no. 5501, from Chiusi: M. Pallottino and H. Jucker, *Art of the Etruscans* (New York, 1955), 143, nos. 62-3, figures 62-3. Cf. for the torus the fragment in Palermo, Paribeni, *op. cit.* (1938), 93, no. 74, plate 19, figure 1. The other side of the urn in Florence represents a line of female dancers, rendered in a manner somewhat different from the banquet: the relief is not so flat, and there is more modelling of

detail. Apparently two different artists were employed.
209. 17. Giglioli, plate 146, figures 1–4; Paribeni, *op. cit.* (1938), 96, no. 78 and plate 22. The two other sides show mourners around the body lying in state, and two riders greeted by a woman (a man? Paribeni, *op. cit.*, 96–7) in the background; a horse race?
211. 18. Occasionally the same pattern occurs on bases of Type II: Paribeni, *op. cit.* (1938), 80, no. 34, plate 14, figure 3.
19. Amazons in battle form a rare exception: *ibid.*, 73–4, nos. 19, 20. For sileni and maenads cf. *ibid.* (1939), 191–2.
20. See preceding note regarding the Bacchic personnel in these representations.
212. 21. The theme was introduced to Etruria, almost certainly, by way of Greek *prothesis* scenes on black-figured lekythoi or pinakes. Comparisons of detail, not to be carried out here, can make clear what is special to either tradition. Thus the ritual mourning is represented in a relief formerly in Berlin (Paribeni, *op. cit.* (1938), 95, no. 77, plate 21) as happening in a building, perhaps the porch of a house. Above one sees the typically Etruscan open gable, complete with rafters and the horizontal course of rooftiles projecting from the floor of the pediment.
22. An Etruscan counterpart to the assembly of men exists among the terracotta revetments from Velletri; Andrén, 1, 412, no. 1:6, 11, plate 128, figures 449–50; *idem, Opuscula Romana*, VIII (1971), 3–4, plate 2, figures 3, 4, 6. There is some discussion about the meaning of these reliefs. The iconographic scheme resembles Greek representations illustrating the council of the gods, in which, however, the goddesses regularly participate; cf. the frieze of the Siphnian Treasury at Delphi. The absence of women in the Velletri frieze supports the opinion that it represents a council of human magistrates. It constitutes an Etruscan secular analogue to the Greek assemblies of deities. For Etruscan magistrates and public officers, see J. Heurgon, *La Vie quotidienne chez les étrusques* (Paris, 1961), 68–70. The gathering of the ladies, as represented in the Chiusi reliefs, has neither antecedents nor parallels elsewhere, to my knowledge. It must be considered an invention of the local artists.
23. Since, most likely, the style of the reliefs in Munich was derived from vase paintings, it fell to the local artists to adjust the manner of drawing proper to the vases to the demands of carved representations. A similar procedure produced the military scenes – an exceptional subject among the Chiusine bases – on two fragments in the Museo Barracco, of excellent quality and likewise reminiscent of vase paintings; Paribeni, *op. cit.* (1938), 109, no. 117, plate 27. In the ladies' party, the low *diphroi* on which some guests are seated appear to imitate Greek furniture; cf., in

addition to the Munich base, the relief in Palermo, Paribeni, *op. cit.* (1938), 94, no. 75, plate 20. The grecizing details in Etruscan Late Archaic art, especially the stylization of textiles, folds of garments, etc., require a special study. The selectiveness of the Etruscan artists, and the consistency of their selections, are also matters to be investigated.

CHAPTER 18

213. 1. The popularity of Etruscan bronze candelabra in late-fifth-century Greece is confirmed by a fragment from a comedy by Pherecrates preserved in Athenaios 15.700C. For additional testimonies and actual finds of Etruscan metalwork in Greece see G. Karo, 'Etruskisches in Griechenland', *Archaiologike Ephemeris* (1937), 316–20, and E. Kunze, 'Etruskische Bronzen in Griechenland', *Studies presented to D. M. Robinson*, 1 (St Louis, 1951), 736–46.
2. Neither a monograph nor a catalogue comprising all extant specimens is yet available. The shield here illustrated [140] (Vatican, Museo Gregoriano Etrusco) is one of the finest. Head well preserved; inset eyes of two-coloured enamel; traces of gilding on the forehead (M. Pallottino and H. Jucker, *Art of the Etruscans* (New York, 1955), 142, no. 59, plate 59). Others: T. Dohrn, in Helbig, *Führer*, 1, 522, no. 692; Riis, 67 and plate 12, figure 1; W. L. Brown, *The Etruscan Lion* (Oxford, 1960), 101–3, plate 41.
3. A mask of 'Achelous' in Rome, Museo di Villa Giulia no. 51101, is said to stem from the decoration of a biga: R. Bartoccini and A. De Agostino, *Museo di Villa Giulia. Antiquarium e collezione dei vasi Castellani* (Milan, 1961), 11–12 and plate 5; M. Moretti, *Museo di Villa Giulia* (Rome, 1964), 115, figure 91; probably from Tarquinia.
4. Lion's head, originally part of a Tarquinian shield, found at Castel San Mariano near Perugia: Pallottino and Jucker, *op. cit.*, 142.
214. 5. See Dohrn, *op. cit.*
6. Dohrn, *op. cit.*; Riis, 67.
7. K. A. Neugebauer in *J.D.A.I.*, LVIII (1943), 210–33.
215. 8. Tripod in Copenhagen, National Museum, from San Vincenzo near Populonia: P. J. Riis, 'Rod-tripods', *Acta Archeologica*, X (1939), 1–5, plates 1 and 2; V. Poulsen in *Etruscan Culture, Land and People* (Malmö and New York, 1962), figures 408–10. Tripod from Metapontum, in Berlin: Neugebauer, *op. cit.*, 233; J. Charbonneaux, *Greek Bronzes* (New York, 1962), 58, plate 2, figure 1.
9. New York, Metropolitan Museum of Art 60.11.11: D. von Bothmer, *Metropolitan Museum of Art Bulletin*, XIX (1961), 149, figures 19–21.
216. 10. The decorative exuberance characteristic of

the tripods, as of the other archaic Vulcian bronze implements, has much in common with the decorative temperament of the early impasto vase stands discussed above, p. 76.

11. A complete tripod of this type was found in the Adriatic harbour town of Spina: S. Aurigemma, *Il R. Museo di Spina in Ferrara* (Bologna, 1936), 216, plate 103. Fragments were also found on the Athenian Acropolis. For these and other Vulcian finds from Greek sites, especially Olympia, see Kunze, *op. cit.* (Note 1), and Neugebauer, *op. cit.*, 231, figure 20.

12. The numerous Etruscan bronze pitchers with beaked spouts can only be mentioned here, not discussed. Apparently they were products of Vulci also: P. Jacobsthal and A. Langsdorff, *Die etruskischen Bronzeschnabelkannen* (Berlin, 1929), 63-4. The rich class of the candelabra, as well as the bronze vases with handles in human form, is more profitably included with the next section; see below, pp. 299-301. It should be mentioned, however, that incense burners of the type described above are not rarely listed, erroneously, as candelabra: e.g. in Giglioli, or Moretti, *op. cit.* (Note 3). Incense burners have an incense bowl on top of their shafts, candelabra do not; Dohrn, *op. cit.*, 546.

217. 13. Neugebauer, *op. cit.*, 265-8, figures 45-6; F. Magi, *La raccolta Benedetto Guglielmi nel Museo Gregoriano Etrusco*, part II (Città del Vaticano, 1941), 165-71, plates 47-9.

14. V. Poulsen, 'En Orientalsk Bronze', *Meddelelser fra Ny Carlsberg Glyptotek*, XXIII (1966), 1-13. Early Etruscan antecedents are the Loeb tripods, above, pp. 162-4, and a terracotta stand in Boston: C. Vermeule, *The Classical Journal*, LXIV (1968), 51-3, figures 3, 3A, and 3B.

218. 15. Magi, *op. cit.*, 169-70. I consider it possible that the necklace (amulet?) depicts the same beast as the guardian animals around the base, usually described as does but here called, tentatively, canines.

16. British Museum bronzes no. 598: S. Haynes, *Etruscan Bronze Utensils* (London, 1965), 18, plate III. The dancer-caryatid was a stock motif: variants in the Louvre, Giglioli, 111, figures 1 and 2; another in the Cleveland Museum of Art, Teitz, 38-9, no. 23, figure on p. 134.

17. In either case the consistent choice of the animal decoration was hardly unintentional, though its meaning escapes us. See above, Note 15.

18. Girl dancer balancing an incense burner on her head: painting, Tomb of the Jugglers, Tarquinia, M. Moretti, *Nuovi monumenti della pittura etrusca* (Milan, 1966), 19, plate on pp. 22-3; another, Tomb of the Monkey, Chiusi, R. Bianchi Bandinelli, *Le pitture delle tombe arcaiche, Clusium*, fasc. 1 (Rome, 1939), plate IV. Dancing youths: Rome, Villa Giulia, Moretti, *op. cit.* (Note 3), 123, figure 103;

Karlsruhe, Badisches Landesmuseum, J. Thimme, *Bildkatalog* (Karlsruhe, 1968), figure 47, illustrated in K. Schefold (ed.), *Die Griechen und ihre Nachbarn* (Propyläen Kunstgeschichte, 1) (Berlin, 1967), figure 402.

219. 19. Neugebauer, *op. cit.*, 210-33. Our illustrations 146-8, Copenhagen, Ny Carlsberg Glyptotek: Poulsen, *op. cit.* (Note 8), figures 412-14. Similar groups, New York, Metropolitan Museum of Art: von Bothmer, *op. cit.*, 149, figures 19-21.

20. P. Zancani-Montuoro, 'Un mito italiota in Etruria', *Annuario della Scuola archeologica di Atene*, XXIV/XXVI (1946/8), 85-98.

221. 21. See above, Note 19; Neugebauer, *op. cit.* (Note 7), 210.

22. *Ibid.*, 207-10.

222. 23. Charbonneaux, *op. cit.* (Note 8), 113-15.

24. Giglioli, plate 67, figure 3.

223. 25. Cf. for instance the somewhat later decorative statuettes of marine creatures from the find of Castel San Mariano near Perugia, which Banti (335-6, plate 88a) ascribed to a Caeretan workshop; also O. W. von Vacano, *Die Etrusker* (Stuttgart, 1955), 446, no. 77a, plate 77a.

26. Above, Chapter 17, pp. 206-7 and Note 9; Chapter 7, pp. 99-100, illustrations 68, 69. For Etruscan bronze statuettes in general see E. H. Richardson, 'The Etruscan Origins of Early Roman Sculpture', *M.A.A.R.*, XXI (1953), 89-122; eadem, *The Etruscans* (Chicago, 1964), 104-9. Stepping kouroi, see below, Chapter 23, pp. 290-2.

224. 27. Richardson, *The Etruscans*, 105.

28. Metropolitan Museum of Art, acc. no. 17.190.2066, left foot restored: G. M. A. Richter, *Greek, Etruscan and Roman Bronzes. Metropolitan Museum of Art* (New York, 1915), 34-8, no. 56. Additional bibliography, Vacano, *op. cit.*, 445, no. 70, plate 70; Teitz, 44-5, no. 30, ill. pp. 146-7.

29. No. 509. Found at Pizzirimonte near Prato but probably imported from a southern centre. Richardson, *The Etruscans*, 106, plate 25b; Teitz, 59-60, no. 48, ill. p. 149.

30. No. 450. Teitz, 53-4, no. 41, ill. p. 148.

226. 31. Striding figures rendered in a relief-like side view also pose a problem among Greek bronzes: Charbonneaux, *op. cit.*, 91-2. Etruscan figures like the javelin-thrower from Brolio described in Chapter 7, illustration 67, or the lady from Falterona [152], tend towards a solution midway between stepping straight forward and a sideways motion.

32. P. J. Riis, *From the Collections of the Ny Carlsberg Glyptotek*, II (1938), 156-8, gives a list of the known examples. Cf. W. Lamb, *Greek and Roman Bronzes* (London, 1929), 137-8.

228. 33. Bronze 'situla' from the necropolis of Olmo Bello, Tomb 2: Moretti, *op. cit.* (Note 3), 61 and

figure 44. In this instance the central statuette represents a fettered animal (a bear?); the surrounding figures seem to perform a dance. Late seventh century.

34. Berlin Antiquarium no. 7872: *Führer durch das Antiquarium*, I (Berlin and Leipzig, 1924), 70, plate 25; Giglioli, plate 105, figure 2.

35. New York, Metropolitan Museum of Art: G. M. A. Richter, *Handbook of the Etruscan Collection* (New York, 1940), 29, figure 81; Pallottino and Jucker, *op. cit.* (Note 2), 145, nos. 73–4, figures 73–4.

36. Br. no. 560: Haynes, *op. cit.* (Note 16), 15–18, plates 11, 3 and 4.

CHAPTER 19

231. 1. For stone sarcophagi in Etruria, see below, Chapters 28 and 29.

2. Three inscribed gold tablets discovered in 1964 during excavations at Pyrgi testify to the closeness of these connections. All three report the dedication of a temple to Uni (Latin Juno)-Astarte, in almost identical wording. Two tablets are written in Etruscan; the third renders the same text in the Phoenician language. The donor of the temple was a 'king' of Caere, Thefarie Velianas; approximate date, first half of the fifth century: G. Colonna, M. Pallottino, L. V. Borelli, G. Garbini, in *Archeologia Classica*, XVI (1964), 49–117, plates 34–9; G. Colonna, *ibid.*, XVII (1965), 286–92; *idem, S. Etr.*, XXXIII (1965), 191–219, plates 56–61.

3. M. Moretti, *Il Museo Nazionale di Villa Giulia* (Rome, 1964), 83–4, figure 58. Mid sixth century.

4. This detail may reflect a source of ultimately Egyptian origin: cf. B. Schweitzer, 'Hunde auf dem Dach. Ein mykenisches Holzkästchen', *Mitteilungen des deutschen archäologischen Instituts, Athen*, LV (1930), 107–18.

5. That in the Louvre: Giglioli, plate 116, figure 2. The sarcophagus illustrated by Giglioli on the same plate, figure 1 (London, British Museum), does not require discussion here: it is now generally recognized as a modern imitation. Sarcophagus in the Villa Giulia: Moretti, *op. cit.*, 84–5, figures 59–60. Both sarcophagi were composed of four separate parts. For a more detailed discussion of the technical details see Herbig, 98–9. Although both sarcophagi have been frequently illustrated, authoritative publications are lacking. The one in the Villa Giulia is in good condition, and so exhibited that the relatively few, indispensable restorations can be clearly recognized. Therefore the above description was based chiefly on this rather than the Paris sarcophagus, where details cannot be so readily judged. For the same reason I refrain from a discussion of the colours

which were certainly applied to both monuments, but seem better preserved on the sarcophagus in the Louvre. This question, also, must await future investigations.

6. J. Heurgon, *La Vie quotidienne chez les étrusques* (Paris, 1961), 98–103. Apparently the custom became fashionable around the middle of the sixth century. Earlier – or more rustic? – Etruscans feasted while seated at a table, like the banqueter on the lid of the late Villanovan ossuary from Volterra, above, Chapter 15, Note 15.

7. J. Charbonneaux, *Greek Bronzes* (New York, 1962), 107, plate 14, figure 3.

232. 8. For instance, the cinerary urn in the Louvre: Giglioli, plate 64, figure 2.

9. A tendency towards the angular-geometric manifests itself in Etruscan art on many occasions, in various periods. It has often been observed: see E. H. Richardson, 'The Recurrent Geometric in the Sculpture of Central Italy', *M.A.A.R.*, XXVII (1962), 159–98. I consider this trend a Villanovan heritage; cf. above, Chapter 2, p. 23. It was one of two possible modes in which the early Etruscan formalism could express itself. The other was the 'wiry' style of the early Vetulonian bronzes, which led to quite different results; there the limbs, especially arms detached from the body, were bent in curving and rounded forms as if fashioned from malleable, 'wiry' strands of metal. The two bronzes, E. H. Richardson, *The Etruscans* (Chicago, 1964), plate 5a and b, may help to make the contrast clear. These contrasting formal conceptions must be considered prehistoric survivals in central Italy, antedating the Orientalizing period.

10. The art of making terracotta statuary on a large scale was probably first cultivated in Greek workshops in southern Italy. The earliest example so far known is the enthroned god from Paestum, about a decade older (*c.* 530–520) than the Cerveteri sarcophagi: E. Langlotz and M. Hirmer, *L'arte della Magna Grecia* (Rome, 1968), plates III and IV and p. 250 with bibliography.

11. Andrén, 31–3. See also above, Chapter 11, pp. 134–5.

12. Copenhagen, H.182: Andrén, I, 32; V. Poulsen, 'Etruscan Art', in *Etruscan Culture, Land and People* (Malmö and New York, 1962), plate 43. End of the sixth century. Other heads from the same series, now in the Vatican, London, Berlin, New York, and Philadelphia: Giglioli, 33, text to plate 176, figure 2.

233. 13. Copenhagen, H.192: Andrén, 49:III:7; Poulsen, *op. cit.*, plate 42; a similar specimen in Berlin, Giglioli, plate 182, figure 2; another in the Villa Giulia, from Pyrgi, G. Colonna, *Archeologia Classica*, XVIII (1966), 97, plate 40.

234. 14. Excavations at Pyrgi: M. Pallottino, 'Scavi nel santuario etrusco di Pyrgi', *Archeologia Classica*,

X (1958), 315-22; G. Colonna, *Notizie degli Scavi* (1959), 143-261. Also above, Note 2. For Etruscan pediments cf. E. H. Richardson in *Cosa* II, *The Temples of the Arx, M.A.A.R.*, XXVI (1960), 307-12.

235. 15. G. Colonna, 'The Sanctuary of Pyrgi in Etruria', *Archaeology*, XIX (1966), 16-17, figure 8; *idem, Notizie degli Scavi* (1970), Supplement 2, 48-71, plates 1 and 2, and figures 35 and 36.

16. This passage is due largely to Emeline Richardson. Literature: E. Paribeni, *Archeologia Classica*, XXI (1969), 53-7, plates 17-19; G. Colonna, *ibid.*, 295-6, plate 107; *idem, Notizie degli Scavi* (1970), Supplement 2, 48-71, figures 35 and 36, plates 1 and 2; I. Krauskopf, *Der thebanische Sagenkreis* (Mainz, 1974), 43-5, 108 Sie 6, plate 17.

236. 17. This dates from about 510; the relief from Pyrgi may be assigned to the quarter century between that date and 485, approximately. It reflects an advanced stage of Greek Late Archaic rather than an Early Classical style. But cf. G. Colonna, *Notizie degli Scavi* (1970), Supplement 2, 81-2, for a date later in the fifth century.

237. 18. J. D. Beazley, *Der Kleophrades Maler* (Berlin, 1933), plate 27.

19. Principal source is Pliny, *N.H.* 35.157. A considerable difficulty with implications beyond the scope of this volume arises from Pliny's assertion that the statue was commissioned by the elder Tarquin, Tarquinius Priscus, whose reign according to traditional chronology ended in 578. At stake in this controversy are not only the building history of the Capitoline Temple but also the change from the Etruscan monarchy to the Roman republic. The date, 509, to which the official records (the *Fasti*) assign the dedication of the temple cannot be disregarded, however. Possibly work on the foundations of the temple began under the elder Tarquin, while the superstructure was built by his grandson, Tarquinius Superbus. For the dedication ceremony to take place, the temple had to be more or less complete, and the cult statue set up within; cf. M. Pallottino, *S. Etr.*, XXXI (1963), 28-9. The alternative to this reconstruction of the events is to assume that Tarquinius Priscus was indeed king in 509, in which case the expulsion of Tarquinius Superbus could not have happened before the middle of the fifth century, contrary to the opinion commonly held by most later Roman historians. For the defence of the latter alternative and further bibliography see E. Gjerstad, *Legends and Facts of Early Roman History* (Lund, 1962). Neither solution is likely to have much effect on the chronology of Vulca, whose share of work seems at any rate closely aligned with the final building stage; that is to say, not far from the date (509) of the dedication. Vulca's Jupiter lasted for over four hundred years, until the destruction of the old temple

in the fire of 83 B.C. (Cicero, *in Catilinam* III.9). The subsequent Roman portrayals of the Capitoline triad habitually represent the god as enthroned. But the original statue apparently was represented standing: Ovid, *Fasti* 1.202. See also below, Chapter 20, pp. 249-50.

20. Above, Note 10.

21. Pallottino, *op. cit.*, 28-9.

22. A. Rumpf in Pauly-Wissowa, *Real-Lexikon*, Zweite Reihe IX A, 1, cols. 1223-6 s.v. 'Vulca'.

23. Only one quadriga is mentioned by Plutarch; below, Note 27. Cf. also Rumpf, *loc. cit.* This probably was correct. 'Quadrigae', the plural used by Pliny, should be understood as referring to the quadriga as a multiple object. In 283 B.C. it became necessary to replace the Archaic acroterium by a new group made of bronze; Livy, 10.23.12.

24. Pliny, *N.H., loc. cit.*

25. See above, Note 22.

26. E. Gjerstad, 'The Etruscans and Rome', in *Etruscan Culture, Land and People* (Malmö and New York, 1963), 151-4.

27. Accordng to Pliny, Vulca was called to Rome: 'Vulcam Veis accitum . . .', *N.H., loc. cit.* Plutarch, *Poplicola* 13, seems to have held a different conception when he reported the miracle of the fictile quadriga which in the firing expanded instead of shrinking. The Veientines were so much impressed by this omen that they refused to deliver the finished group, excusing themselves by the fact that Tarquinius Superbus, who ordered it, had meanwhile been expelled. Even this story leaves open the possibility that the workshop which refused delivery was a Veientine atelier, temporarily active in Rome. Besides, the incident as told by Plutarch has all the hallmarks of an edifying legend, a prophecy *ex eventu*, to confirm long-cherished beliefs. Its weight as a record of fact must be deemed slight. Cf. Gjerstad, *op. cit.* (Note 19), 52-3. For a convenient collection of ancient sources concerning Vulca and his workshop, see J. J. Pollitt, *The Art of Rome* (Englewood Cliffs, N.J., 1966), 8-16.

239. 28. M. Santangelo, 'Veio, Santuario "di Apollo": scavi fra il 1944 e il 1949', *Bollettino d'Arte*, XXXVII (1952), 147-69; E. Stefani, *Notizie degli Scavi* (1953), 29-112.

29. E.g. R. Wittkower, *Art and Architecture in Italy: 1600-1750* (Pelican History of Art), 3rd ed. (Harmondsworth, 1973), plate 1, Maderno's façade of St Peter's, or plate 147 (B), Stra, Villa Pisani, by F. M. Preti.

240. 30. P. Zancani-Montuoro, *Annuario della Scuola Archeologica di Atene*, VIII-X (1946/8), 85-98.

31. The votive material is not yet published: cf. Q. Maule and H. R. W. Smith, *Votive Religion at Caere* (Berkeley and Los Angeles, 1959), especially 104-5.

241. 32. Zancani-Montuoro, *op. cit.*

33. Examples are frequent among the cippi of Chiusi: above, Chapter 17, p. 207. Cf. also the statuette from Falterona, above, Chapter 18, pp. 224-6 [152]. Apollo's cloak is the semicircular tebenna, the ancestor of the Roman toga; L. B. Warren, 'Roman Costumes', in *Aufstieg und Niedergang der römischen Welt*, I, vol. 4 (Berlin and New York, 1973), 590-1.

242. 34. This anatomy of the leg has near antecedents among the Tarquinia paintings (Tomb of the Augurs) and Caeretan hydriae (Busiris Painter). Ultimately it was probably derived from Ionic Greek examples such as the Herakles pediment of the Siphnian Treasury; for this latter see B. Sismondo Ridgeway, *A.J.A.*, LXIX (1965), 1-5, plates 1-2. These comparisons also recommend the period between 515 and 490 as the most suitable date for the Portonaccio statues.

35. Comparisons between modelling techniques used in the Portonaccio statues and earlier local ceramics may help to verify the Italic quality which G. Kaschnitz-Weinberg sensed in the Portonaccio style; see my 'Prolegomena to a Book on Roman Art', *M.A.A.R.*, XXI (1953), 61-4, especially 63.

244. 36. Santangelo, *op. cit.*, 156 and 159 figure 27. Cf. Banti, plate 23b and p. 298.

37. Often illustrated. See bibliography in Giglioli, text to plates 179 and 181.

38. Giglioli, plate 178, figure 1; Santangelo, *op. cit.*, 158, figures 25-6; Banti, plate 23a and p. 298.

245. 39. See above, Note 34, on the date of the Portonaccio sculpture.

CHAPTER 20

247. 1. Andrén, I, 107-9, no. 1:1, plate 36. During the Hellenistic period this acroterion was replaced by a statue of Mercury; hence the modern designation of the building, 'Temple of Mercury'.

2. The style corresponds to Greek art on the chronological level of the east pediment of the temple at Aegina. A good Etruscan parallel is the small bronze from Populonia, now in Florence, representing the suicide of Ajax: Giglioli, plate 217, figures 1 and 2.

3. Vergil, *Aeneid* VII, 641-702; cf. X, 163-214. For a similar display of armorial fashion in a battling group of lesser quality from Satricum (Conca), see Giglioli, plate 167, figure 2.

4. Santangelo, 113-16; Andrén, I, 109-12, II, plate 38.

5. E.g. Giglioli, plate 172, figure 2 (Satricum); plate 172, figure 4 (Rome). Cf. plate 180, figure 1 (Falerii, from the large temple in the so-called Vignale).

248. 6. E. Gjerstad, 'The Etruscans and Rome in

Archaic Times', in *Etruscan Culture, Land and People* (New York and Malmö, 1962), 153, figure 137. Also Andrén, 341-2, no. 1:3, with reference to a similar specimen from Falerii.

7. Giglioli, plates 198-9; probably votive statues, not architectural decoration. Andrén, 456.

8. V. Poulsen, 'Etruscan Art', in *Etruscan Culture, Land and People*, figures 396-8. Actually only a small number of moulds was used; perhaps not more than two to produce the heads. The variety of expressions is due to details modelled by hand, and especially to the position of the heads, which differs in every instance (Andrén, 470-3, no. 11:13). For a parallel from Campania see the central group on the lid of the bronze urn in London, above, p. 228, illustration 156.

9. P. Zancani-Montuoro and U. Zanotti-Bianco, *Heraion alla Foce del Sele* (Rome, 1951-4), I, plates 41-59.

249. 10. Circus Maximus, Cloaca Maxima, Temple of Castor, etc. Survey of ancient sources in J. J. Pollitt, *The Art of Rome* (Englewood Cliffs, N.J., 1966), 9-16; especially Livy, 1.56.1.

11. For instance, for the acroteria (above, p. 237) the year of the dedication, 509, need not be binding. To complete the roof statues the workshop may have been in operation beyond that date.

12. No. A55, S-6: Teitz, no. 44, figure 152. Height of preserved parts, 17.2 cm. Supposed provenance, Piombino. The stylistic evidence suggests south Etruscan origin. The face, with finely striated beard, overlapping moustache, and small apron below the smiling lower lip, compares well with the Tarquinian 'Achelous' above, pp. 213-14, illustration 140. Cf. also the elegant bronze of a reclining banqueter in the British Museum, Poulsen, *op. cit.*, figure 422, which seems to be Vulcian. The modelling of the torso and the undulating folds of the cloak resemble closely the statuette from Monteguragazza (below, pp. 295-7) which appears to be a provincial, perhaps somewhat belated, outcome of the art of Veii: Santangelo, 28-9. A small bronze of much coarser workmanship, representing the same type: New York, Metropolitan Museum of Art inv. no. 24.97.114. In accordance with Ovid, *Fasti* I, 202, the thunderbolt ought to be restored in the right hand which now is lost; this leaves the left free to hold the sceptre. A late echo of the same statue may be preserved on a Praenestine cista in Berlin [317]: L. B. Warren, *A.J.A.*, LXVIII (1964), plate 13, figure 5. There the god stands on his chariot. The likely date of the cista is around 200 B.C.; Vulca's statue was then still in existence.

250. 13. Lack of early temple buildings: F. E. Brown, *Roman Architecture* (New York, 1961), 10-13. Early *xoana* in Etruria: above, p. 179. The rare instances

which perhaps represent deity are women; all are statuettes, not large statuary. Images of the gods appear in early Etruscan art in narrative contexts, as figures in action, but hardly as isolated, inactive incorporations of the divine presence. Cult images are usually of the latter type. They can be regarded as an innovation, adopted after the Greek example, in the Late Archaic period. Varro's information that the Jupiter Capitolinus was the first cult statue in Rome is not invalidated by his rather hypothetical belief in a purer, pre-iconic form of all religion. Cf. P. Boyancé, 'Sur la théologie de Varron', *Revue des Études Anciennes*, LVII (1955), 65-7 and bibliography.

14. The two artists shared their work, both the ceramic part and the colouring: Pliny, *N.H.* 35.154.

15. The names, Gorgasos and Damophilos, indicate Doric origin; this condition applies to the city of Tarentum, for instance.

16. The record of the statue as worded by Pliny, *N.H.* 34.15-16, seems to include elements of the original dedication ('dedicated to Ceres from the property of Spurius Cassius') transcribed, possibly, by Varro. An Archaic inscription of this kind would have been very brief – hardly more than four or five words. The rest ('who was put to death', etc.) would then represent a commentary added by some later writer. A much later date for the building of the temple was recently suggested by A. Alföldi, *Early Rome and the Latins* (Ann Arbor, Mich., n.d.), 92-5, because of its special relation to the Roman plebs. But the building may well have antedated its eventual designation as sanctuary of the plebs. The same seems to be true of the shrine of Diana near by, which perhaps was even older: A. Alföldi, *A.J.A.*, LXIV (1960), 137-44.

17. K. Lehmann-Hartleben, *Drei Entwicklungsphasen griechischer Erzplastik* (Stuttgart, 1937), 2-5. The passage in Pliny, *N.H.* 34.15-16, stresses the fact that this was the earliest statue of a deity in Rome cast of bronze. As it goes on to say that bronze came subsequently to be used for statues of mortal men also, we might assume that Pliny knew of no earlier bronze statue whatsoever in Rome, yet he mentions statues of the Kings of Rome on the Capitoline and of Horatius Cocles in the Forum, and he assumes that these belonged to the Regal period and to the first years of the Republic.

18. E. Simon in Helbig, *Führer*, II, 277-81, no. 1454.

19. Restorations: *ibid.*, 278. Possibly the rifts in the hind legs were caused by lightning, but this is not certain. If it were so, the matter would be of some importance because, according to Cicero, *De div.* 1.20, a bronze she-wolf represented with the twins was hit by lightning in 65 B.C. But this work which stood in the Capitoline temple is described as a group; it can hardly have been identical with the statue still

preserved. A fresh technical examination of the latter has been made recently by O. W. von Vacano; see 'Vulca, Rom und die Wölfin', in *Aufstieg und Niedergang der römischen Welt*, I, vol. 4 (Berlin and New York, 1973), 566-8. The cast was hollow, with relatively thick bronze walls, in keeping with Archaic technology.

20. The Capitoline temple, for instance. There are other choices, however, such as the early sanctuaries of Mars.

252. 21. The back mane had a long history in early Etruscan art from the Orientalizing period: W. L. Brown, *The Etruscan Lion* (Oxford, 1960), 28-9. The collar of small curls around the head resembles the lion heads of the Tarquinian shields; *ibid.*, 101-2, plates 40-1. For the mane around the neck, see Note 22.

22. The 'question-mark' hair differs from the 'flaming' design in several ways. The locks are shorter. Their lower, and sometimes also their upper, ends form pronounced, curling hooks. As the hooks are coiled upward at the lower end, and downward at the upper, when hooks are formed at that end, the total design of each lock tends to create a form closed in itself like a spiral. When a number of these shapes, all of the same size and outline, are repeated, covering a sizeable area in every direction, as in the mane of the Capitoline Wolf, a decorative pattern of abstract regularity results which has little in common with natural representation. Similarly patterned manes in eastern art: gold rhyton with winged lion, Archaeological Museum, Teheran, R. Ghirshman, *The Art of Ancient Iran* (New York, 1964), figure 290; similar rhyton, New York, Metropolitan Museum of Art, *ibid.*, figure 306; also the bronze stand from Persepolis, likewise in the museum of Teheran, which W. L. Brown (*op. cit.*, 104, plate 61g) already compared to the lions' heads on the Tarquinian shields, if for a different detail (cf. Ghirshman, *op. cit.*, figure 291).

253. 23. Cf. the preceding note.

24. For further discussion see the following chapter. The early Etruscan treatment of the eye as an integral part of the cast surface, in hollow bronzes, was never quite discontinued. It reappears occasionally in Italo-Hellenistic art (head of a boy in Florence, Giglioli, plate 366, figure 1; below, illustration 305) and again during the Roman period.

CHAPTER 22

263. 1. M. Moretti, *Tarquinia. La Tomba della Nave* (Milan, 1961).

2. This group of paintings will be discussed further: see pp. 269-74, *The Eternal Banquet*.

264. 3. H. Leisinger, *Malerei der Etrusker* (Stuttgart, 1954), 78–80. See also below, p. 266 and Note 9.

4. Two pairs of pillows are placed on the couch. Each pair is surmounted by headgear resting on a wreath; one apparently represents the conical hat of a woman. This assemblage of objects may refer, symbolically, to the matrimonial bed, the *lectus genialis*, but the stereotype of the dining couple on a couch, so popular in Etruscan Late Archaic and Classical art, could also be involved; though the imagery differs, it might have evoked the same idea. As yet no certain decision can be made, except that obviously the empty bed, towering like a catafalque, was the object of the ceremony. See also Pallottino, 82.

266. 5. Leisinger, *op. cit.*, 50–8; Pallottino, 67–72.

6. Prentiss Duell, 'The Tomba del Triclinio at Tarquinia', *M.A.A.R.*, VI (1927), 7–68; Leisinger, *op. cit.*, 59–97; Pallottino, 73–80.

7. Leisinger, *op. cit.*, 81–4; Pallottino, 87–90.

8. F. Weege, *Etruskische Malerei* (Halle, 1921), 92–6, figures 78–9, 81–2, watercolour reproductions at Strasbourg, plates 84–6, Beilage II, after the original tracings by Baron Stackelberg; Pallottino, 61–4.

9. See R. Ross Holloway, *A.J.A.*, LXIX (1965), 344, 346, plate 82, figure 17.

10. Above, Note 8.

268. 11. R. Bartoccini, C. M. Lerici, M. Moretti, *La Tomba delle Olimpiadi* (Milan, 1959), 75 figure 4, 78–81 figures 5–8.

12. See above, pp. 193, 198, about heraldic symmetry.

13. Pallottino, 64.

269. 14. Holloway, *op. cit.*, 344–7.

15. Similar 'gardens of bliss', if differently furnished, lived on in the memory of the Greeks (Hesperides), as in eastern folklore; e.g. in Persian narratives (Nagib al Mamalek) and the *Arabian Nights*.

16. For this matter and the following remarks, cf. S. De Marinis, *La tipologia del banchetto nell'arte etrusca arcaica* (Rome, 1961), 39–57.

17. Above, Note 7.

271. 18. Pallottino, 83.

19. Leisinger, *op. cit.*, 81.

274. 20. R. Bianchi Bandinelli, *Le pitture delle tombe arcaiche, Clusium*, fasc. I (Rome, 1939), 29–35.

276, 21. This part of the frieze is poorly preserved; see *ibid.*, plate IV and text pp. 13–14. Similar travel baskets with lids open: Tomb of the Jugglers, Tarquinia (M. Moretti, *Nuovi monumenti della pittura etrusca* (Milan, 1966), plates 22–3).

22. A. Alföldi, 'Die Herrschaft der Reiterei in Griechenland und Rom nach dem Sturz der Könige', *Gestalt und Geschichte* (Basel, 1965), 13–47, especially 17–21.

277. 23. K. Lehmann, 'The Dome of Heaven', *The Art Bulletin*, XXVII (1945), 2–4.

24. Bianchi Bandinelli, *op. cit.*, 21, figure 21.

278. 25. The dancers on a wall of the rear chamber in the same tomb are probably by the same artist; *ibid.*, plate VII (M). They are very sketchily represented – perhaps unfinished. Precisely for this reason they also give a rare insight into the initial stages of the preparatory drawing. Notice, especially, the geometric approach to live forms, in the straight lines and broken angles which precede the final image.

26. Bianchi Bandinelli, *op. cit.*, plate C. The banqueters in the Tomb of the 'Pulcella' at Tarquinia resemble those in the Tomb of the Hill, in temperament; both paintings may be contemporary, *c.* 460–450 (Leisinger, *op. cit.*, plates 85–8 and p. 24).

279. 27. For the Chiusi cippi, see above, pp. 207 ff. Originally the tongue patterns were probably borrowed from contemporary terracotta decoration; cf. Giglioli, plate 168, figure 2, amongst many other examples. They were a handy ornament for the ceramists. In wet clay the parallel striae could easily be produced by a rounded spatula.

28. Apparently these 'columns' originated as a simplified version of braided ornament; see E. Pariboni, *S. Etr.*, XII (1938), plate 11, figures 2 and 3.

29. *Ibid.*, plate 28 and p. 110 no. 118.

30. Similar armed dancers perform among the athletic spectacles in the Tomb of the Monkey and the Tomb of the Hill; Bianchi Bandinelli, *op. cit.*, 13, figure 14, plate VI C.

281. 31. Catalogue and classification: F. Magi, 'Stele e cippi fiesolani', *S. Etr.*, VI (1932), 11–85. Additions by F. Nicosia, *S. Etr.*, XXXIV (1946), 149–64. Cf. Riis, 137–8.

282. 32. Catalogue and classification: P. Ducati, 'Le pietre funerarie felsinee', *Monumenti Antichi*, XX, pt 2 (1912), cols. 361–460.

33. *Ibid.*, cols. 479–97.

34. *Ibid.*, cols. 406–7, no. 82.

35. *Ibid.*, cols. 503–5.

36. See above, pp. 271–3.

CHAPTER 23

283. 1. The latest painted terracotta slabs: F. Roncalli, *Le lastre dipinte da Cerveteri* (Florence, 1965), 96–7. Of post-Archaic wall paintings in localities other than tombs we know two small fragments: one from Veii (Santangelo, 104–5) shows the head of a woman facing, possibly an echo of Polygnotan art; the other, later still, is from Falerii (*ibid.*; Banti, plate 24c and p. 299).

2. Above, Chapter 16, Note 15.

3. Cf. T. Dohrn in *R.M.*, LXXIII/LXXIV (1966/7), 19–21.

4. Historisches Museum, inv. 45132: I. Jucker, *Aus der Antikensammlung des bernischen historischen Museums* (Bern, 1970), 46–7, no. 53, plates 18–19.

284. 5. *Corpus Vasorum Antiquorum* (Deutschland 16), *Schloss Fasanerie*, 2, no. 151, pp. 30-1, plate 71, figures 1-4.

285. 6. Above, Chapter 16, Note 21; also Dohrn, *op. cit.*, 19-28.

286. 7. T. Dohrn in Helbig, *Führer*, I, 549-50, no. 734. The straight vertical stance of the figures, contradicting the circular frame, matches the somewhat earlier mirror from Praeneste, above, illustration 134.

287. 8. No. B.542: Ducati, II, plate 144, figure 372; V. Poulsen, 'Etruscan Art', in *Etruscan Culture, Land and People* (Malmö and New York, 1962), figure 442. Details were inlaid with silver. S. Haynes, *Etruscan Bronze Utensils* (London, 1965), 19, plate 6, suggests Vulcian origin, which may well be correct; she also calls attention to the close resemblance between this mirror and the Attic amphora in the Louvre by Phintias, also from Vulci, representing Leto being carried off by Tityos; P. Arias and M. Hirmer, *A History of Greek Vase Painting* (London, 1962), plate 91.

9. T. Dohrn in Helbig, *Führer*, I, 544, no. 727; Giglioli, plate 134, figure 1.

288. 10. Ducati, II, plate 122, figure 321; M. Moretti, *Il Museo Nazionale di Villa Giulia* (Rome, 1964), 332. The pose of the wounded, kneeling duellist is matched by numerous examples in Late Archaic Greek red-figure vase painting, for example the figure of Hector on a cup by Duris in the Louvre (Arias and Hirmer, *op. cit.*, plate 144); the dying 'Aegisthus' of the much disputed relief in Copenhagen, Ny Carlsberg Glyptotek no. 30, has a similar pose (Giglioli, plate 135, figure 1). This relief ought to be mentioned here although its material - marble - precludes Etruscan Late Archaic or Early Classical origin. It is nevertheless possible that the Copenhagen relief renders an Early Classical prototype, perhaps south Italian, or even Etruscan, with Roman archaizing additions such as the hair and diadem of 'Orestes'; cf. M. Gjødesen, *A.J.A.*, LXVII (1963), 348, note 156.

11. Giglioli, plate 229 figure 2 and plate 230; O. W. von Vacano, *Die Etrusker: Werden und geistige Welt* (Stuttgart, 1955), 74-80, plate 105; G. Mansuelli, *Etruria and Early Rome* (London, 1966), 130, and colour plate 35. The Gorgoneion is of the Archaic type but modernized: Santangelo, 60. The seated sileni with syrinx compare well with apparently Vulcian bronze handles: Teitz, 73-4, no. 62, figure on p. 166.

290. 12. Etruscan bronze statuettes: see above, Chapter 18, Note 26; also D. Mitten and S. Doeringer, *Master Bronzes from the Classical World* (Cambridge, Mass., 1967), 149-224; and Teitz, with additional bibliography.

13. Two Archaic statuettes from Etruria may be nude goddesses, but their Etruscan origin is disputable. 1. Orientalizing - or Syrian - ivory statuette from Marsiliana, A. Minto, *Marsiliana d'Albegna* (Florence, 1921), 86-7, 216-18; Huls, 40, no. 13; H. Jucker in K. Schefold, *Die Griechen und ihre Nachbarn* (Propyläen Kunstgeschichte, 1) (Berlin, 1967), figures 395b and c and p. 319. 2. Marble statuette from Orvieto, A. Andrén, *S. Etr.*, XXXV (1967), 50-1, no. 1, plates 16-19; *idem, Antike Plastik*, VII (1967), 10-24, plates 1-8. The Villanovan water carrier from Vetulonia [60] is a native work but not a deity; she may be a servant. For representations of young men see Chapters 16, pp. 186-7, illustration 122, and 18, p. 217, illustration 144.

291. 14. Br. 3: Riis, 61, plate 1, figure 1; M. Pallottino and H. Jucker, *Art of the Etruscans* (New York, 1955), figure 68 and p. 144.

292. 15. Liebighaus no. 785; *Kleinplastik aus dem Liebighaus* (Frankfurt am Main, 1960), figure 5 and p. 2.

16. Above, pp. 206-7.

17. Cf. also Mansuelli, *op. cit.*, 86-8.

293. 18. Veii plundered by the dictator Camillus (396): Livy, 5.22. Two thousand statues (presumably of bronze) taken from Volsinii (264): Pliny, *N.H.* 34.34. Cf. also below, Chapter 25, Note 1.

19. British Museum no. 3212: Poulsen, *op. cit.* (Note 8), figure 441.

20. Cf. the youth from Ligorio in Berlin: W. Lamb, *Greek and Roman Bronzes* (London, 1929), 146-7, plate 52a.

294. 21. Ny Carlsberg Glyptotek no. 29: Poulsen, *op. cit.*, figures 437-40; P. J. Riis, *Acta Archeologica*, XXXVII (1966), 67-75.

22. Now in the Antiquarium Comunale: T. Dohrn in Helbig, *Führer*, II, 582-3, no. 1811; E. Gjerstad, *Early Rome*, IV, 2 (Lund, 1966), 454, figure 126.

23. Also in the Antiquarium Comunale: Dohrn, *op. cit.*, 599-600, no. 1833.

295. 24. Andrén, I, 46-7, no. III:1, plate 14.

25. Illustration 212, terracotta revetment, Arezzo, Museo Archeologico: G. Becatti, *L'età classica* (Florence, 1965), 74 and colour plate on p. 75.

26. Santangelo, 28; Mansuelli, *op. cit.*, 122-3.

297. 27. Museo Archeologico inv. no. 72725: Santangelo, 45-6. The object in his right hand has not so far been plausibly explained. Similar objects are whips in the hands of riders or chariot drivers, e.g. in the silver relief in London, above, illustration 106.

298. 28. British Museum B 522.

29. Collection L. Pomerance, New York, N.Y.: Teitz, 66-7, no. 55 illustrated on p. 164. Cf. the hoofed satyr, probably Campanian, *ibid.*, 68-9, no. 57 illustrated on p. 165. Related, if perhaps slightly earlier, censers are in the Metropolitan Museum, New York (*ibid.*, 42-3, no. 27 illustrated on p. 135)

and in the Villa Giulia, Rome (Giglioli, plate 213, figure 4). Stepping kouroi serve as their carriers. The kouros statuette which supports a thymaterium of more archaic design in Munich, Antikensammlung (Giglioli, plate 212, figures 1 and 3) may be placed at the head of this series, which is commonly assigned to Vulci (Teitz, 42-3).

299. 30. Etruscan candelabra: T. Dohrn in Helbig, *Führer*, I, 516-18, no. 684; above, Chapter 18, Note 1. Selected illustrations in Giglioli, plates 214-16, 307-9. The candelabra and finials from Spina seem of a different and often lesser quality than those known from Vulci: S. Aurigemma, *Scavi di Spina*, I (Rome, 1960), plates 18, 100; I, 2 (Rome, 1965), plate 31. Candles attached to candelabra: painting from the Golini Tomb at Orvieto, Giglioli, plate 245. Candelabra exported to Greece: E. Kunze in *Studies presented to D. M. Robinson*, I (St Louis, 1951), 736-46. Campanian urns: above, pp. 226-8.

300. 31. No. 47.11.3; Teitz, 57-8, no. 46, illustrated on p. 153. For the beard of the older man see illustrations 156, 174, and the following note.

301. 32. Giglioli, plate 217, figures 1 and 2. The style, on a level with the east pediment of the temple at Aegina, seems related to a statuette in London, British Museum Br. 452: E. Richardson, *Etruscan Sculptures* (New York, 1966), plate 20, said to hail from Umbria. Both are probably Vulcian: Riis, 91. The face may also be compared to the terracotta acroterion from Falerii, here illustration 171; see detail, Poulsen, *op. cit.* (Note 8), figure 427.

33. British Museum Br. 498.

302. 34. Votary, Baltimore, Walters Art Gallery no. 54.99: Teitz, 78-9, no. 69, illustrated on p. 170 (here illustration 228); Turan, Fogg Art Museum, Cambridge, Mass., Teitz, 71, no. 59, illustrated on p. 155 (here illustration 227).

35. Now in the collection of Contessa Aria Castelli at Bologna: Giglioli, plate 252, figures 1 and 3; S. Doeringer and G. M. A. Hanfmann in *S. Etr.*, XXXV (1967), 647 and note 4, plate 141. Type of body armour: *ibid.*, 648-9. A copy of the standing warrior, alone (*ibid.*, 645-53, plates 139-40, Mitten and Doeringer, *op. cit.* (Note 12), 172, no. 173), is probably modern: H. Jucker in *Gnomon*, XLI (1969), 609.

36. Collection L. Pomerance, New York, N.Y.: Teitz, 70-1, no. 58, with bibliography, illustrated on p. 169. Hooks issue from the base of a similar statuette in Berlin: L. Goldscheider, *Etruscan Sculpture* (London and New York, 1941), 17. The hooks may have carried utensils, as suggested above, but the alternative proposal deserves consideration also: that they carried oil lamps, and the whole was a chandelier to be hung from a ceiling. Cf. the lamp stand(?) from Tomb 128 at Spina: S. Aurigemma, *Il R. Museo di Spina in Ferrara* (Bologna, 1936), 218, plate 104.

303. 37. Now in Ferrara, Museo Archeologico: Aurigemma, *op. cit.*, 140, plate 68. Mythical interpretations as Achilles or Orestes (Santangelo, 61) hardly fit the character and age of this boyish figure. Sacrifice of hair was a maturity rite in Greece. In Rome it was known as an ancient custom of the native nobility: Petronius, *Satyricon* 29. For style and costume, cf. London, British Museum Br. 681 from Falerii Veteres (G. Hafner, *R.M.*, LXXIII/LXXIV (1966/7), 33, plate 7, figure 4).

CHAPTER 24

305. 1. Above, p. 258.

2. A. Andrén, 'Marmora Etruriae', *Antike Plastik*, VII (1967), 7-10.

306. 3. G. M. A. Richter, *Kouroi*, 2nd ed. (New York, 1960), no. 181, figures 533-40.

4. B. S. Ridgeway, 'The Bronze Apollo from Piombino in the Louvre', *Antike Plastik*, VII (1967), 43-71, plates 24-34.

5. Ny Carlsberg Glyptotek inv. 2235: F. Poulsen, *Catalogue of Ancient Sculpture in the Ny Carlsberg Glyptotek* (Copenhagen, 1951), 45-6, no. 28; M. Gjødesen, 'Fyrst Sciarras Bronze', *Meddelelser fra Ny Carlsberg Glyptotek*, XXVII (1970), 11-75. Southern Etruscan (Caeretan) origin of the Sciarra statue: Riis, 29-30, 165; V. Poulsen, 'Etruscan Art', in *Etruscan Culture, Land and People* (Malmö and New York, 1962), figures 459-60 and plate 50. Formal relations between the Sciarra and Piombino bronzes were first noticed by F. Poulsen, *op. cit.*, 46. On the Apollo of Piombino see E. Langlotz, *Athenische Mitteilungen*, LXXVII (1962), 119 and note 28; R. Brilliant, *Gesture and Rank in Roman Art* (New Haven, 1963), 28; Ridgeway, *op. cit.*

307. 6. The statue from Piombino probably rendered a young dedicant holding a *phiale* like the statuette from Monteguragazza [213]; there is no sure sign that it represented Apollo. The Greek dedication on its left foot is 'to Athene, as a tithe'; Ridgeway, *op. cit.*, 66-8. This leaves the question open, to what particular Athene it was addressed. Among the Italian cults of more than local importance, the Temple of Athena Tyrrhena at Surrentum may offer a suitable answer. The cult was Campanian-Etruscan, and gifts from abroad (e.g. Rome) are on record. In such a place a dedication in Greek would not seem unusual; the age of the inscription is disputed, however. Whether the statue was to be shipped from south to north or vice versa when it came to grief in the waters of Populonia is left to speculation. But the time of the catastrophe is more or less determined by the lead tablet with the names of two Rhodian artists, found inside the statue: not before the advanced second

century B.C. (Ridgeway, *op. cit.*, 68). Among the possible reasons for transfer at this late date, violence is the most likely. One cannot be certain, however, that this was the first relocation which the Piombino kouros underwent. There were sufficient wars in Italy to make booty change hands and places between 460 and the conquest of Sulla which destroyed Surrentum.

308. 7. The broad contour of the face, in the Ionic manner, has antecedents in Caere (Riis) but also elsewhere; cf. the small terracotta head of Mercury from Veii, Santangelo, 99-100. The asymmetrical eyebrows recur in a Proto-Classical terracotta head in Berlin (G. Hafner, *R.M.*, LXXIII/LXXIV (1966/7), 31 and plate 5, figure 2). The somewhat older bronze torso in New York (E. Homann-Wedeking, *Athenische Mitteilungen*, LX/LXI (1935/6), 201, plates 77-9; Riis, 29, note 8) seems a related work made, possibly, in a south Etruscan or early Roman foundry.

8. See list in E. Richardson, 'The Etruscan Origins of Early Roman Sculpture', *M.A.A.R.*, XXI (1953), 82-9.

9. Cf. p. 247; also below, Note 13.

309. 10. No. 1956.43: G. M. A. Hanfmann, 'An Etruscan Goddess', *Archaeology*, IX (1956), 230-2; D. Mitten and S. Doeringer, *Master Bronzes from the Classical World* (Cambridge, Mass., 1967), 169, no. 168; Teitz, 71, no. 63, illustrated on p. 155.

310. 11. Walters Art Gallery no. 54.99: Mitten and Doeringer, *op. cit.*, 171, no. 171; Teitz, 78-9, no. 69, illustrated on p. 170.

12. Staatliche Museen, Antikenabteilung, Fr. 2159: Mitten and Doeringer, *op. cit.*, 163, no. 160, with bibliography.

311. 13. E. Richardson, 'The Recurrent Geometric in the Sculpture of Central Italy', *M.A.A.R.*, XXVII (1962), 197-8; G. Mansuelli, *Etruria and Early Rome* (London, 1966), 89. G. Colonna, *Bronzi votivi umbro-sabellici a figura umana*, I, Periodo 'arcaico' (Florence, 1970), contains a comprehensive catalogue of these figures.

14. Mansuelli, *op. cit.*; Richardson, *op. cit.* (Note 13), 197 and note 203.

15. Kansas City, Nelson Gallery-Atkins Museum 30-12: Teitz, 63-4, no. 51, illustrated on p. 154. The mirror handle, London, British Museum Br. 553, seems about contemporary: E. Langlotz and M. Hirmer, *L'arte della Magna Grecia* (Rome, 1968), plate 90.

16. Museo Archeologico no. 586: Giglioli, plate 221, figure 2; Santangelo, 45-6; Richardson, *op. cit.*, figures 103-4.

312. 17. Richardson, *op. cit.*, 196.

313. 18. Above, pp. 207, 291; Giglioli, plate 221-2.

314. 19. Illustrations 231, 232, spear-thrower, London, British Museum Br. 444: Richardson, *op. cit.*,

197, figures 110-11; Colonna, *op. cit.*, 76-7, no. 175, plate 50. Illustration 233, spear-thrower, Perugia, Museo Archeologico: Giglioli, plate 222, figure 1; Colonna, *op. cit.*, 81, no. 187, plates 57-9.

315. 20. Institute of Arts 37.134: Teitz, 72-3, no. 61, illustrated on p. 168.

21. Museum no. 50-62: Teitz, 78, no. 68, illustrated on p. 172.

316. 22. Mansuelli, *op. cit.*, 136 and plate 40.

317. 23. Museo Gregoriano Etrusco no. 13886: T. Dohrn, 'Statue eines jugendlichen Kriegers (Mars von Todi)', Helbig, *Führer*, I, 551-2, no. 736; F. Roncalli, *Il 'Marte' di Todi* (Città del Vaticano, 1973). Early fourth century.

318. 24. Detroit Institute of Arts 46.260: Teitz, 76, no. 65, illustrated on p. 162; Richardson, *op. cit.* (Note 8), 115-16. For the *toga sine tunica*, see Pliny, *N.H.* 34.23 (equestrian statue of Camillus). Apparently this was the costume of the early nobility, including royalty: Pliny, *loc. cit.*; Livy, 1.8.3.

25. O. Vessberg, *Studien zur Kunstgeschichte der römischen Republik* (Lund, 1941), 21-3, 93.

26. E.g. the terracotta statue, M. Santangelo, 'Veio, Santuario "di Apollo"', *Bollettino d'Arte*, XXXVII (1952), 154, figure 16, which sports a Greek himation in lieu of the rounded toga. The shorter mantle, similarly draped, of the Malibu Jupiter [174] may be called a toga.

27. Orvieto, Museo dell'Opera del Duomo, from Via San Leonardo: Andrén, I, 160, 164-5, 11, plate 59; Riis, 100; Santangelo, 56-7. Cf. the fourth-century bronze Jupiter in Baltimore, Walters Art Gallery 54.975 (Teitz, 79-80, no. 70, illustrated on p. 171) for the hair-do. A much-copied type of herm in Phidian style reflects a related Greek model (W. Fuchs in Helbig, *Führer*, I, 781-2, no. 1079) while the large female head from the same temple as our illustration 239 (Andrén, plate 60), which is less grecizing, compares well with Etruscan works of the period, e.g. the urn from Chianciano, our illustration 242. These circumstances rather argue against the date in the first century B.C. suggested by Banti, 166.

319. 28. Lo Scasato area: T. Dohrn in Helbig, *Führer*, III, 721-2, no. 2813; Santangelo, 106.

29. No. 40777: Dohrn, *op. cit.*, 536-7, no. 2567; Santangelo, 99. 'Idolino': P. E. Arias, *Policleto* (Florence, 1964), plates 19 and 23, figure 91.

321. 30. Museo Archeologico no. 73694: Riis, 116, no. 12; Giglioli, plate 231; colour plate, G. Becatti, *L'età classica* (Florence, 1965), 159. While after *c.* 450 all seated figures in this category are women, the Archaic list included seated men as well: Riis, 115, nos. 2-4; Mansuelli, *op. cit.*, 131 and plate 37.

31. Museo Archeologico no. 73577: Giglioli, plate 234, figure 3; Riis, 117, no. 21; Mansuelli, *op. cit.*, 131-2, plate 36. Volterran alabaster, polychrome.

Illustration 244, Florence, Museo Archeologico: Giglioli, plate 235; Riis, 116, no. 14. Vanth: R. Herbig, *Götter und Dämonen der Etrusker* (Mainz, 1965), 22-3. For the facial expression cf. the somewhat earlier archaistic bronze in London, British Museum, S. Haynes, *Antike Kunst*, IX (1966), 103-4, plates 24 figure 5, 25 figures 3-5.

323. 32. A. J. Vostchinina, 'Statua cineraria in bronzo di arte etrusca nelle collezioni dell'Ermitage', *S. Etr.*, XXXIII (1965), 317-28. It is likely that this surprising work was cast locally, by an artist with southern Etruscan – perhaps Faliscan – tendencies, about 400. The facial profile seems a descendant of the Veii Apollo; other details, and the romantic mood of the whole, carry Tarentine reminiscences. On either count this statue differs from the formal classicism of the Mars from Todi. Closer to the latter is the bronze head in London (S. Haynes, *S. Etr.*, XXXIII (1965), 523-5); but notice the cast eyes with incised iris and pupil, in the domestic tradition.

33. The eastern Greek type of reclining man and seated woman on a *kline* reached Italy through Tarentum: A. Levi, *Le terrecotte figurate del Museo Nazionale di Napoli* (Florence, 1926), xxii-xxiii, 24-30. Heads with tufts of hair or curls covering the temples are frequent in this group: *ibid.*, 36-8, nos. 141-7, figures 38-9.

34. Illustration 243: above, Note 31. Catullus, 39.11 coined the label *obesus etruscus*.

35. Herbig, 15-16 nos. 7-9, and 46-7 no. 83. All four came from the same tomb ('Tomba dei Sarcofagi'). For no. 83 see below, Note 39; nos. 7-9 have been transferred to the new Museo Archeologico at Cerveteri, but are not yet adequately published; see Herbig for descriptions. For no. 9, which follows a Greek architectural type, probably the latest of the four, cf. G. Hafner, *Archäologischer Anzeiger*, LIV (1939), cols. 449-74.

324. 36. E. Panofsky, *Tomb Sculpture* (New York, n.d.), 26-7, 54.

37. W. von Bissing, *S. Etr.*, VII (1933), 123-32; Herbig, 106 (Type III), 109-10; E. Colozier, 'Les Étrusques et Carthage', *École française de Rome, Mélanges d'archéologie et d'histoire*, LXV (1953), 79-86. Chief characteristics of the Punic type are its material, marble; figures represented as upright statues, though seen horizontally; and their awkward position upon the ridge of the lid. Three specimens are known from Carthage; one was found at Tarquinia (Herbig, 63, no. 121). There is little doubt that the last named was an import from Carthage. It is the finest of the four, and also seems the earliest, dating from *c.* 330.

38. E. Kukahn, *Anthropoide Sarkophage in Beyrouth* (Berlin, 1955), 28-31.

39. The available data allow the following conclusions.

1. All ancient sarcophagi that place a human figure horizontally upon a domatomorphic lid are genetically related.

2. Examples occur in Etruria and Carthage but not in Greece.

3. The manner of adjusting the roof form to the figure varies, as does the interpretation of the latter as either standing (Carthage) or reclining (Etruria).

4. The four Caeretan sarcophagi (above, Note 35), three of which show a supine figure inserted between the two gables of a roof, demonstrate the emergence of the type in Etruria about the third quarter of the fifth century.

5. The related Punic sarcophagi of the late fourth and early third centuries appear to be a sub-group with special characteristics; their rendering of garments and faces shows close Greek connections. Thus far, the chronological advantage seems to lie with Etruria (Caere).

40. Museo Gregoriano Etrusco no. 421: Herbig, 46-7, no. 83, plates 1 and 2; T. Dohrn in Helbig, *Führer*, I, 474-5, no. 612.

325. 41. Royal Ontario Museum; formerly Coll. L. Curtius. Unpublished. Marble or hard limestone. The much discussed head in Palestrina (Vessberg, *op. cit.* (Note 25), 176, and plate 21, figures 1 and 2) may be a late - and provincial - outcome of this rare Etruscan portrait style in stone.

42. This is the only one of the four Caeretan stone sarcophagi whose sides have been so decorated. The reliefs occupy one long and one short wall; their lack of surface modelling recalls the cast bronze reliefs discussed in Chapter 23, pp. 287-90. The representational grammar includes archaic reminiscences such as the abrupt turn backward combined with forward-moving feet; cf. the painted frieze in the Tomb of the Monkey, R. Bianchi Bandinelli, *Clusium*, fasc. 1, *Le pitture delle tombe arcaiche* (Rome, 1939), plate 111, top (p. 279). At the same time, the artist distinguishes between stance - flat-footed - and step with raised heel in the Classical manner. He was also familiar with the crossed step which became popular in Etruscan art in the late fifth century: T. Dohrn, *Grundzüge etruskischer Kunst* (Baden-Baden, 1958), 25-8. Evidently the ineptitude of many details was due not so much to archaism as to the sculptor's insufficient preparation for work in stone. Note the rigid stylization in the head of the deceased man if compared, for instance, to the head of the Detroit rider [238] - a near contemporary, by all odds. Likely date: last quarter of the fifth century.

CHAPTER 25

327. 1. Almost all references to lost Etruscan bronzes are records of military conquest, without descriptive

details: capture of Veii in 396, O. Vessberg, *Studien zur Kunstgeschichte der römischen Republik* (Lund, 1941), 17, nos. 43-6. Statue of Jupiter Imperator from Praeneste, transferred to Rome in 338, *ibid.*, no. 47. For the two thousand statues which the Romans took from Volsinii in 264, see Chapter 23, Note 18. Pliny, *N.H.* 34.34, calls them *signa* - human images rather than deities; the name can include ex votos in sanctuaries and honorary statues in public places, or even statuettes: Vessberg, *op. cit.*, 21, no. 58, and p. 95.

2. See Pliny, *N.H.* 34.43, on the colossal statue of Apollo in the library of Augustus, which was praised for *pulchritudo* (shape and finish) as well as size. Described as Tuscan, it was probably a Classical, not an Archaic work. See Vessberg, *op. cit.*, 23, no. 69; A. Andrén, *Antike Plastik*, VII (1967), 8, note 6.

3. Museo Archeologico inv. no. 1. Found at Arezzo, outside the Porta S. Lorenzo, in 1553. For restorations, partly by Benvenuto Cellini, see Notes 5 and 6; also Giglioli, plates 228 and 229, figure 1; Banti, plate 85B and pp. 333-4.

4. G. M. A. Richter, 'Greeks in Etruria', *Annuario della Scuola Archeologica di Atene*, XXIV/XXVI (1946/8), 79-83.

5. W. Amelung, *Führer durch die Antiken in Florenz* (Munich, 1897), no. 247, pp. 253-5.

6. W. L. Brown, *The Etruscan Lion* (Oxford, 1960), 155-7, plate 57a. Stylistic parallels recommend a date in the second quarter of the fourth century for the Chimaera.

7. The Etruscan inscription on the right foreleg is a dedication to Tinia (Jupiter); the Chimaera was religious property.

328. 8. Illustration 249, Hercules, bronze statuette, Paris, Bibliothèque Nationale no. 536.

9. British Museum Br. 1249.

10. Giglioli, plate 261, figure 3; M. Renard in *Studies presented to D. M. Robinson*, I (St Louis, 1951), 753, plate 92c.

330. 11. For the elongated statuettes of this type see O. Terrosi-Zanco, *S. Etr.*, XXIX (1961), 423-59; G. Colonna, *Bronzi votivi umbro-sabellici a figura umana*, I, *Periodo 'arcaico'* (Florence, 1970), 108-14, nos. 330-40. They were called *ipsilles* or *subsilles* in Latin. For the connection between the Classical, modelled specimens and the flat, Archaic examples, *ibid.*, 113, no. 343, note 78.

Illustration 252, haruspex, Rome, Villa Giulia: Santangelo, 132.

12. Illustration 253, Diana (rather than Aphrodite?), Paris, Louvre Br. 321, from the sanctuary of Diana at Nemi: D. Mitten and S. Doeringer, *Master Bronzes from the Classical World* (Cambridge, 1967), 182, no. 186.

13. Cf. the wooden effigies from Rocca San Felice,

sanctuary of the goddess Mofeta, Avellino, Museo Provinciale Irpino: R. Bianchi Bandinelli and A. Giuliano, *Etruschi ed Italici prima del dominio di Roma* (Milan, 1973), 113-14, figure 134.

331. 14. Andrén, I, 171-6, 11, plates 64-7; E. Richardson in *Cosa* 11, *The Temples of the Arx, M.A.A.R.*, XXVI (1960), 305-6. For a connection between the style of these terracottas and the Mars of Todi, see F. Roncalli, *Il 'Marte' di Todi* (Città del Vaticano, 1973), 103-8, plate 14, figures 1 and 2.

15. Above, Chapter 23, Note 31. Candelabra, fourth century and later: T. Dohrn, *R.M.*, LXVI (1959), 48; E. Pernice, *Gefässe und Geräte aus Bronze. Die Hellenistische Kunst in Pompeii*, IV (Berlin and Leipzig, 1925), 43-57.

332. 16. Illustration 254, bronze statuette, citharist rather than Apollo (finial, middle fourth century), Paris, Bibliothèque Nationale no. 100: E. Richardson, *M.A.A.R.*, XXI (1953), 92, figure 6.

17. Soldier and rearing horse: Giglioli, plate 307, figures 1 and 3. Youth and rearing horse [255], Florence, Museo Archeologico: *ibid.*, plate 306, figure 4; replica in Basel, Antikensammlung, W. Zschietzschmann, *Etruskische Kunst* (Frankfurt am Main, 1969), plate 141. The designation 'Alexander and Bucephalus' is unfounded; G. Bendinelli, *S. Etr.*, XVIII (1944), 29-43, plates 5-7.

333. 18. Illustration 256, censer base (triskelion) from Vulci, Vatican, Museo Gregoriano Etrusco no. 12654: Giglioli, plate 311, figure 5.

334. 19. Illustration 257, discobolus, statuette on a censer base, Rome, Villa Giulia inv. 1720: T. Dohrn, in Helbig, *Führer*, 111, 625, no. 2682; Giglioli, plate 311, figure 3.

20. Examples in Giglioli, plate 311; S. Haynes in *Art and Technology* (Cambridge, Mass., 1970), 182-4, figures 8-10a; Teitz, 96-7, no. 88, illustrated on p. 196. Chronology: G. Becatti, *S. Etr.*, IX (1935), 299-303, and plate 38, nos. 1 and 3; probably last quarter of the fourth century.

21. Birds around a cup or water basin: K. Parlasca, *J.D.A.I.*, LXXVIII (1963), 256-93; Haynes, *op. cit.*, 184.

22. Illustration 258, censer, Rome, Villa Giulia: M. Moretti, *Il Museo Nazionale di Villa Giulia* (Rome, 1964), 327-9, figure 215; T. Dohrn in Helbig, *Führer*, III, 855, no. 2984; Giglioli, plate 310, figure 1. Winged caryatids, early Etruscan: Chapter 6, pp. 79-80, and R. Herbig, *Götter und Dämonen der Etrusker* (Mainz, 1965), 13, plate 16, figure 1. The satyr seems to rub or crush something, using two stones(?) as pestles; preparing incense for the coal fire on top?

23. On the whole, the decor of the cistae, including the frequent mythical narratives, agrees with their assumed function as feminine articles; cf. p. 365. A seeming inconsistency is the handles with warriors

lamenting a dead comrade – a military subject; but see p. 335 and Notes 26 and 27 for their mythical connotations.

335. 24. Praenestine cistae: Moretti, *op. cit.*, 282–7; Giglioli, plates 283–95. Their home was Praeneste: occasional finds abroad, such as the handle from Vulci, Santangelo, 90, must be considered exports. See also below, p. 373 (cast reliefs), pp. 353–9 (engraved decorations).

25. Illustration 259, bronze cista handle from Palestrina, two soldiers carrying a dead comrade, Rome, Villa Giulia no. 25210: Giglioli, plate 282, figure 1.

26. H. Jucker in K. Schefold, *Die Griechen und ihre Nachbarn* (Propyläen Kunstgeschichte, 1) (Berlin, 1966), 325, no. 417.

27. Santangelo, 129; Teitz, 86–7, no. 77, illustrated on p. 180, among others. Sometimes the dead person is a woman; Moretti, *op. cit.*, 290, figure 196; T. Dohrn in Helbig, *Führer*, 111, 824, no. 2954.

28. The handle of the Ficoroni cista (Bacchus between two satyrs) gives a clear example; Giglioli, plate 286, figure 1. Nude maenads: T. Dohrn in Helbig, *Führer*, 111, 626, no. 2688. Antecedents in Apulian vase painting: O. Brendel, *J.D.A.I.*, LXXXI (1966), 238, note 56.

336. 29. Illustration 260, bronze statuette, 'Phrixus', from the handle of a fire shovel from Palestrina, London, British Museum Br. 1227: S. Haynes, *Etruscan Bronze Utensils* (London, 1965), 25–6, plate 14.

CHAPTER 26

337. 1. Banti, 112; additional material, M. Moretti, *Nuovi monumenti della pittura etrusca* (Milan, 1966).

2. Tomb of Orcus: Pallottino, 99–102, 111–14; A. Rumpf, *Malerei und Zeichnung* (Munich, 1953), 122, 129.

3. Santangelo, 160; R. Herbig, *Götter und Dämonen der Etrusker*, 2nd ed. (Mainz, 1965), 20–2, plate 36.

338. 4. This seems the opinion of the majority; but see also Beazley, 8–9.

5. Already Polygnotus' 'Nekyia' included a similar demon, Eurynomos: Pausanias, 10.28.1. The hellish female spirits have parallels in Apulian vase paintings; O. Brendel, *J.D.A.I.*, LXXXI (1966), 232–4, figure 18 on p. 235.

339. 6. Santangelo, plate 162. The spiked pattern hemming the himation with which Teiresias veils his head (H. Leisinger, *Malerei der Etrusker* (Stuttgart, 1954), plate 93) recurs in another, approximately contemporary Etruscan Hades scene: calyx krater, Paris, Cabinet des Médailles no. 920 (Beazley, plate 21, figure 2).

7. Pallottino, 97–8. A wall along the longitudinal axis divided the rear half of the tomb into two compartments: the masters dine on the right, the servants are on the left. See Banti, 167–8, plate 61, and bibliography on p. 354.

341. 8. The 'Boy Blowing on a Fire' by Antiphilos (Pliny, *N.H.* 35.138) perhaps formed part of a kitchen scene. For the pose of illustration 264 see G. Lippold, *Antike Gemäldekopien* (Munich, 1951), 143 and note 2, plate 21, figures 116, 119.

9. Pallottino, 105–10.

10. Chapter 19, p. 231. Egg offered by a banqueter, Tomb of the Lionesses: Chapter 16, p. 185 and illustration 121.

11. G. Mansuelli, *Etruria and Early Rome* (London, 1966), 182–4, and others.

12. The hairstyle and jewellery worn by the wife of Larth Velcha (Pallottino, 107) match those of the Alkestis on the skyphos in Boston [271], which Beazley thought late Faliscan: below, Note 30.

13. Florence, Museo Archeologico: Herbig, 26–7, no. 27; Pallottino, 93–6. The lid may have been added later; it is inscribed with the same name which was scratched on the painted wall. For marble sarcophagi of comparable shape from Sicily, see G. Hafner, *Archäologischer Anzeiger*, LIV (1939), col. 463, nos. 11–13.

343. 14. Pallottino, 93; L. Curtius, *Die Wandmalerei Pompejis* (Leipzig, 1929), 302, figure 99 on p. 153.

15. Beazley, 3, 25–7. The Rodin cup is inscribed Avles Vpinas: a personal name, cf. below, Chapter 31.

344. 16. Vatican, G.112. Beazley, 55–6, and plate 12; T. Dohrn in Helbig, *Führer*, I, 559–60, no. 745.

17. Cabinet des Médailles no. 1066. Beazley, 6, 54–5, plate 10, figure 3; T. Dohrn, *R.M.*, LXXIII/LXXIV (1966/7), 22, plate 3, figure 2.

18. Beazley, 80–96.

19. No. 1799a (P. Zanker in Helbig, *Führer*, 111, 690–2, no. 2776). Birds, a by-play in the air: red-figure neck amphora (Pelops and Hippodameia), Arezzo, Museo Civico (P. E. Arias and M. Hirmer, *A History of Greek Vase Painting* (London, 1961), plate 212).

346. 20. No. 1794i: Zanker, *op. cit.*, 698–9, no. 2787.

347. 21. See Beazley, 8–10 and 133–80.

22. *Ibid.*, 63–7.

348. 23. *Ibid.*, 25.

24. Museo Archeologico no. 4026. Beazley, 33–5, plate 9, figure 1; *ibid.*, *J.H.S.*, LXIX (1949), 2 and note 7. The subject is uncertain and the title 'Argonauts' unfounded; dependence on a larger painting remains likely, however.

25. Beazley, 52–6.

26. Admetos–Alkestis: Beazley, plates 30 figure 1 and 37 figure 1; cf. below, Note 30, for the latter painting. Achilles and Trojan prisoner: *ibid.*, plate 31, figure 1.

27. All replicas in Rome, Villa Giulia: Zanker, *op. cit.*, 686–7, no. 2770. Two are inscribed in Faliscan dialect; the modern name of the painter refers to these inscriptions, 'foied vino pipafo cra carefo' (Beazley, 106–7). The same schema was also known in the engraving studios, as shown by the Berlin mirror which renders young Dionysos re-united with his mother, 'Semla' (Beazley, *op. cit.* (1949) (Note 24), 6, figure 7 and plate 6a). See also below, p. 362 [281].

28. Beazley, 152, plate 35, figure 6.

29. Faliscan *stamnos*, Bonn: Beazley, 7–8 and plate 24, figures 1 and 2.

30. Museum of Fine Arts 97.372: Beazley, 166–7 and plate 37, figure 1.

349. 31. *Ibid.*, 113–15.

32. Hands of dancers: *idem, ibid.*, 114, comments on the cup, Boston Museum of Fine Arts 01.8123. 'Crossed step': above, Chapter 24, Note 42. 'Eccentric stance': Chapter 24, pp. 315–17.

33. Museo Archeologico 79240: Beazley, 115. Parrhasios' 'Curtain' (Pliny, *N.H.* 35.64) might have been so painted.

351. 34. Louvre H100: Beazley, 119, no. 5. Lasa: Herbig, *op. cit.* (Note 3), 25–8; R. Enking, *R.M.*, LVII (1942), 1–15.

35. Duck askoi: Beazley, 110–20. Waterfowl or birds that appear to be waterfowl – geese, swans, etc. – are commonly associated with the realm of Turan in Etruscan art; so is Lasa. See the following chapter, pp. 364, 367.

36. Volterra: Beazley, 123–32.

CHAPTER 27

353. 1. There is little bibliography on the Praenestine cistae as a class: cf. Chapter 25, Notes 23–4.

2. Inv. no. 1768a: T. Dohrn in Helbig, *Führer*, III, 822–5, no. 2954; Giglioli, plates 291 figure 2, 292 figure 1.

354. 3. Inv. no. 1752: Dohrn, *op. cit.*, 840–8, no. 2976; *idem, Die ficoronische Ciste in der Villa Giulia in Rom* (Berlin, 1972). The hairy, winged bystander is probably the demon Sosthenes, who, like Boreas, was associated with the Bosporus region: Dohrn, in Helbig, *Führer*, III, 843. He descends to foretell the defeat of Amykos, and is therefore represented as a seer; cf. 'Calchas' on the Vatican mirror, below [280]. About the 'reading' order of the frieze see Dohrn, *loc. cit.*, and G. Mansuelli, *S. Etr.*, XXI (1950/1), 401–6.

355. 4. Pliny, *N.H.* 35.130, lists Kydias as coeval with Euphranor. The tradition that he came from Kythnos, off the Attic coast, rests on dubious grounds: G. Lippold, 'Kydias (3)', in Pauly-Wissowa, *Real-*

Encyclopädie, XI, 2, col. 2303. The 'Argonauts' is his only recorded painting. Connections with the Ficoroni cista: A. Rumpf, *Malerei und Zeichnung* (Munich, 1953), 129; J. D. Beazley, *Etruscan Vase Painting*, 34–5, and *J.H.S.*, LXIX (1949), 2, note 7; Mansuelli, *op. cit.*, 401–2; L. Guerrini, *Enciclopedia dell'Arte Antica*, III, 647–8, 'Ficoroni', with colour plate.

5. Beazley, 58–9, plate 14, figure 1; T. P. Howe, *A.J.A.*, LXI (1957), 341–50 and plate 102; Dohrn, *Die ficoronische Ciste*, 29–30, plate 31.

6. Beazley, *loc. cit.*; T. Dohrn in Helbig, *Führer*, III, 845.

7. Hortensius: Pliny, *N.H.* 35.130. Porticus Argo-nautorum dedicated in 26 B.C. by Agrippa: Dio Cassius, 53.27; E. Nash, *Pictorial Dictionary of Ancient Rome*, II (New York, 1962), 291–3, s.v. Saepta Julia.

8. Artist's signature: 'Novios, Plautios, med. Romai. fecid.' Owner's dedication: 'Dindia. Macolnia. fileai, dedit.' Both inscriptions require explanation. Praenestine cistae were not usually signed by their makers, nor by their donors. Neither was it customary for artists to mention their domicile in a signature, though citizenship is often named. The designer of the Ficoroni cista, perhaps of Campanian background, was a freedman of the Plautii. Evidently his status resembled that of M. Plautius, an Asian Greek who painted murals in the temple of Juno Regina at Ardea where he held citizenship (Pliny, *N.H.* 35.115); see Note 21. Dindia Macolnia, who ordered the Ficoroni cista for her daughter, belonged to the Etruscan aristocracy of Praeneste. It follows that Novios delivered a remarkably decorated cista of Praenestine type to a Praenestine customer but wished to make it known that he executed it in Rome. This set of data would seem less paradoxical if he offered a first-hand copy of a large mural then on view in Rome.

9. The boxing gloves of the contestants date the frieze, and probably its model as well, after 336/335; Beazley, *op. cit.* (1949) (Note 4), 2.

359. 10. H. Jucker in K. Schefold, *Die Griechen und ihre Nachbarn* (Propyläen Kunstgeschichte, I) (Berlin, 1966), figure 419 and pp. 325–6.

11. E. Gerhard, *Etruskische Spiegel* (Berlin, 1840–97), supplements by K. Klügmann and H. Körte, vols. I–V; Beazley, *op. cit.* (1949) (Note 4), 1–17; G. Mansuelli, 'Gli specchi figurati etruschi', *S. Etr.*, XIX (1946), 9–137; XX (1948/9), 59–98; R. Herbig, 'Die Kranzspiegelgruppe', *S. Etr.*, XXIV (1955/6), 183–205; D. Rebuffat-Emmanuel, *Le Miroir étrusque d'après la collection du Cabinet des Médailles* (Collection de l'école française de Rome, XX), 2 vols. (Rome, 1973).

12. Beazley, *op. cit.* (1949), defines the time from the end of the fifth to nearly the end of the fourth century

as the classic period of the Etruscan mirrors; he further distinguishes between an 'early classic' and a 'late classic' stage. About the relatively scarce output of the mid fifth century, here called Proto-Classical, cf. p. 286. Beazley's terminal date for all Etruscan mirrors, end of the third century (*op. cit.*, 17), may prove too high.

360. 13. G. Matthies, *Die Praenestinischen Spiegel* (Strasbourg, 1912); M. A. Del Chiaro, 'An Etruscan Bronze Mirror produced at Caere', *A.J.A.*, LXXV (1971), 85-6, plate 20, figure 1.

14. Metropolitan Museum of Art, inv. G.R.131: G. M. A. Richter, *Greek, Etruscan and Roman Bronzes* (New York, 1915), 273-4, no. 797; L. Ghali-Kahil, *Les Enlèvements et le retour d'Hélène* (Paris, 1955), 265, no. 210, and plate 90, figure 2. Beazley, *op. cit.*, 6, figure 4 and plate 5a, refers to Iliad VI for a different reading.

15. Vatican, Museo Gregoriano Etrusco inv. no. 642: Giglioli, plate 298, figure 1; T. Dohrn in Helbig, *Führer*, I, 542, no. 724; R. Herbig, *Götter und Dämonen der Etrusker* (Mainz, 1965), 5, 38, plate 5.

362. 16. Beazley, *op. cit.*, 6, figure 7 and plate 6a; Herbig, *op. cit.*, 6, 36, figure 2. A weak replica in Kansas City, Teitz, 88-9, no. 78, illustrated on p. 182.

364. 17. Beazley, *op. cit.*, 11-12, figure 13; Herbig, *op. cit.*, 25-7, 37, and figure 9.

365. 18. London, British Museum, Br. 626: Beazley, *op. cit.*, 9-10, figure 9 and plate 8b.

19. London, British Museum, from Palestrina: Beazley, *op. cit.*, 13, and figure 17.

20. See below, pp. 415-17.

21. Pliny, *N.H.* 35.17, probably overrated the age of the murals in Lanuvium which represented Helen and Atalanta nude, side by side; though he may have been right in likening them to the murals at Ardea (M. Plautius', above, Note 8). The iconography which he describes is Etruscan Late Classical, at the earliest; more likely, Etruscan-Hellenistic.

22. Museo Archeologico inv. no. 80933, from Perugia (Tomba Sperandio): Beazley, *op. cit.*, 12 and plate 9; Ducati, 11, plate 248, reproduces the tomb group.

367. 23. Pliny, *N.H.* 35.60, ascribes the invention of shading to Apollodorus (late fifth century); but the shading of nude parts in female figures seems to have been an innovation of the advanced fourth century: A. Rumpf, *J.H.S.*, LXVII (1947), 10-21, plates 1-5; *idem*, *J.D.A.I.*, XLIX (1934), 6-23 (Nikias, Pliny, *N.H.* 35.130).

24. From Perugia: Beazley, *op. cit.*, 12-13 and figure 15. Replica in a Roman collection, *ibid.*, 13, note 57. Jucker, *op. cit.* (Note 10), figure 420 and p. 326.

25. Lasa and Fortuna Primigenia: Herbig, *op. cit.*, 25-7 and 38, bibliography to plate 7. The identification is contested: M. Pallottino, *Etruscologia*, 6th ed.

(Milan, 1968), 241, note 2. Horace, *Odes* I, xxxiv, 14, thought Fortuna winged; conventional Roman iconography pictures her wingless.

26. Beazley, *op. cit.*, 12.

27. *Ibid.*, 14 and figure 19; A. B. Cook, *Zeus*, III (Cambridge, 1940), 89-94, figure 33; P. C. Sestieri, *S. Etr.*, XIII (1939), 251-6.

368. 28. Hera and sileni: above, Chapter 18, pp. 219-21, Note 20, and illustrations 146 and 147; O. Brendel, *J.D.A.I.*, LXXXI (1966), 225-6 and note 32. Milk versus wine: *ibid.*, 254 and note 92.

369. 29. Bibliothèque Nationale, Cabinet des Médailles, inv. no. 1287, from Vulci: Giglioli, plate 296, figure 4; Herbig, *op. cit.* (Note 15), 6-9, figure 3 and plate 6, bibliography p. 38; Ghali-Kahil, *op. cit.*, 269-70, no. 224 and plate 94, figure 2; Rebuffat-Emmanuel, *op. cit.*, no. 1287, pp. 51-64, 521-6, plates 5 and 71.

370. 30. Brendel, *op. cit.*, 234, note 49.

31. D. Earl, *The Age of Augustus* (New York, 1968), figure 81.

32. A. Alföldi, *Die trojanischen Urahnen der Römer* (Basel, 1957); G. Highet, *The Classical Tradition* (New York, 1949), 54. Trojan founders of Italian cities in medieval legend: H. Buchthal, *Historia Troiana* (London, 1971), 2-7.

33. Vergil, *Aeneid* XII, 829-42.

34. Berlin-Charlottenburg, Staatliche Museen, Antikenabteilung, inv. no. 30480: L. Curtius, *Archäologischer Anzeiger*, LXIII/LXIV (1948/9), cols. 57-64. The engraved mirror, *ibid.*, figure 4 and col. 59, note 1, is a later replica: the lock of hair before the ear of Talos compares with the ship's boy of the Ficoroni cista and other profile heads of young men from the second half of the fourth century onward.

35. Castor and Pollux, Curtius, *op. cit.*, figure 5. This designer added a pensive Minerva, and Turan reaching out for the knee of Talos: is she groping for the vulnerable vein? In other versions Medea fells Talos for the love of Jason: Apollodorus, I 140 f.

373. 36. The mask is still unexplained. It may carry chthonic connotations: P. Ducati, 'Le pietre funerarie felsinee', *Monumenti Antichi*, XX (1912), 653-5.

37. Giglioli, plate 290, figure 2. Only two of the three feet are ancient: Dohrn, *Die ficoronische Ciste*, 10-11, plates 26 and 29.

38. Dohrn, *op. cit.*, 26; cf. the relief mirror representing Herakles and Iolaos(?) with Athena in the centre, Paris, Bibliothèque Nationale, inv. no. 1288 (Giglioli, plate 226, figure 1), probably second quarter of the fourth century.

39. 'Boston Throne', Hans von Steuben in Helbig, *Führer*, III, 262-3; B. Ashmole and W. J. Young, *Boston Museum of Fine Arts Bulletin*, LXVI (1968), 124-66, with bibliography; for the volutes see especially figures 1-3.

40. South Italian hand mirrors: E. Langlotz and M. Hirmer, *L'arte della Magna Grecia* (Rome, 1968), plates 89, 126, 127, and bibliographies on pp. 283-4, 296-7. Feet of Praenestine cistae: Giglioli, plates 290-3. Tarentine connections: feet of the Chrysippos cista [274] (pp. 353-4); Lasa(?) kneeling on an Ionic capital, Giglioli, plate 290, figure 6; T. Dohrn in Helbig, *Führer*, III, 822.

41. An exception is the pediments of funerary *naiskoi*, which are architectural. This matter is of some importance because Etruria has not so far yielded indisputable pedimental decoration after the Greek fashion antedating the fourth century. Unlike the Tarentine funerary *naiskoi*, which can be traced to the early third century (J. C. Carter, *A.J.A.*, LXXIV (1970), 125-37), the Etruscan are make-believe architectures, and their pediments imitations in low relief. But they testify to the growing popularity of Greek pedimental composition in fourth-century and Hellenistic Etruria. Examples: A. De Agostino, *Populonia, la città e la necropoli* (Rome, 1965), figure 13; M. Moretti, *Il Museo Nazionale di Villa Giulia* (Rome, 1964), 25, figure 13 (Early Hellenistic, from Vulci); *ibid.*, 45, figure 34 (Late Hellenistic terracotta model); façades of rock-cut tombs at Norchia and Sovana (Early Hellenistic to second century), G. Rosi, *Journal of Roman Studies*, XV (1925), 42-5.

374. 42. Ducati, *op. cit.* (Note 36), cols. 454-60; chronological summary, cols. 461-5.

43. *Ibid.*, col. 373, no. 12, figure 52 front. The back, which is also unusual, shows various myths (Scylla, Circe) and demons in six small squares; in the last square, a nereid.

375. 44. Illustration 289: Ducati, *op. cit.*, col. 453, no. 188, and figure 45. Cf. also col. 423, no. 130, and plate 3. See also Herbig, *op. cit.* (Note 15), 30 and plate 48, figure 2. S. Haynes, 'Etruscan Bronzes in the British Museum', *Art and Technology* (Cambridge, Mass., 1970), 182-4, figures 8-9, 10a. Two splendid specimens support the handle of a recently discovered bronze krater from Tuscania (Tomb I of the Curunas family): M. Moretti, *Nuovi tesori dell'antica Tuscia*, exhibition catalogue (Viterbo, 1970), 65-6, no. 44, plate 24.

45. Ducati, *op. cit.*, cols. 377, 651, no. 17, figure 66, and cols. 653-5.

46. *Ibid.*, cols. 457-8, no. 195, cols. 531-2, figure 24; Giglioli, plate 237, figure 3; detail: M. Moretti, G. Maetzke, M. Gasser, L. von Matt, *Kunst und Land der Etrusker* (Zürich and Würzburg, 1969), plate 178.

376. 47. Ducati, *op. cit.*, no. 168; plate 4 (front) and col. 615, figure 58 (back); M. Moretti, *et al.*, *op. cit.*, figures 177, 179.

377. 48. Ducati, *op. cit.*, cols. 541-5.

49. Ducati reached the same conclusion, *op. cit.*, cols. 680-2.

50. *Ibid.*, cols. 611-18.

CHAPTER 28

379. 1. Stone sarcophagi in general: R. Herbig, *Die jüngeretruskischen Steinsarkophage* (Die antiken Sarkophagreliefs, VII) (Berlin, 1952); Caeretan sarcophagi (Tomba dei Sarcofagi), *ibid.*, nos. 7-9, pp. 15-16, plates 3-4; no. 83, pp. 46-7, plates 1-2 (here illustration 246). Imitations of wooden chests, *ibid.*, 101-2, with parallels outside Etruria; below, p. 384 (this chapter) and illustration 296. Cf. F. N. Pryce, *Cypriote and Etruscan Sculpture* (London, British Museum, 1931), 184-8.

2. Herbig, 15-16. Greek sarcophagi: G. Hafner, *Archäologischer Anzeiger*, LIV (1939), cols. 449-74; G. Rodenwaldt, *R.M.*, LVIII (1943), 2-5. Also above, Chapter 24, p. 324 and Notes 36-9.

3. Sarcophagus from Bomarzo, London, British Museum D.20: Herbig, 35-6, no. 62 and plate 6. Crouching animals, guardians of the roof: above, p. 231. The semi-nude winged figure in the front relief, left corner, seems a Lasa rather than a Vanth. If, as it appears to me, she holds hammer and nail, she must represent Atropos; cf. above, p. 367.

4. Herbig, 101-4, discussion of 'chest type' (*Truhentypus*) and 'portico type' (*Hallentypus*). A speciality of the former is heraldic groups of animals attacking a quarry in the middle; e.g. the groups of griffin (with snake-tail) and lion devouring a doe on either long side of Copenhagen, Ny Carlsberg Glyptotek H.278 (Herbig, 32, no. 50, plate 11b); Pryce, *op. cit.*, 188, suggested a date about 250 for this relief.

5. Herbig, 108.

380. 6. Trojan prisoners: Herbig, nos. 63 plate 29, 73 plate 36 (for this sarcophagus see below, Note 7). Polyxena: *ibid.*, nos. 63 plate 29, 79 plate 34. Cassandra: *ibid.*, no. 63 plate 29. Iphigeneia: *ibid.*, no. 85 plate 32. Clytemnestra: *ibid.*, no. 79 plate 33. Niobids: *ibid.*, no. 80 plate 30a.

7. *Ibid.*, 105; cf. also Beazley, 8, apropos the sarcophagus of Torre San Severo. Recently M. Cagiano de Azevedo questioned the authenticity of this sarcophagus: its reliefs may have been carved into the ancient box by a modern hand (*R.M.*, LXXVII (1970), 10-18). There are indeed signs of modern interference, especially the garish paint. I do not consider the case closed; but this is not the place for detailed discussion. See also D. von Bothmer in *Papers of the Metropolitan Museum of Art*, XI (1961), 8.

8. E.g. on the sarcophagus in Boston (here illustration 294), Herbig, 14-15, no. 6, plates 37-8. Cf. this chapter, p. 382.

9. Herbig, 17, no. 12, and plate 47a. Marathon: Pausanias, 1.15.1.

10. Herbig, 43, no. 78, plate 43c; 17, no. 13, plate 50.

381. 11. *Ibid.*, 13-14, no. 5, plate 40a-d.

382. 12. The procession is the only demonstrably older theme; see this chapter, p. 379. Whether any preserved sarcophagus with mythological decoration antedates the year 350 is doubtful; the representations of non-mythical battles appear to be still later. All except the latest type of procession seem to have fallen into disuse after *c.* 200. See also Herbig, 105-8.

13. For the typological divisions see Note 4 above.

14. Ny Carlsberg Glyptotek H.273: Herbig, 31-2, no. 49, plates 41-2; *idem, Götter und Dämonen der Etrusker* (Mainz, 1965), 25-7 and plate 45, figure 2; T. Dohrn, *Grundzüge etruskischer Kunst* (Baden-Baden, 1958), 46.

384. 15. Necropolis Ponte Rotto: T. Dohrn in Helbig, *Führer*, III, 507-8, no. 2534; M. Moretti, G. Maetzke, M. Gasser, L. von Matt, *Kunst und Land der Etrusker* (Zürich and Würzburg, 1969), 94, 102-3. 'Cassone' seems preferable to 'trunk' (Herbig's *Truhe* or *Kasten*), in order to distinguish this type of box from the chests on four feet (see above, Note 4).

16. Herbig, *op. cit.*, 27 and note 40a. For female nudes in Late and post-Classical Etruscan art see p. 365.

17. Comparable dark clouds of irregular shape and with scalloped edges occur in Tarquinian painting, e.g. the Tomb of Orcus, above, p. 338, illustration 261.

385. 18. From the Tomb of the Chariots, above, pp. 266-9: Pryce, *op. cit.*, 188-91; Herbig, 36-7, no. 63, plate 29b.

386. 19. U. Hausmann, *Hellenistische Reliefbecher aus attischen und böotischen Werkstätten* (Stuttgart, 1959), 19-40. Early book illustration, *ibid.*, 42-5; also K. Weitzmann, *Illustrations in Roll and Codex* (Princeton, 1947), 47-77.

20. Herbig thought the sarcophagus at Chiusi (his no. 13, p. 17, plate 50) rendered the Celtic invasion of Delphi (*ibid.*, 105); above, Note 10.

CHAPTER 29

387. 1. Portraiture in general: E. Buschor, *Das Porträt, Bildniswege und Bildnisstufen in fünf Jahrtausenden* (Munich, 1960); R. Bianchi-Bandinelli, 'Ritratto', *Enciclopedia dell'Arte Antica*, VI, 695-738; J. D. Breckenridge, *Likeness, A Conceptual History of Ancient Portraiture* (Evanston, Ill., 1968).

2. Herbig, 110-11.

3. Few sarcophagi are dated by outside evidence; Herbig, 122-4. Coins found near or underneath a sarcophagus: *ibid.*, 122-3; M. Moretti, *Nuovi tesori*

dell'antica Tuscia, exhibition catalogue (Viterbo, 1970), 71.

4. Inv. no. 75268: Herbig, 22-3 and figures 2-6.

388. 5. *Ibid.*, 123-4.

6. *Ibid.*, 63, no. 121, plate 21a. See above, Chapter 24, Notes 37 and 39.

7. Herbig, 43-4, no. 79, plates 33-4; T. Dohrn in Helbig, *Führer*, I, 476-7, no. 617.

8. Ny Carlsberg Glyptotek H.278: Herbig, 32, no. 50, plates 11-12.

9. Staatliche Museen E.74: Herbig, 12, no. 4, plate 45a and b.

389. 10. The open eyes notwithstanding; so also Herbig, 13, no. 5.

390. 11. E. Panofsky, *Tomb Sculpture* (New York, n.d.), 80 and figures 331, 358.

12. 'Magnate' sarcophagus, Tarquinia, Museo Nazionale no. 9873: Herbig, 62-3, no. 120, plates 18-20, 94c and d. 'Thinker', Tarquinia, Museo Nazionale no. 9875: *ibid.*, 56-7, no. 107, plate 26a.

13. *Ibid.*, 56-7, no. 107; cf. 62-3, no. 120.

14. Museo Nazionale no. 9872: Herbig, 62, no. 119, and plates 27, 28a and b.

391. 15. Comparable quasi-archaistic zigzag folds occur still later, in the pediment from Talamone (Giglioli, plate 335) or alabaster urns from Volterra: for example, F.-W. Pairault, *Recherches sur quelques séries d'urnes de Volterra* (Rome, 1972), plates 11, 21, 26.

16. Herbig did not separate this group from the rest. Characteristic examples are his nos. 71a (p. 39, plate 109c), 72 (p. 40, plate 44a), 76 (Hastia Afunei, pp. 41-2, plate 57a), 104 (p. 56, plate 44c), 109 (p. 58, plate 46b), 148 (pp. 67-9, plates 71-3, 74a).

17. Herbig, 67-9, no. 148, plates 71-3, 74a.

392. 18. G. M. A. Richter, *The Portraits of the Greeks*, I (London, 1965), 131-2, Type IV, figures 708-10.

393. 19. Pliny already considered the inscribed name and other personal information constituent parts of a portrait: *N.H.* 34.17. For the modern controversy cf. above, Note 1; also the various essays on this subject by B. Schweitzer, *Zur Kunst der Antike. Ausgewählte Schriften*, II (Tübingen, 1963); G. Kaschnitz-Weinberg, *Ausgewählte Schriften*, II, *Römische Bildnisse* (Berlin, 1965), 1-54; R. Herbig, 'Die italienische Wurzel der römischen Bildniskunst', *Das neue Bild der Antike*, II (Leipzig, 1942), 85-99; G. M. A. Richter, 'Origins of Verism in Roman Portraits', *Journal of Roman Studies*, XLV (1955), 39-46, plates 1-10.

20. Beazley, 128 (the Nun Painter); G. Hafner, *R.M.*, LXXII (1965), 60, LXXIII/LXXIV (1966/7), 46, 48, plate 16, figures 1-2; M. M. Pasquinucci, *Le kelebai volterrane* (Florence, 1968), 7-8, 60-1.

21. Hafner, *op. cit.* (1965), 41-61, and *op. cit.* (1966/7), 29-52. Votive practices at Etruscan sanc-

tuaries: Q. F. Maule and H. R. W. Smith, *Votive Religion at Caere: Prolegomena* (Berkeley and Los Angeles, 1959), 60–2.

22. Illustration 304, terracotta votive heads, Vatican, Museo Gregoriano Etrusco, nos. 13852, 13854: Hafner, *op. cit.* (1966/7), plate 10, figures 1–2.

394. 23. E. Buschor, on Euripides: *op. cit.*, 106; cf. H. Keller, *Das Nachleben des antiken Bildnisses* (Freiburg, 1970), 22, note 23.

395. 24. E.g. Herbig, 73–4, no. 188, plates 21c–e, 91d.

25. E.g. *ibid.*, 38–9, nos. 66–9, with reference to F. N. Pryce, *Cypriote and Etruscan Sculpture* (London, British Museum, 1931), 193–9.

26. Tarquinia, Museo Nazionale no. 9890: Herbig, 66, no. 138, plate 10a and c; related example, *ibid.*, 50–1, no. 90, plates 23–4.

27. *Ibid.*, 39, and Note 25 above.

28. E.g. the 'round heads' of the third and second centuries, Herbig, nos. 110 (p. 58, plate 84a and b), 66 (p. 38, plate 80a), 205 (p. 78, plate 100d).

396. 29. Above, Note 11; details in Herbig, plate 94c and d.

30. M. C. Kraay and M. Hirmer, *Greek Coins* (New York, n.d.), plate 101 and p. 313, no. 291.

398. 31. Giglioli, plate 366, figure 1; G. Kaschnitz-Weinberg, *R.M.*, XLI (1926), 137–8, plates 1 and 2.

32. Orvieto, Golini Tomb I: see drawing, head of a young man, Giglioli, plate 247. Kaschnitz-Weinberg, *op. cit.*, figure 8 on p. 164.

33. Louvre br. 19: Giglioli, plate 259; Kaschnitz-Weinberg, *op. cit.*, 142–5, 159–60.

34. Varro, *de re rustica* 2, 11; additional testimonies in J. J. Winckelmann, *Geschichte der Kunst des Altertums* (ed. J. Lessing, Berlin, 1870), 194.

35. Museo Nazionale no. 9820: Giglioli, plate 256, figures 1 and 2; Kaschnitz-Weinberg, *op. cit.*, 182 and 180, figure 18.

399. 36. Inv. 1183: Giglioli, plates 254–5; bibliography, T. Dohrn in Helbig, *Führer*, 11, 268–70, no. 1449.

37. Kaschnitz-Weinberg, *op. cit.*, 138–40, plates 4–5; R. Bianchi Bandinelli, *Dedalo*, VIII (1927/8), 5–36.

38. Total height 0.69 m. Dohrn, *op. cit.*, 268.

400. 39. Lists in O. Vessberg, *Studien zur Kunstgeschichte der römischen Republik* (Lund, 1941), 91–114; T. Dohrn, *Die ficoronische Ciste in der Villa Giulia in Rom* (Berlin, 1972), 46–7.

40. Only the forepart of the neck is antique; Dohrn in Helbig, *Führer*, 11, 268.

41. Demosthenes: Buschor, *op. cit.* (Note 1), 117–19, figure 81; Richter, *op. cit.* (Note 18), 11, figures 1397–1406. Later imitations of sickle-shaped hair, in the style of the 'Brutus': Titus Tatius, denarius of L. Titurius Sabinus, obv. (*c.* 88 B.C.); M. Bieber, *Antike Kunst*, XIV (1971), 110 and plate 36, figure 5.

The group of Roman kings on the Capitoline hill, probably third-century, may have furnished the model for the coin portrait, which was a historical restoration; Vessberg, *op. cit.*, 120–2.

CHAPTER 30

403. 1. For the condition of the Etruscan cities after 400 see: A. Boëthius in *Etruscan Culture, Land and People* (New York and Malmö, 1962), 94–119; A. J. Pfiffig, *Die Ausbreitung des römischen Städtewesens in Etruria und die Frage der Unterwerfung der Etrusker* (Florence, 1966); H. H. Scullard, *The Etruscan Cities and Rome* (Ithaca, N.Y., 1967), 267–84; W. V. Harris, *Rome in Etruria and Umbria* (Oxford, 1971), 41–201.

2. Volterra: Banti, 207–8; Populonia and Vetulonia: *ibid.*, 186–7, 194. The metal industries of Vetulonia never regained their former importance; perhaps they were taken over by nearby Rusellae, the eventual heir of both cities; cf. M. Pallottino, *Etruscologia*, 6th ed. (Milan, 1968), 192–5; Banti, 187.

3. Cf. the search for the towns of Cortuosa and Contenebra: Boëthius, *op. cit.*, 95–6; Sovana and Norchia: Banti, 133–4, 138–9. Even the location of Volsinii, certainly a conspicuous place in its day, is still uncertain, the most likely contenders being the present cities of Orvieto and Bolsena: Banti, 162–4, bibliography p. 354; more recently, F. T. Buchicchoi, *R.M.*, LXXVII (1970), 19–45, plates 11–19.

4. Boëthius, *op. cit.*, 95–6; E. Wetter, *ibid.*, 167–8.

404. 5. Roman roads, northbound: J. B. Ward Perkins and M. W. Frederiksen, *Papers of the British School in Rome*, XXIII (1955), 44–72; XXV (1957), 67–208, plates 17–47; *idem, Journal of Roman Studies*, XLVII (1957), 139–43; Wetter, *op. cit.*, 169–96 and map, plate 19; Harris, *op. cit.*, 161–9.

6. Via Flaminia, northbound, with connections to Rimini and Ancona, was opened about 220; Ancona served as a military harbour in the Illyrian War of 178.

7. The Tyrrhenian Via Aurelia, about 240, served the Roman ports in the territories of Caere, Tarquinia, and Vulci: Alsium, Pyrgi, Graviscae, and Cosa. It ran along the coast, bypassing the old Etruscan cities (Harris, *op. cit.*, 147–9, 150, 165; see map, above, Note 5).

8. Colonies: Harris, *op. cit.*, 147–8. Alliances: *ibid.*, 129–44. Caere: M. Sordi, *I rapporti romano-ceriti e l'origine della civitas sine suffragio* (Rome, 1960); Boëthius, *op. cit.*, 125, note 38.

405. 9. Caere: Banti, 77–8. Vulci: *ibid.*, 133–4. Chiusi: *ibid.*, 215–16; R. Bianchi Bandinelli, 'Clusium', *Monumenti Antichi*, XXX (1925), cols. 505–8.

10. Livy, *ab urbe condita* 28, 45; Pallottino, *op. cit.*, 329–30. Vulci was omitted for reasons unknown, cf. Banti, 133.

11. Banti, 113-14.
406. 12. C. Ricci, *Monumenti Antichi*, XLII (1955), 893-912, plate 12; Boëthius, *op. cit.*, 97, figures 77, 79; J. Heurgon, *La Vie quotidienne chez les étrusques* (Paris, 1961), 201-12; A. Stenico, *S. Etr.*, XXIII (1954), 195-214. Details still require discussion: e.g. the damaged objects on the pillars framing the master bed were hardly satchels (Boëthius, *op. cit.*, figure 79) but could be portrait busts (Heurgon, *op. cit.*, 204).
13. For example, the Inghirami Tomb from Volterra, now in Florence, Museo Nazionale Archeologico: Banti, 201-2, plate 70a; Boëthius, *op. cit.*, figure 100.
14. Alabaster urns from Volterra, Volterra, Museo Guarnacci. For similar urns see Giglioli, plates 396-412.
408. 15. Social change in Hellenistic Etruria: Boëthius, *op. cit.*, 97-101; Heurgon, *op. cit.*, 76-94, especially 81-6 on freedmen and 91-4 on the collective *familia* of *patronus*, servants, and clients. Prohibition of banquets, imposed on the formerly free households of Volsinii: Heurgon, *op. cit.*, 80-1.
16. Prophecies, devotions, religious ceremonies: Heurgon, *op. cit.*, 279-93; processions, funerals, etc.: *ibid.*, 59-63, 70-3. Triumph: H. S. Versnel, *Triumphus. An Inquiry into the Origin, Development and Meaning of the Roman Triumph* (Leiden, 1970); cf. L. Bonfante Warren, *A.J.A.*, LXXV (1971), 277-84, plates 65-8.
17. Porcius Licinius, as quoted in Gellius, *Noctes Atticae* 17.21.45.

CHAPTER 31

409. 1. A. Furtwängler, *Die antiken Gemmen*, III (Leipzig and Berlin, 1900), section 8, Etruscanizing and Hellenizing gems.
410. 2. The remainder of the text is by Emeline Richardson.
Etruria: R. Mengarelli, *S. Etr.*, IX (1935), 83-4, plates 19-24; G. Hafner, *R.M.*, LXXII (1965), 41-61, plates 14-25, LXXIII/LXXIV (1966/7), 29-52, plates 5-18. Latium: A. Della Seta, *Museo di Villa Giulia* (Rome, 1918), 301-2; N. Bonacasa, *S. Etr.*, XXVI (1958), 40-1, plate 4. Campania: M. Bonghi Jovino, *Capua preromana. Terrecotte votive. Catalogo del Museo Provinciale Campano*, I (Florence, 1965), 24-5, plates 35-9, 42-62; P. Mingazzini, *Monumenti Antichi*, XXXVII, 2 (1938), plate 23. Latin colonies: Cales, W. Johannowsky, *Bollettino d'Arte*, XLVI (1961), 264, figures 14-15; Luceria, R. Bartoccini, *Japigia*, XI (1940), 203-6, figures 16b-18; Carsoli, A. Cederna, *Notizie degli Scavi* (1951), 215-19, figures 19, 20, 22.
3. Head from Falerii, Rome, Villa Giulia 7311: Della Seta, *op. cit.*, 185, plate 40; G. Kaschnitz-

Weinberg, *Rendiconti della Pontificia Accademia Romana di Archeologia*, series 3, 3 (1925), 344-6, figure 10; Giglioli, plate 420, figure 4. Head from Tarquinia, Tarquinia, Museo Nazionale 3733: *Arte e civiltà degli etruschi*, exhibition catalogue (Turin, 1967), 129-30, no. 365, plate figure. Heads from Caere: Vatican, Museo Gregoriano Etrusco 13758: Hafner, *op. cit.* (1966/7), plate 13; Kaschnitz-Weinberg, *op. cit.*, 326, plate 18, figure 2; no. 13761: Hafner, *op. cit.*, plate 17; Kaschnitz-Weinberg, *op. cit.*, 326, plate 18, figure 1; Mengarelli, *op. cit.*, 93-4, plate 23, figure 2, and plate 24, figures 1-3.
4. Museo Gregoriano Etrusco no. 14207: Kaschnitz-Weinberg, *op. cit.*, 346-7, plate 24; Banti, 295, plate 16; Hafner, *op. cit.* (1965), 58-60, plate 25, figures 3 and 4.
411. 5. L. Savignoni and R. Mengarelli, *Notizie degli Scavi* (1903), 247-57, figure 22. The sanctuary was sacred to Juno Lucina. The lady disappeared from the Museo Nazionale Romano during World War Two, but reappeared (with new feet) in the exhibition of Master Bronzes from the Classical World, Fogg Art Museum, 4 December 1967-23 January 1968; cf. D. G. Mitten and S. Doeringer, *Master Bronzes from the Classical World* (Cambridge, Mass., 1967), 181, no. 185.
6. Mitten and Doeringer, *op. cit.*, 183, no. 187.
7. Museo Archeologico Prenestino 1499, formerly Museo di Villa Giulia 13134: G. Quattrocchi, *Il Museo Archeologico Prenestino* (Rome, 1956), 41, no. 105, figure 30; K. A. Neugebauer, *Antike Bronzestatuetten* (Berlin, 1921), 105-6, figure 57.
8. Cf. the material from Todi, G. Becatti, *S. Etr.*, IX (1935), 299-303, plates 38-9.
9. Cf. Giglioli, plate 313, figures 3 and 4; G. M. A. Richter, *Greek, Etruscan and Roman Bronzes* (New York, 1915), 217-18, no. 598, figure on p. 218.
10. Museum of Art no. 47.68: S. Wunderlich, *Bulletin of the Cleveland Museum of Art*, VII, 1 (1947), 164-6.
412. 11. F. Messerschmidt and A. von Gerkan, *Nekropolen von Vulci*, *J.D.A.I.*, 12. Ergänzungsheft (Berlin, 1930), 62-163, plates 1-39; A. von Gerkan, *R.M.*, LVII (1942), 146-50; Pallottino, 115-24; R. Bianchi Bandinelli and A. Giuliano, *Etruschi ed Italici* (Milan, 1973), 256-60, with good colour plates.
12. M. Cristofani, *Dialoghi di Archeologia*, I (1967), 186-219, plates 17-38.
13. W. L. Brown, *The Etruscan Lion* (Oxford, 1960), 158-60, plate 55d.
413. 14. I. Krauskopf, *Der thebanische Sagenkreis* (Mainz, 1974), 53, 104, Pol 3, plate 23, figure 1; Pallottino, 119.
15. Messerschmidt and von Gerkan, *op. cit.*, plate 14; T. Dohrn, *Grundzüge etruskischer Kunst* (Baden-Baden, 1958), 25-8, figures 3-7.

16. A. Alföldi, *Early Rome and the Latins* (Ann Arbor, Mich., n.d.), 221-8.

17. F. Messerschmidt, *J.D.A.I.*, XLV (1930), 64-74; Beazley, 89-92.

414. 18. Festus S. 228, portraits of M. Fulvius Flaccus and T. Papirius Cursor. Pliny, *N.H.* 35.22, M. Valerius Maximus Messala's victory over the Carthaginians and Hieron: O. Vessberg, *Studien zur Kunstgeschichte der römischen Republik* (Lund, 1941), 25-6, nos. 83 and 84.

415. 19. British Museum 633: J. D. Beazley, *J.H.S.*, LXIX (1949), 16-17, figure 22, plate 11b; Messerschmidt, *op. cit.*, 75 8, figure 12.

20. L. Curtius, *Die Wandmalerei Pompejis* (Leipzig, 1929), figures 2 and 3 on pp. 5 and 6. The description of the mirror is Professor Brendel's.

416. 21. H. Brunn and G. Körte, *I rilievi delle urne etrusche*, 11, 2 (Rome, 1870-1916), 254-8, plate 119, figures 1 and 2; Messerschmidt, *op. cit.*, 75-8, figures 14-16.

22. M. Pallottino, *Rendiconti dell'Accademia Nazionale dei Lincei*, series 6, vol. 6 (1930), 49-87, plates 1 and 2; Giglioli, plate 299, figures 2 and 3.

417. 23. Berlin, Staatliche Museen, Antiken-Abteilung: Giglioli, plates 293 figure 2 and 294 figure 1; I. S. Ryberg, 'Rites of the State Religion in Roman Art', *M.A.A.R.*, XXII (1955), 20-2, plate 6, figure 13; L. B. Warren, *A.J.A.*, LXVIII (1964), 35-42, plates 13-14, figure 3.

418. 24. Ryberg, *op. cit.*, 160, notes 57 and 58.

25. Vessberg, *op. cit.*, 26-46, Period 4.

26. J. Heurgon, *La Vie quotidienne chez les étrusques* (Paris, 1961), 284-6; idem, 'The Date of Vegoia's Prophecy', *Journal of Roman Studies*, XLIX (1959), 41-5.

27. Heurgon, *op. cit.* (1961), 74-94.

28. M. Pallottino, *Etruscologia*, 6th ed. (Milan, 1968), 231-3; Heurgon, *op. cit.*, 92-3; F.-H. Pairault, *Recherches sur quelques séries d'urnes de Volterra à représentations mythologiques* (Rome, 1972), 31-3.

29. M. Cristofani, *La Tomba delle Iscrizioni a Cerveteri* (Florence, 1965), 53-61; Heurgon, *op. cit.*, 86-7.

419. 30. Heurgon, *op. cit.*, 142-5, 284, 289-90; Tarquitius Priscus, idem, *Latomus*, XII (1953), 402-15.

31. G. Dennis, *Cities and Cemeteries of Etruria*, 2 vols., 3rd ed. (London, 1878), 327-36; F. Weege, *Etruskische Malerei* (Halle, 1921), plates 47-9; Pallottino, 125-8 (he dates the tomb in the first century B.C.); M. Cristofani, *Le pitture della Tomba del Tifone* (1972).

32. Pallottino, 128.

33. Curtius, *op. cit.* (Note 20), 323-36, figures 182-5.

420. 34. Cristofani, *op. cit.*, 25.

35. *Ibid.*, 16, figures 13 and 14; H. Beyen, *Die pompejanische Wanddekoration*, 11 (The Hague, 1960),

House of the Silver Wedding, tetrastyle oecus, p. 49, figure 4, ships' prows in arches.

36. Beyen, *op. cit.*, 11, House of the Menander, caldarium, p. 153, figure 186. These are caryatids too, though they hold up the cornice with the tips of their wings only.

37. Ash urns: H. Brunn and G. Körte, *I rilievi delle urne etrusche*, 3 vols. (Rome, 1870-1916). Chiusi: J. Thimme, 'Chiusinische Aschenkisten und Sarkophage der hellenistischen Zeit', *S. Etr.*, XXV (1957), 87-160. Perugia: G. Dareggi, *Urne del territorio perugino* (Rome, 1972). Volterra: Pairault, *op. cit.*, entire.

38. Pairault, *op. cit.*, 23-6, 38, plate 4; Dareggi, *op. cit.*, 16-17, 49, urn no. 37 plate 23 figure 1; 52, urn no. 45 plate 28 figure 1; 53, urn no. 48 plate 30 figure 1.

422. 39. Teitz, 101-3, no. 94, with bibliography, ill. p. 199; J. Thimme, *S. Etr.*, XXIV (1954), 101-2, figure 44; Banti, 332, plate 81b; R. Bianchi Bandinelli and A. Giuliano, *Etruschi e Italici prima del dominio di Roma* (Milan, 1973), figures 357-8.

40. A. von Gerkan and F. Messerschmidt, *R.M.*, LVII (1942), 222-6, figures 39-42, plate 20; Giglioli, plate 417, figure 1.

41. See the fine photograph of the head, Dareggi, *op. cit.*, plate 56.

42. British Museum Tc. D. 786: H. B. Walters, *Catalogue of the Terracottas in the . . . British Museum* (London, 1903), 428-9; Banti, 333-4, plate 82a and b; S. Haynes, *Etruscan Sculpture* (London, 1971), plate 111.

43. M. Bieber, *Entwicklungsgeschichte der griechischen Tracht*, 2nd ed. (Berlin, 1967), 35, plate 34 with chiton, plate 39 without chiton. Cf. also E. Langlotz and M. Hirmer, *L'arte della Magna Grecia* (Rome, 1968), figure 161, marble figure of a muse from the theatre of Syracuse.

424. 44. Volterra, Museo Guarnacci inv. 394: H. Brunn and G. Körte, *op. cit.*, 11, 1, p. 50, plate 18, figure 3. Pairault, *op. cit.*, 42-3, a 'monument' of type 3a with architectural frame and lions' claw feet; p. 50, caryatid figures.

45. O. W. von Vacano, *R.M.*, LXVIII (1961), 12-37, plates 4, 6, figures 2 and 3, 7; I. Krauskopf, *Der thebanische Sagenkreis und andere griechische Sagen in der etruskischen Kunst* (Mainz, 1974), 56, 97.

46. Vacano, *op. cit.*, 52, plates 5, 8, figure 2; Krauskopf, *op. cit.*, 56.

425. 47. C. Robert, *Oidipus. Geschichte eines poetischen Stoffs im griechischen Altertum*, I (Berlin, 1915), 454-6; Vacano, *op. cit.*, 29.

48. Dareggi, *op. cit.*, plates 46, 47 figure 1, 52 figures 1 and 2.

49. Vulci: Andrén, 216-18, plate 79, figure 275. Bolsena: *ibid.*, 208-12, plate 78, figures 266-8. Cosa:

F. E. Brown, E. H. Richardson, and L. Richardson Jr, *Cosa II*, *M.A.A.R.*, XXVI (1960), part III, 206-31, part I, figure 22.

50. A. M. Colini, 'Indagini sui frontoni dei templi di Roma', *Bulletino Comunale*, LI (1924), 318-19 and note I; Brown, Richardson, and Richardson, *op. cit.*, part III, 307.

51. Andrén, I, ccxvi; Brown, Richardson, and Richardson, *op. cit.*, part III, 307-8. Rome, Via San Gregorio: Andrén, 350-60, plates 110-12; I. S. Ryberg, *Rites of the State Religion in Roman Art*, *M.A.A.R.*, XXII (1955), 22-3, plate 6, figure 14. Luni: Andrén, 283-7, plates 93-4. Cosa: Brown, Richardson, and Richardson, *op. cit.*, part III, 366-7, part I, figures 89-92. Imperial pediments: Colini, *op. cit.*, 333-4, plate 2.

52. Arezzo: Judgement of Paris?, Andrén, 268-9, plate 89, figures 318-19. Città Alba: Discovery of Ariadne, *ibid.*, 298-300, plates 98-100. Falerii: Rescue of Andromeda, *ibid.*, 147-8, 56 figure 184. Luni: Slaughter of the Niobids, *ibid.*, 287-92, plate 95, figures 339-40. Talamone: Seven Against Thebes, *ibid.*, 227-34, plates 82 figure 285, 83 figure 289. The fragmentary pedimental figures from the Temple of Jupiter and the Port Temple at Cosa also seem to have been parts of mythological scenes: Brown, Richardson, and Richardson, *op. cit.*, part III, 313-16, figures 2-4; 330-2, figures 20-1. The subject of the pediment of Temple B in the forum of Cosa was the Discovery of Paris (unpublished).

426. 53. O. W. von Vacano, *R.M.*, LXXVI (1969), 142, figure 2; M. Zuffa in *Studi in Onore di A. Calderini e R. Paribeni*, III (Milan, 1956), 272-3, figures 2 and 4.

54. Colini, *op. cit.*, 334-5.

55. Cf. P. E. Arias and M. Hirmer, *A History of Greek Vase Painting* (London, 1961), figures 173-5, 205, 218-19, plate L.

56. Apotheosis of Homer: M. Bieber, *The Sculpture of the Hellenistic Age* (New York, 1955), figure 497; Telephus Frieze, 'Building of the Ship', *ibid.*, figure 478.

57. Vacano, *op. cit.*, 142, figure 2 and plate 54; Krauskopf, *op. cit.*, plate 24, figure 3.

58. Andrén, 304; Zuffa, *op. cit.*, 277-9, figure 4.

59. S. Reinach, *Répertoire de peintures grecques et romaines* (Paris, 1922), 112 figure 6, 113 figures 1-4; Curtius, *op. cit.* (Note 20), 308-12, figures 176-9; G. A. Mansuelli, *Ricerche sulla pittura ellenistica. Riflessi della pittura ellenistica nelle arti minori* (Bologna, 1950), 91-3.

60. Taranto, Museo Nazionale I G 4104: Langlotz and Hirmer, *op. cit.*, plate XV; 22492: *ibid.*, plate XX.

427. 61. Mansuelli, *op. cit.* Cf. Dohrn, *R.M.*, LXVIII (1961), 2-3. Individual figures or small groups were often reassembled to form new compositions and even

to illustrate new stories: the 'sleeping Ariadne' becomes 'the stolen Helen' on an ash urn in Volterra, Museo Guarnacci 257 (Pairault, *op. cit.*, 159, 222-3, plate 114a). The more usual composition in which Helen is urged on board ship by a young man and a boy (*ibid.*, 223-30, plates 114b, 115-18, 120-21) reappears in reverse in a painting from the House of the Tragic Poet (L. Ghali-Kahil, *Les Enlèvements et le retour d'Hélène* (Paris, 1955), 238-9, no. 189, plate 39, figure 3). The figure of the fleeing Hippodameia on a splendid urn in the Vatican, Museo Gregoriano Etrusco 13887 (Pairault, *op. cit.*, 169, plate 9a; Dohrn, *op. cit.*, 1-4), is taken from the Thetis of the south frieze of the Pergamene altar and reappears as the Frightened Girl in the great frieze of the Villa of the Mysteries (O. Brendel, *J.D.A.I.*, LXXXI (1966), 217-20, figures 8-9). The vindictive winged Fury who stands in the centre of the composition on the urn seems to have come with the girl to the frieze in the villa (*ibid.*, 232, figures 11 and 17a), which suggests that even in the first century Campania was borrowing from the same sources that Etruria had used in the second, however they may have been diffused.

62. L. Cederna, *Notizie degli Scavi* (1951), 169-224.

429. 63. S. Haynes, 'The Bronze Priests and Priestesses from Nemi', *R.M.*, LXVII (1960), 34-8. Illustration 325: London, British Museum 1920 6-12, 1.

64. L. Savignoni and R. Mengarelli, *Notizie degli Scavi* (1903), 255, figure 23.

65. Haynes, *op. cit.*, plates 15 figures 1 and 2, 16, 17 figure 1.

66. A. de Ridder, *Les Bronzes antiques du Louvre*, I (Paris, 1913), 50, no. 310, plate 27; Haynes, *op. cit.*, 40, no. 16.

67. Haynes, *op. cit.*, 41-5; B. F. Cook, *Metropolitan Museum Journal*, I (1968), 167-70; A. Minto, *Notizie degli Scavi* (1934), 56, figure 10b.

430. 68. Q. Maule and H. R. W. Smith, *Votive Religion at Caere: Prolegomena* (Berkeley and Los Angeles, 1959), 61; M. Bonghi Javino, *Capua preromana. Terrecotte votive*, II (Florence, 1965), 46-59, plates 14, 18-24, 26-8.

69. Museo Gregoriano Etrusco inv. 12.207: Giglioli, plate 368, figure 4; T. Dohrn in Helbig, *Führer*, I, 535-6, no. 716, with earlier bibliography.

70. Giglioli, plates 369-70; T. Dohrn, *Der Arringatore* (Monumenta Artis Romanae, VIII) (Berlin, 1968).

432. 71. G. Kaschnitz Weinberg, *R.M.*, XLI (1926), 182-3, Beilage 26-7; E. H. and L. Richardson, *Yale Classical Studies*, XIX (1966), 262-3; Dohrn, *op. cit.*, 13-15.

72. E. H. and L. Richardson, *op. cit.*, 267.

SELECT BIBLIOGRAPHY

DUCATI, P. *Storia dell'arte etrusca*. 2 vols. Florence, 1927.

Etruscan Culture, Land and People. Archaeological Research and Studies Conducted in San Giovenale and its Environs by Members of the Swedish Institute in Rome. New York and Malmö, 1962.

GIGLIOLI, G. Q. *L'arte etrusca*. Milan, 1935.

GJERSTAD, E. *Early Rome*, IV. Synthesis of Archaeological Evidence (Skrifter utgivna av Svenska Institutet i Rom, 4°, XVII:4). Lund, 1966.

HEURGON, J. *La Vie quotidienne chez les étrusques*. Paris, 1961.

JUCKER, H. 'Vorrömische Kunst in Sardinien, Mittel- und Norditalien', in K. Schefold, *Die Griechen und ihre Nachbarn* (Propyläen Kunstgeschichte, I). Berlin, 1966.

MANSUELLI, G. *Etruria and Early Rome*. London, 1966.

MORETTI, M., MAETZKE, G., GASSER, M., and MATT, L. VON. *Kunst und Land der Etrusker*. Zürich and Würzburg, 1969.

MÜHLESTEIN, H. *Die Kunst der Etrusker*. Berlin, 1929.

PALLOTTINO, M., and JUCKER, H. *Art of the Etruscans*. New York, 1955.

PALLOTTINO, M. *Etruscologia*. 6th ed. Milan, 1968.

RICHARDSON, E. H. *The Etruscans: Their Art and Civilization*. Chicago, 1964.

SANTANGELO, M. *Musei e monumenti etruschi*. Novara, 1960.

ZSCHIETZSCHMANN, W. *Etruskische Kunst* (Monumente alter Kulturen). Frankfurt am Main, 1969.

A. GENERAL

BANTI, L. *Il mondo degli Etruschi*. 2nd ed. Rome, 1969.

BIANCHI-BANDINELLI, R., and GIULIANO, A. *Etruschi ed Italici prima del dominio di Roma*. Milan, 1973.

BOËTHIUS, A., and WARD-PERKINS, J. B. *Etruscan and Roman Architecture* (Pelican History of Art). Harmondsworth, 1970.

DENNIS, G. *The Cities and Cemeteries of Etruria*. 2 vols. 1st ed. London, 1848.

DOHRN, T. *Grundzüge etruskischer Kunst* (Deutsche Beiträge zur Altertumswissenschaft, VIII). Baden Baden, 1958.

B. MUSEUM CATALOGUES

AURIGEMMA, S. *Il R. Museo di Spina in Ferrara*. Bologna, 1936.

BARTOCCINI, R., and DE AGOSTINO, A. *Museo di Villa Giulia. Antiquarium e collezione dei Vasi Castellani*. Milan, 1961.

BEAZLEY, J. D., and MAGI, F. *La raccolta B. Guglielmi nel Museo Gregoriano Etrusco*. Vatican City, 1939.

HINKS, R. P. *Catalogue of the Greek, Etruscan and Roman Paintings and Mosaics*. London, British Museum, 1933.

LEVI, D. 'Sculture inedite del museo di Chiusi', *Bollettino d'Arte*, XXVIII (1934/5), 49–75.

MINGAZZINI, P. *Vasi della Collezione Castellani.* Rome, 1930.

MORETTI, M. *Il Museo Nazionale di Villa Giulia.* Rome, 1964.

PRYCE, F. N. *Catalogue of Sculpture in the Department of Greek and Roman Antiquities of the British Museum*, I, 2, *Cypriote and Etruscan.* London, 1931.

RICHTER, G. M. A. *Greek, Etruscan and Roman Bronzes.* New York, The Metropolitan Museum of Art, 1915.

RICHTER, G. M. A. *Handbook of the Etruscan Collection.* New York, The Metropolitan Museum of Art, 1940.

RUMPF, A. *Katalog der etruskischen Skulpturen.* Berlin, Staatliche Museen, 1928.

WALTERS, H. B. *Catalogue of the Bronzes, Greek, Roman and Etruscan in the Department of Greek and Roman Antiquities, British Museum.* London, 1899.

C. EXHIBITION CATALOGUES

Ancient Art in American Private Collections. A Loan Exhibition at the Fogg Art Museum of Harvard University, December 28–February 15 1955. Cambridge, Mass., 1954.

Arte e civiltà degli etruschi. Torino, Giugno-Luglio, 1967. Turin, 1967.

JUCKER, H. and I. *Kunst und Leben der Etrusker.* Kunsthaus Zürich, 15 Januar bis Ende März 1955. Zürich, 1955.

MITTEN, D., and DOERINGER, S. *Master Bronzes from the Classical World.* The Fogg Art Museum, City Art Museum of St Louis, The Los Angeles County Museum of Art. Cambridge, Mass., 1967.

MORETTI, M. *Nuovi tesori dell'antica Tuscia.* Catalogo della mostra. Viterbo, 1970.

Mostra dell'Etruria padana e della città di Spina. Catalogo. 12 settembre–31 ottobre 1960. Bologna, Palazzo dell'Archiginnasio. Bologna, 1960.

TEITZ, R. S. *Masterpieces of Etruscan Art.* Worcester Art Museum April 21 to June 4 1967. Worcester, Mass., 1967.

D. MYTH AND RELIGION

ALFÖLDI, A. *Die trojanischen Urahnen der Römer.* Basel, 1957.

ALTHEIM, F. *A History of Roman Religion* (tr. H. Mattingly). New York, 1938.

DOHRN, T. 'Die Etrusker und die griechische Sage', *R.M.*, LXXIII/LXXIV (1966/7), 15–28, plates 3–4.

DUMÉZIL, G. *La Religion romaine archaïque.* Paris, 1966.

GHALI-KAHIL, L. *Les Enlèvements et le retour d'Hélène* (École française d'Athènes. Travaux et Mémoires, X). Paris, 1955.

HAMPE, R., and SIMON, E. *Griechische Sagen in der frühen etruskischen Kunst.* Mainz, 1964.

HERBIG, R. *Götter und Dämonen der Etrusker* (herausgegeben und bearbeitet von E. Simon). Mainz, 1965.

KRAUSKOPF, I. *Der thebanische Sagenkreis und andere griechische Sagen in der etruskischen Kunst.* Mainz, 1974.

RYBERG, I. S. *Rites of the State Religion in Roman Art, M.A.A.R.*, XXII (1955).

VACANO, O. W. VON. *Die Etrusker: Werden und geistige Welt.* Stuttgart, 1955.

E. VILLANOVANS AND EARLY ETRUSCANS

ÅKERSTRÖM, Å. *Der geometrische Stil in Italien* (Skrifter utgivna av Svenska Institutet i Rom, IX). Uppsala, 1943.

FREIHERR VON BISSING, W. 'Untersuchungen über die phoenikischen Metallschalen', *J.D.A.I.*, XXXVIII/XXXIX (1923/4), 180–241.

FURUMARK, A. *Det äldsta Italien.* Uppsala, 1947.

GJERSTAD, E. 'Decorated Metal Bowls from Cyprus', *Opuscula Archeologica*, IV (Skrifter utgivna av Svenska Institutet i Rom, XII). 1946.

HENCKEN, H. *Tarquinia, Villanovans and Early Etruscans* (American School of Prehistoric Research, Peabody Museum, Harvard University, Bulletin no. XXIII). Cambridge, Mass., 1968.

HERRMANN, H.-V. *Die Kessel der orientalisierenden Zeit* (Olympische Forschungen, VI). Berlin, 1966.

HOLLAND, L. A. *The Faliscans in Prehistoric Times* (Papers of the American Academy in Rome, V). 1925.

KARO, G. 'Orient und Hellas in archaischer Zeit', *Athenische Mitteilungen*, XLV (1920), 106–56.

POULSEN, F. *Der Orient und die frühgriechische Kunst.* Leipzig/Berlin, 1912.

RANDALL-MACIVER, D. *Villanovans and Early Etruscans.* Oxford, 1924.

SUNDWALL, J. *Die älteren italischen Fibeln.* Berlin, 1943.

F. TOMBS AND TOMB GROUPS

ÅKERSTRÖM, Å. *Studien über die etruskischen Gräber* (Skrifter utgivna av Svenska Institutet i Rom, III). Lund, 1934.

BIZZARI, M. 'La necropoli di Crocifisso del Tufo in Orvieto', *S. Etr.*, XXXIV (1966), 3–109.

CAMPOREALE, G. *La tomba del Duce* (Monumenti etruschi pubblicati dall'Istituto di Studi Etruschi ed Italici, I. Vetulonia, I). Florence, 1967.

CURTIS, C. D. 'The Barberini Tomb', *M.A.A.R.*, V (1925), 9–52, plates 1–43.

CURTIS, C. D. 'The Bernardini Tomb', *M.A.A.R.*, III (1919), 9–90, plates 1–71.

DOHAN, E. H. *Italic Tomb Groups in the University Museum*. Philadelphia, 1942.

DUHN, F. VON, and MESSERSCHMIDT, F. *Italische Gräberkunde*. 2 vols. Heidelberg, 1924, 1939.

GERKAN, A. VON, and MESSERSCHMIDT, F. 'Das Grab der Volumnier bei Perugia', *R.M.*, LVII (1942), 122–235, plates 9–24, Beilage 1–5.

MESSERSCHMIDT, F., and GERKAN, A. VON. *Nekropolen von Vulci. J.D.A.I., 12. Ergänzungsheft.* Berlin, 1930.

PALLOTTINO, M. 'Tarquinia', *Monumenti Antichi*, XXXVI (1937), 123–81.

PARETI, L. *La Tomba Regolini-Galassi del Museo Gregoriano Etrusco e la civiltà dell'Italia centrale nel secolo VII a.C.* Città del Vaticano, 1947.

G. SCULPTURE

1. General

BROWN, W. L. *The Etruscan Lion*. Oxford, 1960.

RICHARDSON, E. H. 'The Etruscan Origins of Early Roman Sculpture', *M.A.A.R.*, XXI (1953), 77–124.

RIIS, P. J. *Tyrrhenika. An Archaeological Study of the Etruscan Sculpture of the Archaic and Classical Periods*. Copenhagen, 1941.

VESSBERG, O. *Studien zur Kunstgeschichte der römischen Republik*. Lund, 1941.

2. Geometric and Orientalizing

HANFMANN, G. M. A. *Altetruskische Plastik*, I. Würzburg, 1936.

3. Canopic Urns

BIANCHI-BANDINELLI, R. 'Clusium. Ricerche archeologiche e topografiche su Chiusi e il suo territorio in età etrusca', *Monumenti Antichi*, XXX (1925), cols. 442–53.

GEMPELER, R. D. *Die etruskischen Kanopen. Herstellung, Typologie, Entwicklungsgeschichte*. Einsiedeln, 1975.

LEVI, D. 'I canopi di Chiusi', *La Critica d'Arte*, I (1935), 18–26, 82–9.

4. Stone Sculpture

ANDRÉN, A. 'Marmora Etruriae', *Antike Plastik*, VII (1967), 7–42, plates 1–23.

BRUNN, H., and KÖRTE, G. *I rilievi delle urne etruschi*. 3 vols. Rome, 1870–1916.

DAREGGI, G. *Urne del territorio perugino* (Quaderni dell'Istituto di Archeologia dell'Università di Perugia, I). Rome, 1972.

DUCATI, P. 'Le pietre funerarie felsinee', *Monumenti Antichi*, XX, 2 (1912), cols. 361–724, plates 1–5.

HERBIG, R. *Die jüngeretruskischen Steinsarkophage*. Berlin, 1952.

HUS, A. *Recherches sur la statuaire en pierre étrusque archaïque* (Bibliothèque des Écoles Françaises d'Athènes et de Rome, CXCVIII). Paris, 1961.

PAIRAULT, F.-H. *Recherches sur quelques séries d'urnes de Volterra à représentation mythologiques* (Collection de l'École Française de Rome, XII). Rome, 1972.

PARIBENI, E. 'I rilievi chiusini arcaici', *S. Etr.*, XII (1938), 57–139, XIII (1939), 179–202.

5. Bronze Sculpture and Relief

BANTI, L. 'Bronzi arcaici etruschi: i tripodi Loeb', *Tyrrhenica. Istituto Lombardo di Scienze e Lettere*, 77–96, plates I-IX. Milan, 1957.

BRENDEL, O. 'Three Archaic Bronze Discs from Italy', *A.J.A.*, XLVII (1943), 194–208.

CHARBONNEAUX, J. *Greek Bronzes*. New York, 1962.

CHASE, G. H. 'Three Bronze Tripods belonging to James Loeb Esq.', *A.J.A.*, XII (1908), 287–323, plates 8–18.

COLONNA, G. *Bronzi votivi Umbro-Sabellici a figura umana*, I, *Periodo arcaico*. Rome, 1970.

DOHRN, T. *Der Arringatore* (Monumenta Artis Romanae, VIII). Berlin, 1968.

HANFMANN, G. M. A. 'Studies in Etruscan Bronze Reliefs. The Gigantomachy', *The Art Bulletin*, XIX (1937), 463–84.

HAYNES, S. 'The Bronze Priests and Priestesses of Nemi', *R.M.*, LXVII (1960), 34–47, plates 12–20.

HAYNES, S. 'Etruscan Bronzes in the British Museum: New Acquisitions and Old Possessions', *Art and Technology. A Symposium on Classical Bronzes*, 177–93. Cambridge, Mass., 1970.

KUNZE, E. 'Etruskische Bronzen in Griechenland', *Studies Presented to D. M. Robinson*, I, 736–46. St Louis, Mo., 1951.

LAMB, W. *Greek and Roman Bronzes*. London, 1929.

NEUGEBAUER, K. A. 'Archaische Vulcenter Bronzen', *J.D.A.I.*, LVIII (1943), 206–78.

RONCALLI, F. *Il 'Marte' di Todi* (Atti della Pontificia Accademia Romana di Archeologia, Serie III, Memorie XI, 11). Vatican City, 1973.

6. Architectural Terracottas

ÅKERSTRÖM, Å. 'Untersuchungen über die figürlichen Terrakotta-Friese aus Etrurien und Latium', *Opuscula Romana*, I, 191–231 (Skrifter utgivna av Svenska Institutet i Rom, XVIII). 1954.

ANDRÉN, A. *Architectural Terracottas from Etrusco-Italic Temples* (Skrifter utgivna av Svenska Institutet i Rom, VI). Lund, 1939–40.

ANDRÉN, A. 'Osservazioni sulle terrecotte architettoniche etrusco-italiche', *Lectiones Boëthianae*, I (Skrifter utgivna av Svenska Institutet i Rom, 4°, XXXI:I), 1–16, plates 1–32. Stockholm, 1971.

RICHARDSON, E. H. *Cosa II, the Temples of the Arx,* part III, *Terracotta Sculpture, M.A.A.R.,* XXVI (1960), 303–80.

7. Votive Terracottas

BONGHI JOVINO, M. *Capua Preromana. Terrecotte votive.* Catalogo del Museo Provinciale Campano. 2 vols. Florence, 1965.

HAFNER, G. 'Frauen- und Mädchenbilder aus Terrakotta im Museo Gregoriano Etrusco', *R.M.,* LXXII (1965), 41–61, plates 14–25.

HAFNER, G. 'Männer- und Jünglingsbilder aus Terrakotta im Museo Gregoriano Etrusco', *R.M.,* LXXIII/LXXIV (1966/7), 29–52, plates 5–18.

MAULE, Q. F., and SMITH, H. R. W. *Votive Religion at Caere: Prolegomena.* Berkeley and Los Angeles, 1959.

8. Portraits

BUSCHOR, E. *Das Porträt. Bildniswege und Bildnisstufen in fünf Jahrtausenden.* Munich, 1960.

HERBIG, R. 'Die italienische Wurzel der römischen Bildniskunst', *Das neue Bild der Antike,* II (Leipzig, 1942), 85–99.

KASCHNITZ-WEINBERG, G. 'Studien zur etruskischen und frührömischen Porträtkunst', *R.M.,* XLI (1926), 133–211.

KELLER, H. *Das Nachleben des antiken Bildnisses.* Freiburg, 1970.

RICHTER, G. M. A. 'Origins of Verism in Roman Portraits', *Journal of Roman Studies,* XLV (1955), 39–46, plates 1–10.

RICHTER, G. M. A. *The Portraits of the Greeks,* I and II. London, 1965.

SCHWEITZER, B. 'Studien zur Entstehung des Porträts bei den Griechen', *Sächsische Akademie der Wissenschaft, Leipzig. Philologisch-kunsthistorische Klasse Berichte über die Verhandlungen,* XCI, fasc. 4 (1940).

H. PAINTING

1. General

BOVINI, G. 'La pintura etrusca del periodo orientalizante (siglos VII, VI a. de J.C.), *Ampurias,* XI (1949), 63–90.

BRENDEL, O. J. 'Der grosse Fries in der Villa dei Misteri', *J.D.A.I.,* LXXXI (1966), 206–60.

CURTIUS, L. *Die Wandmalerei Pompejis.* Leipzig, 1929.

LEISINGER, H. *Malerei der Etrusker.* Stuttgart, n.d.

MORETTI, M. *Nuovi monumenti della pittura etrusca.* Milan, 1966.

PALLOTTINO, M. *Etruscan Painting.* Geneva, 1952.

RONCALLI, F. *Le lastre dipinte da Cerveteri.* Florence, 1965.

RUMPF, A. *Malerei und Zeichnung,* in W. Otto and R. Herbig, *Handbuch der Archäologie.* Munich, 1953.

RUMPF, A. *Die Wandmalerei in Veji.* Leipzig, 1915.

WEEGE, F. *Etruskische Malerei.* Halle, 1921.

2. Painted Tombs

BANTI, L. 'Le pitture della Tomba Campana a Veii', *S. Etr.,* XXXVIII (1970), 27–43.

BANTI, L. 'Problemi della pittura arcaica etrusca. La Tomba dei Tori a Tarquinia', *S. Etr.,* XXIV (1955–6), 143–81.

BARTOCCINI, R., LERICI, C. M., and MORETTI, M. *Tarquinia. La Tomba delle Olimpiadi.* Milan, 1959.

BECATTI, G., and MAGI, F. *Le pitture delle Tombe degli Auguri e della Pulcinella, Monumenti della pittura antica scoperti in Italia,* sez. I, *La pittura etrusca, Tarquinia fasc. 3–4.* Rome, 1956. Cf. review by O. Brendel, *A.J.A.,* LXII (1958), 240–2.

BIANCHI BANDINELLI, R. *Monumenti della pittura antica scoperti in Italia,* sez. I, *La pittura etrusca, Clusium fasc. 1, Le pitture delle tombe arcaiche.* Rome, 1939.

CRISTOFANI, M. *Le pitture della Tomba del Tifone. Monumenti della pittura antica scoperti in Italia,* sez. I, *La pittura etrusca, Tarquinia fasc. 5.* Rome, 1972.

CRISTOFANI, M. 'Ricerche sulle pitture della Tomba François di Vulci. I fregi decorativi', *Dialoghi di Archeologia,* I (1967), 186–219, plates 17–38.

DUCATI, P. *Le pitture delle Tombe delle Leonesse e dei Vasi Dipinti. Monumenti della pittura antica scoperti in Italia,* sez. I, *La pittura etrusca, Tarquinia fasc. 1.* Rome, 1937.

DUELL, P. 'The Tomba del Triclinio at Tarquinia', *M.A.A.R.,* VI (1927), 7–68.

HOLLOWAY, R. R. 'Conventions of Etruscan Painting in the Tomb of Hunting and Fishing at Tarquinia', *A.J.A.,* LXIX (1964), 341–7.

MORETTI, M. *Tarquinia. La Tomba della Nave.* Milan, 1961.

ROMANELLI, P. *Le pitture della tomba della 'Caccia e Pesca'. Monumenti della pittura antica scoperti in Italia,* sez. I, *La pittura etrusca, Tarquinia fasc. 2.* Rome, 1938.

3. Painted Vases

BEAZLEY, J. D. *Etruscan Vase Painting.* Oxford, 1947.

DOHRN, T. *Die schwarzfigurigen etruskischen Vasen aus der zweiten Hälfte des sechsten Jahrhunderts.* Berlin, 1937.
DUCATI, P. *Pontische Vasen* (J. D. Beazley and P. Jacobsthal, *Bilder griechischer Vasen,* V, 1932).
HEMELRIJK, J. M. *De caeretaanse Hydriae.* Dissertation, Leiden. Amsterdam, 1956.
PASQUINUCCI, M. M. *Le kelebai volterrane* (Studi dell'Ateneo Pisano, I). Florence, 1968.

I. GOLD

ROSENBERG, M. *Geschichte der Goldschmiedekunst,* II. Frankfurt am Main, 1915.

J. SILVER

HAYNES, S. 'Drei Silberreliefs im britischen Museum', *J.D.A.I.,* LXXIII (1958), 9–17.

K. IVORY

HULS, Y. *Ivoires d'Étrurie* (Études de philologie, d'archéologie et d'histoire anciennes publiées par l'Institut Historique Belge de Rome, IV). Brussels/Rome, 1957.

L. BRONZE UTENSILS

HAYNES, S. *Etruscan Bronze Utensils.* London, 1965.
MESSERSCHMIDT, F. 'Die "Kandelaber" von Vetulonia', *S. Etr.,* V (1931), 71–84.
RIIS, J. P. 'Rod-tripods', *Acta Archaeologica,* X (1939), 1 ff.

M. CISTAE

DOHRN, T. *Die ficoronische Ciste in der Villa Giulia in Rom* (Monumenta Artis Romanae, XI). Berlin, 1972.

N. MIRRORS

BEAZLEY, J. D. 'The World of the Etruscan Mirror', *J.H.S.,* LXIX (1949), 1–17.
GERHARD, E., KLÜGMAN, A., and KÖRTE, G. *Etruskische Spiegel,* I–V. Berlin, 1840–97.
HERBIG, R. 'Die Kranzspiegelgruppe', *S. Etr.,* XXIV (1955–6), 183–205.
MANSUELLI, G. 'Gli specchi figurati etruschi', *S. Etr.,* XIX (1946), 9–137.
MATTHIES, G. *Die praenestinischen Spiegel.* Strassburg, 1912.
MEYER-PROKOP, I. *Die gravierten etruskischen Griffspiegel archaischen Stils. R.M., XIII. Ergänzungsheft* (1967).
PALLOTTINO, M. 'Uno specchio di Toscana e la leggenda etrusca di Tarchon', *Rendiconti dell'Accademia dei Lincei,* Series 6, VI (1930), 49–87.
REBUFFAT-EMMANUEL, D. *Le Miroir étrusque d'après la Collection du Cabinet des Médailles* (Collection de l'École française de Rome, XX). Rome, 1973.

O. SITULAE

GIULIANI-POMES, M. V. 'Cronologia delle situle rinvenute in Etruria', *S. Etr.,* XXIII (1954), 149–94, and XXV (1957), 39–85.
KASTELIK, J. *Situla Art. Ceremonial Bronzes of Ancient Europe.* New York, Toronto, London, 1965.

P. BUCCHERO

DEL CHIARO, M. 'Etruscan Bucchero Pottery', *Archaeology,* XIX (1966), 98–103.
RICHTER, G. M. A. 'The Technique of Bucchero Ware', *S. Etr.,* X (1936), 61–5, plates 20–3.
SUNKOWSKY, R. 'Eine Bucchero-pesante-Gruppe', *Jahresheft des österreichischen archäologischen Instituts in Wien,* XL (1953), 117–26.
VERZAR, M. 'Eine Gruppe etruskischer Bandhenkelamphoren. Die Entwicklung von der Spiralamphora zur nikosthenischen Form', *Antike Kunst,* XVI, I (1973), 45–56, plates 3–6.

LIST OF ILLUSTRATIONS

Unless otherwise noted, copyright in photographs belongs to the museum, private collection, or other institution given as the location, by whose courtesy they are reproduced. In some cases, despite all efforts, it has been impossible to trace copyright holders. All dates are B.C.

Etrusco-Corinthian pitcher, end of the seventh century. *Rome, Villa Giulia*

39. Bracelet from the Regolini-Galassi Tomb, Cerveteri, *c.* 630. *Vatican, Museo Gregoriano Etrusco* (Anderson, Rome)

40. Large necklace from the Regolini-Galassi Tomb, first half of the seventh century. Gold. *Vatican, Museo Gregoriano Etrusco*

41. Small fibula from the Regolini-Galassi Tomb, first half of the seventh century. Gold. *Vatican, Museo Gregoriano Etrusco*

42. Fibula from Marsiliana d'Albegna, mid seventh century. Gold. *Florence, Museo Archeologico* (Leonard von Matt, Buochs, Switzerland)

43. Bracelet from Vetulonia, mid seventh century. Gold. *Florence, Museo Archeologico*

44 and 45. Bowl from Palestrina, with drawing of concentric bands of ornament on the bottom, late seventh century. Gold. *London, Victoria and Albert Museum*

46. Vase stand from Cerveteri, late seventh century. Impasto. *Rome, Museo Preistorico* (Soprintendenza alla Preistoria e all'Etnografia, Rome)

47. Large amphora, late seventh century. Impasto. *Collection of the American Academy in Rome* (Vasari, Rome)

48. Goblet supported by caryatids from Cerveteri, second half of the seventh century. Bucchero. *Vatican, Museo Gregoriano Etrusco*

49. Goblet from Cerveteri, second half of the seventh century. Bucchero. *Chapel Hill, North Carolina, William Hayes Ackland Memorial Art Center*

50. Guttus with human figure handle from Cerveteri, late seventh century. Bucchero. *Vatican, Museo Gregoriano Etrusco* (Anderson, Rome)

51. Engraved jug from the Tomba Calabrese, Cerveteri, late seventh century. Bucchero. *Vatican, Museo Gregoriano Etrusco*

52. Globular vase from Marsiliana d'Albegna, late seventh century. Impasto. *Florence, Museo Archeologico* (Soprintendenza alle Antichità d'Etruria, Florence)

53. Stamped red-ware storage jar from the Tomba Calabrese, Cerveteri, *c.* 600. *Vatican, Museo Gregoriano Etrusco* (Anderson, Rome)

54. Large disc, late seventh century. Bronze. *The St Louis Art Museum*

55. Disc (breastplate?), late seventh century. Bronze. *The St Louis Art Museum*

56. Statuette of a woman from the Tomba del Duce, Vetulonia, second half of the seventh century. Bronze. *Florence, Museo Archeologico*

57. Statuette of a warrior from Monte Arcosu, Sardinia, probably seventh century. Bronze. *Cagliari, Museo Archeologico* (S. Paretta, Cagliari)

58. Villanovan bit plaque, early seventh century. Bronze. *New York, Albert L. Hartog Collection*

59. Askos with rider on horseback, early seventh century. Impasto. *Bologna, Museo Civico Archeologico* (Fotofast, Bologna)

60. Villanovan statuette of a woman with biconical water jar from Vetulonia, mid seventh century. Bronze. *Florence, Museo Archeologico* (Soprintendenza alle Antichità d'Etruria, Florence)

61. Villanovan handle, late seventh century. Bronze. *New York, Albert L. Hartog Collection*

62. Head of a woman from the Pietrera Tomb, Vetulonia, *c.* 650–630. Sandstone. *Florence, Museo Archeologico* (Soprintendenza alle Antichità d'Etruria, Florence)

63. Torso of a woman from the Pietrera Tomb, Vetulonia, *c.* 650–630. Sandstone. *Florence, Museo Archeologico* (Soprintendenza alle Antichità d'Etruria, Florence)

64. Statuette of a seated man from Cerveteri, *c.* 600. Terracotta. *Rome, Palazzo dei Conservatori (formerly Castellani Collection)* (Dr M. Hürlimann, Zürich)

65. Bust of a woman from Chiusi, late seventh-sixth centuries. Sandstone. *Chiusi, Museo Archeologico* (Leonard von Matt, Buochs)

66. Sphinx from Chiusi, mid sixth century. Sandstone. *Chiusi, Museo Archeologico* (J. Felbermeyer, Rome)

67. Statuettes from Brolio, *c.* 590. Bronze. *Florence, Museo Archeologico* (Leonard von Matt, Buochs)

68. Statuette of a skirted kouros, *c.* 600–570. Bronze. *Florence, Museo Archeologico* (J. Felbermeyer, Rome)

69. Statuette of a skirted kouros, *c.* 600–570. Bronze. *Volterra, Museo Guarnacci* (J. Felbermeyer, Rome)

70. Warrior from Capestrano, mid sixth century. Limestone. *Chieti, Museo Nazionale* (Soprintendenza Antichità degli Abruzzi)

71. Bust of a lady from the Isis Tomb, Vulci, *c.* 600–580. Sheet bronze. *London, British Museum*

72. Standing woman on the Paolozzi funerary urn from Chiusi, late seventh century. Terracotta. *Chiusi, Museo Nazionale* (Leonard von Matt, Buochs)

73. Mask from a Canopic urn, first half of the seventh century. Bronze. *Munich, Antikensammlungen*

74. Canopic urn from Castiglione del Lago, second half of the seventh century. Terracotta. *Florence, Museo Archeologico*

75. Head of a Canopic urn from Dolciano, after 600. Terracotta. *Chiusi, Museo Archeologico* (Leonard von Matt, Buochs)

76. Door relief from Tarquinia, first half of the sixth century. Nenfro. *Tarquinia, Museo Nazionale* (Anderson, Rome)

77. Veii, Tomba Campana, details of rear wall of the first chamber, early sixth century (G. Dennis, *The Cities and Cemeteries of Etruria*, 1878)

78. Stele from Vulci, first half of the sixth century. Nenfro. *Florence, Museo Archeologico* (Soprintendenza alle Antichità d'Etruria, Florence)

127. Tarquinia, Tomb of the Baron, *c*. 500, rear wall (Anderson, Rome)

128. Tarquinia, Tomb of the Baron, *c*. 500, rear wall, central group (Leonard von Matt, Buochs)

129. Micali Painter: Black-figured neck amphora, *c*. 500. *London, British Museum*

130. Micali Painter: Black-figured neck amphora (reverse), *c*. 500. *London, British Museum*

131. Micali Painter: Black-figured neck amphora, *c*. 500–490. *Baltimore, Walters Art Gallery*

132. Black-figured amphora from Vulci, with detail, *c*. 490. *Würzburg, Martin von Wagner Museum*

133. Engraved mirror from southern Etruria, *c*. 500. Bronze. *Munich, Antikensammlungen* (G. Wehrheim, Munich)

134. Engraved mirror from Palestrina, *c*. 490. Bronze. *London, British Museum*

135. Statuette of a kouros from Chiusi, late sixth century. Bronze. *London, British Museum*

136. Statuette of a javelin-thrower from Chiusi, end of the sixth century. Bronze. *London, British Museum*

137. Cinerary urn from Chiusi, *c*. 520–500. Limestone (pietra fetida). *Florence, Museo Archeologico* (A. Egger, Cologne)

138. Cippus base from Chiusi, *c*. 500–490. Limestone (pietra fetida). *Munich, Antikensammlungen* (Hartwig Koppermann, Gauting)

139. Cippus base from Chiusi, *c*. 500–490. Limestone (pietra fetida). *Munich, Antikensammlungen* (Hartwig Koppermann, Gauting)

140. Mask of 'Achelous' on a 'shield' from Tarquinia, *c*. 520–510. Bronze. *Vatican, Museo Gregoriano Etrusco* (Alinari, Florence)

141. Tripod from Vulci, *c*. 510–490. Bronze. *Vatican, Museo Gregoriano Etrusco*

142. Tripod from Populonia, *c*. 530. Bronze. *Copenhagen, National Museum*

143. Hanging spirals on a tripod of Vulci type, early fifth century. Bronze. *New York, Metropolitan Museum of Art* (Fletcher Fund, 1960)

144. Thymaterium (incense burner) from Vulci, end of the sixth century. Bronze. *Vatican, Museo Gregoriano Etrusco* (Anderson, Rome)

145. Thymaterium (incense burner), *c*. 500. Bronze. *London, British Museum*

146. Herakles and Hera, statuettes from a tripod, *c*. 490–475. Bronze. *Copenhagen, Ny Carlsberg Glyptotek*

147. Satyrs, statuettes from a tripod, *c*. 490–475. Bronze. *Copenhagen, Ny Carlsberg Glyptotek*

148. Dioscuri(?), statuettes from a tripod, *c*. 490–475. Bronze. *Copenhagen, Ny Carlsberg Glyptotek*

149. Youth riding a sea monster from Vulci, *c*. 550–540. Nenfro. *Rome, Villa Giulia* (Leonard von Matt, Buochs)

150. Statuette of a girl (Morgan statuette), *c*. 510–500. Bronze. *New York, Metropolitan Museum of Art*

151. Statuette of a youth wearing a toga, *c*. 490–480. Bronze. *London, British Museum*

152. Statuette of a striding woman from Falterona, *c*. 490. Bronze. *London, British Museum*

153. Campanian urn, *c*. 500. Bronze. *(West) Berlin, Staatliche Museen, Antikenabteilung* (Jutta Tistz-Glagow, Berlin)

154. Campanian urn, *c*. 500. Bronze. *New York, Metropolitan Museum of Art*

155 and 156. Campanian urn, with detail of dancers, *c*. 510–500. Bronze. *London, British Museum*

157. Sarcophagus from Procoio di Ceri, mid sixth century. Terracotta. *Rome, Villa Giulia* (Leonard von Matt, Buochs)

158. Sarcophagus with reclining couple, last quarter of the sixth century. Terracotta. *Paris, Louvre* (Archives Photographiques, Paris)

159. Sarcophagus with reclining couple, last quarter of the sixth century. Terracotta. *Rome, Villa Giulia* (Anderson, Rome)

160. Sarcophagus with reclining couple (detail), last quarter of the sixth century. Terracotta. *Paris, Louvre* (Archives Photographiques, Paris)

161. Maenad antefix, late sixth century. Terracotta. *Copenhagen, Ny Carlsberg Glyptotek*

162. Satyr antefix, late sixth century. Terracotta. *Copenhagen, Ny Carlsberg Glyptotek*

163. 'Gigantomachia' relief from Pyrgi, *c*. 510–485. Terracotta. *Rome, Villa Giulia* (Soprintendenza alle Antichità dell'Etruria Meridionale, Rome)

164. Drawing of the Pyrgi columen plaque *in situ* (G. Colonna in *Notizie degli Scavi* (1970), supplement 2, figure 36)

165. Apollo from the Portonaccio Temple, Veii, *c*. 515–490. Terracotta. *Rome, Villa Giulia* (Leonard von Matt, Buochs)

166. Herakles and the Ceryneian Hind (two views) from the Portonaccio Temple, Veii, *c*. 515–490. Terracotta. *Rome, Villa Giulia*

167. Head of Hermes from the Portonaccio Temple, Veii, *c*. 515–490. Terracotta. *Rome, Villa Giulia* (Leonard von Matt, Buochs)

168. Woman and child from the Portonaccio Temple, Veii, *c*. 515–490. Terracotta. *Rome, Villa Giulia* (Leonard von Matt, Buochs)

169. Head of the Apollo from the Portonaccio Temple, Veii, *c*. 515–490. Terracotta. *Rome, Villa Giulia* (Leonard von Matt, Buochs)

170. Gorgon antefix from the Portonaccio Temple, Veii, *c*. 515–490. Terracotta. *Rome, Villa Giulia* (Leonard von Matt, Buochs)

171. Duelling warriors, acroterion from Falerii, *c*. 480. Terracotta. *Rome, Villa Giulia* (Anderson, Rome)

172. Silenus antefix (fragment) from the Capitoline, Rome, late sixth century. Terracotta. *Rome, Capitoline Museum* (Aldo Reale, Rome)

220. Man and woman embracing, statuette group, *c.* 480–470. Bronze. *London, British Museum*

221. Warrior and woman, statuette group from Marzabotto, *c.* 440–430. Bronze. *Bologna, Collection Countess Aria Castelli (S. Etr.,* XXXV, 1967)

222. Discobolus, *c.* 450–425. Suspended bronze statuette. *New York, The Pomerance Collection* (Otto Nelson, New York)

223. Youth from Spina, *c.* 400. Suspended bronze statuette. *Ferrara, Museo Archeologico* (Villani, Bologna)

224. Apollo from Piombino, *c.* 460(?). Bronze. *Paris, Louvre* (M. Chuzeville, Vanves)

225 and 226. Votary (with detail of head), formerly in the Palazzo Sciarra, Rome, *c.* 460–450. Bronze. *Copenhagen, Ny Carlsberg Glyptotek*

227. Statuette of Turan (Aphrodite), second half of the fifth century. Bronze. *Cambridge, Mass., Fogg Museum of Art, Harvard University* (Purchase – Alpheus Hyatt Fund and 24 Friends of the Fogg)

228. Statuette of a votary, late fifth century. Bronze. *Baltimore, Walters Art Gallery*

229. Statuette of a kouros, *c.* 480. Bronze. *(West) Berlin, Staatliche Museen, Antikenabteilung*

230. Statuette of a striding hoplite, *c.* 450. Bronze. *Florence, Museo Archeologico* (Anderson, Rome)

231. Statuette of a spear-thrower, late fifth century. Bronze. *London, British Museum*

232. Statuette of a spear-thrower, late fifth century. Bronze. *London, British Museum*

233. Statuette of a spear-thrower, late fifth century. Bronze. *Perugia, Museo Archeologico (Collezione Mariano Guardabassi)* (J. Felbermeyer, Rome)

234. Statuette of a discobolus, late fifth century. Bronze. *Detroit Institute of Arts*

235. Statuette of a boy holding a patera, late fifth century. Bronze. *Kansas City, William Rockhill Nelson Gallery of Art and Atkins Museum of Fine Arts*

236. Statuette of a young athlete from Monte Capra, late fifth century. Bronze. *Bologna, Museo Civico Archeologico*

237. 'Mars' from Todi, early fourth century. Bronze. *Vatican, Museo Gregoriano Etrusco*

238. Statuette of a horseman, shortly after 430. Bronze. *Detroit Institute of Arts*

239. Bearded head from the Via San Leonardo Temple, Orvieto, shortly after 430. Terracotta. *Orvieto, Museo dell'Opera del Duomo* (A. Egger, Cologne)

240. Male head from the temple at Lo Scasato, Falerii, late fifth century. Terracotta. *Rome, Villa Giulia* (A. Egger, Cologne)

241. 'Malavolta' head from Veii, end of the fifth century. Terracotta. *Rome, Villa Giulia* (A. Egger, Cologne)

242. Mother and child from Chianciano, *c.* 400. Limestone cinerary urn. *Florence, Museo Archeologico* (Alinari, Florence)

243. Banqueter and wife from Città della Pieve, late fifth century. Polychrome alabaster cinerary urn. *Florence, Museo Archeologico* (Brogi, Florence)

244. Banqueter and Vanth, *c.* 400. Limestone cinerary urn. *Florence, Museo Archeologico* (Alinari, Florence)

245. Banqueter, *c.* 400. Bronze cinerary urn. *Leningrad, Hermitage*

246. Sarcophagus from Cerveteri, late fifth century. Campanian limestone. *Vatican, Museo Gregoriano Etrusco* (Anderson, Rome)

247. Head of a young boy, end of the fifth century. Marble or hard limestone. *Toronto, Royal Ontario Museum (formerly L. Curtius Collection)*

248. Wounded Chimaera from Arezzo, second quarter of the fourth century. Bronze. *Florence, Museo Archeologico* (Anderson, Rome)

249. Statuette of Hercules, early fourth century. Bronze. *Paris, Bibliothèque Nationale*

250. Statuette of Hercules, second quarter of the fourth century. Bronze. *London, British Museum*

251. Statuette of a votary, second half of the fourth century. Bronze. *Florence, Museo Archeologico* (Alinari, Florence)

252. Statuettes of 'haruspices', fourth century or later. Bronze. *Rome, Villa Giulia* (Leonard von Matt, Buochs)

253. Statuette of a goddess(?) from the Sanctuary of Diana at Nemi, second half of the fourth century. Bronze. *Paris, Louvre* (M. Chuzeville, Vanves)

254. Finial statuette of a citharist, mid fourth century. Bronze. *Paris, Bibliothèque Nationale*

255. Statuette group of youth and rearing horse, late fourth century. Bronze. *Florence, Museo Archeologico* (Soprintendenza alle Antichità d'Etruria, Florence)

256. Censer base (triskelion) from Vulci, last quarter of the fourth century. Bronze. *Vatican, Museo Gregoriano Etrusco*

257. Statuette of a discobolus on a censer base, mid fourth century. Bronze. *Rome, Villa Giulia* (Leonard von Matt, Buochs)

258. Satyr and winged caryatids on a censer from Todi, late fourth century(?). Bronze. *Rome, Villa Giulia* (Anderson, Rome)

259. Two soldiers carrying a dead comrade. Cista handle from Palestrina, mid fourth century or later. Bronze. *Rome, Villa Giulia* (Moscioni)

260. Statuette of Phrixus on a fire shovel from Palestrina, third quarter of the fourth century. Bronze. *London, British Museum*

261. Tarquinia, Tomb of Orcus I, *c.* 350, 'Velcha'. Wall painting (Anderson, Rome)

262. Tarquinia, Tomb of Orcus II, early third century, Hades and Persephone. Wall painting (Leonard von Matt, Buochs)

299. Reclining couple on a sarcophagus lid from Vulci, mid fourth century. Nenfro. *Boston Museum of Fine Arts*

300. Reclining couple on a sarcophagus lid from Vulci, mid fourth century. Alabaster. *Boston Museum of Fine Arts*

301. Sarcophagus from the Parthunus tomb, Tarquinia, mid third century. Breccia. *Tarquinia, Museo Nazionale* (German Archaeological Institute, Rome)

302. Bearded man on a sarcophagus lid, mid third century. Nenfro. *Tarquinia, Villa Bruschi* (German Archaeological Institute, Rome)

303. Profile 'portraits' on both sides of a Volterra column-krater, late fourth-mid third centuries. *(West) Berlin, Staatliche Museen, Antikenabteilung*

304. Two votive heads, third century. Terracotta. *Vatican, Museo Gregoriano Etrusco* (German Archaeological Institute, Rome)

305. Head of a boy, late fourth century. Bronze. *Florence, Museo Archeologico* (Anderson, Rome)

306. Portrait of a young man, mid third century. Bronze. *Paris, Louvre* (M. Chuzeville, Vanves)

307. Portrait of Arnth Paipnas, before 300. Nenfro. *Tarquinia, Museo Nazionale* (Soprintendenza alle Antichità d'Etruria, Florence)

308. Portrait (two views) of a bearded man ('Brutus'), *c*. 300. Bronze. *Rome, Palazzo dei Conservatori*

309. Cerveteri, Tomb of the Painted Reliefs, early third century, rear wall, centre (Anderson, Rome)

310. Lids of two ash urns from Volterra, second century. Alabaster. *Volterra, Museo Guarnacci* (J. Felbermeyer, Rome)

311. Dionysos and satyr, cista handle from Praeneste, late third century. Bronze. *Palestrina, Museo Archeologico Prenestino* (Alinari, Florence)

312. Lasa, patera handle, late third-early second centuries. Bronze. *Cleveland Museum of Art*

313. Vel Saties and his dwarf Arnza, detail of a wall painting from the François Tomb, Vulci, mid third century. *Rome, Villa Albani* (German Archaeological Institute, Rome)

314. Vanth, detail of a wall painting from the François Tomb, Vulci, mid third century. *Rome, Villa Albani* (German Archaeological Institute, Rome)

315. Cacu and Artile ambushed by Caile and Avle Vipinas on an engraved mirror from Bolsena, third century. Bronze. *London, British Museum* (J. D. Beazley, *J.H.S.*, LXIX, 1949)

316. Scene of haruspication on an engraved mirror from Tuscania, third century. Bronze. *Florence, Museo Archeologico* (Giglioli)

317. Triumph on a Praenestine cista, third century. *(West)* Berlin, Staatliche Museen, Antikenabteilung (Giglioli)

318. Tarquinia, Tomb of the Typhon, second century, Typhon. Wall painting (Anderson, Rome)

319. Tarquinia, Tomb of the Typhon, second century, painted caryatid from the central pillar (M. Cristofani, *Le pitture della Tomba del Tifone, Tarquinii, fasc. 5*)

320. Perugia, Tomb of the Volumnii, house-urn of P. Volumnius, late first century. Marble

321. Perugia, Tomb of the Volumnii, urn of Arnth Velimnas, second half of the second century (Alinari, Florence)

322. Sarcophagus of Seianti Thanunia Tlesnasa (with detail) from Chiusi, mid second century. Terracotta. *London, British Museum*

323. Oedipus and his sons, relief from the ash urn of Avle Cneuna from Volterra, mid second century. Alabaster. *Volterra, Museo Guarnacci*

324. Ariadne discovered by the companions of Dionysus, pediment from Città Alba, late second century. *Bologna, Museo Civico Archeologico* (Villani, Bologna)

325. Priestess or goddess from Lake Nemi, late second century. Bronze. *London, British Museum*

326. Youth sacrificing, late second century. Bronze. *Paris, Louvre* (Giraudon, Paris)

327. Boy playing with a bird, late second century. Bronze. *Vatican, Museo Gregoriano Etrusco* (Anderson, Rome)

328 and 329. Statue of a *togatus* (l'Arringatore), with detail of head, *c*. 90–50. Bronze. *Florence, Museo Archeologico* (German Archaeological Institute, Rome)

The drawings were executed by Mrs Pat Clarke and the map by Mr Donald Bell-Scott.